Barbara Ehrlich White

Renoir

An Intimate Biography

Thames & Hudson

DEDICATION

This book is dedicated to my husband and best friend,
Leon, who, since 1961, has been a constant source of encouragement;
to our sons, Joel and David; to our granddaughters, Ella and Nina;
and to our daughter-in-law, Heidi. Also, I would like to thank
my adviser and mentor, the late Professor Meyer Schapiro who,
in 1961, suggested that I make Renoir the subject of my
doctoral dissertation; this led to my lifelong
study of Renoir.

All paintings illustrated in this book are oil on canvas unless otherwise specified.

First published in 2017 in the
United States of America by
Thames & Hudson Inc.,
500 Fifth Avenue,
New York, New York 10110

www.thamesandhudsonusa.com

Library of Congress Control Number 2017931859

ISBN 978-0-500-23957-5

Printed and bound in China by C&C Offset Printing Co. Ltd

CONTENTS

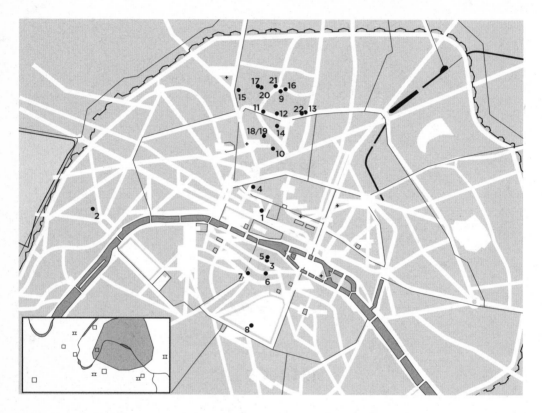

Map of Paris showing Renoir's studios and apartments

ADDRESSES OF RENOIR'S STUDIOS AND APTS:

(1) 23 rue d'Argenteuil, studio and apt (1st arr.)

(2) 43 avenue d'Eylau and apt (16th arr.)

(3) 20 rue Visconti (with Bazille), studio and apt (6th arr.)

(4) 9 rue de la Paix (with Bazille), studio and apt (2nd arr.)

(5) 8 rue des Beaux-Arts (with Bazille) , studio and apt (6th arr.)

(6) 5 rue Taranne (between 170 and 260 boulevard Saint-Germain), studio and apt (6th arr.)

(7) Rue du Dragon, studio and apt (6th arr.)

(8) 34 rue Notre-Dame-des-Champs, studio and apt (6th arr.)

(9) Rue Norvins, studio and apt (18th arr.)

(10) 35 rue Saint-Georges, studio and apt (9th arr.)

(11) 12–14 rue Cortot, studio (18th arr.)

(12) 18 rue Houdon, apt (18th arr.)

(13) 35 boulevard Rochechouart, studio (18th arr.)

(14) 11 boulevard de Clichy, studio (9th arr.)

(15) 15 rue Hégésippe-Moreau, studio (18th arr.)

(16) 13 rue Girardon (6 Allée des Brouillards), house (18th arr.)

(17) 7 rue Tourlaque, studio (18th arr.)

(18) 33 rue de la Rochefoucauld, apt (9th arr.)

(19) 64 rue de la Rochefoucauld, studio (9th arr.)

(20) 43 rue Caulaincourt, apt (18th arr.)

(21) 73 rue Caulaincourt, studio (18th arr.)

(22) 57 bis boulevard Rochechouart (studio and apt) (9th arr.)

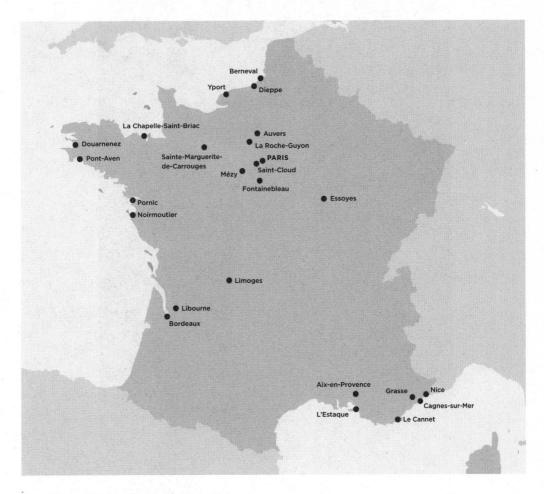

Map of France showing places associated with Renoir

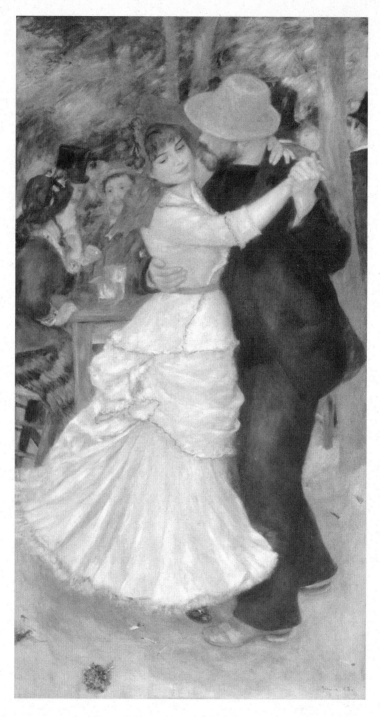

Dance at Bougival, 1883. 179.7 x 96 cm (70⅝ x 37¾ in.).
Museum of Fine Arts, Boston

INTRODUCTION

Jean Renoir's immensely popular 1958 biography, *Renoir, My Father*, is historical fiction, written by Renoir's middle son, the internationally renowned director and producer of forty-one films.[1] Jean affirms his intent in his preface: '*The Reader*: It is not Renoir you are presenting to us, but your own conception of him. *The Author*: Of course, History is a subjective genre, after all.'[2] Professor Robert L. Herbert writes in his introduction to the latest, 2001, edition of *Renoir, My Father*: 'the appeal and the value of Jean Renoir's book is in his imaginative reconstruction of the time and the personages of his father's paintings'.[3] Here Herbert does not say 'of his father', but 'of his father's paintings'. In *Renoir, My Father*, paintings such as *Dancing at the Moulin de la Galette* and *Luncheon of the Boating Party* come alive but the character and personality of Renoir remain elusive.

In 1919, when Jean Renoir was twenty-five, his father died aged seventy-eight. Forty years later, in 1958, Jean wrote *Renoir, My Father*. This loving tribute is censored. Jean and his brothers learned from their father's will, which they saw only after his death, that Renoir had been a devoted father to a secret illegitimate daughter.[4] Jean also knew that his parents' marriage changed from a love affair to estrangement. In *Renoir, My Father*, Renoir's daughter is not mentioned; Jean portrays his parents' marriage as happy. Jean's book has no bibliography and no notes. It quotes two undated letters from Jean's mother to his father. It was not Jean's intention to help the reader understand Renoir's character or personality.

Unlike *Renoir, My Father*, my biography is the result of fifty-six years of professional concentration on Renoir's paintings, character and personality. *Renoir: An Intimate Biography* is based on the factual evidence of more than three thousand letters written by, to and about Renoir during his lifetime, as well as diaries and contemporary interviews. This life story is the culmination of my insatiable fascination with the great painter Renoir: a 1961 doctoral dissertation written under the direction of the brilliant Professor Meyer Schapiro at Columbia University; a 1978 anthology, *Impressionism in Perspective*; a 1984 book, *Renoir: His Life, Art, and Letters*, that is still in print; a 1996 book, *Impressionists Side by Side*, that includes one chapter on Renoir and Monet and one on Renoir and Berthe Morisot; a 2005 chapter in a book on Jean Renoir and Renoir; and articles in scholarly journals about Renoir, as well as more than forty years of university teaching and public lectures about Renoir.[5]

While Jean Renoir's memoir is moving as a loving tribute by a son to his father, *Renoir: An Intimate Biography* informs the reader that Renoir was an inspiring and heroic individual who overcame daunting obstacles – thirty years of poverty followed by thirty years of paralysing illness. Throughout these sixty years Renoir was not only extremely prolific but also amazingly generous.

Pierre-Auguste Renoir is one of the greatest and most creative artists who ever lived. He made 4,654 original works of art: 4,019 paintings, 148 pastels, 382 drawings and 105 watercolours.[6] Today his international popularity is evident: his works hang in museums around the world (see the Appendix) and he is recognized as one of the supreme Impressionists.[7] His contemporaries, too, recognized his genius: in 1914, when Matisse, Monet and Picasso were well known, the art critic Guillaume Apollinaire placed Renoir above them all by declaring: 'Renoir [is] the greatest living painter, whose least production is hungrily awaited by a whole legion of dealers and collectors.'[8]

Since there is no Renoir anthology of letters, in 1961 I began collecting copies of published and unpublished letters by, to and about Renoir written during his lifetime. In writing *Renoir: His Life, Art, and Letters*, I knew about 1,000 such letters. Throughout the subsequent thirty years, I have collected copies of an additional 2,000 letters, many of which were unpublished: they came from the heirs of the family of Renoir's illegitimate daughter, Jeanne Tréhot; from the heirs of Renoir's son Coco, who inherited the family's letter archive; from the heirs of Renoir's sons Pierre and Jean; from the heirs of Renoir's fellow artists, friends and patrons; from the heirs of Renoir's dealer Durand-Ruel; from the recently opened public archives of Mary Cassatt's letters at the Metropolitan Museum in New York,[9] of Vollard's correspondence at the Bibliothèque des Musées Nationaux in Paris, of Albert André's correspondence at the Fondation Custodia in Paris, as well as from catalogues of letter sales, from letter dealers and from letter archives.[10] Hence, this biography is based on knowledge of the contents of more than 3,000 letters by, to and about Renoir. Embedded in my text are quotations from 1,100 letters, including 452 short quotations from 346 unpublished letters. These letters are powerful time-capsules that enable us to be in direct contact with Renoir and his contemporaries through their words.

In my search for letters, I was fortunate enough to meet several people who knew Renoir: Renoir's son Coco, his nephew Edmond Renoir junior, Julie Manet Rouart and Philippe Gangnat. Besides in-person interviews, they all owned letters that they allowed me to copy.

These three thousand letters by, to and about Renoir that were written during his lifetime shed light on his relationships, especially on those with key women in his life. They include Renoir's letters to his illegitimate daughter, Jeanne Tréhot; to his model and wife, Aline Charigot; to others that mention his later model and companion, Gabrielle Renard; to the Impressionist artist, Berthe Morisot, and to her daughter, Julie Manet, whose seven-year diary sheds light on Renoir's close relationship with her mother, with her and with her cousins; and Renoir's letters to his student, Jeanne Baudot.

The extraordinarily gregarious Renoir also had many important relationships with men, all of which are clarified and documented in letters. These include interactions with his sons (Pierre, Jean, Coco); with artist friends (André, Bonnard, Bazille, Caillebotte, Cézanne, Degas, Denis, Manet, Matisse, Monet, Sisley); with patron friends (Bérard, Charpentier, Duret, Gallimard, Gangnat); with dealer friends (Bernheim, Durand-Ruel, Vollard); and with his dealers' sons (Charles, Georges, and Joseph Durand-Ruel, Gaston and Josse Bernheim).

Friendships with men and women even extended into the next generation since Renoir was warm and supportive of his friends' children, especially Berthe Morisot's daughter, Julie Manet; Rivière's daughter, Renée; Cézanne's son, Paul Cézanne junior.

Renoir's important interactions with these women and men, as revealed through letters and diaries, enable us to understand better the complex, maddeningly ambivalent, yet endearing Renoir. Based on this primary source information, we can explore the central question of this biography: what was Renoir's character and personality?

On this subject, Renoir's friend, the artist Camille Pissarro, was most insightful in 1887 when he wrote: 'Who can fathom that most inconsistent of men?'[11] Pissarro's word 'inconsistent' can also be translated as changeable, enigmatic, fickle and unpredictable. From my perspective, the best translation of Pissarro's 'inconsistent' is 'unfathomable'. Indeed, Renoir was conflict-avoiding, double-talking, secretive, shrewd and even sneaky. To stay in the good graces of those on whom he depended, he ingratiated himself with friends of different opinions whose favour he needed. This led him sometimes to express diverse thoughts on the same topic to different acquaintances. Like many people, Renoir's dependent and needy behaviour was often contradictory. At one time or another, he could be gregarious or timid, generous or stingy, passive or aggressive, dependent or independent, indecisive or strong-minded and open or secretive.

Renoir's avowals often contradicted his actions. For example, he wrote to his patrons, the Charpentiers, that he was 'the timid man' yet, at the same time, he regularly asked them for money; he also requested to draw 'the fashion of the week' in their weekly newspaper, and asked them to give his journalist brother, Edmond, a job. Shrewd and calculating, he was more than willing to manipulate those around him to get his way. To avoid conflict, Renoir frequently operated behind people's backs rather than confronting them. For example, he never told his eventual wife, Aline, that he had fathered a child eight years before they met – a child he had resolved not to abandon. Renoir's motive for keeping this secret was to prevent Aline from interfering in his relationship with his beloved daughter, who strikingly resembled her parents – Renoir and his model and first love, Lise. Another example of his shrewd cunning is more mundane: after Aline had picked out an apartment that Renoir did not like, Renoir arranged that she be told 'the landlord does not want any painters' so as to avoid a confrontation.[12]

The complexity of his interactions no doubt worsened Renoir's lifelong high level of anxiety. He had a nervous tick; patrons described his 'unbearable nervous movements', when he constantly rubbed his index finger under his nose.[13] When he was mobile, he constantly paced back and forth. Throughout his life he chain-smoked but, luckily, never developed lung cancer.

Beyond Renoir's wheeler-dealer, manipulative and self-serving character, the letters also reveal his basic generosity, goodness and loyalty to family and friends. Most surprising was his fifty-year secret relationship with his daughter, Jeanne, whose mother never contacted her. Renoir, in contrast, steadfastly supported her. At Jeanne's moment of greatest need (when she had a probable miscarriage at the same time that her husband died), Renoir wrote her: 'I have never abandoned you. I am doing what I can. I have no reason not to take care of you.'[14] Besides his faithfulness to his daughter, he was generous to his friends. For example, Renoir found a patron and an art dealer for Cézanne, who was the artist he most admired. Also, Renoir was extraordinarily generous with his time throughout four years during which he gave psychological support to the young Julie Manet after the death of both of her parents; at the same time he extended this kindness to Julie's two orphan cousins, Jeannie and Paule Gobillard. Renoir was likewise generous to Caillebotte, to Cézanne's son, Paul Cézanne junior, to Berthe Morisot, to Rivière's daughters, Hélène and Renée, to many young artists (including André, Bonnard, Denis, Matisse, Schnerb).

Renoir's generosity extended to men and women, young and old, rich and poor, Catholic, Protestant and Jewish.

We now may wonder why the gregarious Renoir placed so much value in avoiding conflict with those around him. During the six decades that he painted, he was consistently struggling – first, with almost thirty years of poverty or precarious finances, and then, with thirty years of progressive paralysis from rheumatoid arthritis. Renoir came from a lower-class artisan background. His family's patriarch, his father's father, had been abandoned at birth and then rescued by a wooden-shoemaker and his family. This most humble beginning was the core of Renoir's modest and grateful attitude towards the world. Renoir always felt like an outsider in the upper-class art world. Friends were a lifeline for him; they were the source of the financial help, professional contacts and companionship that enabled him to paint despite continuous daunting obstacles. To confront a friend would be to endanger not only the relationship he valued on an emotional level but also his chance of survival as an artist in a world in which he always felt like an interloper.

In a career of almost sixty years and despite the many hardships he suffered, Renoir created more than four thousand paintings that celebrate beauty, joyfulness and sensuality. His images were his ideal and his escape, not his real world. With all of the complications and problems in his personal life, his work was a 'grand illusion' (Jean Renoir's greatest movie was *Grand Illusion*, in which, as in all of his films, there are similarities to his father's paintings).[15] In contrast to his anxious personality, the people in his paintings are calm and relaxed. During his last three decades, when sickness caused him to become weak and shrivelled, his figures became increasingly vigorous and voluptuous. In fact, Renoir was aware of the made-up world that he was creating for others and for himself. Nine years before his death, he wrote: 'Thanks be to painting which even late in life still furnishes illusions and sometimes joy.'[16]

Renoir was passionately in love with painting – both the process and the result. When fifty-five years old, he wrote to a minor painter: 'I also really enjoyed hearing about your painting.... You yourself have to be thrilled with what your own brain does well in order to excite others. I think it is the only way [to excite others].... I am painting lots of [paintings of two-year-old] Jean these days, and I assure you that this is not easy but it is so pretty. And I assure you that I am working for myself, only for myself.'[17] At his death, Renoir's studios contained more than 720 of his paintings, which reveals his attachment to his creations.

What was most tragic in Renoir's life was the change in his ability to paint because of the progressive paralysis of his fingers from rheumatoid arthritis. While Renoir was poor, he had no physical disabilities. Beginning in 1864 when he was twenty-three and throughout the next twenty-four years, his painting was at its most brilliant. However, in 1888, when Renoir was forty-seven, his health began to suffer from the progressive paralysis of his fingers. By 1890, he had finally achieved fame and fortune: the international recognition of the superb quality of his paintings. Sadly, throughout the thirty-one years from 1888 until his death in 1919, Renoir's fingers became more distorted, making it more difficult to paint detail. In essence, Renoir was painting with a severe disability. Nonetheless, in a heroic display of self-confidence, determination and courage, he continued to paint every day, as a 1915 video of him painting aged seventy-four shows us today.[18] Until the end, Renoir painted with optimism, as his friend André relayed to his dealer in 1917, 'as if he had forty more years to live'.[19] Knowing full well that because of his disability his later painting was usually not as accomplished as formerly, nonetheless Renoir continued painting every day. For him, 'good enough' painting with his handicap was much better than not painting at all. This is an extraordinary example of modesty, courage, generosity and optimism that benefited his two sons, who both became disabled by war injuries. This inspiring attitude towards his work continues to benefit all who are lucky enough to learn about it.

Renoir's heroic behaviour was eloquently described a year before his death by one of his young artist friends, Theo van Rijsselberghe (or Rysselberghe, 1892–1926), who was a Belgian painter born in Ghent. He wrote to his wife in 1918: 'I can't adequately describe how impressed I was by my visit to Renoir; it is pathetic, painful and at the same time very inspiring to see a being, infirm and physically disabled to such a degree, unimaginably really, retain such an ardour, such a need to create, always, always, and again. His studio is full of *hundreds*, that's right, hundreds of recent paintings. There are atrocious ones and there are very beautiful ones, there are bewildering ones, but to see this man, full of life, of fire, of faith and ardour, but mutilated, half devoured by gangrene, no longer able to stand up or use his hands, which he no longer has, one is mystified and admiring. I understand that after having seen such a sight, one has an immense respect for such a human will.'[20] Today we can see what van Rijsselberghe found so inspiring by watching the 1915 video of Renoir painting.

Many things that Renoir did, including painting despite his disability, contradict his self-avowed passivity (as a friend told him he often said): 'Sometimes we resemble a cork in the water and we never know where it will lead us.'[21] When Renoir said this, he was a paralysed cripple who was totally dependent on many people, yet, as always, behind the scenes, he carried on being a shrewd wheeler-dealer. Basically, he felt that his friends would be more generous if they believed him to be docile. However, those who knew him well doubtless came to understand that he was not passive but was the clever master of his fate.

Renoir was indeed smart. Despite ending his formal education at the age of twelve, he communicated his ideas about decorative and functional arts and crafts to the general public on several occasions. Artists who exhibited with the Impressionists (Caillebotte, Cassatt, Cézanne, Degas, Manet, Monet, Morisot, Pissarro and Sisley) were all from upper-class and middle-class backgrounds and were better educated than was Renoir. Yet none of them wrote for the public. Perhaps Renoir was inspired to write by his eldest brother Pierre-Henri, nine years older than Renoir, a gem-engraver and medallist, who, when Renoir was twenty-two, published a book-length manual of engraved monograms and later published two other books (see Chapter 1). Renoir's eight years younger brother, Edmond, also wanted to communicate through words and became a journalist.

All of Renoir's publications are pleas to support craftworkers against the machine, which threatened to replace them. Renoir's childhood work as an apprentice in a porcelain factory is relevant. At twelve, he began his career as an artisan and decorator. He was employed by the Lévy porcelain business to copy rococo images on plates and vases. After a few years, the Lévys, victims of 'progress', went out of business when new mechanical methods replaced hand-painting on porcelain. Renoir and many of his craftworking friends lost their jobs. In his opinion, not only was the machine-made dinnerware inferior, but many skilled workers also lost their ability to have a useful, enjoyable life.

Renoir's three publications, in 1877, 1884 and 1911, were all fuelled by his disappointment that craftworkers were now devalued. He hoped that making his ideas public might help support these skilled artisans against the machines. These writings also show Renoir's point of view as that of a humble worker, not of a genius artist. Renoir never forgot his shoemaker grandfather, tailor father and seamstress grandmother and mother. Throughout his life, he disdained material things and ostentation and extolled the virtues of his humble beginnings.[22] These articles appeared when he was thirty-six, forty-three and seventy.

In each case, he turned to a writer friend to help him edit his words. Each article was a collaboration somewhat like that with a sculptor, Guino, who translated his paintings and drawings into sculptures and reliefs from 1913 until 1917, and with Renoir's sons Jean and Coco, who translated his oil sketches into pottery from 1916 until his death in 1919.

In 1877, Renoir suggested to a friend, the writer and government official Georges Rivière, that he write and edit a weekly journal, *L'Impressionniste: journal d'art*, throughout the four weeks of the third Impressionist group show. Included in Rivière's publication were two articles by Renoir that Rivière edited. Both articles were signed 'a painter' but, clearly, the ideas are Renoir's: modern architecture is becoming mechanical and unfair to craftsmen, who are better able to do architectural decoration.[23]

For the 1884 article, Renoir collaborated with Pissarro's cousin, the lawyer Lionel Nunès, who wrote up Renoir's idea for a community of workers and artists, 'The Society of Irregularists'. Its platform suggests exhibiting works in all media derived from a close study of nature. Here Renoir was expanding the idea that a basic characteristic of Impressionist painting was irregularity and that the Impressionists were devoted 'to the unregimented, the spontaneous, and the natural'.[24] Renoir contrasted the nineteenth-century academic art favoured by the yearly government-sponsored Salons with irregularity, unregimented and natural art and crafts. He proposed to unite all the crafts and arts in one society. Their exhibitions would include works by painters, decorators, architects, goldsmiths and embroiderers who based their forms on nature's irregularity, who avoided repetition and copying, and who executed everything by hand. As with his 1877 writing, Renoir expressed his criticism of modern mechanization that was putting the artisan out of work.

Twenty-seven years later, in 1911, Renoir collaborated with the painter Maurice Denis and again with Georges Rivière, both of whom helped edit his ideas in a preface that 'is a lament over the loss of the healthy workshop tradition of Cennino Cennini's era'.[25] Renoir's preface to a new edition of Cennini's late fourteenth-century Renaissance treatise describes how to make frescoes. Again here, Renoir expresses his dislike of modern mechanization. It is also 'Renoir's admiration of the Renaissance workshop tradition [that] implies a recognition of such a hierarchical organization, because he so constantly praised collaboration under the leadership of a master'.[26] Even at the end of his life, when he had achieved worldwide fame and his paintings hung in great museums, Renoir

continued to consider himself a humble artisan, a craftsman of painting, rather than an artistic genius.[27]

While Renoir was worshipped during his lifetime, today he is unfairly and inaccurately denigrated and accused of being an anti-Semite and sexist.[28] I believe Renoir was neither. These allegations are unfair, though occasionally he did make anti-Semitic remarks. In these cases, Renoir was acting like ninety per cent of the French press and like most men and women during the Dreyfus Affair of the late nineteenth and early twentieth centuries. It is worth noting that Renoir worked with the prominent Jewish art dealers, the Bernheims, for his 1913 retrospective. I shall have more to say on this in Chapter 4. As noted earlier, in order to stay in the good graces of those on whom he depended, Renoir ingratiated himself with friends whose favour he needed. This led him to express different opinions to different people, including occasional anti-Semitic or anti-feminist comments (without real hatred or sexism behind such comments).

Renoir's conduct shows that he did not hate Jews. On the contrary, he was close to his Jewish sister-in-law, Blanche Marie Renoir,[29] Jewish patrons and Jewish friends, among them the Bernheims, Cahen d'Anvers, Ephrussi, Fould, Halphen, Mendès and Natanson. Indeed, Renoir was the only Impressionist who frequently (fifteen times) exhibited with the Jewish Parisian dealers, the Bernheims, throughout the Dreyfus Affair and afterwards. Nonetheless, Renoir's wheeler-dealer personality, his manipulativeness, his complex allegiances and the period in which he lived caused him, when with staunchly anti-Semitic friends (including Degas and Julie Manet), occasionally to make prejudiced statements in order to keep their approval. However, Renoir's behaviour was never anti-Semitic.

Sexism, too, was a cultural phenomenon throughout Renoir's lifetime. Most French men and women were patriarchal and treated women as second-class citizens. Indeed, throughout centuries of the reign of kings, France never had a ruling queen, even though the kings often had daughters. Most relevant is France's sexist attitude towards allowing women's voice to be heard: France did not allow women to vote until 1944. In contrast, in Great Britain, women over the age of thirty could vote starting in 1918 and, ten years later, younger women had a right to vote equal to men; in the United States, women could vote starting in 1920. At least nineteen other countries allowed women to vote between 1906 and 1942.[30]

In the context of France's pervasive sexism, Renoir was generous to women in his professional and personal life. Among all his fellow Impressionists, Renoir

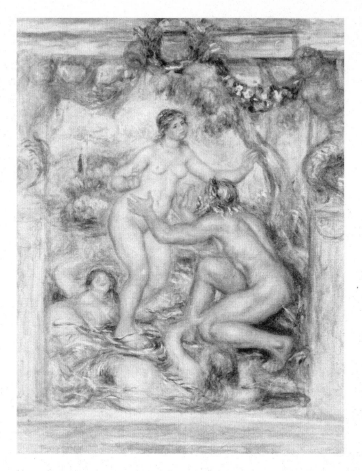

The Saône River throwing Herself into the Arms of the Rhône River, 1915.
102.2 x 84 cm (40¼ x 33⅛ in.). Matsuoka Museum, Tokyo

forged the closest working relationship with the painter Berthe Morisot. It was a platonic and mutually supportive friendship that transcended both social distinctions and gender, between a cultured upper-class woman and a plebeian artisan-class man. Of their friendship, Morisot's daughter wrote: 'M. Mallarmé and M. Renoir were the most intimate friends, the constant visitors on Thursday evenings.'[31] Renoir and Morisot worked together and even painted side by side.[32] Among all his contemporaries, Renoir was the staunchest defender of Morisot's art both during her lifetime and after her death. As he wrote to his dealer: 'exhibit my work with artists like Monet, Sisley, Morisot, etc. and I'm your man, for that's no longer politics, it's pure art.'[33] At his death, Renoir's art collection included

several works by Morisot.[34] Nonetheless, at a time when he was close to Berthe Morisot, he wrote that 'the woman artist is completely ridiculous'.[35] Yet at the same time, he defied the social norms by supporting the career ambitions not only of Morisot but also of his painting student Jeanne Baudot, the singing ambition of Renée Rivière and the possible property ambitions of his secret daughter, Jeanne. Truly, Renoir was complicated.

Renoir painted the *Dance at Bougival* (see page 8) when he was forty-two years old and the personification of the Saône river throwing herself into the arms of the Rhône (see opposite) when he was seventy-four. In these and in all of his images throughout sixty years, Renoir was never a sexist; rather, he celebrated women's beauty and sexuality. Nonetheless, some art critics and scholars accuse Renoir of being sexist because of the sensual ways he portrayed nude women.[36] However, in his art and life, there is no evidence that Renoir believed women to be inferior to men. Indeed, he spent sixty years elevating women's position by celebrating their physical attractiveness and personal value. In this manner, Renoir is the heir to Titian and Rubens, the greatest past artists who celebrated women's beauty. Yet Renoir went beyond his Renaissance and Baroque forebears by his Impressionist freedom, his warm sensuous palette, his mobile and visible strokes and his open and imprecise forms. It would be just as ludicrous to denounce Titian and Rubens as sexists as to denounce Renoir, since all three of these artists spent their lives searching for ways to make women more beautiful, more powerful and more esteemed. So, with Renoir's complexity in mind, we now progress to the artist's life story aided by his words from his extraordinary letters and from those by his friends.

1841–77

**Renoir to age 36;
a Bohemian Leader among the Impressionists;
Model Lise and their Secret Children, Pierre and Jeanne**

In November 1861, when he was only twenty, Renoir made one of the most fortuitous decisions he ever took: to study in the Parisian studio of the Swiss painter, Charles Gleyre. A photograph around this time reveals that Renoir was a serious, intense young man. Gleyre's studio was simply one of many that fed into the École des Beaux-Arts (the government-sponsored art school in Paris), where students learned anatomy and perspective through drawing and painting. The men Renoir met at Gleyre's would become some of the most important companions of his life. About a year after he arrived, first Alfred Sisley in October, then Frédéric Bazille in November and lastly Claude Monet in December 1862 became fellow students.[1] On 31 December 1862, the four were already close friends when they met at Bazille's home in Paris to celebrate the New Year together.[2] Through these friends, Renoir met Paul Cézanne and Camille Pissarro, studying nearby at the Académie Suisse. These artists would not only become lifelong friends, but would also be of critical importance for Renoir's artistic development. In his early twenties, Renoir also made the acquaintances of Édouard Manet and Edgar Degas. Through them, he later met the two women artists, Berthe Morisot and Mary Cassatt. By the early 1870s, all of these painters would form the core of the Impressionist movement. Renoir's charming, gregarious nature allowed him to make friendships despite his lower-class origins. He differed from his new artist friends in that only he came from a lower-class artisan family. The others were from a higher social class, giving them more education and better artistic connections. Bazille, Cassatt, Degas, Manet, Morisot and Sisley were from the upper class, while Cézanne, Monet and Pissarro were from the middle class. When Renoir was around forty, he summarized the origins

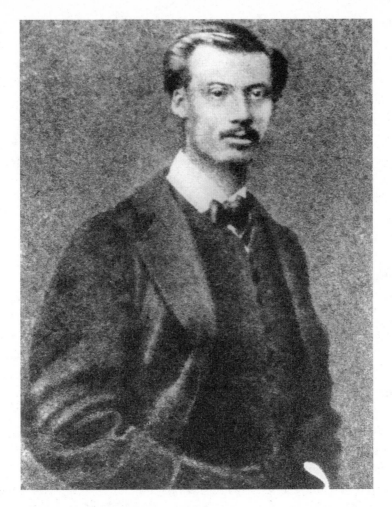

Renoir, 1861. Photographer unknown

of his training: 'Not having rich parents and wanting to be a painter, began by way of crafts: porcelain, faience, blinds, paintings in cafés.'[3] Despite his artisan beginnings, Renoir's more affluent friends saw his lower-class roots as no impediment to his artistic genius. From the beginning of their friendships, when Renoir was short of money to buy paints or food, or needed a place to work or sleep, he was not averse to asking his friends for help, and they were generous, often treating him as if he were a member of their family. It was not only his modest origins that distinguished Renoir, but also his nervous disposition, which was exacerbated by his status as an outsider. Nonetheless, he was beloved and held

in high esteem by many. Edmond Maître, an haute-bourgeois friend of Bazille and a friend of the young painter Jacques-Émile Blanche, expressed his astonishment and pleasure that someone from such humble origins and with such anxiety was able to be a man of character and value. Blanche quoted Maître's description of Renoir aged forty-one: "'When Renoir is cheerful, which is rare, and when he feels free, which is just as rare, he speaks very enthusiastically, in a very unpredictable language that is particular to him and does not displease cultured people. In addition, there is within this person such great honesty and such great kindness, that hearing him talk has always done me good. He is full of common sense, on a closer look, yes, common sense and modesty, and in the most innocent and quiet manner, he relentlessly produces his diverse and refined work, which will make future connoisseurs' heads spin.'"[4]

Renoir's background was more modest than Maître knew: the painter's grandfather, born in 1773, during the reign of Louis XV, in Limoges in central France, had been left as a newborn on the steps of the town's cathedral. That Renoir's grandfather had been abandoned might explain the artist's later sympathy towards his own and others' illegitimate children. His grandfather's birth certificate reads: 'The year of our Lord 1773 and on the eighth of the month of January was baptized...an abandoned newborn boy on whom was bestowed the name François.'[5] Abandoned children were given the last name of their adoptive family. A Limoges family named Renouard took in the child. Twenty-three years later, when François married, the scribe asked for his last name. At the time of his betrothal in 1796, neither François nor his bride-to-be could read or write. When François said 'Renouard', which, in French, is pronounced the same as 'Renoir', the scribe wrote 'Renoir' and thereby invented the family name, since there were no Renoirs in Limoges previously.[6] At the time of his marriage, twenty-two-year-old François was a wooden-shoemaker. His bride, Anne Régnier, three years his senior, came from an artisan family in Limoges: her father was a carpenter and her mother, a seamstress.

François's eldest child (Renoir's father), Léonard, was born in Limoges in 1799 during the French Revolution.[7] He became a tailor of men's clothing. When twenty-nine, he married a dressmaker's assistant, Marguerite Merlet, aged twenty-one, who was born in the rural town of Saintes.[8] Her father, Louis, was also a men's tailor; her mother had no profession. Renoir's parents had seven children of whom the first two died in infancy. The artist was the fourth of the surviving five. Renoir and his three elder siblings were born in Limoges. At

Renoir's birth, Pierre-Henri was 9 (born in February 1832), Marie-Elisa (called Lisa, born in February 1833) was 8 and Léonard-Victor (called Victor, born in May 1836) was 4½.[9]

Pierre-Auguste was known simply as Auguste. His birth certificate states: 'Today, 25 February 1841, at 3 in the afternoon...Léonard Renoir, 41-year-old tailor, residing on boulevard Sainte-Catherine [today boulevard Gambetta]... presented us with a child of masculine gender who would have the first names Pierre-Auguste, born at his home this morning...to Marguerite Merlet, [Léonard's] 33-year-old wife.'[10] When the artist was born, his parents had been married for thirteen years. Since the family was Catholic, on the day of his birth, Pierre-Auguste was baptized at the church of Saint-Michel-des-Lions.

When Renoir's paternal grandfather died in May 1845, Renoir's father moved his family to Paris.[11] At this time, many tailors from the provinces were drawn to the French capital whose population was then under a million.[12] The family travelled by the only available means of transport, a horse-drawn carriage. They found lodgings near the Louvre museum and the Protestant church, the Temple de l'Oratoire, on rue de la Bibliothèque, now in the first arrondissement.[13] Here, when Renoir was eight, his youngest brother, Victor-Edmond (called Edmond), was born in May 1849.

A year prior to Edmond's birth, when Renoir was seven, and for the next six years, he went to a Catholic school run by the Frères des Écoles Chrétiennes (Brothers of Christian Schools). At the same time, Renoir was chosen to sing in Charles-François Gounod's choir at the church of Saint-Eustache in central Paris (from 1852, Gounod was the conductor of the Orphéon Choral Society in Paris). Despite being in a Catholic school and choir, after his youth, according to his son, 'Renoir seldom if ever set foot in a church.'[14]

At some time between 1852 and 1855, because of Baron Haussmann's modernization of Paris, Renoir's family was evicted from their old apartment.[15] Haussmann's renovations replaced old, narrow, dirty streets and crumbling buildings with wide, tree-lined boulevards with elegant structures and effective city sewers. The Renoirs moved a few blocks away to 23 rue d'Argenteuil in today's first arrondissement. That apartment's archives state that a men's tailor, Léonard 'Raynouard', rented rooms on the fifth and sixth floors (America's sixth and seventh floors). The building was described: 'There is a store and thirty-three rented apartments for industrial and construction workers of modest means.'[16] Renoir's parents and their five children lived in three small rooms on the fifth

floor. Their sixth-floor room was probably used for Léonard's tailoring business and for Marguerite's dressmaking.[17] The Renoir family stayed at this address until 1868, when Léonard and Marguerite retired to the suburb of Louveciennes. Having Renoir's childhood home near the Louvre was a happy coincidence, since this great museum had been free and open to the general public at weekends since 1793, and artists could enter any day of the week.

Renoir's eldest brother, Pierre-Henri, followed the family tradition and became an artisan. He trained to be a medallist and gem engraver under Samuel Daniel, an older Jewish man. Daniel took Pierre-Henri under his wing, introducing the young man to his companion Joséphine Blanche, a seamstress, and to their (illegitimate) daughter Blanche Marie Blanc, who was nine years younger than Pierre-Henri. Daniel was Blanche's legal guardian (*tuter datif*), and the family lived at 58 rue Neuve Saint-Augustin. In July 1861, Pierre-Henri and Blanche married, so Renoir had a sister-in-law who was both illegitimate and half-Jewish.[18] When Daniel retired in 1879, Pierre-Henri took over his engraving business. By this point, he had become an authority on the engraving of interlaced ornaments and had, in 1863, published a manual of monograms that, four years later, was translated into English as *Complete Collection of Figures and Initials*.[19] Pierre-Henri later wrote and published two other books.[20] The painter Renoir's various attempts at writing for publication in 1877, 1884 and 1911 were modelled on his older brother's examples.

In 1854 when Renoir was twelve or thirteen, his family's financial needs required that he leave school and go to work. His parents decided that he should follow Pierre-Henri into an artisan trade; it could well have been that Henri's employer was friends with to Théodore and Henri Lévy of Entreprise Lévy, who were described as 'bronze manufacturers' and 'painters, decorators, and gilders on porcelain'.[21] Since Renoir showed artistic ability and since the family came from Limoges, a city renowned for porcelain, his parents thought he might be good at painting on porcelain vases, plates and cups. As a trade, it was closest to easel painting, so that apprentices became skilled in painting. Such workers could also earn substantially more per day than the 3.6 francs that tailors typically earned.[22] Renoir began an apprenticeship at the porcelain-painting workshop of Lévy Frères at 76 rue des Fossés-du-Temple (now rue Amelot, eleventh arrondissement), where he probably worked for four or five years until 1858.[23] As an apprentice, Renoir copied rococo images of flowers and figures. At this time, paintings by Watteau, Fragonard and Boucher were

popular, some recently having been acquired by the Louvre.[24] Renoir saved some of his porcelains, such as 'two vases decorated with flower bouquets, initialed "AR" with the date 1855',[25] as well as meticulous pencil drawings, such as *Birds and Tambourines*.[26] Renoir also saved a pair of vase-shaped chandeliers with a nude figure on the front and a shield on the reverse, and three related pencil drawings.[27] After a few years, when industrialization came to porcelain decoration, Renoir lost his job and began work painting images on window blinds and screens on gauze, calico or oil paper for apartments, shops and steamboats. For two years, he worked for a M. Gilbert at 63 rue du Bac, not far from the École des Beaux-Arts on the Left Bank of the Seine.[28]

While working during the day in this period, Renoir began studying drawing at night at the free municipal drawing school run by the sculptor Louis-Denis Caillouette, the director of the École de Dessin et des Arts Décoratifs, on rue des Petits Carreaux, in today's second arrondissement.[29] Part of the school's method was to have students copy art from the past. At eighteen, on 24 January 1860, Renoir was granted permission to make copies in pencil or oil of works in the Louvre, both in the galleries and in the drawing collection; this permission was renewed throughout the next five years.[30] Renoir treasured some of these early copies (giving some to his nephew Edmond), many of which are classical in style and theme: a detailed pencil drawing of *Hector and Paris*, a painted copy of *Venus and Cupid* (both 1860), a drawing of *Homer with Shepherds* (signed 'Renoir. January 11, 1861'), and a pencil and black chalk copy of a *Bacchanale* (signed 'Renoir. June 15, 1861').[31] Also that year, he painted a copy of Rubens's *The Enthronement of Marie de Medici*. Two years later, Renoir also executed a painted copy of Rubens's *Hélène Fourment* with her son (see page 81).[32] When still an artisan, Renoir's early fascination with Rubens led him to be nicknamed 'Monsieur Rubens', as his younger brother, Edmond, a journalist, explained in an article about Renoir's experiences in the Lévy porcelain workshop: 'After a few months of apprenticeship, Renoir was asked to paint on porcelain objects that were usually given to the workers. This gave way to jeers. They [the fellow workers] nicknamed him M. Rubens, as a joke – and he would cry because they were making fun of him.'[33] Edmond later owned a gravy boat decorated by Renoir with a copy of Boucher's *Diana at the Bath*.[34]

Aside from copies, Renoir was also painting on his own as early as his late teens. He made a still life of a bouquet of flowers signed and dated 'June 1858/ Renoir'. Another of his early works, done when he was around nineteen, was

a portrait of his mother, then aged fifty-three.[35] He painted her head looking sideways, wearing a bonnet. Renoir was attached to this painting: it was the only portrait of his parents or siblings that was still in his private collection at the time of his death.

While Renoir was working during the day and taking drawing classes at night, he met Émile-Henri Laporte, an engraving apprentice and later a painter and decorative artist, who was a fellow student at the École de Dessin et des Arts Décoratifs. Laporte preceded Renoir in the painting classes of the Swiss painter, Gleyre, which were free except for 10 francs a month to pay for the model. In November 1861, when Renoir was almost twenty-one years old, his family allowed him to stop paid artisan work in order to pursue his dream of becoming a painter. Renoir followed Laporte's path, left the drawing class and entered Gleyre's studio at 69 rue Vaugirard on the Left Bank. While there, he continued to study and copy works at the Louvre; in addition, Gleyre wrote Renoir a letter of recommendation so that he could copy prints at the Cabinet des Estampes of the Bibliothèque Nationale.[36] Gleyre prepared students for entrance examinations to the nearby government-sponsored École des Beaux-Arts. In April 1862, five months after Renoir began with Gleyre, even though he was placed poorly (68th out of 80), Renoir was accepted to study at the Beaux-Arts.[37] This art school prepared students to submit works to the annual Salon art exhibition held in April.

Interviewed forty years later, Renoir talked about his training: 'The misunderstanding began as soon as I started studying at the École des Beaux-Arts. I was an extremely hard-working student; I slaved away at academic painting; I studied the classical style, but I never earned the least honorable mention, and my professors were unanimous in finding my painting execrable.'[38] Although far from top of his class, his account is somewhat exaggerated: in 1863, he ranked twentieth out of 80 students who took a figure drawing examination at the Beaux-Arts.[39] In an interview of 1904, '[Renoir] spoke of the advantage that the Impressionists had of being a group of friends who were able to benefit from each other's research. It is good to work in art classes, because when one always works alone, one ends up believing that everything one does is good. In an art school, one sees what one's neighbour does. As a result, one benefits from [seeing] what the neighbour did better than you.'[40]

In the 1860s, the best way for a young artist to make his or her work known to the buying public was to exhibit at the annual state-sponsored Salon. After

paintings were accepted by the official jury, they were put on view and evaluated by critics. These reviews were of great importance and affected the prices that artists could ask for their work. Even as late as 1882, Renoir wrote: 'There are hardly fifteen connoisseurs in Paris capable of liking a painter without the Salon. There are 80,000 of them who won't even buy a nose [of a portrait] if a painter is not in the Salon.'[41] Hence, Renoir diligently submitted his paintings to the Salons of 1863 through 1890, with varying levels of success.[42] Even when accepted, his paintings were usually placed where they were hard to see. In the same 1904 interview, Renoir was asked why he did not exhibit at the Salons: 'It's a very big mistake...to think that I am against exhibitions. On the contrary, no one is more of a supporter of them, because in my opinion, painting is meant to be shown. Now, if you are astonished that you didn't see my canvases in the Salon exhibitions and if you wanted to find out why, it's much simpler than that. My paintings were refused. The jury generally welcomed them – welcomed them, that's one way of saying it – with a burst of laughter. And when these gentlemen one day found themselves by chance in a somewhat less hilarious mood, they decided to accept one, and my poor canvas was put under the moulding or under the awning, so that it would go as unnoticed as possible. I think I've been sending in canvases for about twenty years; about ten times I was mercilessly refused; the other ten times [about] one out of three was taken, and hung just as I told you.... All these refusals, or bad placements, didn't help sell my paintings, and I had to earn enough to eat, which was hard.'[43] Renoir was exaggerating a little. In truth, he had submitted works to the official Salon over the course of twenty-seven years from 1863 until 1890. His paintings were refused four times and accepted ten. Even though he had some success with the Salons for a few years, they never were an ideal exhibition space for his works.

Gleyre's studio closed in the spring of 1864 because of his health problems. At the same time, Renoir was placed tenth among 106 applicants for continuing study at the École des Beaux-Arts. By the time he left Gleyre's studio, he was already following the Realist painter Édouard Manet, nine years older than he. Manet, who was the same age as Renoir's brother Pierre-Henri, became somewhat like an older brother to Renoir, a role model and a supporter.[44] He had been inspired by the previous generation of Realists (Courbet, Corot and others). Manet's two ground-breaking 1863 paintings, made when Renoir was still with Gleyre, were Le Déjeuner sur l'herbe (exhibited at the Salon des Refusés of 1863) and Olympia (exhibited at the Salon of 1865). They caused a furore

among the conservative establishment in Paris but endeared Manet to Renoir and his friends. These two paintings displayed modern themes in a modern style, yet also referred to well-known paintings in museums: the *Déjeuner* recalls Giorgione's *Pastoral Concert* in the Louvre and *Olympia* recalls Titian's *Venus of Urbino* in the Uffizi, Florence. Renoir adopted Manet's goal: to paint modern life in a modern style, yet to be an heir to the great artists of the past. Some of Renoir's early paintings, such as *The Inn of Mother Anthony* (1866; see page 84) and *Lise and Sisley* (1868; see page 85), show that he was evolving his own Realistic style, yet was indebted to Manet.

Renoir and his friends socialized with Manet each Friday evening at 5.30 at the Café de Bade in the centre of Paris. In 1866, Manet changed to the Café Guerbois at 11 Grande rue des Batignolles (now avenue de Clichy) in north-west Paris, an area called the Batignolles. After 1876, they again moved their meeting place, this time to the Café de la Nouvelle-Athènes on place Pigalle. The wealthy, highly educated Manet was both the intellectual leader and the oldest of the group later referred to as the Impressionists. Other future Impressionists who came to the café meetings included Bazille, Cézanne, Degas, Monet, Pissarro and Sisley. The only two core Impressionists who did not attend the café meetings were Morisot and Cassatt, because attending café meetings was not socially acceptable for high-class women. Non-artists who came included Bazille's close friend Maître, who was a rich dilettante painter and musician, the photographer Gaspard-Félix Tournachon, who went under the name Nadar, and the writer and critic Émile Zola, as well as other critics, writers and collectors; even though they were not painters, they came to be associated with this modern art movement.

Among all the younger artists who followed him, Manet considered Renoir his successor and Renoir considered Manet his mentor. This was evident in 1869, when Henri Fantin-Latour painted a large work entitled *A Studio of the Batignolles Quarter*, destined for the Salon of 1870, which shows Manet seated, painting at his easel, surrounded by artist and writer friends.[45] They include, from left to right, Otto Scholderer, Renoir, Zacharie Astruc, Zola, Maître, Bazille and Monet. For this work, Manet had asked Fantin to place Renoir nearest to him. Not only did Fantin comply, but he also surrounded Renoir's head in a gold frame, almost a halo. Renoir stands with bowed head, suggesting his sensitivity and deference. Despite his humble roots, at age twenty-nine, Renoir had not just become friends with the most innovative artists and writers but was seen as their leader's heir. Throughout Manet's lifetime, he continued to be

friendly and encouraging to Renoir, who always esteemed and revered him. Renoir's gratefulness to Manet lasted well beyond the latter's death in 1883; it extended through Renoir's close friendship with Manet's brother and sister-in-law, Eugène Manet and Berthe Morisot, and their daughter, Julie Manet.

Like that of Renoir and his friends, Manet's work was disdained at the annual Salons. Similarly, when Renoir was painting in a Realist style akin to Manet's at that time, his art received negative reviews from most critics. However, some, like Zola, who were favourable to Manet, also viewed Renoir's work in a positive light. When Renoir exhibited *Girl with the Umbrella* at the Salon of 1868, Zola wrote a review about the modernists.[46] Other critics noted Renoir's debt to Manet.[47]

Although considered the elder statesman of the Impressionists, Manet refused to exhibit with them in their group shows. His conservative views led him to believe that the official Salons were the only way to reach the public and critics. Nonetheless, he tried to help their exhibits, as in 1877, when he wrote to the foremost art critic, Albert Wolff: 'You may not care for this kind of painting yet, but some day you will. Meanwhile it would be nice of you to say something about it in *Le Figaro*.'[48]

In the 1870s, the liberal young Impressionists rejected the government Salon exhibitions and official recognition, such as the Légion d'Honneur. Even though Manet was artistically innovative and a leader of the Impressionists, he felt it important to go along with certain conservative trends and refused to exhibit with the Impressionists, instead submitting his works to the official Salons. Later, he accepted the official recognition of the Légion d'Honneur. Even though Renoir was part of the anti-establishment Impressionist group, he differed from his peers and applauded Manet's conservative realism. In 1881, when Manet finally was awarded the Légion d'Honneur and was dying of syphilis of the spinal cord, Renoir, then on a trip, congratulated him: 'On my return to the capital, I will salute you as the painter who is loved by everybody and is officially recognized.... You are the joyous fighter, without hate for anyone, like an old Gaul, and I admire you because of this happiness even in times of injustice.'[49] Manet immediately wrote back: 'You will without a doubt bring us back a mass of works all personal and interesting.... A thousand kind regards, my dear Renoir, and bring back a lot of canvases.'[50] Manet, no doubt, appreciated Renoir's understanding of why he would accept the Légion despite its conservative connotations.

Although Manet esteemed Renoir as a talented artist, the critics and buying public did not, so he had financial problems on and off until he was fifty years old. In his twenties, Renoir was helped by several of his affluent artist friends. Because of his charm and warmth, his wealthy friends introduced him to their families. His friends assisted him by providing studio space, living quarters and money to paint; sometimes they found him commissions for portraits and mural decorations. Indeed, he became financially dependent on many friends but none of them seemed to mind.

Since his parents' apartment had only three rooms for seven adults, Renoir was happy to turn to friends' studios and apartments for the space to paint and store his canvases and to live. Despite the fact that Renoir's parents lived in Paris until 1868 when he was twenty-seven, from 1862 Renoir consistently gave friends' addresses as his own when he exhibited his art. At the Beaux-Arts, Renoir gave his address as 29 place Dauphine on the Île de la Cité, which was the home of his friend Laporte. Throughout the next eight years, on different occasions, Renoir recorded that he lived with various wealthy artist friends – Bazille, Le Coeur, Maître and Sisley. These colleagues recognized Renoir's genius and had no problem allowing him to reside and work with them at the same time that they gave him financial help.

Renoir's wealthy friends were also happy to find him portrait commissions. While Renoir preferred to paint daily life, as did Manet, since such works were hard to sell, Renoir did what he considered second-best; he became a portraitist. Even though photographic portraits were coming into fashion, painted portraits were still popular. Nonetheless, they were always problematic since the artist had to please the sitter. From 1864 and for the next twenty years, portraiture dominated his oeuvre. Of his 397 figure paintings, 164 are portraits compared to 161 daily life images, 28 nudes and 9 decorations.[51] The year that Gleyre's studio closed, 1864, Renoir made portraits of Laporte and his sister, Marie-Zélie Laporte.[52] He also painted portraits of Sisley and of his father, William Sisley.[53] In these portraits, as in many of his commissioned portraits from 1864 until 1870, Renoir painted in a traditional, realistic style. Indeed, his *William Sisley* closely resembles a photograph that could have served as its model.[54] He submitted this portrait to the Salon of 1865 where it was exhibited as *Portrait of M.W.S.*

Sisley and Renoir also worked together on landscape painting in the Fontainebleau area, then accessible by train, 56 kilometres (35 miles) south-east

of Paris. Much later, in 1897, Renoir told a friend: 'When I was young, I used to go to Fontainebleau with Sisley with my paint box and a painter's shirt. We would walk until we found a village, and sometimes only come back a week later when we had run out of money.'[55] In the 1860s, Sisley's family was welcoming to Renoir, who occasionally slept at their home, at 31 avenue de Neuilly, Porte Maillot.[56]

Besides being helped by Laporte and Sisley, Renoir turned increasingly to Bazille, who was from a wealthy Montpellier family. Around 1864, when Bazille had a studio at rue de Vaugirard, he wrote to his parents: 'I am hosting one of my friends, a former student of Gleyre, who does not have an art studio at the moment. Renoir, that is his name, is very hard working. He uses my models, and even helps me to pay for them, partly. It is quite agreeable for me not to spend my days entirely alone.'[57] Bazille's father later remarked on their 'brotherly friendship',[58] evident when Renoir wrote to Bazille: 'Kiss your mother and father for me. Send my best wishes to the whole family, your cousins, to that special aunt we love to talk about, to your sister-in-law and the little one; I like him a lot – there's a child who'll go far. Watch out for the carriages!... Your friend, A. Renoir.'[59] On and off for six years beginning when Renoir was twenty-three, he lived with Bazille in his friend's succession of Parisian apartments that also functioned as studios. From July 1866 through December 1867, Bazille and Renoir lived and worked at 20 rue Visconti on the Left Bank. From January 1868 until the spring of 1870, they lived at 9 rue de la Paix (now 7 rue de La Condamine) in the Batignolles quarter, west of Montmartre, not far from Manet's meeting place, the Café Guerbois. From April 1870, for a few months, Renoir and Bazille returned to the Left Bank and lived at 8 rue des Beaux-Arts. Since this last apartment was tiny, Renoir sometimes (as in the summer of 1870) stayed with Bazille's friend, Maître, who lived nearby at 5 rue Taranne (now the boulevard Saint-Germain).

Bazille not only helped Renoir with living accommodation but was also supportive of Renoir's art. During the time of the May 1867 Salon, when Renoir exhibited *Lise with an Umbrella*,[60] Bazille explained to his parents: 'My friend Renoir did an excellent painting which stunned everyone. I hope he will be successful at the exhibition, he really needs it.'[61]

A few months later, in November or December 1867, Renoir and Bazille painted portraits of one another in their rue Visconti studio (see pages 82 and 83). In addition to supporting Renoir, Bazille occasionally also helped Monet. A few months before the portrait exchange, Bazille wrote to his parents: 'Monet...

will sleep at my place until the end of the month. Therefore, including Renoir, I am lodging two needy painters. It is a veritable infirmary, and I am very pleased about it. I have enough room, and they are both very cheerful.'[62] While he was financially supporting both Renoir and Monet, those two artists developed a friendship that lasted for fifty-seven years. When seventy-one years old, in an interview, Renoir said: 'One is of one's time, in spite of oneself. Ask me about Manet, Monet, Degas and Cézanne, and I can give you clearly formed opinions, since I lived, worked, and struggled with them.'[63] In his old age, Monet felt similarly. A month after Renoir's death, Monet was interviewed and talked about 'our early years of struggle and hope'.[64] Their careers had similar trajectories. Both endured public hostility for almost thirty years before enjoying enormous fame and fortune.

Besides the value to his work, Renoir later said how he benefited from Monet's toughness during the days of the critics' and public's ridicule of the Impressionist style. When an old man, Renoir told his friend Albert André: 'I have always given in to my destiny, I never had the temperament of a fighter and I would many times have given up altogether, if my old friend Monet, who did have the temperament of a fighter, hadn't given me a hand and lifted me back up.'[65] Although Renoir was never as openly outspoken as Monet, he capitalized on his friend's assertiveness and would be inspired by that courage throughout his life. Renoir often claimed to be passive, timid or shy, but his letters and actions reveal that he rarely was.

Monet and Renoir were thus allied in the late 1860s for artistic and personal reasons and also because both turned to Bazille for financial help.[66] At the time, Monet's needs were even more dire than were Renoir's. In 1867, Monet's model and mistress, Camille, bore his son, Jean (the couple later married). Monet's grocer father, then a widower, refused to help because his own mistress had just had a child. Then Monet's monetary problems became worse from July through September 1869. During that period, Renoir was penniless and staying with his parents in Louveciennes, which is near Saint-Michel, a hamlet near Bougival where Monet was living with Camille and the infant Jean. Renoir travelled almost daily to visit Monet. In fact, he so often slept at Monet's home that, a few years later, Monet wrote to Pissarro, 'Renoir is not here so you will be able to sleep here.'[67] In a series of letters to Bazille, each man wrote of his poverty and of their work together. On 9 August 1869, Monet wrote to Bazille: 'Renoir brought us bread from his [parents'] house so that we wouldn't starve

to death.'[68] Renoir confirmed this in a letter to Bazille from Louveciennes: 'I am at my parents' house and almost always at Monet's.... We don't eat every day. But, all the same, I am pleased because as far as painting goes, Monet is good company. I am doing next to nothing because I have very little paint. Things may get better this month. If it's the case, I'll let you know.'[69] Things did get better, since the next month, Renoir and Monet painted together at La Grenouillère (also known as Croissy-sur-Seine, a suburb of Paris).

In late September 1869, when both of them were benefiting from Bazille's support, Renoir and Monet created the first truly Impressionist paintings to have survived, at La Grenouillère.[70] (Pissarro also invented Impressionism around this time, but his canvases of 1869 were destroyed during the Franco-Prussian War.) Monet wrote to Bazille: 'Renoir, who has spent the last two months here, also wants to do this painting [La Grenouillère].'[71] Hence it was together that they developed this new style for landscapes with small figures. Working outdoors, each artist made five paintings in which he employed characteristics now defined as Impressionist: vibrant and varied hues as well as pervasive light tones; high-keyed shades used as reflected hues in the shadows; a seemingly random composition with figures moving beyond the frame; primary importance given to tiny, moving, brightly coloured strokes that suggest indistinct forms; blurred details; dissolved edges and lines; and eroded mass. Beyond the five pairs of paintings at La Grenouillère, through 1873, side by side, Renoir and Monet created fourteen paintings of identical landscapes or still lifes. Renoir also painted eleven portraits of Monet (see page 82) and Camille.[72]

Despite the help of Bazille, Renoir continued to be plagued by a lack of money and needed to seek further support from other wealthy friends. Two years after Renoir met Bazille, Monet and Sisley at Gleyre's studio, he made the acquaintance of Jules Le Coeur, who, like Manet and Pierre-Henri Renoir, was nine years older than he.[73] Jules came from a wealthy Parisian family that created furniture for the courts of Europe. The two men had reasons to be drawn to one another. Renoir, lacking wealth and connections, gravitated towards Jules, one of the more generous and friendly among the upper-class students. Jules, coming from an architecture background, admired Renoir for his greater experience in drawing and painting. Later, Renoir and Le Coeur became extremely close because of their clandestine affairs with two sisters.

Whereas Renoir's previous intimate relationships remain unknown, Jules had been married. At that time, both he and his older brother, Charles, were

successful architects, having decided not to join their father's company. Jules married on 4 May 1861. Eighteen months later, two tragedies befell him. Within a fortnight of giving birth to their son on 3 November 1862, Le Coeur's wife and son both died.[74] Le Coeur was devastated and left Paris; he travelled around Europe and came to the conclusion that he no longer wanted to be an architect. On 24 August 1863, in a letter to his mother, he expressed his desire to become a painter.[75] With her approval, at age thirty-two, he entered Gleyre's studio where one of his cousins studied.[76] There, in early 1864, he met Renoir and his friends.

Le Coeur and Renoir became close companions. When Gleyre's studio closed later that same year, Jules and his family helped Renoir by commissioning portraits and ceiling frescoes and by purchasing paintings. In addition, Jules, like Bazille, supported Renoir and invited him to paint in his studio and to live with him at his various residences in Paris, Marlotte and Ville d'Avray. Hence, throughout his twenties, Renoir stayed at times with Le Coeur and at other times with Bazille. Jules introduced Renoir to his family, who lived in a large compound at rue Alexandre de Humboldt (now rue Jean-Dolent) in the nineteenth arrondissement in north-east Paris. Except for Jules, everyone, including his mother Félicie, his brother, Charles, and two sisters, Louise and Marie, with their spouses and children, resided in the family compound, which included their family home and business complex. Jules's father, Joseph Le Coeur, had died in 1857. At that time, Jules's eldest sister, Louise, then aged twenty-nine, who never married, began to help her mother run the family enterprise. This business, which became in 1861 Le Coeur et Compagnie, flourished, employed hundreds of workers and became one of the most important carpentry and cabinetmaking operations in Paris; they even participated in the renovations of the Louvre.[77]

The first evidence that Renoir knew Jules's family is revealed in a letter from Jules's youngest sister, Marie, in the spring of 1865, to her husband, Fernand Fouqué, a distinguished mineralogist and geologist: 'Jules leaves tomorrow to spend a few days at Mr Brunet's house, near Fontainebleau. Mr Renoir is also going away to the countryside.'[78] At that time, Renoir, Sisley and other painter friends accepted Le Coeur's hospitality at Marlotte, almost 75 kilometres (47 miles) south-east of Paris, where Jules rented a house on the rue de la Cheminée Blanche (today, 30 rue Delort).[79] Renoir occasionally brought along his brother Edmond, then a young journalist and writer aged seventeen, whom Renoir later helped to get employment as a secretary for the Le Coeur business.

Beginning in 1866 and for the next eight years, Renoir painted many works for the Le Coeur family. Jules's sister Marie described Renoir's working habits: 'That poor boy is like a body without a soul when he is not working.'[80] Her observation was in fact true; for the next fifty-three years until his death, Renoir was obsessed with his art and painted every day unless physically incapacitated. The Le Coeurs acquired three Renoir still lifes: *Spring Bouquet* that he signed 'A. Renoir. 1866' and, the same year, *Flowers in a Vase*. Two years later, he made *Basket and Partridge* for Charles Le Coeur. The family also bought Renoir's figure paintings such as *Lise holding Wildflowers*.

However, most of the paintings that the Le Coeurs bought from Renoir were portraits. The first, in April 1866, was of the family matriarch, Mme Félicie Le Coeur.[81] When she hired Renoir to paint her, Marie informed her husband. Shortly thereafter he wrote dismissively to his mother-in-law: 'I learned with great pleasure that you are getting your portrait done, but I must confess I would much rather see it painted by any other person than by Renoir. I have little confidence in that young man's talent; to me, his personality and his behaviour are as unpleasant as possible. I am afraid that the impression I have of the artist will be reflected in the portrait.'[82] These insults were probably based on Renoir's lower-class origins, which still raised eyebrows among those who had not been charmed by the artist's personality.

In the spring of 1866, Renoir was still working on his portrait of Jules's mother at the same time that he was waiting to hear whether his two submissions to the Salon of 1866 had been accepted. Renoir had promised to write telling Jules the news. When Jules heard nothing he became frustrated at Renoir and wrote to his mother: 'Renoir, this animal, left on Monday and told me that he would write to me as soon as he knew. I think that he has not written yet because he does not know anything. However, he could have at least written that he did not know rather than make me think that he has bad news for me.'[83] Jules disparages Renoir by calling him an 'animal', even though he admits that Renoir probably did not yet know about the jury's decision. That same year, besides completing the portrait of Mme Le Coeur, Renoir painted Jules and his dogs in Fontainebleau forest, more a landscape than a portrait.[84]

Two years later, in 1868, Renoir proposed to Jules's brother Charles to paint his wife and son, Joseph, in their garden, and he drew a sketch and posted it to Charles.[85] This work was never completed, yet, around the same time, Renoir made a little oil study of Joseph's head. In 1869, Renoir painted a portrait of

Charles's mother-in-law, Mme Théodore Charpentier. The following year, Renoir made portraits of Charles and of his wife. After the Franco-Prussian War, Renoir continued to make portraits of the family: of Charles's eldest daughter, Marie, aged twelve, and of his next daughter, Marthe, aged nine, and another head of Joseph. In 1874, Renoir painted a bust as well as a full-length portrait of Charles; the latter shows him standing outdoors.[86]

Besides portraits and purchases, Charles helped Renoir to fulfil an early dream: to paint indoor murals to complement architecture. Charles and Jules were childhood friends of the Romanian Prince Georges Bibesco (1834–1902), who came to Paris as a boy. Bibesco studied at the French military academy, became an officer and was part of the French Mexican and Algerian campaigns. In 1867 or 1868, Charles was working on plans for a town house for Bibesco in Paris's seventh arrondissement at 22 boulevard de La Tour-Maubourg. Charles helped Renoir get a commission for two ceiling decorations in that house. In the spring of 1868, Renoir made two preparatory watercolours for the ceiling, one in the style of Fragonard and one in that of Tiepolo.[87] He also painted the Bibesco family crest above the fireplace in the Salle d'Armes (Armour Room).[88] The first stone of Hôtel Bibesco was laid on 23 April 1869. Construction was interrupted by the 1870 Franco-Prussian War, but was completed soon thereafter; Renoir completed his murals by the end of summer 1871.[89] Unfortunately, the house was torn down in the 1910s and Renoir's frescoes were destroyed.

Aside from working on his art, Renoir spent much time with Jules. Beginning in the spring of 1865, Renoir lived intermittently with his friend in his Paris apartment at 43 avenue d'Eylau (now avenue Victor Hugo), in north-west Paris in the sixteenth arrondissement. When Renoir was first accepted at the Salon of 1865, in the booklet of participants he gave Jules's address as his own.[90] In the spring of 1866, while Renoir was in Paris painting the portrait of Mme Le Coeur, Jules invited him to accompany him to Marlotte (where Sisley had preceded them). Renoir could not decide whether to finish his painting in Paris or to go with his friends. Le Coeur's sister Marie wrote a letter describing Renoir's indecisiveness and impulsiveness: 'Yesterday morning, he finally came to work [on her mother's portrait] saying that he had decided not to leave [for Marlotte]. This morning he was still resolved to stay but he accompanied Jules to the railroad and at the last moment left with Jules to Marlotte. He does not have any suitcase, and will therefore be forced to return to get his things.'[91]

It was in Marlotte a few months later that Renoir created his first large group portrait that is also his first scene of daily life: *The Inn of Mother Anthony, Marlotte* (see page 84) portrays his friends after a meal: Jules Le Coeur is the standing bearded man rolling a cigarette.[92] One of his dogs, Toto, a bichon, appears in the foreground.[93] Sisley is on the right, wearing a hat and reading the newspaper, *L'Événement*, in which Zola had written favourably about Renoir's friends Monet and Manet. The facing beardless man has not been identified. Framing the trio of men is the waitress, Nana, at the left, and the proprietress, Mother Anthony, at rear right. The fresco on the back wall is Renoir's caricature of Henri Murger, the author of *Scènes de la vie de Bohème*, which later gave Puccini the theme for his opera depicting a bohemian lifestyle somewhat parallel to Renoir's. The bohemian movement in Paris was active at the time, beginning in the 1840s and continuing into the late 1860s. It was a glorification of free spirits, artistry and romanticism, a counter-cultural way of life that Renoir alludes to in the Murger caricature.

After Jules and Renoir had been friends for a while, and while they were spending time in Marlotte, Jules introduced Renoir to a model, Lise Tréhot, who would be the most important woman in Renoir's life from 1866 through 1872. Jules had met Lise soon after entering Gleyre's studio when he renewed contact with one of his former architect friends, Mathieu Tréhot, who introduced Jules to his two sisters.[94] In 1866, Clémence was twenty-three and Lise was eighteen. Their father, Louis Tréhot, ran a tobacco and wineshop at 71 avenue des Ternes in north-west Paris in the seventeenth arrondissement, and the family lived nearby. By 1866, Clémence had become Jules's mistress. Jules asked Renoir to paint her portrait. That same year, Renoir made a watercolour of Jules and Clémence, *The Stolen Kiss*.[95]

Lise Tréhot started modelling for Renoir in 1866 when she posed for three half-length paintings: *Lise Sewing, Portrait of Lise* and *Woman with a Bird*.[96] Throughout the next seven years, Lise was Renoir's only model. She posed for all his paintings destined for the yearly Salons: the nude, *Diana as a Huntress*, 1867; *Lise (Woman with an Umbrella)*, 1867; *The Bohemian*, 1868; *Algerian Odalisque*, 1870; *Bather with Griffon*, 1870; and *Parisians dressed as Algerians*, 1872.[97] Of these, the first and the last submissions were rejected, but the other four were accepted at the spring Salon.

If we compare a photograph of Lise (see page 42) with paintings for which she modelled, we realize that Renoir always greatly transforms her appearance.

In all Renoir's thousands of paintings of people, he always idealizes according to the model of beauty established by artists of the past, from Greek statues through Raphael, Rubens and Ingres. These artists improved the appearance of people to make them look more beautiful, healthy and happy. Even though Renoir always transformed the person before him, he wanted to paint from a model because he enjoyed the sociability and inspiration. Lise was not only Renoir's model but also his lover and muse. She inspired his first amorous painting, *Lise and Sisley*, 1868, which has been wrongly titled *The Sisley Couple*.[98]

In a letter to Bazille, of September or October 1869, Renoir called the painting 'Lise and Sisley', writing: 'I exhibited Lise and Sisley at Carpentier's.'[99] Marie-Charles-Édouard Carpentier, whose store was at 8 boulevard Montmartre, was Renoir's paint dealer and framer.[100] Renoir hoped to sell the painting for 100 francs, which was the current price for large photographs by the fashionable photographers Disdéri and Adam-Salomon.[101] Unfortunately, *Lise and Sisley* did not sell at the time (see page 85).

It is tempting to surmise that Renoir's infatuation with Lise led him to begin painting the pursuit of love, a theme that, among the Impressionists, was unique to him. Renoir's romantic feelings for Lise no doubt enhanced the passion that he put into all the paintings for which she modelled. *Lise and Sisley* is the first of many paintings of romance in modern Paris where handsome, gallant men pursue beautiful, fashionably dressed young women. Here, as in later paintings, love is conveyed through glance, gesture and posture. This amorous subject matter did reflect Renoir's life and the things he did or would have liked to have done. When Renoir was a young healthy, sociable bachelor, he created his most innovative social scenes in Paris and its suburbs. Two years later, in 1870, Lise posed for *The Promenade*, Renoir's first amorous work in his new Impressionist style.[102] By painting the pursuit of love, Renoir was following Boucher, Fragonard and Watteau, as well as his idol, Rubens. In these romantic works, his male friends stood in for Renoir alongside Lise. Besides this romantic subject matter, Lise also posed for several paintings of nudes and of modern women alone.

Since Renoir was earning little money from his painting and there is no documentation, it is unclear whether he paid modelling fees to Lise. However, besides posing for Renoir, Lise earned money modelling for Bazille. The link between Renoir, Bazille and Lise is confirmed in a letter that Renoir wrote to Bazille in 1869: 'Lise saw your letter.'[103] That same year, Lise posed for Bazille's

The Card Player, Young Woman with Lowered Eyes, Woman with Striped Dress and *Moorish Woman*; in 1870, she posed for Bazille's *La Toilette*.[104]

When Bazille used Lise as a model for *Moorish Woman* in 1869, he may have inspired Renoir in his seductive *Algerian Odalisque* of 1870. The latter is part of a pair with a nude painting of Lise, *Nymph at the Stream*, 1869–70 (see page 85).[105] Renoir's pair of wide horizontal panels calls to mind Goya's *Dressed Maja* and *Nude Maja*. Unlike the Goyas, however, Renoir's two figures are in mirrored poses. Around the time that Lise modelled for *Nymph at the Stream*, she had given birth to one of Renoir's children, and by the time of the *Algerian Odalisque*, she was pregnant with his second child.

In this time of primitive contraception and in a Catholic country with no legal abortions, it was risky for any unmarried woman to have an affair. A year after Renoir met Lise, Sisley and Monet had illegitimate children with their models who were also their mistresses. Sisley's model and companion, Marie-Adélaïde-Eugénie Lescouezec, gave birth to a son, Pierre Sisley, on 17 June 1867.[106] Two months later, on 8 August, Monet's model and companion, Camille Doncieux, gave birth to their son Jean (as noted earlier). Since neither couple was married, neither child was legitimate. However, at their sons' births, Sisley and Monet recognized their children and gave them their last names; in so doing, they legally agreed to support them. As expected, each artist later married his mistress, thereby legitimizing his child.[107]

Having illegitimate children in full view rather than hiding them away as bourgeois people did was considered bohemian and undignified. The parents of both Sisley and Monet were unsympathetic to their sons' circumstances. Furthermore, Bazille, who helped Monet financially, was no doubt displeased with Monet's predicament. Bazille was from a Protestant bourgeois family and is not known to have ever had a mistress.[108] Lise also became Bazille's model but it is presumed that they did not have a sexual relationship.

A year after the births of Pierre Sisley and Jean Monet, the mistresses of both Renoir and Jules Le Coeur – Lise and Clémence – became pregnant at around the same time. Jules Le Coeur was happy with this; his wife and son had died six years earlier. However, Renoir had immediate concerns because of his precarious finances. He knew that Bazille would disapprove and he worried that Bazille might withdraw his financial assistance. While most people knew Lise only as Renoir's model, Bazille knew that she was also Renoir's secret lover. This prompted Renoir to write to Bazille a month before Lise was to give birth:

'I am at Ville-d'Avray.... and if you have some money, it would be good if you would send it to me immediately, so that you won't spend it. You needn't worry about me since I have neither wife nor child and am not ready to have either one or the other.'[109] By asserting his lack of wife or child, Renoir was reassuring Bazille, who was helping him with money, that he was not planning to follow the route taken two years earlier by Monet, who, after he had a child, became more demanding in his monetary requests to Bazille.[110] Renoir wanted Bazille to know that he was not going to become a similar burden even though, secretly, he was about to become a father.

In this situation, Renoir's lower-class background restricted his options even if he loved Lise as much as Monet loved Camille. The middle-class Monet felt entitled to have a child and future wife, but the lower-class Renoir was too dependent on his friends' support to feel enabled to have a wife and child in the foreseeable future. Nonetheless, Renoir continued his relationship with Lise but decided not to proceed as a family with her and their child, and indeed to keep the relationship secret. Renoir's family never learned of his children with Lise, just as Jules's family never knew about Clémence and their child. As I described in the Introduction, it was the accidental discovery of unpublished Renoir letters in 2002, by Jean-Claude Gélineau, that revealed the existence of Renoir's two illegitimate children with Lise.[111] During Renoir's lifetime, the only outside people who definitely knew about Lise's pregnancy were Bazille and Le Coeur, though Sisley, Monet and Maître could have known as well.

Over the summer of 1868, with both Clémence and Lise pregnant, Jules left Marlotte and rented an apartment in a little building at 38 rue de Saint-Cloud in Ville-d'Avray, near Louveciennes, 20 kilometres (12½ miles) west of Paris. There he stayed with Clémence and was often joined by Renoir and Lise. By mid-September, the two couples were awaiting two births. On sequential days, 14 and 15 September 1868, in the same apartment, Clémence gave birth to Jules's daughter, Françoise Le Coeur, at four o'clock in the afternoon and Lise gave birth to Renoir's son, Pierre Tréhot, the next morning at ten thirty.[112] However, Le Coeur's way of handling a secret family differed from Renoir's, since Le Coeur had the money and desire to support Clémence and their daughter, even though he refused to legitimize their family; he never married Clémence. Their daughter's birth certificate says that she was recognized by Le Coeur when he gave her his last name. Clémence, nevertheless, did not recognize her child at the birth. On the birth certificate, Clémence did not give her real last name,

Tréhot, but invented a surname: 'Demoiselle Clémence Élisabeth Angélique Lucenay.'[113] She falsified her name because she feared ruining her future marriage prospects as a single woman with a child. However, ten years later, aged thirty-five, Clémence gave up the hope of finding a husband and did legally register herself as Françoise's mother.[114] It appears that Jules Le Coeur never told his family about Clémence or Françoise and neither of their names appeared in his correspondence.[115] When Françoise was fourteen, in 1882, Jules died and afterwards Clémence called herself 'widow Le Coeur'.[116]

The story of Renoir, Lise and infant Pierre Tréhot is far different. Neither Renoir, then aged twenty-seven, nor Lise, aged twenty, had the money to bring up their son. It appears that Lise did not want to be burdened with an infant and his impoverished father. Probably, Renoir felt that taking financial responsibility for a child would jeopardize his painting career and would disappoint Bazille and other bourgeois friends who were supporting him. Renoir and Lise, unable to keep the child, gave him away. On Pierre Tréhot's birth certificate, Renoir did not register as the father; the document says: 'father of the infant is unknown'. However, Renoir and Le Coeur signed the birth certificate as witnesses at Pierre's birth: 'The witnesses were Messrs. Pierre Auguste Renoir, artist-painter, 27 years old, living in Paris, 9 rue de la Paix in the Batignolles, friend of the mother of the child.' Thus Renoir confirmed that he was living with Bazille at the time. The other registered witness was Jules Le Coeur, described on the birth certificate as: 'a thirty-six-year-old artist Painter' who is 'not a relative of the mother'.[117] Despite the fact that they were giving him away, Lise and Renoir decided to name the child Pierre Tréhot after Pierre-Auguste Renoir.

Infant Pierre may well have been taken 6.5 kilometres (4 miles) away to Paris's Foundling Hospital.[118] Here wetnurses from rural areas regularly came to take infants as foster children; the state paid the wetnurses until the children were aged twelve. Unfortunately, half of all illegitimate children who were separated from their mothers died during their first year. This could have been Pierre's plight. There are no documents or letters about Pierre Tréhot beyond his birth certificate.

After giving away their son, Lise continued to be Renoir's model and lover. Almost two years later, on 21 July 1870, two days after France had declared war on Prussia, Lise gave birth to another of Renoir's children. Her delivery took place in a municipal health establishment, which is today's Fernand Widal Hospital, in Paris's tenth arrondissement at 200 rue du Faubourg Saint-Denis. At the time, Renoir, who had fulfilled his military training, was awaiting assignment

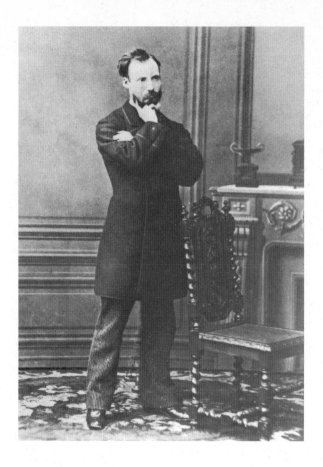

Renoir (in a
photograph he gave
to Monet), *c*. 1870.
Musée Marmottan,
Paris. Photographer
unknown

Lise Tréhot, 16
years old, 1864.
Collection Chéreau,
Paris. Photographer
unknown

Jeanne Marguerite Tréhot, *c.* 1910. Photo by Charles Gallot, Paris

in the cavalry. It is not known if he was present at the birth. He was living within walking distance of the hospital at Maître's Paris apartment on rue Taranne, in the sixth arrondissement. The birth certificate indicates that Lise was also living not far from the hospital, at 26 rue du Colysée (now Colisée) in the eighth arrondissement.[119] This time, Lise gave birth to a girl and named her Jeanne Marguerite Tréhot. Since Renoir's mother's name was Marguerite, it seems likely that Renoir had suggested Jeanne's middle name. On the birth certificate, Lise Tréhot's name is given as the mother, with no mention of the father. The three

other people recorded on the certificate were employees of the public hospital. As an adult, Jeanne looked remarkably similar to both her parents, as may be seen in photographs of the time (see pages 42–43). Two weeks later, Bazille was painting near his Montpellier home and jokingly wrote to Maître: 'Give me news of our friends.... Renoir must be about to become a father, will he give birth to a painting?'[120] Bazille's allusion to birth here, as well as Renoir's allusion to birth two years earlier in his letter to Bazille, suggests that Maître and Bazille were aware of both of Renoir's illegitimate children with Lise. It is probable that Jules Le Coeur also knew.

As with Pierre Tréhot's birth in 1868, now, with Jeanne Marguerite's in 1870, neither Lise nor Renoir had the financial means or desire to bring up their newborn. On Jeanne's birth certificate, Lise states she is 'without profession' while she had said 'dressmaker' on Pierre's birth certificate.[121] Since all girls in France learned to sew in school, being a seamstress or dressmaker was a popular means of employment. In neither birth certificate was Lise comfortable declaring that she was a model, since that type of work was considered only a step up from prostitution.

It is most likely that before Lise left the hospital she had given away newborn Jeanne to Augustine Marie Clémentine Blanchet (née Vannier, aged twenty-eight), a professional foster mother and wetnurse whom Renoir had probably found.[122] There is no evidence that Lise ever contacted Jeanne's foster family, nor did she send money for her support.[123] Lise wanted to marry a rich man so that she and her future children could have comfortable middle-class or upper-class lives. If she had agreed to become the mother of either Pierre or Jeanne, her chances of finding such a husband would have been ruined by having illegitimate children. Yet in 1870, Lise was still willing to continue her relationship with Renoir, in hope that he might become rich and famous – but so far his prospects seemed bleak.

Renoir's reaction to the birth of his second child was different from Lise's – because he was a man and because of his personal background. As a man, even though he came from a poor background and was still poor when Jeanne was born, it was possible that he could become rich. His generous and loving decision to become Jeanne's father was also the result of his background: as I deduce, his own sympathy for his illegitimate grandfather, his guilt over abandoning Lise's first-born, his namesake Pierre, and his continuing love for Lise. In 1868, almost half (47.9 per cent) of abandoned children died within the first

year of their birth compared to 19.1 per cent of infants who were not abandoned.[124] Renoir could have learned that Pierre Tréhot had died in infancy. It is possible that before Jeanne was born, Renoir had decided to stay involved in her life. Many years later in a moment of crisis, he wrote to her: 'I have never abandoned you. I am doing what I can. I have no reason not to take care of you.'[125] At the same time, throughout his life, Renoir was adamant about keeping Jeanne's existence a secret from his parents, siblings, friends and eventual wife and children. It was only after his death, forty-nine years later, that his three sons learned about their half-sister from his will. Out of respect for their father, Renoir's sons decided to retain the secret. Hence, Jean Renoir's son, Alain Renoir, was never told anything about his aunt.[126] Those few people who had known about Lise's pregnancies knew that both infants had been given away, and they believed that the children were permanently gone from the lives of both the artist and his model. When Renoir's health deteriorated in his fifties, he needed to enlist three people to send Jeanne money on his behalf and to help her see him (see Chapter 4). Renoir's secretiveness about his relationship with Jeanne greatly complicated his life but is typical in involving secrets and complicated relationships. This led Pissarro later to write to his son that Renoir was the most unfathomable person he had ever met.[127]

While Renoir ensured that their relationship remained secret, the artist was concerned about his daughter throughout her life. It is most likely that Renoir found the foster mother for Jeanne. Renoir learned about Augustine from a grocer and his wife, whose store was in Montmartre, the artist quarter.[128] The grocer, Jacques Blanchet (who may have been related to Augustine's husband, François Blanchet), and his wife, Marie-Désirée Gautier,[129] were from l'Être-Chapelle, a tiny hamlet near Sainte-Marguerite-de-Carrouges, a small town of 950 people in Alençon commune, Normandy. Augustine and François were relatively prosperous and lived in a three-storey brick home with their two children, François Auguste, aged twelve, and Eugénie Victorine, aged eight; their home had ample space for their foster children as well. Seven years after Jeanne's birth, the Parisian grocer and his wife would be involved in sending their own grandson to be nursed by Augustine Blanchet.[130] The French government paid wetnurses about 144 francs a year from birth through the end of a child's twelfth year, in order to take care of abandoned or motherless children.[131] Besides Augustine's professional motivation, she and her husband were devout Catholics who were performing a charitable act by taking in foster children. Many years later, Jeanne

referred to Augustine as her 'foster mother' and wrote of her and her husband that 'they were always very kind to me'.[132] That Jeanne aged forty-seven wrote this shows that Renoir had made a wise and fortuitous decision in his choice of a foster mother for his daughter.

For Augustine to travel from Normandy to Paris was arduous. First, she took a horse-drawn carriage 25 kilometres (15½ miles) to Argentan and then a six-hour train ride to Paris. As soon as Augustine received Lise's newborn, she would immediately have begun nursing and bonding with the baby. Augustine then returned home with her foster daughter. It is not known whether Renoir ever visited his daughter or corresponded with Augustine during Jeanne's childhood.[133] However, he often travelled to Normandy to paint portraits, so he could easily have taken a train to visit Jeanne.

Given that Renoir insisted on secrecy about his fatherhood (so that later correspondence went to post boxes and never to his home), it is a surprise that he allowed Augustine to permit Jeanne to use Renoir as her last name. Church documents indicate that early in her life, as a young child, she was called Jeanne Marguerite Tréhot. Hence this name appears on her baptismal certificate when she was five on 23 May 1875. The baptism was delayed until this date so that Augustine's daughter, Eugénie, would be old enough at thirteen to become her godmother. Jeanne had her first communion on 24 July 1881 and was confirmed on 15 June 1882 under the name Marguerite Renoir – the name she probably used when attending the school in her district.[134] However, when Jeanne became an adolescent, she decided she preferred the name Jeanne. Thus, when she was a witness in several church ceremonies, she signed her name 'Jeanne Renoir' – on the marriage certificate of her godfather in 1885, on the marriage certificate of her godmother also in 1885, and on the baptismal certificate of her godson in 1893.[135] Also, among the letters Jeanne saved from her father is an envelope with a postmark of 11 February 1892, addressed in Renoir's handwriting to 'Mlle Jeanne Renoir' (see page 165).[136]

At this time, Renoir was in close contact with his family, painting several portraits of them, but never admitting to Lise and their children, as noted.[137] During 1869, in between the births of Pierre and Jeanne, Renoir had painted a stern half-length portrait of his father, Léonard.[138] Léonard, recently retired from tailoring, and his wife lived in a house with a garden in Louveciennes (near, as noted earlier, both Jules at Ville-d'Avray and Monet at Saint-Michel near Bougival). Renoir's father died there on 22 December 1874, and his mother

continued to live in that house with her daughter and son-in-law. In 1870, when Jeanne was born, Renoir completed a pair of elegant portraits of his oldest brother Pierre-Henri and his wife, Blanche.[139]

It is not clear when Renoir began his military service in the ten-month Franco-Prussian War. However, on 26 August 1870, when he was twenty-nine, he reported to Libourne, 575 kilometres (some 360 miles) south-west of Paris, and was given an official record book that gives an account of his military training, which had begun eight years earlier with obligatory reserve duty, when he served first for three months in 1862 and then for another three in 1864.[140] Four years later, he again underwent further military training, which ended on 31 December 1868, almost two years before he was summoned to duty.

Even though photography had been invented in 1839, Renoir's record book includes only a description of his appearance. He was relatively short – '1 metre 69 [5 ft 6½]' – and was described as 'face: oval; forehead: average; eyes: brown; nose: long; mouth: big; chin: round; hair and eyebrows: blond.' Two months after he arrived in Libourne, he received a letter that specified his military assignment: 'M. Renoir, 10th Light Cavalry Regiment and 4th Platoon.'[141] This was a unit trained in rapid movements on horseback.

Two weeks before Renoir was called to serve in the cavalry, Bazille had volunteered in a Zouave regiment, a dangerous, elite infantry corps. Since Bazille was from a rich family, if drafted he could have paid for someone to fight in his place. That Bazille chose not just to serve but in a dangerous unit is evidence of his selflessness and courage. However, his decision upset and angered his friends. When Maître learned of the enlistment, he wrote an imploring, emotional letter to Bazille: 'My dear and only friend, I've just received your letter; you are mad, stark raving mad. I embrace you with all of my heart. May God protect you, you and my poor brother! Ever yours. E. Maître. Why not consult a friend? You have no right to go ahead with this enlistment. Renoir has just come in. I'm giving him my pen. E. Good luck you crazy brute! Renoir.'[142]

Renoir clearly was angry that Bazille was intentionally risking his life out of patriotism without concern for the feelings of his friends. Renoir's and Maître's fears were justified. On 28 November 1870, Bazille – a great talent and a generous human being – was killed at Beaune-la-Rolande. Maître was heartbroken and wrote to his own father: 'Half of myself has gone away.... No one in the world will ever fill the void that he has left in my life.'[143] Renoir was greatly saddened by Bazille's death, as Bazille's father recalled: 'Renoir did not write

to me, but friends of his told me of his emotion and deep sorrow, which don't surprise me, because I knew about the brotherly friendship he felt for Frédéric.'[144] Bazille's father was also devastated and decided that he wanted to own Renoir's portrait of his son, then in Manet's collection. Initially, Manet did not want to part with it but was eventually persuaded by the grief of Bazille's father, who offered a painting by Monet in exchange (see page 83).[145]

Among other artists, both Degas and Manet volunteered to serve in the National Guard, Degas to man a cannon, Manet to became a lieutenant.[146] Other artist friends avoided conscription. Cézanne hid in the small fishing village of L'Estaque, west of Marseilles.[147] Monet and Pissarro fled to London, where they met the paintings dealer, Paul Durand-Ruel. Sisley, who was British, was not drafted.

Renoir was drafted but does not seem to have taken part in combat. Five months after he joined the cavalry, he became gravely ill and was granted leave to convalesce. Writing from his uncle's home, Renoir explained to Charles Le Coeur: 'Finally, I got a bad case of dysentery and I would have kicked the bucket had it not been for my uncle who came and got me in Libourne and took me to Bordeaux.'[148] On 10 March 1871, he was discharged from military duties. Although the French had surrendered, much of the populace objected to France's defeat. Their anger manifested itself in the Commune, the Paris civil war of April 1871. During this time, Paris was a city devastated by cannon fire and bombings.

The Franco-Prussian War officially ended on 10 May 1871, when the Treaty of Frankfurt was signed. It was a decisive Prussian victory that led the Prussian Chancellor Otto von Bismarck to unite the German states under his rule. That same year, Napoleon III's Second Empire ended and the French Third Republic began. The losses of the French forces were enormous – 138,871 dead and 143,000 wounded – compared to the Prussian losses of 28,208 dead and 88,488 wounded.[149] France agreed to pay Prussia, soon to become Germany, five billion francs in war indemnity. The country was humiliated by additional punitive measures when it lost its north-eastern part: most of Alsace and the north-eastern part of Lorraine.

When Renoir returned to Paris in late March 1871, he sought out his old friend Maître, since both of them were mourning Bazille's death. Whereas before the war Renoir had lived with rich artist friends, after the war he rented his own place near Maître's. First, he rented a room on the rue du Dragon in today's sixth arrondissement. A few months later, he found an apartment studio close by

at 34 rue Notre-Dame-des-Champs.[150] Being able to afford his own apartment and studio marked an improvement over his dependent living arrangements before the war.

In Paris in April 1871 the Council of the Commune had established compulsory military service for men aged between eighteen and forty years old. If caught, both Renoir and Maître would have had to participate. Since neither is on record as having served during this time, doubtless both men were hiding. Maître wrote to his father in June 1871 that the area where he and Renoir lived had 'streets in ruins with corpses all around'.[151]

Nonetheless, perhaps to counter this sorry state, Renoir continued developing the Impressionist style that was optimistic and gave the message that life in France was good. Certainly, his positive art was an antidote to the general despair all around him. Soon after his return to Paris, Renoir portrayed Maître reclining on a sofa. Maître's partner, Rapha, whom he had painted once before the war, he painted twice, one a bust portrait, the other a large full-length painting signed 'A. Renoir. April. 1871.'[152] It was extremely unusual for Renoir to include the month and year with his signature. However, this particular month would have called to mind the Commune since, according to the Goncourt brothers' journal entry of 2 April, that month marked the beginning of Paris's civil war.[153]

This large portrait shows Rapha fashionably dressed in a style then advertised in the fashion magazines. Beyond the modernity in the fashion, having her hold a Japanese fan calls attention to the contemporary taste in things Oriental. Rapha stands in a room full of bright flowers with a birdcage nearby.[154] That Renoir painted a joyful portrait during the devastation of a civil war was characteristic in that he created happiness for himself. His paintings never reflect his problems or those of the world.

In addition to contacting Maître, Renoir also resumed his relationship with Lise, who started modelling again in 1871. At this time Renoir was thirty and Lise twenty-three. It is probable that she was worried about being able to find a financially successful husband so that she and their future children could have a comfortable life. Presumably, after seven years with Renoir, she concluded that he would never be able to support her. When, in 1872, she was introduced to her brother's wealthy architect friend, Georges Brière de l'Isle, she terminated her relationship with Renoir and began a new one with Brière de l'Isle.

Even in Renoir's later life, he continued to keep his relationship with Lise a secret. Forty years later, when the painter was seventy-one, in a letter to his

dealer, he said of some works for which Lise had modelled: 'I lost contact with the model who posed for the painting.'[155]

Before Lise left him, in 1872 Renoir painted his most poignant portrait, *Lise in a White Shawl* (see page 87).[156] It was a generous last work that expresses Renoir's deep sadness at Lise's departure. Her eyes and gesture manifest the closure of their relationship. When she left, Renoir gave her both this last portrait as well as the first portrait he had made of her, six years earlier.[157] She kept both portraits until her death. If Lise had any letters from the artist, we will never know, since she destroyed all her personal papers.[158]

Even though Lise had left Renoir in the spring of 1872 for the rich Brière de l'Isle, it would be eleven years before they married (on 21 June 1883). In the intervening time, she bore him three children: Jacques in December 1873, Marianne in August 1875 and Benjamin in January 1879. All three were recognized by Brière de l'Isle and were given his last name. Just like her older sister Clémence, Lise had waited ten years before she recognized her children; however, the great difference between Lise's relationship and Clémence's was that Clémence never became Mme Jules Le Coeur. Lise's recognition of her children coincided with her marriage to Brière de l'Isle. Two years after they wed, the couple had a fourth child, Catherine, who was born in January 1885.[159] The Brières lived in a chic neighbourhood in the sixteenth arrondissement, at 61 avenue du Trocadéro. Lise's husband and children knew she had modelled for Renoir but she never told them about her children with him. It is likely that Lise never contacted her daughter by Renoir, since Jeanne saved many letters from the artist but none from Lise.

Just as Renoir had reconnected with Maître and Lise after his return from the war, so he renewed his friendship with Jules Le Coeur and his family. In June and July 1871, under the direction of Charles Le Coeur, Renoir continued work on the Bibesco ceiling paintings and finished them in the summer of 1871.[160] Two years later, during the summer of 1874, Renoir's ten-year relationship with the Le Coeurs ended suddenly, including his close friendship with Jules. At the time, Renoir and Jules were staying with Charles and his family at their summer house near Paris at Fontenay-aux-Roses. There, Renoir was painting portraits of the family, including one of Charles's mother-in-law, Mme Théodore Charpentier, and one of Charles, then aged forty-four.[161]

Something happened between Renoir and Charles's eldest daughter, Marie, then aged fifteen, that led to Renoir's banishment from the family. This was the same young girl whose portrait Renoir had painted a few years earlier. One

account of what happened was written by Marie herself decades later when she was a grandmother and wrote a notebook of childhood memories. She recalled that one evening, her father had come upon Renoir looking through a keyhole at her and her two cousins who were dancing by candlelight in their slips.[162] The other explanation of what happened was related by Marie's younger sister, Martha, who wrote that Jules had found a blotter with ink writing in reverse; he held the blotter up to a mirror and saw that Renoir had written a letter to Marie. The implication is that Renoir initiated a meeting with Marie that the family suspected could have been intimate in nature. Jules was horrified that Renoir seemed to have propositioned his niece. Knowing that Renoir had fathered two children with Lise, Jules feared what might transpire with Marie. He felt that Renoir's behaviour was sufficient grounds to sever their long friendship, which ended in 1874. A year later, a letter from a Le Coeur cousin indicates that the family had not forgiven Renoir: 'About the faux-pas, you remember Fontenay-aux-Roses and your dear niece Marie [who had to deal] with a man without any principles whatsoever when it comes to morals and decency.'[163]

If the letter story is true, Renoir's inappropriate behaviour towards Marie probably offended Jules, who had long considered Renoir his close friend, someone with whom secrets had been shared. Renoir would have broken Jules's trust and, perhaps, Jules feared that his own clandestine relationship with Clémence would be revealed to his family. In addition to that, Jules's reaction might recall his brother-in-law's objection eight years earlier that Renoir was too low-class to be associating with the upper-class Le Coeurs. It is unclear whether Jules would have reacted the same way if Renoir had come from a wealthy, established family. While the facts are unclear, we do know that Renoir's ten-year friendship with Jules abruptly ended. From that time on, Renoir made no more paintings for the Le Coeurs. He is not mentioned in family letters or in Jules's correspondence. Nonetheless, before this rupture, Jules had acquired at least three Renoir paintings and his brother, nine. When Renoir was ejected from Fontenay-aux-Roses, he returned to Paris. The previous year, he and his brother Edmond had rented a small apartment and a modest fourth-floor studio at 35 rue Saint-Georges, in the ninth arrondissement in the Batignolles area, below Montmartre, where, the decade before, as described earlier, Renoir had attended cafés with Manet and his other friends. Renoir's studio was a sociable hub where many of his non-artist friends came to pose with the attractive women who were his models. In addition, Renoir often rented a second studio. Hence,

when working on *Dancing at the Moulin de la Galette* (see page 86),[164] he leased a house with a garden near the dance hall at 12–14 rue Cortot (now housing the Musée de Montmartre). In 1879, when Edmond was writing an article for the magazine *La Vie moderne* (*Modern Life*), he described Renoir's process: '[What does he do] when he paints the *Moulin de la Galette*? For six months, he lives there, he will make friends with all of these people who have their unique charm that his models would not be able to imitate, and as he mixes with the joyful mood of the popular dancehall, he paints its swirling movement with stunning vivacity.... So, his work, besides its artistic value, has the entire spell of an exact picture faithful to modern life. What he pictured, we can see it every day, is our real life that he captured in images that will be remembered as being among the most lively and the most harmonious of our time.'[165]

During the seven years after Lise left him in 1872 and his next major model, whom he met in September 1878, was Renoir intimate with any of his models? Without letters by, to and about Renoir from this time, we cannot know. During these years, Renoir painted several of his greatest romantic paintings, such as *The Loge*, 1874, *The Swing*, 1876, *Dancing at the Moulin de la Galette*, 1876, *Leaving the Conservatory* and *Woman in the Boat*, both 1877.[166] *Dancing at the Moulin de la Galette* in particular, as a large and prominent painting of modern life, held a place in Renoir's and his admirers' hearts. Although the painting is filled with faces, we have no reliable way of identifying the models. In this period, there is no evidence that Renoir had one key model. Rather, many different women posed – professional models, actresses, as well as casual acquaintances. Similarly, Renoir's male models included his brother, Edmond, and his numerous friends, including some of his fellow artists. Since Renoir's daily-life paintings were not portraits but idealized figures, different people modelled for the same figure. This procedure continued throughout his life, and even, on occasion, a woman would pose for a man's figure.[167]

According to Georges Rivière (a journalist and government official in the Ministry of Finance) in his monograph *Renoir and his Friends*, which was published in 1921 two years after Renoir's death and written almost fifty years after the time discussed, Renoir had many female models in the 1870s (Angèle, Anna, Estelle, Nini and others).[168] Rivière's recollections so long afterwards have little credibility. However, we can document that two actresses and one model did pose for Renoir in the mid-1870s: the actresses were Henriette Henriot and Jeanne Samary; the model was Margot Legrand.

Mlle Henriot (Marie Henriette Grossin) modelled for eleven paintings by Renoir from 1874 through 1876. Because she was well known, he exhibited his first painting of her, a large work showing a fashionable Parisian woman, in the first Impressionist group show in 1874. In other images the actress appears in the guise of a male courtier in front of a partially drawn curtain, and being drawn by a man in a sketchbook. These last two works reflect on the art that both model and painter created, relating to the actual life behind the paintings. It is not known if Renoir paid her for modelling, but he did give her two paintings: the last painting he made of her, in which she wears a low-cut bodice,[169] and *A Vase of Flowers.*[170]

A year after Henriette Henriot ceased to model, Renoir persuaded a more famous actress of the Comédie-Française, Jeanne Samary, to pose (her full name was Léontine Pauline Jeanne Samary and she was married). She appears in at least ten works between 1877 and 1882 in oil, pastel and on cement (two cement medallions, a medium he experimented with in hopes of being able to paint frescoes).[171] As with Mlle Henriot, Renoir often exhibited works for which Mlle Samary posed, as he did with her bust portrait, which he sent to the 1877 Impressionist group show.[172] He exhibited her full-length portrait at the Salon of 1879, and gave her and her husband several of the portraits for which she modelled, which suggests that she probably was not paid for posing.[173]

These women modelling in Renoir's studio drew his male friends there. Among those whom Renoir convinced to pose was the artist Gustave Caillebotte, a wealthy engineer and painter of modern Paris. Renoir and Caillebotte met in April 1874 at the first Impressionist group show. Like Bazille and Jules Le Coeur, Caillebotte became a close friend, almost like a family member. Unlike Le Coeur, Caillebotte trusted Renoir completely from the time that they met until Caillebotte's death twenty years later. Two years after they met, Caillebotte, then aged twenty-eight, made his will, since his younger brother, René, had already died at the age of twenty-six. Caillebotte chose Renoir, then thirty-five, to be the executor of his estate. In his will, he wrote: 'I would like Renoir to be the executor of my will and to accept a painting of his choice; my heirs will insist that he take an important one.'[174] The wording suggests that he felt that Renoir was modest and would not select one of the more valuable paintings.

Caillebotte had been financially supporting Renoir through loans and painting purchases, but Renoir's relationship with him had both give and take. In 1876, Renoir helped Caillebotte to advance his art by inviting him to join the

Impressionist shows. Caillebotte accepted and exhibited that year and in four subsequent group shows, in 1877, 1879, 1880 and 1882. Because of his great wealth, Caillebotte felt that the best way to help Renoir and his artist friends was to purchase their paintings and bequeath them to the Louvre to be displayed with the great art of the past. In the 1870s, Caillebotte purchased 69 works by the Impressionists, including 8 Renoirs – 3 of his greatest masterpieces, *Nude in the Sunlight*, 1875, *Dancing at the Moulin de la Galette* and *The Swing* – and 5 other images – *Woman Reading* and 4 landscapes.[175] The other works were 7 pastels by Degas and multiple paintings: 2 by Millet, 4 by Manet, 5 by Cézanne, 9 by Sisley, 16 by Monet and 18 by Pissarro. Caillebotte's will clearly specified that his entire collection of paintings must go to the Louvre and not to provincial museums: 'I give to the State the paintings that I own. However, I want this gift to be accepted in a way that these paintings would end up neither in an attic, nor in a provincial museum, but rather in the Luxembourg and later at the Louvre.'[176]

Before Renoir began receiving money from Caillebotte, just as he had previously from other artist friends, in 1872, he began a relationship with a young dealer, Paul Durand-Ruel, who gave him money in the form of advances or downpayments for works of art. Before he met Durand-Ruel, Renoir had no dealer, merely an arrangement with the paint merchant Carpentier. Two years earlier, Monet and Pissarro had made the acquaintance of Durand-Ruel in London where they had gone with their families to escape the Franco-Prussian War. Back in Paris after the war, Monet introduced Renoir to Durand-Ruel, who, in March 1872, bought Renoir's *View of Paris* (*Pont des Arts, Paris*) and, two months later, *Flowers (Peonies and Poppies)*, for 200 and 300 francs respectively.[177] Durand-Ruel continued to be Renoir's dealer for almost fifty years and became his close friend. The dealer worked not only with Renoir but also with most of the other Impressionists, selling works and giving advances.[178] He also helped set up group exhibitions outside the official Salons and arranged for publicity for their shows, eventually becoming the dealer for all the Impressionists with the exception of Cézanne.

If Renoir's art was hard for the public to understand despite the beautiful colours and attractive figures, Cézanne's appeared grotesque by its forcefulness and extreme distortions. Consequently, it received the harshest criticism from both the critics and the public. Because of this, Cézanne had no patrons and no dealers while even Renoir had both. Renoir himself, along with Pissarro,

adored Cézanne's paintings. He saw Cézanne's style as a guiding light for his own innovations. This was especially true after Renoir's most Impressionist period of 1871–77, when many of his figures were light, colourful and dissolving. At this time, Cézanne's figures were light and colourful as well, but also sculptural. This intrigued Renoir. From 1877 until his death in 1919, Renoir sought solidity of form in his own way. Because of Renoir's admiration for Cézanne's art, over time, he acquired a few of Cézanne's paintings and watercolours.[179] Renoir actively helped Cézanne by getting Rivière to write favourably about his art and by later getting Cézanne a patron. Even though he was not a client of Durand-Ruel, Cézanne did participate in the group shows started by the Impressionists and facilitated by their dealer. Prompted by their poor reception in the Salons of the 1860s and early 1870s, the Impressionists decided that, in April 1874, a month before the official Salon, they would have their own exhibit.

It was understood that in any given year, an artist could choose to submit to the official Salon or participate in the Impressionist group shows. The artists who were involved in either a few or all of the eight group shows that occurred between 1874 and 1886 included Caillebotte, Cézanne, Degas, Monet, Morisot, Pissarro, Renoir, Sisley and any friends they wanted to invite. However, the independently wealthy Manet refused to exhibit outside the Salons. Even though Manet had trouble with acceptance and placement at the Salons, he persisted in trying to get his work officially recognized and never agreed to exhibit with the Impressionists.

The reason that Impressionism was received so poorly arose out of the increasingly conservative atmosphere engendered by the defeat of France in the war. The reparations made to Germany also sparked an economic depression that lasted more than a decade.[180] At this time, the attempt of the Impressionists to create an innovative style about modern life in France was viewed with suspicion. Besides objecting to the innovative subject matter, the critics and public were shocked by the bright colours, visible brushstrokes, unclear figures and unfocused views, which they saw as destructive and sloppy. They perceived the new art as antithetical to the great art in the museums. The critics' basic misunderstanding evolved into hostility and mockery. A typical cartoon shows a pregnant woman about to enter an Impressionist exhibit with the caption, 'Policeman: "Lady, it would be unwise to enter!"'[181]

Along with Cézanne's canvases, those by Renoir, which were primarily figure paintings, were the most vilified, since his Impressionist, dissolving

Morisot at the age of 32, *c.* 1873. Photographer unknown.
Musée Marmottan, Paris

people were more alarming than sketchy landscapes and still lifes. Furthermore, critics branded Renoir a revolutionary, associating him with those who staged the Commune of 1871, despite the fact that he had had no part or sympathy with them. As Renoir later remarked: 'All these refusals, or bad placements, didn't help sell my paintings, and I had to earn enough to eat, which was hard.'[182]

In December 1873, Renoir, Monet and Sisley, supported by Morisot, Cézanne and Pissarro, joined together to plan what would be their first group show in April and May 1874. In this and future exhibitions, all the artists invited could display any work without a panel's evaluation. The titles of group shows never included the word 'Impressionist', since the critics used that term as a pejorative. Instead, the first exhibition title was 'Société Anonyme des Artistes Peintres, Sculpteurs, Graveurs' (Anonymous Society of Painters, Sculptors and Printmakers). A critic mocked Renoir's *Dancer*: 'His dancer's legs are as cottony as the gauze of her skirt.'[183] The first exhibition was held at the premises of the photographer Nadar at 35 boulevard des Capucines. Afterwards, Renoir sold *The Loge*, now a treasure of the Courtauld Institute in London, for 425 francs.[184] This sale would barely cover his rent of 400 francs for three months. In 1925, Samuel Courtauld purchased the painting for 22,600 pounds.

The following year, 1875, the group mounted their first auction at the Hôtel Drouot, at 8 rue Drouot in the ninth arrondissement. Durand-Ruel was assisting as an expert. At this event, many future patrons bought their first Renoir paintings. The sale prices were low because of the negative opinion of the critics. Worse, some of the crowd at the auction were there to heckle rather

than to buy; they got so violent that the police were called. Despite the rowdiness, Renoir sold twenty paintings with prices ranging from 50 to 300 francs, totalling 2,251 francs, with an average of 112 francs. For comparison, Zola wrote about the Salon of that same year: 'Each portrait, even by a mediocre artist, sells for between 1,500 and 2,000 francs, while those by the better known receive 5, 10 or 20 thousand francs.'[185] Thus, using Zola's arithmetic, if Renoir's works had been valued only as 'mediocre', he would have had twenty times the money that he actually received.

In 1876, at the '2ème Exposition de Peinture' (Second Exhibition of Paintings), Renoir exhibited three of his works that tested the boundaries of the Impressionist style: *Dancing at the Moulin de la Galette*, *The Swing*[186] and *Nude in the Sunlight*. This year, the reviews were worse than ever. *Nude in the Sunlight* was mocked by the most respected art critic for *Le Figaro*, Albert Wolff: 'Try to explain to M. Renoir that a woman's torso is not a mass of decomposing flesh with green and purple spots that indicate the state of total putrefaction of a corpse!'[187] (Eventually, this type of criticism plus the lack of sales of paintings in this style led Renoir to change his Impressionist style to become more clearly defined, more realistic and closer to photography; see Chapter 2).

The next year, 1877, Renoir was one of the organizers of the group show. Two months before the exhibition opened, the artist Armand Guillaumin wrote to Dr Paul Gachet (a friend of the Impressionists and, famously, Vincent van Gogh, whom he looked after in Auvers twelve years later): 'By writing to Renoir, 35 rue Saint-Georges, you would get all the information you need, since that's where the [third group] exhibition is being planned.'[188] In hosting the organization of the exhibit, Renoir was taking an active role in the future of this movement. This process may be the subject of Renoir's painting of 1876–77, *The Artist's Studio, Rue Saint-Georges* (see page 87).[189] The central figure is his friend Georges Rivière, to his left is Pissarro (his bald head and full beard are visible) and to Pissarro's left, Frédéric Samuel Cordey, another artist friend. At Rivière's right, seated on a table, is another artist friend, Pierre Franc-Lamy. In the foreground, seen from the rear with his left side visible, is Caillebotte, who found and paid for the exhibition space at 6 rue Le Peletier, on the same block as Durand-Ruel's gallery.

Renoir also took the initiative in responding to the public's hostility. Since his works had been lambasted during the 1876 group show, he took it on himself to find a vehicle to explain Impressionism to the public. He strongly believed that

the critics and public were misguided and if they could be made to understand Impressionism, their negativity could be changed to understanding and acceptance. Just as his brother Pierre-Henri had done, Renoir decided that writing was the way to reach the people. He asked Rivière, who was already involved in the planning for the third group show, for help.[190] They created a newspaper, financed in large part by Durand-Ruel, to appear weekly between 6 and 28 April 1877, for the duration of the third group show. While the title of the exhibition was '3ème Exposition de Peinture' (Third Exhibition of Paintings), the informative paper was called *L'Impressionniste: journal d'art*. Thus, this group of artists took ownership of the word 'Impressionism' that the critics had used negatively. In four issues, Rivière (who signed himself either G.R. or G. Rivière) strove to explain the new style and to differentiate among its artists.

Since Renoir recruited Rivière, it is likely that many of the opinions were Renoir's and that any idea that Rivière originated would have been approved by him. The first issue began with a copy of a letter to the editor of the foremost Parisian newspaper, *Le Figaro*, in which 'G.R.' poignantly asserts: 'for the honour of the French press, it is really deplorable to give the world this incredible spectacle of idiotic, tactless, hateful writing against people of talent and just at the moment when success was beginning to applaud their efforts.'[191] This was followed by an article called 'Exhibition of the Impressionists', which described the key works of Renoir, Monet and Degas.[192] The second issue's 'Exhibition of the Impressionists' discussed key works by Cézanne, Pissarro, Sisley, Caillebotte, Morisot and then the minor painters Cordey, Guillaumin and Franc-Lamy.[193]

Rivière was not shy in promoting Renoir's art. Beginning with the first article about the group show, Rivière considered that *Dancing at the Moulin de la Galette* was 'the most important of his paintings'. 'It's a page of history, a precious tribute to Parisian life.... No one before him had thought of portraying an event of everyday life on such a large canvas.... It's a historic painting.'[194] Two weeks later, Renoir's friend tried to help him attract clients by writing 'To the Women', an article that tempted them to commission an Impressionist portrait. Rivière enticed female buyers by asking: 'Wouldn't you like to have in your own home a ravishing portrait where one can see the charm that floods your dear being?'[195] While Renoir's name was not given in the article, it was clear that Rivière was talking about Renoir, the only Impressionist who did flattering portraits.

The *Impressionist* also included two articles written by Renoir, each modestly signed 'a painter'.[196] Both are discussions of contemporary architecture,

specifically of the ornamentation and decoration of new buildings that the writer deplored. Renoir cared deeply about the paintings on the walls of buildings and indeed aspired to get commissions for them, as he had for the Prince Bibesco murals. Unfortunately, the *Impressionist* did not lead to a greater understanding of the Impressionists' aims. Nor did it change the hostility and mockery from the critics and public. In May 1877, after the third group exhibition, Renoir participated in a second auction at the Hôtel Drouot. Despite Rivière's efforts to convince the public of the beauty of Impressionist works, the average price of paintings sold was 169 francs. Renoir sold fifteen paintings and a pastel for a total of 2,005 francs, with individual works going from 47 to 285 francs.[197] Since the 1875 auction, the selling price of Renoir's works had remained about the same. Clearly, his art was not valued by the buying public.

In the *Impressionist*, Rivière, no doubt inspired by Renoir's adoration of Cézanne's painting, gave special attention to his submission of fifteen works to the group show. Even though the review of Cézanne's work is signed 'G. Rivière', considering Renoir's fanatical devotion to Cézanne's art, it seems that Renoir wrote these moving words or at least gave Rivière the ideas for this eloquent tribute: 'Mr Cézanne is, in his work, a Greek of the golden age; his paintings exude the calm and heroic serenity of ancient paintings and terracottas. The dimwits who laugh at the *Bathers* [see page 86], for example, remind me of barbarians criticizing the Parthenon. Mr Cézanne is a painter and a great one at that.... His painting has the inexplicable charm of biblical and Greek antiquity; the figures' movements are simple and broad like ancient sculptures, the landscapes have an imposing regality, and his still lifes, so beautiful and so accurate in the relationship between shades of colour, bring a certain solemnity in their truth.... A scene at the sea...is of a surprising grandeur and of an incredible calm; it seems like this scene takes place in one's memory, when remembering one's life.... Works comparable to the most beautiful ones of antiquity, those are the weapons with which Mr Cézanne fights against the hypocrisy of some and the ignorance of others, and that assures his triumph.... One of my friends [no doubt Renoir] wrote to me: "When in front of the *Bathers*, I do not know what qualities one could add to this painting to make it more touching, more passionate, and I am looking in vain for its supposed flaws. The painter of the *Bathers* belongs to a race of the greatest artists. Since he is incomparable, he is easier to reject; yet there are some similar to him whose art is respected, and if the present does not give him justice among his peers, the future will rank him next to the demigods of art."'[198]

Although Renoir had not convinced Durand-Ruel to become Cézanne's dealer, he was more successful in finding Cézanne his most faithful and devoted patron. In 1875, at the Impressionist auction, Renoir had met Victor Chocquet, a customs official married to a wealthy woman. Renoir guessed that the sophisticated Chocquet would admire Cézanne's art, so he brought him to Père Tanguy's art supplies shop where Chocquet bought three Cézanne paintings for 50 francs each (Julien François Tanguy was an especially helpful dealer for Cézanne). Then, Renoir introduced Chocquet to Cézanne, and Chocquet became his patron. Eventually he bought thirty-five works by Cézanne.[199] In 1880, Chocquet commissioned Renoir to make a pastel portrait of Cézanne. Shortly thereafter, Cézanne made an oil copy of this portrait (see page 72).[200]

While Renoir was delighted to have found a patron for Cézanne, it was not at the expense of his own patronage. Over the next five years, Chocquet purchased thirteen paintings by Renoir. In 1875, the Chocquets commissioned a portrait of M. Chocquet (see page 88) and one of his wife. The next year, they commissioned one more portrait of M. Chocquet, two more portraits of his wife and one of their little girl, who, sadly, had died when five years old, for which they had supplied a series of photographs. Around the same time, Chocquet also asked Cézanne to paint his portrait (see page 88). The other paintings by Renoir that Chocquet acquired included a wide variety of subjects: a study for *Dancing at the Moulin de la Galette*, a nude, a genre scene, two landscapes and a self-portrait.

The self-portrait painted around 1875 (see page 89) was purchased by Chocquet in 1876 and sold the same year to a Dr Georges de Bellio.[201] Besides Chocquet, Renoir had several patrons interested in his painting. In all cases, the warm, gregarious artist became a close friend of the patron who also provided him with money, commissions and contacts. Three of the most important were Duret, Murer and Charpentier.

Renoir seems to have met Théodore Duret, a wealthy critic and collector, at the Café Guerbois in the 1860s among Manet's friends. In 1871, Duret and a French banker, Henri Cernuschi, travelled around the world, including in the recently accessible Japan, and collected Japanese art.[202] Back in Paris, in 1873, Duret bought his first Renoir, *Summer* (or *The Bohemian*), a painting of Lise that had been exhibited at the Salon of 1869.[203] Duret had purchased the work from a dealer on rue La Bruyère for 400 francs. The same year, during a visit to Renoir's apartment-studio, he bought *Lise* (or *Woman with an Umbrella*), a large

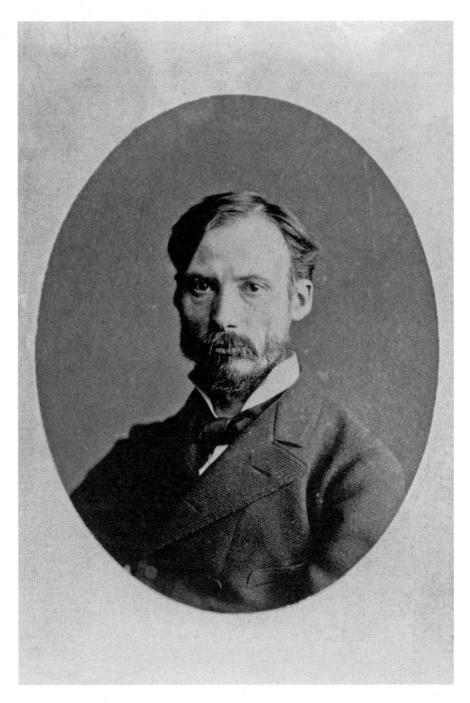

Renoir, 1875. Photographer unknown. Musée d'Orsay, Paris

painting exhibited at the Salon of 1868, for 1,200 francs.[204]. Besides purchasing his paintings, Duret also began sending the painter small sums to pay his rent, as noted in seven letters from Renoir to the collector. For example, around 1875, Renoir pleaded with him: 'Everybody is letting me down for my rent. I'm extremely annoyed. I'm not asking you for any more than you can do, but you would be doing me a real favour. I'll stop by just in case tomorrow morning. Of course, if you can't do it, I will understand.' In a letter of October 1878, he acknowledged: '[My dear Duret,] I received the 100 francs you sent and it made me extremely happy.'[205]

Starting in 1875, another patron who helped Renoir was Eugène Murer, a pastry cook who owned and ran a restaurant at 95 boulevard Voltaire (in the eleventh arrondissement), where Renoir and his Impressionists friends sometimes ate.[206] By 1885, Murer had acquired 'twenty-five Pissarros, twenty-eight Sisleys, ten Monets, sixteen Renoirs, eight Cézannes, twenty-two Guillaumins, and several others'.[207] Since some of the artists were then poor, it seems likely that Murer traded them meals for artworks.

Murer purchased one of the last paintings for which Lise modelled, *The Harem (Parisians dressed as Algerians)*, which Renoir had unsuccessfully sent to the Salon of 1872. Murer also bought eight paintings of 1876: *The Artist's Studio*; *Rue Saint-Georges*; *Confidences*; *Portrait of Sisley*; *Rivière and Margot*; *Woman dressed in Black*; *The Tunnel*; *The Ingenue*; and a landscape, *Garden of rue Cortot in Montmartre*,[208] which depicted the garden behind the studio that Renoir rented when he was working on *Dancing at the Moulin de la Galette*. The following year, 1877, Murer commissioned family portraits of himself, two of his sister, Marie (later Mme Gérôme Doucet), and of his son, Paul Meunier.[209] Renoir had initially asked Murer for 150 francs for each, but Murer was willing to pay only 100 francs each, which Renoir accepted.[210] At the same time, Murer commissioned portraits of himself, his sister and his son from Pissarro as well.[211]

When Renoir was thirty-six, Murer wrote in his journal of Renoir's idiosyncrasies: 'So then – he burst out in his good-natured ogre's voice, nervously rubbing his index finger under his nose as was his habit.'[212] From this we learn that Murer perceived the artist as highly strung, anxious and nervous, but kind. The 'ogre' descriptor might refer to a voice roughened by years of chain-smoking cigarettes.

Perhaps Renoir's most important patrons of 1876–79 were the book publisher, Georges Charpentier, and his wife, Marguerite. They met the artist

when he was in desperate financial straits aged thirty-four. Charpentier had purchased three Renoir paintings at the Hôtel Drouot group auction on 24 March 1875.[213] Between 1876 and 1880, Renoir painted several portraits of Georges, Marguerite and their two children (see pages 70 and 91).[214] In 1876, Renoir decorated the stairwell of their home with two large oil portraits of a man and woman who closely resemble the Charpentiers.[215] Other planned mural decorations for their home around 1879 included figures representing the four seasons.[216] For the Charpentiers' elegant dinner parties, Renoir designed an elaborate place setting for a 'Madamoiselle Leabille' as well as a menu depicting nine different courses.[217]

To M. and Mme Charpentier, Renoir submitted even more entreaties for financial help than to Duret: he asked for 300 francs for his rent and for smaller sums for daily needs (150 francs and 100 francs).[218] His warm, playful personality made his pleas endearing. In one letter, dated '15 October, date rent is due', he drew himself in his nightshirt next to his bed, embracing the postman who was bringing him money, and wrote that, if they sent him 150 francs for his rent, 'I will do to you what I am doing to the postman. Kind regards, Renoir' (see page 64).[219]

Beginning early in 1876, the Charpentiers's Friday salons at their new town house, at 11–13 rue de Grenelle on the Left Bank, were one of Paris's foremost literary, artistic and political gathering places. Several of the authors whom Charpentier published were among his guests: Théodore de Banville, Alphonse Daudet,[220] Gustave Flaubert, Edmond de Goncourt, Joris-Karl Huysmans, Guy de Maupassant and Zola. In June 1878, the Charpentiers published an illustrated edition of Zola's *L'Assommoir* (*The Drinking Den*), a novel about the poverty and alcoholism in the Parisian working class, with woodcuts after drawings by many artists including Renoir. One of Renoir's four illustrations[221] was *Nana and her Friends*, which presents a joyful scene despite the depressed nature of Zola's novel.[222]

Other attendees of the Charpentier salons numbered Salon artists, politicians and composers, including Emmanuel Chabrier, Jules Massenet and Camille Saint-Saëns. Of these, Chabrier later became Renoir's patron and purchased four of his paintings of 1876–79.[223] The Salon artists included Charles-Émile-Auguste Carolus-Duran and Jean-Jacques Henner. The liberal politicians who attended included the future president Georges Clémenceau, Jules Ferry, Léon Gambetta and Jacques-Eugène Spuller.

Cartoon drawing in letter from Renoir to Georges Charpentier, 1875-77. Musée d'Orsay, Paris

Renoir hoped that some of these politicians would be interested in hiring him to create murals for public buildings. Given his 1877 passionate writings about the way decoration in contemporary architecture should be done,[224] it is not surprising that he wanted to work in this manner again, as he had for Prince Bibesco. This goal might explain why many of Renoir's most important canvases, such as *The Inn of Mother Anthony, Marlotte*, 1866,[225] and *Dancing at the Moulin de la Galette*, 1876, are large canvases, suitable for covering walls in public spaces. Since cement was a good surface for varicoloured painting, in 1877, Renoir painted at least five small works on MacLean cement.[226] They were part of a project subsidized by Caillebotte, who financed Alphonse Legrand to become the agent for the London MacLean Cement Company.[227]

Related to this ambition of decorating public spaces, Renoir asked Charpentier for help getting commissions for murals, and Charpentier suggested that he see his friend, the politician Spuller, whose portrait Renoir had painted in 1877.[228] Renoir did so, but ran into problems winding his way through the bureaucracy. In a letter to Charpentier, Renoir wrote: 'Spuller...wants me to tell him: I want to have this ceiling or that wall or staircase in such-and-such a place.... I've ended up thinking that the only one who can give him this information is the Secretary General M. [Joseph] Bardoux [Minister of Fine Arts], who is your friend's [Georges] Lafenestre boss.'[229] Lafenestre was Inspector of Fine Arts. In a second letter, Renoir reported: 'I saw Lafenestre.... He told me to speak to the city but I think that it isn't going to work.'[230] In the end, the Charpentiers were not able to help Renoir in this quest to paint public murals.

They were able, nevertheless, to help get his works accepted by the official Salon. Thus, Renoir decided to abandon the Impressionist group shows after repeated failure to interest the public. By the end of 1877, he had followed in the footsteps of Manet, eschewed the group exhibitions and again submitted to the Salon. He shared his intentions with his fellow Impressionists and was joined by three others – Cézanne, Monet and Sisley. The 1878 Salon jury accepted works by all except Cézanne.

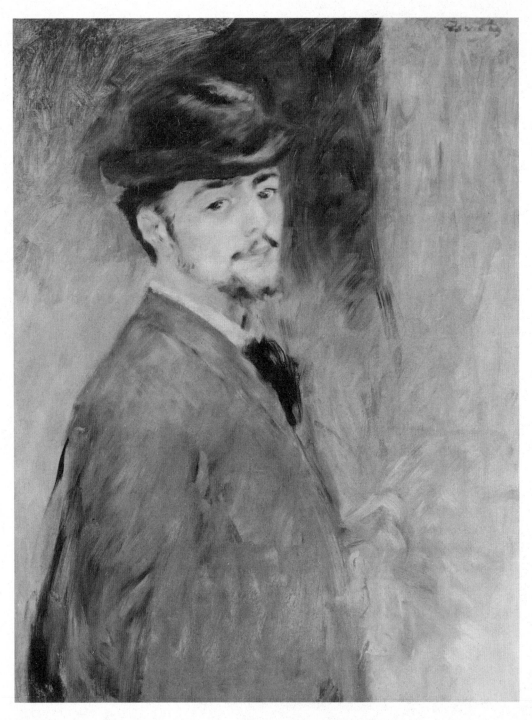

Self-Portrait, 1876, 73.7 x 57 cm (29 x 22½ in.). The Fogg Art Museum, Cambridge, Mass.
Bequest of Maurice Wertheim

Chapter 2

1878-84

Renoir aged 37–43;
Happiness, Poverty and Aline

During the years when Renoir was aged thirty-seven through forty-three, he created his greatest paintings – including *Luncheon of the Boating Party* and the three dance panels, *Dance at Bougival, Country Dance* and *City Dance*.[1] In many ways these were Renoir's happiest seven years, when his creativity flourished. Yet, within that time, in late January 1880, Renoir broke his right arm. Seemingly miraculously, he continued painting prolifically. Marguerite and Georges Charpentier were the key people who aided him in overcoming poverty, public hostility, poor reviews and lack of sales and commissions.

Renoir's appearance in this period is recorded in several self-portraits (see opposite and page 90) and an etching by his friend Marcellin Desboutin (see page 69). By 1878 Renoir was also helping himself by modifying his style. He realized that he could not support himself with figure paintings in his Impressionist style, so he gradually invented a variant, Realistic Impressionism, which was closer to photography. Photographs were immensely popular at this time and could sell for the same price as a Renoir portrait.[2] Hence he modified his style, with less visible brushstrokes and stronger colour contrasts to give the figure a more natural appearance. This style can be seen in most of his figure paintings from around 1878 to 1883. By 1878, he had resigned himself to seek portrait commissions from patrons who, he hoped, would also purchase his scenes of daily life. In this endeavour, Renoir's patron and friend Duret tried to help in his 1878 pamphlet, *The Impressionist Painters*: 'Renoir excels in portraiture.... I doubt that any painter has ever depicted women in a more seductive way.'[3] From 1864 through 1885, Renoir painted close to 400 figure paintings. Of these, about 164 were portraits. Becoming a fashionable portraitist was somewhat distasteful to him since he had to pander to the patron's taste to get paid.

Hence, his artistic freedom was compromised, and he was sometimes prevented from painting as he wished.

After the double disasters that were the 1877 Impressionist show and sale, the group decided not to hold an exhibition the next year. The Charpentiers urged Renoir to return to exhibiting at the Salon, which would take place from 26 May to 8 July 1878. In March of that year, a letter from Pissarro to Caillebotte asserted: 'the Charpentiers are pushing Renoir'.[4] Renoir was willing to follow the Charpentiers' direction and he sent a daily-life scene, *The Cup of Chocolate*, painted early that year, which, though accepted at the Salon of 1878, got little recognition from the critics.[5]

One of the first major paintings in Renoir's new Realistic Impressionist style was the large *Mme Charpentier and her Children* (see page 91), completed in mid-October 1878,[6] which is here illustrated with a contemporary photograph of the children, Georgette and Paul (see page 70). In both the photograph and painting, Paul wears a dress and has his hair long, like his sister. Once Paul went to school, he would cut his hair and wear trousers. It took Renoir about a month to complete the work and he was paid 1,500 francs.[7] Once the portrait hung at their home, Renoir wrote to Mme Charpentier asking if friends could come to view the work: 'M. Charles Ephrussi and M. Deudon...requested that I ask for your permission to see your portrait'[8] and, 'Mme Manet (Morisot, 40, rue de Villejust) asked...for permission to see your portrait.'[9] The Charpentiers were happy to allow such visits. Charles Deudon was the heir to a mining fortune. Earlier that year, in May 1878, Deudon had bought Renoir's *Dancer* from Durand-Ruel for 1,000 francs.[10] Ephrussi, who was from Odessa, Russia, but came to Paris in 1872, was the son of a wealthy Jewish family who had business interests in corn and banking.[11]

With the masterful portrait of Mme Charpentier and her children prominently displayed in their home, attendees at their weekly Friday dinners, impressed with Renoir's work, also began to commission portraits. These commissions were such a boon to Renoir that, in February 1879, Cézanne could write to his patron Chocquet: 'I'm happy to learn of Renoir's success.'[12]

In 1879, the Impressionist group show of 10 April–11 May preceded the Salon, which began on 12 May. While there had been no group show in 1878, in 1879, Renoir had to make a choice between exhibiting with his friends or at the Salon. Although he wanted his friends to think he was a passive follower, in reality, he was not. When an issue was important for his career, Renoir showed no hesitation in acting in his own best interests and was not at all passive.

Marcellin Desboutin, *Renoir*, c. 1876–77. Etching, 16 x 11 cm (6¼ x 4⅜ in.).
Bibliothèque Nationale, Paris

In 1879, he refused to exhibit with his friends at the fourth Impressionist show, even though his friend Monet did join the group and exhibited twenty-nine works.[13] Others who also participated there included Caillebotte, Cassatt, Degas and Pissarro. Following Renoir, both Cézanne and Sisley refused to exhibit with the group and, like Renoir, submitted works to the 1879 Salon jury instead. Unfortunately, the paintings of both Cézanne and Sisley were rejected, but all of Renoir's submissions were accepted, thanks to Mme Charpentier. Since she knew members of the Salon jury, including the academic painter Henner, all four of the portraits that Renoir submitted were accepted: two oils (*Mme Charpentier and*

Georgette and Paul Charpentier, c. 1878.
Photographer unknown

her Children and the actress *Jeanne Samary*) and two pastels (one of a man and one of the Charpentier's little boy, Paul).[14] However, only the portrait of *Mme Charpentier and her Children* was hung in a favourable position. Twenty-five years later, in an interview, Renoir said: 'I had a canvas, yes, just one, but it was a very well placed painting. It was, it's true, the portrait of Madame Charpentier. Madame Charpentier wanted to be in a very good position, and Madame Charpentier knew the members of the jury, whom she lobbied vigorously.'[15]

Renoir was aware of his indebtedness to Mme Charpentier. He acknowledged this directly to her, deferentially closing his letters: 'Your very devoted, Renoir' or 'Your humble painter, A. Renoir'.[16] After the May 1879 Salon, he also wrote to her husband, 'to thank Madame Charpentier from her most devoted artist and, if one day I succeed, it will be entirely thanks to her, because I would most certainly not have been capable of doing so on my own'.[17] Because he had become close to Mme Charpentier, Renoir tried to interest her in the plight of the poor children of Montmartre; he suggested that she establish an infant care centre. Perhaps it was his own feelings of despair for the loss of his first-born, Pierre Tréhot, that fuelled his interest. Mme Charpentier had other concerns at the time but in 1891, she did establish a charity for poor infants.[18]

While the 1879 Salon was in progress, Renoir wrote to Caillebotte: 'Personally, I am having the time of my life. The portrait of Madame Charpentier is hung at eye-level and it looks ten times better than at her house. As for the painting of Mlle Samary, it is hung very high. All in all, I think it's good since everyone is talking to me about it. I think I have greatly improved in my appeal to the masses.'[19]

In addition, Mme Charpentier's painting gained many favourable reviews.[20] One critic characterized it as 'a charming work by Renoir who has become fashionable'.[21] Renoir was launched as a portraitist. From 1879 through 1881, he made 21 portraits of children, 15 of women and 11 of men. As he wrote to Mme Charpentier, 'I started a portrait this morning. I will continue working on another this evening and I am probably going to start a third afterwards.'[22] Pissarro, meanwhile, wrote to Murer: 'Renoir…is having a great success at the Salon. I think he is hitting his stride. Good for him! Poverty is so hard to endure!'[23]

During the 1879 Salon, Renoir began planning a solo pastel portrait exhibition for 19 June–3 July, in the gallery at Charpentier's editorial offices at 7 boulevard des Italiens. In May, Renoir wrote to Mme Charpentier: 'I will exhibit [the portrait of Mlle Samary][24] in your gallery because I'd like, if the gentlemen [in charge] consent, to mount an exhibit only of my portraits, that will attract many people, I think. I have quite a few well-known portraits.'[25] While Renoir's intention was to display only portraits, this show included his painting of two young circus performers and decorative sketches of the four seasons.[26]

Around the same time as the 1879 Salon, the Charpentiers had begun publishing a magazine, *La Vie moderne*. In April, they employed Renoir's brother Edmond as a writer and, in 1884–85, as editor-in-chief. While Renoir's pastel portrait show of thirty works was in progress, Edmond published an article about his brother in the June 1879 issue: 'I promised you a portrait in twenty lines: pensive, dreamy, sombre, a far-away look in his eyes, you've seen him run across the boulevard twenty times; forgetful, disorganized, he'll come back ten times for the same thing without remembering to do it; always running on the street, always motionless indoors; he'll stay for hours without moving or talking: what's he thinking about? The painting he's working on or the one he's going to work on; talk of painting as little as possible. But if you want to see his face light up, if you want to hear him – oh, miracle! – hum some gay refrain, don't look for him while he's eating or in places where one would go to have fun, but try to catch him while he's working.'[27] In addition to describing his brother, Edmond also wrote about Renoir's manner of painting: 'the portrait of Mme Charpentier and her children [was] painted at her home without displacing her pieces of furniture from their everyday places, and where nothing was changed to emphasize one part or another of the picture.'[28] Possibly thanks to Renoir's encouragement, the Charpentiers put on an exhibition of Monet's work at their Vie Moderne gallery in June 1880 and one of Sisley's in May 1881.

Renoir, too, occasionally contributed to *La Vie moderne*. He once passed on an idea of Mme Paul Bérard to Mme Charpentier: 'It is, on the last page of *La Vie moderne*, to present the fashion of the week. I would be responsible for making very exact drawings…. We could make an arrangement with hatters and dressmakers. One week of hats, another of dresses…. I would go to their places to make life drawings from different angles.'[29] While we do not know if that particular idea ever came to fruition, various drawings of women's hats and dresses by Renoir appeared in the magazine through 1884.[30] To illustrate *La Vie moderne*, Renoir also contributed other drawings, including one of Edmond reading.[31]

During this time, Renoir continued to submit works to the Salon. In 1880, Monet joined him there and refused to participate in the group show.[32] Renoir, having had his first big Salon success the year before, now sent the Salon two daily-life paintings (*Mussel Fishers at Berneval*, 1879, and *Sleeping Girl with Cat*, 1880), and two pastel portraits (*Lucien Daudet* and *Mlle M.B.* [Marthe Bérard]).[33] Since Mme Charpentier had no family portraits submitted, she did not assist Renoir in getting his works well placed. Without her help, Renoir's art got little attention from the critics, but he had become popular enough that he continued to have portrait clients. After the 1880 Salon, Cézanne wrote to Zola: 'I was told Renoir is getting some good commissions to make portraits.'[34] One of those commissions came from Victor Chocquet, who asked Renoir to make a pastel portrait on paper of Cézanne that is prominently dated 'Renoir.80'. Chocquet lent it to Cézanne, who copied Renoir's pastel in oil on wood; the copy is of similar dimensions as the original.[35]

Renoir realized that the Salon was better suited to advertising his talents at portraiture than to displaying his genre pieces; over the next few years, he primarily sent portraits to the Salons and each year received many portrait commissions.[36] These commissions came from a diverse group of people. Besides the French Catholic majority, many patrons were Jewish – like the Bernsteins, the Cahen d'Anvers, Ephrussi, the Foulds, the Grimprels, the Halphens and the Nunès. Others were Protestant – such as a new patron, Paul Bérard, who became a close friend.

In the winter of 1878, at a Charpentier soirée, Renoir met Bérard, a wealthy foreign affairs attaché with ties to the banking world.[37] They were introduced by Renoir's patron and friend Deudon, who had bought Renoir's *Dancer* from Durand-Ruel for 1,000 francs in May 1878, as noted earlier.[38] Deudon persuaded Mme Bérard to have Renoir paint a full-length portrait of her daughter, Marthe.[39]

For this single portrait, the Bérards paid him the same amount, 1,500 francs, that Mme Charpentier had paid for her large portrait with her children. Pleased with Marthe's portrait, the Bérards invited Renoir to spend the summer painting at their Normandy chateau in Wargemont near Dieppe. Renoir explained to Caillebotte why he was leaving Paris: 'I have to go spend a month at the Bérards'.'[40] Over the summers of 1879–85, Renoir stayed one or two months and lived in the chateau as if he were a member of the family.

During these seven summers in Wargemont, Renoir would paint about forty paintings for the family.[41] Most were portraits of Bérard, his wife, Marguerite, their four children (André, Lucie, Marthe and Marguerite) as well as their nephew and niece (Alfred and Thérèse Bérard). Renoir even painted their concierge. He also painted genre scenes, landscapes, still lifes and an allegory, *The Celebration of Pan*. In addition, the Bérards encouraged Renoir's love of architectural decoration by asking him to paint some of the wood-panelling. In the first summer, he made an oil painting of flowers for the library door and for one bedroom.[42] During his time at Wargemont, Renoir worked not only for Bérard but also for other wealthy Parisians who summered near Dieppe. In addition, Renoir painted other works that he sent to his dealer, Durand-Ruel.[43]

Dieppe was a popular place where many wealthy Parisians purchased large homes in which to spend their three-month summer vacations. They included the Bérards, Durand-Ruel and Edmond Maître's friends, the Blanches. Dr Émile Blanche was a prominent Parisian alienist (psychiatrist), the director of a mental clinic in Passy in the sixteenth arrondissement, who was also an art collector. He and his wife, Félicie, had a son, Jacques-Émile, then aged eighteen, who aspired to become an artist. During the first summer that Renoir stayed with the Bérards, the Blanches invited Renoir to visit in order to see their son's paintings. Since Dr Blanche was working in Paris, Mme Blanche wrote to her husband describing the artist's visit: 'My dear friend, I see that Jacques has been too humble in his account of M. Renouard's [sic] visit.... They were chatting together in the yard. I begged M. Renouard to come up and see the little paintings that Jacques painted for his studio, and the other paintings. Jacques objected, saying that he was completely opposed to this, that what he did was dreadful. Fortunately, the young man [Renoir] did not listen to him, and after much bickering between Jacques and me, he ended up seeing almost everything. This visit was extremely beneficial for our child who often loses heart, especially when he paints a face from life; this child wants to succeed at the first attempt, like a Master. I'll get

back to what Renouard said. I promise he said this very seriously, mentioning the flaws within his praises: "I am absolutely amazed; there are some perfectly remarkable parts; it would be quite a shame if you did not become a painter; you have extraordinary qualities of colour and composition; there are even some things that are well drawn; I would be very happy to give you some advice in Paris.".... All of this made Jacques really happy. [Renoir] told him that sometimes he spent four months believing that he was not capable of doing anything any more, and all of a sudden, he started painting even better. All of this gave Jacques great enthusiasm. He is working hard in drawing. Besides, you know, my dear friend, that my opinion has always been that he needs a professor who knows how to appreciate his great qualities; otherwise he will not make himself any greater if he only sees and talks about his flaws.'[44]

Renoir's kindness and encouragement to the young aspiring artist was much appreciated, and Mme Blanche soon learned to spell his name correctly. Later in 1879, the Blanches commissioned Renoir to paint three oil paintings, all illustrations of scenes from Wagner's *Tannhäuser*. One, the *Apparition of Venus to Tannhäuser*, was created for their Paris dining room. The other two, *Tannhäuser resting in Venus's Arms* and *Wolfram restraining Tannhäuser from reaching Venus*, were overdoor decorations for their Dieppe chateau, based on the first and third act of the opera.[45] Renoir painted these decorations in Paris but, unfortunately, they were the wrong size. When he discovered this, he redid the paintings in the correct size and gave his dealer the original versions to sell.[46]

Although written several years later, Jacques-Émile described Renoir's appearance when he first met him: 'His face already lined and wrinkled with a sparse and ragged beard, brilliant teary eyes under bushy and fierce eyebrows that didn't manage to make him look any less gentle. He spoke like a working-class labourer with a rasping guttural Parisian accent.' And of the Normandy summers Blanche wrote: 'Every market day he would come from Paul Bérard's in Wargemont on the seat of the chateau's omnibus, wearing a funny pointed hat, pipe in mouth, chatting to the butler.... I would look forward to these Saturdays for the joy of showing Renoir whatever I had painted during the week.'[47]

Even though Renoir was becoming more popular by fulfilling portrait commissions for wealthy patrons, he still preferred painting modern life. For these paintings, he was still using a wide variety of models – actresses, professional models and friends. The only real evidence we have of any specific model during this time is of Margot Legrand.[48] She is mentioned in several of Renoir's letters

dated early 1879. The intensity of his feelings about her suggests that she was personally important to him. In January and February 1879, when Renoir was thirty-eight and Margot twenty-three, she became seriously ill. Renoir wrote a series of distraught letters to two friends who were homeopathic doctors.[49] He wrote to Dr Paul Gachet: 'Dear Doctor, Please be kind enough to go to Miss L...'s house, 47, rue Lafayette.... Some spots have appeared. As she scratches them, they form a white blister.... She writes me that she is suffering greatly.... It could be smallpox. In short, I am very anxious to find out, so anxious that I have accomplished nothing today as I waited for you.... Yours, RENOIR, 35, Rue Saint-Georges.'[50] Receiving no answer, he wrote another anguished letter: 'Dear Doctor, The dear child writes me that she is suffering and does not know what to do. Please be kind enough to go see her, or to let me know if you are ill, or if something has happened to you. I am very worried and very distressed. Your friend, RENOIR.'[51]

Dr Gachet had not responded because, on 17 January 1879, he was in a train accident and was unable to travel to see Margot. Once Renoir learned this, he sought the help of another homeopathic physician friend, Dr Georges de Bellio, who was an early Impressionist collector.[52] Renoir also wrote again to Dr Gachet: 'This morning, M. de Bellio went to see my sick patient. He had seen her several times at my studio and he has a head I painted of her, I think.'[53] Again, he wrote: 'I have given up on smallpox; it might be more humane to let this poor child die peacefully. If there was the faintest hope, I would do anything in my power. But it is extremely serious.'[54] Subsequently, he wrote to Dr de Bellio: 'Dear Doctor, The young girl you were kind enough to treat, unfortunately too late, died [on 1 February 1879]. I am nevertheless extremely grateful to you for the relief you provided her with, even though both of us were convinced it was quite worthless. Your devoted friend, RENOIR.'[55]

These letters show Renoir's heartbreak about Margot's condition, since he cared deeply about her. His use of endearments such as 'dear child', 'this poor child', 'my sick patient' and 'the young girl' could be interpreted today as somewhat belittling – after all, she was twenty-three and he was fifteen years older than her – but at the period they were normal expressions of fondness from a man to a woman.

In September 1878, five months before Margot died, at a time when Renoir, then aged thirty-seven, was enjoying Mme Charpentier's support and his prospects of becoming an eminent portraitist looked good, Renoir met Aline

Charigot, who at nineteen was eighteen years his junior. For the next thirty-seven years, Aline was a key woman in the painter's life. After Margot Legrand died, Aline became his primary model and posed for more masterpieces than any other woman. Many of these are his most vibrant, colourful and romantic images. They convey Renoir's happiness with the woman who was his new model and who would become his mistress and later wife. The years 1879–84 were the time of Renoir's courtship of Aline and the early years in which they lived and travelled together. This budding love brought him a joy that is evident in his letters to her and in the superb quality and prolific nature of his paintings. The period coincides with his new-found success as a portraitist, largely due to Mme Charpentier and his reception at the Salon of 1879.

Aline and Renoir had much in common, both being born outside the cultural hub of Paris and both from working-class families. She was from the devoutly Catholic village of Essoyes, on the Ource river in Champagne, near Burgundy. Eight years before she was born, a census recorded that the population of Essoyes numbered only 1,806 inhabitants.[56] However, while Renoir came to Paris at the age of four from the small city of Limoges, Aline came at fifteen, having spent her childhood in Essoyes. But both grew up poor and lower class, and both mothers were seamstresses and their fathers, a tailor and baker, respectively. Their grandparents were also artisans, Renoir's a wooden-shoemaker (as we have seen) and Aline's a wine-grower.[57]

Despite their similar backgrounds, Aline's childhood was harsher, since she grew up penniless, abandoned by her parents and ill-treated by her relatives. Although Renoir had been poor, he had the support of his family. While Renoir was driven to make whatever compromises he needed to pursue his art, Aline developed an iron will towards getting what she wanted. Even with her hardships, she excelled in schoolwork and was determined to make a good life for herself. It might have been that very iron will that attracted Renoir to her. Aline's toughness helped her and supported Renoir through rough times, especially as Renoir, significantly older than she, struggled with ill health that first manifested itself when she was not yet thirty years old.

Aline's mother, Thérèse Emilie (called Emilie) Maire, was born in Essoyes on 19 January 1841, a month before Renoir's birth in Limoges. It was always awkward for the three of them that he and his future mother-in-law were the same age. Yet the fact that Renoir was of the same generation as her absent father was probably comforting to Aline, who grew up without a caring father

figure. The circumstances around Aline's birth were unfortunate. Emilie was a dressmaker aged seventeen when she became pregnant. Since abortion was illegal in Catholic France, Emilie was forced to marry a baker then aged twenty-two. Six months later, Aline was born. Her birth certificate reads: 'On May 23, 1859, at 6 o'clock, Aline Victorine Charigot, a female child, was born of Claude [Victor] Charigot, a baker, and of Thérèse Emilie Maire a housewife, town of Essoyes, Canton of Essoyes, Arrondissement of Troyes, Département of Aube.'[58]

When Aline was fifteen months old, Victor abandoned his wife and child for his mistress, who lived in Selongey, on the Côte d'Or, 100 kilometres (62 miles) from Essoyes. When he fled, he left his wife a debt of 1,031 francs to a flour and grain dealer. With that much debt, Emilie could not pay the rent and she and Aline were evicted. After all their furniture and possessions were sold, Emilie still owed the landlord 66 francs. Although she had applied for a separation of goods between the two partners, it was not until two years later that a legal decree declared that Victor had 'disappeared from his home...abandoning his wife', thus clearing Emilie of the remaining debt.[59]

Emilie asked for a separation of goods rather than divorce because divorce was illegal in France from 1817 until 1884. Victor, meanwhile, did not find this to be an impediment. He left his mistress and on 17 August 1872, fled across the Atlantic to Quebec and made his way to Winnipeg, Manitoba. There, where the French marriage records were not available, he married an American widow, Louise Loiseau, in a church wedding. Technically, this was bigamy. Amazingly, eleven years later after Louise died in March 1884, Victor wrote to Emilie proposing that after a separation of twenty-four years she come to join him in Winnipeg.[60] Emilie used this letter to obtain a divorce, which was granted in 1888. After Emilie rejected Victor's 1884 proposal, he soon remarried. He and his new wife, Arméline (or Émeline) Reopelle (or Riopel) moved to America and settled in North Dakota, where, in 1886, their daughter Victoria Charigot was born. Despite his utter infidelity to his wife, he never quite forgot their daughter, Aline, and, over the years, occasionally sent tokens or letters.

Shortly after they were abandoned, Emilie aged nineteen and Aline aged fifteen months went to live with relatives. Emilie earned a little money sewing. However, by the time that Aline was eight years old, Emilie came to the conclusion that she could not earn enough as a seamstress in Essoyes. She left Aline with family members and found a higher-paying job as a housekeeper far from Essoyes at Nogent-sur-Seine, Sarcelles, Dreux. Throughout the next seven

years, Emilie rarely saw Aline though she sent money to pay for Aline's clothes and school tuition. Subsequently, she left this employment and found another housekeeping job in Paris where she worked for a widow at 42 rue Saint-Georges, coincidentally close to Renoir at number 35. After the widow died, Emilie left rue Saint-Georges and rented an apartment nearby at 35 rue des Martyrs, in Pigalle, Paris's red-light district, where she worked as a dressmaker.

During the years that Emilie was separated from her daughter, Aline's relatives were not affectionate towards her. Most of the time, Aline lived with a childless uncle and aunt, Claude Charigot, the eldest of her father's ten siblings, and his wife [Marie] Victorine Ruotte, who looked down on her. Claude owned his own home and was a wine-grower; Victorine was a dressmaker and the daughter of wine-growers. Although she harshly criticized Aline, Victorine sympathized with Emilie and called her brother-in-law 'the bastard'.[61] Occasionally, Aline stayed with her father's mother or with her mother's parents, who were cruel. On one occasion, her maternal grandfather tried to take half of Aline's school money, since he felt that Aline was a drain on his finances.[62] Another time, her paternal grandmother pocketed the New Year gift money that Aline's father had sent her.[63]

In this loveless situation, Aline grew not to trust others. Her aunt lamented: 'She never has been able to have a friend.'[64] Aline's deprived childhood could have been one of the causes of her lifelong weight problem. Being surrounded by people who disliked her, she turned to food for comfort. It might also have been partly genetic. Her father's sister, Marie, was extraordinarily overweight.[65] In Victorine's numerous letters to Emilie, she focused on Aline's appearance, though she occasionally also described her schooling and her behaviour. When Aline was ten, Victorine wrote: 'Your Aline is well. She is fat.'[66] When Aline was eleven, Victorine reported: 'I wish you could see how fat she is…. She gained eight pounds during the six weeks that she was with me. The nuns complimented her, saying she looked well.'[67] When Aline was thirteen, in August 1872, her aunt told Emilie: 'she is tall and heavy'.[68]

Aunt Victorine was strict and often complained to Emilie about Aline's wilful and disobedient behaviour. In an undated letter, Victorine related: 'She is less obedient than last year…. She is very difficult to control.'[69] When Aline was eleven, Victorine bemoaned: 'I am at my wit's end. Can you believe that she goes fishing every day? The eve of Ascension, she went into the water [with her shoes on]. Her shoes are no longer fit to wear…. She will never learn. I don't

know what you will do with her.'[70] Aline's teachers at the parochial school had the same problem. Victorine reported: 'The nuns say that they will do all they can to control her but that it is difficult.'[71] Aline was independent, strong-willed and liked to be alone. Eventually, Victorine had a few good things to say about her: 'She is becoming more reasonable; she obeys me well; she also works well; she finished knitting a pair of stockings'.[72]

Aline excelled at her studies. There was a free school in Essoyes and a girls' private Catholic school that took day students and boarders. Despite her limited resources, Emilie sent Aline to the parochial school where she learned religion as well as reading, writing, sewing and cooking. When she was nine, her aunt informed her mother that Aline had won 'first prize in spelling, first prize in arithmetic, and first prize in religious studies', begrudgingly adding: 'She works pretty well for someone her age.'[73] From these letters it is evident that Victorine felt burdened by having Aline with them. When Aline was twelve, her maternal uncles were trying to get her to leave school. Aline herself wrote to her mother: 'My...uncles are jealous. Sometimes they say that I must go to the vineyard [to pick grapes]; other times, that you should find a job for me. They send their children to get wine, milk, in other words, everything that they need.'[74] But she wanted to stay in school, and her mother was willing to pay.

Aunt Victorine approved of Aline staying in school because, since the autumn of 1871, when Aline turned twelve, she had boarded at her school and only came home at weekends and holidays. This kept Aline from being underfoot. A year after Aline started boarding, in a letter to her mother, Victorine suggested that Aline remain at boarding school during the winter of 1872–73 to continue learning more about sewing and then, in the spring, that she spend two to three months as an apprentice to a good dressmaker in Essoyes.[75] Thus, due to a combination of her own love of school and her aunt's wish to keep her out of the house, by age fourteen, Aline had become a seamstress. By the time she was fifteen, Aline's behaviour had begun to worry her aunt. While Aline did not have female friends, in her early teen years she got involved with the local young men. Her aunt, thinking of Emilie's plight, wrote that Aline had done some 'foolish things'.[76] Victorine reported: 'She told me a lie that she should have known I would check for myself.... She was chasing after young Auguste. You know, you would think that it is child's play, but don't fool yourself. He is a little libertine that everyone talks about.'[77] Shortly after she sent this letter, when Aline was fifteen, Victorine decided to get Aline away from the boys in Essoyes,

and sent her to Paris where she joined her mother working as a seamstress. A few months later, on 4 December 1874, Victorine, aged only forty-six, died in an epidemic that killed many people in Essoyes. Aline was lucky to have left town when she did.

In Paris, Aline worked at various jobs to earn money. She did sewing and laundry, for both Renoir and Monet.[78] She also worked as a waitress at a creamery on rue Saint-Georges, across the street from Renoir's studio and apartment. Mlle Camille, a friend of Aline's mother from Essoyes, owned this shop. It was not until Aline had lived in Paris for four years that she actually met Renoir, in September 1878. Seventeen years after they met, Berthe Morisot's daughter, Julie Manet, wrote in her diary that Aline recalled: 'the first time she saw M. Renoir he was with M. Monet and Sisley; all three wore their hair long and they caused quite a stir when they walked along the rue Saint-Georges where she lived'.[79] Although Aline worked on rue Saint-Georges and lived with her mother close by, she wanted to hide their address because of the neighbourhood's bad reputation.

Renoir's first letter to Aline in September 1878 was polite. He addressed her with the formal French 'vous' and as 'Mademoiselle', while in all later letters, he addressed her with the familiar 'tu'. The letter began with a business matter but was basically endearing. In a joking tone, he gave her some advice about her new job as assistant dairy-maid in the creamery: 'Do not serve black soap water as coffee with milk.... Do not get up at noon; doing so might make serving the 7 a.m. hot chocolate a little bit difficult.' He closed by saying: 'give my compliments to Mlle Camille when she gets back.... I'll bring you back a seashell for the trouble you've taken. Kind regards, Renoir.'[80] As this playfulness shows, Renoir found the plump Aline attractive. He was always on the lookout for pretty women to model, and attraction and flirtation were part of his relationship with models, and that is what he seems to be building as early as this first letter to Aline.

As for Aline, this ambitious and well-connected single man held all the attractions of the good life of which she had been deprived as a child. When they met that September 1878, it was four months after Renoir had returned to the Salon and, thanks to Mme Charpentier's help, was beginning to be appreciated as a fashionable portraitist. But it was not just his financial promise. Aline was truly smitten with Renoir and saved all the letters he ever sent.[81]

Renoir, being the same age as her mother, started out acting paternal and even bossy. Perhaps Aline, who had grown up without a father, found this treatment attractive. Certainly she never objected to it. In the first few years of

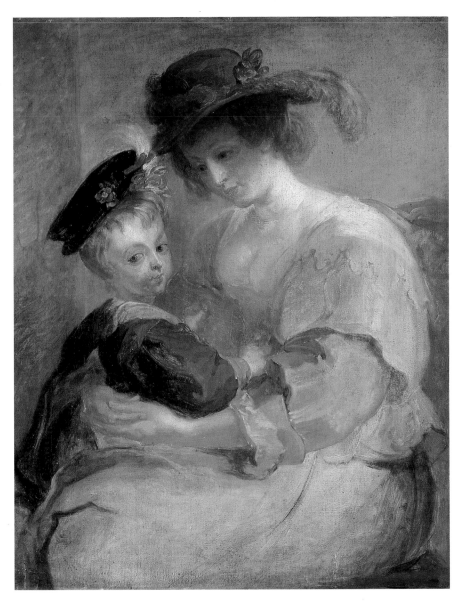

Copy of Rubens's Hélène Fourment with her Son, c. 1863. 73 x 59 cm (28³⁄₄ x 23¹⁄₄ in.).
Private collection, Zoug, Morocco

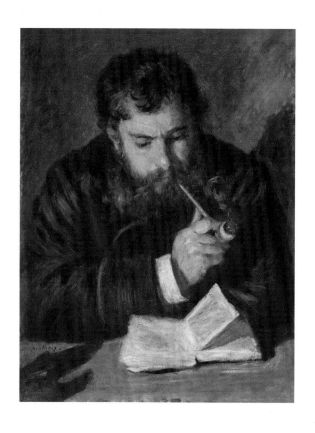

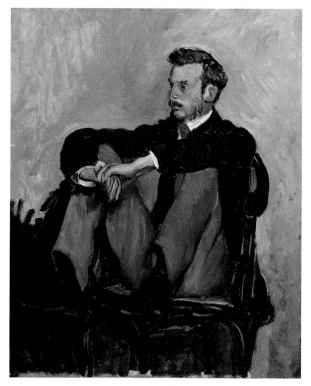

Portrait of Monet,
1872. 60.3 x 48.2 cm
(23¾ x 19 in.).
National Gallery
of Art, Washington,
D.C. Collection Mr
and Mrs Paul Mellon,
Upperville, Mass.

Bazille, *Portrait
of Renoir*, 1867.
106.4 x 74.3 cm
(41⅞ x 29⅛ in.) Musée
d'Orsay, Paris

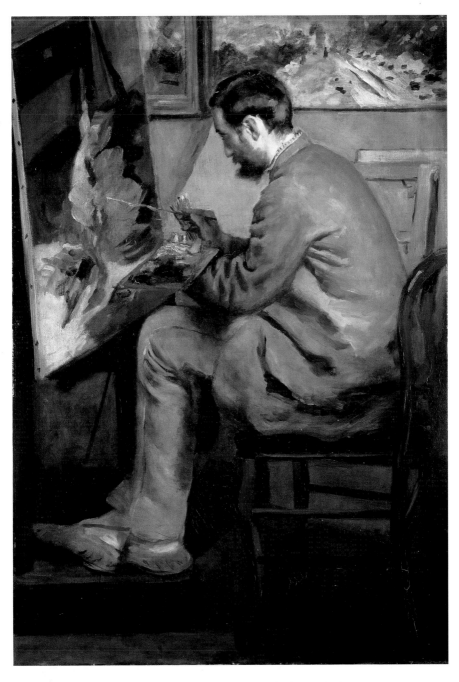

Painting of Bazille, 1867. 106.4 x 74.3 cm (41⅞ x 29⅛ in.). Musée d'Orsay, Paris

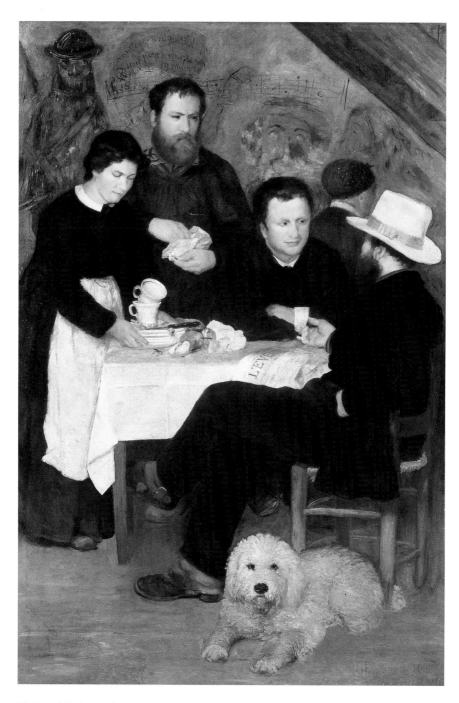

The Inn of Mother Anthony, Marlotte, 1866. 193 x 129.5 cm (76 x 51 in.).
National Museum, Stockholm

Lise and Sisley,
1868. 105 x 75 cm
(42¼ x 30 in.).
Wallraf-Richartz-
Museum, Cologne

Nymph at the Stream,
1869–70. 66.7 x 123
cm (26¼ x 48⅜ in.).
National Gallery,
London

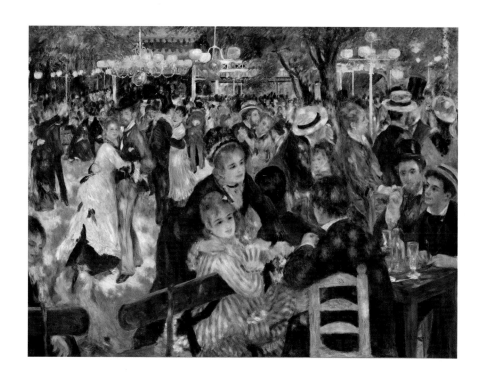

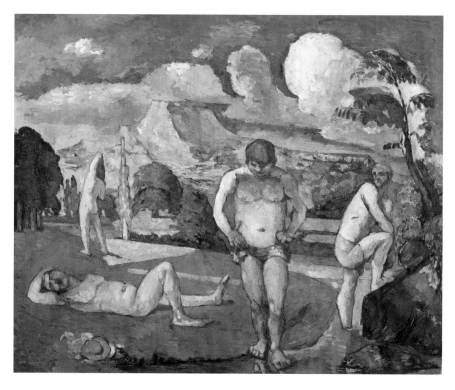

Lise in a White Shawl,
1872. 56 x 47 cm
(22 x 18¼ in.). Museum
of Art, Dallas

The Artist's Studio,
Rue Saint-Georges,
1876–77. 45 x 36.8 cm
(17¾ x 14½ in.).
Norton Simon
Art Foundation,
Norton Simon
Museum, Pasadena

Opposite
Le Moulin de la
Galette, 1876.
131 x 175 cm (51½ x
69 in.). Musée d'Osay,
Paris. Bequest of
Gustave Caillebotte

Cézanne, Bathers,
c. 1876. 79 x 97.2
cm (31⅛ x 38¼ in.).
Barnes Foundation,
Philadelphia, Pa.

Victor Chocquet,
c. 1876. 45.7 x 35.6
cm (18 x 14 in.). Oskar
Reinhart Collection,
Winterthur

Cézanne, *Victor
Chocquet, c.* 1876.
35.2 x 27.3 cm
(13⁷⁄₈ 10³⁄₄ in.).
Virginia Museum of
Fine Arts, Richmond.
Collection of Mr
and Mrs Paul Mellon,
Upperville, Va.

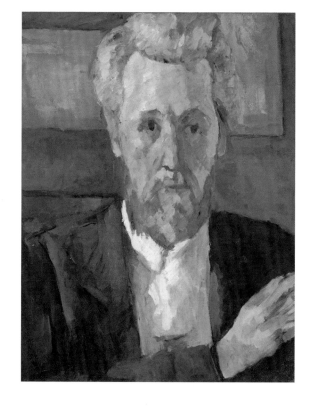

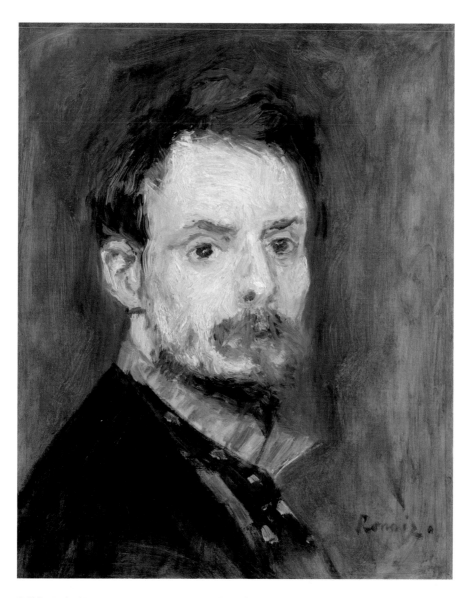

Self-Portrait, 1875–79. 39.3 x 31.8 cm (15½ x 12½ in.). The Sterling and Francine Clark Art Institute, Williamstown, Mass.

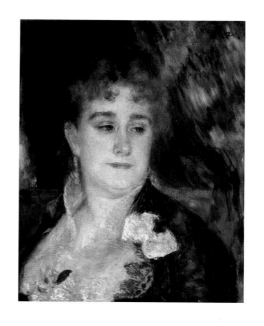

Mme Georges Charpentier, c. 1877. 45 x 38 cm (17¾ x 15 in.). Musée d'Orsay, Paris

Self-Portrait (with Head of a Woman) c. 1879. 19 x 14 cm (7½ x 5½ in.). Musée d'Orsay, Paris

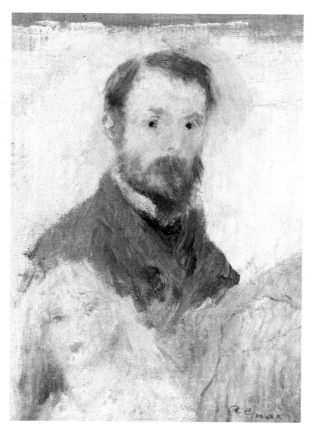

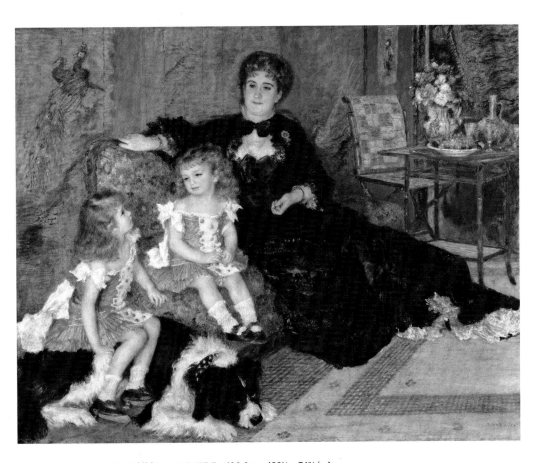

Mme Charpentier and her Children, 1878. 153.7 x 190.2 cm (60½ x 74⅞ in.).
The Metropolitan Museum of Art, New York. Wolfe Fund

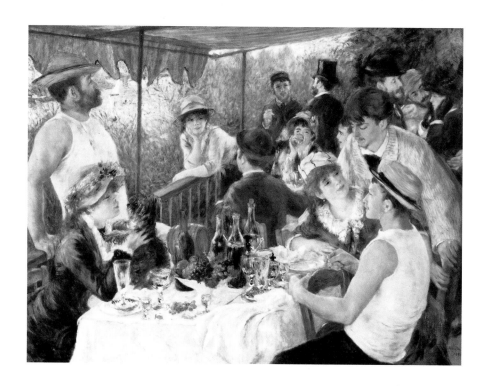

*Luncheon of the
Boating Party*, 1881.
129.5 x 172.7 cm.
(51 x 68 in.). The
Phillips Collection,
Washington, D.C.

Blonde Bather,
1881. 81.6 x 66 cm.
(32⅛ x 26 in.). The
Sterling and Francine
Clark Art Institute,
Williamstown, Mass.

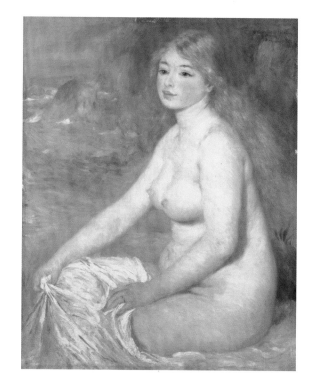

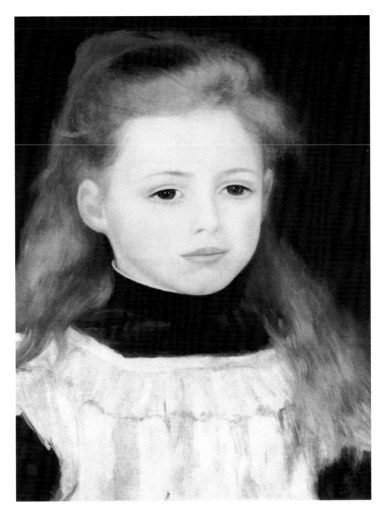

Lucie Bérard in a White Smock, 1884. 35 x 26.7 cm (13¾ x 10½ in.).
Collection Pérez Simon, Mexico City

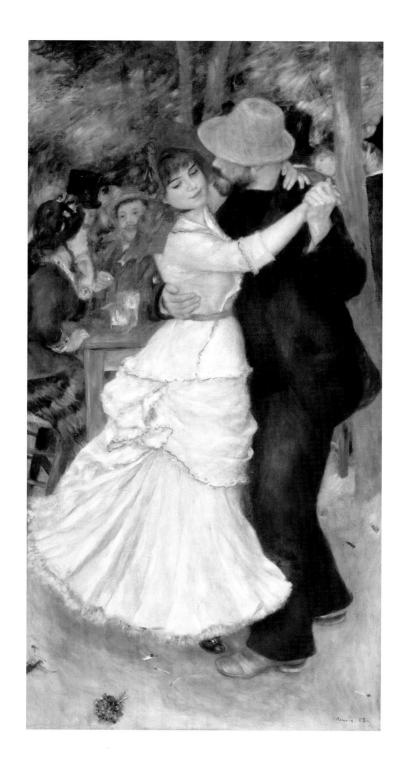

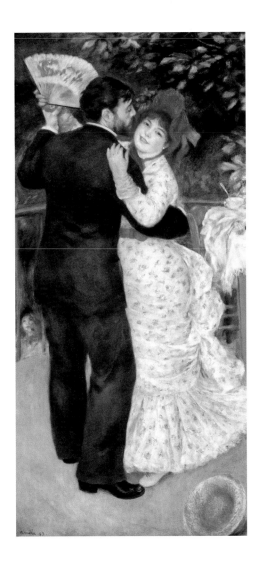

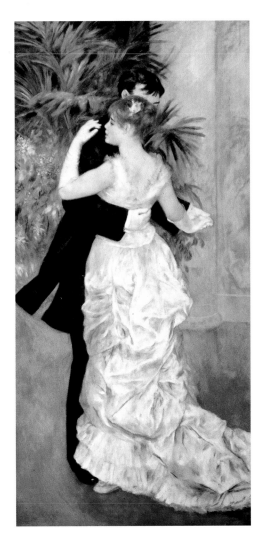

Country Dance,
(Dance at Chatou),
1883. 180.3 x 90cm
(71 x 35½ in.).
Musée d'Orsay, Paris

City Dance, 1883.
180.3 x 90.1 cm
(71 x 35½ in.).
Musée d'Orsay, Paris

Opposite
Dance at Bougival,
1883. 179.7 x 96 cm
(70⅝ x 37¾ in.).
Museum of Fine Arts,
Boston

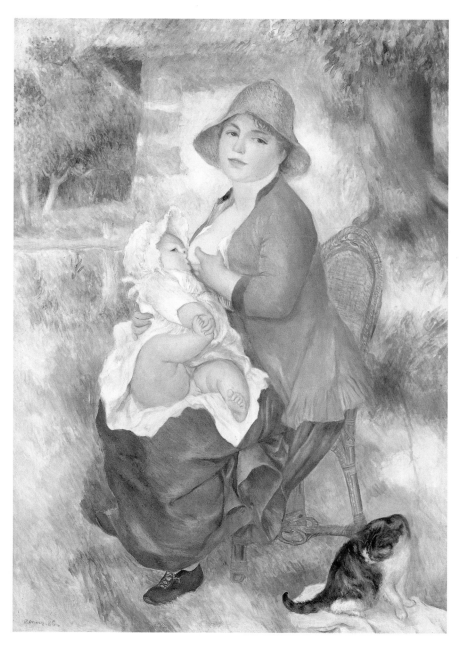

Nursing (Aline and her Son, Pierre; third version) 1886. 73.7 x 54 cm. (29 x 21¼ in.).
Private collection

their relationship, Renoir felt entitled to give her advice about her behaviour in a series of letters. During a hot spell he advised: 'I hope that you are not being foolish and staying in that oven.'[82] Another time: 'Don't be too bored. By the way, I am actually quite presumptuous, am I not?'[83] Similarly, 'Try to manage your time so that you don't get too bored.'[84] Renoir worried about Aline's quick temper and argumentativeness, cautioning her: 'Try not to get angry at anyone.'[85] He also felt justified in instructing her on how to deal with her health problems. Wanting to avoid what could become a tense situation, Renoir told her: 'Know that I won't come back while you are having terrible migraines. Write if you are feeling better.'[86]

Early in their relationship, Renoir insisted, as he had with Lise, that their affair be a secret. The artist was an extremely private person. It was known that Aline was one of several models whom Renoir employed beginning in 1879. However, only a few friends knew that Aline was also his mistress. Renoir's secrecy about their relationship is evident in several letters he wrote to her. One said: 'I am looking for a day when you can come and visit me without causing too much gossip in the vicinity.'[87]

At this point, Renoir had all the power in their relationship. However, years later, Aline would come to dominate. Even so, he found ways behind her back to get what he wanted, often pretending to be more passive than he really was. The beginning of the shift in power dynamics in their relationship is clear in their correspondence. As time went by, his letters became less formal and in doing so, he gave up some of his control. He would address her as 'My dear friend' and end: 'In friendship, with kisses, A. Renoir.'[88]

Aline also began to assert her own power, fishing for compliments and getting a predictable response. Once, when visiting Essoyes, she wrote asking if he felt she was ugly. He replied: 'My dear beloved, I have just read your letter, full of desperation and mischievousness because you want me to respond to you with compliments. You know what? You are far from ugly. Actually, you are as beautiful as anyone could be…. I do not know if you are pretty or ugly, but I do know that I have a strong urge to misbehave again…. If you want, I could go to stay right next to Essoyes if you do not want to come back and I'll come spend a day with you…because although you are so incredibly ugly, I have a desire to kiss you in all the right places, a mad desire…. I send you my love from afar… Crazy about you. Augustine.'[89] The same love that Renoir passionately expressed in his letter is visualized in his penultimate masterpiece, *Dance at Bougival* of 1883.

A few years into their relationship, Renoir resigned himself to the fact that the headstrong Aline would do as she wished regardless of his advice. In 1881, when Aline asked if he thought it wise for her to vacation without him, he responded: 'I am not going to prevent you from spending a few days in Chatou.' He went on: 'I would be happy if you do go. It'll make you fix yourself up a little more. However, you have been neglecting your appearance for so long, that I cannot imagine a radical solution for reducing the size of your waist, but that is your business.'[90] Renoir wanted Aline to take care of her looks and expressed concern about her figure, yet was resigned that she would do as she wished.

Despite these concerns about Aline's girth, when Renoir painted her, which he did increasingly as time went on, he would regularly transform her looks according to his artistic goals. What he had in his imagination superseded what he saw with his eyes. Now, as always, it is impossible to identify which model posed for which figure, since Renoir not only painted the same model differently but also sometimes used different people as models for the same figure.[91] As in the case of Lise, Aline was a source of inspiration, but Renoir never felt bound to follow her actual appearance. Aline had red hair, yet in 1881, he portrayed her as a blonde in *Blonde Bather* (see page 92), as a red-head in *Luncheon of the Boating Party*, and as a brunette in *On the Terrace*.[92] Renoir also took artistic liberties with her figure. In 1881, Aline looks fat in *Blonde Bather* but thin in the other two.

Renoir's love for Aline definitely had a positive influence on his art. Echoing his courtship of her, from 1879 through 1884, he painted his greatest paintings of the joys of romance in Paris and its suburbs – such as *Luncheon of the Boating Party*, *Dance at Bougival* and *Country Dance*.[93] Aline was one of several women who posed for his scenes of daily life. She also modelled for single women indoors and out, a few images of mothers and children, and an increasing number of nudes (see page 194).[94]

The first painting for which Aline modelled is *The Oarsmen at Chatou*, 1879.[95] Renoir's friend Caillebotte posed with her. Chatou, where Renoir loved to paint, is a small town on the Seine 14 kilometres (9 miles) north-west of the centre of Paris. From the Gare Saint-Lazare (not far from Renoir's studio), it was only a thirty-minute train ride away. In order to be able to stay at an inn there, the Maison Fournaise, Renoir bartered portraits that he made of the innkeeper's family.[96] He had first begun painting at Chatou in the mid-1870s, around the time when he wrote to Dr de Bellio: 'Please choose a day to come here for lunch. You won't regret having made the trip since it is the prettiest place near Paris.'[97]

The island at Chatou would also be the setting for one of Renoir's greatest paintings, *Luncheon of the Boating Party*, 1881 (see page 92). In this work, begun a year after he met Aline, she posed as the key figure. She appears in the lower left, wearing a fashionable blue dress with a red and white trim at the collar and a yellow straw hat decorated with a ribbon and flowers. She tenderly holds a small terrier who sits on the table. This could be the same dog in Renoir's 1880 painting of Aline in the grass.[98] It also could be Aline's pet, to whom Renoir refers in a letter: 'My best to Quiqui or Kiki.'[99]

Renoir's painting includes fourteen idealized portrayals of Renoir's friends, who sit or stand around two tables after lunch on the terrace restaurant of the Maison Fournaise. Beyond the terrace, in the upper left corner, are boats on the Seine and a glimpse of the railway bridge. Behind Aline is the son of the restaurant owner, Alphonse Fournaise junior, who was in charge of rowing-boat hire. At the centre, we see the back of a seated man, Baron Raoul Barbier, a cavalry officer and the former mayor of colonial Saigon in Vietnam, who had returned to France in 1876. Barbier talks with Alphonsine Fournaise, the daughter of the restaurant owner, who leans on the railing. The seated woman drinking out of a glass is Ellen Andrée, an actress who sometimes also posed for Manet and Degas. Seated next to her, we see the profile of an unidentified man. Behind him, with his back to us in a black top hat, is the wealthy banker, editor and art historian, Charles Ephrussi. Facing him is his secretary, the poet and critic Jules Laforgue. At the upper right are three of Renoir's close friends who frequently posed for him: the man at the left with a black bowler hat is Eugène-Pierre Lestringuez, a government official. Next to him is Paul Lhôte, an officer in the navy and journalist who has his arm around the famous actress Jeanne Samary. She covers her ears to avoid hearing something risqué that the men are saying to her. Seated at the extreme right, looking at Aline and smoking a cigarette, is Renoir's close friend Caillebotte, an avid boatman and sailor.[100] Behind him is the actress Angèle and the Italian journalist M. Maggiolo. This crowd of Renoir's friends, dressed in modern finery, enacts his usual themes of enjoying life through food, drink and sociability. Romance is also present: Caillebotte looks at Aline; Barbier engages with Alphonsine Fournaise; two men flirt with Samary.

The date that Renoir began this large work has been disputed. Yet in three letters, we learn that he began working on *Luncheon* in September 1879, continued to work on it a year later, in August and September 1880, and completed it

when his dealer purchased it five months later, in February 1881, after sixteen months of work. A letter from Renoir to Bérard in September 1879 clearly states that the work was just beginning: 'I hope to see you in Paris on 1 October for I am in Chatou.... I am working on a painting of some boaters, something I have been dying to do for a long time. I am starting to get old and I didn't want to delay this little festivity any further.... It's expensive enough already. I don't know if I will complete it, but I told Deudon about my hardships, and he nevertheless agreed with me that even if the great expense did not enable me to finish my painting, it's still a step forward: every once in a while you must attempt things that seem too difficult.'[101] Renoir's major expense was that this large painting, some 130 by 173 centimetres (51 by 68 inches), took time that he could have spent making portraits for money. However, since his models were his friends, it is doubtful that he paid them. Yet he had the expense of canvas and oils as well as sometimes boarding at the Maison Fournaise.

The second relevant letter – in August 1880 from Renoir to Aline – confirms that he continued to work on the painting, which he then hoped to complete in the later part of 1880: 'My dear friend, Tell Madame Alphonsine that I'm thinking of going to Chatou around the 8th of September, unless the weather is bad. I would like to finish my luncheon of the boaters which is at the Baron's.'[102] Barbier stored this large work in his Chatou residence.

In the third letter, written in mid-September 1880, Renoir wrote to Bérard of his great impatience to complete the painting and his annoyance with an unexpected portrait commission: 'My dear friend, I still have to work on this blasted painting because of an upper crust tart who had the audacity to come to Chatou and demand to pose. This has put me fifteen days behind in my work.... I am more and more irritated.... I will waste just another week here, since I have done everything, and I will return to doing my portraits.' He continued: 'I will write you next week. I hope that I finally will have finished.... Ah! I vow this will be the last large painting.' Confirming that this letter to Bérard was written in early September 1880, Renoir closed it with: 'Has André returned to his school?'[103] André, Bérard's oldest child, then eleven, attended a private boarding school and had to leave Wargemont by early September.[104]

Renoir's *Luncheon* took sixteen months to paint because of an unforeseen event. After spending four months working on it, Renoir broke his right arm in a fall from his bicycle in January 1880 and had to work left-handed. He reacted to this accident with acceptance and a sense of humour. He wrote to his patron

Duret: 'I have been enjoying working with my left hand; it is a lot of fun and it's even better than what I did with the right. I think that it was a good thing that I broke my arm. It allows me to make progress.' He continued: 'I'm not thanking you for the turmoil that my accident has caused you, but am very flattered by it and I greatly appreciate all of the sympathy that I've received from everyone.... I will be completely better in around a week. I have Doctor Terrier to thank for this quick cure; he was remarkable.'[105] It seems that Renoir became ambidextrous; almost twenty years later, Pissarro wrote to his son: 'Didn't Renoir, when he broke his right arm, do some ravishing paintings with his left hand?'[106] Despite his broken arm, that year Renoir signed 'Renoir.80' on thirteen works including *At the Concert*, *Girl with the Cat*, *The First Step* and *Girl with Hat*, plus ten commissioned portraits.[107] Having a broken arm did not deter the painter; indeed, he vigorously overcame his problem and forged ahead.

Renoir's remarkable productivity at this time is even more extraordinary since, as just noted, *Luncheon of the Boating Party* is one of his largest works. Durand-Ruel purchased it on 14 February 1881 for 6,000 francs, four times as much as the Charpentiers had paid Renoir in 1878 for a painting of similar size.[108] Because the dealer thought it a masterpiece, he exhibited it widely: in Paris, first at a group exhibition on rue Vivienne from late April to late May 1881, then at the seventh Impressionist show in March 1882 and then at Renoir's one-person show at his gallery in April 1883. Then Durand-Ruel sent it to America: to Boston, at the Foreign Exhibition in May–July 1883, and to New York, at the American Art Galleries and National Academy of Design from 18 April to 30 June 1886.

In February 1881, after having received such a high price from his dealer, Renoir aged forty felt comfortable enough to rent his own apartment. He retained his studio in rue Saint-Georges where his brother Edmond continued to live. Renoir found his own flat a few blocks north, at 18 rue Houdon. He invited Aline to live with him, but insisted they keep their relationship a secret from everyone but Edmond, who was sworn to secrecy. Since they had borrowed Edmond's mattress, Renoir wrote to Aline in about March 1881: 'you should send him his mattress so that he says nothing'.[109] Given that Renoir had no intention of marrying Aline until he was financially solvent, he saw no benefit in revealing that they were living together. Indeed, having it known would make him appear as a bohemian and might harm his reputation.

While they were not married, Aline performed wifely tasks such as directing the maid, Cécile, who cleaned both at 35 rue Saint-Georges and at their new

apartment. Since household chores were difficult, with no refrigeration, no indoor plumbing and no running water, it was customary, even for people of modest means, to have household help. Aline paid the maid with funds Renoir sent her from his travels. For example, in the same letter he wrote: 'I'll send you money along with the next letter.'[110] Once, he instructed her: 'Ask Cécile if the shutters are closed on rue Saint-Georges, so that the sunlight does not fade my piano.... Please request that Cécile not touch anything in the studio. There are a lot of things that are out of order, and I'd like to find them the way I left them.'[111] In another letter he asked: 'Is everything still going well with Cécile?'[112] And later: 'I received the letter in which you tell me that your maid serves you poorly. It is not hard for you to get rid of her and get a new one, since you are in charge of your actions, as long as you don't exceed your budget, which never happens, anyway.'[113]

In 1881, besides supervising the apartment, Renoir was eager that Aline become more cultured and he suggested that she take piano lessons. He himself, like many cultivated men of his time, knew how to play the piano. He recommended that his piano be moved from rue Saint-Georges to their apartment and advised her: 'Have them move my piano. You could start taking lessons. That'll keep you busy. I'll give you a note so that the concierge allows it to be picked up.'[114] A few years earlier, Renoir had made a portrait of Mme Georges Hartmann, the wife of a music publisher, standing before a piano. Shortly thereafter, he painted *Girl at the Piano*.[115] Besides suggesting piano lessons, two years later, he encouraged Aline to learn English, which he was also studying at the time. After they vacationed together on the English island of Guernsey off the coast of Normandy in 1883, he wrote to her: 'I urge you to start brushing up on your English, we shall return next year.'[116]

In mid-February 1881, once he had set Aline up in his new apartment, Renoir went on a working trip to Algeria. Before he left, he completed the paintings he intended to send to the 1881 Salon and had arranged for his friend Ephrussi to submit them to the jury. They were paintings for which Ephrussi had found Renoir the commissions – two portraits of the three little girls of Ephrussi's mistress, Louise Morpurgo, Comtesse Cahen d'Anvers. The year before, Renoir had painted their older sister, Irène Cahen d'Anvers.[117] Early in 1881, before leaving for Algiers, Renoir had completed the portrait of the two younger sisters, Alice and Elisabeth.[118] Upon arrival in Algiers, Renoir wrote to Duret: 'I left immediately upon finishing the portraits of the little Cahen girls,

so tired that I can't even tell you whether the painting is good or bad.'[119] Due to Ephrussi's influence, Renoir hoped that these portraits would do better at the Salon than 'the deplorable effect of my exhibit last year'.[120] When Renoir left Paris for Algeria, he planned to return in one month but stayed two. Aline saved ten letters that he wrote her during this trip.[121] None of her letters to him from this time have been found. Nonetheless, Renoir's letters reveal that the couple was very much in love.

The painter had never before been out of the country. Since Algeria was a French territory, he had no problem with the language. He took the train from Paris to Marseilles and then crossed by steamship to Algiers, the capital. In letters, he expressed dissatisfaction, declaring the boat journey 'very unpleasant'.[122] He bemoaned: 'three boring travel days'.[123] A month into the trip, he still had difficulty adjusting and wrote Aline: 'I am the worst of travellers and I am holding myself back from returning home.'[124] He also missed her terribly and in one of his first letters said: 'I was going to write you and ask you to come visit.'[125] Instead, he promised: 'If I come back here during the autumn, I'll bring you to Africa.'[126] And in another letter he reiterated this promise: 'If I return, I intend to take you with me'.[127]

Travelling in February enabled Renoir to leave cold, grey Paris and go to warm, sunny Algiers where he could work outdoors. His primary motive for the trip was to improve his painting. As he later wrote, '[to paint landscapes] is the only way to learn one's craft a little.'[128] His first letter to Aline stated: 'My dear little one, I arrived in good shape, and I will start working the day after tomorrow. I'm starting to look around to try to decide what I should paint first.'[129] Later, he explained: 'One has to manage not to waste time and some time is needed beforehand to get organized.' And: 'I am not allowed to return without bringing back some canvases.'[130] Renoir's dealer and patrons were eager that he paint. He sarcastically joked with Aline: 'Try to write me something very unkind again. You see, since everyone writes me nice things to encourage me in my work, it would create a diversion.'[131] Also in late February he wrote: 'It's very beautiful and I think I'll bring back some pretty things. I have many choices since everything is beautiful.'[132] Renoir wanted to paint, and from this trip Durand-Ruel purchased three Algerian landscapes and a seated Algerian girl, each signed: 'Renoir.81'.[133]

Renoir stayed in Mustapha, a suburb of Algiers 3 kilometres (2 miles) away, and gave his address as 'Helder Café, Military Training Area, Mustapha,

Algiers',[134] informing Aline too, adding that he planned to travel within Algeria: 'I have to take a trip to the South, either right now or later, in 3 weeks.... There is no railway. We will travel by horse-drawn carriages and it isn't very fast.'[135]

To Duret he explained: 'I am in Algiers. I wanted to check out for myself what the land of the sun was like.... It is exquisite, an extraordinary richness of nature.... I do not want to return home without bringing something back with me, no matter how small it is, and I only have one month; that isn't much.'[136] To Mme Charpentier he effused: 'It is a remarkable country...what beautiful scenery...of incredible richness and what lush thick greenery. I will send you a drawing.'[137] He explained to Ephrussi: 'I will not bring back a lot this time; but I shall return because this is a beautiful country.'[138] To Mme Paul Bérard, he wrote a long letter and urged her to take her husband to 'come to see this wonderful landscape.... You must see the Mitidja plain at the entrance to Algiers. I never saw anything more sumptuous or more fertile.... It is remarkably comfortable, the nights are fresh, free of mosquitoes.... The Arabs are charming people.... I must admit that I'm quite happy and when one has seen Algeria, one loves it.'[139] He also wrote directly to her husband: 'Maybe I will be able to bring you something, a landscape or two.'[140]

To Aline, he described a work in more detail: 'Tomorrow I am starting a big painting of Arabs and a big landscape.'[141] *Algerian Festival at the Casbah, Algiers* shows musicians in the middle of a large crowd with old Turkish fortifications in the background.[142] He also painted the *Bay of Algiers*, whose exotic setting and characters, unlike Renoir's earlier works, he hoped would help it sell.[143] Besides landscapes, Renoir toyed with the idea of painting figures, but complained to Bérard how difficult it was to find models. Nonetheless, he did paint young Algerian girls.[144] Probably, Renoir's models were either French or Jewish since at that time Muslim women wore veils covering their faces.

Renoir's brother Edmond was with him for part of the trip. He mentioned this in several letters to Aline: '[I'm] with my brother at the Helder Café.'[145] Later: 'I am angry with my brother who abruptly left Algiers without even letting me know and I am now alone with my thoughts.'[146] Edmond was then working for the daily *La France Méridionale* in Nice.[147] For a while, Renoir felt lonely and contemplated leaving. Missing Edmond, he wrote to Aline: 'Try to send me some news from my brother.'[148] Edmond decided to return to Algeria, but only a few days before Renoir's departure. The artist informed Aline: 'My brother will be here tomorrow.'[149] Even while Edmond was gone, Renoir was not

completely alone since he had several friends then in Algiers. For once, Renoir found himself in the position of lending money rather than borrowing it. He informed Aline: 'As for Lestringuez, he's the only one of my friends who hasn't even borrowed a quarter.'[150]

Something in the description of his time with Lestringuez caused Aline to be suspicious of Renoir's fidelity. Initially, Renoir had written to Aline: 'His [Lestringuez's] trip is paid for by the ministry and he's staying in Algiers with a friend whom I don't know; I haven't seen him twice. The childhood friend with whom he's staying is married and has a plethora of kids and I went to visit only out of sheer politeness.'[151] Perhaps Aline, then aged twenty-two, knowing that a childhood friend of Lestringuez at thirty-four could have teenage daughters, felt that the 'plethora of kids' was a threat, or perhaps she thought the whole story sounded false. Conscious that her father had abandoned her mother, she was inclined to be sceptical of men's behaviour, and wrote an angry response berating Renoir for not telling her the details of Lestringuez's living arrangement.

In the next letter, Renoir assured her: 'I didn't talk to you about it because I had my mind on other matters and I didn't think you would find it fascinating to know that he has a friend whom he visits for three months every three years, which deprives him of his yearly one-month vacation.' Responding to her accusation, Renoir continued: 'You should know that I have enough trouble making money from my paintings without fooling around like that. And it's not fair to Lestringuez who is quite finicky and occasionally unbearable, but whose manners are impeccable and who is very proper.' After all these explanations he continued: 'You see, I do what I can to calm your anger.' Renoir concluded by asserting that he went to bed every night at eight to get up the next morning at six.[152] Even though she was eighteen years younger than he and was an unsophisticated woman from the country, Aline it seems was not afraid to express her concerns about Renoir's faithfulness.

While Renoir was away in Algeria, Aline was considering an invitation from her father to travel to Canada. Victor Charigot, who was then living in Winnipeg, had written to her seven months earlier, urging her to come to Canada where, he asserted, she would earn more money sewing than she made in Paris.[153] The usually decisive Aline could not make up her mind whether or not to go. Renoir knew about Victor's letter and about Aline's dilemma and, in a complete reversal of his prior paternal attitude, left the decision up to her. Thinking that she might go, Renoir requested: 'Write me when you have to leave

so I can manage to get to Paris beforehand.... Write me quickly and try to tell me when you are leaving. I'll only be away for a month, but Heaven knows when you'll be back.'[154] Perhaps the thought of being gone indefinitely scared Aline, since in the end she decided not to visit her father.

While Aline decided to forgo an extended trip away from Renoir, he wound up staying in Algiers longer than planned. As his projected month came to an end, he realized that he needed more time to complete several paintings and delayed his return for a few more weeks. That Renoir stayed in Algiers for two rather than one month is typical of his nature of not being constrained by rigid plans. In many of his future trips he stayed longer than anticipated and changed his itinerary en route. Aline, who had expected him home in late March, often wrote asking when he would return. Renoir explained: 'My dear girlfriend, I am very unhappy because I cannot abandon my two most important landscape paintings, and I'm waiting for two or three days of sunshine. If I could be done with them, I would be back right away. So wait a little longer. As soon as the weather is nice, which won't be long, I'll let you know which boat I'll be taking. In any case, I won't be home later than next week.'[155] Affectionately, he soon promised: 'My dear darling, I'll do all I can to board on Sunday. It's raining and I hope that tomorrow I'll be able to work. I ordered crates [for the paintings] that are ready to go, so that I'll have nothing more to do but pack up in case I'm late. No matter what, I won't stay here longer than Tuesday. Too bad for my studies.'[156] During his return journey, he took precautions to keep their relationship a secret: 'Please warn Mr Deschamps that he will receive a telegram that I will send you from Marseilles without putting your name on it. You'll understand what it means. I'll simply indicate the time of my arrival.'[157]

Midway through April 1881, Renoir returned to Paris and had a joyful reunion with Aline. They had missed each other and were eager to spend time together. Renoir had planned to visit London after Algeria and before his annual summer with the Bérards in Dieppe, but since it was already mid-April, he decided to forgo London in favour of spending more time with Aline. He excused himself to Duret, who was expecting to meet him in London: 'The weather's great and I have models. That is my only excuse.... I wonder if you'll easily swallow my behaviour that is akin to a pretty woman's whims.... What a pity to be constantly hesitant, but that's my basic nature and as I get older, I'm afraid I won't be able to change.'[158] This seems like a flimsy excuse since Renoir had committed himself not only to going to London but also to learning English.

But, from Algiers, Renoir had already written to Duret that he 'was obliged to abandon my English lessons that I will not resume until next winter'.[159]

This is one of many examples of Renoir feigning indecision when in fact he had changed his mind. Often in his life, Renoir tried to soften the impact of his changeability by claiming to be indecisive. That unpredictability prompted Pissarro to ask: 'Who can fathom that most inconsistent of men?'[160] In 1881, Renoir confessed to Aline: 'I am and always will be uncertain.'[161] The following year, he invited Aline to visit Brittany with him but added: 'You know that I can change my mind twenty times. Brittany may end up being Fontainebleau.'[162] After his return from Algiers, Renoir spent the next six months, often with Aline, painting scenes of daily life in the suburbs of Chatou, Bougival and Croissy, and a portrait of Aline that he signed, 'Renoir.81'.[163]

Even though he had enjoyed being with Aline during the spring, Renoir was clear that his art and career always came first. When the summer came, he left Aline in their Paris apartment and went to the Bérards' near Dieppe. Here he continued painting portraits for the Bérards and their Dieppe neighbours. Despite the importance of these portraits to his career, he sometimes became frustrated. In July 1881, he wrote to Aline: 'My portraits are coming along with difficulty.'[164] The next month he reported: 'The weather is still grey. I am very bored. My models are horrible. I do not know from which angle to paint them.'[165] This frustration is not apparent, however, in the lovely portraits he made of the Bérard children and of their Dieppe neighbours.[166]

During the summer of 1881, while Mme Blanche and her son Jacques-Émile were summering in Dieppe, her husband was working in Paris. Jacques-Émile asked his mother if she would invite Renoir to stay with them in order to give him painting lessons. Mme Blanche initially agreed but on the very first day of Renoir's visit, she changed her mind largely because of her prejudice against his lower-class status and her objection to his nervous temperament. As she later explained to her husband: 'I told him [Renoir] that we won't be ready [to have him stay here] for a long time, which is true; but, in addition, he is earning money, but spends it very freely; Jacques can only be badly influenced by him; he is so crazy, in his painting, in his conversation, without any education, very *good*, but rejecting everything that is sane; I think [by not having Renoir visit with us] I have done a great service to Jacques who is so clean, so meticulous in his studio; he [Renoir] needs pots of paint; he makes his canvases himself; he is not afraid of either rain or mud; he wants to do a large painting of naked

children bathing in the sunlight; for that, he wants it not to be too hot, but still sunny; the children will want the weather to be neither windy nor cold, so that they can pose naked for two or three hours in the water. [Such a stupid idea] could take him far! If [his annoying behaviour] wasn't so prevalent, and if it were only a matter of [staying here] five or six days, I might not have been so violently opposed [to his visit], since all his tics at the table and his conversation at dinner have made an unpleasant impression on our nanny and me. Don't forget that we have no male servant, and Dinah, even if our house is ready, would not at all care to serve men, to wash their dirty and wet trousers, and clean their shoes, caked to the tops; because he is not a man to be stopped by the mud in our neighbourhood. Thus, there is no reason for us to let our nice, newly upholstered and carpeted rooms get soiled. You know, M. Bérard has men servants, rooms that won't get ruined, and, surely, servants who don't get in a bad mood as soon as one asks them to do the least thing beyond their routine.'[167]

Jacques-Émile did not perceive Renoir the same way. Around the same time, he wrote to his father describing what had transpired: 'Renoir came to see us yesterday. Mother had invited him, as you know, to come to work with me. Since we did not have a room ready, we were unable to put him up, and it's a good thing, as you'll see. Mother invited him for dinner. We were at the table for a little less than forty-five minutes (usually it takes us fifteen or twenty minutes). Mother got so impatient that she said it would be impossible for her to dine with him. After having invited him, Mother told me the worst things about him. She says he lacks wit, is a scribbler, a slow eater and makes unbearable nervous movements. In short, Mother will do everything she can to uninvite him.... Renoir made a painting of a sunset in ten minutes. That exasperated Mother, who told him that he was only "wasting paint"! Well, it's a good thing that he doesn't notice anything. As for me, I didn't say a word to Mama, I was so annoyed.'[168]

Despite his mother's attitude to Renoir, Jacques-Émile remained a faithful admirer and, the next summer, wrote to his father: 'Right now, I am seeing Renoir a lot and I have greater and greater affection for him. One doesn't realize the enormous qualities of this being, first seeming so boorish.' Then he quoted a letter about Renoir that he had received from Maître: '"When Renoir is cheerful, which is rare, and when he feels free, which is just as rare, he speaks very enthusiastically, in a very unpredictable language that is particular to him and does not displease cultured people. In addition, there is within this person such great honesty and such great kindness, that hearing him talk has always

done me good. He is full of common sense, on a closer look, yes, common sense and modesty, and in the most innocent and quiet manner, he relentlessly produces his diverse and refined work, which will make future connoisseurs' heads spin.'"[169] Jacques-Émile and his mother never agreed about Renoir. Later the young artist purchased some of Renoir's works.[170]

After his 1881 summer in Dieppe, the next time that Renoir travelled, he took Aline with him. They left for Italy in late October, six months after he had returned from Algeria. It is unsurprising that Renoir invited Aline since he had missed her terribly in Algeria and had twice promised to take her with him when he returned abroad. They travelled well together on a trip that was originally planned to be two months but turned out to be six. There is substantial evidence that Aline accompanied him throughout, between his departure from Paris in late October 1881 and his return in late April 1882. In March 1882, there was a report in an Algiers newspaper, *L'Akhbar*, that 'the painter Renoir and his wife' had just arrived from Marseilles on the steamer *Moeris*.[171] Further evidence that the couple was together is the fact that Aline saved no letters from Renoir during these six months. Since she had saved ten letters from his first Algerian trip, she would presumably have saved more from a six-month trip. Aline was also the model for the most important painting Renoir did in Italy, the *Blonde Bather* (see page 92).[172]

Another reason why we can be confident that Aline was with him is her assertion, fourteen years later, to Berthe Morisot's daughter, Julie Manet, and to her own children, that she and Renoir went to Italy on their honeymoon. Julie wrote in her diary: 'Madame Renoir told us [Julie and her mother] about her trip to Italy after her wedding. We found it quite funny to hear her telling us all this, because we'd so often heard M. Renoir talk about it as though he had made the trip on his own, back in the days when we didn't know his wife. She was twenty-two and very slim, she [Aline] said, which is hard to believe.'[173] Jean Renoir also later recorded that his mother told him that she travelled to Italy on her honeymoon.[174]

In essence, this trip was indeed a honeymoon for the couple, who were much in love. Yet they did not marry for another nine years. However, in several paintings of nudes, the model wears a prominent wedding ring on her left hand, as she does in *Blonde Bather*. Nonetheless, this was a common custom for early Renoir nudes, such as *Bather with Griffon*, 1870, and *Nude in the Sunlight*, 1875, perhaps for the sake of propriety.[175]

As Julie Manet's diary reveals, Renoir told no one that Aline was with him, and even kept this secret for more than a decade. He wanted her presence to be hidden from most of his friends, patrons and dealer. Hence his letters during the trip imply or state that he was travelling alone, as he wrote to Deudon: 'I'm a little bored far from Montmartre and...I find that the ugliest Parisian woman is better looking than the most beautiful Italian woman.'[176] To Manet he wrote from Capri: '[Here] I am the only French person.'[177] Only two people knew that Aline was with him during these months – his brother Edmond and his friend Cézanne.

The itinerary of Renoir's two-month stay in Italy can be figured out from his Venetian sketchbook and his letters. (The book, some 13 x 20 centimetres [5 x 8 inches] bears a purchase label from a store in Venice: 'Biasutti...Venezia'.[178]) Within the sketchbook are drawings from his Italian trip and from his second Algerian trip. His itinerary is also corroborated in his letters to Durand-Ruel, Bérard, Charpentier, Chocquet and Deudon, and to Édouard Manet. We learn that Renoir and Aline were in Venice on 1 November 1881.[179] Renoir's intended route is clearly stated in a letter from Venice to Mme Charpentier: 'I've started in the north and I am going down the entire boot [of Italy] while I am here and when I will have finished, I'll have a great time coming to have lunch with you.' In the same letter, he includes a poem for her: 'I'm leaving for Rome/ Farewell – Venice-i-ce/my beautiful country/promised land/beautiful paradice-ra-dice.'[180] Around the same time, he wrote a similar poem to Deudon: 'Farewell Venice-i-ce, my beautiful grey sky, promised land, beautiful paradice-ra-dice. I'm going to Rome and after to Naples. I want to see the Raphaels, yes, Sir, the Ra/the pha/the els. After that, who would not be content...I bet they'll say that I was influenced!'[181]

After Venice, Renoir and Aline took the train south, not stopping in Florence but going directly to Rome, where Renoir could study the Raphael frescoes at the Farnesina and the Vatican. He wrote to Durand-Ruel praising these frescoes when he arrived in Naples on 21 November.[182] While there, he went to see the ancient frescoes from Pompeii that were preserved in the Naples Museum. Later he wrote to Mme Charpentier: 'I carefully observed the Museum of Naples; the paintings of Pompeii are extremely interesting from all points of view.'[183] Renoir's focus on both the Raphael and Pompeian frescoes suggests that he was looking to learn from great muralists of the past to further his goal of creating a new kind of architectural painting, murals inside public buildings. He

hoped to create his own mural style different but comparable to that of Pierre Puvis de Chavannes, the only well-known contemporary muralist of whose works Renoir approved.[184]

In Naples, Renoir and Aline stayed at the Albergo de la Trinacria at 11 Piazza Principessa Margherita, where they lived on and off for the next two months. They took a trip to Capri, where they stayed at the Hôtel du Louvre.[185] There, Renoir wrote to Manet hoping that he would soon get nominated a Chevalier of the Légion d'Honneur.[186] Renoir and Aline also travelled to Sorrento. In mid-January, Renoir made a trip to Calabria and then to Palermo to paint Wagner after he had completed his opera *Parsifal*. Back in Naples, after about a week, Renoir and Aline boarded a train to France. By 23 January 1882, they were at the Hôtel des Bains à L'Estaque, near Marseilles.

Italy was a common destination for artists, given the classical works of the past available for study. Not only earlier artists had travelled there, but also some of Renoir's friends. At forty, Renoir was a latecomer to this source of inspiration, Degas having gone when he was twenty-one for three years and Manet twice in his twenties. Morisot went to Italy the year before Renoir but soon had to return because her daughter became ill.[187] Renoir was still in awe of the things he saw there when he wrote in late 1883 to Deudon, who was then travelling in Naples: 'Go to see the Naples Museum. Not the oils but the frescoes. Spend your life there.'[188]

As in Algiers, Renoir spent much of his time in Italy painting, since he needed to keep sending back works to both his dealer and his studio. Indeed, many people encouraged him to paint during his trip, Manet for example, writing: 'you will without a doubt bring us back a mass of works all personal and interesting.... Bring back a lot of canvases.'[189] Renoir had hoped to paint Italians but, as in Algiers, he had trouble finding models. As he wrote to Deudon: 'To get someone to pose, you have to be very friendly and above all know the language.'[190] Renoir did not know Italian. Nonetheless, he painted a few locals: in Venice two studies of the head of a woman, in Naples a girl's head, *Mother and Child*[191] and *Italian Girl with Tambourine*.[192]

During these two months in Italy, Renoir only made one portrait, that of Wagner, whom he painted for Georges Charpentier. After Charpentier received the portrait, Renoir wrote to him: 'If the portrait that I made for you of Wagner is good enough and if you want to inscribe it with a word of explanation, you can write that this portrait was done at Palermo on January 15, 1882, the day

after Wagner completed Parsifal.'[193] Immediately after completing the portrait, Renoir had written a long letter to Charpentier, describing how uncomfortable he had felt during the brief thirty-five minute sitting: '[I]...was very nervous and regretted that I wasn't Ingres.' He blamed his nervousness on timidity, saying 'the shy person who pushes himself goes too far'.[194] Wagner's wife, Cosima, noted Renoir's agitated manner in her diary on 15 January 1882: '[Renoir] amuses R. [Wagner] with his nervousness and his many grimaces as he works.'[195] After Wagner's death a year later, on 13 February 1883, Renoir made a graphite and charcoal copy of his portrait that was published with the obituary in *La Vie moderne* on 24 February 1883.[196]

The largest number of paintings Renoir made in Italy were landscapes of well-known tourist destinations. In Venice, he drew in the sketchbook already mentioned and painted *The Grand Canal, The Doges' Palace, Saint Mark's Square, Fog in Venice* and *A Gondola*; in and around Naples, *The Sea in Capri, Capo di Monte, Sorrento, Garden in Sorrento, Vesuvius in the Morning, Vesuvius in the Evening* and, south of Naples, *Landscape in Calabria*.[197] Yet, his true goal in Italy was to improve his Impressionist style. He was never satisfied with repeating the same manner of expression. After leaving Rome and once he arrived in Naples, on 21 November, he wrote to his dealer: 'I am still suffering from the illness of experimenting. I am unhappy and I erase, I erase again. I hope that this obsessive habit will end; this is why I am sending you news. I don't think I will bring much back from my trip, but I think I will have made progress, which always happens after long periods of study. We always return to our first loves, but with a little extra note.... I am like children at school, the blank page always needs to be well written and then bam! An ink blot. I am still making those mistakes, and I'm 40 years old. I went to see the Raphaels in Rome. They are very beautiful and I should have seen them sooner. They are full of knowledge and wisdom. He was not searching for the impossible, like I am, but it's beautiful.'[198] And, five days later, he wrote to Bérard: 'I've tried everything, painting with turpentine, with wax, with siccative [a drying agent] etc...all that, only to revert to the painting I started with. But from time to time I have these obsessions that cost me dearly and don't move me forward at all.'[199] His frustration was palpable as he struggled to transform his style.

Renoir was trying to give his figures more solidity and his compositions more structure at the same time as retaining Impressionist light and colour. In Italy, he hoped to learn how to acquire the 'grandeur' that Cézanne had achieved,

and it is likely that it was Cézanne's style that led Renoir to Italy. Renoir was attempting to emulate the classical and sculptural qualities of Cézanne's art, but in his own way. The word 'grandeur' was what Georges Rivière (probably prompted by Renoir) had written about Cézanne's art four years earlier, in his 1877 *L'Impressionniste: journal d'art* article: 'The movements of the figures are simple and noble.... The painting has an astounding grandeur.' And: 'the landscapes are utterly majestic.... The works are comparable to the most beautiful works of antiquity.'[200]

Renoir repeated Rivière's exact words when, from Italy in 1881, he wrote about both the Raphael frescoes in Rome and the Pompeian frescoes at the Naples Museum. The idea of simplicity and grandeur struck him as soon as he had seen the Raphael frescoes and stayed with him even two months later when he had returned to France. From Naples, he wrote to Durand-Ruel of the Raphaels in Rome: 'I prefer Ingres in oil painting. But the [Raphael] frescoes, they are admirable in their simplicity and grandeur.'[201] In late January or early February 1882, he wrote to Mme Charpentier about his trip to the Naples Museum: 'Thus I remain in the sun – not to paint portraits in the light – but while warming myself and observing a lot, I think I will have gained that grandeur and simplicity of the ancient painters.'[202]

The key painting of these Italian studies, inspired by Cézanne, Raphael and Pompeian frescoes, was *Blonde Bather* (see page 92). Aline posed for this work at the Bay of Naples. Here Renoir initiated his unique blend of Impressionism and Classicism, the direction for his future artistic development. He does not renounce Impressionism, but combines it with classicism, creating a new style, Classical Impressionism. This synthesis became the major direction of his artistic explorations in the paintings of the next thirty-eight years. The *Blonde Bather* is Classical in the solidity of the well-defined body as well as the clarity and balance of the pyramidal composition, while also being Impressionist in its pervasive light, bright varied colours and visible brushstrokes. It resembles Raphael's fresco *The Birth of Galatea* in the Villa Farnesina, in that the timeless nude is separated from her surroundings. There is a clear edge around her solid, pyramidal body. Renoir's 1881 nude is different from his *Nude in the Sunlight* of six years before, in which the nude merges into the surrounding tall grass and the effect is ephemeral. Two still lifes that Renoir did in Naples, *Onions* and *Fruits of the Midi*, have similar qualities.[203] The round solid forms of the fruit resemble the round solid forms of the bather's breasts, head and body.

Renoir sold *Blonde Bather* to a prominent Parisian jeweller, Henri Vever, and inscribed the canvas: 'À Monsieur H. Vever/Renoir.81'. He shipped his paintings back to Paris and had Bérard take care of his submissions to the 1882 Salon. Renoir chose two works: *Blonde Bather* and *Portrait of Mlle Yvonne Grimprel*.[204] It is perhaps surprising that the jury rejected *Blonde Bather* and accepted the little girl's portrait. Doubtless, Renoir was disappointed that his first attempt at Classical Impressionism was rejected. However, in the spring of 1882, Durand-Ruel asked him to make another version of this nude, which he later sold to Paul Gallimard. This second version has an even clearer delineation of the nude's body.[205] By requesting a second version, Durand-Ruel was encouraging Renoir to proceed in this new direction. The second *Blonde Bather* was even more Classical and monumental, with greater separation between the body of the nude and the surroundings.

Since this new Classical Impressionism evolved out of a search for qualities that Renoir saw in Cézanne, it is not surprising that his first stop back in France was to visit Cézanne. On 23 January 1882, he informed his dealer: 'I ran into Cézanne and we are going to work together. In about two weeks, I will have the pleasure of shaking your hand.'[206] Renoir expected to be back in Paris by 7 February. Despite the fact that Cézanne dined every evening with his parents in Aix-en-Provence, he lived nearby in L'Estaque with his secret mistress, Hortense Fiquet, and their nine-year-old son, Paul Cézanne junior. Given Cézanne's unusual living arrangement, Renoir felt no hesitation about bringing Aline along. They settled in L'Estaque, too, living at the Hôtel des Bains, also known as the Maison Mistral.

The two artists painted side by side: Cézanne, *Ravine near L'Estaque*, and Renoir, *Rocky Crags at L'Estaque*, signed and dated 'Renoir.82'.[207] Renoir's new broad structure, clear definition of the mountain tops and parallel strokes in his landscape were clearly inspired by techniques that Cézanne was using at the time, as well as the lessons of the frescoes of Raphael and Pompeian artists. Renoir so admired Cézanne's work that when he left L'Estaque he took several sketches discarded by Cézanne while forgetting some of his own completed paintings. The following March, 1883, he wrote asking Cézanne to send back these paintings since he wanted to include them in an exhibition Durand-Ruel was planning for that April.[208] Years later, Renoir revealed: 'I have some sketches of his [Cézanne's] that I found among the rocks of L'Estaque, where he worked. They are beautiful, but he was so intent on others – better ones

that he meant to paint – that he forgot these, or threw them away as soon as he had finished them.'[209]

On 14 February 1882, Cézanne was making plans to go to Paris. Renoir, however, who had expected to return there a week earlier, was still in L'Estaque, gravely ill. He wrote to Durand-Ruel that for the past eight days he had been in bed with 'a terrible flu'.[210] His condition worsened, and around 19 February, he wrote again to Durand-Ruel: 'I'm knocked out because of pneumonia.'[211] Pissarro conveyed this information to Monet on 24 February ('Renoir is very sick in L'Estaque').[212] The same day, Edmond Renoir came to help him. Cézanne, despite his customary aloofness, became concerned about Renoir's health: on 2 March, Renoir wrote to Chocquet: 'Cézanne was incredibly kind to me.... He wanted to bring me everything from his house...because he is returning to Paris.'[213]

This illness was only one of the major problems then confronting Renoir. On 19 January 1882, around the time that he and Aline had left Naples for France, the most important French bank, L'Union Générale, failed and the Paris stock market crashed. It caused a depression that lasted for the next four or five years and resulted in financial problems for Renoir's dealer and for all the artists. Consequently, Renoir was extremely concerned about the sale of his paintings. This worry took shape at the same time that he became seriously ill and when his old Impressionist friends were pressing him to join their new group show, calling themselves Artistes Indépendants. Ten days after Renoir had written to his dealer about his pneumonia, he again wrote to Durand-Ruel, angry since he felt such a group exhibition would hurt his new-found success as a fashionable portrait painter. His two biggest objections were the group's identifying moniker 'Independent' and the inclusion of Gauguin, a highly controversial artist, but he was also strongly opposed since he felt that if he joined the group in March, he would be ineligible to exhibit at the May and June 1882 Salon.

Renoir knew that he owed his recent success to *Mme Charpentier and her Children* at the 1879 Salon. Thanks to its critical reception at that Salon, he had become a fashionable portraitist. The last time that Renoir had exhibited with the Impressionists was in 1877. Subsequently, as noted earlier, he had had works accepted to the Salons of 1878–81. There had been no group show in 1878 and because he had been making his mark through the Salons, he had refused to participate in the group shows of 1879–81. By 1882, the idea of leaving the profitable Salons for the controversial group shows was intolerable.

At the height of his pneumonia, when Renoir's dealer and Impressionist friends pleaded with him to join the March 1882 group show, Renoir flatly refused. Surely this was not the behaviour of a timid, passive man. He explained to his dealer: 'I refuse to be included for a minute in a group called the Independents. The main reason is that I am exhibiting at the Salon, and the two do not go together.... I believe that if I exhibit there, it will cause [the value] of my canvases to drop by 50%.'[214] A few days later he continued: 'The public doesn't like art that seems political and at my age I don't want to be a revolutionary.'[215] Shortly thereafter, in another letter to his dealer, he elaborated: 'There are barely fifteen connoisseurs in Paris capable of liking a painter without the Salon. There are 80,000 of them who won't even buy a tiny portrait if a painter doesn't exhibit at the Salon.'[216] Renoir objected so vehemently to being branded a revolutionary or independent because these terms were then linked in the minds of French people with the bloody 1871 Paris Commune. At the height of the critics' mockery of his art, it was this connection to politics and violence that caused much of his art to be deemed almost worthless. Whether or not Renoir's art at the time was revolutionary is an open question. His work contained themes of modern life, light, bright colours, a rainbow palette and a general freedom, randomness and mobility. Even so, he had just come back from the study of classical works and was beginning to incorporate conservative elements that linked his art with the great art of the past.

At Durand-Ruel's insistence, Renoir allowed him to send works that the dealer owned to the seventh group show as long as it was clearly specified that it was Durand-Ruel and not Renoir who was exhibiting. Durand-Ruel agreed and sent twenty-five Renoir paintings including *Luncheon of the Boating Party*. In this way, three months later, Renoir felt no conflict about exhibiting at the Salon of May and June 1882. Later, he apologized to Durand-Ruel for the angry tone of his letters, writing: 'I wrote to you at the worst part of my illness. I am not going to say that I was acting rationally.'[217]

That illness, severe pneumonia, was at its peak in late February and early March, when Renoir informed Bérard that he had been warned against cold weather. 'The doctor really doesn't want me to return to Paris.... I prefer to go to Algiers for about two weeks.... I'll work a little. So, my dear friend, I must ask you for a rushed favour. I need five hundred francs in Marseilles on Saturday before 3 o'clock because I'm taking the boat at 5 o'clock for Algiers and I haven't a dime left.... It is so frightening to stay flat on one's back for about two months.

God, an illness is a real shame. Outdoors, I'm dizzy. I have lost weight, it's insane and I look like a straw man. I tried to paint a little in my room; my head started spinning after five minutes. It's idiotic.'[218]

Seeking warmer weather, on 5 March, about a month into the illness, Renoir and Aline travelled by boat from Marseilles to Algiers. Renoir planned to remain only a fortnight but spent about six weeks, renting an apartment at 30 rue de la Marine, close to the port and the Grand Mosque and Moorish arcades. While he recuperated and tried to paint, Aline looked after him and their temporary home. From Algiers, Renoir complained to Bérard: 'I have a constant fever that I cannot get rid of.... I can't get down to work. I am taking pills which are supposed to rid me of this nuisance in three days. We'll see.... I think I will write you soon that I'm feeling better. But it is unbearable; when something gets better, another starts again.... It's high time that the sickness ends because, with my ailments, I will become unbearable. I hope that I will write you about something completely different in my next letter.'[219] He described his illness and slow recovery to his dealer: 'At this time, I'm covered with boils which are making me suffer horribly and I am more uncomfortable than ever, but it isn't serious and in a few days, I hope to be rid of this annoyance.... I'm improving very slowly; from time to time I still have some little fevers that remind me I'm still not completely healthy.'[220]

Renoir's Algiers doctor advised him to remain in this warm climate until he fully recovered. By mid-March, things were improving but, under the doctor's orders, he stayed until early May. As his health improved, he wrote to Bérard on 14 March: 'I saw the doctor this morning; he took me off all medicines. I am doing very well, except for my legs, which are not. The doctor said I have to stay in Algiers another month. Little by little I have to stop wearing flannel underwear. He says that it blocks the pores of the skin.... I no longer smoke, but I eat enough for four people.'[221] And in April, 'My fever passed as if by a magic spell and I'm feeling marvellous. Was I cured by my pills or by the sirocco [strong desert wind]?'[222] Even after most symptoms were gone, he continued to have problems, informing Bérard that summer that he was 'still shivering, even in the middle of the day'.[223]

Despite the fact that he was never completely well during this second Algiers trip, Renoir painted four landscapes – two of holy places, for both of which he made preparatory pencil sketches in his sketchbook: *Staircase of the Mosque of Sidi Abd-er-Rahman* and *Mosque of Sidi Abd-er-Rahman*. He

also painted *Garden in Mustapha, Algiers* and *Memory of Algiers*, on which he inscribed 'souvenir of Algiers'.[224]

During this second trip to Algiers, Renoir was able to paint several figures, all of whom dressed in colourful costumes. He explained to his dealer: 'Here I am almost settled in Algiers and talking with Arabs in order to find models, which is quite difficult... But this time, I hope to bring you some figure painting, which I wasn't able to do during my last trip. I saw some incredibly picturesque children. Will I get them to model? I'll do all I can for that. I also saw some attractive women, but I'll tell you later if I succeed. I still need a few more days before I get to work. I'm taking this time to search, for as soon as I am settled, I want to do as many figure paintings as possible and, if possible, to bring you a few somewhat unusual things.'[225] Because many young Muslim women would have found modelling unseemly, he was probably limited in his choice of models to old women, children and non-Muslims. He made two versions of *Old Arab Woman* and several paintings of Algerian children, including *Child with Orange, Little Algerian Girl* and *Ali, the Young Arab Boy*, and oil sketches of *Algerian Types*.[226] Besides Algerian children, he also painted a girl from France, as he explained to Bérard: 'I have lovely people to paint, namely, a pretty little ten-year-old girl, a Parisian. We bought her an outfit. She looks darling in it'.[227] Other images of probably non-Muslim figures include a drawing in his sketchbook and then the corresponding painting, *Young Algerian Girl*, and two paintings of *Seated Algerian Woman*.[228]

While Renoir was still in Algiers, Bérard, following the painter's instructions, submitted two of Renoir's works to the Salon. On 23 April 1882, about a week before Renoir returned to Paris, Bérard reported that 'your portrait of the little Grimprel girl [*Mlle Yvonne Grimprel*] has been accepted to the Salon... Your bather was refused!!!' This was the *Blonde Bather* of 1881 for which Aline had posed at the bay of Naples. Even though Bérard understood that Renoir would be disappointed, he sweetened the news, exclaiming: 'I'm completely thrilled and more and more convinced of your merit and of the merit of your friends.... Success is coming.... All in all, things are going well. It is time for you to succeed; we can't let you be forgotten.' Bérard, his wife and four children, accustomed to Renoir's annual presence in their home, missed him greatly. In the same letter, Bérard wrote: 'Certainly we are counting on you, and we insist that you come here to spend time with us.... You can't imagine how impatient we all are here at rue Pigalle [their Paris address] to see you again. Write and tell me the exact date you will come back.'[229]

Renoir returned to Paris shortly after sending this letter. On his arrival, he turned his thoughts to incorporating the lessons learned abroad into his customary portraits and scenes of daily life. From L'Estaque, before he became ill, he had written to Mme Charpentier: '[It] gives me great pleasure [that] you are still thinking about the pastel of your daughter. I should have hurried back to Paris but I didn't do it because I am learning a lot and the longer I take, the better the portrait will be.... I have perpetual sunshine and I can erase and start over as much as I want. This is the only way to learn, and in Paris we are forced to be content with little.... Raphael who didn't work outside had nonetheless studied the sun since his frescoes are filled with it. Thus, by seeing what is outside I ended up only seeing the larger harmonies without being preoccupied by the little details that dimmed the sunlight instead of lighting it up. I hope to return to Paris to make something that will be the result of these general lessons, and give you the benefit.'[230]

Indeed, on his return to Paris, Renoir incorporated in some of his works the 'grandeur and simplicity' he had gone seeking without diminishing his characteristic luminosity or vibrant colour. These new figure paintings call to mind Cézanne, Raphael and certain Pompeian frescoes in their distinct contours, clear delineation of the features, tight focus and intensity. The most striking portraits in his new style include those commissioned by Durand-Ruel soon after Renoir's return to Paris. Durand-Ruel, a widower, wanted paintings of his five children, who ranged in age from twelve to twenty. Before he got this commission, Renoir had been extremely worried about his relationship with his dealer. After the conflict surrounding the 1882 group show, Renoir had written to Bérard that he was worried about what would happen '*if Durand drops me* [as a client].... I will have lots of things to tell you: my struggles with Durand-Ruel to not be part of the Exhibition of Independents. I had to give in a little. That is to say that I couldn't refuse to allow him to exhibit my canvases that belong to him.'[231] By late June, Durand-Ruel had made it clear that there were no hard feelings. Renoir wrote to Bérard in relief: 'Durand-Ruel wants me to do his entire family, and has told me to set aside the whole month of August.'[232] The dealer wanted the paintings executed during the family's summer vacation, which they spent in a rented Dieppe chateau. Renoir ended up doing four portraits of the five children that summer, which in their greater definition of form appear different from Renoir's earlier figures.[233]

Not all the portraits Renoir made on his return were in his new style. During that summer, he had painted a portrait of Mme Marie-Henriette Clapisson, seated in her garden in Neuilly, a suburb of Paris.[234] Her husband was a retired lieutenant, stockbroker and collector who had purchased Renoir's *Staircase of the Mosque of Sidi Abd-er-Rahman*, 1882, from Durand-Ruel.[235] Mme Clapisson's portrait is in Renoir's old Realist Impressionist style, and the figure seems to sink into the landscape. She was dissatisfied with this painting, so Renoir promised to go back later in the year and redo her portrait, complaining to Bérard in October 1882: 'I am not doing well at the moment. I have to start over Madame Clapisson's portrait. I failed completely. Also, I don't think that Durand is very happy about his family portraits. Anyhow, all this demands reflection and without exaggerating, I must be careful if I don't want to lose the public's esteem.'[236] These early attempts at portraiture after his return did not satisfy anyone. He felt constrained by his expectations of what his buyers wanted, and thus he struggled to find a balance between his artistic aspirations and his material needs. Renoir longed to return to his genre paintings where he could experiment in his new style. He also missed life with Aline in Paris. While working for Durand-Ruel in Dieppe, he had written to her: 'I have nothing to tell you, except that I've begun my portraits and that I can't wait to come back to Paris to work in my studio.'[237] In another letter to Aline, he requested: 'Give everyone my best. Tell them I'll be back as soon as possible, and that I am not staying in Dieppe for pleasure.'[238]

Aline, too, was longing for Renoir's company. Their six-month trip abroad together had strengthened their relationship. She missed him when he left her in Paris to go to Dieppe. After she had been alone for two weeks, she implored him: 'Tell me, my poor dear: Are you cold up there in Dieppe? We are freezing here in Paris. Are you working hard? Will your portraits be finished soon? A month seems so long! Our trip this winter seemed much shorter than the past two weeks without you. Write to me often, and tell me if you are well. All my love, Aline.'[239]

Once he was back in Paris, probably in September 1882, Renoir began work on a new set of paintings, a triptych of dancing couples, that draw their emotional power from his own passionate love-life. These three works recall the modern sociability of *Dancing at the Moulin de la Galette*, 1876 (see page 86) his greatest purely Impressionist painting. Work on the three dancers continued for the next seven months. Although he started his actual work only in September,

he may have been thinking about the dancer paintings as early as March, when, from Algiers, he wrote to his dealer: 'I have ideas for paintings that will cost me a lot of money.'[240] The inspiration for the triptych layout came from traditional Christian art, the many large altarpieces in museums and churches that paid tribute to Jesus Christ or to the Virgin Mary. In Renoir's triptych, he is praising romance in modern Paris through the different social classes. Following the traditional format, the central panel is slightly wider than the side panels.

For the central canvas, *Dance at Bougival* (see page 94), Renoir chose a romantic interlude between an informally dressed couple while, behind them, three figures sit chatting at a table at the left and three others stand socializing behind the tree at the right. The dancing pair's clothing suggests that they are lower class: they wear no gloves and the man appears to be a boatman with a straw hat, a blue collarless shirt and casual shoes.

In the left panel, *Country Dance* (1883; see page 95), Renoir painted a middle-class couple dressed more elegantly, yet the woman's red-orange hat with purple plums is the same that appears in *Dance at Bougival*. The woman wears mustard-yellow gloves, white earrings and carries a fan. Her partner has a white-collared shirt beneath his formal fitted jacket, and he wears shiny black shoes. The right panel, *City Dance* (see page 95), represents a high-class couple. She wears a lavish, low-cut formal gown and long white gloves. He also wears white gloves to complement his tuxedo with tails. Renoir decided he needed to study a real upper-class ball before doing this work. He thought of Duret's friend, the wealthy banker and art collector Henri Cernuschi, who, he learned, was holding a formal dance. Renoir wrote to Duret: 'Can you get me an invitation for the dance at Cernuschi's? I would most appreciate it.'[241] Having gone to the ball, he was able confidently to pose his models for *City Dance*.

Although Aline was not the model for this high-class woman, as Renoir's muse, she modelled for the women in *Dance at Bougival* and *Country Dance*. Fifteen years later, when the three paintings were exhibited in Paris at Durand-Ruel's Renoir exhibition in May 1892, Julie Manet recorded in her diary: 'He told us that in *La Danse* he had used Mme Renoir and his friend Lauth [Lhôte] (of whom he still speaks with affection).'[242] Paul Lhôte, who had modelled in *Moulin de la Galette* and *Luncheon of the Boating Party*, posed for the male dancers in all three panels. For the more formal, upper-class *City Dance*, Renoir chose Puvis de Chavannes's model, Suzanne Valadon, who began posing for Renoir at this time and would occasionally model for him over the next four years.[243]

Renoir worked intensely on the three dance paintings, hoping he would complete them in time to be the centrepiece among more than seventy of his works in an exhibition planned by Durand-Ruel for April 1883. This would be Renoir's first solo painting show. Even though the Charpentiers had shown his pastel portraits in their offices four years earlier, Renoir had never before presented so many paintings in a major gallery. He was one of four Impressionists, along with Monet, Pissarro and Sisley, chosen by Durand-Ruel for single-artist shows that year. Despite the fact that this was an important exhibition, Renoir did not quite manage to complete his triptych on time. Although he delivered the two side panels to his dealer on 28 March, three days before the show was to open, he took two more weeks to complete *Dance at Bougival*, which he brought to Durand-Ruel on 16 April.[244] Hence the triptych of three dancers could only be seen together at the end of the show.

This triptych was Renoir's greatest work in the new Classical Impressionist style. Exhibited at Durand-Ruel's among many of his earlier works, including *Dancing at the Moulin de la Galette*, it enabled the public to understand the evolution of his style. In Duret's preface to the catalogue of this show, he explains: 'We see him acquiring a more expansive manner of painting, endowing his figures with greater suppleness, surrounding them with more and more air, and bathing them in more and more light.'[245] Almost thirty years later, in the first book on Renoir, Julius Meier-Graefe said that the dancers of 1883 were the first instances of a new 'sculptural solidity'.[246] During Renoir's show, Pissarro, whose exhibition followed Renoir's, informed his son: 'Renoir's show is superb, a great artistic success, of course, because here one can't count on anything else.' Yet, as Pissarro pointed out, however great the show, it was extremely unlikely that Renoir would sell any of these works.[247]

In fact, Durand-Ruel, knowing that French patrons were not buying, began looking abroad for places to show and sell Impressionist works. After Renoir's Paris show closed, Durand-Ruel sent *Dance at Bougival* to an exhibition in London at the Dowdeswell and Dowedeswell Gallery, where it was on view from late April until July.[248] Having had no success in London, Durand-Ruel turned his hopes to America, seeking patrons who might not already be prejudiced against the Impressionists. He found an opportunity in Boston at the International Exhibition for Art and Industry. From 3 September to the end of October 1883, Renoir's three dance paintings along with works by Manet, Monet, Pissarro and Sisley were exhibited in the Mechanics Building.[249] The

reception by the public was so good that Renoir was awarded a medal from the city of Boston.[250]

The American audience was responding to the brilliantly expressed romance that Renoir brought to these paintings. *Dance at Bougival*, perhaps his most successful canvas and on a par with his extraordinary *Luncheon of the Boating Party*, has been eloquently described by a modern scholar, Colin Bailey: 'Among Renoir's most perfectly realized figure paintings, *Dance at Bougival* is also his most romantic: the tender yet passionate pose of the dancing couple conveys an ardor and eroticism that are almost palpable. Eyes masked by his boatman's straw hat, the male dancer expresses his intentions through a body language that is as legible today as it would have been a century and a quarter ago. His companion's willing compliance completes the harmony, both visual and sensual, that is at the heart of his painting, even though the touching of ungloved hands and proximity of the dancers' faces would have appeared audacious to a late nineteenth century audience. As light as air, the young woman waltzes "deliciously abandoned" in her partner's arms, his breath upon her cheek.'[251] Bailey is here quoting Renoir's words, inscribed in the painter's handwriting under his pen and ink drawn copy of *Dance at Bougival*: 'She waltzes, deliciously abandoned, in the arms of a blond man who looks like a boatman.' Renoir's drawing was engraved to illustrate a short story, 'Mlle Zélia', by Lhôte who, as noted earlier, modelled for this figure.[252]

Having perfected his new style in the dance paintings, Renoir brought his new-found confidence to his portrait commissions. He needed to redo the portrait of Mme Clapisson so he decided to try this early Classical Impressionist style.[253] This second version recalls Ingres's female portraits in its clarity, seriousness and sensuality. Renoir had had Ingres in mind when he wrote, soon after leaving Italy: 'I prefer Ingres [to Raphael] in oil painting.'[254] The second version of Mme Clapisson's portrait pleased the patrons, who paid him 3,000 francs. It was the only work that Renoir sent to the Salon of 1883, and it was accepted.

In late June 1883, when the Clapisson portrait was still on show at the Salon, Caillebotte invited Renoir to visit at his country home outside Paris in Petit-Gennevilliers, to paint a portrait of his devoted partner, Charlotte.[255] Renoir's elegant portrait in his new style shows Charlotte with her dog.[256] Five months later, Caillebotte made an addition to his 1876 will: 'My intention is that Renoir never has problems because of the money I lent him – I give him back the entirety of his debt and remove his obligation to pay Mr Legrand. Written in Paris on November twentieth eighteen eighty three. Gustave Caillebotte.'[257] This is an

indication that, in November 1883, Renoir was still having financial problems. Six years earlier, he had entered into partnership with Alphonse Legrand with Caillebotte as a limited partner. Although the company was dissolved a year after its inception, technically Renoir owed Legrand money.[258] Hence Caillebotte's addition to his will protected Renoir and indicates that Renoir's financial situation was still dire in 1883, even though he was a popular portraitist.

Benefiting from his Italian studies, Renoir began receiving more commissions, the most prominent of which was from a wealthy Jewish family related to Pissarro.[259] Alfred Nunès, the mayor of Yport, a town near Dieppe, asked for life-size portraits of his two children, Aline Esther, then aged eight, and Robert, aged ten.[260] Renoir completed the portraits to the Nunès's satisfaction, executing them in his new, substantial and richly coloured style. Elegantly dressed Aline stands in a garden holding an umbrella and flowers, while Robert, dressed in a sailor suit, stands at the seashore holding a stick.

Anti-Semitism was common in France at this time, especially prevalent among wealthy Parisians, but Renoir seems to have been ambivalent on this topic.[261] Although he made the occasional anti-Semitic remarks, Renoir liked the Nunès and wrote mostly positive letters about the family. For example, to Aline in August 1883: 'We eat 12 courses per meal, and we have lunch at 1 o'clock after having eaten at 9 o'clock. We should be eating at noon but someone is always late. I have to find a way to eat alone; otherwise I'll be spending the entire day eating and digesting. Aside from that [they are] good people.'[262] In another letter to her around the same time, Renoir explains: 'The children have very sweet dispositions. What's more they aren't bothersome people. Despite this, I am beginning to find the high life rather dull.'[263] He also wrote to Bérard in a similar vein at this time: 'They are very nice people and not at all typically Jewish, at least so it seems to me. They have too many parties, that's their weakness.... Anyway, I'm not too bored since I succeeded in having a place of my own [at Maison Aubourg, rue de l'Église, Yport[264]] fortunately...because in their house, they spend the entire day eating.'[265] The sense one gets from these letters is that Renoir felt that the wealthy family was enjoying their abundance through extravagant meals. Nonetheless, every complaint is accompanied by positive statements about their geniality.

Wealthy Parisians spent their summers in the country and some thought it a good time to commission portraits of their family. With Renoir away fulfilling portrait commissions, Aline was in charge of their Paris apartment and she

endeavoured to make their home attractive. She wrote to him: 'I don't know if I will have enough money to last to the end of the month, because we need more material. We don't have enough for the big curtains to hang at the side of the large window where most of the sun comes in. It is on the west side, I think…. The calico curtains next to the beam and the linen ones on the other side. I will be able to buy just the number of yards needed. I found a shop where they sell by the piece. But as I have already spent forty francs for you, I'm afraid I won't have enough to buy the material. If you are not coming back before the end of the month, please send me some [money].'[266]

Besides making curtains, Aline was in charge of supervising the carpenter, Monsieur Charles. She kept Renoir informed: 'The leak [in the roof] of your studio has not been repaired yet. The men were to come and mend it on Monday, but there was a wedding. Tuesday was a holiday. Today it rained all day, and they say they must wait until it clears up. However, I hope it will be done by the time you come back. I showed Monsieur Charles the drawing for your bed. He will make it as soon as you return. He wants to talk to you about it. You know how stubborn he is. I don't know what he thinks is too high about it. You can discuss the matter together.'[267]

While he was away, Renoir appreciated all that Aline did for him and wrote back to her frequently and sent her money. When close to completing the Nunès portraits, he promised her: 'As soon as I get paid, I'll send you some cash.'[268] He was also concerned that she would overwork herself without him there, advising: 'Don't exhaust yourself unnecessarily working on my studio. Tell me when my upstairs furnace is done and how much it will cost me.'[269] Despite their continuing closeness, Renoir was careful to keep his relationship with her a secret from almost everyone, even after living together for two years. As late as 1883, the few who knew that she was not only Renoir's model but also his mistress included his brother Edmond, Cézanne, Hortense Fiquet, Paul Cézanne junior and Caillebotte and his partner, Charlotte.[270] Even though it risked revealing his secret, Renoir arranged for Aline to visit him covertly in Dieppe. When he had almost finished the Nunès portraits, he wrote to her: 'I want you to come here for a few days after the races; there will be fewer people' (Dieppe's racetrack was and still is famous).[271] At another time he wrote: 'Wednesday I'll wait for you at the train station…. The most convenient train is the one leaving at 7:45 in the morning or the one at 12:45.'[272] In another letter, he wrote about 'purchasing round-trip tickets…. I will work all day and in the evening, I'll be free.'[273]

After finishing the Nunès portraits, Renoir decided to go away with Aline for a month. From early September to early October 1883, they travelled to the two Channel Islands of Guernsey and Jersey. From Guernsey, he wrote to his dealer: 'I hope to return soon around the 8th or 9th of October with several canvases and documents to make paintings in Paris. I have found myself here on a charming beach.... I hope, despite the small amount of things that I can bring back, to give you an idea of these charming landscapes.'[274] In Guernsey or back in Paris, he painted Aline embroidering in *By the Seashore*, 1883.[275] In this painting, Aline's precisely rendered face calls to mind the woman's face in *Country Dance* painted a few months earlier.

Two months later, from 16 to 30 December 1883, Monet and Renoir made a research trip together along the Côte d'Azur from Genoa to L'Estaque. From Monte Carlo, Renoir wrote to Aline about his fears of a return of pneumonia: '[I am in]...an exhausting country, maybe even more dangerous than L'Estaque. Thus I take all possible precautions to avoid a replay of the Estaque incident.'[276] His affection for Aline is evident in his suggestion of intimacy: 'My dear friend, I think it is because you are not here, but the southern sun does not affect me as it used to; I don't think I have the slightest desire any more.'[277] While thinking of her, he also thought of her love of gambling, a pastime he did not enjoy: 'I bet a hundred *sous* for you on red. I lost. The first day with a hundred *sous*, we won 45 francs, but we lost it all the next day. We won't go back. It's deadly dull; that casino is atrociously sad. So see you soon. Love, Auguste.'[278]

Although Renoir was happy with Aline and though he enjoyed his two-week trip with Monet, back in Paris, he missed his Impressionist friends. The sociable Renoir, who had been intimately linked to those friends since he was in his twenties, did not like the fact that, by the time he was in his forties, he rarely saw these companions of his youth. The old Impressionist group had drifted apart for several reasons. First, since 1882, the group had no longer exhibited together.[279] Second, many of the artists had moved from Paris: Cézanne to L'Estaque, Monet to Giverny, Pissarro to Pontoise and Sisley to Moret. Only Cassatt, Degas, Manet, Morisot and Renoir continued to have their primary residences in Paris. Third, each of his artist friends was seeking a more individual style.

Yet the sociable Renoir always enjoyed painting with friends and was happy to paint with Monet in late December 1883 as they travelled along the Riviera. From Genoa, Renoir wrote to Durand-Ruel: 'We judged that it was

preferable to study the countryside carefully so that when we come back we will know where to stop right away.'[280] Renoir thought that this trip was the beginning of a renewed working partnership, similar to working trips that they had enjoyed when they were younger. Side by side, they had painted the same motifs at La Grenouillère in 1869, at Argenteuil in 1873 and 1874 and in Paris in 1875. Renoir had not only worked side by side with Monet but also with Bazille in 1867, with Pissarro in 1869, with Sisley in 1873, with Manet in 1874, with Caillebotte in 1882 and with Cézanne in 1882 (and would later in 1888–89) and with Morisot around 1890.[281] Although Renoir and Monet worked side by side more than either of them had with any other artist, still their artistic paths had always been different. Monet was primarily a landscape painter and Renoir a figure painter. Yet Renoir always felt the importance of painting landscapes, which he believed to be a way to experiment and to improve his painting.

Even though Monet had agreed to this December 1883 trip with Renoir, on his return he changed his mind about working together again. On 12 January 1884, Monet explained in a letter to Durand-Ruel: 'As much as it was agreeable to do the trip as a tourist with Renoir, it would be a nuisance for me to do a working trip together. I have always worked better in solitude, and from my own impressions, so keep this secret, until I tell you otherwise. Renoir, knowing that I am about to leave, would no doubt be eager to come with me, which would be just as harmful for each of us. No doubt you will agree with me.'[282] Monet returned on his own to Bordighera and wrote again to his dealer: 'I wrote to Renoir and I am not making my stay here a secret. I only wanted to come alone, to be freer with my impressions; it is always bad for two people to work together.'[283] His feelings were partly a reaction to the critics who claimed that all the Impressionists were alike. For example, in a review in *Le Figaro* in 1882, Albert Wolff had written: 'Renoir or Claude Monet, Sisley, Caillebotte, or Pissarro, it's the same musical note.'[284] After his December 1883 trip with Renoir, Monet made it clear that thenceforth he wanted to work alone to create a unique style. He was still convinced of this four years later when he again rebuffed Renoir. In January 1888, Monet wrote to his wife: 'This morning I received news from Renoir, whom I have always feared would show up here.... I have too much of a need to be alone and in peace.'[285] Clearly, Monet's and Renoir's needs about companionship while painting differed.

After Monet shot down Renoir's 1884 attempt to return to working side by side, Renoir came up with a new scheme to end his isolation. He attempted to

establish a community of artists, which he called La Société des Irrégularistes (Society of Irregularists). For his new organization, Renoir suggested yearly art exhibitions. In its manifesto, he wrote: 'An association is...necessary.... The association will take the title Society of Irregularists which explains the general idea of its founders. Its aim will be to organize as soon as possible exhibitions of all artists, painters, decorators, architects, goldsmiths, embroiderers, etc., who have irregularity as their aesthetic principle.'[286] Renoir's manifesto also postulated the theory that beauty comes from diversity or irregularity. He explained: 'Physicists say Nature abhors emptiness; they could complete this axiom by adding that it equally abhors regularity.... The two eyes of the most beautiful face will always be slightly dissimilar; no nose is placed exactly above the centre of the mouth; the quarters of an orange, the leaves of a tree, the petals of a flower are never identical; in fact, it seems that every kind of beauty draws its charm from this diversity.... the great artists...have restrained from transgressing its fundamental law of irregularity...the duty of all sophisticated people, of all men of good taste, is to get together without delay, whether or not they have an aversion to struggle and protests.'[287] His philosophy for the Irregularists stemmed from the new style with which he was experimenting in 1884, that of what can be called Ingrist Impressionism. It often shows stylistic diversity within one canvas: Impressionist background, colour and light, as well as clearly delineated and detailed figures, an edge of form reminiscent of Ingres and figures on the picture plane close to the viewer (see pages 93, 96, 194 and 195).

This is another instance of Renoir taking the initiative and belying his claim to passivity. Just as he had in the 1877 Impressionist group show, when he prompted Rivière to create the four issues of *L'Impressionniste: journal d'art*, seven years later he took charge in organizing a new group. In May 1884, Renoir sent his dealer the manifesto, which Pissarro's lawyer cousin, Lionel Nunès, helped him draft.[288] He also showed this proposal to Monet. Unfortunately, Renoir was not able to garner any substantial support for the idea. Eventually he gave up on the plan and nothing came of his Society of Irregularists.

Even though Monet was opposed to painting with Renoir, in the end it was Monet who assuaged Renoir's isolation by creating monthly gatherings of the former Impressionists. These meetings were more like the Charpentiers' soirées than Renoir's attempt to put together an artistic group, since primarily they were social events tied by a common love of Impressionist art. Monet enlisted Pissarro's help, writing in November 1884: 'I wrote to Renoir so that we could

set up a time to dine all together each month, so that we can get together to talk because it is stupid to isolate oneself. As for me, I am turning into a clam and all I do is worry more about it.'[289] Later in the month he reported to Pissarro: 'I saw Renoir who of course was thrilled that we are organizing a dinner.'[290] Besides artists, others participants included the art critics Jules Castagnary and Octave Mirbeau and other writers, collectors and friends, among them Alphonse Daudet and Zola,[291] Stéphane Mallarmé,[292] Philippe Burty, Théodore Duret, Dr de Bellio, Ernest d'Hervilly, Georges Charpentier and Ernest Hoschedé. Unsurprisingly, these gatherings were all-male.

These social occasions may not have been enough for Renoir since his real feelings of isolation stemmed from his problems in forging his new artistic direction, which came to fruition as Ingrist Impressionism in 1884. This new style with its focus on line was so radically different from what any of the other Impressionists were doing that Renoir found himself completely alone. His desire for simplicity and grandeur was not satisfied by his early Classical Impressionism of 1881–83, as in the *Blonde Bather* of 1881 and its replica the following year. Thus, by 1884, Renoir's focus had shifted to an innovative style based on clearly drawn foreground figures with Impressionist backgrounds. The term Ingrist Impressionism is contradictory, since Ingrism is characterized by defined, sculptural figures whereas Impressionism's figures are without boundaries or mass. Ingrist Impressionism incorporates the sculptural qualities of Cézanne, the linear definition and precision of detail of Ingres, the simplicity and grandeur of Raphael and Pompeian frescoes and the colour, light and visible brushstrokes of Renoir's Impressionism. In this new style, the faces of some of Renoir's figures (*Étienne Goujon*, *Pierre Goujon* and *Girl plaiting her Hair*, modelled by Susan Valadon, all 1885; *Woman with a Fan* and *Young Girl with Swan*, both 1886[293]) appear mask-like, reminiscent of Cézanne's portraits.[294]

Gradually, Renoir softened this stiffness as he developed the style. While the ultimate goal of Impressionism (as in *Dancing at the Moulin de la Galette*) was to show life in constant motion, in an Ingrist Impressionist work (as in his key work in this style, *The Large Bathers*, 1887, on which see Chapter 3[295]), the foreground figures capture the stillness of a frozen moment while the background remains Impressionist. Renoir's goal was to create a new classical mural painting as an alternative to that of Puvis de Chavannes;[296] it would combine the simplicity and grandeur of Classicism with the light, colourful style of Impressionism and would be suitable as decoration for the walls of public buildings or wealthy

people's homes. Hence when he first exhibited *The Large Bathers*, he subtitled it *Experiment in Decorative Painting* (*Essai de peinture décorative*).

In 1884, Renoir first tried out this new Ingrist Impressionist style with a portrait of the youngest daughter of Paul Bérard. The year before, Renoir had painted three-year-old Lucie in a white blouse and smock (see opposite). When she was four, Renoir again painted her and wrote to Bérard that he had not yet completed the 'little head of Lucie in my new style', jokingly declaring that this style would become 'the last word in art…one always believes one has invented the train until the day when one notices that it doesn't work…. I am beginning a little late in life to know how to wait, having made enough fiascos like that. (see page 93).'[297] It is presumed that Renoir painted that first Ingrist Impressionist work of 1884 from a photograph. A while later, during the summer of 1884, when staying with the Bérards at Wargemont, he further elaborated this style in a large, exhibition-size group portrait, *Afternoon of the Children at Wargemont*.[298] Lucie is in the centre, holding her doll, Marguerite aged ten reads a book on the sofa at left and Marthe aged fourteen sews at right. The painting is Renoir's first large work in the new Ingrist Impressionist style. During that year, he also experimented in Ingrist Impressionism in works such as the portrait of the boy *Paul Haviland* and the genre painting, *Girl with Straw Hat* (see page 93).[299]

Renoir was not the only Impressionist looking to evolve a unique style. In March 1884, Monet wrote to his wife that Renoir's struggles echoed the other Impressionists' frustrating quests to evolve their art individually: 'Renoir wrote…that he spent all of his time working and then scratching out his work. We [Impressionists] are definitely struggling and yet people will always criticize us for not making any effort.'[300] At the same time, in May 1884, Durand-Ruel, the main dealer for most of them, was facing bankruptcy as a result of the collapse of the Union Générale bank two years earlier. Renoir and Monet urged their dealer to sell their paintings at low prices, Renoir writing: 'As for the paintings, if you must make sacrifices [sell them for little], don't worry about it. I'll make more for you and they will be better.'[301]

That June, during this time of Renoir's artistic and financial uncertainty, Aline became pregnant. Renoir was then forty-three. His father had been forty-two when Renoir was born, so perhaps the artist felt this was good timing for him. Unlike when Lise had been pregnant with his children, now both Aline and Renoir hoped to be able to raise their child. Renoir's secret relationship with Aline was stable and happy even though the rest of his world was unsettled.

Lucie Bérard, 1883. 35 x 27 cm (24¼ x 19¾ in.). The Art Institute of Chicago, Collection of Mr and Mrs Martin A. Ryerson

Chapter 3

1885-93

**Renoir, aged 44–52;
Baby Pierre,
Success and Sickness**

Several months before Aline gave birth to Renoir's son Pierre on 21 March 1885, the artist painted a radiant portrait of her that captures her joyfulness during her pregnancy with her first child (see opposite and page 194). She appears noticeably heavier than in *Country Dance* (see page 95) and *Dance at Bougival* (see page 94), for which she had modelled two years earlier.[1] A true rustic, she wears a straw hat and peasant jacket; she wears no wedding ring. Pierre's birth certificate specifies that he was born at home 'at 6 o'clock [in the morning], at 18 rue Houdon [Paris], son of Pierre-Auguste Renoir, a 44 year old painter, [who] has declared his recognition, and of Aline Victorine Charigot, 25 years old, without a profession, living at the aforementioned address'.[2] Aline did not record that she was a model perhaps because of modelling's low reputation. It seems to have been Renoir who decided on the names of his first two children with both Lise and with Aline: his firstborn son with each woman has his own first name, Pierre, and his second child with each woman was named Jean or its female equivalent, Jeanne.

Renoir decided not to marry Aline at this point so that he would not have to be financially responsible for her. As a devout Catholic, Aline might well have had objections to having a child out of wedlock, but with the example of her own mother, who had been forced to wed and then abandoned, she knew that being married guaranteed neither fidelity nor support. Renoir was following the same path as many of his artist friends – Cézanne, Monet, Pissarro and Sisley – who had had children with their mistress models but did not marry them because they feared they would not be able to support them. All these friends, however, later married their children's mothers, once each artist became

Portrait of Aline, 1885. 65.4 x 55.2 cm (25¾ x 21¼ in.). The Philadelphia Museum of Art.
The W.P. Wilstach Collection

financially stable. They had also legally recognized their children at their births so that their children had their father's last name, as did Renoir, giving his son Pierre his last name, Renoir.

In recognizing Pierre, Renoir had changed from how he had acted towards Lise at their children's births: both Pierre and Jeanne Tréhot had their mother's last name, as noted in Chapter 1. Now, by recognizing his newest child and giving him his last name, the painter was legally accepting the financial responsibility of fatherhood. Two days after the birth, Renoir, accompanied by his brother and a friend, took his newborn to the eighteenth arrondissement town hall. The birth certificate states that Renoir recognized his son 'in the presence of Victor Renoir,[3] a 48-year-old tailor living at 35 rue Laval [in the nearby suburb of Saint-Cloud] and Corneille Cornet, a 39-year-old cabinet maker residing at rue des Trois Frères [in Montmartre].' Renoir chose Caillebotte as the baby's godfather, one of a select few who knew about Aline and infant Pierre. Others who shared the secret included Renoir's brother Edmond and certain friends (Cézanne, Monet, Murer, Pissarro, Sisley and Drs Gachet and de Bellio). Meanwhile, most of his wealthy upper-class friends and patrons (including people to whom he was close – Bérard, Durand-Ruel and Berthe Morisot, who was the sister-in-law of his mentor, Manet) only knew Aline as his model and did not know about their child. This created a double life that Renoir lived until he married Aline five years later, in 1890.

Renoir was firm in his desire for secrecy concerning his newborn. During Pierre's childhood, he wrote to Murer when the collector's friend, the writer and journalist Paul Alexis (also known as Trublot), was writing an article on Murer's art collection, which included about thirty Renoir paintings. 'If you see Trublot tell him he's a very nice fellow, but that I'd be very happy if he didn't say a *word* about me; he can say as much as he wants about my canvases, but I hate the idea of the public knowing how I eat my cutlets and whether I was born of poor but honest parents. Painters are very boring with their pitiful stories, and people don't give a damn about them.'[4]

This insistence on privacy stemmed from Renoir's need to keep his career afloat in an upper-class milieu despite his own continuing financial difficulties. The Parisian elite, however, were not the only people from whom Renoir kept secrets. He never told Aline, for example, about his previous two children with Lise. For Renoir, keeping secrets was a way of keeping control. By hiding different parts of his life from different friends, he maintained a state of separation and

autonomy, a world in which he was the only person who knew everything; none of his friends or family knew about all his varied friendships. Even Pissarro, who was an exceptionally perceptive person, could write (to his son in 1887): 'Nor can I understand Renoir's comment at all...but who can fathom that most inconsistent of men?'[5] Pissarro's words – 'le plus changeant des hommes' – can be translated as inconsistent, changeable, changing or fickle. And Renoir was indeed complex and variable: sometimes passive but other times assertive, sometimes indecisive but other times clear-minded, sometimes shy but other times forceful. He fostered his reputation for passivity, indecision and shyness in order not to appear threatening to his friends who were sometimes also his benefactors. Secrecy enabled him to maintain control and to steer his own ship.

Even though Renoir was determined to keep his private life a secret, the subject matter of his art reflected what he was hiding from his friends. Previously, he had often painted men and women romancing in modern Paris. After Pierre was born, he never depicted an adult man wooing an adult woman in a modern setting. Indeed, Renoir's settings change to become timeless, secluded rural places. From this time forwards, adult men almost completely disappear from Renoir's paintings. They are replaced, at Pierre's birth, by male children. Thereafter, he no longer painted large groups of figures in the city and suburbs. Instead, he painted individuals and small groups of women and children in the country. Renoir began to paint Aline in all kinds of traditional scenes that often call to mind earlier images of the Virgin and Christ Child. He replaced modernity and contemporary fashion with figures in simple, timeless garments.

Many works record Aline's activities as a new mother. In 1885 and 1886, Renoir made three paintings of Aline nursing Pierre in a rural setting (see page 96), for which he made precise preparatory drawings (see page 137).[6] They call to mind Renaissance Madonna and Child images in which the Virgin is nursing a semi-nude male infant.[7] As in some Christian images, Aline's breast and Pierre's penis are visible.[8] Renoir was fond of these images and kept the first painting in his studio until his death. (Beyond images of motherhood, Aline posed for many nudes, some reminiscent of Venuses in art of the past.) In numerous paintings and drawings she feeds Pierre seated in a high chair, hugs him while hanging up laundry, takes him boating, talks to him as she knits outside.[9] Renoir painted Aline, one-year-old-Pierre and a neighbour outside a house in Brittany surrounded by trees with carefully delineated leaves, and in group scenes where Aline and her friends pick grapes, wash clothes and talk to an apple seller (see

page 193).[10] He also made numerous paintings, drawings and even a lithograph of his son alone.[11] His nephew Edmond Renoir junior, who was a year older than his son, also features in many paintings and drawings.[12]

While Pierre and his life became a major theme in Renoir's art, what the artist portrays is always a healthy, happy child. As usual, this was an idealized version of Renoir's reality: Pierre was a sickly child and Renoir a concerned father. In May 1886, Renoir wrote to Caillebotte: 'Pierre has been sick for five months, mucous fever [a mild form of typhoid] first, bronchitis second; we're taking him outside for the first time today for five minutes.'[13] A year later, on 10 June 1887, when Pierre was two, he had an operation that Renoir described to Murer: 'my little one [had]...a delicate operation (on the foreskin). [The recovery] will take a long time and he won't be able to leave here for some time.'[14] Because Renoir was short of money, he gave the doctor a still life, *Gladioli*, inscribed 'Au Docteur Latty/Souvenir d'amitié/Renoir' (To Dr Latty, souvenir of friendship, Renoir).[15]

Pierre's recuperation did not go well, and Renoir had concerns for both him and Aline. In mid-June, Renoir was on a painting trip and wrote to her: 'I hope that Pierrot will finally improve and even recover completely. I have great faith in Latty, but this wound which won't heal and which doesn't seem to improve worries me. Maybe I'm wrong. That's why, in my absence, I wanted to refer you to [Dr de] Bellio so that should something happen, you would know what to do and you wouldn't be alone, but I still hope everything will turn out for the best.' Pierre's treatment was expensive, but Renoir was willing to exhaust his resources to protect his child. In the same letter, he responded to Aline's concern about the cost of a train ticket should she need to take Pierre to a doctor: 'Don't worry about the extra 4 francs, 16 sous; all that matters is that the boy gets better. Kiss poor little Pierre.'[16]

As Renoir's worries continued, he wrote to his two homeopathic doctor friends and patrons, de Bellio and Gachet, as he had eight years earlier when his model Margot had contracted smallpox (see Chapter 2). Now he implored de Bellio, 'You would be so kind if you would come to see my kid, not as a doctor but as a friend – just to tell me what you think. He had an operation on his foreskin two weeks ago today and it isn't healing because of the eczema. The doctor says it isn't serious, but I am worried because of how long the [healing process] is taking and you may be able to give us some advice.'[17] After de Bellio had examined Pierre, he convinced Renoir to have the operation redone. Renoir

Drawing for Nursing Composition with Two Infant Heads, 1886. Sanguine heightened with white chalk on beige prepared canvas, 91.4 x 73.3 cm (36¼ x 28¾ in.). Musée de Strasbourg, France

wrote to Murer: 'My kid needs to be operated on again. I have been wearing myself out for the past two months to no avail dressing his wound and now we have to start all over again. This time I am selecting a good surgeon and I hope there will be no problems.'[18] By the time Gachet came to see Pierre, the child already had undergone the second surgery and was doing better. Renoir again wrote to Murer: 'Doctor Gachet was, as usual, very kind to us. Please send him our best wishes and tell him things are going better and better.... Aline has to stay inside [with Pierre] all day long. I have to take over a little when I go home.'[19] A later letter to Murer states: 'As for my kid, everything is going well, even though it's not over because we have to wait for the stitches to fall out by themselves, which takes a long time.'[20]

Throughout this difficult ordeal, Renoir proved a devoted and concerned father, never begrudging his son help despite his financial uncertainty. He showed his love and affection for Pierre constantly. At the bottom of one of his letters to Aline this summer, he made a drawing for his son and wrote: 'I'm drawing you a little railroad and I'll see you soon.'[21] Although Pierre recovered completely from his operations, Renoir continued to be concerned about his son's health. Two years later, in December 1889, he wrote to Bérard, who was one of the people cognizant of Pierre: 'After a month of [Pierre] feeling faint, my kid ended up getting mucous fever.'[22] Eleven years later, Renoir would recall Pierre's second bout with mucous fever, blaming it on coal: 'Oh, coal. With coal, who needs wars anymore? It kills miners; it kills those who use it and those who travel by it.... In '89 I had the same problems with Pierre who got mucous fever caused by my (improved) coal stove.'[23]

At no point did Renoir hesitate to spend money for his son's health despite the fact that from 1884 through 1888 his finances were in dire straits. While he had done well in the late 1870s thanks to Mme Charpentier and continued to do well in the early 1880s, enabling him to travel, his finances had plummeted by 1884. The effects of the financial crash of 1882 continued to affect both Renoir and his dealer. Even while working on a high-profile commission for four portraits of the children of a senator, Dr Étienne Goujon,[24] Renoir aged forty-four despaired of being able to support himself with his work, writing to Aline in late 1885: 'Dear friend...My portraits aren't going well and it's likely that I won't be able to finish them.... Painting sickens me and I feel like I'm not good at anything any more. Too old, undoubtedly. I think, my poor dear, that it would do you good to get used to my old age, or else. Anyway, I still hope that

Montmartre will cure me, although my spirits are quite low. Don't have my floor painted. I've incurred enough expenses since I'm not sure I'll be able to earn a living. Now we need to think about saving money. Despite all this, I kiss you as much as I am able. Auguste.'[25] Despite the letter's despair, he closed with 'Auguste', suggesting intimacy and reminiscent of his earliest letter to Aline, which he had jokingly signed 'Augustine', instead of his customary 'Renoir'.

Renoir's friends were aware of his financial difficulties. To his son Lucien, Pissarro wrote in January 1886: 'I don't understand anything any more, Renoir and Sisley are penniless.'[26] Seventeen months later, by June 1887, Pissarro again wrote to Lucien: 'How Sisley and Renoir get by is incomprehensible!'[27] While Renoir had previously been able to get through hard times by making portraits, those commissions dried up during this period, almost certainly due to his stylistic change.[28] The new Ingrist Impressionist style displeased many who had liked his earlier flattering Realist or Classical Impressionist portraits. These new images were harsh, with their sombre frozen expressions, heavily lidded eyes and exacting linear definition, in some ways resembling, as noted in Chapter 2, Cézanne's contemporary reviled portraits that appear mask-like and inert.

With the spectre of poverty looming as Renoir worked on his new style, he decided to stop living full-time in Paris, and instead rented homes in the countryside where the cost of living was significantly lower. To save money, he moved his studio within Paris, writing on 18 October 1886 to Bérard: 'I have moved [my studio] and I am thrilled about it. 1,200 instead of 3,000 francs. I am still waiting for the chimney cleaners.'[29] He often went to Aline's hometown of Essoyes. For his frequent trips to the country, he explained in a letter to Berthe Morisot and her husband, Eugène Manet, early in December 1888: 'I am currently living the peasant life in Champagne so as to escape the expense of Paris models. I am painting laundresses, or rather washer-women on the banks of the river.'[30] Rural life had the added benefit that Renoir's family was easier to keep hidden. Furthermore, Aline preferred the country to the city, and the restless Renoir was artistically inspired by changing scenery, so they moved often from one rural spot to another.

When Pierre was three months old, their first family trip was to La Roche-Guyon, a small town 72 kilometres (45 miles) north-west of Paris, near Giverny, where they rented a house from June through August. Two months later, they went to Essoyes from September through October so Aline could show off her baby to her relatives.[31] The next summer, 1886, they returned to La Roche-Guyon

for the month of July. Then they rented a house, La Maison Perrette, on the coast of Brittany in Saint-Briac for the months of August and September. They returned to Essoyes for Christmas and New Year of 1886.[32] In 1887, Renoir signed the lease for 15 June 1887 to 1 April 1888 on a house and enclosed garden in the Paris suburb of Le Vésinet.[33] In January 1888, Renoir, Aline and Pierre went to visit with Cézanne and his family at Jas de Bouffan, a property that Cézanne owned near Aix-en-Provence. Then they moved to the Hôtel Rouget in Martigues (46 kilometres/29 miles south-west of Aix) during February and March 1888. In the summer after leaving Cézanne country, Renoir and his family went for an extended visit at Caillebotte's home in Petit-Gennevilliers, near Argenteuil, in July 1888 and again in September 1888. They returned to Essoyes in November and December 1888.

Among these various rural abodes, Aline's favourite destination was her hometown, where she had lived for her first fifteen years. During her childhood, her relatives had viewed her with a combination of pity and disdain because of her parents' situations and her own rebelliousness. Now, more than a decade later, Aline returned proudly as both the common-law-wife and mother of the child of a famous artist. While she loved being in Essoyes, Renoir complained to Bérard that he was lonely since there were no other painters around: 'I have started to work again, but without much enthusiasm, because I am absolutely alone here.'[34]

The Renoirs' frequent rural vacations were more pleasurable for Aline than for Renoir, who took a long time to accustom himself to living far from Paris. One of his ways of coping with isolation was to leave Aline and baby Pierre for a few days to go on painting trips. When Pierre was eighteen months old, Renoir left them and wrote from outside Paris to Murer: 'I have just returned from Champagne to see my son and I will be returning to Argenteuil in order to finish a ton of things I started.'[35] Renoir's escapes to Argenteuil and other suburbs of Paris satisfied his need to be closer to his favourite city. Later, when Pierre was three, Renoir had become more comfortable with the rural way of life, as he wrote to Morisot and her husband from Essoyes: 'I'm becoming more and more rustic, and I realize a little late that winter is the really good time: the fire in the large fireplaces never gives you a headache, the blaze is cheerful, and the wooden clogs keep you from being afraid of cold feet, not to mention the chestnuts and the potatoes cooked under the ashes, and the light wine of the Côte d'Or.'[36]

When in the countryside, Renoir often invited trusted friends to visit and, whenever possible, he rented a large enough cottage to accommodate them, such as a house for three months in La Roche-Guyon, north-west of Paris.[37] The first guests after Pierre was born were Cézanne, Hortense and their son Paul, aged thirteen, from 15 June to 11 July 1885, just as Renoir and Aline had visited them three years earlier in L'Estaque.[38] Cézanne informed Zola that he was at: 'Grande Rue, Cézanne at Renoir's, at La Roche.'[39] Cézanne's painting, *Turn in the Road at La Roche-Guyon*, and Renoir's *La Roche-Guyon (Houses)*, both 1885, might have been painted side by side; both have the same distinctive rooftops.[40] Renoir also made another Cézannesque landscape there, with two small figures on the path.[41] Cézanne either gave his painting to Renoir or left it behind when he left La Roche-Guyon, since his painting was in Renoir's collection.[42]

Before and during the Cézannes' visit at La Roche-Guyon, Renoir tried to help Cézanne. His generosity towards his friend had been evident in 1877 when he had encouraged Rivière to write enthusiastically about Cézanne's painting in *L'Impressionniste: journal d'art*. Eight years later, Renoir was again acting generously when he tried to persuade his own dealer, Durand-Ruel, to include Cézanne among the large roster of Impressionist painters whom he then represented (Degas, Manet, Monet, Morisot, Pissarro, Renoir and Sisley). However, Durand-Ruel had refused to represent Cézanne, whom Renoir considered the greatest among his contemporaries. More than a decade after Durand-Ruel had become the main Impressionist dealer, Renoir decided to try again and, in 1885, he brought Durand-Ruel a Cézanne watercolour still life, *Carafe and Bowl*, of 1879–82, which he hoped the dealer would purchase for the modest sum of 200 francs. After not hearing from Durand-Ruel for a long time, Renoir concluded that the dealer did not want the work, not even for 200 francs. Even so, while the Cézannes were visiting in June–July 1885, Renoir wrote to the dealer from La-Roche-Guyon: 'Madame Cézanne [the Cézannes did not marry until 1886] is supposed to stop by your place to get the 200 francs for the still life. I had brought you this picture thinking that I might encourage this great artist to bring you other things.' This sentence reveals Renoir's passion for Cézanne's work and his willingness to confront his dealer to assert his evaluation of Cézanne's art, knowing full well Durand-Ruel's opinion. Since nothing had come of Renoir's plan, he told Durand-Ruel that he was free to return the picture to Mme Cézanne. Or, to be respectful of her feelings, Renoir suggested that Durand-Ruel could make an exchange by

giving Mme Cézanne the 200 francs but keeping a Renoir work worth the same and giving Renoir the Cézanne still life. As Renoir wrote in the same letter: 'I'll swap with you, as we agreed.' He excused himself: 'not wanting to make you responsible for something that I had wanted to happen that had not succeeded, which should teach me to mind my own business'. In his deferential manner, Renoir concluded his letter by apologizing: 'Please excuse me for this fiasco.'[43] Durand-Ruel refused to buy Cézanne's *Carafe and Bowl* and never became his dealer. Instead, Renoir acquired the still life and Mme Cézanne was pleased with the 200 francs.

While Cézanne had been willing to work alongside Renoir in 1882 and 1885, Monet still felt strongly, as he had in January 1884, that working with another artist would be detrimental to his painting. Thus when Renoir invited him to visit, Monet turned him down. Renoir had not fully understood Monet's feelings, so he continued to try to entice him to stay. In August 1886, while Renoir was renting La Maison Perrette in Saint-Briac, Brittany, he even wrote to Durand-Ruel of his intentions: 'I wrote to Monet to point out beautiful things for him [in Saint-Briac].'[44] As he wrote to Monet, 'I have a house for two months with five or six rooms for the two of us, and if you're interested, and if you want to come, don't worry about it, it wouldn't be a problem', signing it: 'Your friend, Renoir.'[45] Monet declined this invitation. Again, in January 1888, Monet refused to let Renoir visit him, as Monet explained to his wife: 'He is settled in Aix at Cézanne's house, but he complains of the cold and he asks if where I am is warm and beautiful. Naturally I am not going to try to get him to come.'[46]

Another possible reason for Monet's unwillingness to be with Renoir was the occasional friction between them. For example, in an 1885 gathering, presumably at the Café Riche in Paris, Monet mocked Renoir in a way that deeply hurt his feelings. (The Café Riche was the location of monthly Impressionist dinners from 1885 to 1894 where those in attendance included Monet, Renoir, Caillebotte, Pissarro and Sisley.) Subsequently, Renoir wrote to Caillebotte, who had also been present, asking if he would first write to Monet to explain: 'it pisses me off. It is of no use to be made fun of.... I will write to Monet myself after you do.' At the end of his letter, Renoir repeated 'Please write to Monet.'[47] This is typical of how he approached problems with friends; he tried not to confront the issue head on, but to soften it by using other friends to help him.

Renoir wanted to continue his working relationship with Cézanne. Three years later, after the Cézannes had spent time with the Renoirs in La

Roche-Guyon, in January 1888, Renoir told Monet to write to him: 'at Cézanne's house, Jas de Bouffan, Aix-en-Provence'.[48] However, the Renoirs' stay with Cézanne's family was short-lived, as Renoir later explained to Monet: 'We suddenly had to leave Mother Cézanne's home because of the sordid stinginess prevailing at that house.' It may have been Cézanne's mother whom Renoir considered stingy, but that did not deter him from deciding to remain in the area in order to continue painting with Cézanne: the Renoirs moved to the Hotel Rouget in Martigues for the next two months.[49] In March 1889, Cézanne wrote to Zola that Renoir 'asked me to send him two landscapes that he had left at my house last year'.[50]

During the summer of 1889, Renoir and his family returned to be near Cézanne. This time they rented a house from Cézanne's brother-in-law, Maxime Conil, in Montbriant, a property west of Aix. Renoir made several landscapes of the same motifs that Cézanne was painting, so the two artists could have been painting side by side. Of Mont Ste-Victoire, Renoir made two oils and of *The Pigeon Tower at Bellevue* two oils and an oil study.[51] Throughout the 1880s, Cézanne adopted bright, varied colours and a luminous atmosphere reminiscent of Renoir.[52] Renoir, for his part, continued to be inspired by Cézanne's grandeur and simplicity, while both artists painted with parallel brushstrokes.

In addition to spending time with Cézanne and his family, the Renoirs also visited Pierre's godfather, Caillebotte, and his companion, Charlotte. In September 1888, when Pierre was three, Caillebotte invited them to spend time at his home at Petit-Gennevilliers, north of Paris.[53] There, Caillebotte painted a half-length portrait of Aline outdoors, wearing a straw hat, surrounded by flowers.[54] Three years later, on another visit, Caillebotte again painted Aline outdoors, this time in a full-length seated portrait.[55] Just as Renoir in 1883 had given Caillebotte his portrait of Charlotte,[56] in 1891, Caillebotte gave Renoir his full-length portrait of Aline.

While Renoir was spending time with Cézanne and Caillebotte, perhaps the biggest influence on his art in the mid-1880s was the popular muralist, Pierre Puvis de Chavannes. Puvis, seventeen years older than Renoir, was a friend of Morisot, a client of Durand-Ruel and an artist for whom Valadon had modelled. His works had traditional themes, such as the Mother and Child (alluding to the Virgin and Christ Child)[57] and nudes (alluding to classical statues of Venus) with clearly defined figures but with no Impressionist colour, light or paint-strokes. It was during the years 1884–87, while Renoir and his family

Study of two nudes for *The Large Bathers*, c. 1886–87. Red chalk on yellowish paper, 125 x 140 cm (49¼ x 55⅛ in.). The Fogg Art Museum, Harvard University, Cambridge, Mass. Bequest of Maurice Wertheim

were spending so much time visiting with friends or renting inexpensive rural cottages, that he was experimenting with his Ingrist Impressionist style, which was also influenced by Puvis.

One of the features of Renoir's art during this period is a focus on drawing and minute detail. Uniquely in these four years, Renoir saved more drawings than paintings. Sometimes he even planned the pastel drawing as the final finished work while the oil was more sketchy and less complete. This is evident in the detailed large pastel, *Girl with the Rose*, signed and dated 'Renoir.86',[58] and the smaller, related *Girl in Straw Hat*, which omits the lower part of the pastel with the rose and is signed but not dated.[59] Similarly, the pastel *Laundress and Child* may be compared with the slightly larger but less detailed oil that omits the two figures in the background.[60] Sometimes Renoir executed only a detailed portrait drawing, such as the portrait of Madeleine Adam, then fourteen years old, the daughter of a banker.[61]

Renoir's major works of this Ingrist Impressionist period until 1889 were three paintings in the *Nursing* series and *The Large Bathers*, 1887 (see pages 96 and 194). He planned to exhibit one *Nursing* with *The Large Bathers*. For these important works, he made numerous preparatory oil sketches and drawings, such as the drawings for *Nursing* and the oil sketches and drawings for *Large Bathers* (see opposite); several of even the smallest features such as fingernails or leaves were planned in detailed drawings.[62]

For the *Nursing* paintings, we learn about Renoir's method from a diary entry by Morisot whom Renoir invited to visit his studio on 11 January 1886: 'Visit to Renoir. On a stand, a red pencil and chalk drawing of a young mother nursing her child, charming in subtlety and gracefulness. As I admired it, he showed me a whole series done from the same model and with about the same movement. He is a draftsman of the first order; it would be interesting to show all these preparatory studies for a painting, to the public, which generally imagines that the Impressionists work in a very casual way. I do not think it possible to go further in the rendering of form.'[63] Although Renoir showed Morisot numerous drawings of Aline nursing baby Pierre, Morisot assumed that the subject was only a model.[64] As noted earlier, Renoir never informed Morisot that this woman and child were his own family (see page 137).

Morisot was enamoured with Renoir's new direction, but he was having problems with his linear style. Renoir had never before had such difficulty, from Realism in 1866, to Impressionism in 1868, to Realist Impressionism in

1878 and finally to his early Classical Impressionism in 1881. However, when he embarked on Ingrist Impressionism in 1884, he struggled to integrate Ingrist linearism with Impressionist colour, stroke and luminosity. His joy in painting became tarnished by confusion and anguish. By 1886, his artistic direction had eluded him. This led him to destroy some of his works, resulting in the fewest number of extant paintings from any period of his life.

Starting in 1886 – especially in the second half – Renoir wrote letters expressing his frustration with his new style. In August, in a letter from La Roche-Guyon to his old friend and patron Bérard, he wrote: 'I scratch out, I start again, and I think that the year will go by without my having finished a single painting. This is why I refuse to allow the visit of any painters... I prevented Durand-Ruel from coming over. I want to discover what I am looking for before I give up. Let me keep trying... I have gotten too deeply involved in my search to give up without regretting it... Fortune maybe at the end.'[65] He did indeed complete fewer paintings than the preceding year: only two of his works are dated 'Renoir.86'[66] and only four or five others seem to have been completed that year. In this time of confusion, unlike all other times in Renoir's life, it seems that he wanted to work alone. However, this does not seem to have done him much good. In another letter to Bérard from that period, he wrote: 'I am depressed. I was waiting to be in a better mood – which will be difficult because I have truly lost my year. I am unable to start painting. I'm at a point where I'm just waiting for winter with impatience to be in my studio, since outdoors hasn't worked for me this year. But, I don't want to cry any longer on your shoulder since a good sunburst will quickly make me forget my displeasure, but it doesn't want to come. I'll write to you when I am more in control of myself.'[67] Around the same time, he also confided in Murer: 'I'm being asked for figure work, and I'm doing some, or rather I'm trying to do some. Generally it costs me a lot to get to the point where I stop scratching them out.'[68]

After having worked with such frustration in August and September 1886 in Brittany, Renoir complained in a letter to Monet in mid-October: 'When I got to Paris, I scraped everything [off the canvases], canvases on which I had worked tirelessly and where I thought I had found great art as did Pissarro.'[69] Here Renoir was being sarcastic, since he disliked Pissarro's new style. Alone among the Impressionists, aside from Renoir, Pissarro had struck out in a new direction, following Seurat and others into a Pointillist, Neo-Impressionist style, which Renoir detested. By comparing his own work to Pissarro's in this

way, he was expressing his extreme dissatisfaction with his own experiments. Pissarro himself was aware of Renoir's turmoil, and later told Lucien about the summer of 1886: 'Apparently...Renoir destroyed all he had done during last year's summer'.[70] Meanwhile, Monet reiterated this in a letter to his wife: 'When he returned to Paris, he scratched out everything he had brought back from Brittany, but nonetheless, he expects to have a good show at Petit's gallery'.[71]

Despite his frustrations with his style, Renoir felt that his next exhibition would bring a positive response. At this time he was preparing his major work, *The Large Bathers*, for which he had made numerous preparatory drawings, as noted earlier, over the course of several years and for which he had great hopes (see page 194).[72] He expressed his conflicting disappointment and optimism in a letter to Bérard: 'I'll begin working immediately because Durand keeps repeating paintings, paintings...paintings, and the paintings never come because I've scraped off everything. Yet in spite of this I am persuaded that I'm going to surpass Raphael and that in 1887 the people shall be dumbfounded'.[73]

While Renoir was struggling with his style, Durand-Ruel was spending increasing amounts of time promoting sales in New York. Renoir felt abandoned and believed that his dealer would not find a better market in America than he had in France. While Durand-Ruel was away, another Parisian art dealer, Georges Petit, held an exhibition at his gallery on rue de Sèze. From mid-June to mid-July 1886, Renoir had the opportunity to exhibit some works in his new style. His former patron, Mme Charpentier, helped him get into this show by loaning her painting, *Mme Charpentier and her Children*, 1878 (see page 91), which had been a success at the Salon of 1879. The Clapissons also loaned their *Portrait of Mme Clapisson*, which had appeared at the Salon of 1883. Along with these two older works, Renoir exhibited the third and final version of *Nursing* [*with Cat*], 1886, his new Ingrist Impressionist work (see page 96).[74]

Among all the major art critics who reviewed the exhibition, Octave Mirbeau was the only one who liked Renoir's new style. He praised *Nursing* for 'the charm of the Primitives, precision of the Japanese, and the mastery of Ingres'.[75] Renoir was so grateful for the positive review that he wrote to Mirbeau to thank him for his courageous article.[76] Durand-Ruel, however, did not share Mirbeau's opinion. On 18 July 1886, on his return from New York, he went to the Galérie Georges Petit and saw Renoir's *Nursing*. As Pissarro wrote to his son on 27 July 1886, 'Durand-Ruel went to Petit; he saw the Renoirs; he does not like his new style at all, not at all'.[77] It is strange that Durand-Ruel so disliked Renoir's

new style since it has echoes of a renowned painting, *Summer*, or *Harvest*, of 1873 by Puvis de Chavannes, one of Durand-Ruel's clients.[78] In Puvis's work, immediately purchased by the French government, in the foreground centre, a woman nurses an infant in a Classical style somewhat akin to Renoir's *Nursing*.

Despite Durand-Ruel's dislike of Renoir's new style and Renoir's own reservations, he persevered, working harder than ever to complete *The Large Bathers* in time for Petit's 1887 show. Aline posed for the central nude and Valadon for the nude on the left. Drawings for this work in progress had begun by January 1886, when Morisot visited Renoir's studio.[79] In her diary, she commented: 'Two drawings of nude women going into the water I find as charming as the drawings of Ingres. He told me that nudes seemed to him to be one of the essential forms of art.'[80]

In May and June 1887, *The Large Bathers* was exhibited at Georges Petit's gallery. In the catalogue, Renoir added the title *Experiment in Decorative Painting*, expressing his desire for this work to be hung as a mural, as discussed in Chapter 2. He was affirming that his bathers were like Puvis de Chavannes's popular decorative panels of semi-nudes, a success at the Salon of 1879.[81] We know that Renoir had been interested in mural decoration since the Bibesco murals of 1868; a decade later, Georges Charpentier had unsuccessfully tried to help him find a government mural painting commission. Now, another decade later, Renoir hoped that his *Bathers* would show his abilities with wall decoration. As *Nursing* had traditional prototypes in images of the Virgin and Child, so *The Large Bathers* calls to mind art of the past – specifically François Girardon's seventeenth-century relief of bathers from Versailles.[82]

Most of the reactions to Renoir's *Large Bathers* were negative, including the opinion of his dealer. Durand-Ruel had consistently disliked every example of Ingrist Impressionism that Renoir had shown him, including the pre-Ingrist portraits of his own family of 1882.[83] Thus it was not surprising that he disapproved of Renoir's newest work. Pissarro reported in October 1888: '[Renoir] told me that everyone, from Durand[-Ruel] to his old collectors, were criticizing him and attacking his attempts to abandon his romantic period [Impressionism].'[84] While in January 1886, Morisot had thought Renoir was a skilful draughtsman, a year later in mid-May 1887, Pissarro had the opposite opinion: 'Renoir, lacking a gift for drawing, and lacking the beautiful colours that he instinctively felt before, becomes incoherent.' Pissarro explained his objection to Renoir's new style: 'As for Renoir, again the same hiatus...I do understand what he is trying to

do; it's very good not to want to stand still, but he chose to concentrate only on line; his figures detach themselves from one another without regard for colour; the result is something unintelligible.'[85]

In fact, Pissarro's dislike of Renoir's Ingrist Impressionism echoed Renoir's dislike of Pissarro's Neo-Impressionism, causing friction between the two. Pissarro wrote in September 1887 that he had said to Renoir, 'As to you, Renoir, you wander around at random. I know what I am doing.'[86] He also reported other artists and critics who disliked Renoir's new style. At the time of Petit's May 1887 show, Pissarro wrote: 'Bracquemond…was rather critical of Renoir, though he thought some parts of the large painting [*The Large Bathers*] very well drawn. I agree with him about the parts. It is the whole, the synthesis, which is faulty, and this they refuse to understand!'[87] The next day Pissarro again informed Lucien: 'I saw [the critic] Astruc who thundered forth against the decline of Renoir's works.'[88] A year later, in October 1888, Pissarro recounted Renoir's troubles in more detail: 'I had a long talk with Renoir.... He seems to be very sensitive about what we think of his exhibition. I told him that for us, the search for unity was the goal that every intelligent artist should aim for, that even with big faults, it is more intelligent and more artistic.... [With his new style] he doesn't get any more portrait commissions!... For goodness sake!'[89]

However, not everyone's reaction was negative. Several of Renoir's critic friends expressed favourable opinions. The Polish-born Téodor de Wyzewa praised *The Large Bathers* as 'this gentle but strong painting'.[90] Gustave Geffroy effused: 'Here Renoir has doggedly worked towards an intellectual and pictorial ideal…[combining] the luminous purity of the primitives and the serene draftsmanship of Ingres.'[91]

One artist who was deeply moved by Renoir's works in this period was Vincent van Gogh, who was completely unknown at this point and who had never met (nor would ever meet) Renoir. Van Gogh had arrived in Paris in February 1886 and stayed for two years with his brother Theo, an art dealer. Theo, entrenched as he was in the world of Parisian art, must have taken his brother along to the Georges Petit exhibitions, since Van Gogh later wrote from the French countryside: 'I very often think of Renoir and that pure clean line of his. That's just how things and people look in this clean air.... There are women like a Fragonard and like a Renoir.'[92]

In addition to Van Gogh, there were a few artists among Renoir's friends who appreciated the new direction. His former student Blanche, by then a

fashionable portraitist, was so enamoured of the 1887 *Large Bathers* that he purchased it in 1889 for the low price of 1,000 francs.[93] Another admirer was Monet, who knew that Renoir had struggled with his new style and that Durand-Ruel had disliked *Nursing* the year before. Monet decided to try to help Renoir by writing to Durand-Ruel, who had not yet seen the *Bathers*: 'Renoir made a superb painting of his bathers. Not understood by all, but by many.'[94]

Perhaps the most important supporter of Renoir's Ingrist Impressionism, however, was Berthe Morisot. She thought Renoir a superlative draughtsman and applauded his new focus on line. The same year that Renoir completed *The Large Bathers*, Morisot and her husband asked Renoir to paint an oil portrait of their daughter, Julie Manet (see page 195). Renoir made several preparatory drawings of *Julie with a Cat* and then traced the final drawing onto the canvas to serve as a guide for his painting.[95] This portrait combines an Ingresque emphasis on the eyes and contour of the face with pervasive light and bright colours.

Renoir loved Morisot as much as any artist friend he ever had. They were the same age but their backgrounds were totally different. When they first met, exhibiting together in 1874, Renoir must have been drawn to Morisot by her wealth and connections. She, like Bazille and Jules Le Coeur, was a potential source of support for him. But as time passed, their relationship became more profound, a friendship that would last beyond her death, which preceded his by twenty-four years. Renoir included Morisot and her art in the pantheon of his gifted friends. In 1882, when he was sick in L'Estaque, in a letter to his dealer, he had written that he was only willing to exhibit with '[real] artists like Monet, Sisley, Morisot, etc'.[96] He later painted next to Morisot, just as he had earlier with Monet and Cézanne.[97] However, Morisot, as a woman of the upper class, was excluded from the Café Riche gatherings since it would have been unseemly for her (or later, for similarly upper-class Mary Cassatt) to attend. Consequently, around the same time that the Café Riche meetings began, Morisot and her husband started a weekly dinner party at their fashionable Neuilly apartment – a party to which Aline was not invited. Although many attended these dinners, including Degas, Whistler and Mallarmé, Julie Manet wrote in her diary that Renoir, along with Mallarmé, was one of the two most regular attendees and that he had become an intimate friend of her parents.[98]

Despite his closeness to Morisot, Renoir deliberately kept a large part of his life from her. As described earlier, though he had invited Morisot to his studio to see his drawings for *Nursing*, he hid the fact that these images his dear friend

was seeing were of his own family. It is likely that Renoir was ashamed of his lower-class mistress and son in front of this high-class woman who had been married five years before her child was born. Renoir probably worried that he would lose Morisot's respect if she knew who Aline and Pierre were. Yet, there is no doubt that he considered Aline an important part of his life. He loved her and Pierre dearly. His devotion to her is reflected in the ever-increasing girth of the nudes in his art, consistently portrayed with tenderness and affection. This paralleled Aline's physical condition, which Renoir simultaneously worried about and painted lovingly. From the time she modelled for him until the end of his career, Renoir painted ample nudes, whether it was Aline or another woman posing, since voluptuous nudes were pleasing to many people of his time. Nonetheless, Aline's increasing girth continued to trouble the artist. When Pierre was recuperating from his delicate operation, Renoir wrote to her: 'Try to take care of your health conscientiously so that I don't end up with two invalids, and try to exercise a little. I worry that your fat will play nasty tricks on you. I'll admit that it isn't easy to lose weight, but I wouldn't want you to get sick before your time.... Take care of yourself.'[99]

As with Morisot, despite his love for Aline, Renoir kept secrets from her. He never told her about his earlier children with his model, Lise. Also, Aline's peasant background and her status as a secret kept her from being included in Renoir's social circles. As has been seen, he would periodically leave her and their son behind to travel, work or socialize. This became a lifelong pattern such that they often led separate lives, communicating by letter to arrange to see one another frequently. Basically, Renoir liked his privacy and freedom, as he once expressed to his dealer: 'do not think that I will sell my independence to anyone. It is the only thing that I hold dearly: the right to do foolish things.'[100]

It was not until Renoir and Aline had been married for more than a year that Aline and Morisot finally met. Even then, Renoir was less than gracious about their introduction. Morisot and her family were at their vacation estate in Mézy, 43 kilometres (26 miles) north-west of Paris. Renoir was such a frequent guest there that he was invited to visit at any time without notifying the family that he was coming. One day, during the summer of 1891, he simply arrived in Mézy with Aline and Pierre, then aged six, and never made any introductions. In a letter to Mallarmé of 14 July 1891, Morisot exclaimed: 'I saw Renoir for a moment with his family. I shall tell you about this later.'[101] As promised, she wrote later: 'I shall never succeed in describing to you my astonishment at the

sight of this incredibly heavy woman whom, I don't know why, I had imagined to be like her husband's paintings.'[102] Clearly, by this date, Morisot had learned that Renoir had a wife and child but in this letter expresses her disappointment and discomfiture at Aline's actual appearance, which Renoir had idealized in his paintings.

Besides Morisot and Aline, another woman who continued to command his affections was his widowed, elderly mother, Marguerite Merlet Renoir, then still living in Louveciennes with her daughter, Lisa, and Lisa's husband, Charles Leray. Renoir's mother was eighty in 1887, at which time Renoir, the dutiful son, wrote to Bérard how, whenever possible, he 'commute[d] between Paris and Louveciennes'.[103] The following year, in March 1888, in a letter to Durand-Ruel, the artist wrote: 'My mother has pneumonia and the doctor is very worried.'[104] Pneumonia was (and still is) the leading cause of death among the elderly. In a letter of 1883, Renoir had explained to Murer: 'I go to Louveciennes every Thursday.... My mother has been sick for a year. When I have a free minute, I go to see her in Louveciennes.'[105] His devotion to his mother continued until her death aged eighty-nine in 1896.

As a man of late nineteenth-century France, Renoir wrote contradictory things about women. On the one hand, he was devoted to Morisot, Aline and his mother, treating each of them with respect. On the other, some of his statements on women in general would today be called sexist. To understand this, a modern person must understand the prevalent attitudes of the society in which Renoir lived. At that time, most men and women thought that women's place was in the home and that their position should be decidedly second to the man in their family. Feminism was a new and radical idea that had not gained much traction in France, where most people felt it as a threat to their way of life. The concept of male superiority was so ingrained that women did not get the right to vote in France until 1944. In this light, had Renoir expressed feminist opinions, he would have been considered radical, something he avoided scrupulously throughout his life. To him, radical or revolutionary ideas conjured up images of the Paris civil war, the Commune of 1871.

In 1888, when the critic Philippe Burty asked for Renoir's opinion of feminism, Renoir replied: 'I think literary women, lawyers and politicians like Georges Sand, Madame Adam, and other bores are monstrous; they're nothing but calves with five hooves. The woman artist is completely ridiculous, but I certainly approve of the singer or the dancer. In Antiquity and amongst simple

folk, a woman danced and sang, but nonetheless was no less a woman. Grace is her domain and even her duty. I well understand that today this ideal has been slightly tarnished, but what can we do? In ancient times, women sang and danced for free, for the pleasure of being charming and gracious. Today, it's all for money which takes away the charm.'[106] Renoir's statement is shocking given his relationship with women, particularly with his fellow artist Morisot. It is clear that he thought of her as an exceptional woman. Years after her death, her daughter recalled in her diary: 'Sometimes I think again of the sentence with which M. Renoir replied to M. Mallarmé when one Thursday evening, leaving the house, he was speaking of all of Maman's qualities: "...and with all that, any other woman would find a way of being quite unbearable."'[107] The qualities of which Renoir was speaking were Morisot's artistic talents, her beauty and her charms as a hostess.

Today we view Renoir's statement as belittling and disrespectful of women, but it must be viewed in the contexts of the time and Renoir's desire to be uncontroversial. When he writes of Georges Sand being 'monstrous... nothing but calves with five hooves', he echoes others like Baudelaire, who had railed against Sand, writing that 'she is stupid, heavy, and garrulous. Her ideas on morals have the same depth of judgment and delicacy of feeling as those of janitresses and kept women.... The fact that there are men who could become enamoured of this slut is indeed a proof of the abasement of the men of this generation.'[108] In truth, Renoir's actions of kindness, generosity, open-mindedness, love and respect for the women in his life speak louder than the words he sent his friend Burty.

Renoir had plenty of reasons in 1888 for parroting the majority opinion. Not only were his controversial new Ingrist Impressionist style and lack of patrons causing problems, but also his health began to trouble him. Just as six years earlier he had feared that his pneumonia would return to haunt him, his new and sudden issues with his teeth and eyes inspired a terror that he would develop a much more serious illness that ultimately could prevent him from painting, a fate worse for him than death. Indeed, his fears were justified, since these symptoms turned out to be the warning signs of rheumatoid arthritis, a disease that would slowly debilitate him throughout the next thirty years until his death.[109] In August 1888, Renoir wrote of his condition: 'I woke up this morning with neuralgic head pains... I went to the dentist... I don't know how long I am going to be wrapped in cotton and wool.'[110]

Four months later, Renoir suffered his first real battle with rheumatic paralysis. It started in Essoyes on 29 December 1888, with a resurgence of pain in his teeth, as he explained to Georges Charpentier: 'I am suffering from atrocious dental neuralgia.'[111] He began to worry that he would not be able to travel back to Paris or to continue painting. In January 1889, to Morisot's husband, Eugène Manet, he lamented: 'I am sick: I caught cold in the country, and I have a facial, local, rheumatic etc. paralysis.... In short, I can no longer move a whole side of my face, and for diversion I have two months of electrical treatments. I am forbidden to go out for fear of catching another cold. It's not serious, I think, but up until now nothing has improved [with my facial paralysis].'[112] Soon thereafter he wrote another letter to Eugène: 'I am having trouble with my eyes, just like Degas.'[113] In December 1888, he had written in despair to his dealer: 'I was thinking of coming back one of these days but my teeth started hurting again. I haven't slept for several days. I'm not suffering at the moment, but half of my head is swollen and I can't open one eye. It is impossible for me to eat. What's going to happen after this? I really can't travel in the state I'm in.... Tomorrow, I hope my eye will open up and I can finish my paintings.'[114] A few days later, he rallied enough to plan to travel and explained to Murer: 'I'm going to Paris tomorrow or the day after that. I'm very annoyed; I think I have an abscess in my ear. I'm suffering horribly. Write to me at [my apartment] 18 rue Houdon.'[115]

Nine months later, Renoir continued to be plagued with bouts of intense pain, which he described to Bérard: 'I have still been suffering intensely after going to the dentist. Today I am in less pain.... After having suffered like the damned because of my teeth and the hunger caused by their absence, I'm going to have all new teeth and if my health recovers, I'll return to work.'[116] Although Renoir did return to work, his health never recovered. He suffered through multiple tooth extractions and was reduced to eating mashed food or liquids through a straw.[117] At this time, when he was forty-eight years old, photographs of Renoir show him as emaciated, frail and aged. His art, however, became even more intensely hedonistic. The voluptuous, serene women of his paintings embraced a sensuality that was shrinking from his life.[118] His art, more now than ever before, was his escape and his medicine.

When Renoir was nearly fifty, he was interviewed on 31 January 1891 by André Mellerio for an article on artists in their studios, which appeared in the periodical *L'Art dans les deux mondes* (the two worlds being America and Europe): 'An emaciated figure, worried, very original...with pointed cheekbones, sunken

cheeks, his forehead full of prominent veins. With thinning hair, falling down at the back or sometimes standing on end pushed up by the abrupt stroke of his hand. His beard greying, a little rough. A very thin body, long fingers. Renoir is predominantly nervous.... Standing, shaky in his gestures, he gets excited; the weak tone of his voice grows stronger. He finishes assertively, makes a half-turn on the spot, sets off for the other end of the room, with a shake of the head, a jerky step, as though trying to put an end to the discussion.... Renoir's tormented nature forms a contrast with his artistic conception of women, so softly harmonious. The woman is, in his work, of exquisite grace, in fine, velvety colours. Upon vaporous, almost transparent backgrounds, she charms: the complexion is very white, the cheekbones bright pink, full lips of a refreshingly pure red. And in this rich flesh tint with bold tones united by elusive nuances, shines the vividness of the eyes, deeply black or blue, always filled with intense life.'[119]

For an anonymous interview in the next year, in August 1892, a journalist came to Renoir's home and reported in the daily *L'Éclair* (Lightning): 'M. Renoir lives in Montmartre [at 13 rue Girardon], in a small house with a remarkable view. In his small garden frolics the young Pierre Renoir, a well-behaved child who is idolized by his father.... The painter works every single day. In the morning he arrives early, from his little home on the Montmartre hill, to his studio at the impasse Hélène. He works tirelessly until noon; then, after a short break, returns to work all the rest of the afternoon.... But in addition to all the effort that he puts into this work, he is continually starting again! If you visit his studio – and I warn you that if you are not one of the rare friends for whom the door opens partway, you might not be welcome – you will be struck by the torment of his talent, torment that is evident in hundreds of sketches, trials, studies, in some canvases that lie here and there.... The life of M. Renoir is all work and contemplation. He is the most simple and modest person that one can imagine.'[120]

At the time of this interview, five years after *The Large Bathers*, even Durand-Ruel agreed that Renoir's art had become beautiful. After the largely hostile response to his Ingrist Impressionist works, Renoir modified his style. He softened his lines and integrated the formerly disengaged figures into their Impressionist setting, thereby satisfying Pissarro's assertion that unity was the goal of art. This moved him back to a Classical Impressionist style, on which he would create variations until his death thirty-one years later. He continued to depict motherhood, the family and the nude. As he became increasingly ill, his

fine motor skills slowly diminished and he began painting with broader and freer strokes (see page 193).

Yet from 1888 or 1889, during the first few years of his renewed Classical Impressionism, Renoir retained his uncertainty about his artistic direction. In July 1888, when the critic Claude Roger-Marx invited him to exhibit his works, Renoir responded: 'When I have the pleasure of seeing you, I will explain to you what is very simple, that I find everything I have done bad and that it would be very painful for me to see it exhibited.'[121] Three years later, Renoir continued to have doubts about his style. On 5 March 1891, he wrote to Durand-Ruel: 'I am giving myself a lot of trouble to stop messing around. I have been fifty for four days [sic] and at this age if you are still searching, it is a little old.'[122] The same day, he expressed similar thoughts to Bérard: 'I always dream of things above my strength and I will never know how to just do what I'm good at. I'm simply too old to cure myself. I will die impenitent.'[123]

At last, a month after those disheartened letters, Renoir wrote to Durand-Ruel with increased confidence: 'I am bringing back some studies. In Paris, we will judge what they are worth. Here, I can't know. In any case, I think I've made some progress and will be able to work in my studio in a productive fashion.'[124] It seems that the dealer did not share Renoir's optimism and must have said something about the manner in which he should paint to please clients. Three months later, in July 1891, Renoir complained to Cassatt, who told Pissarro, who in turn wrote to his son: 'It seems that, according to Miss Cassatt, he [Durand-Ruel] takes everything from Renoir who is very annoyed that he is obliged to make paintings that please!'[125] In typical Renoir fashion, he never addressed his complaints to his dealer.

Despite the fact that Renoir felt constrained by requests from Durand-Ruel, he was concurrently seeking to revive his business as a portraitist by painting a large family portrait to be exhibited at the Salon, as he had with the portrait of the Charpentier family. Back in January 1888, Renoir had written a proposal to a friend, the Jewish symbolist poet, Catulle Mendès, who lived with the composer and virtuoso pianist Augusta Holmès; together they had five children, three of whom Renoir wanted to paint: 'My dear friend, I...would like you to tell me at once if you want portraits of your beautiful children.[126] I would exhibit them at Petit's in May. See how I'm rushed. Here are my conditions, which you will prob-ably accept. 500 francs for the three portraits, life-size and [the three] together. The eldest at the piano giving the pitch while turning towards her sister who is

tuning her violin. The littlest is leaning against the piano listening as one should always do at her young age. That's it. I would do the drawing at your house and the painting at mine. P.S. The 500 francs are payable 100 francs each month. Please respond. Your friend, Renoir, 28 rue [de] Bréda [his studio].'[127] Along with the letter, Renoir enclosed a detailed drawing showing his vision for the painting. Mendès agreed to the proposal, and Renoir completed the portrait on time, but it was not exhibited at Petit's. Instead, it was included in Durand-Ruel's show of May and June 1888 and then again at the official Salon of May and June 1890 (see page 196).[128] This group portrait was not a success at the Salon, perhaps because of its intense colour and stylized faces. In the end, Renoir's attempts to revive his portraiture business did not succeed. He received one commission in 1888, from Durand-Ruel for a portrait of his daughter Marie. The next year he received one portrait commission for a portrait of Mme de Bonnières. Thereafter friends occasionally commissioned portraits.[129]

The year 1888 was a major turning point for Renoir, not only in his art, which became increasingly classical, not only in his health, which began to decline steadily, but also in his finances, which took a meteoric upturn. Durand-Ruel, who had disappeared to America, had a huge success in New York, where he opened a gallery and began to sell Impressionist paintings for much better prices than anyone in Europe was willing to pay. By 1890, Renoir and the other Impressionists finally began to achieve critical and financial success. Durand-Ruel later told an interviewer: 'Oh! Without America, I would have been lost, ruined, to have bought so many Monets and Renoirs! Two exhibits I put on there in 1886 saved me. The American public didn't mock us at all [in contrast to the French public]. They bought – moderately, it is true, but, thanks to them, Monet and Renoir could finally support themselves; and since then, as you know, the French public followed since they had obstinately kept their negative point of view before.'[130] Durand-Ruel was here referring to his April 1886, successful exhibition of primarily Impressionist paintings in New York at the American Association of Art, which included thirty-eight oils and pastels by Renoir among a total of about three hundred pieces.[131] Because of public interest, the show was prolonged through May and June at the New York National Academy of Design.[132] In August, Durand-Ruel had written to one of his clients, Fantin-Latour: 'Do not believe that the Americans are savages. On the contrary, they are less ignorant and less conservative than our French art lovers. I have been very successful with paintings that took me twenty years to get people to appreciate in Paris.'[133]

From 25 May to 30 July 1887, Durand-Ruel returned to New York for the second show at the National Academy of Design.[134] Five paintings by Renoir were shown.[135] Renoir was unconvinced by Durand-Ruel's claims, writing in May 1887: 'I am afraid that you'll lose your focus [on French sales] and chase rainbows with your American distraction.... It seems to me that quitting Paris is unwise; you are going to find the same difficulties elsewhere.'[136] Nevertheless, Durand-Ruel was so encouraged by his American sales that, in 1888, he opened a gallery in New York that thrived for sixty-two years.[137]

Throughout 1889, Renoir was still feeling poor. In August, Monet was collecting funds to buy Manet's seminal *Olympia*, which he and his friends considered the first modern painting. The Americans seemed on the point of purchasing the work. Monet felt it was important that it stay in France, so he organized his artist and patron friends to establish a fund to purchase the painting for the Louvre. On 11 August, Renoir responded: 'Impossible to find the money.... I hope Manet will go to the Louvre, but it will have to be without my help. All I can do is say that I hope you will succeed in what you are trying to do.'[138] Five months later, Renoir was able to scrape together the modest contribution of 50 francs.[139] By 1890, both he and Monet started to see huge sales in America, the turning point in their careers. Many of their works were sold, and the selling prices were high. Renoir would never be poor again.

The undercurrent of friction between Renoir and Monet had surfaced again when the latter began to obtain success before the former. In 1889, Duret wrote to Caillebotte about the two artists: 'I was sorry to read what you had written me about the quarrel between Monet and Renoir. Men who as friends had endured misfortune and who break up as soon as success comes to them unequally.'[140] Monet, however, expected that their friendship and Renoir's fortunes would both improve. By July 1891, he was writing to Pissarro: 'I hope that you are now better off materially and I would be happy if you had some of the luck that is favouring me. Besides, I expect that the rebound will soon come for you and for Renoir.'[141] Later that year, his wish came true and Renoir and Pissarro enjoyed Monet's material success.

Slowly, Impressionist work began to sell more and at higher prices in France. In 1892, even the French government endorsed Renoir's work. Henry Roujon, the Director of Fine Arts, who was a friend of Mallarmé and Roger-Marx, commissioned Renoir to paint a work. Renoir offered them five oils of young girls at the piano. In April 1892, Roujon chose *Young Girls at the Piano*,[142] which

the French government purchased from the artist for 4,000 francs and displayed at the Musée du Luxembourg, which was where works by living French painters were displayed.

Even though Bérard continued to be a good friend of Renoir's, the painter had been without a patron since Bérard stopped buying his paintings after 1884. Finally, alongside his American success, in 1889, a new patron, Paul Gallimard, appeared.[143] Gallimard was an art collector who owned the Théâtre des Variétés in Paris. He had two young sons, Raymond and Gaston, two and four years older than Renoir's son, Pierre. Renoir became close friends with Gallimard and his family. In the spring of 1892, Renoir accompanied Gallimard on a trip to Madrid where Renoir admired the Velázquez paintings in the Prado.[144] After their return, Gallimard commissioned Renoir to paint a portrait of his wife and invited him to come to paint at Gallimard's summer home in Normandy, Villa Lucie in Benerville near Deauville.[145] The next year, in the spring when Pierre was eight, Renoir wrote to his patron: 'Pierre wants to come with me. If you don't respond, I'll bring him and our linens.... We will sleep in the city and we'll even do our own housekeeping.'[146] Again, in April 1893, Renoir wrote: 'We are going home soon. It's raining at the moment so I'm waiting 3 or 4 days for better weather to finish and come home...please give my greetings to Mme Gallimard and the children.... We'll stay until Tuesday I think – more if the good weather doesn't return. But I believe that the good weather will soon return and allow me to do some more studies.'[147] During that same year, Renoir agreed to become a teacher to Gallimard's distant cousin, an art student, Jeanne Aline Baudot, then aged sixteen.[148] Her father, Dr Baudot, became a good friend of the artist. Renoir agreed to mentor Jeanne but he also suggested that she study at the women's studio at Académie Julian and that she copy paintings at the Louvre. Not only did Renoir become her teacher but he also welcomed her into his home and she became a lifelong friend (see page 173).

With all the success in America and a new, stable French patron, Renoir finally felt financially secure enough to marry Aline. There was no longer any pressing need to keep her and Pierre a secret. Nonetheless, Renoir still usually socialized without Aline. Just like before their marriage, she was his stay-at-home wife, in charge of the home and children. On 14 April 1890, the couple wed and thereby legitimized Pierre. The marriage licence was from the ninth arrondissement and certified that 'Mr Pierre Auguste Renoir, painter residing at 11, boulevard de Clichy, son of deceased Léonard [Renoir] and Marguerite

Merlet and Aline-Victorine Charigot, a dressmaker, residing at 15, rue de Bréda, daughter of absent Claude [Charigot] and Thérèse Emélie Maire were married today in this town hall.' Even though they were living together at 18 rue Houdon in the eighteenth arrondissement, for propriety Aline gave her mother's address although it was in the heart of Paris's red-light district, and Renoir gave his studio's address. Their witnesses were Renoir's long-time friends: two government officials, Paul Lhôte and Pierre Lestringuez, and two painters, Frédéric Zandomeneghi and Pierre Franc-Lamy. The certificate stated that 'the future husband and wife had declared that they acknowledge the legitimation of their son Pierre, born in Paris on 21 March 1885, that would result from their marriage'.[149] At the same time, the couple were given (without charge) an official family record book, *Livret de famille*, which they were told to bring to the mayor of the arrondissement to record births and deaths.[150] In this booklet they recorded the birth of Pierre and later of their two subsequent sons. Renoir's only known painting of Aline that year is a painted sketch.[151]

Five months later, the family moved from the apartment on rue Houdon

to a rented house with a garden at 13 rue Girardon. The move took them from below Montmartre to the eighteenth arrondissement on the hill of Montmartre. Their residence was called the Château des Brouillards (Chateau in the Mist). In October 1890, Renoir wrote to Murer: 'Here are my addresses so as not to get mixed up: (Studio) Villa des Arts (impasse Hélène) (avenue de Clichy) and apartment: 13 rue Girardon.'[152] He also installed a studio in the rue Girardon house. A few years later, Morisot and Julie Manet paid an unexpected visit,

Renoir in his Paris studio, after 1892.
Photographer unknown

which Julie recorded in her diary: 'Since M. and Mme Renoir were out, we were entertained in the garden by Pierre who was very kind. He wanted to show us his father's paintings and said that he [Renoir] now had two studios, one a bit lower down in Montmartre, and one at home for when he had a cold. After a while Mme Renoir came home. She took us up to the studio and showed us the landscapes M. Renoir did in Brittany.'[153]

One of the reasons why Renoir and Aline had moved to a bigger place was that they hoped to have another child. Shortly after they married, Aline became pregnant, but this pregnancy brought her difficulties. Renoir, off painting with Morisot at her summer home, expressed his concerns about his wife to Dr Gachet. 'I made a point of recommending rest before I left for Mézy, but you can't rely on women; when their health is at stake, it's impossible to make them take care of themselves in due time, and I'll never change them. Nevertheless, according to the letter I received, everything looks like it is going well, and I thank you again for having visited [her].'[154] Although this letter brings to mind Renoir's earlier worries about Aline's health, his complaining tone and appeal to a friend for help with his wife are more like Renoir's roundabout interactions with Monet when Renoir refused to face a conflict. It appears that Renoir was treating Aline in a distanced manner, suggesting an increase in the separation between the two.

Early in their relationship, Renoir had given Aline advice in a benevolent, paternal manner, with affection and gentleness, but now he realized that she no longer heeded him. His frustration with this certainly comes through, especially in his sexist assertion that 'you can't rely on women'. It calls to mind his statement to Burty two years earlier. Clearly, Renoir felt helpless to affect Aline's actions, and, as a way of taking power back, he ascribes her perceived faults to women in general. Also, Renoir's sexism is a way of flattering Gachet, to make an alliance between them as men. Whatever the outcome of Renoir's plea to Gachet, whether Aline rested or not, the pregnancy did not go well, and eventually she miscarried. Both she and Renoir were deeply disappointed, even more so two years later when she miscarried again.

Despite her grief, Aline had finally achieved a state of happiness and stability as a nouveau-riche woman. She exerted a fair amount of power in her new role, both over Renoir, now truly bound to her, and over people she had known since her childhood. Nevertheless, she was doubtless aware that Renoir kept much to himself, that he still did not share everything in his life and never would.

Some of Renoir's most important relationships from which Aline was excluded were with Morisot and her husband, and with Mallarmé, of whom Renoir had painted a striking portrait in 1892 (see page 197). As Julie Manet later wrote in her diary, in September 1898: 'M. Mallarmé and M. Renoir were the most intimate friends, the constant visitors on Thursday evenings', a weekly event to which Aline was not invited.[155] Nearly two years earlier, Julie had elaborated: 'It was lovely to see the spirited painter and the charming poet chatting together as they have so often done at our house on those Thursday evenings in the high-ceilinged pink salon, where the hosts, in their own surroundings, were among those they loved, among precious friends.'[156] She also recorded that Mallarmé was 'named as my guardian, and it was he and M. Renoir who were the two great friends of Papa and Maman'.[157]

Sadly, this warm foursome came to an end in 1892. Eugène suffered a long illness and, on 13 April 1892, died at the age of fifty-nine. After his death, Renoir became even more supportive of Morisot. He joked with Morisot when he wrote: 'I thought of you often, but I had absolutely forgotten my role of family adviser',[158] and he encouraged her to continue painting.[159] Because of her trust in and admiration of Renoir, Morisot asked him to be Julie's second unofficial guardian.

Mallarmé and Renoir would not have become close friends without Morisot's Thursday dinners, which began in the mid-1880s.[160] The poet asked Morisot and Renoir to provide illustrations for his book of poems, *Pages*. In 1887, Renoir sent Mallarmé an illustration, a pen and ink drawing of a nude woman called *The Phenomenon of the Future*. In 1889, he made this drawing into an etching for the book's frontispiece.[161] This was Renoir's first etching and he later wrote to Mallarmé: 'Dear Poet, Allow me to exhibit the only etching I've executed that you possess. I am participating in an exhibition where an etching is obligatory [in 1890, Durand-Ruel was planning an exhibition of painter-printmakers].'[162] When Mallarmé's *Pages* was published in 1891, he gave Renoir a copy inscribed: 'My dear Renoir, I am proud that your name is here connected to mine, Stéphane Mallarmé.'[163] The following year, Renoir painted Mallarmé's portrait.[164]

As for Morisot, she and Renoir had a close bond from their earliest time exhibiting together at the first Impressionist group show in 1874. Their relationship was always easy, and they had much in common. They were the same age, and each felt connected to the other not only through their art, but also through

their particular adoration of Édouard Manet, Renoir's mentor and Morisot's brother-in-law. Both were also extremely sociable.

While Renoir was close to Morisot, he did not share this relationship with Aline. Neither woman knew much about the other. Aline, eighteen years younger, had no professional interest in art, and she grew up without a loving family, with no siblings, abandoned by both parents. It is not surprising that she became a loner, as her aunt had reported: 'She has never been able to have a friend.'[165] Since she always had to rely on her own source of strength, Aline became strong-minded and uncompromising. Unlike the extremely socially adaptable Renoir, Aline was used to achieving her goals without help. As a result, when Renoir agreed to marry her, she thus gained enough power and social status to do as she pleased. Aline got her way most of the time and Renoir did what he wanted behind her back. She often ignored his wishes, something he complained about to friends in letters, as has been seen.

One of the ways in which Aline's power manifested itself was the family's seaside vacations. Aline loved the water, and, as a child, had enjoyed wading in the Ource river in Essoyes. From August through October 1892, when Pierre was seven, the family went to Brittany, where they stayed at various hotels near the water at Pornic, Noirmoutier and Pont-Aven.[166] Renoir was trying to paint landscapes and indeed painted many, despite his complaints about being near the seaside.[167] At the same time, Aline insisted that he teach Pierre how to swim. He mentioned this in several letters, including one to Morisot, in which he wrote: 'I ended up being stranded at Pornic where I am teaching my son to swim; so far so good, but I should be painting landscapes.'[168] He bemoaned his fate to Bérard: 'For the moment I am at the beach, which is hardly pleasant for me.'[169] During the last month of this Brittany trip, he began to lose patience. From Pont-Aven, he wrote to Murer: 'In short, I had only come to accompany my wife, who loves to travel and…here I am and here I stay. I was grumbling as I left. I hate moving around so much.'[170]

Perhaps it was because Aline became increasingly domineering after their marriage that Renoir decided to keep another important fact from her: his involvement with the marriage of his illegitimate daughter, Jeanne. As his rheumatoid arthritis progressed, he continued to feel that he wanted Aline to know nothing about Jeanne. Aline's increasing bossiness probably convinced him that, should Aline ever learn about Jeanne, she would interfere with his relationship with his daughter. In this sphere, Renoir did not trust Aline.

His relationship with Jeanne throughout her childhood and up to the age of twenty-two is undocumented since no known letter predates 1892. Given that Jeanne carefully preserved all the letters from her father and none from her mother, we must presume that Lise never contacted her. Lise, doubtless, ignored her daughter because of her own subsequent life.[171]

While there are no known letters from Renoir to Jeanne before 1892, it is possible that, during her childhood, Renoir might have visited her and her foster family as he travelled to paint portraits and landscapes. If indeed he visited Jeanne, her striking physical resemblance to her mother must have moved him. Among the letters that Jeanne saved from her father was an envelope postmarked 11 February 1892 in Renoir's handwriting, addressed to 'Mlle. Jeanne Renoir', confirming that he not only approved of her using his last name but also used it himself.[172] A few days after the 11 February envelope with its letter, Renoir wrote another letter to Jeanne in which he addressed her as 'tu', an intimate pronoun that a father would use with his daughter.[173] For late nineteenth-century France, it is amazing that Renoir should acknowledge an illegitimate daughter and act like a father to her, but even more amazing is that he allowed Jeanne to use his last name, so that she became known in her church and town with the surname Renoir. Well before that time, when Jeanne was eleven, she used 'Renoir' in the village school and it was recorded as her last name in official church documents of 1885, continuing to 1893.[174] It can be assumed that Renoir had given Jeanne his approval to use his last name since the priest, the same man who had recorded her last name as Tréhot in her third baptism certificate in 1875, agreed to record her last name as Renoir in her first communion document of 24 July 1881 and in her confirmation of 15 June 1882.

Jeanne's foster parents must have loved her, since they went to the trouble of including her in their family by making their daughter, Eugénie, her godmother.[175] The foster family arranged a third baptism for five-year-old Jeanne when Eugénie became a legal adult at age thirteen. They also chose a close family friend as godfather, Valentin Joseph David junior, then also thirteen (1862–1932). Jeanne's third baptismal document provides the same information as had Jeanne's birth certificate: 'Third baptism; in the year eighteen seventy five on May twenty-third, was baptized by us, the undersigned priest, Jeanne, Marguerite Trehot, born from an unknown father and from Lise Trehot, on July twenty-first eighteen seventy in Paris. The God father: Valentin David, The God

Envelope in Renoir's handwriting, 11 February 1892, addressed to Mlle Jeanne Renoir
and postmarked from boulevard de Clichy, Paris, where Renoir had a studio

mother: Eugénie Blanchet, have signed with us. Brochard, Priest in the church
of Sainte-Marguerite de Carrouges.'[176] The document also records in different
handwriting, 'Reconnue par Renoir' (recognized by Renoir), which must have
been written later since this note is false: Renoir never recognized Jeanne legally.
Perhaps he recognized her unofficially, since, when she took her first communion
aged eleven, the priest recorded her name as: 'Marguerite Renoir' (using Renoir's
mother's name).[177] The following year, when she was confirmed in the same
church, her name again was recorded as 'Marguerite Renoir'.[178] Later, Jeanne
must have decided that she preferred her first name to be Jeanne. Thenceforth,
in various other church documents in which she is recorded as a witness, she
signed her name as 'Jeanne Renoir': on the marriage certificate of her godfather
on 13 June 1885, on the marriage certificate of her godmother on 24 November
1885 and on the baptism certificate of her godson on 2 February 1893.[179]

While Renoir must have approved his daughter's use of his last name,
it was impossible for him to recognize her legally before 1890 when he got
married. The law in France specified that an abandoned child could not be
reclaimed by an unmarried parent because it would put the child in what was

considered an immoral situation. Furthermore, reclaiming a child was a rarity in France; less than 2 per cent of foundlings were restored to a parent.[180] Yet Renoir did what was morally commendable by caring for Jeanne throughout his lifetime.

Renoir was generous to his daughter. In a letter to her of 14 February 1892, he wrote to her that he had sent her a government bond for 400 francs.[181] Thereafter, he sent her money in every letter. His dealings with his daughter were some of the kindest and most selfless interactions over his entire life. He could well have washed his hands of her, as Lise had done. Instead, his actions show true affection for his daughter, respect for her as a person and connection to his earlier life.

Renoir's involvement in Jeanne's life extended well beyond the monetary. Starting in mid-June 1893, and for the next twenty days, Renoir wrote a series of letters to her and to her fiancé, Louis Théophile Robinet, who had written to ask Renoir's permission to wed his daughter. At this time Jeanne was twenty-three and Louis eight years older. He was a baker in Beauvain, near the town of La Ferté-Macé, both about 15 kilometres (9½ miles) from the town where Jeanne's foster parents lived, Sainte-Marguerite-de-Carrouges. Jeanne kept Renoir's reply on 19 June 1893 in its envelope, addressed to 'Monsieur Louis Robinet': 'Dear Sir, In response to your marriage proposal to Jeanne, I want to let you know that I am very pleased, and that because Jeanne is free to choose as she pleases, she has made a good choice. I have nothing else to say, except to wish you good health, while I am confident in your good intentions. I wish you happiness with a very serious and genuinely honest wife. With all my best regards. Renoir, June 19, 1893.'[182] Renoir shows here respect for Louis and esteem for his daughter, praising Jeanne's qualities not as a beautiful young woman but as a serious and honest one.

The same day, Renoir also wrote to Jeanne: 'At the same time I'm writing to Monsieur Louis Robinet.' He explained his attempts to get a copy of her birth certificate, which she needed in order to get married. Since she had been born in a public hospital in the tenth arrondissement in Paris, Renoir needed to go to that town hall to retrieve a copy of the document. He wrote: 'My dear Jeanne, I worked as quickly as possible, but in Paris, before you can access this type of information, you must wait...a while. Anyway, you'll receive your birth certificate Wednesday morning. It will be posted directly to you from the city hall to Sainte-Marguerite. Should you not receive it, write me immediately. You don't need anything else, and I'll send you a separate note to show the mayor

in case he refuses the documents. I think it will arrive in time so you can be married the 10th [of July]. I am also putting aside 100 francs for you. As soon as you have the documentation and your problems are settled, I will send it to you to add to your savings account. I will bring you the rest on your wedding day. Best to you, Renoir, 19 June.' In the margin he wrote: 'The other note is to show the mayor in case there is any trouble.'[183] The anticipated trouble was the fact that, as described in Chapter 1, her birth and baptism certificates gave the name Jeanne Marguerite Tréhot, yet since at least 1885, she had signed her name 'Jeanne Renoir', as just described, most recently in February 1893, five months before her wedding, at her godson's baptism.[184]

After Renoir wrote these letters to Louis and Jeanne, he went to visit Gallimard at his country house in Benerville-sur-Mer near Deauville. Benerville is about 118 kilometres (73 miles) away from Sainte-Marguerite-de-Carrouges. Eleven days later, on 30 June, Renoir wrote his daughter sensible fatherly words concerning a marriage contract with Louis: 'My dear Jeanne, I have finally received the good news [that your birth certificate was accepted]. I am sending you 500 francs. As soon as you respond, I will send you more. For the marriage contract, do what is in your best interest. I cannot advise you on this. You need to consider everything including the most unpleasant things, and you need to think about your [future] children. Perhaps a contract is preferable, but as I said, do as you please. Let me know how much money you have left. Do not include your stock. As agreed I will make up the difference up to three thousand.' Thus, it seems, Renoir gave his daughter the considerable dowry of 3,000 francs, twice what Louis had in cash.[185] Renoir continues his letter: 'Spend the least possible on your wedding. No unnecessary frivolity. Be frugal. Let me know in one of your letters the distance between your place [in Sainte-Marguerite where the civil ceremony would be held on 9 July] and La Ferté [where the religious ceremony would be held on 10 July] and if carriages are available. In short, tell me the quickest and the easiest way to come. I don't want to take the carriage from Argentan; it's a lost day.... Best wishes to you, Renoir. Respond at once. June 30, '93'.[186] Renoir may ostensibly have been visiting Gallimard, but this letter makes it clear that he intended not only to help fund the wedding but also to attend both the civil and religious ceremonies.

Despite Renoir's efforts, there were legal complications with the wedding due to the discrepancy between the name on Jeanne's birth certificate and the name she went by, but he continued to assist her. On 3 July, he wrote again:

'My dear child, I am giving you a letter for the notary. Go there as soon as possible. I will pay all the fees. I believe this is the only solution to the problem. In the letter I explain things to him as best I can. If we need to contact the public prosecutor, ask the notary how to go about it. Seal the letter and post it as soon as possible.'[187] Just before her wedding, Jeanne seems to have been too busy to respond. Renoir, exasperated with the lack of news, chided her: 'My dear Jeanne, I can see that I will never be able to know if my letter to the notary reached him or if it got lost. Are you ill? Why are you not responding to me? I am waiting to send you money. I wanted to send you wine but by slow mail. It's too late. It would not get to you on time. Fondly, Renoir. I hope to have heard from you by tomorrow morning.'[188]

Ever anxious, Renoir wrote again after two days: 'My dear child, I know that I'm pressuring you a bit to confirm receipt of the money that I sent you, but because a letter of mine was once lost, I don't want it to happen again. That is why I always ask you to reply promptly. I hope that your troubles are coming to an end. That good ol' mayor of yours is insane. He doesn't know how to do his job. I am sending you one thousand francs all at once. Please respond by return post, if you are able. Fondly, Renoir, Friday, July 7, '93.'[189]

That same day, Jeanne and Louis signed a marriage contract in the office of Maître Drouet, a notary in the village of Sainte-Marguerite-de-Carrouges.[190] Two days later, they signed a civil contract in a ceremony at six o'clock in the evening, in the mayor's office in Sainte-Marguerite. The document states: 'Robinet Louis-Théophile, a baker, residing in Carrouges (Orne), born in Courberie (Mayenne), the twenty-eighth of May, eighteen sixty-three, as it shows in his birth certificate that was shown to us, the latter having fulfilled military law as seen in his military record, which was shown to us, of age, the son of the deceased couple Robinet....' Of the bride, the civil contract asserts: 'Tréhot Jeanne Marguerite, without any specific profession, residing in this town, the village of L'Être-Chapelle [part of Sainte-Marguerite-de-Carrouges], born in Paris (tenth arrondissement), the twenty-first of July, 1870, as shown by her birth certificate, which was shown to us, of legal age, the illegitimate and not legally recognized daughter of Tréhot Lise, whose residence is unknown.' The civil contract also included the names of four witnesses, one of whom was Jeanne's foster father, François Blanchet, who was described in the 7 July marriage contract as 'Blanchet François, landowner, fifty-six years old, living in this town, village of l'Être-Chapelle, friend of the bride.'[191] The following day, 10 July 1893, they held a religious ceremony.[192]

The correspondence between Renoir and Jeanne shows his intention to be present at his daughter's wedding although there is no documentation to prove that he attended any of the ceremonies. Nevertheless, after the wedding, he kept in touch with his daughter and son-in-law. Five days later, on 15 July, Renoir, then 149 kilometres (92 miles) north in Montebourg, wrote a letter to his son-in-law that he sent to their new home at 8 rue de Levant, La Ferté-Macé (4.8 kilometres/3 miles from the bakery where Louis worked).[193] Later on, Renoir continued to plan to visit his daughter and son-in-law in secret. An undated letter after the wedding reads: 'My dear child...I will let you know when I can come to see both of you.... Affectionately, Renoir.'[194] A month after Jeanne's wedding, in August 1893, Renoir vacationed with Aline and Pierre in Pont-Aven in Brittany, as they had the previous summer, his wife and son still completely unaware of this other branch of his family.

Chapter 4

1894–1900

Renoir aged 53–59,
Baby Jean, Continuing Success,
Worsening Sickness and Marital Strife

After one miscarriage in 1890 and a second two years later, Aline and Renoir were thrilled when their second son, Jean, was born on 15 September 1894. The birth took place at their home at 13 rue Girardon in Montmartre. The name 'Jean' had no family significance for Renoir or Aline, but was and is a common Christian name. It is also the name of which 'Jeanne' is the female equivalent, the name of Renoir and Lise's daughter, unknown to Aline. Jean was Renoir's first legitimate child. A few days after his birth, Renoir registered him at the mayor's office. The birth certificate states: '[In] the 18th arrondissement, on fifteen September 1894, at 11 p.m. was born at the home of his father and mother, Jean Renoir of the male sex, of Pierre-Auguste Renoir, fifty-three years old, artist-painter, and of Aline Victorine Charigot, thirty-five years old, with no profession, married and living at 13 rue Girardon. [This record was] drawn up by us on eighteen September 1894, at 9 a.m., at the presentation of the child and the above declaration by the father.'[1]

Renoir spread the news of this joyous occurrence to a number of friends, for example to Murer's sister, Marie Meunier: 'Dear Mademoiselle, A strapping baby boy. Everyone is doing fine. Regards, Renoir.'[2] The next day, he wrote to Monet: 'My dear friend, I want you to know that last evening a second son was born who is named Jean and who starts out well in life... Everyone is fine, up until now.'[3] Then he informed Morisot: 'I have a perfectly ridiculous piece of news for you...namely, the arrival of a second son, who is called Jean. Mother and baby are in excellent health so far. Regards to the sweet and charming Julie and to the no less charming mother.'[4] Morisot responded: 'After you deliberate another ten years, my dear Renoir, you will have a girl!'[5]

Renoir smoking on the steps of his residence at the Château des Brouillards, Montmartre, 1894. Modern print after original, 18.4 x 13 cm (7¼ x 5⅛ in.). Photo by Martial Caillebotte. Private collection

Letter from Renoir to Berthe Morisot Manet, 17 September 1894. Private collection

Renoir, Aline and baby Jean in front of Château des Brouillards, Montmartre 1894. Modern print after original, 20 x 14.6 cm (7¼ x 5⅛ in.) Photo by Martial Caillebotte. Private collection

Jean Renoir was baptized ten months later at Saint-Pierre de Montmartre. Renoir chose his dealer's youngest son, Georges Durand-Ruel, then aged twenty-eight, to be the godfather. The birth certificate had specified only 'Jean Renoir' but on the baptismal certificate his parents added 'Georges' after his godfather. For godmother, Renoir and Aline chose Renoir's student, Jeanne Baudot, then seventeen (see opposite).[6] Through Renoir, Jeanne became a friend of Julie Manet and her cousins Jeanne and Paule Gobillard, all four of whom enjoyed painting and looked up to Renoir for guidance. A few days before the baptism, Renoir had written to the godfather: 'Dear Mr Georges; Monday at 10.30, 13, rue Girardon, in order to be at the Church of Saint-Pierre of Montmartre at precisely 10.45. Renoir. For the boxes of sugar-coated almonds [traditional gifts for the guests at French baptisms], you take care of it. We don't need very many. We are doing this baptism without great ceremony. Lunch after leaving the Church around noon in order to wait for Dr Baudot who can't come earlier.'[7]

Renoir's circumstances in 1894 were entirely different from nine years earlier when Pierre had been born. Pierre's birth was a secret; Jean's was public. Renoir had been poor; now he was rich. He felt secure in his profession, since for the most part the American and French public were buying his work. Even if he were to develop a new style that became unpopular, Durand-Ruel had scores of earlier canvases to satisfy the market. In 1894, Geffroy wrote an essay noting the dramatic change in Parisians' appreciation of Renoir's works between his one-man shows at Durand-Ruel's of April 1883, when the public reacted with mockery and indifference, and of May 1892, when they reacted to many of the same works with overwhelming acclaim.[8] With the change in attitude came enough money for Aline and Renoir to become members of the French upper-middle class, the haute bourgeoisie. They even had enough money to send Pierre,

then aged nine, to a fashionable boarding school, the Jesuit-run Sainte-Croix de Neuilly, popular with the sons of rich Parisians.

Two years after Jean's birth, in May–June 1896, Durand-Ruel put on an exhibition of forty-two canvases by Renoir that garnered much praise from the critics. Another review by Geffroy was particularly effusive, and Renoir thanked him in a humorous and self-deprecating manner: 'My dear Geffroy, Everyone thinks that your article on my show is superb. As for me, I'm a little ashamed because I find that the review's acclaim is much better than its cause.'[9] His friend the critic Natanson also wrote glowingly.[10] One influential critic, Frantz Jourdain, however, gave a scathing review, describing the show as 'thirty or so distressingly feeble canvases'.[11] Nonetheless, Jourdain's opinion was not enough to affect Renoir's success.

On Aline, Renoir's new-found affluence and their marriage had a profound effect. She no longer had to fear her mother's fate of a disappearing husband; famous Renoir could hardly vanish. Aline's life had changed dramatically after Jean's birth, whereas after Pierre's she had continued her life as a lower-class woman who took care of the baby, modelled for her husband, cooked and performed other duties with minimal outside help. At that time, as described earlier, she was Renoir's primary model and was depicted in dozens of drawings and paintings that portray the tenderness between her and her infant son. In contrast, by 1894 she had taken up the role of an upper-class Parisian woman, and stopped doing the pedestrian tasks of childcare, modelling and housework. The only humble tasks she still enjoyed were occasional cooking and gardening;

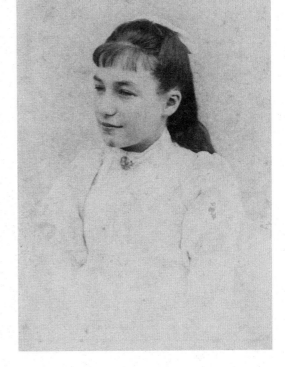

Jeanne Baudot, age 16, when she first began studying painting with Renoir, c. 1893. Photographer unknown

her primary job was to manage a growing staff of people who worked for the family. In contrast to his depictions of Aline with baby Pierre, Renoir made no paintings or drawings of Aline alone with baby Jean. The only extant images showing them are two photographs taken the same day by Martial Caillebotte, the artist's brother.[12] One shows a standing Renoir and Aline in front of their Montmartre home as she lifts baby Jean from his carriage (see page 172). The other, taken the same day, shows Aline wearing the same cape and hat, seated in the garden with Jean, and the baby carriage behind. While Aline enjoyed her new role as a well-off woman, it changed her relationship with her husband, who saw himself as a working painter and never felt that he was upper class. Renoir's primary concern was to be able to paint, which was becoming increasingly difficult because of his worsening health.

In Aline's new, upper-class life, she hired many people to work for the family. Among them was her distant cousin, Gabrielle Renard, who came from Essoyes to Paris to become Jean's 'nursemaid'.[13] Gabrielle's father was the same age as Renoir and her mother was one year younger, so Gabrielle might have seen Renoir in a paternal way. In 1894, she had just turned fifteen, the

same age that Aline had been when she had been ousted from her aunt's house and had come to Paris to join her mother as a seamstress. Renoir was fifty-three years old, thirty-eight years older than Gabrielle, and suffering from rheumatoid arthritis. While Gabrielle had been hired for Jean, Renoir soon co-opted her as his primary model, often posing with the infant Jean (see page 241).[14] She also posed alone, both clothed and nude, and would continue to do so for eighteen years.

Aline and Jean in the garden of Château des Brouillards, Montmartre, 1894. Modern print after original, 20 x 14.6 cm (7⅞ x 5¾ in.). Photo by Martial Caillebotte. Private collection

Gabrielle, age 15, when she came to work for the Renoirs, 1894.
Photographer unknown

Two years after Gabrielle was hired, Renoir painted a large portrait of his family in their rue Girardon garden.[15] The work was planned as the centrepiece of Renoir's 1896 show of forty-two works at Durand-Ruel's gallery, where it had the title *Portraits*, later being called *The Artist's Family* (see page 198).[16] This is the last Renoir painting in which Aline appears with any of her children, and she looks strikingly different from all her previous portrayals. She appears not only upper class, being lavishly dressed, with a huge hat and fur stole, but also haughty, looking away from everyone stiffly and without emotion. In fact, her gaze does not meet the eyes of those in the painting nor those of the artist or viewer. Aline and Jean are the two central figures in the canvas, both round-faced and red-headed, both wearing elaborate headgear. Pierre is dressed in a sailor suit, as was customary for sons of the upper class.[17] The young girl at the right may be a neighbour's daughter or may be standing in for Jeanne Tréhot.[18] The fact that a girl appears at all in this family portrait could indicate that Renoir was

portraying his own reality, in which his daughter was, as this girl is, separated from everyone else, with her identity hidden.

One sees a striking change between how Renoir portrayed Aline as his model in the 1883 paintings, *Dance at Bougival* and *Country Dance*, and how he portrayed her as his wife in this 1896 painting. In the two earlier works, she is radiantly happy, beautiful and active. In this, she is unhappy, unattractive and stiff. Renoir's life story, enriched by his letters, reveals that he saw her differently as his model and as his wife. In those thirteen years between the joyful and the sombre paintings, both Aline and Renoir had changed and their relationship had suffered. Much of the problem arose from their differing aims for status and wealth. While Aline aspired to an upper-class lifestyle, Renoir's goals were widely different, as Robert L. Herbert has stated: 'Renoir, an upwardly mobile son of artisans who never forgot his orgins, took pride in his disdain for material things.... Despite the wealth of his later years, he maintained the same patina in his household of plain furnishings and old clothes, whose utter lack of osten-tation recalled both his own youth and that of the mythical medieval past.'[19]

In Renoir's painting of his family, Gabrielle is the loving adult. She is dressed humbly and crouches below Aline, emphasizing their relative status. Gabrielle gazes tenderly at Jean whom she supports around the waist, as Jean clutches her blouse. She appears relaxed, beautiful and loving, similar to Renoir's earlier depictions of women in *Dance at Bougival* and *Country Dance*, for example (see pages 94–5). In contrast, Renoir's unflattering portrayal of his wife suggests that their relationship had become more strained, as Aline increas-ingly demanded an affluent lifestyle that Renoir tried to reject.

While Aline's identity as Renoir's wife became known to his friends, whether by her choice or by Renoir's, she did not participate in Renoir's social life, as evidenced by an 1897 diary entry of Julie Manet's: 'Monsieur Renoir came to dinner, preceded by the two little maids who accompany him on the round of visits on Sundays.'[20] Even as Renoir's relationship with Aline was deteriorating and as he continued to suffer from rheumatoid arthritis, he felt the troubles of others: many of his friends and their families were developing their own serious health problems. In December 1893, he responded to a letter from Bérard, whose daughter was ill: 'I'm very sad that your lovely Marthe [then twenty-three] is in poor health. In Paris, everything isn't going well either. I am surrounded by sick people. First my friend Maître. It is terrifying. Caillebotte is sick. Bellio etc.... and the sombre weather. I forgot [the composer] Chabrier,

who is usually so healthy, who is now in a terrible state. Only Monet is in superb health as always.'[21] Out of those Renoir mentioned, only Martha and Maître recovered. Caillebotte, Chabrier and de Bellio died the following year, along with Lhôte. A few years later, Sisley, a good friend in Renoir's youth, died in 1899, reported by Julie Manet in her diary: 'Monsieur Renoir is saddened by the death of Sisley, who was his companion when he was young and for whom he has kept a great affection even though he hadn't seen him since the death of Uncle Edouard [Manet had died in 1883].'[22]

Caillebotte's death was especially hard on Renoir. He had been a close friend for more than twenty years and was Pierre's godfather. On 21 February 1894, a month before Jean was born, Caillebotte died from pulmonary congestion at the age of forty-six. Renoir had been his friend since 1874 and was his executor.[23] When it came to administering the estate, Renoir felt uncomfortable telling Monet that Caillebotte had chosen him as executor, since it implied that Renoir was the leader of the Impressionists and not Monet. A few weeks after Caillebotte died, Renoir wrote to Monet: 'At first I was a little embarrassed and wanted to talk with you but now it is useless. The will is very clear and I must follow it exactly.'[24] Caillebotte had also wanted Renoir to ensure that his companion, Charlotte, receive the house in which they had lived together. Although Caillebotte had never married her, he wrote in his will: 'In addition, I leave the little house that I own in Petit Gennevilliers to Miss Charlotte Berthier.'[25]

The other major task that Caillebotte left to Renoir was the distribution of his private art collection. Although Renoir had been Caillebotte's best friend, Caillebotte's art collection did not favour Renoir over their artist friends. Over the years, Caillebotte had purchased nearly seventy works, many of them important masterpieces (see Chapter 1). Initially, Caillebotte bought pieces from the Impressionist sales and exhibitions to help his fellow artists monetarily, but soon he was purchasing works with the intention of giving them to the French state, as specified in his will. There he had listed the artists he intended to include; all were represented in his final collection except for Morisot.[26] Perhaps he did not purchase her works because she, out of all the artists he collected, was the most financially secure and did not need his help.

Despite his foresight in providing for his Impressionist friends, Caillebotte did not mention his own works in his will. The generous Renoir was worried that works by Caillebotte might never go to the Louvre. In that same letter to Monet, Renoir continued: 'I'm getting back the *Rowers* to try to get it accepted

by the Luxembourg. I think that it's Caillebotte's most typical painting.' In addition to getting Caillebotte's works accepted by the French government, Renoir wanted to preserve Caillebotte's legacy by putting on an exhibition of his art. He continued to Monet: 'I want to make arrangements with you for his exhibition.... I have rented a studio by the month at 11 boulevard de Clichy to house the collection and meet with the commission.'[27] The two artists assisted Durand-Ruel in planning the Caillebotte retrospective, held on 4–16 June 1894, shortly after Caillebotte's death, at Durand-Ruel's gallery.[28]

It took three years of meetings between Renoir and members of the government commission assigned to accept or reject Caillebotte's bequest to evaluate each piece. Several influential members of the artistic community as well as the general public were appalled that the government was considering accepting any of these paintings and drawings. The renowned artist Jean-Léon Gérôme called the bequest 'a pile of shit'. A similar evaluation was expressed in a readers' survey conducted by *The Artist* journal: the Caillebotte bequest was considered 'a pile of excrement whose exhibition in a national museum publicly dishonours French art'.[29] The state finally agreed to take forty works including Caillebotte's *Rowers*, even though his will had specified that the Louvre must take all or none. Renoir, after consulting with Caillebotte's brother, agreed to accept the state's position. The commission rejected the other paintings and pastels. Today the accepted works are among the treasures of the Musée d'Orsay, the branch of the Louvre devoted to nineteenth-century art.

One of Renoir's great solaces after Caillebotte's death in February 1894 was his increasing closeness to Morisot. As he had helped her through her husband's death in 1892, now Morisot helped Renoir cope with the loss of Caillebotte. Renoir's greatest involvement in the lives of Morisot and her daughter coincided with Julie (born in 1878) beginning her diary, which spanned the years 1893–99. Julie often wrote about her mother's life, such as this entry from March 1894: 'In the evening, Maman had people over for dinner – Monsieur Degas, Monsieur Mallarmé, Monsieur Renoir, Monsieur Bartholomé; Paule and Jeannie were also guests.'[30] Paule (born in 1869) and Jeannie (born in 1877) Gobillard were the orphaned daughters of Morisot's sister, Yves Gobillard (she had also left a son, Marcel, born in 1872). Following Yves's death in 1893, Morisot invited the two girls to live with them at their home at 40 rue de Villejust (now rue Paul Valéry) in the sixteenth arrondissement. Julie loved her cousins, and the three of them remained close for the rest of their lives.

Although Renoir knew and liked the cousins, his first allegiance was to Morisot and Julie. In January 1894, he wrote to Morisot suggesting that he do a portrait of her with Julie: 'If you are willing to give me two hours, that is, two mornings or afternoons a week, I think I can do the portrait in six sessions at the most.'[31] In the portrait, Morisot, by then fifty-three, looks old and tired. A mourning widow, she is portrayed in profile, dressed in black, which contrasts with her white hair; Julie sits on the arm of her mother's chair, looking at the viewer with an anxious expression.[32] They sat for Renoir at his rue Tourlaque studio; sometimes after a painting session, he took them to his home, where Aline made them lunch (see page 180).[33]

In March, Renoir invited them for dinner: 'Mallarmé will give me the pleasure of coming to dinner in Montmartre next Wednesday. If the climb in the evening is not too arduous for you, I thought that he would like to meet you there. Durand-Ruel will come, and I am going to write to the above-mentioned poet to invite [Henri] de Régnier for me. P.S. I am not mentioning sweet and lovable Julie: that is of course taken for granted, and I think that Mallarmé will bring his daughter [Geneviève].'[34]

Less than a year later, in late February 1895, Julie came down with influenza. As she was recovering, Morisot contracted the disease. Within a few days, she was dead. At the time, 'flu was a common cause of death, and Morisot had a heart weakened by rheumatic fever as a child. On the day that she died, 2 March, Renoir was painting with Cézanne at Jas de Bouffan, near Aix. Immediately he learnt the news, he boarded a train and, once arrived in Paris, went to see Julie. In old age, in 1961, Julie recalled this visit: 'I have never forgotten the way he arrived in my room in the rue Weber and held me close to him; I can still see his white Lavallière cravat with its little red dots.'[35] Renoir was shattered by Morisot's death, a great loss to him, which happened about a year after Caillebotte had died. The day after Morisot died, Renoir took it upon himself to inform their friends. Since Monet was painting in Norway, he notified the painter's wife, Alice: 'I am sorry to have to tell you very sad news. Our good friend Madame Berthe Manet died yesterday evening. I am still shaken by this unexpected event.... We will bury her Tuesday morning at 10 a.m., I think. There won't be an announcement since she only wanted her friends at her burial.'[36] And to Pissarro: 'My dear Pissarro. I have the deep sadness to tell you of the death of our good friend Berthe Manet. We will take her to her final resting place Tuesday morning at 10. Renoir, March 3, 1895.'[37] The funeral was on 5 March 1895.

Berthe Morisot Manet and her Daughter, Julie Manet, 1894. 81.3 x 65.4 cm (32 x 25¾ in.).
Private collection

Two weeks after Morisot's death, Renoir poured out his heart to Monet. Along with his deep grief, he expressed concerns about Julie, now an orphan at sixteen. Renoir explained that Julie was being cared for by Paule: 'The older cousin, Paule, is a charming girl who is very sensible and can very well perform her role as mother. The poor little one [Julie] is very weak and worries us a lot.' In the same letter, Renoir says that he goes often to see Julie in hopes of lifting her spirits: 'That shakes her up a little. That's all that one can hope for right now.' He explains how Morisot had made sure that Julie would not be alone: 'Morisot also left a considerable amount of money to the little Gobillard cousins, which will make them more comfortable to stay with Julie.' Renoir was deeply moved by Morisot's devotion to her daughter:

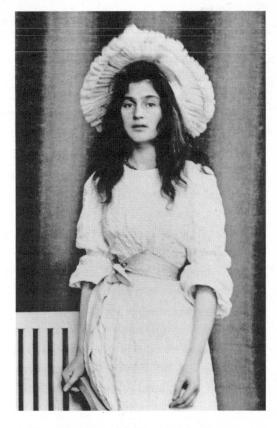

Julie Manet, age 16, c. 1894. Photographer unknown

'This poor woman did not lose her mind for a moment and thought of everything. A few minutes before her death, she said goodbye to all her friends without forgetting anybody, asking them all to take care of Julie.'[38]

Renoir was also struck by Morisot's generosity to Mallarmé's daughter, Geneviève, then aged thirty-one, who Morisot had suspected was unmarried because Mallarmé, a poor high-school teacher, could not afford to give his daughter a dowry. Morisot had made an addition to her will to give a small dowry to Geneviève. Renoir concurred with the hope that by Morisot's kindness, 'she can perhaps save this poor child from solitude. A little money will help her to get married.'[39] Morisot's benevolent foresight for her own daughter, her nieces and Mallarmé's daughter, moved Renoir profoundly.

One of the ways that Julie began to recover was by helping Renoir, aided by Degas and Monet, to plan the retrospective of her mother's art that Durand-Ruel

held a year after Morisot's death, on 5–23 March 1896. Julie helped choose which works to exhibit, how to frame and display them and how to prepare the catalogue. In her diary, she wrote: 'M. Renoir is quite touching in the way he looks after us and in the way he talks to us about Maman's exhibition.'[40] In about February 1896, Renoir wrote to Julie: 'Dear little friend… Now you need to busy yourself with framing; start with the main things. We'll have to see Braun, the photographer, to find out if he will be able to hire us an easel. We can use it to show some drawings and some watercolours, if at all possible. Be kind enough to write to Monet so that he gives titles for the catalogue. We're in a rush and I'm still waiting for the photographer. Think about the catalogue.'[41]

Julie became a frequent guest of the Renoirs. During the five years after her mother's death until 1900, Renoir came to her home seventeen times, which sometimes included dinner, according to her diary. Eleven times, they met at other people's homes – six times in 1898 at the Baudots's, twice at Degas's in November 1895, and at Mallarmé's in December 1897, Henri Rouart's in January 1898 and Henri Lerolle's in November 1899. Julie visited Renoir's studio nine times. She came to his home, usually with her cousins, ten times for dinner and seventeen times without dinner. He also met the three girls at the Louvre three times in November and December 1897.[42]

Aline, too, became close to the girls. In October 1897, she wrote to Paule: 'The bouillabaisse is set for Sunday the 31st of October at noon; please join us because I am making it in your honour. My best wishes…and to the three of you, all my friendship. A. Renoir. P.S. If Charlotte [Lecoq] can come, bring her.'[43] Aline was extremely kind to the three orphan girls. Perhaps she had wanted girls of her own, or perhaps she wanted to give these motherless children the affection that she had never had as a child.

Julie and her cousins also went on vacations with the Renoirs, travelling with the family on five short trips of one to three days from July to December 1898.[44] The Renoirs also invited them on significantly longer trips. Perhaps these travels began as a way for Renoir to help Julie recover. The first, a two-month holiday in Brittany from August to October 1895, was only five months after Morisot's death. Then, starting two years later, the Renoirs took the three girls on yearly long trips together: in 1897, 16 September–19 October in Essoyes; in 1898, 7 September–24 October again in Essoyes; and in 1899, 28 July–12 August in Saint Cloud.[45] Unlike Renoir's letters to his daughter Jeanne, which always mention money, neither Renoir's letters to Julie nor Julie's diary ever mention this subject.

Renoir always treated the girls as if they were his own daughters, going out of his way to help and protect them. When he invited them to Brittany in July 1895, he and his family were already there. The three girls needed to take a two-day train trip to join them, so Renoir left his family and met the girls after their first day on the train. Julie explained: 'We were anxious to find M. Renoir. Thankfully we saw him at Châteaulin station and he took us to a hotel, where we spent the night.' She added: 'He is really very kind to take the trouble to come out and meet us.'[46] A few months later in Paris, she recorded: 'M. Renoir (who gives me the impression of being our protector) saw us on to the tram.'[47] During this 1895 trip, Renoir made many paintings of two girls together, probably inspired by the cousins.[48]

Julie adored Renoir. She wrote extensively about him in her diary, continually praising him and never saying anything negative. After the Brittany trip, she noted: 'M. Renoir has been so kind and so charming all summer; the more one sees of him, the more one realizes he is a true artist, first class and extraordinarily intelligent, but also with a genuine simple-heartedness.'[49] Four years in his company did not diminish her admiration: '[Renoir] talks so interestingly. What intelligence! He sees things clearly as they are, just as he does in his art.'[50] At the end of their last long visit with Renoir in 1899, Julie and her cousins hated leaving him. She wrote sadly: 'We have just left M. Renoir who was so delightful, so kind, so high-spirited with us during the two weeks which we spent in Saint Cloud. He thanked us ever so kindly for having stayed with him. "People my age don't tend to be very entertaining," he said. We regretfully bade him farewell, while making all sorts of recommendations for his treatment in Aix [the health spa of Aix-les-Bains].'[51] Over the course of these four years of visits, the girls even became comfortable making suggestions about Renoir's paintings. Julie wrote in her journal in August 1899: 'He is finishing a self-portrait which is very good.[52] He first made himself look a little hard and too wrinkled; we insisted that he remove several wrinkles and now it looks more like him. "I seem to have sufficiently captured my inquisitive eyes," he said' (see page 199).[53]

In fact, Julie felt much closer to Renoir, her unofficial guardian appointed by her mother, than she did to her official guardian, Mallarmé, whom she saw much less often and rarely mentioned in her diary. After spending a month with the Renoirs in Essoyes in 1897, Julie wrote: '[Renoir] has a great deal of influence over the young people who admire him, and says such philosophical things, so charmingly, that one automatically believes them. If only all men of his age could

have as good an influence over young people. M. Mallarmé doesn't give enough advice. He could give ethical advice in the most delightful manner, and he has such a worthy lifestyle (M. Renoir greatly admires his character) that he ought to guide young people; instead of which he is over-indulgent with them...men of ability should lead the young.'[54] A year later, the poet died unexpectedly at the age of fifty-six on 11 September 1898. At that time, Julie and her cousins were visiting the Renoirs in Essoyes. Shortly after Mallarmé's death, cousin Jeannie wrote to Jeanne Baudot: 'It is M. Renoir who took us to say a final farewell to our unfortunate friend. He [Renoir] was, as in all circumstances, absolutely kind, and he really touched the Mallarmé ladies [wife and daughter] more than others among their crowd of special friends.'[55] Renoir was once again stricken by the death of a good friend (see page 203).

Mallarmé's death was not the only loss Renoir suffered throughout the four years he spent hosting Julie and her cousins. His own mother, who had been widowed in 1874, died aged eighty-nine on 11 November 1896, in her home at Louveciennes. Marguerite Renoir was then living with Renoir's brother Victor and his sister Lisa and her husband, Charles Leray. As his mother became more elderly, Renoir visited her more often and for longer periods. Sometimes he took Pierre along to see his relatives. For example, before going with Aline, baby Jean, Julie, Jeannie and Paule to Brittany in July 1895, Renoir wrote to Bérard: 'I have settled for a little while at Louveciennes... I am working not too badly. I have models here, and that is going rather well.'[56] A year later, Renoir wrote to Geffroy before picking up Pierre on a Friday from his boarding school: 'I am going to get my kid in Neuilly at 6 p.m. and then I'm going back to Louveciennes till...Wednesday.'[57]

When his mother died, Renoir was in his mid-fifties and his own health was declining steadily. The progression of his rheumatoid arthritis manifested itself in attacks that came and went. During each episode, he was in pain and his feet would swell, his fingers would stiffen and part of his face would become paralysed. These ordeals were horrific for him because they interfered with his painting, the most important thing in his life. In her diary Julie Manet wrote extensively about his increasing debility, for instance in January 1899: 'Spent the morning at M. Renoir's who was ordered to stay in bed for his unremitting rheumatic pains. He does not seem too upset.' A week later, she noted: 'M. Renoir is still not doing very well. He can't work, nor go out, and his rheumatisms are still plaguing him.'[58] Seven months later, Julie wrote: 'M. Renoir's health changes

every day. Sometimes he seems to be fine, then his feet or his hands swell up.' And five days later: 'It's so awful to see him in the morning; he doesn't even have the strength to turn a door handle.'[59]

It was not only Julie but all his friends and family who were deeply concerned about Renoir's health. In December 1893, before Jean's birth, the poet Henri de Régnier described the artist: 'Renoir has a face that is agitated and yet paralysed on one side, with one eye already half-closed.' While Renoir felt paralysed, it would not have been a true paralysis but an inflammation from his rheumatoid arthritis that caused swelling and stiffness.[60] Régnier continued: 'His features and body were thin and he appeared extremely nervous, his face twitching and intelligent, refined and with watchful eyes.... With a sombre mien and simple movements...Renoir partook of his meal with provincial, rustic gestures, his hands already deformed.'[61]

Despite the fact that Renoir knew he would never get better, he remained optimistic, refusing to give up his work or his life. When he was still a relatively young fifty-eight years old, Renoir explained to his dealer: 'I have not mentioned my health because it's pretty difficult to describe. One day it's bad and one day better. All in all, I think I'll have to get used to living like this. My feet still refuse to become less swollen. I have always predicted that when I matured artistically in relation to myself for my painting, it would not work any more. I have nothing to complain about; it could have been worse.'[62] He felt lucky to be alive. A month later, in March 1899, he confided in his friend Bérard: 'I think that I must get used to living with my pains. If they don't get worse, I'll be lucky.'[63] Each rheumatic attack nevertheless left Renoir a little worse. He was acutely aware of the downward progression of his illness and that such a decline was inevitable. No cure existed for the disease. Gradually Renoir's fine-motor skills decreased so that it was more difficult for him to manipulate the brush for fine details. Consequently, out of necessity, his strokes became looser and freer. Even so, he would live to paint for another twenty years. He refused to let his illness come between him and the people in his life. As an extraordinarily social person, Renoir no doubt feared that his debilitating illness would alienate his family and friends. To avoid this, he was determined to retain a positive attitude.

As a way to forestall the disease's progress, Renoir remained as active as possible. To retain his hand–eye coordination and his agility, he played cup-and-ball (*bilboquet*), and to keep up his strength, he took long walks. On 27 October 1895, Julie recorded in her diary that Renoir walked from his

house in Montmartre to pick up Pierre at his boarding school in Neuilly and back, a total of about 12 kilometres (7½ miles).[64] In addition to long walks, Renoir did not hesitate to climb stairs. In April 1897, the family decided to move from their three-storey house in Montmartre to an elegant apartment at 33 rue Rochechouart on the fifth floor (which is described in more detail later in the chapter). It is astonishing that, during the five years that they resided there, both Renoir, with his worsening arthritis, and Aline, with her increasing weight, were able to climb five winding flights of stairs to reach their apartment.

One of the few recommendations that Renoir's doctors could make for his worsening arthritis was to retreat south, away from the winter weather. To alleviate his suffering, beginning in 1898, Renoir, accompanied by Gabrielle, started going south when Paris was cold. Aline and the children visited from time to time. Here, clearly, Aline was abdicating her role both as Renoir's partner and care-giver. Each year, Renoir rented a different house on the Mediterranean, somewhere between Cagnes and Nice. On the first trip, in February 1898, Renoir and Gabrielle spent ten days in Cagnes. Renoir returned north, enthusiastic about the area.[65] The next year, he and Gabrielle returned to Cagnes during February to April.[66] With each passing year, the southern soujourn became more extensive. In 1900, Renoir remained in the south for more than four months, from January to mid-May. He wrote to Jeanne Baudot that he and Gabrielle, 'have settled into a large, clean, and sunlit house...three kilometres [2 miles] from Grasse and one kilometre from Magagnosc'.[67] Later, Aline and Jean joined them, but Pierre remained in boarding school in Paris that year.[68]

For his partial paralysis and pain, Renoir's doctors recommended treatments at medicinal spas. Apart from aspirin (the German company, Bayer, was selling it worldwide by 1899), the only other treatment the doctors could recommend was at these spas. Renoir always resisted going to spas because he did not believe they were effective. As he realized, the heat has no long-term benefit and does cause some swelling. Nonetheless, in August 1899, Julie related that reluctantly and timidly Renoir went to Aix-les-Bains's thermal baths at the foot of the Alps for a two-week treatment. Before he went, she wrote in her diary: 'We talked about Aix – Renoir wants to be done with his treatment there, taking the waters, as he does not believe in it. He only goes to avoid being reproached for not having followed the advice given him. "If the treatment is too irritating, I'll make Gabrielle take it", he told us, for he is taking Gabrielle with him while Mme Renoir stays peacefully in Essoyes.'[69] This suggests that Aline did not want

to be involved with Renoir's care. Seven months later, Renoir wrote to Jeanne Baudot with a contrast between Aline and Gabrielle: 'My wife is putting on weight. Gabrielle is still the amazing cook you remember.'[70] It seems that Renoir also did not want to be involved in this mode of care. When at Aix-les-Bains, he wrote to his dealer: 'I was very tired and the treatment made me even more nervous than usual.'[71] Even Julie noticed that his uncontrollable nervous tick had been worsening. She wrote in a diary entry of 1895 that he was continuously 'rubbing his nose'.[72] This was the same nervous tick that both Murer and Mme Blanche had written about twenty years earlier.

The epithet 'high-strung' was used by both Aline and Julie to describe Renoir's temperament. In a letter to Jeanne Baudot in August 1897, after Renoir broke his right arm for the second time (while biking in Essoyes with the caricaturist, Abel Faivre), Aline wrote: 'My dear Jeanne, You see that our patient is doing well, particularly his spirits, which is quite extraordinary considering how high-strung he is.... Very soon he will be able to work with his left hand.'[73] Renoir downplayed the seriousness of his injury. Julie was impressed with his attitude and recorded in her diary: '"In life it's the same as in art", says M. Renoir, "everything is a matter of comparison." He's putting up with his broken arm very well, declaring that he'd rather have that than something else.'[74] Three years later, in early August 1899, Julie discussed his arthritis in her journal: 'The illness is aggravating for him and yet he, so highly strung, puts up with it very patiently.'[75]

In 1896, Natanson published an article in *La Revue blanche* describing Renoir's extreme anxiousness: 'He comes and goes, sits down, stands up, has hardly stood up when he decides to sit down again, gets up and goes in search of the latest cigarette forgotten on the stool, no, not on the stool, or on the easel, no, on the table, not there either, and at last he decides to roll another which he may well lose before he has had the time to light it.'[76]

As his declining health worsened his nervousness, it also worsened his indecisiveness. Although at times Renoir could be decisive, at other times, he was trapped in agonizing uncertainty. In her diary, Julie described one such episode on 5 February 1898: 'I went to M. Renoir's studio to say goodbye as he's leaving for the Midi [the south of France] tomorrow. Well at least he says he is from time to time, but at other moments he really doesn't know what he's doing. He keeps changing his mind.' Renoir did go and on 26 February, Julie wrote: 'M. Renoir got back this week.'[77] A year later, she again commiserated in her diary about someone who 'changes his mind all the time, like M. Renoir'.[78]

Renoir exploited his own flaw by playing on the expectation that he was indecisive even when he was not. By so doing, he tried to avoid confrontation. On 16 August 1900, he accepted the invitation to become a Chevalier (Knight) of the Légion d'Honneur, the government-sponsored award for lifetime achievement. He knew that Monet would be furious that he had accepted this honour from 'the establishment'. Unlike Monet, Renoir never saw a contradiction between being an innovative artist and accepting official recognition that would help his reputation and sales. He had revealed his true feelings about the award in 1881, when Manet had been offered it (as noted in Chapter 1): 'I will salute you as the painter who is loved by everybody and is officially recognized.'[79] Now, almost twenty years later, in 1900, despite Renoir's positive feelings about the award, he tried to soften Monet's expected anger by blaming his acceptance on his own indecisiveness. A week after he had accepted the award, Renoir confessed sheepishly to Monet: 'Dear friend…I wonder what difference it makes to you whether I've been decorated or not. You are admirably consistent in your behaviour, while I have never been able to know the day before what I would do the next. You must know me better than I do myself, just as I very probably know you better than you do yourself. So, rip up this letter and let's not talk about it any more and long live friendship! My best wishes to Mme Monet and to everyone at your house. Yours, Renoir.'[80]

Renoir's feigned indecisiveness about accepting the Légion d'Honneur did not fool Monet, who felt sad about what Renoir had done. The same day that he received Renoir's letter, Monet wrote to his biographer and friend Geffroy: 'You doubtlessly know of Renoir's decoration. I am very saddened by it and Renoir knows it so well that he wrote me as if to apologize, the poor man. Isn't it sad to see a man of his talent, after having struggled so many years and so valiantly survived this struggle in spite of the administration, to accept the honour when sixty years old? Humans are really pathetic! It would have been so great to have all remained uncorrupted by rewards, but who knows? Maybe I'll be the only one remaining pure in this regard, unless I become really senile.'[81] On top of this disappointment, Monet seems to have expressed his thorough distaste to his son-in-law and pupil, Théodore E. Butler, who wrote to a fellow artist: 'Did you see that Renoir had been decorated? – Mr Monet was utterly disgusted.'[82] Despite his disapproval, Monet continued to care about Renoir. A year later, Monet wrote to a friend who was living near Renoir in the Midi: 'Do you sometimes see Renoir, and is he really in better health? If accepting the medallion of

the Légion d'Honneur could have done the miracle of making him feel better, I would forgive him for his weakness.'[83]

Although Monet and other anti-establishment liberals disapproved, Renoir's conservative friends were delighted that he had received and accepted this honour. The painter joked in a letter to his dealer: 'Yes, my dear Durand-Ruel, I am the culprit. So I hope that the firm of Durand-Ruel will take up a collection to buy me an honorary throne [that is, toilet].'[84] Bérard not only approved but had accepted such an honour himself. In his 1900 acceptance letter, Renoir wrote: 'I have chosen M. Paul Bérard, chevalier of the Légion d'Honneur, 20 rue Pigalle, Paris, to represent me in accepting my decoration as chevalier of the Légion d'Honneur.'[85] (He abandoned his pretence of indecision when he was later offered higher ranks in the Légion, those of officer in 1911 and commander in 1919, which he accepted gladly; see Chapters 6 and 7.)

Renoir's trust in this long-standing institution indicates his staunch conservatism, which increased as he aged. Although some of his Impressionist friends, like Pissarro and Monet, denigrated the art of the Louvre, Renoir venerated the great art of the past. Just as he had gone to see the frescoes in Italy to inspire his own work, so he repeatedly took Julie, Jeannie, Paule and Jeanne Baudot to the Louvre to copy paintings. For example, in December 1897, Julie wrote in her diary: 'Monsieur Renoir came to see us at the Louvre. He gave Jeanne an excellent lesson and told her to take a section and finish it in one go. He said that Ingres always painted a torso in one go, free to begin it again the following day.'[86]

Julie in particular took Renoir's old-fashioned views to heart. She came from a wealthy, conservative family and was surrounded by friends of the same opinion. She even supported the traditional view that women were inferior to men, writing for example: 'M. Renoir was charming, affectionate, and likeable as a woman never would be.'[87] Julie often wrote approvingly of Renoir's conservative opinions. In September 1897, she reported: 'Monsieur Renoir attacked all the latest mechanical contraptions, saying that we are living in an age of decadence where people think of nothing but travelling at dozens of kilometres an hour; that it serves no useful purpose; that the automobile is an idiotic thing; that there is no need to go so fast; that the whole thing will mean change.... The labourer is no longer capable of thought, of bettering himself.... Whatever is the point of going so fast?... Isn't M. Renoir right? What a sound mind, always saying such sensible things.'[88] Renoir, who came from an artisan background,

feared industrialization that would replace workers with machines. Beginning with the appearance of Darwin's book, *The Origin of Species*, in 1859, science began to pervade all aspects of life, which Renoir found horrifying. This is ironic since, from 1868 through 1877, Renoir had been a leader of a modern art move-ment.[89] At that time, Renoir's choice of Impressionist daily-life subject matter, as in *Dancing at the Moulin de la Galette*, 1876 (see page 86), was as innovative as his style, with its feeling of freedom and randomness, a palette that is light and bright, strokes that are mobile and visible, an arrangement that is random and non-focused and forms that are open and imprecise. Both the subject matter and style had caused conservative critics violently to reject his work. By 1878, however, he was already moving away from the modern Impressionist style and, by 1884, he had also rejected the daily-life subject matter. Perhaps it is not surprising, then, that Renoir rejected modernity in other aspects of his world.

Renoir directed his strongest negative feelings towards the assembly line, since mass-production seemed to him the antithesis of craft: 'He spoke about socialism [Julie Manet recorded in July 1899], which does so much harm: "It has taken everything away from the people, from the workers. Religion, which for them was such a consolation, has been replaced by an extra twenty-five centimes a day. It's not by making the labourer work fewer hours a day that you will make him happy, because a man without work gets up to no good and the labourer will spend his free time in a bar. What is needed is to get him to do work which is less taxing. There is no longer anything of interest for the working man to do. In the olden days he would make a chair after his own fashion, and with pleasure; now, one makes the legs, another the arms, and a third puts the whole thing together. They want to do the job in the fastest time possible so they can be paid."'[90]

The most controversial example of Renoir's conservatism occurred during the Dreyfus Affair, the political and social crisis that gripped France and much of Europe from 1895 until 1906. It concerned a Jewish military officer from Alsace-Lorraine, Captain Alfred Dreyfus, who was falsely accused of selling French military secrets to the Germans. In 1894, Dreyfus was court-martialled for treason and sentenced to imprisonment on Devil's Island. In truth, a French army major, Count Ferdinand Walsin-Esterhazy, had forged evidence that resulted in the conviction of the innocent Dreyfus by a secret military tribu-nal. From 1895, when Dreyfus was humiliated at Paris's École Militaire, until eleven years later when he was honoured at the same institution as a Chevalier

of the Légion d'Honneur, intense anti-Semitism flared throughout France. The conviction tapped into an existing undercurrent of anti-Semitism strong in most of Europe at this time.

Renoir, too, became caught up in the Affair as an anti-Dreyfusard, particularly because of his political conservatism and fear of anarchism. Entrenched in his anti-modern position, surrounded by many conservative friends and with his long history of bowing to popular opinion, it is hardly surprising that Renoir got on the anti-Dreyfus bandwagon. After all, ninety per cent of French people had done the same, as had his friends Degas, Forain, Guillaumin, Julie Manet, Rodin, Henri Rouart, Rouart's four sons and Valéry.[91] Yet in Renoir's case, anti-Dreyfus did not mean anti-Semitic, if we define anti-Semitism as hatred of or discrimination against Jews as a national, ethnic, religious or racial group. In 1984, when I published *Renoir: His Life, Art, and Letters*, I concluded there, particularly on the basis of Julie Manet's diary, that Renoir was anti-Semitic. However now, after having studied Renoir for an additional thirty years, after having read an additional two thousand letters by, to and about Renoir, and after diligently studying his character and personality, I have changed my opinion and I do not believe that Renoir was an anti-Semite.

Nonetheless, during the Dreyfus Affair, Julie Manet recorded in her diary statements that show Renoir's anti-Dreyfusard position. She wrote in 1898: 'today I was at Renoir's studio, where the Dreyfus Affair and the Jews were being discussed. "They come to France to earn money, but if there is any fighting to be done they hide behind a tree", said M. Renoir. "There are a lot of them in the army, because the Jew likes to walk around wearing a uniform.... They are asking that the Dreyfus Affair be made public, but there are some things which simply cannot be said. People don't wish to try to understand that sort of thing," he added. M. Renoir also let fly on the subject of Pissarro too, "a Jew" whose sons are natives of no country and do their military service nowhere. "It's tenacious, this Jewish race. Pissarro's wife isn't one, yet all the children are, even more so than their father."[92] The patriotic Renoir who had served in the Franco-Prussian War was infuriated that Pissarro's children, as practising Jews, had a religious exemption from joining the military. While his language is racist, it does not demonstrate hatred. Neither does Renoir's behaviour, as will be seen later. Four factors contributed to Renoir's use of such pejorative language.

First, prejudice against the Jewish people was commonplace in late nineteenth- and early twentieth-century Europe. France, in particular, was still

smarting at its humiliating defeat by Germany in the Franco-Prussian War twenty years earlier, in which Alsace-Lorraine, Dreyfus's homeland, had been ceded to Germany. The idea that anyone would sell information to the Germans was anathema to an overwhelming majority of the French people, and Dreyfus's Jewishness only fed this fury in a largely prejudiced public. Most French newspapers (with subscriptions of more than two million) were anti-Dreyfusards and asserted his guilt; many fewer papers (with subscriptions of 200,000) believed Dreyfus to be innocent.[93] Among the Dreyfusards were Cassatt, Charpentier, Mallarmé, Mirbeau, Monet, Pissarro, Signac and Zola. On 13 January 1898, after the Dreyfus Affair had raged in France for four years, Zola published 'J'accuse', a 'Letter to the president of the Republic', in a pro-Dreyfus newspaper, *L'Aurore*, in which he charged French generals and statesmen with convicting an innocent man and – the worst crime – upholding the verdict through lies and suppression of evidence, once they knew that Dreyfus was not guilty.[94]

Second, Renoir's racist language stemmed from his political conservatism, staunch patriotism and fear of anarchism, as advocated by Pissarro.[95] As for the latter, Renoir worried that any association with anarchism would cause the value of his paintings to decrease. Like Cézanne, Renoir believed in Dreyfus's guilt; both artists were staunch nationalists who trusted the French statesmen, military and popular press. Dreyfus's innocence would reveal a weakness within the French military, which nationalists like Renoir and Cézanne were unable to accept, independent of Dreyfus's religion.

Other conservative friends of Renoir, however, had motivations beyond nationalism to oppose Dreyfus and the Dreyfusards. For example, two of Renoir's closest friends at this time, Degas and Julie Manet, were decidedly both anti-Dreyfus and vehemently anti-Semitic. Degas's anti-Semitism was extreme. By 1895, Degas, then partially blind, had begun to have his maid, Zoé, read aloud the anti-Semitic daily paper, *La Libre Parole*. As a result of the Dreyfus Affair, Degas broke up with his Jewish childhood friends, the Halévys, even though they had converted to Catholicism. Daniel Halévy, in a diary entry of 5 November 1895, wrote: '[Degas] has become a passionate believer in anti-semitism.' Julie Manet was also both anti-Dreyfusard and anti-Semitic, as her diary details. In January 1900, she became engaged to marry Ernest, one of Henri Rouart's four sons, who were all anti-Dreyfusard extremists.[96] Evidence of Julie's anti-Semitism can be found in her diary of September 1899, where she records a contribution that she and five of her friends sent: 'We, six young girls, are sending the modest

The Washerwomen (Aline with 4 year old Pierre) c. 1889. 56.5 x 47 cm (22¼ x 18½ in.). The Baltimore Museum of Art, The Cone Collection, formed by Dr Claribel Cone and Miss Etta Cone of Baltimore, Md.

Bather arranging her Hair, 1885, 92 x 73 cm (36¼ x 28¾ in.). The Sterling and Francine Clark Art Institute, Williamstown, Mass.

The Large Bathers, an Experiment in Decorative Painting. 1887. 117.8 x 170.8 cm (46⅜ x 67¼ in.). The Philadelphia Museum of Art. Bequest of Carroll S. Tyson, Jr.

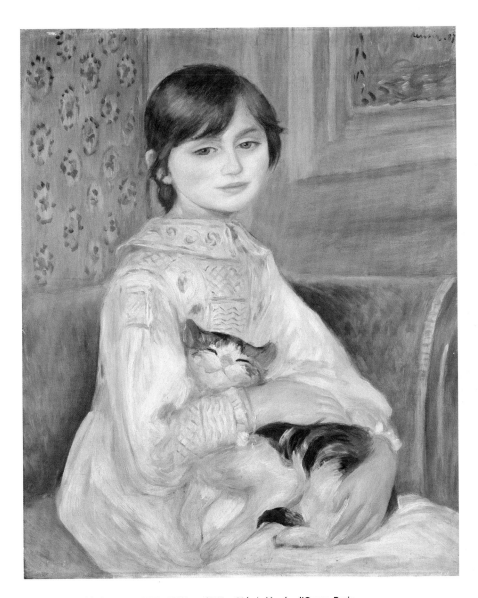

Julie Manet with Cat, 1887. 63.5 x 53.3 cm (25½ x 21 in.). Musée d'Orsay, Paris

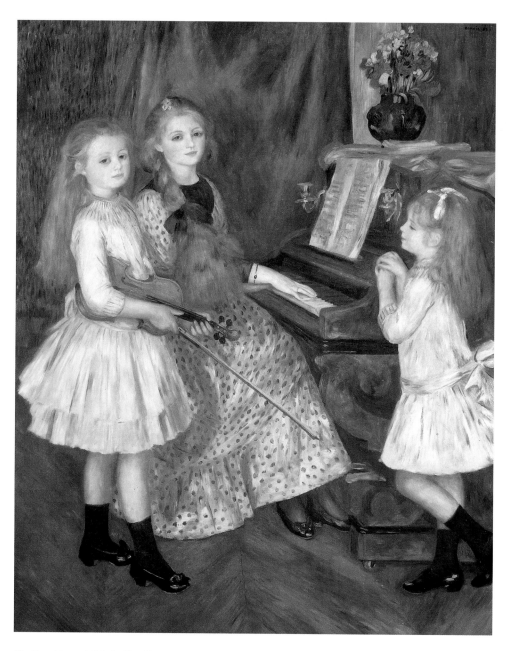

The Daughters of Catulle Mendès, 1888. 162.2 x 130 cm (63⅞ x 51⅛ in.). Metropolitan Museum of Art, New York, Collection of Mr. and Mrs. Walter H. Annenberg

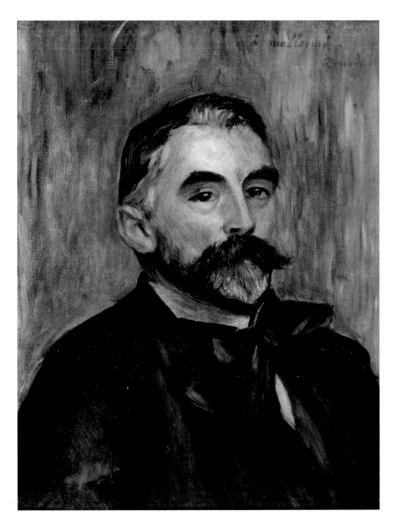

Stéphane Mallarmé, 1892. 50 x 40 cm (19⅝ x 15¾ in.). Musée d'Orsay, Paris

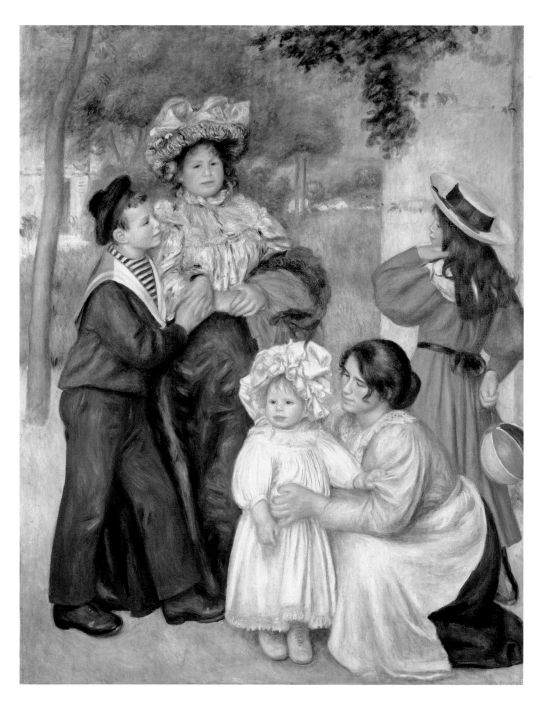

The Artist's Family, 1896. 172.7 x 137.1 cm (68 x 54 in.). The Barnes Foundation, Philadelphia, Pa.

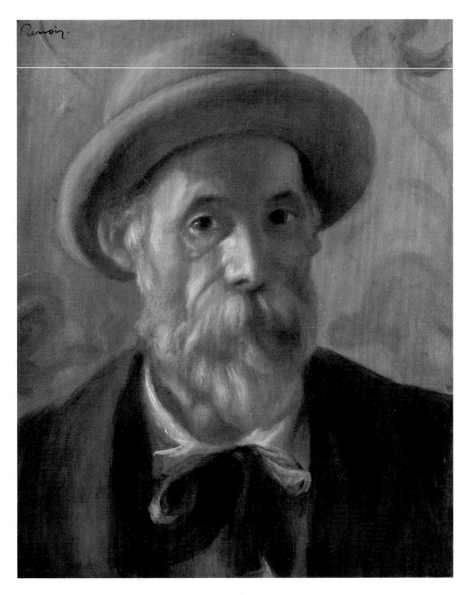

Self-Portrait, 1899. 38 x 31 cm (16¼ x 13¼ in.).
The Sterling and Francine Clark Art Institute, Williamstown, Mass.

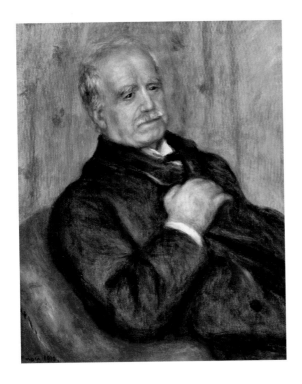

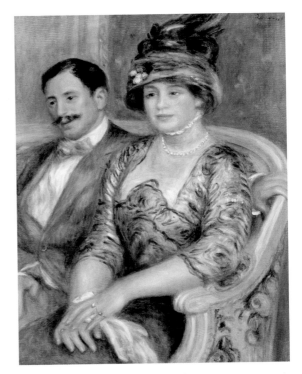

Paul Durand-Ruel,
1910. 65 x 54 cm
(25⅝ x 21¼ in.).
Collection Durand-
Ruel & Cie

*Monsieur et Madame
Gaston Bernheim de
Villers,* 1910. 81 x
65 cm (31⅞ x 25⅝ in.).
Musée d'Orsay, Paris

sum of six francs to *La Libre Parole* to support the workers of La Villette for a fund to repatriate Jews to Jerusalem.'[97]

Third, Renoir's socio-economic status and family background also contributed to his position as an anti-Dreyfusard. As outlined earlier, his paternal grandfather had been abandoned by his parents and taken in by a shoemaker, and Renoir always felt himself a stranger in the company of his more affluent, better educated and better connected Impressionist friends, most of whom were upper class or, in a few cases, middle class. The entire art world was dominated by those in the upper class, so Renoir felt like an outsider looking in on an exclusive milieu. In order to validate his presence as part of this circle, Renoir often felt the need to acquiesce in majority opinion. To disagree with the consensus would be to underline his difference from the art world and thereby separate himself from it. Renoir, the outsider, could not afford to distance himself any further.

Finally, Renoir's manipulative personality may also help explain his anti-Dreyfusard position, which pleased the people around him. Among the thousands of surviving letters from Renoir, the most prejudiced is one to Bérard from around 1899, in the middle of the Dreyfus Affair and before Renoir developed a friendship with the Bernheims: 'Dear friend, Duret (still the Dreyfus affair) is protecting the Bernheims, horrible Jews, against Durand-Ruel. When I see him, Duret, I'll ask him to meddle in his own affairs. He is a man we can no longer invite. Best, Renoir. The Bernheims probably promised strong commissions, this is the secret.'[98] Here Renoir is upset because he suspects that Duret was trying to sell some of his Renoir paintings to Bernheim rather than to Durand-Ruel, who was then Renoir's principal dealer. This letter was Renoir's calculated attempt to warn Bérard that should he want to sell any of his forty Renoir paintings, he should deal with Durand-Ruel or Renoir would be angry with him, just as he was with Duret. Today such language is considered racist and is less common; during Renoir's time, and especially during the Dreyfus Affair, it was commonplace.

Renoir's words must be read in conjunction with his actual behaviour towards Jewish people before, during and after the Affair, which demonstrates no hatred. To recapitulate earlier chapters: for four or five years in his teenage years, he had worked for a Jewish porcelain-maker, the Lévy brothers. When he was twenty, his brother Pierre-Henri married the daughter of his boss, a Jewish woman, Blanche Marie Blanc.[99] Renoir had a lifelong relationship with Henri and Blanche. In the 1870s and early 1880s, thanks to his patrons Charpentier, Duret and Ephrussi, Renoir had many Jewish patrons who commissioned portraits.[100]

Even at the height of the Dreyfus Affair, in 1898, he had no qualms about eating at the home of his friend, the Jewish writer Thadée Natanson (see opposite). Renoir also kept up his friendships with other Jews, including Arsène Alexandre, Charles Ephrussi, Catulle Mendès and Claude Roger-Marx, and among his Jewish patrons were the Cahen d'Anvers, Foulds, Halphen, Nunès, Stora and Mendès.

The complicated friendship with Pissarro is relevant to this discussion. Pissarro was a fellow Impressionist with whom Renoir remained friends for forty years until Pissarro's death in 1903. In Renoir's 1876–77 painting of artists in his studio (see page 87), he included Pissarro, his bald head seen in profile. Pissarro, born a middle-class Jew, became an agnostic and married a non-Jew; nonetheless, as noted earlier, his children continued to practise as Jews. Thanks to his friendship with Pissarro, Renoir was happy in 1883 to accept portrait commissions from Pissarro's wealthy Jewish cousin, Alfred Nunès.[101] The following year, Renoir sought out another Nunès cousin, Lionel, who helped Renoir draft his manifesto for the 'Society of Irregularists'.[102] A few years later, friction developed between Renoir and Pissarro because of their divergent artistic directions. While Renoir experimented with Ingrist Impressionism, which Pissarro outspokenly denounced, Pissarro moved into Pointillism, a style Renoir deplored. Both during that period and afterwards, Pissarro's well-known anarchism frightened Renoir, the staunch French patriot and defender of French nationalism. In fact, in 1881 and 1882, not only Renoir but also Monet and Caillebotte had found the political opinions of Pissarro and his friends, Gauguin and Guillaumin, to be too revolutionary.[103] Pissarro's anarchist sympathies were so well known that he had to flee to Belgium in 1894 to escape a round-up of anarchists in Paris. Julie Manet wrote in her diary in October 1897: 'We also talked about the Natansons. M. Renoir said it was very dangerous to support anarchists such as Fénéon, who busy themselves with literature while awaiting an opportunity to throw themselves into politics and who will end up by doing something terrible. He must be right. Writers support too many bad causes, whereas painters are of sounder mind. Pissarro, however, is an anarchist.'[104]

While Pissarro's anarchism distanced Renoir and Julie Manet, his Jewishness put off Degas. In one incident alluded to by the artist Paul Signac in February 1898, when Degas and Renoir were walking together, he noticed that Pissarro was approaching. Degas crossed the street. Caught by his closer friendship with Degas, Renoir followed him across the street to avoid Pissarro. Signac wrote in his diary: 'He [Pissarro] told me that since the anti-Semitic

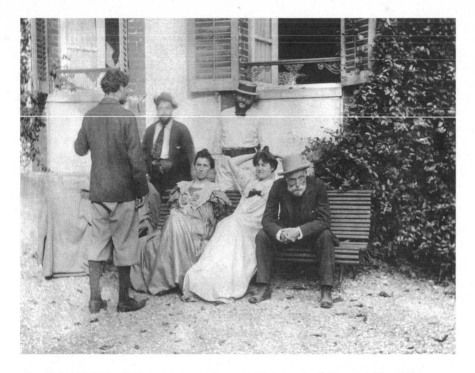

Pierre Bonnard, Cipa and Ida Godebski, Thadée and Misia Natanson and Renoir in the garden of Le Relais, the Natansons' estate at Villeneuve-sur-Yonne, on the evening of Mallarmé's funeral, 11 September, 1898. Gelatin-silver print, 13 x 18 cm (5⅛ x 7⅛ in.). Photo by Louis-Alfred (Athis) Natanson. Vaillant-Charbonnier collection

incidents, Degas and Renoir avoid him and don't acknowledge him any more. What can be going through the heads of these intelligent men for them to become so stupid?'[105] In this instance, Renoir's allegiance to Degas coincided with the anger he felt at Pissarro's anarchism. Degas for his part refused to talk to Pissarro ever again.[106] Renoir's behaviour was petty, rude and pusillanimous, an example of his wheeler-dealing and of the effects of contemporary politics. Despite the fact that they were never close, Renoir and Pissarro retained a mutual respect and an on–off professional friendship. Indeed, around 1900, Renoir made a portrait drawing of Pissarro, which he signed 'A. Renoir', as if to affirm friendship with Pissarro.[107]

When Pissarro died in November 1903, during the Dreyfus Affair, Renoir, who was painting in the south of France, took the train back to Paris to attend the funeral at the Père Lachaise cemetery. In contrast, Degas told the Pissarro family that he had been sick, which was his usual excuse when he refused to

attend former Jewish friends' funerals.[108] If Renoir had been an anti-Semite, he, too, could have given the excuse of illness (actual in his case), but his relationship with Pissarro was sufficiently strong to make him attend the funeral.

Ironically, it is Renoir's friendship with the Bernheims that provides the strongest evidence for his not being anti-Semitic (see pages 200 and 243). Renoir began his friendship with the art dealer Alexandre Bernheim and his two sons, Josse and Gaston Bernheim-Jeune (both then twenty-five years old), in 1895. The amity between Renoir and the Bernheims spanned twenty-five years until the artist's death and is evident in the thirty-eight letters from him to the family from 1898 to 1919, and those written on his behalf by Gabrielle and Pierre.[109] Renoir also gave them valuable business tip-offs: for example, in 1909 Renoir told them that Mme Cahen d'Anvers had put his large portrait of her daughters, which he had exhibited at the Salon of 1881, into their maids' quarters in their home on Avenue Foch since Mme Cahen d'Anvers had decided that she disliked the painting. The Bernheims found the portrait and bought it from her in 1909, keeping it in their private collection for thirty-one years.[110] In 1912, when Renoir could no longer walk, Josse and Gaston brought a Viennese doctor to Paris to try to cure Renoir's rheumatism. Renoir's closeness to the Bernheims may be judged from the fact that when he died in 1919, his son Jean sent the telegram announcing his death to the Bernheims' home rather than their office.

The Bernheims became one of Renoir's three main art dealers, along with Durand-Ruel and Vollard (see page 200). In 1895, the two sons began to buy Renoir's works from the artist for their private collection.[111] By 1898, Renoir himself was writing to M. Bernheim.[112] Later, at the midpoint in the Dreyfus Affair, in January and February 1900, Renoir worked with the Bernheims to put on a major exhibition with sixty-eight of his paintings. It is unlikely that, if Renoir were anti-Semitic, the Bernheims would have wanted to exhibit his paintings in their gallery, nor is it likely that Renoir would have consented to a solo show of his paintings with the most renowned Jewish art dealers in Paris. For the remaining nineteen years of his life, he continued to work with the Bernheims: they showed his paintings in fifteen different exhibitions in their gallery, including a second one-man show in 1913 with forty-two paintings.[113] In the case of the Bernheims, Renoir's actions speak louder than his words. Although he at least once made a racist comment about the Bernheims, as quoted earlier, Renoir's friendship with and long professional commitment to the family demonstrates that his prejudice did not extend to hatred. With this

example and with evidence of his continued faithfulness to them and to his other Jewish friends and colleagues, it is clear that Renoir was not an anti-Semite.

Friendship, such as that which Renoir had with the Bernheims, had always been his lifeblood and became even more important to him as he became increasingly sick. His friends provided the emotional support that he needed in order to persevere in his painting. While he lived and travelled with a bevy of servants, various family members and his care-giver and model, Gabrielle, he longed for the companionship of male friends outside his family circle. As he put it to his patron Gallimard in 1900: 'There aren't enough men in my life. It's a little monotonous in the evening.'[114] By the time he wrote that complaint, the most important female companions in his life were gone. Lise had left him around 1872; his close relationship with Aline from 1878 to 1890 had become more strained but nevertheless continued (their sons Jean and Claude being born in 1894 and 1901); his close professional and social friendship with Morisot had ended with her death in 1895 and, in 1900, his close relationship with Julie and her cousins ended when Julie and Jeannie married.

Renoir travelled with other friends over the years. In 1892, he had voyaged to Spain with Gallimard; with him, three years later, he went to Holland and London.[115] In 1896, two years after Caillebotte's death, he travelled with Caillebotte's brother to the Wagner opera festival at Bayreuth[116] and enjoyed museums in Dresden.[117] In October 1898, Julie recorded in her diary: 'M. Renoir is in Holland with [the artist Abel] Faivre, Durand-Ruel's son, M. Bérard, and E [unidentified].'[118] They stayed in Amsterdam and visited The Hague to see a major Rembrandt exhibition.[119] Still, these visits did not fill the void in Renoir's heart created by the deaths of Caillebotte and Morisot. Nevertheless, in 1894, Renoir had made the acquaintance of two men who would come to fill that vacuum, Ambroise Vollard and Albert André, though both were significantly younger than the painter. When they met, the artist André was twenty-five and the art dealer Vollard was twenty-eight, closer in age to Renoir's eldest son, Pierre, then aged nine, than to him at fifty-three; in a way, they became new sons to Renoir.

André and Renoir met at the 'Exposition Indépendant' of 1894, where the young artist had works on display.[120] At this time, André was already a client of Durand-Ruel but had earlier become a follower of Renoir's art; his work reflects this influence in its bright colour, pervasive light, scenes of daily life and, most of all, his optimistic view of life. During the coming years, André spent a great deal of time with Renoir, often with another young artist, Marguerite Cornillac,

called Maleck, who later became André's wife. André and Maleck loved Renoir dearly and became part of his extended family.

Similarly, Renoir took a fatherly interest in Vollard's budding career as an art dealer. From the first time they met, Renoir felt a close kinship with the young dealer. Vollard was twenty-seven years younger than Renoir, the same age as Renoir's first son, Pierre Tréhot, would have been. Vollard was a Creole, born and raised on Réunion, the island east of Madagascar colonized by France. At nineteen, he went to Montpellier in central France to study law. Two years later, in 1887, he travelled to Paris to continue his studies but soon gave up law to become an art dealer. The young Vollard perhaps made Renoir think of his earlier self, an outsider who by his wits was able to join the insular art world. Just as Renoir had a secret life with his illegitimate daughter, Vollard had a secret life with Madeleine de Galéa, born Moreau, who was also a Creole born on Réunion, in 1874. They had been childhood friends. She came to Paris before Vollard and married a diplomat, Edmond de Galéa. When Vollard arrived in Paris he stayed with the de Galéas for a while. Some rumours suggest that Madeleine's son, Robert de Galéa, was actually Vollard's son. In Vollard's will of 1911, the de Galéas were among his heirs.[121] Vollard's unorthodox relationship with Mme de Galéa and her son could have reminded Renoir of his relationship with his secret daughter.

Renoir became so close to Vollard that eventually he trusted him with the secret of Jeanne, something he never told Durand-Ruel, ten years his senior, a devout Catholic and a widower with five children. In 1899, Renoir needed someone responsible and accessible to be his contact for the mayor in the town where Jeanne and Louis lived. At this time, Renoir probably explained to Vollard that this Mme Robinet was his daughter. Perhaps because Renoir asked Vollard for assistance with his daughter, he felt a debt that made him more inclined to accept Vollard's commissions than he would otherwise have been. Vollard had already revealed his appreciation of Renoir's work, and of its monetary value, in 1892, two years before they met, when he had acquired the *Nude Woman*, 1880, for 250 francs.[122] In 1893, he asked 400 francs for it but did not sell it until 1898 when it went for 2,000. (Eventually, Vollard bought the painting back and in 1910 sold it to Rodin for 20,000, nearly a hundred times its original price.[123])

In 1894, both Renoir and Pissarro encouraged Vollard to take on Cézanne as his client, which Durand-Ruel still refused to do. These two senior artists' enthusiasm convinced Vollard. In November 1895, Vollard mounted a large

show with 150 Cézanne works, during which Pissarro wrote to his son: 'my enthusiasm is nothing next to Renoir's'.[124] Nonetheless, at this point Cézanne was suffering from periodic outbursts of irrational behaviour and drifted apart from Renoir. As Pissarro wrote again to his son, in January 1896: 'my word, it's a variant of what happened to Renoir. It seems [Cézanne is] furious with all of us: "Pissarro is an old fool, Monet is a wily bird…. I'm the only one with temperament. I'm the only one who knows how to make a red"!!…. As a doctor [Augiar] assured us…he was unwell, and that we shouldn't notice, that he was not responsible. What a shame that a man endowed with such a beautiful temperament should be so lacking in stability.'[125] Despite Cézanne's mental problems, Vollard eventually sold 680 of his paintings, which was two-thirds of the artist's total output. Becoming Cézanne's dealer made Vollard enormously wealthy and universally esteemed as an important dealer.

While his friendship with Vollard grew, Renoir wanted to be faithful to his dealer of twenty-two years, but he also wished to be able to give his new friend some of his work. Although Renoir had always given or sold pieces directly to his friends, he might have worried that Durand-Ruel might take offence if he gave or sold paintings to another dealer, even one with whom he had a close friendship. Nevertheless, he was willing to sell Vollard minor works such as twenty small pieces for 1,400 francs in October 1895.[126] Additionally, Renoir exchanged his own art for similarly priced pieces in Vollard's possession, including two watercolours by Manet in 1894 for 350 francs and in 1896 several Cézannes, including *Red Rocks, Lilac Hills, A Large Old Painting (Idyll)* and a *Mont Ste-Victoire*, valued at 2,000 francs each.[127] For the last, Renoir was willing to give Vollard one of his early Impressionist paintings, *The Lovers*, 1875.[128]

Vollard also commissioned Renoir to make lithographs, both in colour and monochrome. For example, around 1894, Renoir had made an etching of Julie and Jeannie, *Pinning the Hat*, that also served as an illustration in Geffroy's 1894 book, *La Vie artistique*.[129] Three or four years later, Vollard arranged for Renoir to be aided by an expert printer, Auguste Clot, in making the same image into both a colour and monochrome lithograph, which became one of Renoir's most popular prints.[130] In addition to selling them, Vollard published Renoir's etchings and lithographs.[131]

In September 1897, Vollard had dealings with Aline when Renoir broke his right arm for the second time.[132] When Jean's godfather, Georges Durand-Ruel, learned of the mishap, he wrote to Renoir: 'I learned that you had a nasty

accident, that you broke your arm; I hope that everything was put back into place and that it will only be a matter of time until you can use your arm like before. You have decidedly bad luck with that arm, since my father told me it was the same one you broke once before.'[133] Thus, on 7 September 1897, Aline wrote on Renoir's behalf to Vollard: 'I received the 300 francs that you sent me. I will remain in Essoyes till the end of October. If you make any dazzling sales, please send me what you can.'[134] Around this time, a year after Renoir's mother had died, Aline told Vollard about the many early works that still remained with Renoir's siblings in his mother's former home.[135] Vollard went to Louveciennes and bought all these works, from the basement to the attic.[136] He also acquired works by Renoir from other owners, including Vincent van Gogh, who had admired Renoir. After Vincent's death in 1890 and his brother Theo's death in 1891, Vollard had approached Vincent's sister-in-law, Johanna van Gogh-Bonger, and in 1897 purchased three works by Renoir.[137]

A few years after Renoir met Vollard and André, an old friend who had drifted away reappeared in his life. Georges Rivière had been a close companion during the Impressionist years of the mid-1870s, but was not a big presence in Renoir's life after that. However, in 1897, Rivière's wife, Maria Eva Jablotska, died of tuberculosis, leaving Rivière with two young daughters, Renée and Hélène, aged twelve and fifteen. Rivière then began reaching out to his old friends, and he and his daughters became close to the Renoirs. It is possible that Aline welcomed the appearance of Rivière's two girls since she loved having Julie and her cousins and always treated them with kindness. Julie, Jeannie and Paule, in turn, began to like Aline more and more. On 17 November 1897 in Paris, Julie wrote in her diary: 'We visited Mme Renoir, who is leaving for Essoyes again. She was very nice to us, and Jean is sweet.' A month later, Julie recorded: 'We went to the Renoirs for dinner.... Mme Renoir [was] as pleasant as could be. She has really taken to us since we spent so much time chatting to her about her part of the country.'[138]

Perhaps because Aline was unusually obese, Julie often wrote about that in her diary. At Essoyes in September 1897, for instance, Julie recorded: 'M. Renoir's sister-in-law has arrived with her son; I prefer Mme Renoir, frankly fat and peasant-like. The other woman has a fatness which has no roundness; she is very ugly with her big, protruding eyes; she didn't say a word and seemed very uncomfortable.'[139] Aline's girth was a theme on which Julie dwelled throughout her diary, beginning during her first 1895 summer trip with the Renoirs. After

ten-year-old Pierre and Aline had been in the water: 'Pierre said to her, "Maman, when you are seen from below, you're even fatter."'[140] Julie also recounted another weight-related anecdote: 'we remained stranded several times on sandbars. After much fruitless effort to extricate ourselves, Mme Renoir, putting all her energy into pressing down with her weight at the front of the boat, succeeded in making it move forward.'[141] Julie also took note of Aline's lack of endurance: 'We spent the day and had lunch at St Nicolas.... A car came to take Mme Renoir and we walked back with M. Renoir.'[142] Aline periodically tried to lose weight but we know from what Renoir and others wrote that she continued to struggle with her weight for the rest of her life. In December 1897, Julie reported: 'She...only drinks milk. She is terribly hungry and she is becoming thinner, or less fat.'[143] Nonetheless, a few years later, Renoir wrote to Jeanne Baudot: 'my wife is gaining weight'.[144]

Julie Manet might have liked Aline, but she mentions Aline's bossiness again and again. Aline liked to mother the girls and thought of herself as the chaperone of the three 'little Manets', as she called them, according to Jeanne Baudot's recollection, who wrote that Aline prevented the three cousins from accepting an invitation to a party that her own parents had allowed her to accept.[145] Aline was also controlling of Renoir. As Gabrielle took over tasks that Aline had formerly performed, including modelling for Renoir, Aline's role in the family became more supervisory, and she managed everyone, including her sick husband. In 1899, Renoir complained to Bérard that his wife coddled him 'like a big baby'.[146] The ailing Renoir, hating conflict, found it easier to let her have her way than to protest about any decision she made, though he often got what he wanted by going behind her back. Julie wrote about the couple's inter-actions in February 1898: 'He was very amusing today: "I should have married a henpecking wife." "But, isn't that the case...", we ventured, Paule, Jeanne Baudot and I. M. Renoir seemed very surprised and a little while later told us that we had just informed him of something of which he was unaware.'[147]

With Aline so headstrong, one of the few ways for Renoir to do as he wished was to live essentially a separate life from his wife. They slept in sepa-rate rooms, sometimes on different floors, and they often travelled without one another. In December 1900, Renoir wrote to Durand-Ruel: 'My wife is going to spend the New Year break in Paris. She'll come to give you some news from me and give me some from you when she returns.'[148] The next day, André wrote to Durand-Ruel: 'I went today to see Father Renoir who is recovering from a touch of gout which struck him last week. I am going to stay several days with him

when he will be alone, since Mme Renoir needs to go to Paris next Saturday.'[149] Renoir often took advantage of his wife's absence to work, as he wrote in 1898 to a friend: 'My wife left for her hometown for a month and I would like to take advantage of the peace and quiet to get as much work done as possible.'[150]

Despite all this, Renoir often acquiesced to whatever Aline wished. As in the past, Aline continued to insist on seaside holidays, which she knew Renoir despised. In the summer of 1895, when Pierre was ten, they rented a little house in Tréboul on the Baie de Douarnenez, Brittany. Renoir complained to Bérard: 'What bothers me is the obligatory sea bathing at the end of the month...which, in spite of the horror I have of the seashore, I am going to be forced to swallow.'[151] Julie was also well aware of Renoir's displeasure, recording: 'He was swimming so he could teach Pierre to swim and dive but became more and more uncomfortable in the water, while Mme Renoir, who ran out of breath doing even a few strokes, acted as a buoy.'[152] Three years later, in July 1898, Aline demanded another seaside vacation against Renoir's wishes, wanting to rent a chalet in Berneval near Dieppe. In order to choose a place to stay, Aline planned a day trip there with Renoir, Jean, Julie, Jeannie and Paule. In her diary, Julie wrote: 'Monsieur Renoir didn't feel like renting one of the frightful chalets here, but Mme Renoir did; so they rented one.... Renoir said to us as we were leaving: "You are very lucky that you will not return here again."'[153]

But it was not only vacations that Aline controlled. She loved living in Essoyes and decided to buy a house there. Although the family was still renting their Montmartre home at rue Girardon, they had accrued enough money to afford to buy a country house. Julie Manet reported in her diary on 29 November 1895: '[Renoir] now has to go to his wife's part of the country to buy a house that he doesn't want to buy.'[154] Nevertheless, Aline convinced Renoir to acquire a rustic house on three floors. It took a year to finalize the purchase, which occurred in September 1896.[155] Until this point, Renoir had never owned a home or studio; he had always rented. Even though Renoir had disliked the idea of buying the house, he grew to enjoy working in Essoyes. He often painted the hills covered with vines, the grape-pickers carrying baskets on their back or pushing wheelbarrows, and the women washing clothes in the Ource river. Aline loved Essoyes even more. As Renoir wrote in 1898: 'My wife is still in her country, which she leaves reluctantly.'[156]

In Paris, meanwhile, from October 1896, Renoir rented a studio at 64 rue de la Rochefoucauld, in the ninth arrondissement, which Julie Manet described

as his 'superb studio in Rue de la Rochefoucauld'.[157] The following April, the family moved off the Montmartre hill down to an apartment on the same street, at number 33. The new apartment had a yearly rent of 2,000 francs, which was well within Renoir's means, since his credit from his dealer for 1 September 1896 to 31 August 1897 came to 6,680 francs.[158] Their apartment was in an elegant corner building, on the top residential floor, reached by climbing five winding flights of stairs. A huge balcony surrounded the apartment. Renoir's room had a bathroom with a toilet, a washbasin and running cold water. For washing, maids heated cold water in the kitchen and brought it to the bedrooms. Renoir's room was connected to Aline's, and a corridor led to the children's room, an additional bathroom, the kitchen, dining room and living room. Wood or coal burned in fireplaces that heated every room. From 1860 onwards, there were electric lights in the Paris streets, yet gas lamps lit this apartment. All the servants for each family in the building lived on an unheated sixth floor, accessible only via a rear staircase, with five maids' rooms, a basin with a drain, running cold water and a stand-up toilet.

Throughout these years, Renoir continued to portray Jean, making at least sixty paintings, drawings and etchings from Jean's birth to age seven. Renoir treasured these works and saved fourteen paintings of Jean alone and four of Jean with Gabrielle in his studios (see page 241). The earliest images portray Jean as a newborn. Later, he appears as a baby with a huge, white, frilly bonnet, sucking a biscuit. In some he sits with Gabrielle at a table on which they play, read or write. Renoir wanted to be able to paint long, silken locks, so he refused to allow Jean's hair to be cut. As Julie Manet noted in her diary when Jean was two years old: 'Jean has taken on the look of a little girl.'[159] The next year, 1897, she praised his red hair: 'Jean is sweet with his red hair against the russet trees.'[160] Renoir's adoration for his son shines through in his work of which Julie wrote: 'The portrait of Jean in a black velvet outfit with a guipure lace collar and a hoop in his hand is hung in the salon. It looks very good and one could almost take it for the portrait of a little prince.'[161]

Jean was a charming child, upbeat, gregarious and funny. Julie again, in December 1896: 'The little kid is always excited, witty and very funny. He tried on the model's hat, played the violin, kidded around. He doesn't like Mozart, she doesn't like Mozart.'[162] When Jean was four, of a journey to Berneval in July 1898, Julie wrote: 'At 8 o'clock we were at the Gare St Lazare Station where we found M. and Mme Renoir and Jean, who fidgeted like a little devil for the entire

journey and interrogated a person, who had some canaries with her, about her life, what she was going to do in Dieppe, etc'.[163] A few days later, Renoir wrote with delight to Jeanne Baudot about her godson: 'Jean is handsome and quite a handful', and two years later to her, 'Jean has had a growth spurt'.[164]

Much to Renoir's relief after the trouble with baby Pierre, Jean was healthy, as his father commented to Monet when Jean was six months old: 'Happily, everything is going well for the moment at my house. Jean is in great health and has gone through the winter without any problem. Let's hope it continues.'[165] He caught the common childhood diseases of chickenpox[166] and measles,[167] and had one serious case of bronchitis when he was two, in February 1897, as Renoir described: 'We never stopped having sickness this winter and, now, Jean still has bronchitis. We have been very worried. The fever has stopped increasing. I hope that he will pull through again.'[168] But, all in all, Jean was rarely ill and when he was six, Renoir could inform his godmother: 'Jean is superbly healthy.'[169]

The month that Jean was born, Pierre began to attend Sainte-Croix de Neuilly boarding school, which he attended for nine years. He loved Sainte-Croix, which specialized in theatre studies and football. Pierre showed an early aptitude for acting, perhaps because he was accustomed to being looked at from modelling for his father. After he started school, he modelled for Renoir much less, both because he was rarely home and because Renoir preferred painting younger children, especially before they had their hair cut. Nonetheless, Pierre appears in a few paintings, the most important of which, *Lunch at Berneval* (1897–98), shows him as the focal figure in the right foreground, immersed in his homework; in the background Gabrielle sets out breakfast and speaks to a long-haired Jean now wearing trousers.[170] A related painting also shows Pierre reading in profile. Renoir also made a few head-and-shoulder portraits of Pierre (a painting and three pastels).[171] In July 1895, at the end of Pierre's first year at school, he won ten prizes, including first prize in grammar and English, second prize in calculus and drawing and a 'unique prize for wisdom'.[172]

That summer, the family went on the vacation to Brittany where newly orphaned Julie Manet and her cousins joined the Renoirs for the first time. She was touched that 'Pierre came to meet us' off the train.[173] Ten-year-old Pierre was six years younger than Julie. During that summer, Julie later recalled, 'He was a delightful child, and used to trot off behind his father carrying a tiny panel saying, "I'm going to do a small sketch."'[174] That September, she wrote: 'Jeannie and I went for a very nice walk with M. Renoir and Pierre.'[175] A month

later, after Julie and Renoir had walked back from Sainte-Croix with Pierre, she wrote: 'Monsieur Renoir constantly uses the phrase "Little Kiddo" [*petit moutard*]. Since this summer, we too began nicknaming him the "Little Kiddo" because one day he told us, referring to the trip to Brittany: "It's quite a long trip for a little kiddo like me!"'[176]

When Renoir and Aline were away from Paris, they relied on family friends to help Pierre at boarding school. One such helper was Léon Fauché, Renoir's studio neighbour. In April 1899, Renoir wrote to Durand-Ruel: 'I will ask Fauché to ask you for 100 francs to buy clothes for Pierre.'[177] Bérard was another friend enlisted to help, Aline jotting down the basics to him: 'Pierre Renoir, Sainte-Croix School, 30 avenue du Roule, Neuilly (Seine), Sunday – pick him up at 10.30 in the morning and bring him back before 8.30 in the evening.'[178]

One of the most reliable of Pierre's care-givers was Jeanne Baudot. Pierre did not have his own godmother, while his godfather, Caillebotte, had died the year Pierre left for school, and Jeanne became his surrogate godmother. In February 1900, Renoir wrote to her: 'I'm delighted that Pierre's having such a great time with you. This makes up for his being so far away.'[179] And a month later, Renoir thanked her for taking Pierre to a play: 'Pierre was very happy to see the classical theatre. He has wanted to go there for a long time. You're spoiling him too much.'[180]

In the winter of 1897, when Pierre was twelve and Jean was three, Victor Charigot, their maternal grandfather, who by then had moved to North Dakota, came to France and met his grandsons for the first and only time.[181] Years after this visit, Jean wrote to Pierre, 'The little girl that our grandfather Charigot showed you a photograph of, is our aunt or half-aunt (I do not know what to call her) Victoria.'[182] Victor stayed in France for a few months, returned to his American family and died aged sixty-two in December 1898.[183]

Unlike Aline's father, Renoir was always a devoted father and guardian. Besides being involved in the lives of his sons and secret daughter, he continued to take a fatherly interest in Julie Manet and her cousins. In January 1900, Renoir learned that Julie was engaged to Ernest Rouart, whose father, Henri, the engineer, painter and collector, was a close friend of Degas's, as noted earlier. Renoir wrote to Julie from Grasse: 'A thousand times Bravo!!! My dear Julie, Now this is really good news that has filled my wife and me with joy. Now I can tell you that he is the fiancé of our dreams. My wife spoke about him to Degas when we were coming back together from a dinner at your home. Our wish is

now accomplished, once again, Bravo!!!.... My wife and I send you all our love, and I'm ordering a new suit. Renoir.'[184] Four months later, on 31 May 1900, Julie and Ernest were married in a double wedding ceremony with Jeanne Gobillard and the poet Paul Valéry. (Paule Gobillard never married but remained close to Jeanne and Julie, their husbands and their children.) Although Renoir and Aline had planned to go to the wedding, a week before the ceremony, he had written to his dealer a discouraged note: 'I am taking care of myself as best as possible, I assure you, even though I know it's useless.'[185] The day before the wedding, he was still in Grasse and in poor health.[186]

Renoir was able to have the relationship with Julie that he could never enjoy with his own daughter, Jeanne. With Julie, he could be openly fatherly and had no need to worry about money since she had her own inheritance and status as a member of the upper class. In contrast, Jeanne had to be kept secret and was poor, illegitimate and lower class. Renoir could not contact her openly and was restricted to sending surreptitious letters. Jeanne was a terrible correspondent and her indecisive behaviour, not too dissimilar to his own, frustrated Renoir. His correspondence with her often included curt discussions of money and pleas for letters of response. No letters from him to Jeanne and Louis exist from the six years after their marriage in 1893: it may be that Renoir stopped in to see them during this period, since he often visited friends not far from the couple. Then, from 1899 and 1900, Jeanne saved six letters from her father, in which he writes only about Jeanne and Louis's request for money to buy a house that contained a bakery where Louis could work. He tells her nothing about his life, health or family, and asks her nothing about how she and her husband are doing. These six letters are strictly about business.

The artist had never wanted to own his own house and was sceptical about the young couple's need to own a home. Aline had pressured him into buying their Essoyes house only recently, in 1896. It could be that Renoir thought that his comparatively young daughter, then twenty-nine, and her husband aged thirty-seven should not make such a commitment. Nonetheless, he decided to help, and sent them a letter to inquire about the details of their proposed purchase: 'I was never able to figure out exactly if these people wanted to sell their house or if it is you who likes it and who hopes to own it. If they wish to sell, how much are they asking for it? Do they want it to be paid all at once, or will they give you more time to pay for it? When you find out all that, write me when you have the chance. And if they do not want you, but someone else, as a

buyer, as you implied, why worry?.... If this deal does not work out, you won't die; you'll find something else somewhere.' He continued: 'I see that the Madré house, where the oven is, went up in price. Your husband had mentioned only four thousand francs.' And added: 'I will send you money in a few days. Don't answer those questions I asked until after you receive these funds. Renoir.'[187]

The fact that Jeanne would not be the one to inherit the house if Louis should die first also concerned Renoir. According to the Napoleonic Code, should the husband die first, wives came after up to thirteen of her husband's close relatives as inheritors. Renoir advised, in another letter: 'My dear Jeanne, *Read this carefully, and give it some thought.* According to your marriage contract, should you happen to die first, your husband inherits the house, since you yourself have no inheritors. But it is a different scenario should your husband be the one to die first. He has heirs and they will inherit the house.' Since Louis had no living parents, adult siblings or children, the heirs Renoir mentions must have been his underage siblings. Renoir worked out a simple scheme to get round this problem: 'Thus, to protect yourself from this serious drawback to you, be kind enough to discuss this with the notary and check with him if my suggestion is a valid one. I simply suggest that it is stipulated on the deed that the money was provided by M. Renoir, or else your husband should write me a receipt fashioned according to the model featured on page two.' Renoir's proposed receipt stated: 'I hereby acknowledge owing Monsieur Renoir the sum of four thousand five hundred francs, borrowed towards the purchase of a house in Madré (Mayenne). Monsieur Renoir commits himself to require this money only after the death of both Robinet spouses...etc. Signed Robinet, This receipt to be authenticated by the mayor.'[188] Such a document would mean that the house effectively belonged to Renoir and that he was lending it to the couple until they both should die. In this way, Renoir was being generous to both his daughter and his son-in-law. Jeanne and Louis followed his advice.

Once Renoir had dealt with the business aspects of this process, he added warmth and congeniality in his postscript: 'P.S. Of course it is understood that I hope that both of you will die as late in life as possible and a long time after me. But in business, you have to think of everything and if I did not do so, I would be in the wrong towards both of you. Your husband is a nice guy whom I like very much and I hope he lives to be a hundred years old. R.'[189]

Renoir's shrewdness extended to his end of the transaction as he came up with a way to keep his gift a secret from Aline and others. He divided the 4,500

francs into three parts. His bank account would have shown a transaction of only 1,500 francs. Another 1,500 came from Vollard, to whom Renoir presumably gave a minor work of art. The third source was Fauché. On 9 February 1899, Renoir informed his daughter that his third was on its way: 'My dear Jeanne, I have just sent you fifteen hundred francs, –1,500–. Be kind enough to reply as soon as you have been notified.' To keep Aline unaware of the transaction, Renoir requested: 'Write me back at 14 rue Pigalle, Mlle Maliversery.'[190] Mlle Maliversery was one of the Renoirs' maids who resided separately from the family.

For his part, Vollard wrote on the same day to Jeanne: 'Madame, Monsieur Renoir asked me to send you *fifteen hundred francs*.' The young dealer requested that when she received the money, she should confirm this by writing to: 'Vollard, Art dealer, 6, rue Laffitte...Paris.'[191] This February 1899 letter seems to be the first exchange between Jeanne and Vollard. The probable plan was that Vollard would first be contacted and he, in turn, could communicate confidentially with the artist. In the same letter of 9 February, Renoir wrote to Jeanne that he would later send her more money on top of the 4,500 francs for the house: 'I will send you one thousand francs around 14 April, not before.'[192] At this time, his rheumatoid arthritis was beginning to act up, and he was planning to leave for Cagnes for the rest of winter until spring. To Jeanne, in the same letter, he only wrote: 'I am leaving Sunday and I want to know if this money has arrived before I go', urging them to respond: 'Since I only leave on Sunday, I have time to receive an answer because you won't hear from me for about six weeks.' He continued with fatherly advice: 'Now I persist in advising you both not to rush so as not to make any blunders you would regret later. You are old enough to know what you want. Only you are responsible if you do silly things, whereas I only have to tell you to do what you wish without letting yourself be carried away.'[193] He did not tell her where he was going or why. As with every relationship in his life, Renoir kept some things secret. He was in Cagnes from mid-February to mid-April 1899.

Louis and Jeanne had the necessary funds but finalizing the purchase of a house moved more slowly than anticipated. Negotiations began again eighteen months later, on 15 August 1900. Jeanne, it seems, had been reluctant to tell Renoir the details of the potential purchase. He again wrote to Jeanne in an annoyed tone: 'Dear Jeanne, Go to the notary with all the relevant information and bring me up to date. I'll come to see you around the 25th, I think, or at the end of the month. Had you told me this at once instead of being so secretive,

I would not have worried so much. But you told me that you could not explain things in a letter etc. Anyway, as long as nothing terribly bad has happened. Give me the information that I asked you for and I will do the best I can. Above all, do not tell those in your village that you want this house or they will make you pay double its worth. Say the opposite.'[194] Again, Renoir's advice shows his shrewd business sense. The details of what happened next are unclear. There is no evidence of whether or not Renoir visited them as he had promised. It is also unknown whether the house they purchased was the one about which they had corresponded, but Jeanne and Louis did eventually buy a house with an oven that served both as their home and as Louis's bakery.[195]

Even in the south of France, Renoir worried that Aline would somehow find out about his secret daughter. When he wanted to send another small sum of money, he posted it from Châteauneuf-de-Grasse, a town neighbouring Magagnosc, where he was renting a house. In February 1901, he told Louis to reply to him at the post office in that town: 'Please respond directly to M. Renoir, General Delivery, Châteauneuf-de-Grasse, Alpes-Maritimes.'[196] To escape the cold, Renoir stayed in Magagnosc from mid-November 1900 through April 1901. Aline, Jean and Gabrielle were with him much of the time. Early in this trip, Aline became pregnant with their third child.

Chapter 5

1901–09

Renoir aged 60–68;
Baby Coco,
Debilitating Illness and Worldwide Fame

When Claude Renoir, called Coco, was born on 4 August 1901, Renoir was not happy. A month after Coco's birth, the painter wrote to a friend: 'I have just received your kind congratulations, but it does not make me any prouder. The nice little kid could very well have stayed where he was. I will get used to this little by little, but I am really very old [he was sixty] and somewhat tired of everything.'[1] At this point, Renoir and Aline were in much worse physical shape than they had been at the births of their two older children. Renoir's rheumatoid arthritis was increasingly debilitating, and he was often tired and in pain. His hands and fingers were subject to temporary paralysis, the

Aline pushing Coco's carriage, Le Cannet, 1901–02. Photographer unknown

worst scenario for any painter. For her part, Aline at forty-two years old was overweight and often sick with bronchitis. She was also experiencing the first signs of diabetes, which would plague her for the rest of her life.

Aline's condition contributed to the difficult delivery, which took place at the family's house in Essoyes.[2] Renoir wrote to Jeanne Baudot's mother on the day of Coco's birth: 'Here I am in charge of a third son. The operation was painful, but the result is good. All is well now.'[3] Three days later, he reiterated this to Wyzewa: 'My wife had a third boy, and she was pretty ill. Fortunately, today everything is fine. We have re-entered the calm', although he himself was having 'daily and rather strong attacks of rheumatism'.[4] However, the delivery was also difficult for the baby. As Renoir explained to Jeanne Baudot, 'Currently, young Claude cannot nurse because he had to have his tongue pulled when he came into the world, and the resulting swelling, which is starting to decrease, makes this kind of exercise uncomfortable for him. We hope this small inconvenience will be gone by tonight or tomorrow.'[5]

Perhaps Renoir's preoccupation with his own health caused him to be less involved in naming this third child. Or perhaps Aline insisted on the name Claude, popular in her family.[6] Renoir was somewhat sceptical of the name and joked, in the same letter to Jeanne Baudot: '[Jean's] baby brother is named Claude as in a Reine [Queen] Claude [greengage plum].'[7]

Aline, Coco and Pierre, Le Cannet, *c.* 1902. Photographer unknown

A year later, Coco was baptized, as the certificate states: 'On 21 August 1902, Claude Albert, who was born on 4 August 1901, was baptized in Essoyes, the son of Pierre-Auguste Renoir and of Aline Victorine Charigot, residing in Essoyes.'[8] The godfather was Albert André (giving Coco's second name) and the godmother was Mélina Renard, a close family friend from Essoyes. She and her husband, Joseph Clément Munier, a local wine-grower, took care of the Renoirs' Essoyes house when they were absent.[9]

Painting and drawing Coco appealed to Renoir strongly, despite his misgivings about having another child at this stage in his life. In the end, Coco modelled more frequently than both his brothers combined. At the time of Renoir's death in 1919, his studios contained 7 portraits of Pierre, 20 of Jean and 38 of Coco. Sometimes he portrayed Coco alone, as at age six, when he mimics his father, painting indoors at a miniature easel.[10] At other times, Renoir posed Coco with Renée Jolivet, the daughter of the local midwife who may have helped deliver Coco.[11] Renée came to the Renoirs when she was sixteen and worked for the family for several years as nursemaid to Coco and model to Renoir. In the large *Claude and Renée*, 1903,[12] she stands holding Coco who is wearing the same hat, dress and shoes that Jean had worn seven years earlier in the large *Artist's Family*, 1896 (see page 198).[13] Cognizant that Coco was not included in *The Artist's Family*, Renoir decided when Coco was around four years old, to paint a companion piece. He depicted Coco walking with Renée in a similarly large canvas, *The Promenade*, c. 1906 (see page 242).[14] Until his death, Renoir displayed these two large family portraits on the same wall of his Cagnes home.[15] These two large paintings displayed together call to mind Rubens's Marie de Medici cycle in the Louvre and suggest that, as with Renoir's similarly big *Large Bathers, Experiment in Decorative Painting*, 1887 (see page 194), he still wanted to do decorative wall paintings in the tradition of the Pompeian painters and Raphael, Rubens and Puvis de Chavannes.

A family photograph taken in about 1902 in Renoir's Paris studio when Coco was about one shows Renoir with his white beard and cane, looking frail and elderly (see opposite). Aline, wearing a frilly blouse and long skirt, holds baby Coco. Pierre at seventeen appears adult and serious in his jacket and tie, while Jean at eight looks young with his short hair. None of the three boys resembles one another. Not visible in this black and white photograph, Pierre had dark hair and Renoir's dark eyes; Jean took after Aline with reddish-brown hair and blue eyes; Coco had Aline's blue eyes with Renoir's blond hair and eyebrows and later

The Renoir family (Aline, 43; Coco, 1; Jean, 8; Pierre, 17; Auguste, 61) in the painter's studio
at 73 rue Caulaincourt, Paris, c. 1902. 9 x 6 cm (3½ x 2⅜ in.). Archives Vollard, Musée d'Orsay, Paris.
Photographer unknown

inherited Renoir's delicate thinness.[16] Besides looking unlike one another, each of the sons grew up in widely different circumstances, resulting from the large difference in years among them. Pierre was raised in secrecy and poverty; Jean was born into stability and wealth; Coco grew up with preoccupied, sick parents.

The constantly moving family complicated Coco's childhood. Renoir's health necessitated yearly trips south. As the artist wrote in 1902: 'Unfortunately, terrible rheumatism makes it necessary for me to leave Paris when the cold weather comes.'[17] While he had formerly spent two months in the south and the remainder in the north, from about 1899, Renoir gradually increased the time in the south until it was eight months, with the remaining four spent moving back and forth between Paris and Essoyes. Gabrielle always accompanied Renoir. Usually, Aline preferred to spend her time in Essoyes with baby Coco, making occasional visits to Renoir. Until Pierre left school, he spent the year boarding at Sainte-Croix and visited his parents during the vacations.[18] Aided by France's excellent railway system, the family came and went continually. As Renoir complained to Jeanne Baudot in 1903: 'Too much coming and going, really. What a crazy idea people had to invent the railways. I am one of its many victims.'[19] In the south, Renoir and Gabrielle lived in many different rented apartments, houses and even hotels on the French Riviera or Côte d'Azur, between Le Trayas and Cagnes-sur-Mer. Sometimes, he sought treatment at medicinal spas. Once, at a particularly elegant spa, Bourbonne-les-Bains, Aline and the children came to visit.[20]

Even in the months he spent in the north, Renoir was always on the move. He regularly commuted between his wife in Essoyes and the art world in Paris. Despite three children and debilitating health problems, art was still the main focus of his life. Just as he had in the past, he often travelled to paint portraits. Seventeen days after Coco's birth, Renoir wrote to André's girlfriend, Maleck: 'I will leave Essoyes in two days...to do portraits', giving as a return address his Paris apartment, 33 rue de la Rochefoucauld.[21] He was going to Fontainebleau at the request of Alexandre Bernheim to paint his sons' fiancées, the Adler sisters.[22]

Aline, meanwhile, lived on a different schedule from Renoir. While she spent most of her time in Essoyes, she sometimes visited her husband in the south, bringing along Coco as well as Jean and sometimes Pierre. When Coco was two years old, Renoir commented sympathetically about Aline's comings and goings: 'It is quite difficult with a child.'[23] Back in February 1902, Renoir wrote to his dealer: 'My wife arrived yesterday in good health with the two little ones.'[24] Then, the following month, Pierre came down to join the family during

spring vacation, about which Renoir wrote to Jeanne Baudot: 'We are looking forward to seeing Pierre Friday morning.'[25] (André had written the same month to Durand-Ruel: 'Currently the whole Renoir family is reunited.'[26])

Even though Renoir was happy with family reunions, these gatherings distracted him. In February 1904, Renoir wrote from Paris to Aline, who was then in Essoyes with Coco: 'I think it is preferable to leave me alone down there until Easter.'[27] Easter was on 3 April that year; Renoir wished to spend two months in Cagnes with only Gabrielle, without his family. Aline must have agreed to his wishes since she did not insist on coming sooner but brought the family for the Easter holidays. At this point, she and Renoir were so emotionally disengaged that two months apart, even with a small child, was acceptable to both of them. Despite the visits of his family, Renoir often felt isolated from his friends and colleagues. To combat his solitude, during several of the winters from 1903 through 1908, Renoir rented the Villa de la Poste in Cagnes, a house connected to the post office. He rejoiced in the constant flow of people going to get their letters, exclaiming: 'We are less isolated.'[28] Two photographs of around 1906 show both Renoir and his five-year-old-son near a brick fence outside the Villa de la Poste (see pages 224–25).

In contrast, in Paris Renoir loved being part of the artistic community. However, the family's fifth-floor apartment posed difficulties. Early in her pregnancy with Coco, Aline had found it impossible to climb the stairs, so she had avoided living there and spent most of her time in Essoyes, and Renoir's poor health made the climb burdensome for him, too. In April 1902, he decided to move to a first-floor apartment at 43 rue Caulaincourt in the eighteenth arrondissement. The same month, he also moved his studio to the first floor at 73 rue Caulaincourt. In a letter of 1 May 1902, nine months after Coco's birth, Renoir explained: 'I've returned to Paris. My wife is in Essoyes and will be so until my [Paris] apartment is all set up.'[29] The Renoirs' Paris staff arranged the move so that Aline did not need to be involved. Even though she became comfortable with the new apartment, she preferred spending her time in Essoyes (as Renoir wrote in 1898 to Julie Manet, as noted in Chapter 4).

Aline's health was increasingly an issue. Numerous letters and documents show that she refused to do anything about her obesity and early symptoms of diabetes. Renoir's sympathy for her problems was tempered by long-standing frustration. For example, from Cagnes in December 1903, he wrote to Jeanne Baudot: 'I am very worried about my wife. She wrote me that Doctor Journiac

Coco in front of the Villa de la Poste, Cagnes, *c.* 1906. Photographer unknown.
Jean Renoir Archives at UCLA

has discovered that she is suffering from albuminuria. I have been worried for a long time that this would happen to her and I think, or rather, I fear, that it is quite serious. I think she will be coming back soon and that I will be able to have more news. I wrote to her that it was nothing, considering her difficult labour and delivery of Cloclo, but I do not believe a word of what I wrote.'[30] Albuminuria (a condition in which the protein albumin enters the urine) is frequently found in diabetics when the disease is long-standing and left untreated. Unfortunately, during Aline's lifetime, the only possible treatment was weight loss, with which Aline unsuccessfully struggled. Insulin, the modern method of controlling diabetes, was not discovered until seven years after Aline's death. Five years after the initial albuminuria diagnosis, Aline was still refusing to deal with her condition, as Renoir wrote to Rivière in early 1908: 'My wife has albumin and despite the doctor's recommendation she continues to do the opposite of what she should do.'[31]

Diabetes lowered Aline's immune system, making her highly susceptible to respiratory illnesses. For example, from Paris in September 1908, Renoir wrote to a friend: 'My wife has a cold in Essoyes with Claude. I left her there without knowing if she'll recover with this cold weather.'[32] Two years later, Gabrielle added to another letter from Renoir: 'Madame Renoir is recovering from a very bad cold. She isn't over it yet.'[33] Colds were not the worst of her problems, as Renoir complained in the summer of 1906: 'I left my wife with severe bronchitis and emphysema. It'll end up going badly, but having a woman cared for is above human strength.'[34] These quotations capture Renoir's frustration and resignation to the fact that Aline refused to take care of herself.

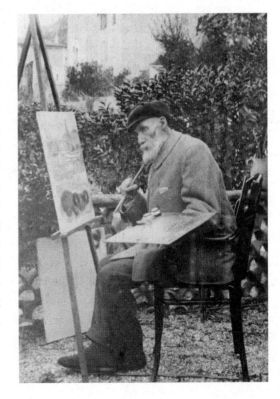

Renoir painting in front of the Villa de la Poste, Cagnes, c. 1906. Photographer unknown. Durand-Ruel Archives, Paris

As Renoir's disgruntlement and frustration distanced him further from his wife, Gabrielle assumed many of Aline's former roles. Although she had been hired to look after Jean, now her primary responsibility was to Renoir. A devoted employee, she was his maid, model, care-giver and companion. Despite the fact that she was related to Aline, Gabrielle was technically hired help. Everyone referred to her as Renoir's maid.[35] When writing in her journal about Gabrielle, Julie Manet also designated her as Renoir's 'nursemaid'.[36] Gabrielle, too, thought of herself as of lower status, referring to Renoir deferentially as 'the boss'.[37] She consistently equated herself with people whose class was lower than that of Renoir and his friends. For example, in 1905, she wrote a note on the reverse of Renoir's congratulation letter to Maleck on her marriage to André: 'I'm taking the liberty of sending my love to both you and M. André. Hello from all our neighbours and from the washerwomen. Gabrielle.'[38]

Renoir himself defined her this way, as when he wrote to Bernheim: 'P.S. I shall be alone with my maid. R.'[39] Gabrielle was subject to Renoir's unpredictability and indecisiveness. For example, in April 1904, when they were in Cagnes, Renoir explained to Maleck: 'I am pretty tired of the south of France.... I can't tell you the exact date of my departure, it's nerve-wracking. I might suddenly tell Gabrielle that we are leaving tomorrow and phew.'[40] His easy companionship with Gabrielle shows his modest view of himself, since despite reaching the height of fame, he still thought of himself as a person who could be friendly with someone from a lower class. He jested self-deprecatingly to André: 'I am a poet. People say this to me every day. Poets dream. The sun, the scents, the distant ocean. What do I know? I joke around with Gabrielle.'[41]

Gabrielle's primary duty was modelling. Since Renoir painted every day, she modelled frequently. The artist Jacques-Félix Schnerb, who visited Renoir in February 1907, described her in his diary: 'One of his maids [is] a brown-haired woman. I think she is the same model who posed for the resting woman at the Salon d'Automne.' He also wrote of seeing Gabrielle 'posing seated, her shoulders covered with an Algerian scarf, her breasts somewhat visible. We chat while he continues to paint, holding his brush in his hand, which was deformed by gout, and he is vigorously scrubbing the canvas whose image is clear to see.'[42] While called a maid, Gabrielle was actually part of the family, both literally as Aline's relative and figuratively in her closeness to Renoir. She appears to have been a kind, warm person who was compassionate about Renoir's suffering, caring enough that she asked Renoir's friends for help on his behalf. In January 1908,

in a short note on the back of a letter that Renoir wrote to Rivière, she explained that he 'has had a small hernia for the last few days and he's worried even though he isn't getting it checked out. Please write to reassure him.'[43]

In turn, Renoir felt equally responsible for Gabrielle. When she needed medical attention, he was willing to return to cold Paris so that she could see a doctor. In the height of winter, in mid-February 1904, they left Cagnes by train and travelled overnight to Paris. There they joined Pierre at the family apartment. The rest of the family was staying elsewhere: Aline in Essoyes with Coco and Jean at his Paris boarding school. After arriving in Paris, Renoir explained in a letter to Aline: 'Tomorrow Gabrielle is going to see a specialist with Mlle Cornillac for her pimples. I preferred to delay [my return to the south of France] so as not to have to come back if she were sick. In the south of France it wouldn't be fun [for her to be sick].'[44] Renoir never even considered replacing Gabrielle or sending her to Paris alone.

Furthermore, Gabrielle was privy to Renoir's deepest secret – his illegitimate daughter. As Renoir and Gabrielle travelled by train here and there, they stopped to visit Jeanne, her foster family and friends. At this period, it is astonishing that Renoir managed to keep any secrets at all because his fame and fortune were rising rapidly. After twelve years of primarily bad reviews and another twelve of decidedly mixed reception, from 1888 onwards, the evaluations of Renoir's art had become overwhelmingly positive. The acclaim that his paintings had found in America had quickly spread throughout France and the rest of Europe. Fame did not suit Renoir. He did not feel like a star and was annoyed to be treated in this fashion. The unprecedented public acclamation accentuated his existing anxieties. This negativity had many possible causes: his infirmity, his years of struggle, his view of himself as a craftsman and his possible fear that fame would impede his creative progress. However, he managed to persevere by maintaining his modest outlook, as he wrote to Durand-Ruel in early 1909: 'I am glad to know that the collectors are less stubborn. Better late than never. But this will not keep me from continuing my daily grind, as if nothing had happened.'[45]

Even though he disdained being in the spotlight, Renoir made an effort to find out what was said about his art, subscribing to two newspaper services. In 1904, they sent him 59 reviews of exhibitions from Austria, France, Germany, Spain, Switzerland and the United States. Between 1901 and 1910, Renoir's paintings were shown in 29 exhibitions around the Western world, of which 8 took place in France (4 at Bernheim's gallery and 4 at Durand-Ruel's), 8 in

Germany, 2 in the United States, 4 in Britain, 3 in Belgium, 1 in Switzerland and 3 in the Austro-Hungarian Empire. All these exhibitions were group shows, except for Durand-Ruel's in Paris in 1902.[46]

Renoir, a leader of the Impressionists and, therefore, an artistic revolutionary, had always been worried that newspaper critics would portray him as a political revolutionary as well; he feared being considered in the same category as the anarchist Pissarro. At last, in October 1904, at the opening of the Salon d'Automne (which had replaced the May Salon of earlier years), an interview was published in *La Liberté* that refuted this false image of Renoir. The journalist, C. L. de Moncade, began: 'I have been to see the painter Renoir, and I confess that my first impression was one of complete stupefaction. I thought I was going to meet an ardent, impetuous man, pacing feverishly the width and length of his studio, delivering indictments, demolishing established reputations, vindictive, if not full of hatred, in short, an intransigent revolutionary.' Yet, Moncade discovered, 'He is a sweet old man, with a long white beard, a thin face, very calm, very tranquil, with a husky voice, a good-hearted manner, who welcomes me with the most amiable cordiality.' Renoir, too, did his best to dispel his reputation as a political revolutionary: 'You see...my existence was exactly the opposite of what it should have been, and it's certainly the most comical thing in the world that I am depicted as a revolutionary, because I am the worst old fogey there is among the painters.'[47] Indeed, by 1904, Renoir had not only accepted the official government award of the Légion d'Honneur but was also painting in a more conservative style than he had in the 1870s, and was included in a series of photographs of notable Parisians called *Nos contemporains chez eux* (Our Contemporaries at Home; see page 229).

Renoir's exhibit at the 1904 Salon, which included masterpieces such as *Luncheon of the Boating Party* and *On the Terrace*,[48] got superlative reviews, but the artist still could not believe that the critics and public would continue to appreciate his works. Despite his success, he went on seeing the Salon as a humbling experience, as he told Moncade in the same interview: 'Certainly I'm in favour of Salons, they're an excellent lesson in painting. One thinks one has a marvel which is going to bowl everyone over. In the studio, it's enormously effective, it receives much acclaim, and your friends come and pronounce it a masterpiece. Once in the Salon among the other canvases, it's not at all the same thing any more, and it doesn't bowl anyone over. So it's also a lesson in modesty.'[49] Five years later, after continuing positive acclaim, when asked if he

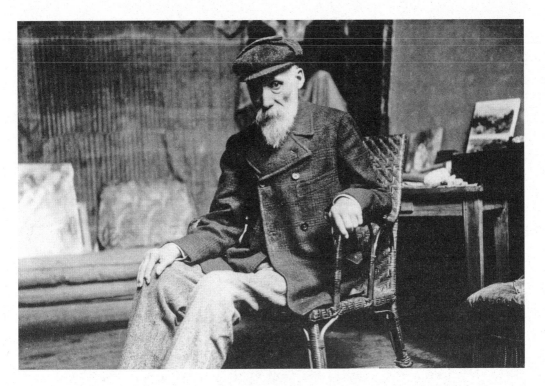

Auguste Renoir, Painter, 63 years old, 1904. 11.5 x 17 cm (4⅝ x 6¾ in.). Photo by Dornac *(Our Contemporaries at Home* series). Bibliothèque Nationale, Dept. des Estampes et de la Photographie

would exhibit again at that year's Salon, Renoir answered: 'What do you want? When I exhibit, I get yelled at.'[50] After twenty-five years of mockery, Renoir could not believe that the public would continue to appreciate his art.

The market value of his art nevertheless continued to rise. Quickly mounting prices for his works prompted feelings of disgust in Renoir. He thought of himself as a serious craftsman and was displeased that the prices had become exorbitant. In late April 1903, a month after a sale in Paris,[51] Renoir complained to Jeanne Baudot: 'My dear Jeanne.... I am disgusted by painting; these high, ridiculous prices have crazed everyone and everyone is selling, even my friend Bérard, multi-millionaire. Here's the result the Bernheims, who will surely kill the chicken that lays the golden eggs, were looking for. I don't care, but it disgusts me.'[52] The Bernheims were trying to sell Renoir's paintings at increasingly elevated rates. For example, in 1907 an article in the British scholarly journal, *The Burlington Magazine*, by the art historian Léonce Bénédite, discussed

this phenomenon: 'The Metropolitan Museum of New York made last spring an acquisition which may be termed sensational: it purchased the *Portrait of Madame Charpentier* [*Mme Charpentier and her Children* (see page 91)] by Auguste Renoir for the sum of 92,000 francs [in fact, 84,000 plus tax, totalling 92,400 francs]. Whatever may have been the recent rise in the prices of the productions of the so-called "Impressionist" school, this is an enormous figure for a modern work by a living artist.' That sum was double the previous highest price received for an Impressionist painting, and more than sixty-one times what the Charpentiers had paid for the painting twenty-nine years earlier. Bénédite linked the high value to the importance of the artist who, he wrote, 'will remain one of the most original masters of the French school in the second half of the nineteenth century'.[53] Despite these enthusiastic articles by both reviewers and scholars, Renoir continued to worry that his success was only temporary.

Renoir also had difficulty placing a value on his work that corresponded to the market. Durand-Ruel had to urge him to revalue the insurance on the pieces Renoir kept in his various studios and residences since theft of such valuable objects was a distinct possibility. As early as 1901, Georges Durand-Ruel was writing to him: 'Like my father, I find that your paintings are not insured for an adequate sum. You must not only augment the total worth of your paintings, which is now 20,000 francs for the contents of each studio, but you must also increase the maximum indemnity to be paid for the loss of an individual paint-ing which is now 3,000 francs. I don't know for how much [you have insured] the paintings at your house; you'll have to determine that yourself, but as for the maximum sum to be paid for each painting, it must at least be raised to 10,000 francs and maybe up to 15,000 to have a larger margin for your large family portrait [*The Artist's Family*; see page 198] and for any other important painting that you could have.'[54] This would have meant an increase in insur-ance value of three times for most works and five times for the largest canvases.

There was another kind of theft: forgery. Renoir's work was now so popular and valuable that forgeries abounded. In March 1903, Renoir and Durand-Ruel became aware of forgeries being sold by a Parisian dealer, Barthélémy. Durand-Ruel worried that the forgeries would bring down the prices of Renoir's authentic work: 'My dear Renoir... I abhor just as you do what is going on at Barthélémy's with your paintings.... They are selling cheap what doesn't cost them a thing and prevents serious business. We cannot sell your paintings at a loss...these forger/dealers say we sell them for much too much.' Nevertheless,

Durand-Ruel did not see any way to stop the problem: 'Be without illusions as I try to be. We are obviously living among rascals.... It's a collective fate.'[55] Renoir for his part suspected that his rue Caulaincourt studio neighbour, Léon Fauché, was involved not only in creating these forgeries but also in stealing paintings from his studio.[56] Renoir was especially upset since he had trusted Fauché not merely with the key to his studio but in dealings with his son Pierre. Once Renoir suspected Fauché to be involved with the forgeries, he wrote to Jeanne Baudot in February 1903: 'I would like to close this letter by thanking you for the entertainment you provide for Pierre. Knowing that he spends less time at Monsieur Fauché's makes me feel better about not being in Paris.'[57]

Even respectable collectors wound up with fakes among their authentic works. Again in 1903, the dentist Dr Georges Viau, who had one of the largest collections of Renoir's paintings (including authentic works bought from Murer in 1896), was tricked in this way. Renoir was clear when explaining to André in December how he knew that forgers were involved: 'The paintings that are from my studio are never signed or rarely, but I never sign sketches. Thus, the sketches at Viau's have false signatures and are not my works.'[58] While Durand-Ruel had previously been passive, once they began to discover forgeries within important collections, the dealer felt that something had to be done: 'It is absolutely necessary to stop this traffic [in forgeries] which is becoming intolerable and would bring enormous damage to our common interest as well as to your reputation.... There is an enormous commerce in these false paintings which those rascals sometimes sell for more money than the real ones. You must do everything possible to stop this traffic which is not only of questionable value but very harmful to all of us.'[59]

Back in March 1903, Renoir had decided to turn the tables on the perpetrators, as he explained to André: 'I haven't done anything to deserve this, believe me. Nonetheless, when I'm in Paris, I will think about a way to cause a little trouble for Sir Barthélémy.'[60] Contrary to Renoir's usual practice of avoiding confrontation, he decided to sue Barthélémy and Fauché. Early in 1904, Renoir registered a formal complaint, but on the advice of a lawyer, he withdrew the charge the following month since he was told it would be ineffective. As he explained to Durand-Ruel: 'I consulted with a highly esteemed lawyer for a long time; he advised me not to send the second complaint.... There's a forger, we must attack him squarely, so it's up to the police to punish him severely or to make him come and give him a reprimand.... As for the [false] pastels, Viau

hasn't the right to keep them. What's more, the lawyer thinks that the commotion about the fake paintings does more harm than good and that it does nothing but scare off collectors.'[61] Unfortunately, whatever actions Renoir took proved insufficient. Three years later, when Viau's collection went up for sale, it still included some of the problematic works obtained through Barthélémy. Nonetheless, Renoir's paintings continued to gain in popularity and value. Since forged paintings with Renoir's signatures continued to appear on the art market, Durand-Ruel continued photographing those works by Renoir that he purchased – a practice he had begun in the early 1890s. Vollard did the same and even had Renoir sign the photographs.[62]

Forgeries and high prices were not the only worries; he also feared alienating the public by overexposure of his art. As he wrote to Durand-Ruel in March 1902: 'Restrained shows with few canvases have, in my opinion, a greater impact. I think that exhibitions that are too large give the idea that the figures were made too easily. That takes away their feeling of rarity...it looks like painters lay paintings like eggs.'[63] Two years later, he reiterated his concerns when invited to the 1904 Salon d'Automne. Three weeks before the event, he pleaded with Durand-Ruel: 'Please don't put too many things in this exhibit. Rarity gives more value than abundance.'[64] Durand-Ruel sent thirty-five paintings (eighteen from his stock), which were displayed in a separate Renoir room. A month later, during his interview, Moncade asked: 'And now, will you exhibit regularly?' Renoir answered: 'I don't know, really.... Truthfully, I'm a little tired of sending things. And then, what do you want me to say? This Salon d'Automne seems fairly useless to me.... But there are really too many exhibitions and it seems to me quite sufficient to bother the public once a year.'[65]

Durand-Ruel nevertheless frequently exhibited Renoir's works. From 1902 through 1909, the dealer put on a series of yearly Renoir exhibitions, never with less than twenty-two paintings and drawings.[66] Perhaps he felt compelled to protect his claim to Renoir's art since, in 1900, Alexandre Bernheim had mounted a Renoir show with sixty-eight works, as described in Chapter 4.[67] Nine years later, when Bernheim wanted to put on another Renoir exhibition, Renoir expressed the same fears that he had voiced earlier to Durand-Ruel: 'My dear M. Bernheim, You know what it is to be popular – it always starts well and always ends badly. Which means that if you show my paintings too often, people will quickly have had enough of them.... In fact, you would really give me great pleasure if you dropped the idea of this exhibition altogether.

R.'[68] Unlike Durand-Ruel, Bernheim had neither the leverage nor the collection to flout Renoir's wishes; he postponed his idea for a big Renoir show for four years until 1913.

Since 1872, Durand-Ruel had been Renoir's primary dealer, although Renoir had always felt free to sell directly to friends and patrons. He had always been close to Durand-Ruel personally, and at first the artist felt guilty when he sold pieces to any other dealer. In April 1901, he sheepishly admitted to his dealer: 'I had the weakness to be unfaithful to you a few times with [the priest and collector] l'Abbé even though I gave him what *you refused and found horrible*, which is, by the way, true. But if I only sold good things I'd die of hunger.... Please excuse my weaknesses.'[69] As usual, when Renoir thought he might be in trouble with a friend, he wrote pre-emptively with overly dramatic excuses. A few days later, Durand-Ruel wrote back: 'You wrote me that I refused to take the paintings that you sold to l'Abbé Gauguin. Where did you get that idea? Never in my life would I have refused to take them, especially because they are very beautiful.'[70]

Yet despite Durand-Ruel's possessiveness, Renoir had become friendly with Bernheim in 1898, as shown by several letters, so it was no surprise when he later began selling works to that dealer.[71] Durand-Ruel knew that he could not prevent Renoir from selling to other dealers, as many of the other Impressionists did, but in 1903, he pressed Renoir to be faithful: 'Keep on working well and make me a lot of nice things without worrying yourself.'[72] Five years later, in December 1908, he tried to intimidate Renoir out of dealing with the Bernheims: 'My dear Renoir, I have just had a painful surprise which I certainly wasn't expecting and wish to let you know. The Bernheims have just succeeded by a series of underhand manoeuvres, which started a while back, to convince Monet to sign a contract for the series of Venice landscapes..... I do not understand Monet, but I will not reproach him. He certainly has been duped and as I didn't doubt he would give in to the Bernheims' temptations...I am writing all of this confidentially to alleviate my heart; don't say a word when you see them and don't speak to anyone about this. They will come to visit you one of these days because they are leaving for the Midi tomorrow. Be wary of them and of their lovely words... I mistrust them... Well that's enough of this subject but I was trying to give you a few details to guide you.... They are merchants whom conscience does not bother. Monet will realize it pretty soon if he keeps listening to them.'[73] Here Durand-Ruel was talking down to Renoir, ten years

his junior. If Renoir had been an anti-Semite, Durand-Ruel's reasoning might have convinced him not to deal with the Bernheims. But Renoir was not an anti-Semite. Durand-Ruel's warning failed to convince Renoir, who continued to exhibit and be friendly with the Bernheims. Furthermore, he made it clear to Durand-Ruel that he would continue that business and personal relationship with the Bernheims.

Renoir disliked being treated in this fashion and wrote back at once: 'My dear Durand-Ruel, All that you tell me surprises me so much that I have a hard time believing it. As for me, a mediocre businessman, do not think that I will sell my independence to anyone. It is the only thing that I hold dearly: the right to do foolish things. To let things happen and to know how to wait, that is the motto of the wise man. Regards, Renoir.' For the normally conformist Renoir, this was an extremely confrontational response. Durand-Ruel's tone must have truly angered him. He added in a postscript: 'What makes me sad is seeing you waste your good health on useless things you can't avoid. It is very annoying that you are old. I would have said, "Come visit for a while", but I wouldn't want to tire you. Send Georges.'[74] For Renoir who always craved company to tell his old friend not to visit shows how upset the artist had become over this incident. Nevertheless, they eventually resumed a good relationship and, by January 1911, Renoir was happy to host Durand-Ruel and his companion Prudence for two weeks at his home in Cagnes.[75]

That Renoir had the energy and confidence to stand up to his dealer is impressive since his health was quickly deteriorating. By 1908, at the age of sixty-seven, Renoir had outlived most of his Impressionist colleagues; his only remaining fellow artists were Cassatt, Degas and Monet, all of whom were having trouble with their eyes. While Renoir's eyes were not failing, his bones and joints were. He had no teeth and ate mashed or liquefied food, often sipped through a straw. And he was frail and thin, his rheumatoid arthritis wreaking havoc on his body. He experienced episodes of pain that essentially paralysed him; when the remission came, it left him in a progressively worse condition. His mobility and manual dexterity were severely impeded by ever more con-torted and rigid joints. Extreme thinness for his height of 169 centimetres (5 ft 6½) also caused problems, as he explained to his dealer in 1904: 'What bothers me most at the moment is that I cannot stay seated because of my thinness, 97 pounds [44 kilos].... The bones pierce the skin and quite soon, I cannot remain seated. But I nonetheless have a good appetite. Let's hope I end up gaining some

weight.'[76] It is ironic that Renoir should have struggled to gain weight when his wife struggled to lose it.

The loss of dexterity in his hands posed his biggest problem. In 1901, the painter Odilon Redon visited him and described with sympathy: 'I saw him suffering great pains and so handsome in his noble dignity!...[there is] something in the sound of his voice where I noticed all his exquisite sensitivity...[which I noticed] while holding his sick and beautiful hand.'[77] Two years later, Renoir wrote to his old friend Bérard: 'I write poorly. I have horrible pain in my hands.'[78] Holding a pen became so arduous that his handwriting became increasingly illegible, so sometimes he dictated his letters as when one of his maids wrote: 'as you know, he has lots of difficulty writing with his sickly hands and he asked me to write for him'.[79] Nonetheless, for the rest of his life, Renoir persisted in writing and painting whenever he could (see pages 322–3).

The arthritis also struck at his legs, gradually eroding his mobility. Sometimes he used a cane or crutches to get around; at other times he could not walk at all. From Cagnes in May 1908, André reported to Durand-Ruel: 'The legs are not doing well at all. He has advanced arthritis and water on the knees. We are obliged to carry him in webbing.'[80] A photograph taken around 1909–10 shows André and Renoir's cook carrying Renoir in a chair on poles. During the next two years, Renoir could walk only rarely and with great pain and difficulty. Other photographs show him using a wheelchair when painting. From February 1905, he had hired a car and driver, explaining to André: 'I am still very sick. I am working nonetheless, having decided to get a car that is leased monthly since my legs refuse to move. I am actually fairly happy. I am thinking about doing some landscapes that I wouldn't otherwise be able to do (don't say anything to Durand-Ruel who is against landscapes).'[81]

At that period, there was only one option for relief. Medicinal spas with hot sulphur springs had been in use since the Roman Empire, using the oldest form of medical treatment, hot- and cold-water therapy. Spa waters could reach 65.5 degrees Celsius (150 Fahrenheit), available in baths, steam showers, rubs and drinks. Since Renoir blamed his worst attacks on the cold weather, it seemed that hot treatments might help. He began experimenting with spa treatments as early as September 1899 and tried six more times over the next decade, visiting Aix, Saint-Laurent and Bourbonne-les-Bains, sometimes for as long as a month. For the first several trips, he went alone with Gabrielle but in 1904, a month in the elegant Bourbonne-les-Bains attracted Aline to visit him with Jean and

Coco; it was 117 kilometres (72 miles) east of Essoyes. A month before Renoir went, he wrote: 'For the past two years I've been waiting for hot weather and the result is that I have had a raging attack. I can't move one finger.'[82] A few days after he arrived, Renoir wrote two letters to André, who knew of his aversion to medicinal spas: 'Since I can no longer move or work, I've given in and I'm here to take the thermal baths', his hotel's stationery claiming: 'Bourbonne-les-Bains Grand Hotel of the Thermal Spa facing the public baths and the casino/ Telephone/ Electrical Lighting/Garage for Automobiles/Telegraphic address: Termalotel'.[83] In the second letter he complained: 'Recently I haven't been able to sit.... I can't stand or lie down.... I am going to stay here for about a month.'[84]

Even though Renoir had little hope that such treatments would help, he knew that they were his only chance at relief. Unlike his wife, he scrupulously followed all the doctor's orders, as he reported to Jeanne Baudot that August 1904: 'I'm carefully following my treatment. I have a very considerate doctor who tires me as little as possible.... Up till now...I don't see any improvement. I cannot work, which makes time drag. Apart from extreme weakness, I am well. I eat quite a bit. I can't understand why I cannot regain my strength. I'm exhausted.... I can't remain seated for long because I'm so thin. If I don't gain weight, I won't be able to travel. The pain is unbearable.'[85] He feared that the treatments would not help or that they might worsen his condition. In 1901, a week into a spa treatment, Renoir wrote to Vollard: 'I still have three weeks of massages and medicinal baths. I will return either cured or completely exhausted.'[86]

Most of the time, the treatments simply did not work. After leaving Bourbonne-les-Bains in 1904, Renoir's paralysis continued to be so bad that he could not paint. He wrote to Julie Manet Rouart, 'I still don't see the benefit of these medicinal baths. I have seen loads of people arrive lame and return cured; how annoying to be unlike everybody else. I have to get used to it. I am stuck. It's going slowly but surely; next year I will be a little worse and so on. I have to get used to it, and that's all; let's not talk about it any more.'[87] He was even more pessimistic writing to Durand-Ruel: 'I can hardly move and I really think things are all botched up for painting. I won't be able to do anything any more. You must understand that under these circumstances, nothing interests me.'[88] Renoir feared that this attack marked the end of his ability to paint.

Eventually, however, he was able to work again, and when he did he infused more sensuality into his paintings. As his illness became worse, art became an even more central focus of his life, acting as both medicine and

religion. As his medicine, it provided relief from pain; as his religion, it inspired him with hope, which he might otherwise have lost. Seemingly in defiance of his physical condition, in the years 1903–06, Renoir portrayed the most sensual nudes he ever created – idealized nude women who lift their hair to reveal their curvaceous bodies.[89] The nudes he painted after his recovery in late 1904 contain a powerful sexuality, something Renoir had probably lost. These voluptuous nudes seem to compensate for his own physical deterioration. His figures grew heavier and more active while he himself became thinner and less mobile. It was heroic that, in the face of endless suffering, Renoir could shed all his personal anguish and remain the positive painter he always had been. Renoir's nudes of this period returned to the classically inspired tradition of the past's idealized nudes and heroic figures. They follow his earlier works, such as *The Blonde Bather*, 1881 (see page 92) and the *Large Bathers* of 1887 (see page 194).[90] Renoir admitted his traditional intentions to Paule Gobillard in 1907: 'I am continuing to search for the secrets of the masters; it's a sweet folly in which I am not alone.'[91] A year later, one of his close companions, Rivière, reported to Renoir a conversation that he had had with a friend: 'We talked of you, and the reasons why he likes your painting are the ones that you would give yourself: it's originality in tradition.'[92] In fact, Renoir had all along been practising originality in tradition. Even in his most innovative works of 1868–83, he had incorporated many aspects of the art of the past – for example, in *Nude in the Sunlight*, 1876, whose posture recalls Greek statues from the fourth century BC.[93]

Just as in 1881, when Renoir had been inspired by the frescoes of Raphael and the Roman artists at Pompeii, so in the early 1900s he continued to follow the artist who had most inspired him from his youth onwards, the great seventeenth-century Flemish painter, Peter Paul Rubens. He was enamoured with Rubens's sensuality, classical themes and minimal pigment. Téodor de Wyzewa wrote in his diary in 1903: '[Renoir] told me about the genius of Rubens, of the tremors of delight that one experiences in front of his painting.'[94] Renoir also effused about Rubens to the American artist and critic Walter Pach in a series of interviews from 1908 to 1912. In late summer 1910, Renoir went to Munich to paint a portrait and to see the many Rubens paintings in its Pinakothek.[95] He told Pach: 'The work of the painter is so to use colour that, even when it is laid on very thinly, it gives the full result. See the pictures by Rubens in Munich; there is the most glorious fullness and the most beautiful colour, and

the layer of paint is very thin.'[96] Renoir tried to achieve the fullness he admired in the sculptural quality of his paintings and in his minimal use of paint.

One of the works that exemplifies this fullness is Renoir's 1908 version[97] of the Rubens masterpiece, *The Judgment of Paris*, a painting that Renoir had admired in 1892 at the Prado in Madrid. The Rubens depicts the Greek myth about the origin of the Trojan War: Paris, a mortal prince, chooses among three beautiful nude goddesses, Aphrodite/Venus, goddess of beauty and love; Athena/Minerva, goddess of wisdom and war; and Hera/Juno, goddess of women, marriage and childbirth and queen of the gods. Unlike Rubens's Paris, who is in the process of making his choice, Renoir's is shown giving the golden apple to Aphrodite.[98] Renoir, like Paris, chose beauty in his art and love for his many friends. The same year, 1908, Renoir painted other classical, sensual themes such as in *Ode to Flowers*, which alludes to a poem by the classical Greek poet, Anacreon.[99] And in 1909 he portrayed reclining male river gods that call to mind the Parthenon marbles.[100]

Originality in tradition in his art gave Renoir a sense of artistic community with the artists of the past whom he admired. In a parallel fashion, he needed a personal community of daily companionship and assistance from friends and servants. For Renoir to be able to paint joyfully, he needed to work in the company of others, whether he was painting people, landscapes or still lifes. Since he was increasingly crippled, he could no longer easily visit friends, so he depended on them coming to him. From the south of France, he wrote to Rivière: 'What I feared was isolation; even with this beautiful sun, it's still isolation.'[101] Around the same time, mid-November 1908, he wrote to another friend: 'The isolation of my house has made me crazy.'[102] To combat this loneliness, Renoir made all his homes welcoming places and encouraged his friends to come for long visits. They either stayed with him or, if Renoir had no unoccupied rooms, they resided in a nearby hotel until a room in his house became available, as shown by his 1903 note to Maleck: 'the house is full but there are rooms at the Hôtel Savournin close by. But this would only be for a few days. As soon as Pierre and my wife leave, we will have room.'[103]

In addition to enjoying company, Renoir needed many people to assist him with daily tasks: to help him dress, bathe, eat, prepare his palette and place it on his lap, and place his brush between his rigid fingers. Since he was a chain-smoker, he needed help to light his cigarette, place it between his fingers and take it out when he wanted to paint. He and Aline shared a large staff of

employees, some of whom travelled with them while others worked primarily at one residence or another. In July 1908, Renoir wrote to Aline: 'La Grande Louise wrote and said she was at your disposal. I am writing to Clément that you could arrive on Tuesday. Write to let them know your plans. If you stop in Essoyes on the way, I will meet you there. I send my love to you and the kids.'[104] Other servants they shared included maids, washerwomen, laundresses and a chauffeur, Pierre Ricord, nicknamed Baptistin. As we have seen, Renoir's most dedicated employee was Gabrielle. In addition, sometimes when he travelled south, he took various Paris staff with him to help him get established. For example, Georgette Dupuy, a maid nicknamed La Boulangère because of her baker husband, accompanied Renoir to Cagnes in 1908, but soon returned to work at his Paris apartment where Pierre was then living.[105]

In order to have space for their increasing staff, family and friends, in 1898, Aline bought the barn next to their Essoyes home so as to combine the two buildings.[106] Renovations took a few years to complete. Once completed, the house had a ground floor with a living room, a kitchen and Renoir's studio. Four bedrooms, including Renoir's and Aline's, occupied the next floor. On the top floor were three rooms, of which at least one was a maid's room. There was running water and flush toilets for which there was a septic tank. They also had a small outhouse in their yard. Renoir later had a two-storey studio constructed in the garden and his house studio was transformed into a dining room.

In 1907, well after the Essoyes renovations were terminated, Aline decided she wanted a fancier apartment in Paris. Since she sensed that her husband might object to the idea, she decided not to tell him her plan, described shortly; rather, she contacted Renoir's friend and patron, Maurice Gangnat. Gangnat, a brother-in-law of Paul Gallimard, had been a wealthy young man involved in the steel industry until he contracted malaria in 1902, at which time his wife persuaded him to retire and become an art collector. After having bought 12 paintings directly from Renoir in 1905 for 20,000 francs, Gangnat eventually bought about 160 Renoir paintings.[107] With many of Renoir's former patrons having recently died – Marguerite Charpentier in 1904 and Georges Charpentier and Paul Bérard in 1905 – Renoir was happy to have such an avid new collector. In 1906, Renoir painted a portrait of Gangnat's son, Philippe, aged two.[108] Gangnat, knowing Renoir also had a young son, sent Coco a Christmas gift that year. Renoir wrote to him: 'Dear M. Gangnat; Last night Coco received the magnificent Buffalo Bill toy, which came just at the right moment and was

received with extreme happiness. Since my wife is in Paris and since I can't move, I had only the toys from Cagnes to give him.... Thank you so much for having thought of Coco whom you made very happy.'[109] In 1909, Gangnat also commissioned two large works for his dining room: *Dancer with Tambourine* and *Dancer with Castanets*.[110]

During these years as Renoir's most supportive patron, Gangnat also met Renoir's wife and family. Hence in 1907 Aline felt able to contact him directly for help in finding the family a new Paris apartment. Gangnat did indeed find an apartment to Aline's liking, on boulevard Malesherbes in the seventeenth arrondissement in north-west Paris. Then he must have written to Renoir in Cagnes for his approval, whose response has survived: Renoir, knowing nothing of Aline's intentions, forestalled any deal: 'Please wait.'[111] A few weeks later, Renoir again wrote to Gangnat: 'It is only now that I realize the inconveniences of this apartment. The landlord will ask me to sign a contract that would imply agreeing to a bourgeois fatherly way of life. I cannot do it because I have an industry of comings and goings of grimy models, crates of canvases, etc. etc. The concierge will be annoyed and the landlord will tell me to leave and we will have to start moving again.... You have to know how to live in your own milieu and I hadn't thought it through.... Thus tell my wife that the landlord does not want any painters. We will avoid unnecessary letters and useless discussions that way.'[112] Just as Aline had gone behind Renoir in arranging this deal, so Renoir circumvented Aline by persuading Gangnat to drop the whole affair without himself confronting his wife. After seventeen years of marriage, this deterioration in communication mirrored the deterioration of trust in their relationship.

Although Renoir prevented Aline from acquiring a fancy apartment in Paris, she and Renoir did agree that they needed a permanent southern residence. After almost a decade of renting houses along the Côte d'Azur, in June 1907 they decided to buy their own home on a nine-acre property in Cagnes called Les Collettes (which means a region of small hills). When he was sixty years old, Coco wrote about the purchase: 'The decision was rapidly made on 28 June 1907, to buy the property from Mme Armand [for 35,000 francs]. The house was immediately started and was able to be lived in during the autumn of 1908. My mother had won. She was happy. Finally she had a house that suited her. And, what's more, she had no more cause to envy Mme Deconchy[113]...and she could even call herself a farmer! My father was less satisfied. This house disappointed him a little. It was too big. It crushed him. He struggled to preserve his reputation

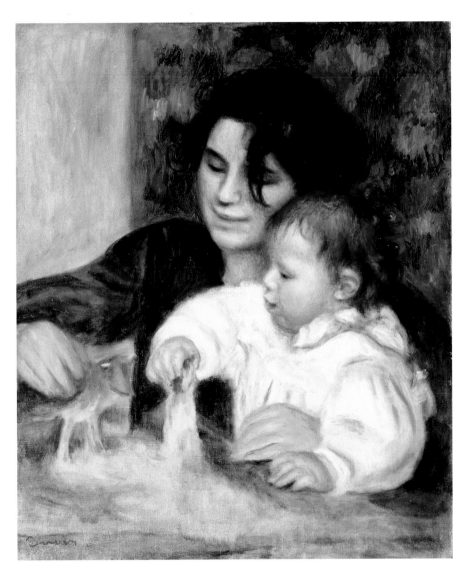

Gabrielle and Jean, 1895. 65 x 54 cm (25⅝ x 21¼ in.). Orangerie des Tuileries, Paris.
Bequest of Walter-Guillaume

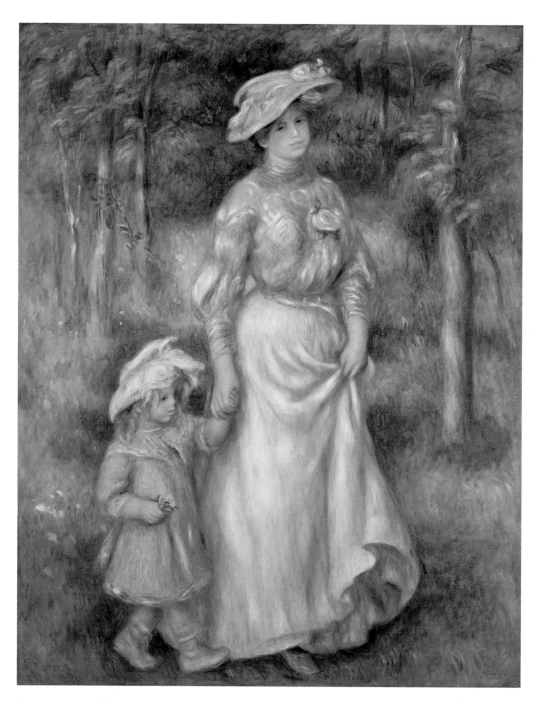

The Promenade, c. 1905, 164.5 x 129.4 cm (64¾ x 50¼ in.). The Barnes Foundation, Philadelphia, Pa.

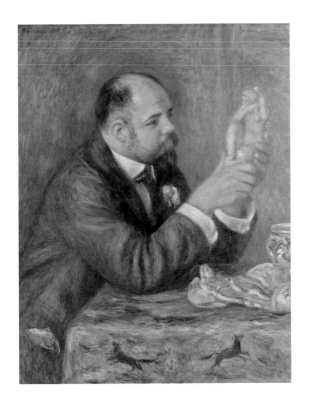

Ambroise Vollard,
1908. 80.6 x 64.8
cm (31¾ x 25½ in.).
Courtauld Institute
Galleries, London.
Courtaud Collection

Bust of Coco, 1908.
Bronze, H. 28 cm
(11 in.). The National
Gallery of Art,
Washington, D.C. Gift
of Sam A. Lewisohn

The Artist's Son Jean drawing, 1901. 45 x 54.6 cm. (17¾ x 21½ in.). Virginia Museum, Richmond, Va.
Gift of Mr and Mrs Paul Mellon

*Jean Renoir as
a Huntsman*, 1910.
172.7 x 88.9 cm
(68 x 35 in.).
Los Angeles County
Museum of Art.
Gift of Jean Renoir
and Dido Renoir

Mme Aline Renoir,
1910. 81.3 x 65 cm
(32 x 25⅝ in.).
The Wadsworth
Atheneum Museum
of Art, Hartford,
Conn. The Ella
Gallup Sumner
and Mary Catlin
Sumner Collection

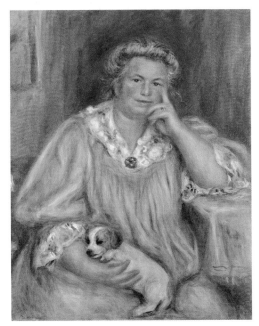

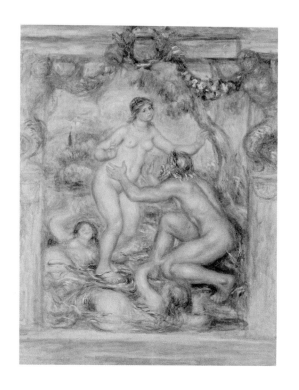

The Saône River
throwing Herself
into the Arms
of the Rhône River,
1915. 102.2 x 84 cm
(40¼ x 33⅛ in.).
Matsuoka Museum,
Tokyo

The Great Bathers,
1919. 110 x 160 cm
(43¼ x 63 in.).
Musée d'Orsay, Paris

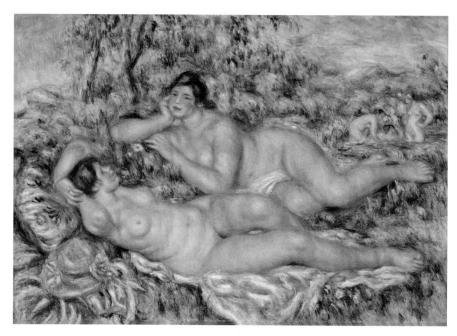

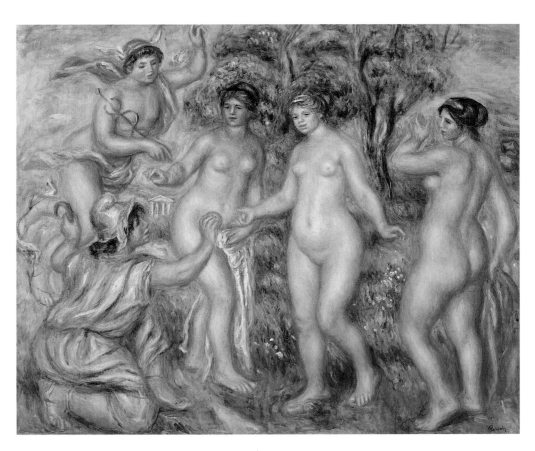

The Judgment of Paris, 1913. 72 x 92 cm (28⅜ x 36¼ in.). Hiroshima Museum of Art

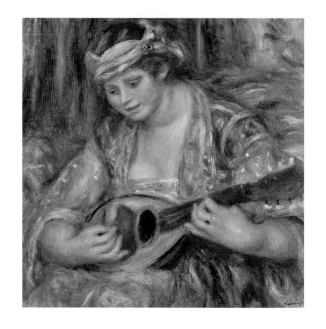

Girl with Mandolin, 1919. 56 x 56 cm (22 x 22 in.). Private collection, New York

The Concert, 1919. 75.6 x 92.7 cm (29¾ x 36½ in.). The Art Gallery of Ontario, Toronto. Gift of Ruben Wells Leonard Estate 67ßß

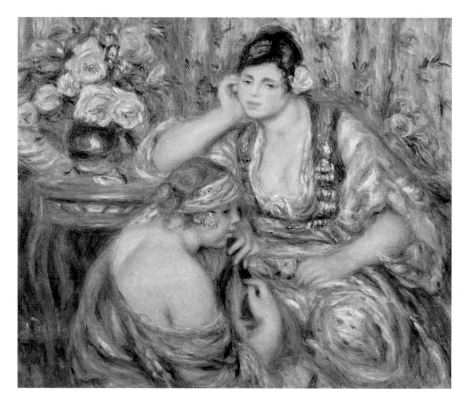

as a down-to-earth person. He didn't want either a "villa" or a "garden". But for him all of this was secondary; the light was playing in the olive trees.'[114]

Les Collettes's estate had many olive trees. Its rustic farmhouse, however, was not adequate for the ailing Renoir so he and Aline hired architects and builders to create a new house and garden studio.[115] During construction, the family lived in a house down the street, and their new villa was completed by mid-November 1908, as Renoir happily informed Durand-Ruel.[116] The huge ground floor consisted of a living room, a dining room, an office, a kitchen and three bedrooms. Upstairs were bedrooms for each of the five family members, as well as two indoor studios. Like the renovated Essoyes house, this one had all the modern conveniences of electricity, hot water and bathrooms with flush toilets. Also like Essoyes, it was intended to host many guests: a year later, Rivière wrote from Les Collettes that, besides the Renoirs, there were six or seven others sleeping overnight there.[117] By then, Renoir was beginning to prefer country life to city life. Paris's population tripled from 935,000 in 1841 to 2,888,000 in 1911. The city had become too industrialized for him, with mass-produced automobiles and a public transport system of buses and subways.[118] When Schnerb visited him in Paris in June 1909, the young artist noted in his diary: 'He is going to go to the country. In Paris the commotion makes him dizzy. He is afraid of the cars.'[119]

Aline had always been happier in the country. Consistent with her rural upbringing, she loved to garden. She also liked to cook.[120] Not only did she have an extensive garden in Essoyes but she also planted vegetables at rented houses, such as the Villa de la Poste in Cagnes, from where Renoir wrote in sympathy: 'The dry weather is preventing the green peas, artichokes and other things from growing.'[121] Thus it is no surprise that Aline insisted on a large garden with fruit trees at Les Collettes. Renoir wrote to Julie Manet Rouart in March 1908: 'We are planting like the old man in La Fontaine [one of whose fables is entitled 'The Old Man and the Three Young Ones']. An old man planted, to plant at this age... doesn't amuse the old man, but amuses my wife more than one would have thought possible. The green peas are growing well, the potatoes too. Thus, for the moment, we have perfect happiness.'[122] In a letter of July 1909, Renoir asked a friend: 'Did you receive the lemons my wife sent you last month?'[123] Aline even kept chickens.

Humble tasks had been part of Aline's family background – her own mother having been a maid and seamstress, and her relative Gabrielle being

the family's nursemaid, model and care-giver – but she also enjoyed being haute-bourgeoise and the boss. Gabrielle's letters call Aline 'la patronne', the boss or manager, just as she called Renoir 'le patron'.[124] Aline enjoyed acting as the manager of the Renoirs' estates and as the hostess to their visitors, who were all Renoir's friends and business associates, since she remained the loner she had always been. Nonetheless, on a visit to the Renoirs in Cagnes in 1906, the painter Maurice Denis had written in his diary: 'Dined at Renoir's. His wife never stops telling funny stories.'[125] Once their new house in Les Collettes was ready in November 1908, they began inviting friends. Among the early guests was Monet. By this time, they had been friends for forty-five years. 'Monet is within our walls', Renoir informed Paule Gobillard.[126] Monet had been keeping track of Renoir's health through Renoir's neighbour in Cagnes, Germaine Salerou, Monet's second wife's daughter, who wrote to her mother daily.

Another of the earliest guests at Les Collettes was Renée Rivière, the younger daughter of Georges Rivière, whose wife had died in 1897 (see Chapter 4). Aline, not having a daughter and having been long separated from her own mother, had particular compassion for Renoir's young women friends whose mothers had died, like Julie Manet and her cousins. Renoir had come to know Renée, who was the same age as his son Pierre, when he painted her portrait in 1907.[127] The next year, in February, before their new house was ready, the Renoirs invited Renée to live with them at their rented villa, since it had a piano that she could use in her singing studies.[128] After she arrived, he wrote to Julie Manet Rouart: 'Renée is learning singing exercise after singing exercise and is making rapid progress. You see it is the trilogy of painting, music and architecture. Cagnes is becoming an intellectual centre. Paris is provincial and there you have it!'[129] He also reported on Renée's progress to her father: 'Renée is still vocalizing and I think she is making some remarkable progress. Above all, she is beginning to lose the Parisian accent – which is deplorable for music.'[130] When Renée returned for a second visit a year later, the Renoirs had moved into their new home at Les Collettes, for which Aline had ordered a Pleyel piano (whose payment went through Durand-Ruel).[131] The artist wrote to Renée's father: 'Tell Renée to bring her music, especially the kind that's a little vulgar. I'm a bit fed up with beautiful music…. Also, tell Renée, she must sing in the church at Easter, I promised the priest.'[132]

Renoir's support calls to mind his encouragement of Julie Manet and her cousins in their painting. In November 1909, he explained to Mme Gangnat:

'I wrote to my friend [Rivière] to tell him again what I've told him a hundred times, that parents owe their children [encouragement to develop] a career whether or not the family has money. Since Renée has one [profession], it's idiotic to not help her to live her dream. The daughters of concierges are lucky. People admire them and send them to the Conservatory and they are not hurt by it.'[133] Here Renoir contrasts the daughters of an haute-bourgeois family like the Rivières and a working-class family like that of an apartment caretaker, asserting that upper-class people should let their daughters become professional singers. Renoir and Aline had other interests in their young guests like Renée. Aline especially took pleasure in matchmaking. She introduced Renée's older sister, Hélène, and Renoir's nephew, Edmond Renoir, the son of Renoir's younger brother Edmond. They were married on 29 November 1909, Renoir giving them his portrait of Georges Rivière painted that spring.[134]

Meanwhile, Renoir had been involved in art sales with all his dealers, Durand-Ruel, Bernheim and Vollard. Occasionally, Vollard exhibited Renoir's work in group shows, starting in February 1901.[135] During the first decade of the twentieth century, he continued to acquire Renoir's paintings directly from the artist, as in January 1909, when he bought a group of studies for 5,350 francs.[136] In 1907, Vollard bought *La Grenouillère*, 1869 – one of the foundational works of Impressionism – and three other works for a total of 10,000 francs.[137] Less than a year later, on 28 April 1908, he sold *La Grenouillère* to the Russian collector Sergei Shchukin for 20,000 francs.[138] Renoir had also put Vollard in contact with his brother Edmond, who in 1904 sold him nine oil sketches and three drawings for 1,000 francs.[139] Vollard acquired Renoir's works from other dealers and collectors, too, as well as at auctions.[140] In addition, he directly commissioned prints, paintings and even sculpture from the artist. Renoir joked about how Vollard pushed him with his innovative schemes: in August 1904, when he was having back problems, he wrote to André: 'Right now I can't sit because of a second tailbone that pushes me from behind just like Vollard.'[141]

So that he could sell more Renoir works, Vollard had to generate ideas for acquiring that art – both works already made and new pieces that Vollard commissioned Renoir to make. In 1902 he asked Renoir to make a lithograph portrait of Cézanne. By this time, Cézanne was becoming increasingly anti-social and paranoid, possibly due to his untreated diabetes. As the art historian John Rewald wrote: 'Illness and old age accentuated the morbid traits in his character, and what was once only sensitivity and suspicion turned sometimes into a real

persecution mania. More than ever before he feared getting into the clutches of others.'[142] Nonetheless, Cézanne held Renoir in high esteem and wrote to Joachim Gasquet on 8 July 1902: 'I am pursuing success through work. I despise all living painters, except Monet and Renoir, and I want to succeed through work.'[143] Because Renoir was aware of Cézanne's idiosyncrasies, he did not attempt to make a portrait from life. Instead, he decided to base his lithograph on his own 1880 pastel that had been commissioned by Chocquet. Renoir made the lithograph with the help of the printer Auguste Clot, and Vollard had about a hundred copies printed.[144] At some point between 1915 and 1917, Vollard secured Renoir's permission to use the pastel and lithograph as the bases for a bronze medallion of Cézanne of which he sold multiple copies.[145]

Renoir's lifelong admiration for Cézanne's art had caused him to acquire four paintings and two watercolours by Cézanne, which were still in his possession at his death.[146] In October 1906, Cézanne died in Aix-en-Provence. Three years later, concerned about an appropriate tribute, Renoir wrote to Monet: 'A bust of Cézanne in the museum (the Aix museum is very pretty), and above all, a painting.... I think that a painter should be represented by his painting.'[147] Besides Cézanne's legacy, Renoir was concerned enough about Cézanne's son, also called Paul, aged thirty-four in 1906, and his mother, aged fifty-six, to keep in touch with them. In time, he and Aline even found a wife for Paul.

In addition to the lithograph of Cézanne, Vollard commissioned Renoir to draw a portrait of Monet in 1905. However, as Monet's wife, Alice Hoschedé, explained to her daughter in October 1905: 'Monet received a very sad letter from Renoir, who is very sick right now, saying that at this time he couldn't do the drawing of Monet but that he would be happy to see him before his departure for the Midi.'[148] A year later, in October 1906, Alice reported back: 'When Monet arrived, he found a note from Renoir saying that he was expecting him to pose for his drawing and to stay for lunch.'[149] After the sitting in Renoir's Paris studio, Alice wrote again: 'Monet is delighted with Renoir's work. They were, I believe, very happy to see each other, even though Mme Renoir was present.'[150] This last comment suggests a certain dislike of Aline. A decade later, Vollard used Renoir's drawing of Monet for a sculpted medallion in the same series as that of Cézanne.[151]

Renoir was also commissioned by Vollard in 1904 to make a series of twelve lithographs, again to be printed by Auguste Clot. Among them were a profile bust of Vollard, a three-quarter-length portrait of Louis Valtat, two heads of Coco and several studies of nudes.[152] Clot made 1,000 sets, 50 on Japan paper

and 950 on vellum. Paintings, too, were commissioned. Vollard had admired Renoir's *Large Bathers* of 1887 (see page 194) when he saw it on loan from J.-É. Blanche in Bernheim-Jeune's 1900 Renoir exhibition. In the spring of 1903, Vollard asked Renoir to paint a new version in his current freer, more sculptural style.[153] On completion that year, Vollard paid him 1,000 francs.[154] Three years later, Vollard commissioned an oil sketch profile bust of himself.[155] Then in 1908, the dealer requested a larger and more finished portrait. On 7 May, Renoir invited Vollard to visit him in Cagnes in order to pose: 'Come whenever you like. Now I'm all set up to work.'[156] In this portrait, Renoir shows Vollard holding a statuette by Aristide Maillol, *Crouching Woman* (see page 243).[157]

Maillol was one of Vollard's artist clients, whom he also commissioned to make a bust portrait of Renoir, to be reproduced in bronze replicas. To create the sculpture, Renoir invited Maillol to Essoyes, where he 'stayed...ten days or so. I was very well received.' Maillol recalled Renoir's condition: 'He gave me a tremendous amount of trouble. It was an impossible face. It was all sick and deformed. There was nothing in it; there was only the nose. When I got there and saw him, I was perplexed. He had no mouth, he had drooping lips. It was awful.... But he had shaved off his beard. Oh! I really had trouble.' Maillol continued: 'I ate alone with Renoir. We had lunch together, just the two of us, facing one another. He didn't eat. He only drank milk. He said to me, "Eat." I devoured the whole leg of lamb. It was a little leg. I had a feast' (see page 255).[158]

Renoir considered the near life-size bust of great importance and stopped painting to pose for it, as Maillol remembered: 'I worked on Renoir's bust day and night. He didn't paint. I said to him: "You can work, you know." He responded: "No, I want to take this seriously." He didn't touch his brushes. He posed day and night. This portrait made him very happy. He observed its progress. He said to me: "It's really coming alive."'[159] Indeed, on 12 September 1906, Renoir wrote to Vollard: 'My bust is going splendidly.'[160] Unfortunately, as Maillol reported, 'The last day the bust [made of wax for bronze casting] collapsed. It made him very sad. It happened during the night. I must have made it too moist. These things happen. When we entered the studio, he was more upset than I was. He was dismayed. I picked up the bust and started over. But it was no longer the same. It wasn't as good.' Of the second version, Maillol continued: 'I made an original, a terracotta that was for him. I lent it to Vollard: he wanted to mould it, I think, to make some bronzes.'[161] Before returning it to Renoir, Vollard did indeed have a mould made from which numerous casts were produced (see page 255).[162]

As usual, Renoir forged a warm relationship with this new friend and years later, as Maillol recalled, 'Renoir had also invited me to come to Cagnes. He really wanted us to come to Cagnes. I would have gone there, but the [First World War] came.'[163]

At Vollard's suggestion, Renoir tried sculpture himself in 1907. Since his arthritic hands could not manage clay, he too used soft wax, and made only two pieces with his own hands, portraits of Coco (see page 243). The first was a low-relief profile medallion, the second a bust statue.[164] Later, through the lost-wax process, Vollard had fifty bronze copies of the medallion and thirty of the bust made. Since the house at Les Collettes was still being constructed when Vollard had the copies of the medallion made, it was also copied into the white marble mantlepiece of the dining room.

Renoir's other close companion during these years, Albert André, became a friend of the dealer too. When André got married, Vollard gave the couple Renoir's *Small Head of a Woman*, a painting made during Renoir's 1881–82 Italian trip.[165] Vollard knew from André and Maleck's devotion to the artist that they would treasure any Renoir painting. André had become Renoir's constant companion, visiting him more often than anybody else. As another client of Durand-Ruel's, André wrote to him about his visits to Renoir: 'As for Renoir, he is younger and more brilliant than ever (I mean when the brush is in his hand). I will stay a few more days with him since he's really too kind for me to be able to leave him.'[166] Paintings and other letters attest that André was a frequent guest until Renoir died in 1919,[167] the latest companion painter, after Bazille, Sisley, Le Coeur, Monet, Cézanne, Morisot and Caillebotte. Both André and Renoir held an optimistic view of the world and wanted their paintings to express joy and sensuality through bright light, vibrant colours and visible brushstrokes. In February 1902, Renoir wrote to Durand-Ruel: 'Here I have everything I need: a large room to work in and company. Albert André is extremely agreeable and painting together is better for work.'[168] Still, André felt intimidated and had trouble painting side by side with his highly regarded friend, writing to Durand-Ruel a month later: 'Having Renoir next to me paralyses me completely, whereas my presence does not intimidate him at all. He has made four or five superb canvases and dreams of a bigger one.'[169]

Besides painting side by side, Renoir allowed André, more than anyone else, to depict him in numerous paintings and drawings from 1901 until 1919. Sometimes, André captured him alone, as in the 1901 portrait of him in his garden, smoking a cigarette.[170] At other times, André portrayed him with his

Aristide Maillol, *Bust of Auguste Renoir*, 1906. Bronze, height 30.5 cm (12 in.). The Fogg Art Museum, Harvard University, Cambridge, Mass. Bequest of Maurice Wertheim

family, as in *Renoir painting his Family at his Studio, 73 rue Caulaincourt, Paris, 1901*.[171] Here, Renoir, seen from behind, is painting Gabrielle holding Coco while Aline sits nearby, her girth hidden by Coco's baby carriage; Jean, wearing the same clown outfit as in Renoir's 1901 portrait of him, *The White Clown*, stands between the two women.[172] Only Pierre is absent, then at school. André had taken up a position in the Renoir family in fact as well as affection when Renoir had appointed him godfather of Coco that year. Like the godfathers of the two older sons, André was Renoir's good friend. Since the younger artist often came on extended visits to the Renoirs, he had the chance to interact with his godson.

Renoir, too, visited André and Maleck, sometimes when en route between the Côte d'Azur and either Paris or Essoyes, staying with them, for example,

in May 1903 in Laudun, a town near Avignon, as Renoir reported: 'I will stop for a while at Albert André's in Laudun.'[173] During his visits to the Andrés, Renoir painted many pieces, including *Portrait of Marguerite Cornillac André* and *View of Laudun from the House of Albert André*, both of 1904,[174] and a photograph taken there in 1904 shows him with Maleck and Gabrielle.[175] When André became engaged to Maleck in November 1905, Renoir sent her a note praising 'the excellent character of your future husband', adding affectionately: 'My dear Marguerite, I send you all my congratulations and the greatest desire for happiness for the longest possible time.'[176]

While the infant and child Coco had been a frequent model for his father, as he grew older, he ceased to appear so often in Renoir's works. As with his older brothers, when Coco insisted on short hair and boyish clothes, Renoir found him less appealing as a model. Additionally, Coco himself seems to have lost interest: in 1909, Renoir told Schnerb that his child was too big to model and did not want to pose any more.[177] Although Coco had reached the age where the two older boys had been sent to boarding school, Coco's education was less structured. He and Aline continued moving back and forth each year to Cagnes, Essoyes and Paris, and his parents hired tutors so that he could remain with Aline on these travels, while education officials in Essoyes also took responsibility for coordinating Coco's lessons in a way that would accommodate his needs.[178] In January 1908, for example, when Coco was six years old, Gabrielle informed Rivière on the back of a letter to him from Renoir that, 'Coco and Jean will be tutored every day, one at the priest's and the other at the young woman's.'[179]

Seven years earlier, when Coco was born, Renoir had painted several portraits of Jean, one of which Renoir kept in his collection until his death, *The Artist's Son Jean drawing* (see page 244).[180] He sports a boy's haircut and outfit. Jean later recalled that his father had suggested that a pencil and a piece of paper should be given to him so that he could draw figures of animals while Renoir was painting him.[181]

In 1902, when Jean was eight, Aline decided that he should follow Pierre to his boarding school. Since this would be Pierre's last year at Sainte-Croix, Aline felt that, despite the fact that Jean was a year younger than Pierre had been when first attending boarding school, having his older brother as a fellow boarder might help Jean adjust to living away from home. Unfortunately, Jean disliked this first boarding school and, after only six months there, at the Easter break of 1903 refused to return. His parents immediately arranged for him to

go to a boarding school near Renoir in the south of France: 'My wife and Pierre have to leave around the 20th [of April]. I think Jean will stay because we've boarded him at [Collège, middle school] Stanislas of Cannes where he is happy as a king.'[182] Jean was not as happy as Renoir imagined and he only remained at Stanislas for a few months.

By the next autumn, Jean was attending another boarding school in Paris, École Sainte-Marie de Monceau, in the rue de Monceau, close to the family's Paris apartment in rue Caulaincourt. Since Renoir and Aline were often in the south of France, several of their friends took Jean on weekend outings as they had done for Pierre. Renoir was grateful for their efforts, writing to Jeanne Baudot at the end of 1903: 'I am almost ashamed of having taken up all your time for your godson, but you did it so kindly that I do not want to offend you by thanking you. You have made me extremely happy, that's all.' In the margin of the letter, he wrote: 'Gabrielle told me to give you her best', underlining the next words: '*That is her Jean*', and ending: 'She asked me to tell you how happy she is [that Jeanne had been good to Jean]. R.'[183] After all, Gabrielle had been Jean's nursemaid for his first nine years and she continued to be close to him. Not only Jeanne Baudot but also André's wife Maleck helped Jean. A few days after Renoir wrote to Jeanne Baudot, he wrote to André: 'I would really appreciate it if you would thank Mlle Cornillac for Jean. I will do it myself soon.'[184]

Despite his dislike of boarding, Jean did well in school. In January 1905, when he was eleven and still a boarder, the head of Sainte-Marie, Alain Meunier, wrote to Renoir: 'Sir... His health is still well; I think that you will find him taller and stronger.... Last week he was the first in grammar analysis. This week he is second in maths. I am very satisfied with his work. The only thing that we can reproach him for is his chatting, but don't worry, it's nothing serious. He is preparing himself earnestly for his first communion and knows his catechism very well. The ceremony will take place around 15 May and I hope that Jean will earn the right to read the Renewal of Baptismal Promises because of his good grades. You can see that everything is going well and that your little Jean is still a nice child whom we all like, and over whom I watch closely.... For Mardi Gras vacation, if you think it is too much to leave Jean with M. Pierre for 3 days in Paris, I can watch him for you for one or two days here or there. The [family of Maurice Denis] have invited him to spend a day with their little children because he amuses them with his stories and his cheerfulness. I will do what you decide in terms of this subject.'[185]

The Denis family were not Renoir's only friends to enjoy Jean's company. Three years later, Rivière gave Renoir his assessment of Jean, then aged 14: 'My daughters [Renée, then 23, and Hélène, then 26] received a letter from Jean, which was pretty amusing with oddly constructed words. He has a good ironic tone tempered by kindness. This could be very nice once he has acquired more skill.... Jean's personality is a little wild but this may transform into an exceptional quality with age and contemplation. He will be able to master and control his behaviour.... When it becomes necessary, Jean will know how to tame himself.'[186]

Jean's wildness might have been due to his persistent unhappiness with the strict discipline of his boarding schools. His parents allowed him to try other boarding schools, but he never found one he liked. Eventually, Renoir and Aline allowed Jean to stay at home – which meant moving from Paris to Essoyes to the Cagnes vicinity – and, like Coco, to be tutored at home. In a radio interview in 1958, Jean explained that one of the reasons why he disliked boarding school was that the atmosphere was icy compared to the warmth of his home.[187] Although the Renoirs led a chaotic existence, travelling among residences in Paris, Essoyes and Cagnes, Jean felt homesick for the company of his family – especially for his father. While Jean physically resembled Aline, with his red hair, blue eyes and round figure, he was temperamentally more similar to his father. Both were gregarious, optimistic, joyful, witty and well liked by people of all ages. Jean's closeness to Renoir is demonstrated by his biography, *Renoir, My Father*, which expresses his deep love; the book contains not one even mild criticism of his father.[188]

Renoir for his part returned Jean's affection; indeed, Jean was his favourite son. In the same 1958 interview, Jean described an instance of Renoir's indulgence towards him. He recalled that he had left his school without permission at a time when he knew that his family was in Paris. When he entered Renoir's studio, he told his father that school was out for vacation. He recalled that his father was not fooled but did not object to Jean staying at home for a week.[189] It was the same indulgence that allowed Jean to change schools frequently and finally be tutored at home. Renoir had endearing nicknames for all his boys when they were children (Pierre was 'Pierrot' and Claude was Coco, 'Cloclo' or 'Clo'[190]), but only with Jean did he continue to use a nickname, 'Jeannot', into adulthood.

This special affection for Jean also manifested itself in the way father and son addressed one another in letters. When Jean was nine, Renoir wrote to

Jeanne Baudot: 'When I think about how Jean is in the fifth grade and how he still writes, "Dear Papa", I am delighted.'[191] Jean continued this practice throughout the next sixteen years until his father's death when Jean was twenty-five, concluding with, 'My love to all, Jean.'[192] Similarly, Renoir wrote affectionately to Jean: 'Dear Jeannot' and signed off as 'Papa Renoir'.[193] In striking contrast, Renoir wrote more formally to his eldest son, beginning letters with 'My dear Pierre' and ending with 'Best wishes, Your father, Renoir.'[194]

Fatherly care was also expressed in continual worrying about Jean. Renoir knew how much the family meant to his middle son so, when he realized that he would be too ill to be present at Jean's first communion in spring 1905, Renoir pleaded with Jeanne Baudot: 'You are my only hope in making sure poor Jean does not end up alone at his first communion. My wife does not want me to return because of the cold, and she is watching me closely. I am counting on you to attend this ceremony, which will take place 18 May at Le Vésinet [a suburb of Paris].'[195] In addition to taking care of Jean's emotional wellbeing, Renoir also worried about his son's physical safety, as shown by a letter to Aline when Jean was fourteen: 'Give Jean my love and tell him to only go swimming in the sea with reliable people.'[196] Not only present worries about Jean plagued Renoir but also potential dangers. In 1908, six years before the outbreak of the First World War, the artist was concerned about the political antagonism that was already evident. Renoir mused: 'At least the war is being avoided. I was very frightened, like all fathers. I was thinking about Jean; you understand.'[197] Jean was at this point fourteen and therefore only a few years away from being called up for military service, whereas Pierre aged twenty-three would immediately have been drafted. However, Renoir expressed no worry about Pierre in that letter.

While Renoir and his middle son had a nearly ideal rapport, tensions appeared in the artist's relationship with his eldest son. Some of these stemmed from Pierre's decision to pursue a career on the stage, to which Renoir objected because he did not think acting left anything permanent, whereas painting did. Although Renoir clearly loved Pierre, he never understood why his son wanted to be an actor. Almost thirty years after Renoir's death, Pierre said in an interview: 'However, to speak truthfully, I must admit that he did not take theatre or cinema seriously. He was very independent in character. One day, while in my dressing room, he said to me with a certain disdain: "So, do you really like a job like that? All they have to do is call you and you come right away."'[198]

In an earlier interview, Pierre had identified this point of contention: 'My youth took place in an atmosphere of art. [Yet] when I spoke of doing theatre, my father, Auguste Renoir, narrow-mindedly said "How can you have a job where you have to arrive whenever anyone calls you?"'[199] Clearly, Renoir never associated acting with artistic creativity, since he thought of an actor as someone who was merely carrying out a director's will.

Pierre's love of acting began while he was a student at Sainte-Croix. Not only did he excel in drama, but he also loved to see professional performances. Pierre often asked his father to get him free tickets to the Théâtre des Variétés, owned by Renoir's patron, Gallimard. At first, Renoir was happy to contact Gallimard, as in December 1902: 'I would like to ask you for two tickets for Pierre and a friend for any evening.'[200] Over time, however, Renoir became exasperated with Pierre's frequent requests and wrote to Gallimard: 'I told that idiot Pierre to bother you directly to have three theatre tickets for himself, Albert André and Mlle Cornillac.'[201] On another occasion he also expressed his annoyance to André: 'My dear friend; I am sending you Pierre's letter. I'm sorry to bother you but I can't always take care of him. To hell with him. Renoir.'[202] One wonders why Renoir was so provoked by Pierre and one doubts whether the artist would have been so short-tempered with Jean.

When Pierre graduated from Sainte-Croix with a *bac classique* (baccalaureate) in July 1903, he immediately began two years of preparatory studies to enter the Paris Conservatory, the state-run academy founded in 1795 for performing arts that included drama, music and dance.[203] He moved into the Renoirs' Paris residence and assumed familial responsibilities. Pierre took his father's art to dealers, as when Renoir wrote to Bernheim in 1906 of a painting he wished to donate to an auction to benefit the family of the painter Eugène Carrière, who died that year: 'Simply send a note to my son, Pierre, who will bring it to your shop whenever you want.'[204] Since Durand-Ruel handled some of Renoir's financial affairs (such as his rent), Pierre acted as the courier and helped his father, as when Renoir wrote to Durand-Ruel: 'I will ask Pierre to bring the sum for my rent in order not to bother you.'[205] When neither Renoir nor Aline was in Paris, Pierre acted as the liaison between Jean's boarding school and his parents, as indicated by a letter of 1904 from Renoir to Aline: 'If Jean isn't doing well, Pierre will write you about it.'[206]

Five months after Pierre left Sainte-Croix, Renoir enlisted André's help to deter him from an acting career: 'I would love it if you would nag Pierre from

time to time to open his eyes about a career. It's difficult, but I'd be so happy to see him get excited about something other than being a ham actor.'[207] Yet nothing deterred Pierre. While Renoir never showed much enthusiasm for the profession chosen by his eldest son, he always gave him the money necessary to pursue his professional goal. When Pierre was accepted into the Conservatory in 1905, Renoir signed a document dated 21 October that gave his approval and guaranteed financial support for 'his twenty-year-old son in his theatrical career'.[208] Renoir gave Pierre permission to ask Durand-Ruel and Vollard for money as needed. Several letters from Pierre to these dealers request 'five hundred francs'[209] or 'a thousand francs'.[210]

Pierre began studying at the Conservatory in September 1905, but in May 1906, aged twenty-one, he took a break to start his three-year military service.[211] After one year of service, he was able to return to the Conservatory for his second year, in September 1907, while continuing his military training part-time. At the beginning of his military service, Pierre was given an official booklet, entitled 'Class of 1906', that states that he lived at the family's Paris home, 43 rue Caulaincourt in the eighteenth arrondissement, which they rented until 1911. The booklet included Pierre's physical description: 'Brown hair and eyebrows; brown eyes; average size forehead; average size nose and mouth; round chin; oval face; height 1 metre 76 centimetres [5ft 9¼].'[212] Even though photography had been invented in 1839, in Pierre's service booklet, as in Renoir's from 1870 (on which see Chapter 1), no photograph was included. A comparison of the descriptions in their two booklets shows some physical resemblance between father and son but a difference in height. Pierre was seven centimetres taller than his father, who was 169 centimetres (5 ft 6½). Both had oval faces, brown eyes and average-size foreheads. However, Renoir's nose was long and his mouth large, while Pierre's were 'average size' and his hair and eyebrows were brown, while Renoir's were blond.[213] In July 1906, two months after Pierre began his military service, Renoir wrote to a friend: 'I saw Pierre in military uniform. It suits him very well.'[214] Pierre remained in the reserves until 21 May 1909.

Before graduating from the Conservatory in 1908, Pierre entered an acting competition. Aline, in Cagnes at the time, had wanted to see it, but Renoir forgot to tell her the date. When he wrote to her to apologize, he described their son's performance with more pride than could have been expected from someone who had initially mocked Pierre's ambitions: 'My dear friend; I'm furious at myself for not having sent you a telegram about the competition. I was convinced that

Saturday was Sunday and that you wouldn't receive it before the letter. Pierre performed excellently and took first prize. Besides, the whole audience asked for an encore. This caused quite a scene.'[215]

As part of the customary agreement with the Conservatory for acting students, Pierre had contracted to spend the two years after graduation as an actor in one of the state theatres, the Comédie-Française or the Odéon, where he would be paid 2,400 francs the first year and 3,000 francs the second. Thus, in the autumn of 1908, Pierre began working at the Odéon where, over the next fourteen months, he performed in thirteen different plays.[216] At the same time, he continued to take acting classes at the Conservatory under the direction of André Antoine (1858–1943) and Eugène Silvain (1851–1930). At this time, a reviewer in the literary journal *Comoedia* wrote about Pierre: 'Monsieur Renoir has a strange beauty.... He is tall, slender and has dark brown hair.... His voice is beautiful and deep, not monotonous; it often betrays his intentions that always reveal an artist, a conscious artist, educated and sincere. Monsieur Renoir is twenty-four years and three months old.... This young man who holds a big name in art (he is, I believe, the son of the great painter Renoir) is very gifted.'[217] Thus, Pierre was launched as a successful actor. However, after the first year, he became unhappy at the Odéon and wanted to join a prestigious troupe who performed at both the Théâtre de l'Ambigu and the Théâtre de la Porte Saint-Martin and were directed by Jean Coquelin (1865–1944) and André Hertz (1875–1966). In order to sever his contract with the Conservatory, Pierre would have to pay a large fine of 10,000 francs.[218] Deciding that it was worth the hefty penalty, he applied and was accepted by Hertz. Renoir happily paid this money and wrote to his son on 10 January 1909: 'I am delighted to know that Hertz asked you. It will keep you busy and end your boredom.'[219] So far from his initial antipathy towards acting, Renoir here seems more concerned with his son's happiness than anything else. Pierre was indeed content in that group and stayed for more than a decade as a key actor with them.

Renoir also made his friends and contacts available to his son. Around 1909, Pierre wrote asking his father if he knew anyone who could help him at the Théâtre du Gymnase in Paris. Pierre noted that the theatre had Paul Paulin's bronze bust of Renoir on display, which Paulin had inscribed: 'To my friend Renoir, Paul Paulin, 1902'.[220] Renoir, hoping that Paulin might be able to help, wrote to Pierre: 'I know absolutely no one at the Gymnase, but if Paulin has a bust there, he must know someone. Go find Paulin who would be happy to

help. He knows everyone in Paris. And write to me what he tells you. Maybe he knows someone who I know etc.... You will find Paulin's address at Vollard's or anywhere in Paris. Best, Renoir.'[221]

In return, Pierre assisted his disabled father and kept him company when he was in Paris. On 27 June 1909, when the young artist Schnerb came to visit Renoir on rue Caulaincourt, Pierre was present and voiced an opinion that seems to parrot what Renoir would have said: 'What annoy painters are exhibits where each artist strives to outdo his neighbour.' Then Schnerb recorded Renoir's response: 'That is well said. Everyone must work for himself. At first no one notices you, but little by little, you make yourself known. Nothing gets done all at once.'[222] In expounding this idea, the old Renoir (he was 68) showed his support for both the actor Pierre (aged 24) and for the artist Schnerb (aged 30).

While Renoir was able openly to support his three sons, he had to hide his affection for his eldest child, Jeanne, even when tragedy struck. Jeanne's husband, Louis, had become seriously ill, and died aged 45 on 25 July 1908, in their home in Madré, making Jeanne a widow at 38. It seems that she must have been pregnant at the time with what would have been her first child but she suffered a miscarriage, probably caused by the stress of Louis's death. These two deaths led to severe depression to the point where she became anorexic. The evidence of her miscarriage comes from a receipt of Jeanne's order for not one but two coffins on the day after Louis's death: she went to the Madré carpenter, requesting 'an oak coffin, 0.03 millimetres [⅛ in.] thick, for 60f' and 'a little pine coffin for 2f'.[223] Two coffins – one for 60 francs and one for 2 – suggests that the latter was tiny, which I believe indicates that it was for the foetus of Jeanne's unborn child. Jeanne's protracted grief over her husband's death would certainly have been intensified if she miscarried what would have been her first child. That her grief was inconsolable, as expressed in letters by Renoir, Gabrielle and Georgette, makes it seem likely that, indeed, Jeanne had miscarried the only child she would ever have.

Three months before Louis's death, Renoir had learned that Jeanne's husband was seriously ill, but he himself had been too sick to travel to Madré. He asked Vollard to go in his place. The trip to Madré would not have been difficult for Vollard, who was then at his vacation home in Cabourg, Normandy, 128 kilometres (some 80 miles) away. Before he left, Vollard wrote to Jeanne with questions about her finances. When she answered, Vollard responded: 'I received your letter and thank you for the information that you gave me.

So that I can report to M. Renoir on the state of your financial affairs, it would be very helpful to know the type of marriage contract you have, assuming you have one... I will be in Madré some time Thursday morning. I will be happy to visit you at your home, and will only stay a short while.'[224] As noted in Chapter 3, Jeanne's marriage certificate specifies that she did have a contract.

Vollard must have found that the Robinet finances were in a dreadful state. Louis had been so ill that he must have been unable to work for some time, and the couple had no other source of income. They had an outstanding debt to the local carpenter for some repairs on their home and bakery totalling 22 francs 70 centimes, dating to 31 March 1908, a month before Vollard's visit. This bill went unpaid until 2 August, when Jeanne included this sum along with her payment for the two coffins. After the carpenter delivered the two coffins at a cost of 62 francs plus a bolt for 60 centimes, he sent her a total bill for 85 francs 30 centimes. After she had paid, he gave her the receipt mentioned earlier: 'I acknowledge having received the sum of 85f 30c from Mme Robinet on 2 August, Isaïe Hébert, carpenter in Madré.'[225] Presumably, Renoir, through Vollard, paid the bill. In May, Vollard had travelled to Cagnes to tell Renoir about his daughter's plight (and to pose for his portrait with the Maillol statue; see page 243).[226]

Three months later, the mayor of Madré, according to the arrangement he had made with Renoir, notified Vollard of Louis's death. Four days after the tragedy, Vollard sent a sympathetic letter to Jeanne: 'Madame: I was notified in a letter from the Mayor of Madré of the great misfortune which has befallen you. I wasn't able to notify M. Renoir who is currently away, but I took it upon myself to send you, in his name, a money order for the small sum of 200 francs, to be paid to you at your home. Please accept my condolences, Vollard, 6 rue Laffitte.'[227] Renoir could not be reached because his health had deteriorated to the point of desperation and he could not walk. To try to remedy this, he had travelled with Gabrielle to Bourbonne-les-Bains for a month's treatment. Once he heard the disastrous news, he sent Jeanne a heartfelt letter assuring her that she had his support. With compassion and in handwriting shaken by rheumatism, he wrote: 'My dear Jeanne, I am unable to move right now because of my rheumatism; otherwise, I would have come to see you immediately.... I am writing so that you stop constantly worrying. It's a terrible misfortune that happened, but you never need to despair. You are thirty-eight years old and I have never abandoned you. I am doing what I can. I have no reason not to take care of you.' Later in the letter he reiterated and underlined: *'Never despair.'*[228]

Indeed, Renoir had been looking out for Jeanne all along. His foresight had ensured that the house remained in Jeanne's possession rather than reverting to Louis's male heirs as it would according to the Code Napoléon, as I detailed in Chapter 4. Since the house was in Renoir's name and since Renoir had lent it both to Louis and to Jeanne, she now owned the house in her own name; it would continue to be hers until her death, when ownership of the house would revert to Renoir. In that first letter after Louis's death, Renoir stated: 'If you need anything at all, I have assigned Vollard to stand in for me. If you are thinking of giving up the bakery, do so. If, on the other hand, you want to have the oven fixed in order to rent it out, tell Vollard. I will send you the necessary amount of money to do it. Think about it and do what's best. You are old enough to think sensibly.'[229] Here he encourages Jeanne to become a landlady, just as he encouraged Renée Rivière in her singing. What Jeanne did with the bakery is not clear but, two years later, Madré had a new baker, a certain Pierre Gervais Robinet, aged twenty-eight. It is uncertain whether this Robinet was any relation to Louis, and it is also unclear whether Pierre rented the bakery in Jeanne's home.

A few months after Louis's death, Renoir wanted Jeanne to open a bank account so that he could send her money. He wrote: 'My dear child... I need to know if you have received your bankbook so I can send you money. I am going to take care of your life annuity. You can trust me on that.... With love, Renoir.'[230] Renoir wanted to continue looking out for Jeanne even after his death. He decided to set up an annuity of 450 francs that would run from his death until hers. He funded this by means of government bonds left to her in his will. As early as the first letter to her after her husband's death, Renoir began constantly reminding her of his intentions to provide for her. As soon as he was able to set up the annuity, he informed her: 'I've deposited in a bank the money needed for your annuity. Even after my death you will be taken care of.'[231]

On 14 October 1908, Renoir went to a Paris notary, E. Duhau, and made out a will that included a section about Jeanne: 'This is my will– I the undersigned Pierre Auguste Renoir, an artist, have made out my will as follows.– I bequeath an annuity of 450 francs to Madame Jeanne, widow of M. Robinet, wife of baker in Madré (Mayenne) who will enjoy the use of it during her life beginning on the day of my death.– This annuity will be assured by registering with a tax of three per cent for the French state by means of French government bonds on 450 francs in her name and for her enjoyment. This gift will be given without any fees or taxes. I revoke all previous wills.– Done and written entirely by my hand

in Paris the 14th of October 1908 [signed] Renoir.'[232] In this will, Renoir avoided using the name Tréhot, possibly so that his heirs would not become suspicious, since they might have known that Lise Tréhot was Renoir's first model. It is unclear how Renoir came to the figure of 450 francs for Jeanne's annuity, since this sum was low and, indeed, less than he sent her per year while he was alive, which was often more than 600 francs a year. Six years later, in 1914 (just as the devaluation of the franc was beginning), Renoir's instructions to his son Jean on how much to pay a maid provide a comparison with the amount of money he gave to Jeanne: 'As for the baker's wife [La Boulangère, Georgette Dupuy], pay her about 50 francs from me, either two francs a day if you feed her during your stay, and three francs a day if you do not.'[233] If Georgette worked full-time for the Renoir family, she would have earned 750 francs a year without food, and 500 with meals. In contrast, Renoir's monetary gifts to his daughter while he was alive were generous. However, his annuity appears stingy since it was less than what he paid his maid a few years later. Yet Georgette was living in Paris, which was a considerably more expensive place to live than his daughter's small village in the countryside.

During the sixteen years from Jeanne's marriage until Louis's death, Renoir had not made a practice of sending Jeanne money on a regular basis, although nine years earlier he had given the 4,500 francs for her house, and sent an additional gift of 200 francs two years later. Presumably, Louis had made enough money with the bakery to support the couple. After Louis's death, however, Renoir began to make regular monetary gifts to his daughter. For example, around February 1909, when Renoir was making travel arrangements,[234] he explained to Jeanne: 'Vollard will regularly send you 50 francs each month during my absence, plus 100 francs immediately for your winter expenses. If, for any cause whatsoever – sickness or other things – you have need for more money, don't worry, write Vollard.... I am leaving for Venice with a very bad cold and then on to Egypt. I will see you in the spring. With love, Renoir.'[235] This amounted to 600 francs a year plus additional monies. Even a letter from Gabrielle deals with financial assistance: 'Tomorrow I will send you 100 francs.'[236] In total, before Renoir's death, Jeanne could expect a minimum income from her father of 600 francs per year plus gifts of 100 francs from time to time.

Even though Jeanne owned her own home with a rentable bakery, Renoir's annuity for his daughter of 450 francs a year was meagre. Because of the

devaluation of the franc from 1914, by the time of Renoir's death in 1919, the annuity he had set up in 1908 was worth less than half (39.5 per cent) its original value. In 1908, the average miner's salary, for example, was 1,256 francs a year, but in 1919 after deflation, 3,269 francs. Similarly, in 1911, the maximum annual salary for an experienced postman in Paris was 1,900 but in 1919 after deflation, 3,900 francs.[237]

We do not know why Renoir never changed Jeanne's annuity after the franc's devaluation during the last five years of his life. The explanation may lie in his illness and possible worry that making legal changes would risk revealing his secret, still known by only five people – Gabrielle, Vollard, Georgette Dupuy and her husband and M. Duhau. Nonetheless, not giving Jeanne a larger annuity appears stingy and out of character for the usually generous Renoir. Certainly, he was aware that he had more than 700 valuable paintings in his three studios, and many paintings in the warehouse of his dealer that were yet to be sold. He also owned two estates, in Essoyes and in Cagnes. Hence, he knew that his three sons would become enormously wealthy. It will never be known why Renoir did not increase his daughter's annuity so that she would get a more liveable income after his death. Besides discussing money, Renoir's letters to her reveal that he was concerned about Jeanne's health, since she remained sickly for a long time. Even a year after the double tragedies of Louis's death and her miscarriage, her health continued to worry her father: 'My dear Jeanne...I hope you are feeling better and that I will find you in good health.... With love, Renoir.'[238] Gabrielle expressed equal concern: 'I hope you are feeling better.'[239]

Gabrielle's letters to Jeanne reveal that an affectionate relationship had developed between the two women who were only eight years apart in age. For example, since Jeanne had told Gabrielle her fears about losing Renoir, Gabrielle updated her on his condition in the same letter: 'Monsieur Renoir is still doing okay. He isn't worse. At his age, you cannot expect him to get any younger. His stomach is good and in spite of his rheumatism, I certainly hope that he can still live for a long time.... M. Renoir asks me to send you his love. Write to me. With love, Gabrielle.'[240] In the past, Gabrielle used to accompany Renoir to Madré when he went to visit Jeanne. However, as his health worsened, these visits became increasingly difficult. At the time of Louis's death, Renoir hoped that he would still be able to make the trip. That October, knowing how bereft his daughter was, he wrote: 'My dear child.... If the weather warms up, I will try to come and visit you. With love, Renoir',[241] and again, about four months

later, 'I will see you in the spring' but it is unclear whether he was able to travel either time.[242]

Since it was unlikely that he would be able to visit Jeanne, Renoir had to devise a way for her to come to him. Obviously, she could not stay in the Paris apartment where Pierre was living and where Aline might show up at any time. Instead, Renoir hoped to arrange for Jeanne to stay at the nearby apartment of Georgette Dupuy. Georgette, only two years older than Jeanne, had been an employee of the Renoir family since before 1894, when she had asked Renoir to be a witness at her wedding to a baker, to which Renoir agreed, signing her marriage certificate: 'Pierre Renoir, 55-year-old-painter, 7, rue de Tourlaque', his studio address.[243]

Since Jeanne was a shy person, Renoir worried that she would not feel comfortable staying with people she did not know. Therefore, he asked Georgette to befriend Jeanne so that his daughter would eventually agree to stay with the Dupuys when coming to visit him in Paris. By this time, Renoir must have confided in Georgette about his secret daughter. Renoir's actions show that he hoped that a friendship might develop between Georgette and Jeanne so that Jeanne would be willing to stay with Georgette when she visited her father in Paris. His hopes rested, in part, on the facts that both women had been married to a baker and were only two years apart in age. As a first step, he arranged for them to begin a correspondence. Shortly after Louis died, Renoir asked Georgette: 'Would you be kind enough to write to Madame Robinet telling her that she should hire a little maid so she won't be alone and that she should ask Vollard for anything she might need. It is important to me that she doesn't lack anything.'[244] By telling Georgette to instruct Jeanne rather than doing it himself, Renoir not only managed to get the two women communicating but also, in his typical fashion, avoided doing anything directly in a sensitive situation. Despite his lack of direct involvement, his idea was sympathetic and compassionate. (It is not clear whether Jeanne ever did hire a maid.)

The correspondence between Georgette and Jeanne continued for nearly a year before they met. During this time, Renoir's hands hurt so badly that he asked Georgette and Gabrielle to write his letters for him. In this way, Georgette also became involved in his efforts to provide money for his daughter. Thus, in May 1909 Georgette, who had come down from Paris to Cagnes for a few days to help, wrote in one of her letters to Jeanne: 'I am writing you on behalf of Monsieur Renoir whom I am visiting for a few days. As you know, he has a lot of

difficulty writing with his ailing hands and he has asked me to do it for him. He sends you his best and asks how you are…. Please be kind enough to respond to me at home…and to acknowledge receipt of the 100 francs that I am sending you on behalf of Monsieur Renoir. He asks me to tell you that he will send you more when he returns to Paris in a month. He sends you his love.'[245] Once he had Georgette and Jeanne corresponding for a year, his next aim was that Georgette should go to Madré to meet Jeanne. At Renoir's request, Georgette offered to come by train the 230 kilometres (143 miles) from Paris. Jeanne wrote back to her about other issues but never mentioned the proposed visit, so Georgette responded: 'I am writing to M. Renoir at the same time as I am writing to you…. Now I told you in my last letter that I will soon come to visit you, and you didn't answer me on this subject. I would like to know if it's OK since I don't want to come over without your approval. I understand very well that you don't know me and that is always bothersome, but really, I am not bothersome. I am just a simple working woman, and you will see that when we meet, we will become good friends. My husband travels a lot and I accompany him sometimes; since he is heading in the direction of Alençon, I thought I could stop by and say hello. Well, let's hope that it will be soon and that you will want to have me over. While waiting for a positive response from you, my husband and I send you our warmest regards.'[246] It seems that Jeanne accepted Georgette's plan and that the two women met in the spring of 1909, since Georgette wrote on 15 July of seeing Jeanne 'again' (see next paragraph). Jeanne's health was evidently still somewhat fragile, for Georgette ended a subsequent letter: 'I hope that you are feeling better and better!'[247]

Renoir's third step in his planned Jeanne–Georgette friendship was to have Jeanne spend a month with Georgette and her husband, not in Paris but in the seaside town of Saint-Brieuc in Brittany. Perhaps Renoir hoped that this vacation would do the same for Jeanne as his excursions with Julie and her cousins after Morisot's death had done for Julie, giving Jeanne an interruption from her mourning. On 15 July 1909, close to a year after Louis's death, Georgette wrote a letter inviting Jeanne along on her vacation. Georgette must have already invited Jeanne since she expected Jeanne to be ready to leave that same day for a month-long trip: 'My dear little Jeanne…We are finally going to see each other again…. If, by any chance, you are ready to leave at that time, I will wait for you at the Alençon station until 2 p.m. and from there we will go off towards Saint-Brieuc to join M. Dupuy for a month. If you wish, you only need

to bring a few pieces of clothing so you can change and a dress for Sundays. I'll bring the rest. If this suits you, it's agreed.' Georgette included an alternative: 'Now, if you are unable to leave for Alençon as I told you, then at 2:16 p.m., I will take the train which will take me to Neuilly where I'll arrive at 3:53 p.m.… So, my little Jeannette, we'll meet either at 2 p.m. in Alençon or at 3:53 p.m. at Neuilly St Ouen on *Friday*. That's all agreed, right? Until I see you again, I send you all my love. Here enclosed is a note from M. Renoir. I will tell you what he told me to tell you in person. See you soon, Georgette.'[248] Georgette preferred that Jeanne meet her at Alençon, which would enable them to get to Saint-Brieuc earlier but would also be easier for Georgette. However, Alençon was more difficult for Jeanne since it was about 35 kilometres (21½ miles) from Madré. Georgette realized that there was a more convenient train stop for Jeanne at Neuilly-le-Vendin/Saint-Ouen-le-Brisoult, less than 2 kilometres (about 1 mile) from Jeanne's home.

Renoir's letter in the same envelope stated: 'My dear Jeanne, Madame Dupuy is supposed to stop by to visit you on her way to Saint-Brieuc. You should go with her for a little while. If you decide to, don't forget to give your address to the postman so that you can access your money. With love, Renoir.'[249] From available letters, we cannot be sure whether Jeanne agreed to Georgette's plan to spend a month together during a time that included the anniversary of Louis's death on 25 July. Even if Jeanne did go, it seems that the trip may not have gone well and she may have returned to Madré sooner than planned. All that we know is that in the next letter from Georgette to Jeanne, only a month later, dated 23 August 1909, Georgette seems disappointed and distant, icy and formal. This time she began her letter not with 'Dear little Jeannette' but 'Dear Mme Robinet'. For the closing, instead of 'Georgette' she signed 'M. Dupuy and I send you a big hello. See you soon, Mme Dupuy'. This letter, which was sent at Renoir's behest after Georgette returned to Paris, also stated: 'I wrote you to ask if you received the 100 f[rancs] that Mr Renoir sent you from Burgundy [Essoyes] but I didn't receive an answer.… Please tell him if you received the 100 francs he sent about one and a half months ago.'[250] It was precisely for this reason that Renoir had told her to give the postman her holiday address, as just noted.

Despite the fact that Georgette may have been annoyed with Jeanne, Renoir's plan to have Jeanne stay with Georgette and her husband in Paris proceeded. In September 1909, when Renoir knew that he would be alone in Paris with Gabrielle and Georgette, he invited Jeanne to visit: 'My dear Jeanne, Since

I can't come to see you, if you want, come to stay with Mme Dupuy as soon as possible, preferably around Tuesday, and I will be able to see you a little. With love. Renoir. September 09. Write us what day you are coming so we can pick you up at the railway station.'[251] Whether Jeanne accepted this invitation is not known but she did come to Paris several times and stayed with Georgette and her husband. On one of those visits, Renoir had her photograph taken as a gift to her (printed on its reverse is 'by Charles Gallot, photographer of intellectuals, Boulevard Beaumarchais, Paris', not far from both Renoir and the Dupuys' homes). Jeanne's photograph (see page 43), the only one she possessed at her death, shows her in a stylish, high-necked, black dress with tight sleeves, puffed shoulder pads and a fitted bodice – probably also a gift from her father. She appears uncomfortable and shy, but it is striking how much she resembles her parents in photographs of them at around the same age (see page 42).[252]

1910–15

Renoir aged 69–74;
Dismissal of Gabrielle,
Outbreak of War,
Death of Aline

Around 1910, Renoir painted a number of portraits of himself, his wife and their sons. His sudden desire to preserve the images of himself and his family might well reflect his fears about his mortality in the face of his worsening arthritis. Clearly, these family portraits had sentimental value for him, since Renoir kept all but one (*Profile Self-Portrait*) in his studio until his death.[1]

Renoir based his portraits of Aline, Jean and Coco on the canonical art of the past that he admired in museums. The first of these, done in 1909, was a large portrait of Coco, then aged eight, in the pose and costume of Watteau's *The Clown Gilles* (c. 1715–21, Paris, Louvre).[2] Next, in 1910, in an even larger size, Renoir portrayed Jean at sixteen as a hunter (see page 245).[3] This canvas is the same height as *The Artist's Family*, 1896 (see page 198), but not as wide. Jean's regal posture with his rifle and hound, Bob, are a reference to Velázquez's *Prince Baltasar Carlos in Hunting Dress* (1635–36, Madrid, Prado).[4] In 1910, Renoir also made the first significant portrayal of Aline (see page 245) since *The Artist's Family* fourteen years earlier.[5] He painted her in the pose of a fres-coed Greek mother-earth figure, *Arcadia* (2nd century BC), from the Basilica at Herculaneum.[6] The portrait realistically conveys Aline's prematurely aged appearance and portliness (the latter highlighted by their small puppy), which are confirmed by a photograph of the time with Renoir and Coco.[7] Renoir also made two oil sketches of Aline sewing.[8]

In contrast with his paintings of Coco, Jean and Aline that each refer to a famous painting from the past, Renoir's 1910 portrait of Pierre at twenty-five is a simple bust. Interestingly, it is strikingly similar in pose and size to Renoir's

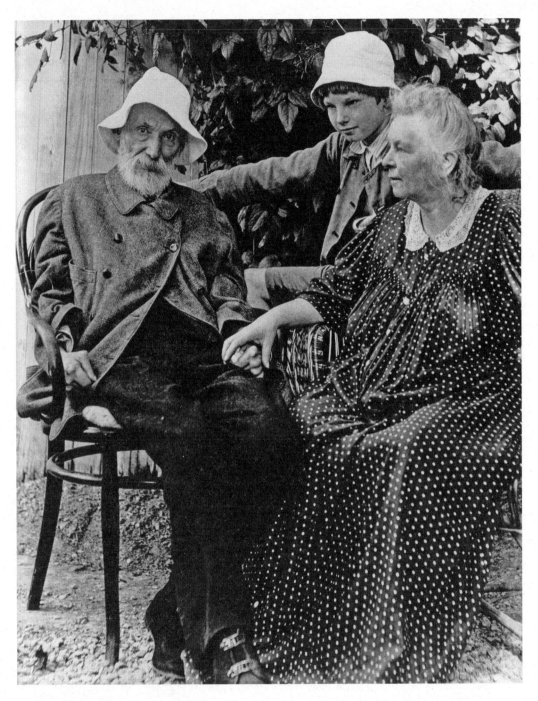

Renoir, Coco and Aline, Essoyes, 1912. Photographer unknown. University of California, Los Angeles, Art Library Special Collection, Jean Renoir Collection

self-portrait from the same year.[9] However, while Pierre's portrait is idealized, Renoir's self-portrait captures an acceptance and acknowledgment of his situation, also seen in the photograph with Aline and Coco just mentioned. That same year, Renoir painted another self-portrait, in profile.[10]

By 1912, Renoir's health was so fragile that it is easy to see why he might have been feeling his mortality. He weighed only 44 kilos (97 pounds, less than 6 stone), and had difficulty eating because of a dry mouth from his illness and the fact that his teeth had been removed. He could barely sleep, as he complained to Renée Rivière: 'Unfortunately my rheumatism makes me suffer constantly. Every night I have feet like an elephant.'[11] In fact, by 1912, Renoir's legs had become too weak to support the weight of his thin body. The Bernheims, in one last attempt to save Renoir's mobility, found a Viennese doctor whom they brought to Paris in order to treat him. The doctor put him on a strengthening diet for a month. When the doctor returned to test Renoir's walking, the painter was able to take a few steps on his own, with tremendous effort. He decided that the great effort required to walk would drain the energy he needed to paint, concluding that he would prefer to paint.[12] Around that time, he wrote to Rivière: 'I have *lost my legs*. I am *unable to get up*, sit down, or take a step without being helped. Is it for ever?? That's it. I sleep badly, tired out by my bones, which tire the skin. That's how skinny I am.'[13]

Those closest to him reflected the gravity of his worry. Gabrielle had been with Renoir for eighteen years as a caring companion and model. In June 1912, she wrote to Vollard: 'The boss can no longer move on his own; he is completely debilitated in his legs and arms. His hole is healing well and there is barely anything left. This hole has really bothered us.'[14] That 'hole' was the result of a rheumatoid nodule, a mass of tissue under the skin, probably an ulcer on his buttock, which broke down with the pressure of sitting and later became ulcerated, causing an open sore. As noted before, the only commercial medicine then available was Aspirin, the successor to salicylic acid, which Renoir would not have liked since it caused severe indigestion; indeed, most people refused to stay on it.

A stroke Renoir suffered in the spring of 1912 decreased his mobility even further, leaving him unable to move his arms as well as his legs for a few days. In June 1912, Aline wrote to Durand-Ruel: 'My husband is doing a little better. He is beginning to be able to move his arms, his legs are still the same. It is impossible for him to stand on them, but he is a lot less discouraged despite

that. He is getting used to his immobility. It is really sad to see him in this state.'[15] And three days later: 'My husband is doing better. He's been working [painting] in the garden for ten days now. It's very hot. It's done him a world of good. He still can't walk, but painting still interests him more and more.'[16] Since holding a pen was harder for Renoir than holding a paintbrush, sometimes Gabrielle wrote letters on his behalf, such as the five letters she wrote from Renoir to the Bernheims around 1911–13.[17]

Just as he had in 1905, Renoir decided to compensate for his lack of mobility by renting a car. In February 1911, even before his legs failed entirely, he wrote to his dealer: 'I am going to rent a car for a month.'[18] The next month, Renoir and Aline visited the car and bicycle shop of her cousin. Aline wrote to Durand-Ruel: 'Renoir saw several cars which didn't suit him. It's for that reason he's ordered a car in which he'll feel like he's in a living room. I hope that he will be satisfied with it because it's a very big expense, but he has the right to treat himself, even to an expensive whim.'[19] In May 1913, how Renoir could travel from Cagnes to Paris was still an issue, as Cassatt in Grasse, near Renoir in the south, explained to her New York friend, Louisine Havemeyer: 'It is a problem how to get him to Paris, but they are going in an auto and will take eight days to do it.'[20] Automobile travel had become necessary since Renoir could no longer take the train, as a letter to Durand-Ruel from Aline five months later confirms: 'My husband put up with the car very easily. He finds it more agreeable than the train.'[21] This worked out so well that Renoir eventually hired a chauffeur, Baptistin.[22] Owning an automobile in 1913 was rare: in 1911, only 64,000 vehicles were registered in France.[23]

Renoir's declining health necessitated that the family once again move their Paris residence. In the new apartment, at 57 bis[24] boulevard Rochechouart in the ninth arrondissement, the artist could be wheeled between home and studio, which were on the same floor. In 1911, the family also rented an apartment with a studio in Nice, just over 12 kilometres (8 miles) from Les Collettes, so that Renoir could be close to his doctors. This corner residence was on the third floor at 1 place de l'Église-du-Voeu and 1 rue Palermo (now rue Alfred Mortier). It was rented from the Roumieux-Faraut family. Renoir made frequent trips back and forth between Cagnes and Nice, as did Aline, of whom Renoir related: 'My wife will shuttle between Cagnes and Nice.'[25] As Renoir explained in November 1911, he needed frequent treatments for rheumatoid nodules: 'The role of the surgeon consists of getting rid of my growths. It doesn't hurt, but it's

a long and bothersome process.' Despite the obvious benefit of being near his doctors, when explaining why they were renting in Nice, Renoir wrote in the same letter: 'I had to rent an apartment in Nice so that the children can get to school more easily.'[26] Jean, by then seventeen, and Coco aged ten were attending the Lycée Masséna, within walking distance of their apartment (though most of Coco's education came from private tutors). Additionally, Renoir found Nice more enjoyable than Les Collettes. He told André: 'I am very happy in this apartment in Nice. I feel less abandoned than in Les Collettes, where I feel like I'm in a convent.'[27] Nice was 'more lively' than Cagnes, and another benefit was that it was much easier to find models there than in the countryside, as he wrote: 'I hope to find models without having them come from Paris.'[28]

The fact that Renoir was still painting even in his pitiful condition was a subject of much amazement to his friends. In December 1912, when Renoir was seventy-one, Durand-Ruel, ten years older, visited and reported: 'Renoir is in the same sad condition, but his strength of character is still amazing. He is unable to walk or even to get up from his armchair. He has to be carried everywhere by two

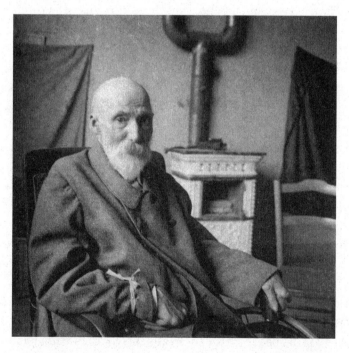

Renoir in Nice, 1913. Gelatin-silver print, 8 x 8.26 cm (3⅛ x 3¼ in.).
Photo by Konrad Ferdinand Edmund von Freyhold. Collection Roland Stark

people. What torture! And, despite that, he is still in a good mood and is still happy when he can paint. He has already done several things, and yesterday during the day he painted a whole torso that he began in the morning. Sketchy but superb.'[29]

Two months later, Cassatt, then sixty-nine, visited Renoir, reporting to Louisine Havemeyer: 'It does one good to see his courage.'[30] A few months later, she wrote again to her friend: '[Renoir] really is to be admired, such courage! And such a helpless cripple, and sufferer. What a blessing that he can paint all the time, and that he is persuaded that what he does now is better than anything that he did before.'[31]

In November and December 1913, and again in April and May 1914, the German painter Konrad Ferdinand Edmund von Freyhold (1878–1944) visited Renoir both in his Nice apartment and at Les Collettes while he stayed at Hotel Savournin in Cagnes. Von Freyhold had been commissioned by a Swiss collector, Theodor Reinhart, to purchase two works from Renoir, which he accomplished.[32] He also took many photographs of Renoir and his family, for one of which Renoir, uncharacteristically, removed his hat, revealing his bald head (see opposite); another shows Renoir painting the 1914 *Seated Bather* (see pages 278–79).[33]

Renoir was not the only Impressionist suffering from ill health. By this point, 1913, only Cassatt, Degas and Monet were alive, of whom Degas, then aged seventy-nine, was in poor shape – Cassatt reported to Havemeyer: 'Degas [is] a mere wreck.'[34] A year later, Joseph Durand-Ruel relayed to Renoir: 'I recently saw Degas. Talking with him is not an easy thing, for he can barely see anything and doesn't hear much…. Miss Cassatt had [cataract] operations on her two eyes.'[35]

Monet, in contrast, was in relatively good health, but deep in mourning for his wife, Alice Hoschedé, who had died in May 1911. He and Renoir remained good friends and saw each other about once a year. Three months after Alice's death, on 27 August 1911, Renoir and Gabrielle went to Giverny to console Monet. The day before, Gabrielle wrote to Vollard: 'Tomorrow, Sunday, Durand-Ruel's car will pick us up to go to visit his friend Monet. He is still crying over his wife's death on the banks of his pond. We are going to try to console the poor man.' She explained that Mme Renoir was at the spa in Vichy with her car and chauffeur.[36] The day after their visit, Monet wrote to Bernheim-Jeune: 'Renoir came to see me yesterday which made me very happy. He is always valiant in spite of his sad condition, while I'm losing hope even though I'm the healthy one.'[37] Monet was concerned about Renoir's health and kept track of him through Alice's daughter, Germaine Salerou, who was Renoir's neighbour in Cagnes, as

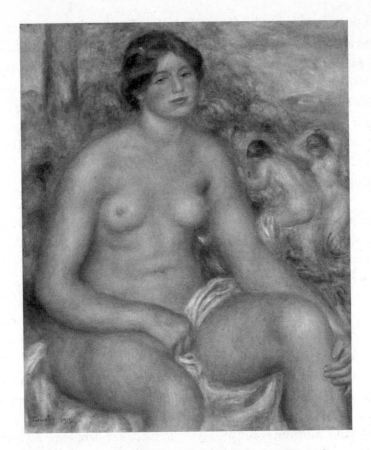

Seated Bather, 1914. 81.1 x 67.2 cm (31⅛ x 26⅞ in.). The Art Institute of
Chicago. Gift of Annie Swan Coburn to the Mr and Mrs Lewis I. Coburn
Memorial Collection

well as through the Durand-Ruels, to whom Monet wrote in June 1913: 'I was
told that Renoir is not well; please let me know how he is. I am counting on you,
you know, and if you see him, send him my best.'[38]

In spite of or perhaps even because of Renoir's debilitated condition,
several art critics stated that his art was improving. Their opinions could have
been inflated because of the pathetic contrast between the sickly artist and his
joyful works. The Parisian critic and poet, Guillaume Apollinaire, 'the main
impresario of the avant-garde', wrote in 1912, when Monet, Matisse and Picasso
were also highly esteemed: 'the aged Renoir, the greatest painter of our time and
one of the greatest painters of all times, is spending his last days painting won-
derful and voluptuous nudes that will be the delight of times to come'.[39] Even two

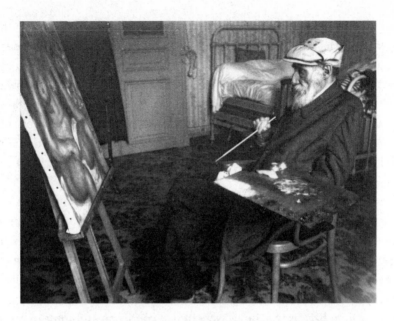

Renoir in Nice or Cagnes working on *Seated Bather*, 1913–1914. Gelatin-silver print, 8 x 8.26 cm (3⅛ x 3¾ in.). Photo by Konrad Ferdinand Edmund von Freyhold. Private collection

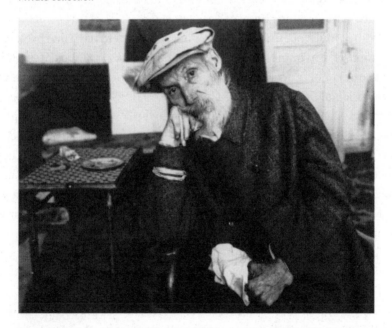

Renoir in Nices or Cagnes pausing while working on *Seated Bather*, 1913–14. Gelatin-silver print, 8 x 8. 26 cm (3⅛ x 3¼ in.). Photo by Konrad Ferdinand von Freyhold. Private collection

years later, Apollinaire's praise had not dimmed: 'Renoir [is] the greatest living painter, whose least production is hungrily awaited by a whole legion of dealers and collectors.'[40] Similarly laudatory, Walter Pach, a young American critic, helped by Gertrude Stein, interviewed Renoir four times from 1908 onwards. His 1912 *Scribner's Magazine* interview began: 'To have attained the famous three-score years and ten, and be producing work which surpasses that of his youth and middle age, to have seen the public change its attitude from hostility to homage, to be one of the best-loved of living painters: such is the lot of Pierre-Auguste Renoir.'[41]

Renoir's popularity rocketed during his later years, not only among critics but also the general public. Once, for a dinner at the Grand Hôtel de Californie in Cannes with Josse Bernheim-Jeune Dauberville and his wife Mathilde, Renoir was pushed in his wheelchair 'through the corridors to where the dining room was and faithful Gabrielle tied a napkin round his neck and put the knife and fork between his fingers that were deformed by rheumatism. He was obliged to have a spittoon because his lungs were in bad condition and some of his food was mashed by a machine. All the hotel guests had recognized him and, when Gabrielle pushed his chair back at the end of the meal, everyone stood up and applauded him for a long time.'[42]

With so much popular interest, it is not surprising that the first book-length monograph of any Impressionist was of Renoir: in 1911, Julius Meier-Graefe wrote about Renoir's art with a hundred reproductions, which was translated from the original German into French the next year.[43] Some years later, Renoir's close friend Albert André wrote another monograph whose text was approved by the artist before its publication in May 1919, seven months before Renoir's death.[44] Back in 1911, on 20 October, the French government promoted Renoir to the rank of officer of the Légion d'Honneur. While liberals like Monet had objected in 1900 when Renoir accepted the first rank of knight, eleven years later, Monet applauded him: 'My dear Renoir, My congratulations for your nomination to the rank of officer.'[45]

This popularity had the predictable result of increasing the prices of Renoir's paintings. In 1899, Monet's paintings had fetched higher prices than Renoir's but by 1912 things had changed. For example, two Monets, *Banks of the Seine at Argenteuil* (c. 1873–74) and *Terrace at Ste-Addresse* (c. 1866–67) were each sold for 27,000 francs,[46] whereas two comparable Renoirs, *Parisian Lady* (1874) and *A Morning Ride in the Bois de Boulogne*, were sold for 56,000 francs and 95,000

francs respectively.[47] Avid collecting drove up the prices of Renoir's canvases. For example, his friend Maurice Gangnat amassed 161 works, the largest Renoir collection in Europe.[48] The only collection in the world to surpass Gangnat's became that of an American doctor, Albert C. Barnes of Philadelphia, a millionaire who had patented the antiseptic Argyrol. On 11 December 1912, Barnes first bought two Renoir paintings for 30,000 francs from Vollard. The following year, Barnes wrote to another American collector, Leo Stein: 'I am convinced that I cannot get too many Renoirs.'[49] Eventually Barnes acquired 181 Renoirs.[50]

From 1910 until Renoir's death in 1919, at least 37 exhibitions in at least 12 countries displayed a total of at least 605 of Renoir's works.[51] The year with the most exhibitions was 1913, a year before the outbreak of the World War, when 8 different shows displayed a total of 102 Renoir paintings. The most acclaimed exhibition was that in March 1913 at Bernheim-Jeune's in Paris with 52 of Renoir's major canvases from 1867 to date. An accompanying illustrated catalogue edited by Octave Mirbeau, contained 58 reviews by other critics dating from 1876.[52] Even during the war, there were 224 Renoir works on view in 14 exhibitions.

When the Bernheims decided to publish a book on Rodin, which came out in 1915, they asked Renoir to make a drawing of the sculptor.[53] In November 1913, Renoir replied: 'Dear Mr Bernheim, I would be delighted to do a drawing of Rodin.'[54] Gustave Coquiot, a critic working for the Bernheims, was the author and acted as the liaison to Rodin, informing him: 'Madame Renoir and Renoir await you and Madame Rodin. They are very well settled and *everything is ready for your visit*. Renoir lives in *Cagnes* and, in the region, everyone will be able to show you his house. *Remember that Renoir is going to do your portrait for our Album that will be published by Bernheim. Cagnes* is mid-way between Antibes and Nice. It is only a few kilometres from Nice.'[55] Renoir priced the drawing at 1,000 francs.[56] Later, Vollard convinced Renoir to make a lithograph from this drawing, with the collaboration of Auguste Clot, and 200 impressions of the Rodin portrait were printed.[57]

Renoir's own opinion was ambivalent, despite all this acclaim for his graphic work as well as for his paintings. On the one hand, as we have seen before, in 1913 Cassatt reported: '[Renoir] really is to be admired, such courage! And such a helpless cripple, and sufferer. What a blessing that he can paint all the time, and that he is persuaded that what he does now is better than anything that he did before, and that he has made money enough to give himself and his

family every comfort.'[58] On the other hand, the next year, after the First World War had begun, he confided to André: 'As for me, I'm painting, if you can call it painting. Just to kill this damn time, which gets old, but like the old guard [the elite guard in Napoleon's army], doesn't die. I keep rotting here like an old moulding cheese.'[59] Perhaps he did not really believe the praise of others, or perhaps some of his old self-deprecation was resurfacing.

Whatever he felt about the quality of his work, the act of painting remained in this period a source of comfort for Renoir, as revealed by the inherent optimism of his art. Aged sixty-nine, he had written to André early in 1910: 'I am so lucky to have painting, which even very late in life still furnishes illusions and sometimes joy.'[60] Although Renoir was here contrasting his life and art, Mirbeau saw the two as interconnected: 'His whole life and his work are a lesson in happiness. He has painted with joy...Renoir may be the only great painter who has never painted a sad picture.'[61] Perhaps Renoir 'never painted a sad picture' because he thought of his work as an escape from the reality of his situation: 'It is unbearable, especially at night, and I am still obliged to take drugs, useless as that is. Apart from this inconvenience, all is well and I work a little to forget my sufferings.'[62] Indeed, how much Renoir painted was an indication of how he was feeling physically. As Aline wrote to Durand-Ruel in 1911 after Renoir's recovery from a particularly difficult setback, 'Renoir is doing very well. He has a renewed taste for work, which is with him a sign of good health.'[63]

Even his physical limitations could not prevent Renoir from working on large canvases when he felt inspired. When in 1910 he was painting *Jean Renoir as a Huntsman* (which measures 173 x 89 centimetres [68⅛ x 35 inches]; see page 245), sometimes his chair was placed on a trestle so that he could be lifted to the appropriate height, or pulleys were attached to the canvas to raise or lower it.[64] Renoir desired to paint such a large canvas in order to call to mind famous murals, such as Raphael's story of Psyche that he had admired in 1881 on the walls of the Farnesina in Rome.[65] In painting such a large work, the increasingly frail artist hoped for immortality of his own. In André's 1919 biography, he quotes Renoir as saying: 'It is now that I have neither arms nor legs that I want to paint large canvases. I dream only of Veronese, of the Wedding at Cana!.... What a misery!'[66] Renoir explained his feelings about great art of the past to Walter Pach in their interviews over 1908–12: 'There is nothing outside of the classics. To please a student, even the most princely, a musician could not add another note to the seven of the scale. He must always come back to the first

one again. Well, in art it is the same thing. But one must see that the classic may appear at any period: Poussin was a classic; Père Corot was a classic.'[67]

In the same period, Renoir also expressed his high regard for artisan craftwork. Renoir was writing on this subject for a preface to the reissue of a French translation of the *Libro dell'arte* (The Craftsman's Handbook, *c.* 1390) by Cennino Cennini, an artistic descendant of Giotto.[68] The two-year project began in July 1909, and resulted in both a review in the journal *L'Occident* in December 1910 and in a book published by Bibliothèque de l'Occident in 1911. In November 1909, Renoir was working on the preface with the help of Maurice Denis and Georges Rivière, who transcribed and edited Renoir's words.[69] He not only praises craftworkers but also links them to the classical tradition. Renoir's porcelain-painting background gave him sympathy for artisans, and the fact that Cennini's craftworkers were creating frescoes appealed to Renoir's love of the wall paintings he had admired in Italy in 1881.

Renoir's preface explored why the artisans of the past (contrasted to those of his time) were great artists: 'Whatever the merit of these secondary causes of the decadence of our crafts, the principal one in my view is the absence of ideals.'[70] One ideal that Renoir speaks of is faith. Not faith in God, since Renoir never displayed any interest in organized religion, as his own son wrote: 'Renoir seldom if ever set foot in a church.'[71] Renoir's faith was in art and beauty. In his Cennini preface, Renoir wrote: 'All painting, from that of Pompeii, made by the Greeks [in fact, artists under the early Roman Empire], to Corot's, passing by Poussin, seems to have come out of the same palette.... However, to explain the general value of earlier art, we must remember that the master's teaching was surpassed by something else, also now gone, that filled the soul of Cennini's contemporaries: religious feeling, the most fecund source of their inspiration. It is that which gave to all their work simultaneously this frank and noble character in which we find so much charm. In a word, there then existed a harmony between men and the milieu in which they moved, and this harmony came from a common faith. This is explained if one agrees that the conception of divinity among superior peoples has always implied ideas of order, hierarchy, and tradition.'[72] Even though Renoir was not religious, his admiration for art in museums resembles the religious veneration that he perceived in the art of the masters of the past.

Given this attitude, when Vollard came to Renoir in April 1913 with the proposal that he collaborate with a sculptor who would translate his paintings

into sculptures in the round or into reliefs, it is no surprise that Renoir was intrigued, since this would enable his artistic creations to continue in a different medium. In this collaboration, Renoir would be like Cennini and his sculptural collaborator would be like Cennini's artisan assistants. Renoir certainly could not sculpt on his own, since his hands were so crippled that he could no longer work even in soft wax, as he had done five years earlier. However, on one occasion he took some earth from the garden of Les Collettes and made the head of the *Small Standing Venus*.[73] Thereafter, he directed but did not actually execute further sculptures. From 1881 with the *Blonde Bather* (see page 92), Renoir's figures had become increasingly sculptural, a quality that he found in his most beloved precedents – Pompeian artists, Raphael and Cézanne. In a joking letter of April 1914 to André, Renoir explained how Vollard arranged this collaboration: 'My dear André, Everything is chance in life, and when Vollard talked to me about sculpture, at first I told him to go to hell. But after thinking it over, I let myself be persuaded in order to have some pleasant company for a few months. I don't understand much about that art, but I made fast progress in dominoes for three people by working hard at it.'[74] While Renoir gives his reason for accepting as a desire for company, it seems unlikely that he would have agreed if the idea of sculpture had not appealed to him.

Vollard's initial proposal was that Renoir work with Maillol, but the sculptor demurred. Instead, Maillol proposed his assistant of three years, Richard Guino, who had transferred Maurice Denis's paintings into sculpture the previous year. The plan was that Guino would work under Renoir's direct supervision; Renoir would make all the critical decisions, such as size and style. When he was satisfied with a piece, Renoir's name would be affixed to the sculpture. Vollard would need his written consent in order to cast the pieces that he had purchased from the artist, after which the dealer would hold exclusive casting rights. Thus, on 19 April 1914, Renoir wrote to Vollard: 'I authorize Monsieur Ambroise Vollard, picture-dealer, owner of my three sculpture models: small statue with base *Judgment of Paris*, large statue with base *Judgment of Paris* and the clock *Triumph of Love*, to reproduce them in any material.'[75] Vollard would pay Guino, and Renoir would get the sale price of future purchases, less Vollard's commission. This collaboration began in the spring of 1913 (when Guino was twenty-three and Renoir was seventy-two) and continued for more than three years. Guino, five years younger than Pierre, became part of the Renoir family. Not only was he a companion for Renoir, but he also became a good friend to

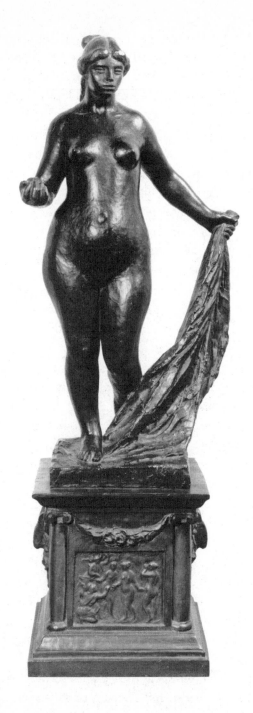

Renoir assisted by Richard Guino, *Large Venus Victorious* with *Judgment of Paris* on the base, 1915–16. Bronze, H. 184.8 cm. (72 in.). Tate, London

Jean, only four years younger; he also befriended the adolescent Coco. Jean and Coco often wrote Renoir's letters to Guino. His presence enabled Renoir to remain active and work even during rheumatic attacks. As Rivière wrote to Jean in October 1914: 'The arrival of Guino will certainly distract your father a little. It will be a precious source of work without fatigue for him.'[76]

Of the fourteen statues in the Guino-Renoir partnership, half are related to Renoir's 1913 version of his *Judgment of Paris* (see page 247; for the first, of 1908, see Chapter 5).[77] One of Renoir's goals in this new version was to make the figures heavier and more three-dimensional and thus easier to sculpt. Gabrielle wrote to Bernheim-Jeune of her preference for this new version: 'At the moment he is working on a large painting, the same as the one you saw in Cagnes, the *Judgment of Paris*, but this one is much more beautiful than the other one. He is well and works every day.'[78]

Under Renoir's supervision, Guino made five figures in the round and two reliefs based on the 1913 painting. Two of the statues are busts of Paris, one beardless and one with a beard.[79] The other three statues were of Venus: a small statuette, a medium statuette and a large statue (see page 285).[80] The two reliefs of the *Judgment of Paris*, a small bas-relief and a large high-relief, became the bases that supported the small and the large statues of Venus.[81] Renoir planned to display one of the bronzes of his large Venus statue in his garden at Les Collettes, for which he made a watercolour of the statue in its setting on which he inscribed: 'Let the base of the statue be at the level of the water with small rocks and aquatic plants.'[82] As Renoir and Guino worked on this project, Renoir tried to improve his conception for the large Venus by researching the heights of classical precedents. In February 1914, he wrote to André: 'My dear friend, I have something annoying for you to do for me. I don't even know if it can be done. It would be to find out the exact height from the heel to the top of the head of a statue of a Greek woman, not the Venus de Milo, who looks like a big policeman, but for example the Venus of Arles or the Medici or some other. You can get this information, I think, from the casts in the Louvre. If you can get this information for me in this way or another, let me know as soon as possible. If it's impossible, I'll do without it, that's all.'[83] Whether or not André was able to get Renoir this information, work was already under way a few months later when Cassatt reported to Durand-Ruel: 'The big statue is progressing.'[84] The height of Renoir's large *Venus* is between the heights of the two classical statues that he asked André to investigate. Otherwise, the proportions of Renoir's are entirely

different from those of the ancient statues: Renoir's is heavy, with a small head, sloping shoulders, small breasts, long torso, protruding stomach and wide hips.

In addition to having Guino follow the body type and gestures of the figures in his 1913 *Judgment of Paris*, Renoir provided live models. From Les Collettes in October 1913, Jean wrote to Guino in Paris: 'My dear Guinot [sic]; Papa has asked me to tell you to wait a little before you bring a model, for he might have someone in mind: Renée who posed in Essoyes for the little Venus.'[85] Three months later, Renoir told Vollard that he was ready to receive Guino in Nice, adding that he had two models, male and female, so he hoped Guino would not delay in coming.[86] The male model was to pose for the figures of both Paris and the flying Mercury, the female model for the three goddesses. Until November 1913, Gabrielle continued to model for Renoir, as she had for both versions of the *Judgment of Paris*, including for the male figure of Paris.[87] However, during the seven months that Guino worked for Renoir from April 1913 until Gabrielle's departure in November 1913, there is no indication whether or not she posed for Guino.

Renoir's *Judgment of Paris* paintings are the first depictions of a romantic encounter since 1885's *In the Garden*,[88] but there was no corresponding love affair in Renoir's life. His relationship with his wife had become increasingly strained and distant, often causing them to live apart. Renoir, accompanied by Gabrielle to the end of November 1913, and by other maids after that time, spent the majority of his time in Cagnes or Nice while Aline shuttled from Essoyes to Paris, Nice and Cagnes. The couple did periodically meet, as indicated by his letter of 24 June 1911 to her: 'I hope I'll find you still in Paris. I will be there during the first week of July.'[89] So much physical separation worked well for the couple no doubt because of their emotional separation.

Aline's continual refusal to accept doctors' orders regarding her health increasingly frustrated Renoir. For example, in January 1914, he wrote to André snidely: 'My wife still has a bad cold, of course.'[90] By this time, Aline's diabetes had been officially diagnosed. Another diabetic, Mary Cassatt, wrote to Joseph Durand-Ruel in February 1914 about Aline's diabetes.[91] In fact, Gabrielle had given Aline's illness a name two years earlier: 'Madame Renoir is doing okay. She still has diabetes. She has lost a lot of weight.'[92] As noted in Chapter 5, there was no medical treatment for diabetes then, but Aline made efforts to control it by regular trips to the spa at Vichy.[93] Unfortunately, spa treatments were as little use to Aline as they had been to Renoir. Her weakened immune system

predisposed her to respiratory problems such as emphysema and bronchitis. For example, in 1910, on the reverse of a letter from Renoir to Gangnat, Gabrielle had noted: 'Madame Renoir is recovering from a very bad cold. She isn't over it yet.'[94] The following June, Gabrielle had written to Vollard: 'The *patronne* has been coughing for three weeks. She still has bronchitis.'[95]

The very fortune that made their lifestyle possible acted as another source of friction between Aline and Renoir. As he explained in 1913: 'My wife loves luxury; I hate it and accept it only when forced upon me.'[96] Aline had always pursued more luxury and comfort than Renoir desired. She wanted to purchase houses in Essoyes and Les Collettes and to rent an expensive apartment in Paris. In complete contrast, all Renoir's studios and his personal attire were modest. Nonetheless, given that Renoir had become a suffering paraplegic, he was pleased to have enough money, as Cassatt wrote to Havemeyer in 1913: 'He has made money enough to give himself and his family every comfort.'[97] With or without Renoir's permission, Aline never hesitated to ask Durand-Ruel or Vollard for funds.[98] She also made some money on the side by selling art. As Cassatt wrote to Havemeyer in 1912: 'Mme Renoir bought a little "pochade" [quick sketch] by Cézanne for 100 francs long ago, not so very long ago, & now they offer her 18,500 francs for it, but she wants 20,000 francs. It is folly.'[99] In hopes of gaining more money, Aline also pursued gambling, as Renoir had joked to Mme Gangnat in a letter of November 1910 to her husband: 'This [note] is for Mme Gangnat: my wife went to Monte Carlo and she won 200 francs. I will be able to buy myself a brimmed hat, which I have wanted for a long time.'[100]

Aline's goal of becoming haute-bourgeoise led her to reject what she felt were menial tasks. Rather, she saw herself as the manager of their various residences. She insisted on being present to greet Renoir's guests and kept track of which rooms were available when. In March 1911, she wrote to Durand-Ruel: 'If your son Georges intends to come, he'd better hurry up. I won't have any free rooms after the 20th.'[101] And in 1913, to Vollard: 'You were planning to come at the end of the month. I have a room for you.... Aline Renoir.'[102]

There was also an expanding staff to supervise at their three residences. Madeleine Bruno, a model from Cagnes, recalled: 'there were many employees at Les Collettes: Grand' Louise who was from Essoyes as were Gabrielle and Lucienne,[103] the chamber maid, Léontine from Cagnes, Antoinette Herben, Bailé the gardener, and Baptistin, the chauffeur.'[104] In addition, the Renoirs had part-time workers. Aline was most directly involved with the gardeners, since she

enjoyed being able to send her own produce to Renoir's friends. For example, in December 1912, Renoir informed Paule Gobillard: 'My wife is going to send you some [olive] oil that is perfect and abundant this year.'[105]

Aline put her management skills to good use as a matchmaker. Just as she had previously taken great interest in pairing up Rivière's elder daughter, Hélène, and Renoir's nephew, Edmond Renoir junior,[106] she later turned her attention to Hélène's younger sister, Renée, who had lived with the Renoirs while studying singing (see Chapter 5). Rivière wrote an ecstatic and grateful letter to Aline in late 1912 announcing that Renée (then twenty-seven) was engaged to marry Paul Cézanne junior (who was forty): 'Madame, Mme Cézanne and her son came to visit me this afternoon and you can guess right away the reason for their visit. It was a marriage proposal. Paul Cézanne and Renée are in love and have declared [their betrothal].... I didn't want to wait more than a few hours to announce an event that you helped to bring about and that will delight you just as much as me.... This marriage pleases me infinitely.... Must I really insist on the feelings of gratitude that I feel when thinking of your role in this marriage? No, don't you agree, you don't need to do another good deed for me for my affections for you to continue, and you know me well.'[107] Eight days later, he wrote to Renoir: 'I don't need to be long-winded to tell you how happy I am about Renée's upcoming marriage [they married in January 1913]. No matter why or when I think about the marriage, I rejoice. By the way, I received a very kind letter from your wife; please tell her that I was very touched.'[108] Renée expressed her heartfelt appreciation to Aline years later by naming her children Aline Cézanne and Jean-Pierre Cézanne (combining Aline's two older sons' names).

Mary Cassatt, who struggled to understand Renoir's family, did not share the good opinion that Rivière, Renée and Paul Cézanne had of Aline. Cassatt based her observations both on what she witnessed and on what her maid, Mathilde Valet, learned from the Renoirs' servants. In Cassatt's opinion, there was a sharp contrast between Aline, whom she viewed as cold and distant from her husband, and Gabrielle, whom Cassatt perceived as loving and devoted to Renoir. In a letter to Havemeyer of February 1913, Cassatt analysed the situation: 'I went to see Renoir the other day, it does one good to see his courage. It is a strange household; the only one with heart is the former model and now nurse. I was told she drank occasionally but one forgives that when one sees her devotion, as for Mme Renoir, she is away most of the time.'[109] For example, eighteen months earlier, Aline had decided to go to a spa at the same time that

Renoir planned to pay a condolence call to Monet, so Gabrielle accompanied Renoir.[110] Both Gabrielle and Cassatt believed that Aline liked being on her own. At that point, as previously noted, Aline thought that going to spas would control her diabetes, as Cassatt informed Durand-Ruel early in 1915: 'I saw Renoir this afternoon, very well and painting with a pretty colour – no more red. Mme Renoir wasn't there, having gone to Nice. He told me that she was also feeling very well. The Renoirs' cook told Mathilde [Cassatt's maid] that no, she wasn't herself and that [the cook] thought that [Aline's] diabetes had gone to her head. This woman [the cook] has worked very long for the Renoirs. Now Mme Renoir doesn't want to follow any diet; they say that if she goes regularly to Vichy, it isn't necessary.'[111] In July 1913, Cassatt had written again to her New York friend Havemeyer about Gabrielle: 'It is a curious household; fortunately for [Renoir] there is a former model now nurse, whose devotion is beautiful.'[112]

Despite the strange dynamics of Renoir's family being known, it came as a shock to everyone when Aline abruptly fired loyal Gabrielle in November 1913. No one knew why. A letter of 28 December from Cassatt to Havemeyer reveals the writer's dismay: 'The wife sent off the former model who has been with them eighteen years and was Renoir's devoted nurse. She, the wife, was jealous and says she takes the nursing on herself, that she doesn't, and he is without a nurse, he who is as helpless as a baby; that poor girl was very fond of him; he now is without affection around him.'[113] The Bernheim family's perception of why Aline had fired Gabrielle was similar, as a grandson later reported: 'The loyal Gabrielle who cared for him with such devotion represented his ideal woman: model, nurse and guardian angel. After so many years, Madame Renoir, was suddenly seized by a fit of jealousy against this dear and loyal guardian and forced Renoir to fire her, which he had to do, though sick at heart, in order to achieve calm in the household.'[114]

After Gabrielle left in November 1913, Renoir himself subtly revealed new friction in his relationship with his wife when he wrote to Georges Durand-Ruel the following month that it would be best if Paul Durand-Ruel would not visit him in Cagnes until Aline was there: 'My wife prefers to be here when he visits. She doesn't trust me.'[115] Soon after Aline dismissed Gabrielle, Cassatt again wrote about the Renoirs in a letter to Havemeyer: 'His wife I dislike and now that she has got rid of his nurse and model, she is always there.'[116] Joseph Durand-Ruel made a similar observation to his brother on 20 April 1914: '[Mme Renoir] is watching her husband closely and seems to tell him what to do for everything.

[I] wasn't able to chat with Renoir alone for two minutes.'[117] In March 1915, Cassatt told Havemeyer: 'Vollard and Mme Renoir come to luncheon tomorrow. M. Renoir wanted to come. You may be sure she did not urge him.'[118] It seems that Cassatt believed that Mme Renoir did not want Renoir to join them.

The only explanation any of Renoir's friends could give for the sudden departure of Gabrielle was jealousy on Aline's part, as we have seen from both Cassatt and the Bernheims. Certainly, all Gabrielle's letters show that she was a caring person who was pained by Renoir's suffering. But what would be the cause of Aline's jealousy? There is no evidence whether for or against Renoir and Gabrielle having had a sexual affair throughout the previous eighteen years. By 1913, most probably Renoir and Gabrielle were not having any kind of affair, since Renoir was too debilitated and Gabrielle was in a long-term relationship with an American artist, Conrad Slade (on whom more shortly).

It is much more likely that Aline was jealous of Gabrielle's access to Renoir's secrets and her important position in Renoir's private life. I surmise that the only thing that could possibly have made Aline angry enough to fire Gabrielle would have been the discovery of Renoir's biggest secret – his illegitimate daughter, Jeanne Tréhot. Aline could have found out about her through a practice she had begun three years earlier, that of snooping through Gabrielle's things. Gabrielle had reported to Vollard: 'His wife will bother you all the time. She came when the boss wasn't here and she filched some etchings from me that he wanted to keep. He is nice but his wife is very annoying. She will annoy you the whole time.'[119] Despite Gabrielle's knowledge of Aline's snooping around her room, it could be that Gabrielle had left evidence of Jeanne Tréhot's existence in her room, such as Jeanne's newly written will that named Gabrielle as her sole heir. Jeanne wrote her will on 12 June 1913, kept one copy for herself, which remained with her family papers, and sent the other copy to Gabrielle. In this will, she identified herself as Jeanne Marguerite Tréhot. Aline, probably knowing that Renoir's first model was Lise Tréhot, could easily have deduced that Jeanne was Renoir's illegitimate child. The fact that Jeanne had made Gabrielle her only heir would have shown Aline that Gabrielle not only knew about Renoir's illegitimate daughter but also had become Jeanne's favourite person.

The copy of Jeanne's will that she kept at home reads: 'This is my last will and testament: I, the undersigned, Jeanne Marguerite Tréhot, widow of Louis Théophile Robinet, residing in the village of Madré give and bequeath by this will to Mlle Gabrielle Renard, who lives with Mme Dupuy, rue [de] Clignancourt,

no. 23, in Paris, all the possessions movable and immovable that I will leave when I die, as my general legacy and my only heir excluding all others.'[120] We know that Gabrielle did not in fact live with Georgette Dupuy but with the Renoirs nearby at 57 bis boulevard Rochechouart. While Gabrielle remained where Renoir was living, Jeanne could not send her will to that address since Aline could have intercepted the letter. Instead, Jeanne sent all her correspondence with Renoir to either Georgette Dupuy or Vollard, people who were privy to Renoir's secret. If, as I propose, Aline found the will in Gabrielle's room and confronted her as to who Jeanne Tréhot Robinet was, it is likely that Gabrielle would have refused to answer, even if Aline had threatened to dismiss her. Gabrielle was much closer to Renoir than she had ever been to Aline so would doubtless have chosen to remain silent.

When Aline fired Gabrielle, the person most important for Renoir's physical and psychological wellbeing, she must have intended to hurt him. He was then seventy-two. It was the strongest way she could punish her husband for thirty-five years of secrecy and deception. It is possible that since Renoir avoided conflict, indirectness was the only weapon that Aline had. If my suppositions are correct, Aline must have felt extremely hurt and betrayed. Doubtless, her pain was intensified because her father had deceived her mother. Aline's suspicions could explain why she would not allow Joseph Durand-Ruel two minutes alone with Renoir. It is even possible that Aline never directly confronted Renoir about Jeanne's will, for Gabrielle would have told Renoir why Aline had fired her. It is probable that, if Aline had come to know Renoir's secret, they felt there was nothing to discuss.

If Aline indeed discovered Renoir's secret (as I believe), this revelation would have delivered a blow to the little control that Renoir still had over his own life. With his health spiralling out of control and his physical limitations increasing, it is easy to see why Renoir expressed a view that Rivière later reminded him of having said a month after Gabrielle's dismissal: 'Sometimes we resemble a cork in the water and we never know where it will lead us.'[121] André quoted a similar statement by Renoir in his May 1919 book, whose text Renoir approved: 'Today, as I look back on the life behind me, I compare it to one of those corks thrown in the river. It dashes ahead and then is taken by a backwater, brought backwards, dives, resurfaces, is caught by some grass, makes a hopeless effort to break free and ends up getting lost, I don't know where.'[122] Renoir had always used his secrets to keep a part of himself invulnerable. Once

Gabrielle in Renoir's studio at 38, blvd de Rochechouart, Paris, c. 1912–13. Original print 18 x 24 cm (7⅛ x 9½ in.). Private collection. Photographer unknown

Aline unearthed this hidden information, the only thing Renoir could do was to maintain as much control as possible by never revealing the truth behind Gabrielle's dismissal and thus continuing to keep Jeanne Tréhot a secret from everyone, including his close friends and children. Even though Aline probably now knew, she could never disclose Renoir's secret without besmirching his reputation and her own. Hence she would never have revealed this secret.

Luckily for Gabrielle, when Aline fired her, Conrad Slade invited her to live with him at Cagnes's Hotel Savournin.[123] At that time, Gabrielle was thirty-five

and Slade forty-two. The couple had met when Slade had moved to Cagnes in 1906 with the express intention of befriending Renoir, whom he greatly admired.[124] Gabrielle and Conrad stayed together for the next thirty-seven years until Conrad's death in 1950. If Slade had not welcomed Gabrielle, she would have been obliged to return to her family in Essoyes since she had little money. After she moved out of Les Collettes, it took her a while to adjust to her new situation, during which she lost contact with everyone but Renoir. When she did reach out to Jeanne Tréhot, on 8 December 1913, she wrote on Hotel Savournin stationery: 'My dear Jeanne; This letter comes from a phantom. When I see you I will explain why you have not heard from me for so long!' Since Gabrielle was living in a hotel, she was out of touch with Georgette Dupuy and asked Jeanne: 'Have you heard from Mme Dupuy? I don't know what she has been doing. It's been a month since I last heard from her. If she has written to you, let me know.' However, she had kept in touch with Renoir and reported to his daughter: 'M. Renoir is well; he told me to send you 100 francs. When you receive it, let me know at the address on the heading.... M. Renoir asks me to send you his best wishes and I give you my love. Gabrielle Renard.'[125] Even though Renoir's secret had probably been uncovered by Aline, he did not allow it to change his relationship with Jeanne. As in the past, after Gabrielle was dismissed, Renoir still gave Gabrielle 100 francs to send to Jeanne along with an expression of his love, as he had, for example, in December 1910.[126]

Gabrielle's letter to Jeanne clearly states that she would see her shortly: 'When I see you I will explain'. From November to December 1913, Gabrielle had risen in status from famous painter's maid to the partner of a wealthy Bostonian. All surviving documentation shows that she was kind and generous; it is likely that she explained to Jeanne that she no longer needed to be the beneficiary of Jeanne's will. Subsequently, Jeanne made a new will, writing: 'I revoke all former wills.' Her new will was identical to the former one except for the designated heir; instead of Gabrielle, Jeanne named two heirs. Both were her foster family's relatives: '1. Georges David my godson, son of Valentin David and of Alphonsine Gautier for the first half and 2. Louise Gautier, my goddaughter...for the other half.' Jeanne's revised will reveals that she was a devout Catholic, as were her foster family: 'I want a second-class funeral in the cemetery of Madré, and to be buried in a casket of good-quality oak, and that the funeral be held as soon as possible after my death in the church of Madré. I also want an annual mass celebrated in my honour and in the honour of my

late husband. I give and bequeath to the Madré charitable organization a sum of 200 francs, tax-free, on condition that this organization oversee the care of our grave in the cemetery.'[127] This clarifies her intention to be buried in the same tomb as her husband.

Gabrielle's promised visit in the winter of 1913–14 was a continuation of visits that she and Georgette had been making on Renoir's behalf since he had become too crippled to go to Madré himself. Ever since the death of her husband in 1908, Jeanne had been frail and sickly, which worried her father, Gabrielle and Georgette. For example, Georgette had proposed a visit some years before: 'Little Jeannette; Your letter made us very happy, but it's really a shame that you're always sick. You should try to eat a little more but when you are not hungry, it is not easy. You would need a glutton like me around to make you eat. In any case, we will do our best to come and see you at Easter…and when I am there, you will have no other choice but to eat.' It seems that only Jeanne's involvement in Madré's Catholic community kept her functioning, as shown by Georgette adding: 'Right now, my little Jeannette, I have beautiful communion crowns from the shop where I work that are not too faded. I thought that they could be useful to you in your processions. So if you want them, let me know and I'll send them to you. In the meantime take good care of yourself so that we will find you fresh as a daisy when we come…. Much love to all. Say hello to all of Madré.'[128]

In addition to her life in Madré, Jeanne visited her father in Paris once a year starting in 1909, as described in Chapter 5, usually for a week in late August when Aline and the children would be in Essoyes. Renoir wrote to her in July 1910: 'Dear Jeanette; I made sure that you can come to Paris at the end of August in better conditions than last year [see Chapter 5]. I know that you are OK. I am very glad about that. I am sending you a little money to put aside. With love…Renoir.'[129]

In anticipation of Jeanne's late summer visit to Paris, Georgette and Jeanne also corresponded in July. The earlier friction between them had disappeared and Jeanne invited the Dupuys to visit her in Madré. Georgette responded: 'Little Jeannette…. Now my little Jeannette, you asked us to go to Madré. You must know that it is not because we do not want to that we cannot come, but M. Dupuy has a lot to do these days. I think that on 15 August he will maybe have a few days off. I was going to send you some grapes but if I am coming in two weeks, then I will bring you some; it is safer. I am fixing up your little room. And if that is possible we will spend a week with you and we will travel back together',

so that Jeanne could visit her father in Paris. In the same letter, Georgette also reported: 'Monsieur Renoir is in Germany until the end of August. He is well and before leaving, he asked me to write you and to give you all his love.'[130] Since Jeanne had planned to visit her father in Paris in August, the news that Renoir was in Germany until the end of the month seems to have made her anxious. To reassure her, Renoir wrote: 'My dear Jeanne; I received the letter you wrote to Madame Dupuy. At this time I am so busy that I don't know what to say. I am with the Germans and I may have to be away for a few days. Please don't worry. I am always thinking of you. Don't ask of me more than what I can do. When things quiet down, I will tell you. With love, Renoir.'[131] When Renoir returned to Paris, Jeanne's visit went ahead as expected. Four months later, on 28 December 1910, Renoir began planning for his daughter's next annual visit: 'My dear Jeanne; I wish you a happy new year and good health. I am as well as possible. I hope to see you again this summer. I am sending you one hundred francs at the same time [as this letter]. With love, Renoir.'[132]

While Renoir's eldest child, forty-year-old Jeanne, was struggling with widowhood in 1910, his youngest, nine-year-old Coco, was still a child. Because both Renoir and Aline were ailing during his childhood, Coco was raised more by assorted maids and models than by his parents. His education, too, was never stable for more than a few months at a time because of the family's constant moving. When Coco was ten and Jean seventeen, Renoir settled in Nice, as we have seen, so that the boys could attend the local day school, the Lycée Masséna. As Renoir explained to Durand-Ruel in 1912, they rented an apartment in 'Nice...for the children in school, it's less complicated'.[133] Around the same time, Gabrielle wrote to Vollard: 'Claude goes to school with Jean every morning.'[134] Whether the family was in Essoyes, Paris, Cagnes or Nice, Coco was also privately tutored. For example, on 25 March 1915, Renoir wrote from Les Collettes: 'Coco is in Cannes with a teacher to catch up on missed schoolwork, which makes the house a little too quiet.'[135]

Until Coco was nine, he posed for a total of forty-five portraits. Modelling then tapered off until he was fourteen, producing only five portraits. During this period, Coco sometimes helped his father even when he was playing. In February 1910 when Coco was only eight, his chain-smoking father let him play with a cigarette-roller Durand-Ruel had sent: 'I received the machine to make cigarettes; it is making the children happy. Coco makes them and I don't need to tell you that this toy has, for the time being, dethroned his locomotive.'[136]

Aline, meanwhile, took an interest in her young son's religious upbringing. Thanks to her, Coco's first communion, when he was eleven, was a big family event. On 19 March 1913, from Cagnes, Renoir wrote to André, Coco's godfather: 'Claude's Communion will take place around 18 or 25 May with great pomp. Lunch at the Hotel Savournin.'[137] The day of Claude's communion, Jean, then in military training in the centre of France, wrote: 'Dear Coco, Thursday's your First Communion – I'm very happy and will think of you on that day.... At the moment of the great event, I will be, without a doubt, on a horse in the fields. Pray to the Good Lord for your Papa and your Maman. Your big brother who loves you very much.'[138]

Coco was an affectionate and energetic child, more interested in play than in study. A year earlier, in May 1912, Gabrielle had written a note on the back of one of Renoir's letters to Arsène Alexandre: 'Claude is very funny. He goes to school every day and he is the sweetest of the three children.'[139] The next year, Renoir wrote to Bernheim from Les Collettes: 'I shall be staying in Nice for Coco's teachers, because all he does here is climb trees which is excellent but nevertheless not sufficient for a boy of his age.'[140]

While Coco was shuttled about because of his parents' nomadic lifestyle, only Pierre had a stable, permanent residence in the family's Paris apartment while building his acting career, as described in Chapter 5. He even had business cards and postcards printed with 'Pierre Renoir...43 rue Caulaincourt'.[141] Since Pierre did not make enough money to be independent, he relied on his father's fortune and, in return, became the family's Paris representative. Thus, in June 1911, Gabrielle wrote to Vollard, 'You must have seen Pierre who surely gave you our news.'[142] Pierre also relayed information within his family, as demonstrated by a September 1912 letter from Aline to Durand-Ruel: 'I saw Pierre yesterday and he gave me good news about his father.'[143] Additionally, Pierre acted as Renoir's companion when the artist visited Paris. For example, in August 1911, Renoir wrote to Monet, then in Giverny: 'Sunday I plan to come by car to see you with Pierre.'[144] Meanwhile, Pierre had his parents' permission to get money from his father's dealers. In 1910, when Pierre's theatre company was touring, he wrote: 'My dear Vollard, I am leaving tomorrow night for Holland and I want to be safe by having a pretty large sum of money with me. I would like 1,000 francs.'[145] Another note to Vollard stated: 'I am coming to bother you again. I need another 1,000 francs. I will stop by [your office] tomorrow, Saturday, afternoon.'[146]

At the time, Pierre was a highly gifted and lauded young actor in Paris. From 1910 until he was drafted in mid-1914, he performed in twenty-one plays at the Théâtre de l'Ambigu and at the Théâtre de la Porte Saint-Martin.[147] Pierre also performed in two silent films: in 1911, *La Digue* (The Sea Wall), directed by Abel Gance, and in 1912, *Les Deux Gosses* (The Two Lads), directed by Adrien Caillard.[148] In November 1912, Rivière reported to Aline that he 'seemed very happy with his work. The role [of the German General von Talberg in *Coeur de Française* (Heart of a French Woman) at L'Ambigu] that he has just developed has made him a star and is very good for him.'[149] Indeed, Pierre had received favourable reviews in the daily theatre journal *Comoedia*: 'Monsieur Renoir, in the role of General Von Talberg, achieved a well-deserved and dazzling success', and '[His role] is acted with authority and sobriety, which are remarkable for a young actor.'[150] A year later, a critic praised his 'performance of infinite tact and naïve sensitivity', and writing: 'This young actor has made surprising progress during the past few years, and he is right to expect a good future.'[151]

In 1909, when he was twenty-four, Pierre met his first love, Colonna Romano (1883–1981), at the Paris Conservatory. She was an actress at the Odéon theatre, joining the Comédie-Française in 1913. Nicknamed Colo, her real name was Gabrielle Dreyfus, from a Jewish family. In 1910, when Pierre introduced her to his parents, Renoir liked her so much that he asked her to pose for him and, throughout the next three years, had her sit for a total of seven portraits.[152] Renoir's esteem for Colonna caused him to give his 1912 portrait of her to the Fine Arts Museum of his birthplace, Limoges, writing in December 1915: 'I authorize Monsieur Vollard, 6 rue Laffitte to take the head of Colonna for the museum of Limoges.'[153] Three years later, in March 1918, Renoir wrote to the critic Geffroy: 'I have a portrait of Colonna [*Young Woman with a Rose*, 1913, now Musée d'Orsay] that I would like to give to the Luxembourg [Museum, Paris].... Consult either Vollard or Durand-Ruel to see what needs to be done.'[154] The government paid Renoir a token sum of 100 francs and the painting went on display at the Luxembourg in that year. Another portrait of Colonna Renoir refused to let go and it remained in his studio until his death, when Pierre acquired it.[155]

It is unclear when Pierre and Colonna ended their relationship but by 1913 he had become involved with another actress, Véra Sergine (1884–1946), then twenty-nine, whose real name was Marie Marguerite Aimée Roche. Like Colonna, Véra was from a Jewish family; her father was the assistant director

at the Ministry of Justice and Religion.[156] Also like Colonna and Pierre, Véra had attended the Conservatory and then gone to the Odéon before pursuing her career in other Parisian theatres.[157] She also starred in silent films, such as when she partnered Pierre in 1912 in *Les Deux Gosses*. Véra was so well known that the French playwright, Henri Bataille, wrote a laudatory tribute comparing Véra to distinguished French Jewish actresses: 'Our elders had Rachel, Desclée, and Sarah Bernhardt[158] who, even today, still amazes us. We, the younger ones, we have Véra Sergine...our veritable interpreter, our tragic muse, but always human and real.'[159]

By the summer of 1913, Véra was pregnant with Pierre's child. On 4 December 1913, Claude André Henri Renoir was born. The names Claude and André came from the Renoirs,[160] while the name Henri may have come from Véra's family.[161] Just as when Pierre himself had been born, both parents legally recognized their son but the couple did not marry immediately. Unlike Pierre, however, baby Claude was not a secret from the family and close friends.[162] Pierre, Véra and baby Claude lived together at 30 rue de Miromesnil in the eighth arrondissement.[163]

Jean, meanwhile, had begun his military training. Just like his father forty years before, he wanted to join the cavalry; indeed, he wanted it to be his profession, as Renoir's was art and Pierre's was the theatre. Jean and many young men like him were eager to regain the glory of France, since the nation was still smarting from its territorial and financial losses in the Franco-Prussian War. The cavalry attracted Jean not only because of his father's military service, but also because of its tradition dating back hundreds of years. Looking back in 1958, Jean compared the costume and rules of his cavalry regiment to the 'Regulations of Louvois', the minister of war under Louis XIV.[164] Later still, in 1970, Jean romantically described the cavalry experience: 'The people in that war were like knights during a crusade of the 12th century or characters from an episode in Virgil.'[165] In order to join the cavalry as an officer, Jean had to fulfil the educational requirements. He had graduated from the Lycée Masséna in 1912 with a standard certificate but also needed the more advanced *baccalauréat classique*, which entailed oral and written examinations in mathematics and philosophy. Jean gained his *bac classique* at a branch of the University of Aix-en-Provence in Nice in early 1913.[166]

Renoir supported Jean's aim by using his connections, such as with Rivière, an official in the finance ministry. As early as November 1912, Rivière wrote

Jean Renoir in dragoon regalia with plumed helmet, cavalry boots, and sword, Paris, 1913. Photo by Chamberlin, 35 blvd de Clichy, Paris. Univ. of California, Los Angeles, Art Library Special Collection, Jean Renoir collection

to Aline: 'Does Jean still want to join the army?.... If he decides to enlist, let me know ahead of time so that I can take the necessary steps at the Ministry of War or at the Guards and so that our good man is placed in a good regiment and in the best conditions.'[167] Jean decided to take advantage of his father's connections, as Maurice Denis's diary shows: 'Had lunch at Renoir's place.... Jean Renoir...is going to enlist in the dragoons.'[168] Thanks to Rivière's help, after Jean's basic cavalry training, he was placed in the prestigious 1st Dragoons regiment in Joigny (150 kilometres [94 miles] south-east of Paris and 136 kilometres [85 miles] due west of Essoyes).[169]

Jean started his three years of officer training as a private aged eighteen on 17 February 1913.[170] His military record book shows that his height was 180.3 centimetres (5 ft 11), taller than his father, so tall that his regulation sleeping bag was too short for him.[171] He wrote to his mother: 'Dear Mama, If you have some shopping to do, at the same time please buy me a sleeping bag big enough for my long legs – and a grey blanket, or one that won't soil easily.'[172] The patriotic uniform of his troop pleased him with its red trousers, blue jacket, white collar, white gloves, ostentatious, metal helmet with plume and old-fashioned sword.[173] He was so proud of how he looked that he had two photographs taken to give as Christmas or New Year presents in 1913/14. His pose calls to mind his father's portrait, *Jean Renoir as a Huntsman*, of only three years earlier, where he looks significantly younger (see page 245). Jean sent one of the photographs to his godmother, Jeanne Baudot, who wrote to Renoir: 'Jean did me the pleasure of sending me his photograph and I have just responded that I am proud of my godson and think that he nobly represents his regiment and his country.'[174]

The day Jean began his training, his superior officer wrote to Renoir on stationery inscribed '1st Regiment of Dragoons, The Colonel': 'I am very proud that your son has chosen to enlist in my regiment and that you have consented to trust me with him.... I will take special care of him, and I hope that...he will soon really enjoy the regiment. I would be very happy if, because of his hard work, I will be able to give him his first stripes [designating a rise in rank] as quickly as possible.'[175] Jean's dragoon training made progress, as Rivière wrote to Renoir two months later: 'This evening I received a letter from Jean who was a little tired, he wrote, after five hours of manoeuvres in the sun...he can take part in exercises, which are pretty difficult in this period of intensive instruction; moreover, he doesn't complain!'[176]

The colonel's prediction of a swift rise through the ranks was well founded because Jean loved the military and sportsmanship. He was promoted to corporal only eight and a half months after he started, and was popular in his troop, as Rivière informed Renoir on 21 December: 'Our dragoon is adored by his comrades; his bosses hold him in high esteem; he is very military. His colonel invited him to dine a few days ago and this is a true mark of the consideration this big chief has for Jean. I don't need to tell you how happy this news made me; thus, I rushed to impart it to you.'[177]

However, things did not always turn out as Jean wanted. Another letter of a few weeks earlier from Rivière to Renoir reveals that Jean was worried about a potentially unpleasant move of his group from Joigny to Luçon in the Vendée in west-central France. Rivière wrote: 'About five minutes ago Jean left my house where he slept the other night. Our young corporal is in good health from all points of view, that is to say that his morale is as excellent as his physical state. What spoils the picture of his military life is the prospect of a transfer of his regiment that could end up stationing them at a camp at Luçon, in the Vendée. This is obviously an exile since it's fifteen or sixteen hours by train to go from Luçon to Paris and I don't know how long to go to Cagnes.'[178] In January 1914, Jean wrote: 'Dear Mama, I believe that the die has now been cast. We will leave for Luçon.... The most annoying thing I can see in our departure is that the officer corps is going to be completely changed – good officers don't get sent to Luçon! All the good people who command us will either go east or to the garrisons near Paris – only the incompetent ones will stay.'[179] The same month, Renoir wrote to Durand-Ruel: 'Jean's regiment is definitely going to the Vendée. We, along with the poor boy, are very upset.'[180] The regiment made the arduous journey from Joigny to Luçon on horse, all of 490 kilometres (306 miles). In Luçon, Jean felt so isolated that he had to ask for news, writing to André on 10 April 1914: 'As soon as I can...I'll come to visit you. You will see that I am not dead and you can give me some details about the art exhibition [at Durand-Ruel's].[181] As isolated as I was, I could not get hold of any magazines, so that I don't know anything about anything.... Jean Renoir, 1st Dragoon, 4th Squadron.'[182]

That spring, Jean was promoted again, this time to the rank of sergeant. On hearing the good news, Aline planned to visit him. The trip must have been difficult for her, but she had always been devoted to all her children. Jean tried to help her with her plans and wrote to her: 'The Hotel de la Poste is not as good as the Duc de Bourgogne Hotel – as for the food, I don't know.... My love to you

as well as Papa and Coco, Jean.'[183] After Aline left, Renoir informed André: 'My wife is at Luçon visiting Jean for about a week.'[184]

With war looming on the horizon and a beloved son already active in the military, Renoir clung to his painting as an escape from the frightening reality that his two older sons might be hurt or killed. Hence, on occasion he accepted a portrait commission. The most notable during this period was of the German actress Tilla Durieux (1880–1971; see page 305), whose husband, the Jewish dealer Paul Cassirer (1871–1926), was Renoir's primary contact in Germany. Cassirer had a gallery in Berlin where he exhibited Renoir's work in 1904–05 and 1912, the latter being a major show with forty-one Renoir paintings.[185] In her diary of July 1914, Tilla Durieux wrote that she and her husband came to Paris where she posed for Renoir in his studio fifteen times, usually two hours in the morning and two hours in the afternoon during the first two weeks of July.[186] She modelled in her majestic costume from George Bernard Shaw's *Pygmalion*.[187] In her journal, she recorded the discussions she and Renoir had during her posing sessions. The painter told her how he had visited Munich in 1910.[188] Durieux and Renoir also discussed music; Renoir expressed his preference for Bach and Mozart over Wagner to whom he could no longer listen.[189] Durieux was impressed by Renoir's modesty, quoting what he said to her: 'I no longer want to do portraits, but I am happy I decided to undertake this work. It has helped me to make progress, don't you think so?.... I have made progress, haven't I?'[190] Renoir's vibrant, heartfelt portrait of Durieux is one of his great paintings (see page 305). When the actress and her husband were ready to leave Paris, they could not take the portrait with them since the paint was still wet. On 20 July 1914, they left Paris in their chauffeured car and drove through Belgium and Holland where 'no one expected a war'.[191] Eight days later, on 28 July, Austria declared war on Serbia and, on 3 August, Germany declared war on France. With the interruption of the First World War, Renoir could not send the portrait to Germany so he kept it in his studio until his death, at which time it went to Durand-Ruel. Then, by the mid-1920s, the portrait went to the Cassirer-Durieux collection in Berlin.[192]

Tensions in Europe had come to a head. On 28 June, Archduke Franz Ferdinand, the heir to the Austro-Hungarian throne, and his wife, Sophie, Duchess of Hohenberg, were assassinated. On 1 August 1914, the French government declared a general mobilization. France mobilized 8,410,000 men between the ages of eighteen and forty-six, which was 91 per cent of men of those ages. Nearly half (43 per cent) of the entire French male population fought

in this war.[193] Pierre, who had already completed his military training and had been in the reserves for five years (see Chapter 5), was drafted as a private in a reserve artillery unit. One might imagine that Pierre was sad to leave his career, Véra and baby Claude. In contrast, his brother Jean later described his positive feelings: 'We were all of us then believing in the importance of this war. We were absolutely sure that we were rescuing humanity, that we were bringing democracy to the world.'[194] These hopes, pinned on France's grand traditions, were out of touch with reality since France's military was pathetically outdated, especially the cavalry. With their swords and horses, they were ill-prepared for barbed wire, trenches, machine-guns and poison gas.

The war was extremely stressful for Renoir. About six weeks after it began, he wrote to André of 'unbearable dizzy spells', doubtless brought on by fears for his two older sons.[195] Also, living in France meant that the war surrounded the painter. On 2 September 1914, the Germans advanced until they were only 48 kilometres (30 miles) from Paris. The French government abandoned the capital and took refuge in Bordeaux. The very next day, Aline, Renoir and Coco, then in Paris, evacuated to Cagnes. Even there, they could not escape the war. A month later, they hosted a large group of French soldiers, as the compassionate Renoir wrote: 'We had sixty soldiers staying with us, all fathers; they left this morning, disappointed to leave Les Collettes; they are sad but very brave, the poor men.'[196] Painting was Renoir's only escape, as he wrote to Georges Durand-Ruel: 'Me, I am aging here peacefully, as much as the constant anxiety of this ridiculous war will allow, and I am working a little so as not to think about it. That's one benefit.'[197] Renoir felt anguish about 'this ridiculous war' both because two of his sons were in the military but also because he had many friends who were German, such as the painter and photographer von Freyhold and the dealer Cassirer.

By August 1914, when the war began, artillery had developed enormously and gun wounds were a great danger. The machine-gun had been invented and perfected; guns firing 1,000 bullets a minute were common. In the early days of the trench war, gunners amused themselves by cutting down trees with their bullets. The new rifled and breech-loading cannon accurately fired projectiles (shells) filled with explosive that detonated on impact.[198]

On 2 September 1914, the same day that the French government evacuated Paris, Pierre was shot in the arm, abdomen and leg during the first major offensive of the war, severely injuring him and handicapping him for life. Thirty years later, when interviewed about his war experiences, Pierre said: '"My war"

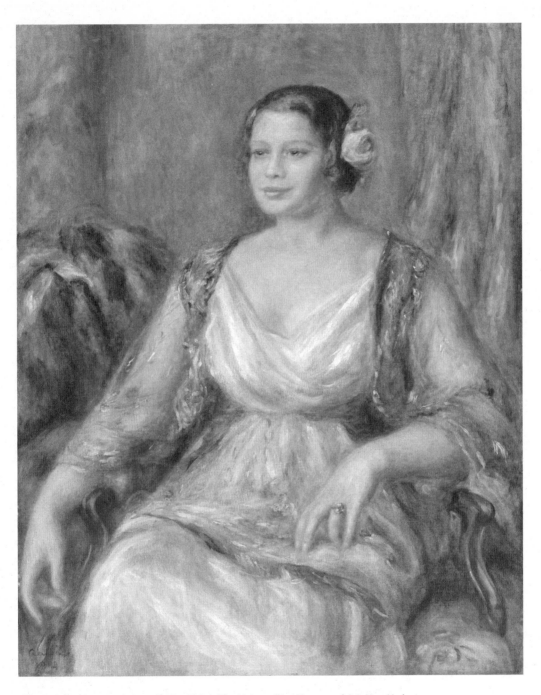

Tilla Durieux, 1914. 92 x 73.7 cm (36¼ x 29 in.). The Metropolitan Museum of Art, New York.
Bequest of Stephen C. Clark

was short. I was a foot soldier. The 2nd of September I was injured at the battle of Grand-Couronné [in fact, the main battle began two days later] in Nancy.'[199] Pierre was transported 848 kilometres (527 miles) to a military hospital in Carcassonne in the south, where he waited for treatment. When Renoir received the bad news, he wrote to André: 'Pierre, wounded in his right arm, is in the Carcassonne hospital. His radius was shattered by a bullet that went through his arm.'[200] In another letter, to Mme Gangnat, Renoir wrote: 'His arm was very badly hurt and we don't know if he'll ever be able to use it again.'[201] Pierre later told a journalist: 'A big scare nearly ruined my career. After a serious injury in the war, I was very afraid of losing an arm and I would not have been able to do anything in theatre other than stage-managing or administrative work. My arm was saved, but slightly shrunken.'[202] Pierre's war injury did not stop him pursuing an energetic forty-year acting career in sixty-five films and eighty-four plays.[203] Pierre's perseverance in spite of his crippled arm echoes his father's resoluteness in painting despite his paralysed fingers.

After hearing that Pierre had been wounded, Renoir became very concerned that he had not heard anything about Jean. He sent an inquiry to Army headquarters: 'Request for information about: Renoir/Jean/1st regiment of the Dragoons/Staff of the 5th and 6th Squadrons/Cavalryman/[from] M. Renoir resident of Cagnes – Alpes-Maritimes/His father/Cagnes, 15 September 1914', and signed it 'Renoir'.[204] Six days later, Renoir received this reply: 'The Sergeant/Renoir/Jean returned from the front in good health. He is currently at the headquarters of the 1st regiment of Dragoons at Luçon/Luçon 21 September 1914/Chief of the Headquarters of the Company.'[205]

Jean did not make it through the early part of the war unscathed, however: in late September he contracted a venereal disease.[206] To save the sensibilities of those who heard about it, Renoir called it a horse's kick, a common euphemism for gonorrhoea. Renoir informed Mme Gangnat in October: 'Jean was kicked by a horse near Amiens. Saved by a good man, a dairy merchant. He found himself in a hospital with Germans [the hospital in Amiens was briefly occupied by the Germans]. Anyway, he is at the moment with his garrison (troops) in Luçon and is recovering well. You see that with all these terrible events, we are still part of the lucky ones, so far. This stupid war weighs heavily upon me. I'm not the only one. This is progress and civilization in full absurdity.'[207] A few weeks later, on 17 November, Renoir updated André about Jean: 'Although he is very happy for now, he is always impatient to go back and join his comrades at the front.'[208]

In late October 1914, with two sons in hospitals, Aline, despite her own worsening health, decided to visit them both. Renoir explained to his dealer: 'My wife is leaving on Saturday to go to visit them, one in Carcassonne, the other in Luçon. It is a tiring trip, and above all long [from Cagnes to Carcassonne is 457 km (284 miles); from Carcassonne to Luçon 555 km (345 miles); from Luçon to Paris 440 km (273 miles)], but they will be happy to see their mama a little. I am sorry not to be able to do it too.'[209] While Aline travelled, Renoir was alone with his servants. Rivière, knowing that Jean intended to visit his father before returning to the front, wrote to Jean of his concern: 'If, however, you can remain in Nice until the end of November, this would give your brother time to arrive in Cagnes after undergoing his new operation. That way, your father would not be alone for long. That would also be one less major concern for you.'[210] A few weeks later, Renoir sent a heartfelt letter to his old friend Monet: 'I think of you quite often, and as I grow old, I begin to think of our youth. This distracts me a bit from the present.... My wife left three weeks ago to see her kids, Pierre and Jean. Jean is healing and will be leaving again soon, I think. As for Pierre, I don't understand a thing. He has been injured for 75 days and it's still the same; one of his bones is very much shattered. It has to be operated on and it's being put off every day, which worries me a lot. Nevertheless, I am among the fortunate ones for the moment. One cannot be difficult in times like these; there are some who have more to complain about than I.'[211]

Two and a half weeks later, Pierre had been released from the hospital although his surgery had not yet occurred. On 12 December 1914, André wrote to Durand-Ruel: 'I saw Madame Renoir and Pierre in Marseilles. One of the poor boy's arms is in a pitiful state. He is missing about 7 centimetres [3 in.] in the radius and is obliged to have a sort of small cast to help his ulna hold up the weight of his hand.'[212] During Pierre's six-month wait for his surgery, he decided to marry Véra, thus legitimizing their son, Claude junior, just as Renoir and Aline had legitimized Pierre when they married. The wedding took place in Cagnes-sur-Mer on 23 December 1914, thirteen months after Claude had been born. Their marriage certificate states: 'The newlyweds have recognized, in order to legitimize, Claude, André, Henri Renoir born in Paris (8th [arrondissement]) the 4th of December 1913 and registered him as the son of Pierre Renoir and of Marie, Marguerite, Aimée Roche, known as "Véra Sergine".'[213]

Both Renoir and Aline were unhappy with the match. Before the wedding, André wrote to Durand-Ruel: 'Renoir is very depressed for family reasons. Pierre

is getting married in two days and the new daughter-in-law gets on his nerves. He doesn't say a word to her, nor to the child for that matter.'[214] Renoir's objection to Véra could not have been related to her Jewish roots since he had been fond of Pierre's former Jewish partner, Colonna. It was Véra's personality that bothered Renoir. As for Aline, her feelings were clear even to Cassatt: 'I saw Renoir and Mme. the other day, the wounded actor son is doing well; he had just been married to an actress; the baby is fourteen months old. The Renoirs hate the match. She is, it seems, "une grande artiste" tragic and the mother [Aline] said he has always desired to marry "une grande artiste". Then all he had to do was to marry Sarah Bernhardt, the mother bitterly said.'[215] At this time, Sarah Bernhardt was seventy years old.

Neither of Véra's parents attended the wedding: Véra's father was dead and, with the war in progress, Véra's mother was stuck in Paris. Despite their misgivings, Renoir and Aline consented to sign the marriage documents since two parental signatures were required.[216] Nonetheless, Renoir did not attend the small wedding, as André told Georges Durand-Ruel: 'On that day, Papa Renoir preferred to be ill in his room. To tell the truth, he was laid low by a severe cold.'[217] The mayor of Cagnes, Ferdinand Deconchy, officiated during the courthouse ceremony while his wife, Thérèse Savournin, served as one of the witnesses.[218] Albert André, Paul Cézanne junior and the painter Henri Roussel-Mazule also served as witnesses.[219] In fact, later, Renoir warmed to Pierre's new family. He painted a portrait of Véra, a half-length with the same pensive hand gesture as in Aline's 1910 portrait. Claude, the only grandchild born during the artist's lifetime, also modelled for Renoir.[220]

One of the reasons Pierre waited so long, even until after his wedding, to have arm surgery was that Renoir was using his connections to get Dr Antonin Gosset of France's Academy of Medicine, then considered the best surgeon in France.[221] A few days before the wedding, André had contacted a friend who knew Dr Gosset: 'I asked Gosset through a friend what he thought and he offered his services.'[222] In the end, Dr Gosset had to perform numerous small operations, the first of which took place six months after Pierre was shot. On 25 March 1915, Renoir told Georges Durand-Ruel: 'Pierre is supposed to be operated on today by Gosset.'[223] A month later, Renoir wrote to André: 'Pierre is going to be operated on again one of these days in about a week. He is doing well.'[224] Two months later, Rivière wrote to Renoir: 'I chatted for a moment with Pierre on the telephone this afternoon. He is doing well; according to the surgeon, his

arm is on the right track.'[225] Thanks to Gosset, Pierre's arm was saved, though paralysed and withered. He had to learn to write with his left hand, and could neither ride a horse nor hold a sword. His other injuries caused temporary leg pains that made it difficult to walk. He also had lifelong abdominal pains for which he needed to wear a torso brace.[226] His abdominal injuries may have made him impotent, since he never had another child.

The severely injured Pierre was happy to be discharged from the army to return to his career and family. In contrast, Jean at twenty-one, who had not yet had a serious injury, was enthusiastic about continuing the fight. On 20 January 1915, Cassatt wrote to her friend Havemeyer: '[Jean] wrote a cheery letter, full of go from the front, laughs at the discomfort of the trek.'[227] The same month, Jean wrote to his godfather, Georges Durand-Ruel, who informed Renoir: 'I received two or three letters from Jean who still seems very happy to me and seems to think that everything is going well.'[228] Jean's passionate service was rewarded by his promotion on 20 February 1915 to 2nd Lieutenant and his move to an elite company, the Alpine Chasseurs, a troop of light infantry trained for mountainous terrain. Although by this time, Jean had switched to the infantry, his title continued to be cavalryman or dragoon. Two weeks later, Cassatt wrote to Paul Durand-Ruel: 'I saw Renoir the day before yesterday. As you know, his son is a second lieutenant in the Alpine Corps, an elite branch of the service, very exposed. He [Renoir] is proud of him but fears for the future.'[229] On 25 March, Renoir informed Georges Durand-Ruel from Cagnes: 'Here is Jean's address: second lieutenant at the 6th regiment of Alpine Chasseurs, 2nd company, send to *Nice to forward to the front*.'[230]

That spring of 1915, Jean took leave to visit his family in Cagnes. On 16 April, Renoir reported to André: 'Dear friend, Jean has left here for Gérardmer. He had 250 Alpine Guards with him. I was told that he will not stay for very long.... How time flies despite the troubles. R.'[231] On 21 April, Jean and his fellow soldiers arrived at their battalion headquarters in Gérardmer in Lorraine. They stayed there only briefly, then travelled 757 kilometres (470 miles) to the front, which was in a valley near Munster in Alsace, then part of Germany. On 27 April 1915, Jean was shot in the upper thigh by a German sniper, as he recalled in a 1968 interview: 'I was shot in the leg by a Bavarian infantryman.'[232] Jean's son Alain later recalled that his father had told him that he was 'shot when going to take a piss'.[233] Jean was returned the 757 kilometres from Alsace to a hospital in Gérardmer. His medical report in his military record book stated: 'Certificate

of Hospital Stay; second Lieutenant Renoir Jean of the corps of the 6th battalion of cavalry; indication of injury: sub trochanteric fracture of the left femur from a bullet received around 27 April; shortening [of the femur] by about 4 centimetres [1½ in.].' The record book confirms the date: 'Wounded by bullet 27 April 1915.... Unfit [for military service] for 6 months.'[234] A month after Jean was shot, Renoir wrote to one of the Bernheim sons: 'Dear Gaston...Jean has been badly wounded; a bullet penetrated through the front of his thigh and out through his buttock, breaking the top of his femur. He is suffering terribly and is condemned to stay completely still for months. Just one centimetre higher up and he would have been killed. How lucky he was. Kindest regards, Renoir.'[235]

Aline hurried to Gérardmer to be with her injured son. In a gesture of goodwill, she asked the head of the military hospital if she might donate some supplies; the hospital administrators gave her a long list, all of which she brought in her chauffeured car.[236] She stayed in a nearby hotel for several weeks, not wanting to leave with Jean's health in such a precarious state. Jean's injury was preventing blood from flowing into his left leg, which turned a deep blue, indicating early stages of gangrene. To avoid an amputation, Jean's doctors performed a Laroyenne operation,[237] making holes in his pelvis and upper thigh into which they inserted rubber pipes which circulated filtered water to flush the pus from his wound, thus restoring blood flow. On about 14 May, Aline wrote: 'My dear Rivière, Last night Jean underwent a serious operation which lasted more than an hour. When they brought him back to his bed, he was very ill and I left him feeling very worried. Because of this, I was in a hurry to see him this morning; I found him in a much better state than I dared hope. His fever at eight this morning was 37.4°C [99.3°F]. You see how little that is. The doctor I saw last night did not hide the fact that Jean's condition is still very serious. An infection is still to be feared, but if he continues to improve, in ten days' time we can consider him saved. Luckily he was in good health when this bullet hit him.... I will keep you up to date and thank you for all the trouble you've gone through but I believe that we have time on our side. Most affectionately, Aline Renoir.'[238]

Soon after surgery, Aline again wrote to Rivière: 'Jean is doing better. I don't know whether I should claim victory yet.... Today is the nineteenth day [since he was shot]. It truly is a miracle.... Most affectionately, Aline Renoir.'[239] Jean's gangrene receded as his leg turned from dark blue to lighter blue to pale pink to healthy skin colour. He regained the use of his leg, but always walked

with a limp, since his left leg remained shorter than his right. On Saturday, 22 May, Aline again wrote: 'My dear Rivière, I am leaving Gérardmer.... You know, my leaving means that Jean is doing well. The poor thing has still another forty-five days here, so I promised to come back to see him.'[240] Four days later, Aline explained her complicated travel plans to Rivière: 'I am leaving Jean this evening. I'm going to Essoyes where I'll arrive tomorrow evening at nine o'clock. I will be in Paris on Monday evening, only for a few days.'[241] Then she intended to spend a little time with Renoir in Cagnes while she organized her family to move up to Paris so that she could more easily visit Jean in Gérardmer.

Jean was moved to a different hospital before Aline had a chance to return to Gérardmer. Almost a month after she left, on 21 June 1915, Rivière wrote to Renoir from Paris: 'Dear friend, I learned from a postcard I received today that Jean was transported to Besançon and that he was settling in well.... According to the tone of his postcard, it seems that our wounded one valiantly underwent the long [146 km (91 miles)] and certainly difficult trip. If there is something I can do here, please let me know.'[242] Jean reported his own status lightly and with good humour. On 22 June, he wrote to Aline from Besançon: 'I am doing very well here, spending pleasant afternoons in the shade of cherry trees.... The treatments are not the same as Professor Laroyenne's but they're sufficient for what I have now. My wound could be cared for by anyone. It's an easy dressing to do. For example, Miss Tititi[243] has been replaced by a more forbidding sister who is looking to impose convent discipline on us. That doesn't please us after having lived so freely in the woods, and I am afraid the nun will be driven crazy by the exuberance of the Chasseur Officers being cared for here. Love to you all. Jean.'[244]

Perhaps because Jean's own condition had gone from something dire to something minor, when he learned that his mother was taken ill, he assumed that she would quickly recover. The day before, on 21 June 1915, Jean had written to her: 'Dear Mama, Papa's letter...told me that you are ill. I hope that it isn't anything serious. For that matter, the fact that you are thinking of undertaking the journey [back to visit me] makes me think you are not suffering too much. Nevertheless, I wouldn't want you to tire yourself out needlessly.... The best hotel here is the Hôtel d'Europe, rue de la République. Love to all of you, Jean.'[245] Unfortunately, Jean had underestimated the seriousness of his mother's condition. Three days later, Renoir was writing: 'Dear Mr Bernheim, my wife is very ill, almost beyond hope. I am stuck in bed myself and cannot go to visit Jean in

Besançon.'[246] It took another two days for Jean to become aware that Aline was not well enough to travel. Then he wrote: 'Dear Mama, I'm still doing very well. Now it's your turn to be taken care of, not I, who do nothing more than wait around in bed, which I have now got used to and find almost agreeable. Try to get well soon and above all don't worry about me. My wound is healing.'[247]

Despite Renoir's assertion that he was too ill to travel, the painter began making plans to visit Jean with one of his maids, Grand' Louise. The trip that Renoir envisioned would have taken seven hours on two different trains (changing in Lyons), an ordeal during the war for a man who could not walk. Jean thought this was a terrible idea and wrote in the same letter to his mother: 'I must confess that I am not reassured to know that Papa is going to travel alone with Louise. Once they get to Besançon station, what will they do? And how will they change trains? I would be very sorry if Papa, by coming to see me, were to tire himself out. Much love to you all, Jean.'[248] Young Jean touchingly expresses the depth of his feelings for his old father, aged seventy-four. Fortunately for Jean's peace of mind, Renoir never attempted this trip. The same day that Jean wrote this letter, the Renoirs moved from Les Collettes to their Nice apartment, Place du Voeu, so that Aline would be closer to her doctor. Renoir lamented to Maleck: 'I am in Nice. My wife who is very sick has me stuck here. I cannot go to see Jean at Besançon. This poor boy waits for us every day. She [Aline] is doing a little bit better this evening.'[249]

In spite of this optimism about Aline's condition, she died the next day, 27 June 1915, a month and a day after leaving Jean in Gérardmer. She was fifty-six. The cause of death was kidney failure due to her untreated diabetes. As Renoir had predicted twelve years earlier, her albuminuria foreshadowed her premature end. Aline died in the family's Nice apartment in the presence of Renoir and Coco, then nearly fourteen. At the time, Pierre was with Véra and Claude junior in Paris.[250] Immediately on hearing the news, he left for Nice. The day after Aline's death, Pierre and Renoir's friend Deconchy, the mayor of Cagnes, signed the death certificate: 'The twenty-seventh of June, nineteen fifteen, two o'clock in the afternoon, Aline Victorine Charigot, born in Essoyes, Aube, 23 May 1859, unemployed, daughter of Claude Charigot, deceased, and Thérèse Emilie Maire, his unemployed wife, married to Pierre-Auguste Renoir, living in Cagnes, Alpes Maritimes, has deceased, Place du Voeu.'[251]

Jean was still recovering in Besançon. Soon after Aline's death, Véra and Maleck went separately to the military hospital there to tell him. On 1

July, four days after Aline's death, Renoir wrote in concern for Jean's sorrow: 'My dear Vollard, Jean was notified by Sergine and Madame André. You are therefore free from the task. Write him something. That should distract him, St Jacques Hospital, Besançon.'[252] Two days later, Renoir thanked Maleck: 'My dear Marguerite, I am very grateful that you made that mad dash to Besançon. You did me a big favour, a very big favour. We will speak of it later on. All the best to your husband. Yours truly, Renoir.' He further delayed his trip to visit Jean because of Aline's death and his own poor health. In the same letter to Maleck, he explained: 'Jean wrote to tell me not to go to Besançon, that he is being evacuated to Paris. So I'm waiting here, not knowing what to do.'[253]

When Aline died on 27 June 1915, even though both were gravely ill, neither Renoir nor Aline had burial plots. It could be that he refused to think about his death. Despite wartime and despite being in Nice, he found a temporary solution. He arranged that Aline's body be placed in the burial crypt of their Nice landlords, the Roumieux-Faraut family, in their burial plot, number 3434, in the Château Cemetery in Nice.[254] Three months after Aline's death, on 22 September 1915, Renoir had Pierre purchase a burial plot in the Essoyes cemetery. Not only was that cemetery practically in the backyard of Renoir's home, but Renoir's brother Victor, who had moved to Essoyes, had also been buried there in 1907.[255] Pierre went to Essoyes and purchased the plot in his father's name. The sales document states: 'We, the Mayor of the town of Essoyes in view of the request posed by Mr Renoir Auguste, artist painter residing in Cagnes (Alpes-Maritimes) to obtain in the town cemetery a burial place for the tomb of Mme Charigault [a common misspelling] Aline, his wife, and her descendants and ascendants.... It is granted in perpetuity to M. Renoir, Auguste to cover an area of 3.25 metres x 2.5 metres x 1.3 metres [c. 11 x 8 x 4½ ft] of ground in the communal cemetery to place the tombstone of Mme Charigault Aline, her descendants and ascendants.'[256] This phrasing deliberately excludes Renoir, who did not intend to be buried with his wife. Indeed, Renoir's wording on this bill of sale clearly expresses his intentions: after his death, his children could not place his body in Aline's plot. Perhaps being in the same plot as Aline was distasteful to Renoir because of their stormy past – especially Aline's firing of Gabrielle, which had left Renoir 'helpless as a baby'.[257]

The way that Renoir handled Aline's burial decisions and the fact that they were not buried together showed his family and friends that he had not had a great marriage and that, in his own subtly manipulative way, he could

at last reject Aline. Four and a half years later, at the time of his own death he still had not purchased a plot for his own tomb.[258]

Aline's body remained in the crypt in Nice for seven years until well after Renoir's death; at that date, the family sent it to the Essoyes cemetery. Nonetheless, Renoir wanted something of his once passionate love for Aline to appear eventually on her tombstone. A year after her death, Renoir commissioned Guino to create such a statue. As the prototype for the sculpture, Renoir thought of a painting then in his studio, his 1885 *Nursing*, of Aline nursing infant Pierre.[259] Before Guino's arrival, Renoir made a new oil sketch of *Nursing*.[260] In July 1916, he wrote to Guino: 'Please come as soon as possible to Essoyes. I have a study of my wife sitting. I would like you to model a clay bust from the painting. I'm counting on you.'[261] Guino created a statue 53.7 centimetres (21⅛ inches) high, the 'clay bust' Renoir specified, of Aline nursing based on Renoir's 1916 oil sketch.[262] However, this nursing statue did not satisfy Renoir, who asked Guino to make another bust-size statue, this time based on his 1885 *Portrait of Aline*,[263] another painting he kept in his studio (see page 133). In this painting, a flower appears on Aline's hat, which Guino follows in his statue. In Cagnes, on 22 January 1918, Guino wrote: 'Received from M. Auguste Renoir the sum of three thousand francs for a copy in painted plaster of a bust of Mme Renoir.'[264] This statue 59.7 centimetres (23½ inches) high was later cast in bronze.[265] Two and a half years after Renoir's death, when the bodies of Aline and Renoir were transported from Nice to Essoyes, and when the vertical tombstones were in place, Guino's bust of Aline was placed atop her tomb. On top of Renoir's tomb, the family placed Guino's 1913 bust of Renoir (see page 355).[266]

Renoir treated Aline's death as a non-event. Aside from purchasing her burial plot and eventually planning for a statue to go atop her tomb, his lack of bereavement starkly contrasts with Monet's prolonged grief after the death of his second wife, Alice Hoschedé Monet, in 1911. Monet's friends were still discussing his profound mourning three years later when Monet's son Jean died. At that time, in early 1914, Cassatt wrote to Durand-Ruel: 'The death of his son is very sad for Monet who has been so distressed by the death of his wife.'[267] Monet displayed his grief in every letter by writing on black-bordered mourning stationery, whereas Renoir never used black-rimmed paper and barely mentioned his wife's death in any correspondence. In all the known correspondence, Renoir mentioned Aline's death only twice: first, the day after she died, he wrote: 'My dear Durand-Ruel, already ill, my wife returned from Gérardmer shattered.

She never recovered. She died yesterday, thankfully without knowing it. Your old friend, Renoir.'[268] Second, three years later, Renoir informed a Japanese student, R. Umehara: 'My wife died three years ago and my two eldest were very seriously wounded.'[269]

The only record of expressions of true grief came from Aline's mother, who, six months after Aline's death, wrote to her grandson, Jean: 'I feel very sorry for you my dear children and also for your father who really deserves sympathy. What a loss and what grief for everyone.'[270] Emilie, then aged seventy-six and suffering from rheumatism and asthma, missed her daughter not only for her company, but also because Aline had been supporting her, perhaps without Renoir's knowledge. Aline had died during the war when things were, as Emilie wrote in the same letter: 'more than four times more expensive than usual.' Three months after Aline's death, from Essoyes where she was living, Emilie had tentatively appealed to Renoir for money. The painter responded by having Grand' Louise send her 200 francs. Receiving no further funds, Emilie had become desperate by mid-December 1915 and reached out instead to Jean, aged twenty-one, whom she perhaps thought might be more sympathetic. In the same letter, she wrote: 'I cannot tell you how painful it is for me to have to ask you for money.... Why take away from me, at the age of seventy-six, what my poor child was giving me.... I have received 200 francs since 4 Sept; it is impossible to live [on this]; you are driving me into debt.... I am depending on you, my dear Jean, to speak to your father on my behalf.'[271] It is not known what transpired after this letter. However, two years later, on 1 March 1917, Emilie died. Even though Aline's body was still in the Nice crypt, Thérèse Emilie was buried in Aline's plot since she was an ascendant. Aline's father, Victor Charigot, had died in 1898 in America and was buried there.[272] Because Victor had been a failure as a husband and father, the family made sure not to include 'Charigot' on the tombstone where Aline and her mother were buried. Instead, Aline is designated as Aline Victorine Renoir and her mother as Thérèse Mélanie Maire, her maiden name.[273]

In December 1915, six months after Aline's death, while Emilie was seeking a way to have her son-in-law support her, Renoir was preoccupied with an enormous inheritance tax that he had to pay to the French government based on the estimated worth of his total estate as a result of his wife's death. On 17 December, he wrote to Vollard: 'I have, according to the notary in Cagnes, 25 thousand francs to pay before 26 December.'[274] A day later, Renoir wrote to

Gangnat: 'For a month I have been negotiating with a notary who tells me that this inheritance will cost me 25,000 francs. A highly regarded lawyer in Nice said to me that this is extremely exaggerated.'[275] To determine how much money he owed the government, Renoir needed to provide inventories from his multiple studios and apartments in Cagnes, Nice, Essoyes and Paris. From Cagnes, Renoir tried to enlist friends and family in Paris (Durand-Ruel, Gangnat, Pierre and Vollard) to help in the Paris inventory. Also on 18 December, Renoir wrote again to Vollard: 'Here is the address of La Boulangère to get the keys: Madame Dupuy 23 rue [de] Clignancourt, Paris.'[276] Renoir was involved in the minutiae of this legal process. In the same letter, he sent Vollard a list of eighty-two paintings and the valuation of each. The most valuable were four figure studies, each priced at 5,000 francs: *Portrait of Louise, Women on the Sofa, Woman as Venus, Bust of Milkmaid*. The least valuable was *Bouquet* at 300 francs. His list specified the total value of the eighty-two paintings at '99,200 francs'.[277] Therefore, the estimated tax of 25,000 francs was roughly at 25 per cent.

In forming the inventories and dealing with the lawyers, Renoir tried to pay as little tax as possible. He affirmed that his unsigned works had no value at all and that he should not have to pay tax on them, writing to Gangnat in mid-December 1915: 'I must tell you that the sketches and paintings that are not signed have no value since I can and I must always look at them before sending them away.'[278] Renoir insisted on dealing with the officials himself, as he wrote to Jeanne Baudot: 'My dear Jeanne, Everything has been going relatively well.... Drawing up inventories has left me numb. I must deal with notaries, attorneys, etc.'[279] Renoir's annoyance about taxes was still continuing seven months after Aline's death, when he wrote to André: 'Since my wife's death, I haven't had a moment of quiet: two notaries, one lawyer, inventories and a huge sum to pay for the paintings I have left and all the rest. Anyhow, I can't complain too much. I am more or less on my feet (in a manner of speaking).'[280] Thus, while Monet's passionate relationship to his second wife left him bereaved for a long time after her death, Renoir's sadly failed marriage left him preoccupied with losing money to taxes rather than with losing his partner of thirty-seven years.

It was a pity that Renoir, the painter of love, suffered such an unfulfilled relationship. What had started as a passionate love affair with Aline in 1878 continued to be warm and supportive while the couple were poor, unmarried and the parents of infant Pierre. By the time they married in 1890, after Renoir had become rich, famous and sickly, Aline had become more insistent on a

luxurious lifestyle, which Renoir detested. Since Renoir shied away from conflict and would not fight directly for what he wanted, he often gave in to Aline's demands, such as for a house in Essoyes that he did not want. His only consolation was to complain about his domineering wife to his friends behind Aline's back, and to do what he wanted without her knowledge or approval. Renoir's growing discomfort with Aline's demands explains why they often lived apart.

The other key woman in his life, his daughter, presented a Catch-22 for Renoir's relationship with Aline. On the one hand, Renoir never knew how Aline would behave towards his daughter, the product of his love affair with a model before he had met Aline. He did not know if Aline would be kind to Jeanne, the motherless girl, as she was to other motherless girls – Julie Manet, Jeanne and Paule Gobillard and Renée Rivière. Apparently, Renoir did not believe that Aline would embrace his daughter either out of sympathy with her past or out of respect for his love for Jeanne. As we have seen, Aline's jealousy was a character trait noted by Cassatt,[281] by the Bernheims[282] and by Coco.[283] It seems that Renoir felt that Jeanne would stir up Aline's jealousy, both towards Renoir's first model, Lise, and towards Jeanne herself. Hence Renoir kept this bomb-like secret from Aline.

On the other hand, even if Renoir often acquiesced to Aline's demands, his secret loving relationship with his illegitimate daughter, Jeanne, demonstrates that he was willing to risk his marriage for her. His friendship with Aline deteriorated over the years as a result of differing attitudes to living with wealth, which led to a lack of trust and paucity of communication. In the end, Aline and Renoir's relationship was a shadow of what it had been earlier and was evidence of how alienated they had become throughout the years. The fact that Renoir refused to be buried in the same plot where Aline was buried signalled to his family and friends that their marriage had not been happy. What a sad, ironic situation for Renoir, the painter of love!

Chapter 7

1915–19

**Renoir aged 74–78;
End of War,
International Acclaim,
Pottery with Coco,
Jean and Dédée**

With Aline gone from Renoir's life, the painter continued to pursue the two things that had always been most important to him: to paint and to surround himself with friends. As he wrote on 17 November 1915 to his sculptural assistant, Guino: 'I have been bored and alone for three weeks now and nobody is coming. I only ask one thing, to be with people.... Come as soon as possible.'[1] Despite his determination to keep painting, his crippled body made life difficult for him. He was often bedridden for weeks at a time, as he complained to Georges Durand-Ruel a year later: 'As for me, I'm in very, very bad shape. I have a ton of afflictions that make my life unbearable: loss of appetite, kidney pain, troubles I can't get rid of. I haven't left my room in five weeks now, which isn't fun.'[2]

Renoir's suffering was well known and inspired a range of reactions from his friends. Monet, on one hand, found his perseverance heroic, as he wrote to Georges Durand-Ruel in December 1916: 'As for Renoir, he's still amazing. He is supposed to be very sick, but then suddenly one hears that despite everything he is hard at work and forging ahead all the same. He's just simply awe-inspiring.'[3] André, on the other hand, feared for his friend who he thought might die at any time, as he wrote to their mutual dealer the same month: 'it would be cruel to bother the poor man in his last moments'.[4] A year later, André again wrote to Paul Durand-Ruel of his concerns: 'Renoir continues to make marvellous things but I find that he is getting weaker and weaker. He is starting to wish for death as a deliverance, which isn't a good sign, especially from him who used to make projects as if he had forty more years to live.'[5] This new pessimism worried André because Renoir had always been positive. Renoir himself was aware that,

though he tried to be optimistic, now he occasionally felt hopeless, as when he told Durand-Ruel the following spring: 'I am suffering at the moment from rheumatism in my left foot and I spend horribly disagreeable nights without sleep. The heat of the bed makes me suffer so much that I have to get up in the middle of the night. Until now, all that I have done [for this foot] has been useless. I hope that this [problem] won't last as long as the war.'[6]

Since Renoir could not walk, he developed circulation problems in his feet, resulting in gangrene in one toe. In May 1918, André wrote to Paul Durand-Ruel: 'I have just received some very bad news from Renoir. He has to have his toe amputated. What will happen next?'[7] Almost three weeks later, the toe had not yet been removed, as Renoir explained to Jeanne Baudot: 'My dear Jeanne, I have been suffering day and night for months now, so far without any hope of an end in sight.... And all of this for a mere big toe which needs to be amputated one of these days. Since my feet are so swollen, it is impossible to numb [for the surgery] even just the sick part [the toe]. It is terribly hot these days and I have no fuel [for his car, because of the war] to escape this oven; in any case, my surgeon would prevent me from leaving.'[8] Eventually the toe was amputated.

During Renoir's last years, his deformed hands prompted people to doubt his ability to paint. Some even assumed that assistants painted his later works. In truth, Renoir painted every stroke in all his paintings, even when severely disabled. As proof, Renoir allowed film-makers to record his painting process. In one of these films, Sacha Guitry's *The Great Ones among Us* of 1915, lasting only three minutes, Coco aged fourteen helps his father and alternately gives and removes either a paintbrush or a lit cigarette.[9] Guitry himself (1885–1957), the Russian film-maker, actor and poet, talks with Renoir.[10] Other films also prove that the severely disabled Renoir could still paint.[11] Renoir had adequate mobility in his shoulders and elbows to allow the use of his wrists, thumbs and hands, even though his fingers were partially dislocated and severely damaged by his rheumatoid arthritis.[12] The films demonstrate Renoir's range of movement, which enabled him to lean forwards and back from the canvas, to control his brush finely, to support his right hand with his left and, on occasion, to paint with the two hands together (see page 320).[13] He did, however, need assistance to prepare little mounds of paint on his palette, into which Renoir could dip his brush.

Several accounts contend that Renoir's brushes were tied to his hands but Guitry's and other films clearly demonstrate that it was unnecessary to tie anything since Renoir's rigid fingers were tightly contracted close to one another.

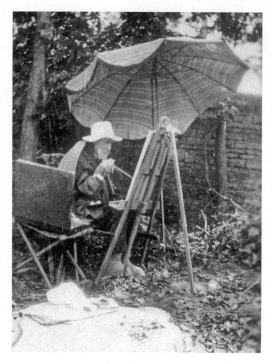

Renoir painting with two hands, c. 1916–17. 7.9 x 6.2 cm (6¾ x 4⅞ in.). Photo by Coco Renoir. Pont Saint-Esprit, Musée d'Art Sacré du Gard, Bequest of Jacqueline Bret-André 2008

Nonetheless, to avoid ripping the fragile skin of his palms with the wooden handle of his paintbrush, a little piece of cloth was inserted in his palm, held in place with linen strips tied round and knotted at his wrists.[14] These films also demonstrate Renoir's chain smoking, undeterred by arthritis in his fingers. Just as Renoir held and manipulated his paintbrush between his thumb and next two fingers, so he grasped his ever-present cigarette between these same three digits. Renoir could skilfully move the cigarette from his right hand to his left and move it back and forth to his lips. In the same manner, the movies show that Renoir moved the paintbrush to and from his palette and from this palette to his canvas. Occasionally he painted by pressing his hands together, as may be seen in a photograph taken by Coco in 1916 or 1917.

Another accurate description of Renoir's painting method appears in André's book on Renoir (written at the end of Renoir's life and approved by the elderly artist[15]): 'I am always astounded and filled with wonder at the dexterity and steadiness with which his martyrized hand operates.... He can no longer change paintbrushes throughout the course of his work. Once chosen and pressed between his paralysed fingers, the brush moves from the canvas to the oil cup where it is cleaned and returns to the palette to take a little paint back to the canvas. Once exhaustion numbs his hand, someone has to pull the paintbrush from his fingers, which cannot open. He has someone give him a cigarette, rolls back his wheelchair, closes one eye, grumbles if he is not satisfied or gives himself little pep talks before returning to work.'[16] In addition to writing about Renoir, André did several paintings showing Renoir at work. André's description perfectly captures what Guitry's 1915 film shows.

During the last four years of his life, as he had from the early 1900s, Renoir continued to portray large, sensual women enjoying the life he could no longer experience. His female figures of this period have superhuman proportions and are active: their heads turn, their limbs move and their backs twist. Sexuality, maternity and comfort pervade these late works.[17] Such images differ profoundly from Renoir's personal crippled, emaciated reality. These paintings doubtless brought comfort to Renoir, who could live vicariously through his images.

Renoir's joyful, life-affirming art raised the spirits of people embroiled in the First World War. In London, for example, in July 1917, a hundred British artists and collectors signed a letter to Renoir praising his 1881–85 *The Umbrellas*,[18] when it was first hung at the National Gallery: 'From the moment when your painting was installed among the masterpieces of the ancient masters, we had the joy of realizing that one of our contemporaries had suddenly taken his place among the great masters of the European tradition.'[19] This tribute must have pleased Renoir, whose stated goal had always been originality within tradition.

Even during the war, Renoir's art sold for extremely high prices. In 1918, *Reclining Nude*, 1903, sold for 135,000 francs.[20] The Durand-Ruels' account with Renoir increased over time. For example, in November 1917, Georges informed Renoir: 'The credit of your account is 35,438.15 francs; to this now should be added 75,000 francs, [for] the value of paintings.'[21] Nine months later, Georges reported again: 'Your credit is 81,050.35 francs; today I am adding 40,000 francs for the paintings I took back with me.'[22] And, of course, Renoir also had accounts with his other dealers Vollard and Bernheim.

More important to Renoir than money was public esteem, which also grew. In striking contrast with the mockery he had received early in his career, late in his life, Renoir was highly esteemed. In September 1919, Renoir was invited to see his *c. 1877 Portrait of Mme Georges Charpentier* (see page 90), recently acquired by the Louvre. That his portrait was placed in the Louvre was exceptional since the Luxembourg Museum was normally reserved for the work of living artists and the Louvre for deceased artists. The exception had been made because of Renoir's illness. On this occasion, Renoir experienced the Louvre by being paraded in a sedan chair on bamboo poles through the galleries, accompanied by dignitaries and curators. He had been invited by Paul Léon, France's Director of Fine Arts. Albert André, who was part of the retinue, wrote: '[Renoir's] last great joy as a painter was the stroll across the Louvre which Mr Paul Léon did with him three months before his death.... "I saw the Noces de

Cana [Veronese's *Wedding Feast at Cana*] from up high!" he said, in recounting this visit, where he was carried through the rooms of the museum like the pope of painting.'[23] Given this treatment, it is unsurprising that France offered Renoir the highest possible rank in the Légion d'Honneur. In March 1919, six and a half years after he had become an officer, he was promoted 'in the name of the President of the Republic...[to] Commander of the Légion d'Honneur'.[24]

The last four years of Renoir's life were not only the zenith of his fame, but also a period of renewed creativity and productivity prompted by his new model, Dédée, who followed three great predecessors: Lise, Aline and Gabrielle. Andrée Madeleine Heuschling (1900–1979), called Dédée, joined the Renoir household aged sixteen in 1916.[25] The photograph reproduced on page 325 shows her standing next to Renoir; on the easel is a painting for which she had posed – *Torso (Study of Nude)* of about 1918.[26] André wrote to Georges Durand-Ruel of her presence on 19 December 1916: 'He is doing magnificent things. He has a model that he likes a lot and he dreams of doing great things.'[27] In André's 1931 book, he elaborated on her importance: 'Finally during the last

Letter from Renoir to Gaston Bernheim de Villers, showing his ability to write and draw.
Galerie Bernheim-Jeune, *Paris Girl with Bird*, 1915–16. 73 x 60 cm (28¾ x 23⅝ in.). Private collection.
Photo courtesy Galerie Bernheim-Jeune, Paris

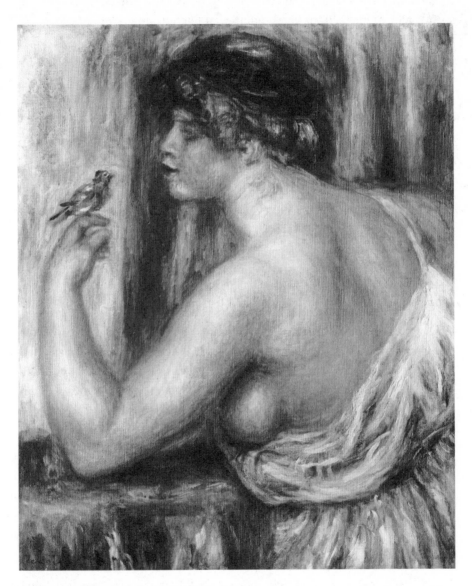

Girl with Bird, 1915–16. 73 x 60 cm (28¾ x 23⅝ in.). Private collection. Photo courtesy Galerie Bernheim-Jeune, Paris

four years, the happy discovery of a beautiful pink and blonde creature seemed to make Renoir's dreams come true and to rejuvenate him completely…. He spends all his time making an abundance of female bathers, of odalisques, of flowers, of landscapes in which women shine like rays of the sun.'[28]

Dédée replaced Gabrielle in modelling and Grand' Louise took over the cooking. Just as in the past anyone wishing to reach Renoir had to go through Gabrielle, now Grand' Louise protected Renoir from the outside world. For example, when an art dealer wanted to buy some Renoir works, he asked Guino in May 1917: 'Could you approach him discreetly or, if you prefer, go through Louise. She will give you the important information.'[29]

As for Gabrielle, she continued to live with Conrad Slade at the Hotel Savournin in Cagnes until early in the war, when the couple moved to Athens for a year.[30] After Aline's death in June 1915, they returned to Cagnes and resumed living at the Savournin, where they were still in residence in March 1918 when Gabrielle wrote to Jeanne Robinet.[31] Gabrielle did not resume modelling because she was now Slade's companion but she continued a close friendship with Renoir and his family. As an expression of his affection, Renoir gave Gabrielle eighteen of his paintings, one for each year that she had modelled for him. This generous gift included four portraits of Gabrielle, along with other portraits, still lifes and landscapes.[32] Through these last years of Renoir's life, Gabrielle was often at his side. For example, in January 1916, Cassatt informed Mme Durand-Ruel: 'I had Mr Renoir over for lunch. He is weak. Fortunately he has this woman living nearby, but she is very tired.'[33] Gabrielle also resumed her role as the source of news about Renoir's health. For instance, in May 1917, André wrote: 'We haven't had news about Renoir for quite some time now. The last news was from Gabrielle who had just come from Cagnes.'[34]

Besides André, Jeanne Tréhot Robinet was another person who relied on Gabrielle for news about Renoir. Jeanne's regular contact with her father had been disrupted by the war, which made her yearly Paris visits impossible. Since Renoir found holding a pen was much more difficult than holding a paintbrush, Gabrielle and others wrote to Jeanne to convey his words and gifts of money.[35] For example, in March 1918, Gabrielle wrote: 'M. Renoir is, as always, doing well and not so well. He is getting on in years: he turned seventy-seven on 25 February. In spite of everything, he still works a little, especially now that the weather is nice; it is more pleasant for him. He asked me to send you all his best wishes. Answer me as soon as you receive this letter. I will send you money….

I hope that you are well and that you aren't too deprived of food. Here we barely have enough and it is very expensive. Love, Gabrielle, Hôtel Savournin, Cagnes, Alpes-Maritimes.'[36]

Renoir also enlisted his chauffeur, Baptistin Ricord, to help him communicate with Jeanne. Eight months later, just after the end of the war, Jeanne got a letter from Baptistin: 'Madame, I am writing you on behalf of Monsieur Renoir who cannot write himself, to ask you to be kind enough to respond to my letter…. After we receive a response, we will send money. Write to M. Baptistin Ricord at Cagnes (Alpes-Maritimes)/Cagnes, 19 November 1919.'[37] It is doubtful

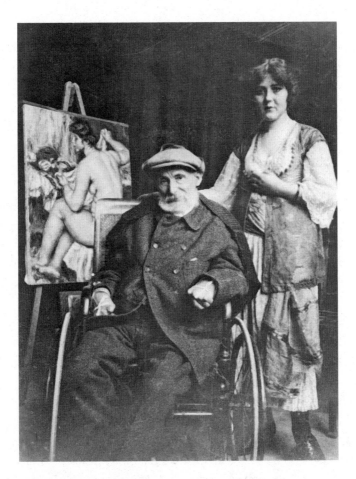

Renoir and Dédée with painting of *Torso (Study of Nude)*, 1918.
Photographer unknown

whether the chauffeur had any idea to whom he was writing or why Renoir was sending her money, since Jeanne's existence was still a secret except for the few individuals already mentioned – Vollard, Gabrielle, Georgette Dupuy and her husband, and M. Duhau with whom Renoir had drafted his 1908 will.

In spite of the war, Jeanne's state of mind seems to have improved in the decade since her husband's death. She was still living in Madré, signing a letter of 1 May 1917 to Vollard: 'Your very grateful, widow Robinet, Madré, Mayenne.'[38] In this letter, she displays an interest in the state of the people around her and there are no more references to her eating problems. Although she had begun renting out the bakery in her home as her father had suggested, two and a half years into the war Jeanne was short of money. Wartime depriva-tions had made living especially difficult and so, in March 1917, as her father had instructed, Jeanne turned to Vollard in her need. However, her first letter received no response. Two months later, she again appealed to Vollard, in that 1 May letter: 'I no longer have proper clothes to go out in because, since the beginning of the war, I haven't stopped mourning my nephews who were killed; there are five: four brothers and their cousin. Also, my shoes and hats are worn, well worn. I am, however, invited to go, during the first days of June, to the com-munion of my little god-daughter, who is the great-niece of my foster mother. It would bother me greatly to say no for they have always been very kind',[39] expressing gratitude and love for her foster family during this stressful wartime period. In the same letter, she also writes poignantly about her father: 'I think that M. Renoir is coming back to Paris soon. I really hope that he'll want to tell me about what's going on in his life. I would be very happy, if he can't write, if you, dear sir, would please share his news with me.'[40] It appears from the same letter that Jeanne at forty-seven continued to rely on her father: 'I certainly hope that M. Renoir won't mind sending me what I need. He should know that I don't waste money because my day-to-day subsistence comes from the fifty francs I get every month [from renting out the bakery].'[41] We have no evidence as to whether Vollard responded; if he did not, Jeanne could have contacted her father through Gabrielle, Georgette or Baptistin.

Until the end of his life, in fact, Renoir sent money to Jeanne. For example, four months before his death, Georgette wrote asking Jeanne if she had received money that Renoir had sent her: 'Please tell him if you received the 100 francs he sent about one and a half months ago. He is fine and kisses you warmly. M. Dupy and I send you a big hello. See you soon, Mme Dupuy.'[42] In 1919, after

the interruptions of the war, it seems that Jeanne was resuming her customary August visit to Paris to see her father.

Although Jeanne lived through the war unscathed, her two half-brothers, Pierre and Jean, were not so fortunate since both were severely injured, as described in Chapter 6. On 24 August 1915, almost a year after being wounded and two months after the death of his mother, Pierre was discharged from the army, classified as an injured veteran and given a lifelong pension of 80 per cent of his army salary. He was decorated with three honours: the Croix de Guerre, Military Medal and Inter-allied Medal.[43] Pierre's arm injuries required extensive operations and he never fully recovered. Later, Jean wrote: 'Professor Gosset, a surgeon of genius, was trying to restore the partial use of his right hand by bone grafts taken from other parts of his body. Pierre was in great pain, but he never complained.'[44] Although Gosset was able to prevent amputation, Pierre's arm was left withered and paralysed. In December 1915, Joseph Durand-Ruel informed Renoir: 'The operation was very painful, and he stayed under the influence of chloroform [anaesthesia] for several days.... His arm is not healed.'[45] Three years later, in October 1918, Renoir reported another surgery to Gangnat: 'The house [in Cagnes] is full after four months of solitude and worries and Pierre will return after having undergone a very painful operation.'[46]

After his discharge, Pierre, then aged thirty, lived primarily in Paris with Véra and Claude junior at 30 rue de Miromesnil. Although he had been injured on 2 September 1914, a year later, on 25 September 1915, he began acting again at the Théâtre de l'Ambigu.[47] He also resumed his role as liaison between Renoir and others in the Parisian art world. For example, in July 1916, Pierre informed Guino: '[Dr] Prat declared that my father cannot leave this week.... Come have lunch or dinner whenever you like; it will make him happy. Best, Pierre Renoir.'[48] He also became something of an adviser to his father as when, in September 1916, Renoir explained to Joseph Durand-Ruel: 'I feared fatigue and I listened to Pierre's advice to cut the trip short.'[49] Then, in the spring of 1918, when the Germans advanced to Paris, the capital was evacuated. Pierre rescued several large canvases from Renoir's studio, which he brought to his father in Nice.[50] Another sign of the developing respect Renoir had for Pierre was his increasing acceptance of Véra and Claude, whom he welcomed into his home alongside Pierre. He allowed the couple to continue drawing on his funds from Durand-Ruel, just as Pierre had done when living alone in Paris: for example, Véra withdrew a total of 4,000 francs between March 1918 and January 1919.[51]

Jean and two other wounded soldiers with Coco and a nurse in the garden of the Hotel Ritz Military Hospital, Paris, 1915. Photographer unknown. Univ. of California, Los Angeles, Art Library Special Collection, Jean Renoir Collection

Meanwhile, the theatre scene in Paris continued despite the war, Véra still acting as well as Pierre. Their fame was such that reporters would travel all the way to Cagnes just to interview them, as in April 1917, when a journalist from *La Rampe* wrote: 'Everyone knows that Madame Véra Sergine married Monsieur Pierre Renoir, the well-known actor who, gone to the front and injured, had been away from the stage for a while. He has just returned to the Porte Saint-Martin Theatre in *The Amazon*. He is the son of the illustrious painter Renoir.'[52] Sometimes, Pierre and Véra appeared together, as in November 1917 at the Vaudeville Theatre.[53] Mostly, however, they acted in different plays. Despite a paralysed and shrunken right arm and persistent pains in his abdomen, over his career Pierre acted in 49 plays and 63 films between his return to the stage in September 1915 and his death in 1952.[54] The critics loved him, writing: 'This tall, handsome, and perfectly elegant young man is waiting patiently and optimistically for this new operation which will perhaps cure him. And to spend his time better while waiting, he is going to act again. He will be a role model by returning to the profession that he was engaged in and loves and will continue no matter what.'[55] Pierre's heroism lay in the perseverance he had learned from

his father, who was continuing to create art despite his worsening physical disability. As one theatre critic wrote about Pierre in 1915: 'Yesterday's emotional audience praised him doubly: as a hero and as an actor.'[56]

While Aline had suffered and Renoir continued to suffer through both sons' injuries and treatments, their plight was similar to many families whose sons had served in the war. In fact, the casualties were so massive and horrendous that 75 per cent of French soldiers were either killed or wounded.[57] As Renoir wrote in 1918 to a former Japanese student, R. Umehara: 'my two eldest were very seriously wounded. The eldest has one arm that only has one bone left in it and the youngest was shot in the thigh through to the top of the knee. He healed thanks to his youth and robust health. But they are alive and I find myself very lucky compared to others who have lost everything.'[58] Yet even though Pierre was out of the fighting after the first month of the war, Jean remained on active service throughout, causing Renoir four years of acute anxiety. Jean, only twenty when the war began, fought valiantly as an officer, first in the cavalry, then in the infantry, then in photographic reconnaissance and finally in the air force, ending as a fighter pilot.

On 7 July 1915, only two weeks after his arrival in the hospital in Besançon and only one week after his mother's death, Jean was transported 411 kilometres (257 miles) to Paris. He underwent seven weeks of medical treatment at the military hospital set up in the Grand Palais, usually an exhibition space, and was told that he would lodge with other wounded soldiers at the Ritz hotel. Renoir, who was eager to meet Jean in Paris, was stuck in Cagnes, as he wrote to Maleck the next day, 8 July 1915: 'My trip is once again delayed, indigestion, fever, etc..... Jean, at the Ritz hotel in Paris, I don't understand that. I will write you as soon as I'm in Paris.... The doctor will tell me when I can escape this scorching temperature.'[59] Nevertheless, a week or so later, Renoir, accompanied by Coco, then fourteen, was finally able to join Jean in Paris. The photograph opposite includes Jean in uniform and Coco wearing a black armband of mourning for their mother.

While continuing his treatments at the Grand Palais, Jean requested permission to live with his father and brother in their Paris apartment. Jean's military record of 7 July 1915, includes a doctor's note: 'The Second Lieutenant Renoir asked to be treated at the Grand Palais all the while being allowed to heal in his home, which seems possible to me from a medical perspective.'[60] At the family apartment (57 bis boulevard Rochechouart), Jean had the benefits of the company of his father and brother, the entertainment of a new film projector

that Renoir had bought,[61] and the presence of Renoir's model, Dédée, whom Jean would grow to love. The same military record book specifies that Jean completed his four months of medical treatment on his leg on 26 August 1915. That autumn, when Renoir needed to retreat to the warmth of Cagnes, Jean was allowed to go south with him to continue recuperating at Les Collettes. During a visit that October, Paul Cézanne junior explained to his wife: 'Jean's presence and the affection he gives [Renoir] and the vitality which he provides rejuvenate Renoir. They spend every afternoon in the car that Jean drives.'[62] Clearly, the injury to Jean's left leg did not unduly hamper his driving ability. Even though Renoir was happy to have Jean close, he felt extremely frustrated with the course of the war, then in progress for a year, as he expressed to Jeanne Baudot: 'Everyone must play their part to remediate this general disaster. Everything has changed drastically for civilians and for the military.'[63]

Jean, too, had his part to play, since the medical inspector soon pronounced him fit for duty. Father and son both knew that a return to the infantry with his left leg 4 centimetres (1½ inches) shorter than his right would spell disaster. On 1 November 1915, Renoir wrote to Rivière: 'I am very upset, not knowing what to do. It is important that Jean's request for the armoured truck division have a follow-up. Otherwise it's a death sentence because he won't be able to defend himself since he has a lot of trouble walking. Tell me what I should do. What do you think is best?' On the back of Renoir's letter, Jean added a note: 'Dear M. Rivière, My father has also written to Élie Faure, 147 blvd. St-Germain. He asked me to tell you so as to keep you informed of all the steps taken.'[64] A week later, on 8 November, Renoir received a response from Faure: 'I have no need to tell you that I will do everything I can for your son. I am writing to my brother-in-law at the same time that I am writing to you. He is an officer in the Minister's Special Service.... The best thing to do to speed this up would be for your son to write him directly with what he wants. He will have been forewarned and very disposed to help, I promise, because we are on more than brotherly terms and, on top of that, he is a great fan of your – allow me the word – genius.... He shouldn't be afraid to give him all the details and be precise.'[65] As soon as Renoir received this letter, Jean wrote to Faure's brother-in-law: 'Major...I applied for tank duty a month ago. But having never received a response, I have abandoned hope of joining this branch of the service, and this is why I have asked to enter the Air Force. Being unable to fight on foot because of my serious leg wound, it would be for me the only way not to rot in the barracks and still be of some service to

the country. My application for the Air Force was sent two weeks ago. I would be happy if you could advise me on this matter and tell me if there is any hope.'[66] Even injured, Jean was fearless. The Air Force appealed to Jean since it served the same function as had the cavalry, scouting ahead of the infantry to report back on the enemy. However, while the hopelessly outdated cavalry dated back to Julius Caesar, aeroplanes were a new technology (the first mechanized flights had taken place in 1901 and the French air force had been founded in 1909). Acknowledging his 'serious leg wound', Jean was still determined to serve his country. Drawing on his father's connections made the difference, and Jean was able to get into the air force. Early in 1916, Renoir sent a letter to André: 'Forgive me if I don't talk about this stupid war, which makes no sense but will never end. Jean is still in Nice, still waiting to leave for the Air Force.'[67]

By 18 January 1916, Jean had begun aviation school in Ambérieu-en-Bugey in central-eastern France and was living at the Hôtel Terminus. On aviation school stationery, Jean explained to Guino: 'Dear friend, I am still in Ambérieu, but in a state of uncertainty. My father probably told you that they don't want me as a pilot due to my injury. Right now, I'm trying to stay on as a reconnaissance observer.'[68] At the time, his position was that of 'Observer'.[69] By the spring of 1916, more pilots were needed, regulations were changed and Jean again applied to become a pilot. His application stated: 'Second Lieutenant Renoir...*Observer*...Request to be a pilot. Would be happy to fly a fighter plane. (Wounded in the leg, would grow much less tired if flying a light aircraft.) Would like to start his training in Buc or Juvisy (or close to Paris) due to the current poor health of his

Renoir and Jean Renoir, c. 1915. Photo attributed to Pierre Bonnard. Albumen print, 10.2 x 7.6 cm (4 x 3¾ in.). Univ. of California Los Angeles, Art Library Collection, Jean Renoir Collection

father, who would like to see him from time to time. Date of the piloting application: 1 May 1916.... For a Caudron plane.'[70] Jean succeeded and later explained that he had joined an aerial photography squadron involved in taking pictures behind enemy lines.[71]

Jean's piloting application was accepted, and he became one of the first thousand pilots in the world.[72] On 4 September 1916, his military papers record that he 'arrived temporarily at the Aviation School of Châteauroux', 248 kilometres (155 miles) south of Paris.[73] He flew a twin-engine, open-cockpit Caudron made entirely of wood.[74] The day after Jean arrived at pilot's school, Renoir wrote: 'Jean is very happy to have his Caudron plane.'[75] Because of Jean's experience as an Observer, it took him only three months to become a pilot, but flying was extremely dangerous. On 19 December 1916, André wrote to Jean's godfather, Georges Durand-Ruel: 'Jean's plane crashed a few days ago, but he came out of it unharmed. Only his aircraft was demolished.... [Jean] got eight days to rest which he is spending near his father.'[76] The Observer accompanying Jean also escaped unharmed, but their photographic equipment was ruined.[77]

In fact, Jean at twenty-two, whose mother had recently died, missed his father and spent every leave he could with him. As noted earlier, Jean also had fallen in love with his father's model, Dédée, so took every opportunity to go home. For example, in July 1917, he wrote to his godfather: 'Maybe we'll go somewhere close enough to Essoyes that I'll be able to get permission to visit my father from time to time.'[78] After Guino gave him a medallion portrait that he had made of Renoir, Jean thanked him: 'I hung the clay image of Papa on the wall. I like glancing at it from time to time, while reading or resting on my bed smoking cigarettes.'[79] On one of Jean's leaves before 1916, the artist Pierre Bonnard came to visit and may have taken photographs of Renoir with Jean, dressed in his military uniform (see page 331).[80] Later, Bonnard used one of his photographs as the basis for an etched portrait of the artist.[81] As much as Jean missed Renoir, the artist longed for his son's company even more, as André wrote to Georges Durand-Ruel in December 1916: 'Jean's departure upset him so much that it was quite a pity.'[82] Renoir expressed it himself another time, writing: 'Jean has seven days leave here but it is going to end and it makes me even sadder.'[83] In a later letter to their shared dealer, André wrote: 'Renoir is not well. He is very worried about Jean's future and has dreams about it at night.'[84] Amid this nightmare, with one son undergoing arm surgery and another flying dangerous missions, Renoir's only joy was to paint and to have the companionship of Coco and Dédée.

Pilot Jean Renoir and an observer in a twin-engined plane, *c.* 1916–17. Univ. of California Los Angeles, Art Library Special Collection, Jean Renoir Collection. Photographer unknown

By the spring of 1917, the French troops gained some relief as the United States entered the war on 6 April 1917. The consistently optimistic Jean got a new Sopwith plane and in May wrote to Guino: 'I am sending you the photo of me in my new plane that I love. I was given a good [aeroplane] model by chance, which seems solid and ascends quickly.'[85] In late August 1917, he wrote to Renoir: 'My dear Papa, Something quite unpleasant has happened to me. They're removing Sopwiths from my squadron, and they're giving everyone Caudron G6s. The Caudron G6 is an aircraft that I find dangerous. It scares me a little, and this is why I'm going to apply to a fighter aircraft section of the air force, where they still have the best types of aircrafts.[86] I'm sure I will be of service to fighter aviation; for example, I will ask for a single-seat aircraft so I can take photographs. Because I'm used to two-seater missions of this kind, I will adapt very quickly to single-seat missions.... The one thing that bothers me is leaving my squadron, where I have good friends and an excellent leader. Nonetheless, I will write up a request to start flying fighter airplanes. If you are able to support me in this endeavour, I ask that of you. This all depends on the

Administration of Aeronautics at General Headquarters.'[87] Renoir doubtless gave Jean his blessing but seems to have hesitated to use his connections at this time. An undated letter states: 'My dear Jean... I have always believed, perhaps wrongly, that sometimes we need to give ourselves up to luck, which often works out better than all the precautions which are most often insufficient.... I think it is best to let things take care of themselves. With love, Papa Renoir.'[88]

Perhaps as a result of Jean's request for a dangerous assignment as a fighter pilot, he moved up the ranks again.[89] As his godfather wrote in September 1917: 'I learned yesterday with pleasure that Jean was promoted to Lieutenant.'[90] By late December 1917, Jean was describing his situation: 'My dear Godfather.... I'm in a period of depressing aerial inactivity. Rain, wind, storm. We can only rarely get off the ground, and even more rarely fly over the Boches [Germans]. My father writes that he is ecstatic for me about this bad weather, but I don't share his feelings.'[91] However, Jean's leg injury began troubling him again in late January 1918, as Joseph Durand-Ruel explained to Renoir: 'With Jean's injuries that keep him from active duty, he will always be kept at the back; you can therefore stay calm and not worry yourself sick.'[92] Nonetheless, in March 1918, Renoir was still fearful for his son: 'My dear Jeannot... I am vainly looking for ways of being useful to you, but can't find any.... It's been a few days since I've heard from you. I know that often several letters with different dates arrive at the same time. Love from all of us, Papa Renoir.'[93] Despite being taken off active duty, Jean's leg continued to worsen, and on 11 June 1918, he began six months of treatment at the Hôpital de la Piété in Paris, while living at home.[94]

The war was won five months later, on 11 November 1918, before Jean could return to active duty. On 21 December, his name was removed from the army lists, disqualified because of his health.[95] It was two months before Jean received a formal discharge from the Ministry of War: '19 February 1919, Ministry of War, The President of the Council...informs M. Renoir (Jean, Georges), Lieutenant of the reserves of the 28th regiment of Dragoons, that by ministerial decision of 14 February 1919...he is discharged.'[96] Yet, only a few days later, on 23 February 1919, Jean was recalled 'on temporary assignment to press censorship' in Nice.[97] His incredulous godfather wrote to Renoir: 'I learned that Jean was recalled to his regiment; I thought he was permanently discharged.'[98] Jean's new position had him censoring newspapers for just over eight months until he was allowed to become a Reserve Officer on 3 November 1919.[99] For his five years of military service, he was given the Croix de Guerre.[100] Although he had once

aspired to a military career, his experiences in the First World War convinced him that 'this type of activity was pointless'.[101]

When Jean first returned home in November 1918, his plan had been to work in the newly formed family porcelain business. Vollard's idea in 1913 of Renoir having a sculptural assistant had meshed perfectly with Renoir's two greatest loves – to paint and to be with people. By 1916, two years into the war, with Jean's realization that he could not have a career in the cavalry and his disillusionment with the military, Renoir began to think of what might work both for his benefit and for that of his two younger boys. He remembered his apprenticeship as a porcelain painter and decided to create a family ceramics industry. In that year, Renoir had begun directing Coco and Dédée in the creation and decoration of ceramic tableware, such as bowls and vases. Just as he had done for Guino when he made paintings and sketches for him to translate into sculpture, now Renoir had his sons and Dédée execute his designs.[102] A kiln was installed in Les Collettes in mid-April 1917. Coco explained to Guino: 'The oven is finished. We are in the middle of painting the studio. The exterior cement isn't finished.'[103] Seven months later, Pierre wrote: 'My dear Guino... Day by day, Jean is becoming more engrossed in ceramics' (see page 337).[104] Not only were Jean, Coco and Dédée involved in ceramics, but occasionally even Maleck André helped. Indeed, Jean had professional aspirations and began to sell his work through Durand-Ruel. In July 1919, he wrote to Paul Durand-Ruel: 'I have some even better results with my pottery and I can probably send you some pieces soon whose colour, despite the lack of motif, will start to look interesting.'[105] The Philadelphia collector, Albert Barnes, was not only enthusiastic about Renoir's painting but also wanted to acquire Jean's pottery. In June 1922, Barnes bought forty-two pieces of Jean's glazed earthenware that are still in the Barnes Foundation.[106]

In 1917, the year before Jean returned to Les Collettes, Coco, then aged sixteen, had decided to make ceramics his career. Renoir, as we have seen, had begun at age thirteen by copying Boucher's paintings onto plates.[107] He retained his love of artisanship all through his life, not only writing his impassioned treatise on Cennino Cennini in 1911, but also returning to painting on ceramics himself. Apollinaire wrote in an article in 1914: 'Renoir, the greatest living painter, whose least production is hungrily awaited by a whole legion of dealers and collectors...likes to relax by decorating tiny pots, thus preserving all his freshness for his paintings.'[108] In an article of 1948, Coco wrote: 'I decided to have a profession that allowed me to be close to my father: ceramics', which fulfilled Renoir's

wishes and allowed him better to bear the last two years of his life. Renoir's interaction with him was as 'the master who was speaking to his disciple'. Coco explained his 'apprenticeship.... Every afternoon, my father would cut short his painting sessions to work with me. He made me draw the shapes of vases and execute decorative motifs.... He was happy and told me about his beginning as a painter on porcelain and his first professional difficulties.'[109]

Coco's upbringing lacked one crucial element that had been present for his two brothers – stability. Pierre had had boarding school and Jean had had Gabrielle, but Coco not only constantly moved from Paris to Essoyes to Cagnes to Nice, but also never had a consistent adult presence. He was brought up by various maids, models and tutors. His early teenage years were even more chaotic, partly due to the onset of the war. When only thirteen, Coco was traumatized in the space of nine months by Pierre having his arm shattered, Jean being shot through the thigh and the unexpected death of his mother. Thus it is unsurprising that Coco latched onto his father, becoming his apprentice in craftwork. Coco also became his father's general assistant, as Georges Durand-Ruel wrote to Renoir: 'If you don't have time to write me, could you please ask Claude to give me news of your trip?'[110]

The elderly, ailing Renoir was preoccupied with his own health and with Jean's precarious military situation, leaving little energy to be concerned with Coco. Renoir deluded himself into thinking that Coco was doing well. In January 1916, he wrote to André: 'Coco is doing well. He is the happiest. He does nothing but run around in the countryside.'[111] A photograph around this time shows Coco barefoot with a rifle in his hand standing next to his father (see page 339).[112] Five months later from Essoyes, Renoir wrote to Vollard: 'Coco is happy. He is trout fishing.'[113]

While Renoir was unaware of his son's problems, Coco's godparents were concerned. His godmother, Mélina Meunier (née Renard), along with her husband Clément, was the caretaker of the Essoyes family house when the Renoirs were away (as noted in Chapter 5). Mélina felt unable to confront Renoir about her godson, even though she was troubled by Coco's choice of profession. In April 1917, her husband wrote to Guino, the only person he thought was close enough to help: 'I can tell from your letter that Claude is going to decide what to do. In reality there is still time, and I think that you can give him good advice. It can come neither from his absent brothers nor his immobile father. [Coco] recently wrote to his godmother and gave us some details about his work; that

Maleck André and André Heuschling (also known as Dédée), in the ceramics studio at Les Collettes, 1920. Gelatin-silver print. Musee d'Art Sacré du Gard, Pont Saint-Esprit

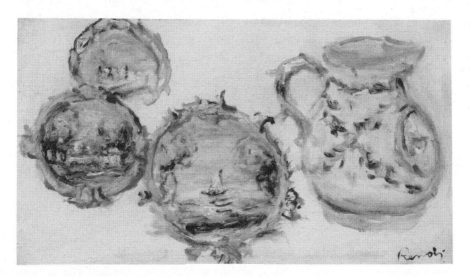

Oil studies for glazed earthenware pottery of plates and pitcher, c. 1916, 31 x 17.8 cm (12¼ x 7 in.). Private collection. Courtesy of Knoedler, New York

he was having an oven built to fire painted plates. But try to tell him to get a job that makes money.'[114]

Meantime, Coco's godfather, André, was more concerned about his behaviour. In December 1916, while visiting Renoir in Cagnes, André expressed his worries to Georges Durand-Ruel: 'I don't know if we will have the courage (my wife is here) to stay much longer. The young Coco is really too abominable, and we look like accomplices by not warning Renoir of the dangers of this education. But on the other hand, it would be cruel to bother the poor man in his last moments.'[115] A few days later, André wrote again to Georges Durand-Ruel: 'Myself, I am completely alarmed by all that I see around this poor Renoir. We don't know what we should or shouldn't say. It's quite troublesome. I don't think I will stay much longer.'[116] Although André clearly understood that Coco was in trouble, like Mélina, he felt unable to confront Renoir. Not only did he fear that Renoir could die at any time, but he had also always been intimidated by his famous friend. Despite his obvious discomfort with Coco's neglected state, André chose loyalty to Renoir over his obligation as Coco's godfather and he never brought the problem to Renoir's attention.

André and Maleck were also unable to confront Renoir because they felt indebted to him for taking them in during the privations of the war. Renoir, who was considered a national treasure as 'the greatest living painter',[117] suffered fewer shortages and offered the Andrés food and shelter. In November 1916, André had explained to Durand-Ruel: 'We are going to Cagnes to Renoir's who is kind enough to offer us hospitality. In addition to the pleasure of being with him, it saves me from a difficult situation. No wood, no charcoal at Laudun, hardly even any light! You can imagine how depressed I feel in these conditions.'[118] Renoir, meanwhile, benefited greatly from the company of his friends, as André reported to Georges Durand-Ruel in the same letter of concern about Coco: 'I've been with Renoir for about two weeks. When I arrived, he had the flu, was confined to his room and was very grumpy. But he regained his health quickly and 2 or 3 days after my arrival, he came downstairs and started painting. He is doing magnificent things.'[119] Renoir, too, wrote to Georges, in January 1917: 'The Andrés are here which gives me pleasant company.'[120] (At this time, Renoir encouraged André to become a museum curator at Bagnols-sur-Cèze.[121]) After spending three months with Renoir, the Andrés left Les Collettes in early March.[122] Three months later, André returned to Cagnes to spend another four days with Renoir.[123]

As a loyal client of the Durand-Ruels, André feared that Renoir might give in to other dealers more easily than in the past, as he wrote to Georges Durand-Ruel in June 1917: 'The poor Renoir is in such a weak state that he is incapable of resisting, as I told you, even the slightest pressure from those around him, that is to say, someone who could take from him and then take from him again every day. I had this experience several times this winter.'[124] Renoir would not have appreciated André's implication that his mind was as weak as his body, but it is highly unlikely that he ever learned of it since André consistently treated Renoir with love and respect.

André showed his devotion to Renoir by spending time with him and continuing to paint and draw him.[125] The younger artist also began work on

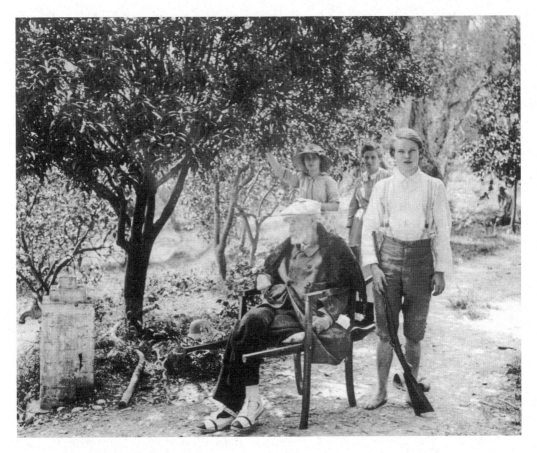

Renoir and Coco (foreground), Les Collettes, c. 1915. 7.6 x 9.2 cm (3 x 3⅝ in.). Univ. of California Los Angeles, Art Library Special Collection, Jean Renoir Collection. Photographer unknown

a book about Renoir that included a long essay and illustrations of thirty-five paintings kept in Renoir's studio. André related to Georges Durand-Ruel: 'I finished the little preface about Renoir that I've talked to you about. I went to read it to Renoir who seemed very touched.'[126] In May 1919, André's book was published by Crès in the series Cahiers d'Aujourd'hui. After he saw André's book, Renoir enthusiastically wrote: 'My dear friend, in reading your preface, I only saw one thing, it is written as much with love as with friendship. No one in the world could have said as much. You see me in a rosy and golden light, but you see me thus. I'm not one to complain that the bride is too beautiful. Renoir.'[127]

It was fortunate for Renoir to have young and healthy friends such as André, since those Impressionist friends who were still alive were elderly. Degas died at seventy-three on 30 September 1917. During his last years, he had become blind and could not work. Renoir expressed his own feelings in a note to their dealer, Georges Durand-Ruel: 'I have received a letter and a telegram informing me of Degas's death. It's fortunate for him and for the people around him. Any conceivable death is better than living the way he was.'[128] Degas's death particularly saddened Cassatt, who had been a close friend. She herself was suffering from cataracts that seriously hampered her work, as she told Durand-Ruel in February 1918. Although she and Renoir had not been especially close formerly, now that they lived near each other in the south of France, they kept in touch. In the same letter to Durand-Ruel, Cassatt wrote that she wanted to visit Renoir but had no means of transport.[129] Six months later, in August, Renoir, then seventy-seven, and Cassatt, then seventy-four, finally saw one another. In a letter to Louisine Havemeyer, she expressed how depressed she felt because of going blind from cataracts. Her first cataract surgery had left her blind in one eye and she feared a second cataract 'operation which may end in as great a failure as the last one'. In the same letter, the depressed Cassatt continued: 'Renoir says the finest death is a soldier's. Why don't they send all of us who are old and useless to the front? Death is a release.'[130] Cassatt was depressed because she could not paint. In contrast, Renoir was lucky since he could still paint and be involved both with Guino and sculpture and with his sons and ceramics.

Monet, too, had been diagnosed with cataracts in 1912, but postponed his surgery for eleven years, during which time he was able to paint. Finally, in 1923, he was lucky enough to have two successful cataract operations. Back in March 1916, Renoir composed a cheerful letter to Monet, then aged seventy-six:

'I'm delighted to hear that you have some large decorations [the *Water Lilies*]; they will be additional masterpieces for the future. As soon as I'm in Paris, around May I think, I'll leave you a note. It will be a real pleasure to share a [meat] chop with you. Just thinking about it makes my mouth water in anticipation.'[131] Monet was close enough to Renoir to know that his description of what he would eat at a meal together was a fantasy, since Renoir ate mashed, diluted food through a straw.

During Renoir's last years, he remained close with his three key dealers – the Durand-Ruels, the Bernheims and Vollard. Since Paul Durand-Ruel was in his eighties, his son Georges became the head of the Paris branch, while his older brother, Joseph, became head of the New York branch. During the war, Renoir donated paintings through Durand-Ruel as a means of contributing to the war effort, as a letter of 1917 from Georges to Renoir mentions: 'I've just seen the two paintings you sent, one for the Journalists' Syndicate, the other for the War Blind; they are both superb. With the numerous paintings that you have already given for various other charities, you have contributed on your part more than any other artist and I understand that you are playing dead like you wrote me the other day.'[132] Since the Durand-Ruels were Renoir's primary dealer from 1872, the artist continued to keep his primary account with their firm; for example, his annual rent of 1,150 francs for the Paris apartment was paid out of these funds.[133] The Durand-Ruels wanted any Renoir artwork that they could get, as Georges told Renoir in May 1917: 'I never write you to ask for paintings because I think that you know that we are always ready to take everything that you will give us. If you have any new paintings or old paintings already in your studio that you want to dispose of, we would be very happy to take them.'[134] Before, during and after the war, the Durand-Ruels continued to display Renoir's art in their Paris and New York galleries and in affiliated galleries throughout Europe.[135]

The Bernheims were also friends who sold and exhibited Renoir's work.[136] Alexandre Bernheim had died in 1915; his two sons, Josse and Gaston Bernheim-Jeune, took over their father's business.[137] The Bernheims had put on Renoir's most important exhibition in 1913 (comprising forty-two major paintings) and they continued to display his works in their sumptuous Paris gallery.[138]

Renoir's third major dealer, Vollard, continued to be a frequent visitor in Paris and a house-guest in Essoyes and Les Collettes.[139] He remained personally close to Renoir because, of the three dealers, only he knew about Renoir's

secret daughter. Certainly, Renoir always felt indebted to Vollard for all his help throughout the years, and even chose him to appear in a documentary film showing Renoir painting.[140] The shrewd Vollard used his intimate relationship with the artist to obtain paintings that would otherwise have gone to other dealers, none of whom understood why Renoir was especially sympathetic to Vollard. In June 1917, André reported to Georges Durand-Ruel: 'Vollard got things because he stayed eight days and schemed during this time to get what he wanted.'[141] Two days later, André wrote again: 'He's shrewd as a monkey.'[142] During one of Vollard's 1917 visits, Renoir sold him his 1869 portrait of his father and three sketches for a total of 12,000 francs.[143] Aside from outright sale, Vollard obtained various Renoir works by commissioning paintings, prints and sculpture, as discussed earlier. In 1917, for example, Vollard sat for his third portrait by Renoir.[144] In this one, he is dressed in a toreador's outfit that he had recently bought in Barcelona. Previously, he had also commissioned Renoir to paint his partner, Mme de Galéa.[145] In 1915, Renoir also worked on an elaborate frame for this portrait.[146] Most important among Vollard's commissions, however, were the sculptures made in collaboration with Guino. This was Vollard's unique niche; no other dealer was involved with Renoir's sculpture.

Other collaborations, however, also engaged Renoir. In 1915, he was asked by the city of Lyons to make the cartoon design for a tapestry. He made an oil painting plus drawings and etchings of *The Saône River throwing herself into the Arms of the Rhône River* (see page 246).[147] Renoir's painting echoes one of his favourite works in the Louvre, Rubens's *Arrival of Marie de Medici at Marseilles* (1621–25). In the male figure's adoring gesture towards the female figure, Renoir was reviving many of his earlier scenes showing men adoring women, such as *Lise and Sisley*, 1868 (see page 85), *Dance at Bougival*, *Country Dance* and *City Dance*, all 1883 (see pages 94–95). Whether Renoir was painting modern life as in his earlier works or painting timeless figures as in his later works, he celebrated life. Cassatt reported a conversation she had with Renoir in August 1918: 'Renoir says that Nature is opposed to Chastity.'[148] Since the Lyons tapestry project was collaborative, Renoir asked his friend André to make the large cartoon based on Renoir's oil, drawings and etchings. Unfortunately, the tapestry was never completed.[149]

Guino was not only Renoir's sculptural assistant but also his companion. Thus, in February 1917, when André and his wife were planning to leave Les Collettes, André wrote: 'Dear Monsieur Guino, Monsieur Renoir has charged me

with telling you that he awaits you with pleasure. We are thinking of leaving this week and it would be kind of you to come as soon as possible to ensure that he won't be without company.'[150] Guino also befriended all three of Renoir's sons, which may explain why the Meuniers turned to him for help in convincing Coco to abandon ceramics and pursue another career. Guino sculpted busts and medallions of the three brothers, Jean thanking him effusively in early 1916: 'Dear friend... I really want to tell you how happy I am that you did my bust. I think about it often and I am glad to know it was so well done.'[151] In the summer of 1917, Jean wrote again to Guino: 'Since my flight team is still in the same spot, I regretted that I hadn't taken the beautiful medallion that you were kind enough to have made of me. But on my next leave I will get it.... Thank you from the bottom of my heart for your unfaltering kindness.'[152]

While these family portrait sculptures were done by Guino alone, two years earlier, at Vollard's request and in collaboration with Renoir, Guino had begun a series of seven portrait medallions of artists.[153] Four were based on Renoir's earlier portraits: his 1880 pastel of Cézanne,[154] the 1882 oil of Wagner,[155] a 1906 pastel of Monet[156] and his 1914 pastel of Rodin.[157] The three other medallions had independent sources: Delacroix's was based on a repro-duction of Delacroix's self-portrait, and the images of Ingres and Corot were based on photographs. Each medallion is 80 centimetres (31 inches) in diameter and shows the subject surrounded by a garland of fruit and leaves, inscribed with the name of the sitter and with Renoir's. Guino's name was never affixed to any of the sculpture he made with Renoir. The medallion series was com-pleted in 1917, when Vollard arranged for them to be reproduced in bronze.[158]

In Chapter 6 we saw that between 1914 and 1917, Guino and Renoir also worked together on various statues related to Renoir's 1913 *Judgment of Paris* (see page 247) painting (the small, medium and large versions of *Venus Victorious*, the small and large bases with frieze of the *Judgment* and two sculpted heads of Paris, bearded and beardless). Related to this theme of love was their *Clock Project*, 1914–17 (also called *The Triumph of Love*). Guino and Renoir also worked on two other statues – *Small Blacksmith*, 1916 (also called *Fire* or *Young Shepherd*)[159] and *The Small Washerwoman*, 1916 (also called *Water, Small Stooping Washerwoman* or *The Small Bather*).[160] After Renoir approved each work, Guino took it to Vollard for reproduction in bronze. Then, in 1917, Vollard told Guino to make a larger version of the *Small Washerwoman*, to be called *The Large Washerwoman*, 1917 (also called *Water, Large Stooping Washerwoman*

or *The Large Bather*).[161] Renoir was never shown this statue for his approval. It is likely that he learned of the deception from his friends André and Georges Besson in late December 1917; Renoir told them that he did not want his name on any piece that he had not supervised; this violation of his agreement with Vollard upset him.[162] His response was to tell Vollard to end his four-year collaboration with Guino. This decisive action when confronted with Vollard's unscrupulous behaviour was entirely unlike André's portrayal of the artist as vulnerable to exploitation by dealers. Even so, Renoir continued his pattern of avoiding unpleasant confrontations. A little over a week after he heard the news, on 7 January 1918, he wrote Vollard a subtly chiding letter: 'If you would have written me sooner, I would have suggested you take Guino to [the sculptor] Bartholomé to be his assistant or helper. You understand why. First of all, Guino is an incomparably skillful and very serious sculptor.... Guino is a charming man whose feelings I would not want to hurt for anything in the world. He does all he can to be nice to me. That is why I am giving you this advice, which could help me without offending anyone.'[163] Despite Renoir's obvious displeasure with the dealer, he had no intention of disrupting his own friendship with and dependency on Vollard. Instead, Renoir intended to withdraw from the three-way sculptural collaboration but did not want to confront either Vollard or Guino. In the same letter, Renoir gave Vollard an excuse: 'Furthermore, since I am extremely tired, very, very tired, I would not mind having a little rest for the time being. In the bad condition that I am in, my life is too complicated for someone my age. And I have reached a point where I can do neither painting nor sculpture nor pottery even though I want to do everything.'[164]

Despite this excuse, it was only eight months later that Renoir began another sculptural collaboration with an independent sculptor, Louis Morel, thirty-one years old and from Essoyes. On 3 September 1918, from Cagnes, Renoir wrote to Morel: 'If by any chance you should feel like coming in this direction, I can offer you hospitality and the expenses of the trip. And I will organize everything in order for you to sculpt.'[165] Morel made high-relief terracottas of several Renoir oil studies and drawings: two versions of *The Dancer with Tambourine*, 1918 (I and II) and one of *The Flute Player*, 1918 (also called *The Pipe Player, Joueur de flûteau*).[166] While Vollard had handled the bronze casting of all the previous statues, this time Renoir chose the Parisian firm of Renou and Colle for Morel's reliefs.[167] By November 1919, Renoir had become dissatisfied with the work of Morel and hired another sculptor, Marcel Gimond

(aged only twenty-three), and they discussed plans for a Temple of Love, modelled on the classicizing version in Versailles, which would house the *Venus Victorious* statue in the garden at Les Collettes.[168] Gimond also wanted to do a bust portrait of Renoir, for which the painter agreed to pose three times, the last sitting only two days before Renoir's death. Later, Mme Gimond gave a copy of this bronze bust to the Musée Renoir in Les Collettes.[169]

Vollard did not seem to take offence with Renoir's dismissal of Guino and the later sculptural projects that excluded him. Instead, the dealer set out to become an even more intimate friend of Renoir. A diary entry of the dealer and collector René Gimpel (1881–1945) in August 1918 relates that Georges Bernheim told him: 'Vollard holds his spittoon, brings him his chamber pot, and helps him...pee!'[170] The motivation for wanting to remain close to Renoir was that Vollard, besides being a dealer and publisher, aspired to write about Renoir, as he had written about Cézanne in 1914.[171] A month after Gimpel recorded Vollard's intimate relationship with Renoir, he described in his diary Vollard's devious scheme to get information from Renoir for his future publications: 'Vollard sat down at a table with ink and writing paper and appeared to be catching up on his correspondence. The painter Émile (1868–1941) Bernard's mission was to make Renoir talk while Vollard took notes on everything he said.'[172] The previous year, in July 1917, Vollard had composed a four-page article, 'How I came to know Renoir'.[173] Now, in 1918, with more information, he published a two-volume illustrated album, *Tableaux, pastels et dessins de Pierre-Auguste Renoir* (*Paintings, Pastels and Drawings by Pierre-Auguste Renoir*), that began with a short, fictitious conversation between Renoir and Vollard, followed by photogravures (a photo-mechanical process using etching, resulting in a high-quality print) of 667 Renoir works.[174] Like André, Vollard showed Renoir the proofs of his book before publication. On 3 March 1918, Renoir thanked him: 'I have received the reproductions that you made for your book about me and I am happy to be able to tell you that I find them perfect. I am delighted.'[175] The following year, Vollard wrote and published another book about Renoir, *La Vie et l'oeuvre de Pierre-Auguste Renoir* (*The Life and Work of Pierre-Auguste Renoir*), with 51 photogravures and 175 drawings.[176] This time, however, Renoir objected to a text passage and tried to prevent publication. As usual, Renoir did not complain directly to Vollard, but instead sent a telegram to Georges Durand-Ruel so that he would handle the problem. On 14 May 1919, Georges replied: 'I received your telegram the other day asking me to stop the

publication of the book; I gave this telegram immediately to Vollard. The same day I received a visit from Monsieur Besson; he told me he was going to have the page skipped and would have it rewritten in a way that would leave out the passage in question.'[177] Vollard's 1919 book was published twelve days after Renoir's death without the offending page.[178]

Just as Renoir welcomed young sculptors such as Morel and Gimond, he continued to be generous to former students. For example, two months before his death, Jacques-Émile Blanche asked Renoir's opinion of Blanche's large composition called *Mémorial*, his personal homage to the dead of the Great War. Blanche intended that his mural would hang in the church of Blanche's Normandy village of Offranville. Having seen the work, Renoir's reaction was complimentary in writing to Blanche: 'It seems to me an interesting work even if a little severe.... It seems to me that you have stuck to the rules of all the great decorative projects of the past which is to me of the utmost importance.'[179]

Two years before Renoir's death, two emerging artists, Henri Matisse and Pablo Picasso (aged forty-eight and thirty-six respectively), asked their dealer, Paul Rosenberg, to introduce them to the aged painter. At the time, both younger artists owned Renoir works – Matisse, four Renoir paintings and an album of prints;[180] Picasso, seven Renoir paintings (on which see shortly). While Rosenberg was able to set up a meeting between Matisse and Renoir, the older artist died before Picasso could meet him.

Matisse first met Renoir on 31 December 1917, when Matisse was forty-eight (indeed, it was his birthday) and Renoir was seventy-six. Matisse, then living in his winter residence in Nice, was only a short distance from Renoir at Les Collettes.[181] The older artist, perhaps remembering how Manet's mentorship had helped him, was so welcoming that the younger artist came back several times throughout the next two years.[182] During his first visit, while Renoir was working on a new version of the *Large Bathers* (see pages 194 and 246), Matisse wrote to his wife: 'I have just come from Renoir's place where I saw some marvellous paintings.'[183] Inspired by his visit, Matisse painted Renoir's gardens with the statue of *Venus Victorious* (see page 285).[184] After another visit,[185] Matisse reported to his wife: 'I saw father Renoir again yesterday morning. He was very kind to me. He told me: "What you showed me gave me great pleasure – very sincerely."... I responded: "Monsieur, you cannot know the great pleasure you have given me." He responded: "You know, the person you are speaking to may not have done great things, but he did something all his own. I worked with Monet, with

Cézanne for years, and I always remained myself." So, I told him how much his approval encouraged me, for I often had doubts, but I know that I can't paint any other way and that's it. He responded: "Well, that's what I like about you."'[186] Just as Renoir continued the legacy of Manet in his modern use of colour, value and composition, Matisse continued Renoir's legacy in his use of light, bright colours and his sensual and joyful figures.

Although both Renoir and Picasso wished to meet one another, they never did. On 29 July 1919, Rosenberg wrote to Picasso, then in London: 'I saw Renoir who will be in Paris on 3 August, and I spoke to him of you. It is too complicated to write everything but he wants to meet you; he was impressed by certain things and even more shocked by others.'[187] Despite never having met Picasso, Renoir deeply influenced the younger artist. From Rosenberg, Picasso purchased seven paintings by Renoir, all from his late period. One of Renoir's nudes, *Bather seated in Landscape drying her Foot*, also called *Eurydice, c.* 1895–1900,[188] inspired Picasso's *Seated Bather drying her Foot*, 1921.[189] Picasso was intrigued by Renoir's 'general evocations of a classical past', 'a golden age rooted in bodily sensuality'.[190] Shortly after the aged painter died, Picasso copied in charcoal a 1912 photograph of Renoir with his crippled hands,[191] as well as three precise line drawings of Renoir's *Lise and Sisley* of 1868. Three years after Renoir's death, Picasso made a variant of Renoir's *Dance at Bougival* in his *Village Dance*, in which a red-hatted woman dances with a hatless man dressed in a blue suit with a white collar.[192] Throughout the next five years through 1924, Picasso's style was at its most classical, including many large nudes directly inspired by Renoir's late bathers.[193] Paintings during Renoir's last year such as *The Great Bathers* (see page 246), *Girl with Mandolin* or *The Concert* (see page 248) retain his optimistic sensuality. He developed a looser brush style that compensated for his loss of fine motor skills.

Renoir's final masterpiece, his last version of *The Great Bathers*, was a joyful painting inspired by the Armistice of 11 November 1918, which brought peace to Europe. The *Great Bathers* of 1919 is a large painting (only a few centimetres smaller than the 1887 *Large Bathers*; see page 194) clearly meant for a museum.[194] Here Renoir creates a summing-up work, just as he had for each style in his career: *The Inn of Mother Anthony, Marlotte*, 1866 (see page 84); *Dancing at the Moulin de la Galette*, 1876 (see page 86); *Luncheon of the Boating Party*, 1881 (see page 92); *Dance at Bougival, City Dance* and *Country Dance*;

The Large Bathers; *The Artist's Family*, 1896 (see page 198); and *Variant of The Bathers*, 1903.[195] Six months after Renoir's death, his model Dédée wrote to Vollard: 'He always told me: "when I stop working, it will be over". I am quite happy that, until the very last moment, he was consoled by his art. He was near death so many times that he wasn't aware that he was dying.'[196] Dédée's assertion that Renoir was unaware supports all the evidence that until the end, he was still able to escape his pain through his art. Just as Renoir predicted, he died shortly after completing *The Great Bathers*. After his death, his sons followed his intention and gave the painting to the state Luxembourg Museum in 1923; it now hangs in the Musée d'Orsay.

Renoir died aged seventy-eight on 3 December 1919, at Les Collettes in the presence of Jean and Coco. Pierre, who was in Paris at the time, immediately came to Cagnes. Upon Renoir's death, Jean sent a telegram to André: 'Father deceased, pulmonary congestion. Jean Renoir.'[197] Six days later, Pierre wrote to Georges Durand-Ruel: 'My father died within two days, succumbing to a pulmonary congestion. His will to live was so intense that he was going to make it, but his heart was so tired and worn that it couldn't pull through. He died in his sleep without any suffering just as he always wished.'[198] Since Pierre had not been present at the death, he reported to Paul Durand-Ruel that he had asked Jean to write a more detailed letter to Georges Durand-Ruel describing Renoir's last hours:[199]

My father had just had broncho-pneumonia which lasted for two weeks. Towards the end of the last month, he seemed to be better and had started to work again, when suddenly on the 1st of December, he felt pretty ill. The doctor diagnosed a pulmonary congestion, but not as serious as last year's. We could not have guessed it would end this way. During the last two days he kept to his room, but was not constantly bedridden.

He said from time to time, 'I'm finished', but without conviction and he said it more often three years ago. The constant care irritated him a little and he didn't stop making fun of himself.

Tuesday he went to bed at 7 after peacefully smoking a cigarette. He wanted to draw a vase, but we couldn't find a pencil.

At 8 o'clock, he suddenly became somewhat delirious.

We were astounded and went from relative confidence to the gravest apprehension. His delirium increased. The doctor came. My father was

restless until midnight, but didn't suffer an instant. He certainly did not know he was going to die.

At midnight he became calm and at 2 o'clock he gently passed away. We didn't have time to alert the priest. Jean Renoir, 20 December.[200]

The public learned the details of Renoir's death six days later from a letter to *Le Bulletin de la vie artistique* from Félix Fénéon, the art critic and adviser to the Bernheims, who was then in Cagnes.[201]

Renoir's death certificate was written the day he died: 'December 3rd, 1919, at 2 a.m., Pierre Auguste Renoir, born in Limoges, 25 February 1841, a painter, Commander of the Légion d'Honneur, son of the deceased Léonard Renoir and of the deceased Marguerite Merlet, his wife, and widower of Aline Victorine Charigot, died in his home in Cagnes.'[202]

Just as Renoir had not made burial arrangements for Aline before her death, so he had not made any arrangements for himself. When he died, his children obtained permission to have his remains temporarily placed next to Aline's body, which had lain for four years in the Château cemetery in Nice (as described in Chapter 6). Renoir's funeral was held three days after his death at the Chapelle du Logis in Nice with an oration by one Abbé Baume.[203]

In the same letter to Georges Durand-Ruel written six days after Renoir's death, Pierre wrote: 'Later we will transport my father's body to Essoyes.'[204] It is curious that Pierre does not mention that his mother's body would also need to be sent from Nice to her burial plot in Essoyes. At the time of writing, Renoir still had no burial plot, but Pierre and his brothers must have decided that their parents would be placed in adjacent plots. Since Renoir's tailor brother, Victor, had moved to Essoyes and had died in 1907, he was already buried in the cemetery there.[205] Eight months after Renoir died, on 12 August 1920, Pierre purchased a plot for his father in the cemetery, next to but separate from the one he had purchased for his mother (see page 355). The artist's plot is both larger and in front of Aline's, their tombstones the same height.[206] The purchase agreement stated: 'to contain, for eternity, the private tomb of Monsieur Pierre Auguste Renoir...and of his family'.[207] Nevertheless, it was not until 7 June 1922, thirty months after Renoir's death, that the remains of Renoir and Aline were moved from Nice to Essoyes.[208] Guino's bronze bust of Aline sits atop her tomb and that of Renoir sits atop his (see page 355).[209]

Renoir's death deeply upset the two elderly remaining Impressionists, Monet and Cassatt. Monet, then aged seventy-nine, who had been a close friend of Renoir for more than fifty years, wrote to his friend and biographer, Geffroy: 'The death of Renoir is for me a painful blow. Along with him a part of my life has disappeared, the struggles and optimism of my youth. It is very hard.'[210] Around mid-December 1919, Monet also wrote to Fénéon: 'You can guess what a pain it is for me, the disappearance of Renoir: he took with himself a part of my life. I haven't stopped thinking of our youth filled with struggle and hope in the last three days.... It is hard to remain the only one, but not for long certainly, feeling myself every day grow older, even though people tell me the contrary.'[211] And a month later, to Joseph Durand-Ruel: 'Poor [Renoir], he is gone. It is a great loss and a real sadness for me as for you.'[212] Cassatt, then aged seventy-five, wrote to Louisine Havemeyer: 'Renoir died on Tuesday. His vitality was certainly extraordinary, & his pictures, bad & good will sell very high. You know what the last were [Cassatt did not like these]. The early ones will remain.'[213]

Renoir's estate, estimated at five million francs, was divided equally among his three sons: Pierre (aged 34), Jean (25) and Coco (18). Pierre assumed

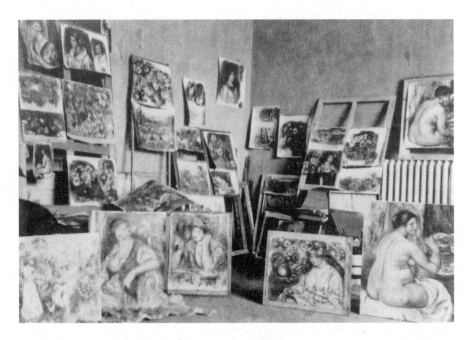

Renoir's studio at Cagnes, c. 1918. Photo by Georges Besson. 13 x 17.5 cm (5⅛ x 6⅞ in.). Archives Matisse, Issy-les-Moulineaux. Photo gift of Jacqueline Bret-André

responsibility in dealing with the family inheritance and wrote in the same letter to Georges Durand-Ruel six days after his father's death: 'We are leaving everything as is, at least until Claude comes of legal age [twenty-one], and my two brothers have wisely decided to live from now on at Les Collettes.'[214] Pierre also assumed responsibility for Renoir's accounts, writing to Paul Durand-Ruel: 'If you still have an account with Papa, either as a debtor or a creditor, could you please be so kind as to do nothing at this moment. I will settle it directly with you.'[215] Meanwhile, Renoir's six dealers – Joseph, George and Paul Durand-Ruel, Vollard and Josse and Gaston Bernheim-Jeune – made inventories of the contents of his two houses in Essoyes and Cagnes, one rented apartment in Paris and his various studios.[216] When Renoir died, there were 644 paintings and drawings in Cagnes and Paris and 76 in Essoyes. Twelve years after Renoir's death, in 1931, André and Marc Elder jointly published with Bernheim an illustrated catalogue of these 720 paintings.[217] After Coco had turned twenty-one, he inherited the house, studio and grounds at Les Collettes in October 1922, while Pierre inherited the house, studio and grounds at Essoyes. Jean, who was starting his career in film-making and needed money, was compensated by receiving a larger portion of the art.

When Renoir's will was issued three days after his death, it must have come as a surprise to his sons to read: 'This is my will– I the undersigned Pierre Auguste Renoir, an artist, have made out my will as follows.– I bequeath an annuity of 450 francs to Madame Jeanne, widow of M. Robinet, wife of baker in Madré (Mayenne) who will enjoy the use of it during her life beginning on the day of my death.– This annuity will be assured by registering with a tax of three per cent for the French state by means of French government bonds on 450 francs in her name and for her enjoyment. This gift will be given without any fees or taxes. I revoke all previous wills.– Done and written entirely by my hand in Paris the 14th of October 1908 [signed] Renoir.'[218]

On reading this will, Pierre, Jean and Coco would surely have enquired about the identity of 'Madame Jeanne, widow Robinet, baker in Madré', asking Gabrielle, Vollard or Georgette; Renoir's three sons must have learned that Jeanne was their half-sister. In contrast, Jeanne had known about her annuity since 1908 when Renoir had established it. Two weeks after Renoir's death, Pierre wrote to his half-sister for the first time: 'Madame…I received a copy of my father's will, which he left in the hands of Maître Duhau, a notary in Paris. In his will, my father bequeaths you a yearly life annuity of 450 francs, starting

on the day of his death. As soon as we have resolved the intricacies created by the fact that my youngest brother is under age – and this will most probably happen very soon – this annuity will be paid to you. I will meet M. Duhau regarding this matter some time in January. Sincerely yours, Pierre Renoir.'[219] On the same day, 17 December 1919, in Madré, Jeanne received a letter from Duhau about her inheritance: 'Madame… You will find here enclosed an excerpt from Monsieur Renoir's will in which he bequeaths you a yearly life annuity of 450 francs. I think I should let you know that Monsieur Renoir's inheritors have no objection to providing you with this annuity as of now, without waiting for the inheritance to be settled.'[220] As Pierre was taking charge of financial matters, eight months later, he again wrote to Jeanne: 'Madame, If my work permits it, I will come to see you in September, but I cannot promise it. Sincerely yours. Pierre Renoir.'[221] Because her annuity was minimal as a result of the devaluation of the franc, soon after Renoir's death, Jeanne contacted her half-brothers to ask for an increase, to which they agreed. Thus, in the end she received a higher annuity from Renoir's estate.[222]

AFTERWORD

Essoyes cemetery with Renoir's tomb, in which Pierre, Jean and Dido are also buried, and Aline's tomb, in which Coco (Claude Renoir), Claude Renoir junior and Aline's mother Emilie are also buried (see page 355).

Pierre inherited his father's heroic perseverance and acceptance of his own limitations. Remarkably, between 1915 and 1951, despite his paralysed, shrivelled arm from his war wounds, Pierre acted in 60 different plays and 63 movies.[1] In 1934, when he was being considered for the Légion d'Honneur (which he received), Pierre summarized his training and extraordinary career: 'Conservatoire de musique, two second prizes in 1908; first prize in tragedy in 1909. Odéon, ten years at the Porte Saint-Martin, Théâtre de Paris, Gymnase, Théâtre Antoine, Théâtre des Arts, La Madeleine, Les Mathurins.... On tour with theatre company: France, Algeria, Tunisia, Spain, Portugal, Holland, Belgium, Switzerland, Italy.'[2]

His personal life was more difficult. Pierre and Véra divorced in 1925. Four months later, he married Marie-Louise Iribe and they divorced in 1930. Seven years later, he married Elisa Ruis.[3] Pierre died in 1952 and was buried in his father's Essoyes tomb where Guino's portrait medallion of Pierre is affixed. Pierre and Véra's son, Claude Renoir junior, the only grandchild whom Renoir knew, was six years old when the painter died. As an adult, he became a camera-man and worked with Jean Renoir and other film-makers (Alexandre Astruc, Roger Vadim and Henri-Georges Clouzot).[4] The younger Claude Renoir, who died in 1993, chose to be buried in Aline's tomb.

Less than two months after Renoir's death, on 24 January 1920, Jean married Renoir's model Dédée, and on 31 October 1921, their son Alain named after his grandmother Aline, was born.[5] Jean continued to work in pottery and ceramics until 1922–23.[6] In 1924, prodded by Dédée, who aspired to be a film star, Jean shot his first movie, *Catherine* or *Une vie sans joie* (*A Joyless Life*), which starred Dédée (using the name Catherine Hessling). Despite Jean's chronic thigh wound, throughout the next forty-two years he became an internation-ally renowned director of forty-one films as well as being an actor, producer, translator, adapter and author; he also employed both his brother Coco and his nephew Claude to work on his films. Jean's movies and plays reveal the same

optimistic, sensual outlook as do his father's paintings.[7] For both Renoir and Jean, 'materialism, machinery, and mass production stifle the individual and degrade nature and artistic quality'.[8] It is unfortunate that Jean's relationship with Dédée had insoluble problems, as had Renoir's with Aline. Jean and Dédée separated before the Second World War and then divorced. In December 1941, Jean went to the United States with his Brazilian 'script-girl', Dido Freire, whom he married in 1944. Jean died in 1979. He had arranged for his family to send his ashes from Beverly Hills to Essoyes so that he could be buried with his father. When Dido died in 1990, her ashes also were sent to Essoyes to be interred with Jean's, as she had arranged. Guino's portrait medallion of Jean appears below his brother's on the tomb (see opposite).

Gabrielle and her partner Conrad Slade continued to live in Cagnes near the Renoirs. Their son, named Jean Slade after Jean Renoir (later Americanized to John), was born on 9 December 1920. Gabrielle and Conrad married on 18 May 1921, with Jean Renoir serving as a witness. The Slades went to the United States in 1941 and soon followed Jean to Hollywood. In 1955, Gabrielle, by then aged seventy-seven and a widow, had a house built in Beverly Hills near Jean and Dido's home, where she lived with her son. Gabrielle helped Jean write his 1958 book, *Renoir, My Father*. She died the following year at the age of eighty and was buried in the Mt Hope Cemetery in Mattapan, Massachusetts, along with her husband and other members of the Slade family.

Coco carried on his father's love of craftsmanship, pursuing ceramics as his father had wanted. Like his mother, he, too, developed diabetes. Two years after Renoir died, on 12 December 1921, Coco aged only twenty married Paulette Dupré; their son Paul was born three years later. Besides later working for Jean in cinema, Coco also owned a cinema, theatre and casino complex. He died in 1969; he had chosen to be buried in Aline's tomb along with his maternal grandmother.

Renoir's daughter Jeanne moved from her home in Madré back to Sainte-Marguerite-de-Carrouges where her foster family welcomed her. Jeanne lived there until her death in 1934 aged sixty-four, and is buried with her husband in Madré's cemetery.

The year after Renoir died, three important exhibitions of his art took place. In Paris, Durand-Ruel exhibited 63 paintings, 13 pastels and several drawings, and in New York, he showed 41 paintings. The Salon d'Automne mounted a show of 31 Renoirs of 1915–19. From 1921 to 1929, Renoir's works

Essoyes cemetery with Renoir's tomb (with remains of Pierre and Jean Renoir) and Aline's tomb (with remains of Coco Renoir). Photographer unknown

were shown in 57 exhibitions, of which 12 were solo shows. In every decade from the 1930s to the end of the 1960s, except for the wartime 1940s, his works were included in at least 20 shows, at least half of them devoted solely to his work.[9] In 1973, a major Renoir retrospective was held at the Art Institute of Chicago and, in 1985, an international Renoir exhibition took place in Boston, London and Paris. The exhibition 'Renoir's Portraits' was held in Ottawa in 1997. In 2003–04, 'Renoir and Algeria' was held in Williamstown, Massachusetts, Dallas and Paris. 'Renoir Landscapes 1865–1883' was held in London, Ottawa and

Philadelphia in 2007–08. Paris, Los Angeles and Philadelphia hosted 'Renoir in the 20th Century' in 2009–10, and in 2012, 'Renoir, Impressionism and Full-Length Painting' was held in New York.

The prices of Renoir's works have continued to spiral. Shortly after his death, *The Pont Neuf*, 1872, which had been sold for 300 francs in 1875, fetched 93,000 francs. In 1923, Durand-Ruel sold *Luncheon of the Boating Party*, 1881 (see page 92) to Duncan Phillips for $185,000. In 1982, the same painting was insured for 10 million dollars while in a travelling exhibition.[10] In 1925, the auction of Maurice Gangnat's collection of 161 paintings brought more than 10 million francs. The *Pont des Arts*, 1867, fetched 200 francs in 1872; in 1932, 133,000 francs; in 1968, $1.55 million. This represents a twelve-thousandfold increase in ninety-odd years.[11] The monetary value of Renoir's paintings continue to be among the highest. In 2006, a list of the highest prices ever paid at auction for any painting listed Renoir's *Dancing at the Moulin de la Galette, Montmartre* (a smaller version of the Musée d'Orsay's version) as selling for $78.1 million on 17 May 1990 at Sotheby's New York.[12] The two paintings of higher value at this time are Van Gogh's *Portrait of Dr Gachet*, sold at Christie's New York on 15 May 1990 for $82.5 million, and later, Klimt's *Portrait of Adele Bloch-Bauer*, sold privately on 18 June 2006 for $135 million.

Today, paintings by Renoir are found in museums throughout the world. In addition to the unparalleled Philadelphia Barnes Foundation with its 181 Renoir paintings on view and the Clark Art Institute in Williamstown, with its 32 Renoirs on view, many major museums throughout the world display Renoirs, including on their websites (see Appendix).[13]

Renoir was truly the last great painter of the ideal sensuous figure. His forebears were the Pompeian fresco artists, Raphael, Titian, Rubens and Ingres. His art influenced Bonnard, Denis, Maillol, Matisse, Picasso and other twentieth-century artists whose work is permeated with the freedom and *joie de vivre* of the Impressionists, fused with a classical search for balanced compositions and form that is substantial and monumental.[14]

On balance, Renoir was a remarkable individual whose life story is heroic and inspiring. Just as his optimistic, joyful art brings happiness to people around the world, the story of his life makes one grateful that there was such a generous person who left the world thousands of works of art to enjoy.

APPENDIX

Selected Renoir Paintings Worldwide

According to the Bernheims' five-volume catalogue raisonné of Renoir's work (Dauberville, 2007–14), he created 4,019 paintings, 148 pastels, 382 drawings and 105 watercolours, totalling 4,654 works, which they list and reproduce. Renoir's most important paintings are on permanent exhibition in museums throughout the world where they can be enjoyed either in person or on each museum's website.

The largest collection of Renoir's paintings is in the Barnes Foundation, in Philadelphia, Pennsylvania, with 181 Renoir paintings, always on view. The second most numerous collection of Renoirs is the Clark Art Institute, in Williamstown, Massachusetts, with 32 Renoirs, always on view. In addition, in most major galleries across the world, paintings by Renoir are on display. The following key museums own several Renoirs, listed with one of their popular Renoir paintings:

Baltimore, Museum of Art: *Washerwomen*
Basel, Kunstmuseum: *Lise with a Seagull Feather*
Berlin, Nationalgalerie: *Lise: Summer*
Boston, Museum of Fine Arts: *Dance at Bougival*
Buffalo, NY, Albright-Knox Art Gallery: *Mme Thurneyssen and her Daughter*
Cagnes-sur-Mer, Musée Renoir 'Les Collettes': *The Farm at Les Collettes*
Cambridge, UK, Fitzwilliam Museum: *High Wind*
Cambridge, Mass., Fogg Art Museum: study for *The Large Bathers*
Cardiff, Wales, National Museum: *The Parisienne*
Chicago, Art Institute: *Two Sisters (On the Terrace)*
Cleveland, OH, Museum of Art: *Mlle Romaine Lacaux*
Cologne, Wallraf-Richartz Museum: *Lise and Sisley*
Columbus, OH, Museum of Fine Arts: *Mme Henriot impersonating a Boy*
Detroit, Institute of Arts: *Jean Renoir as the White Pierrot* (or *The White Clown*)
Dresden, Staatliche Kunstsammlungen: *Captain Edouard Bernier*
Hamburg, Kunsthalle: *Riding in the Bois de Boulogne*
Hartford, CT, Wadsworth Atheneum: *Mme Aline Renoir (with her dog Bob)*
Hiroshima Museum of Art: *Judgment of Paris*
Houston, Museum of Fine Arts: *Still Life with Bouquet*
Kansas City, Nelson-Atkins Museum of Art: *Paul Haviland*
London, Courtauld Institute: *The Loge*
 National Gallery: *The Umbrellas*
 Tate: *Venus Victorious* (statue)

Los Angeles, County Museum of Art: *Jean Renoir as a Huntsman*
Malibu, J. Paul Getty Museum: *Albert Cahen d'Anvers*
Moscow, Museum of Western Art: *Étienne Goujon*
 Pushkin Museum: *Head of the Actress Jeanne Samary*
New Haven, CT, Yale University Art Gallery: *Mont Ste-Victoire*
New York, Frick Collection: *La Promenade*
 Solomon R. Guggenheim Museum: *Woman with Parrot*
 Metropolitan Museum of Art: *Mme Charpentier and her Children*
Norfolk, VA, Chrysler Museum of Art: *The Daughters of Paul Durand-Ruel*
Northampton, Mass., Smith College Museum of Art: *Rapha Maître*
Omaha, Nebr., Joslyn Art Museum: *Piano Lesson*
Otterlo, Kroller-Müller Rijksmuseum: *At the Café*
Ottawa, National Gallery of Canada: *Claude and Renée*
Paris, Musée d'Orsay: *Dancing at the Moulin de la Galette*
 Musée Marmottan: *Claude Monet Reading*
 Musée de l'Orangerie: *Coco Renoir: The Clown*
Pasadena, CA, Norton Simon Museum: *Woman with Yellow Hat*
Philadelphia, PA, Museum of Art: *The Large Bathers*
Pittsburgh, Carnegie Museum of Art: *Garden in the rue Cortot, Montmartre*
Portland, OR, Art Museum: *The Seine at Argenteuil*
Prague, National Gallery: *The Lovers*
Providence, Rhode Island School of Design: *Young Woman reading an Illustrated Journal*
Richmond, Virginia Museum of Fine Arts: *Jean Renoir drawing*
St. Louis, Art Museum: *The Artist's Father, Léonard Renoir*
St. Petersburg, FL, Museum of Fine Arts: *Nursing* (or *Aline and her Son Pierre*)
St Petersburg, State Hermitage Museum: *Portrait of the Actress Jeanne Samary*
San Francisco, Fine Arts Museums: *Algerian Woman*
São Paulo, Museum of Art: *Rose and Blue: Mlles Cahen d'Anvers*
Stockholm, Nationalmuseum: *The Inn of Mother Anthony, Marlotte*
Tokyo, National Museum of Western Art: *Parisians dressed as Algerians*
 Bridgestone Museum of Art: *Mlle Georgette Charpentier*
Toronto, Art Gallery of Ontario: *The Concert*
Vienna, Kunsthistorisches Museum: *Bather*
Washington, DC, National Gallery of Art: *The Oarsmen at Chatou*
 Phillips Collection: *Luncheon of the Boating Party*
West Palm Beach, FL, Norton Museum of Art: *M. Germain*
Winterthur, Switzerland, Collection Oskar Reinhart: *Victor Chocquet*

NOTES

Many of the previously published letters and reviews cited have been newly translated from the original French sources, which are listed in the Notes and Bibliography. Mistakes in Renoir's spelling and punctuation have generally been corrected. All dates and locations in the text and notes are as Renoir or other writers gave them. Bracketed dates or locations are inferred from a letter's content or are deduced from the similarity of the letter to other correspondence. Shortened forms are used in most references; complete information about each source is given in the Bibliography. If a review appears only once, it is cited in full in the Notes and is not in the Bibliography. On names: during Renoir's lifetime, artists were called by their last names, thus Pierre-Auguste Renoir was called Renoir by his friends and later by his wife and sons. Similarly, his friends were called Monet, Cézanne, etc. Women artists were also called by their last names preceded by a title, e.g. Mlle Morisot and Mlle Cassatt. Women who were not artists, like Renoir's wife, were called by their first names, e.g. Aline and Gabrielle.

Introduction

1 Jean Renoir, *Renoir, My Father*, intro. Robert L. Herbert, 2001.

2 *Ibid.*, n.p. [p. v].

3 *Ibid.*, n.p. [pp. xii–xiii].

4 See Ch. 1; Gélineau, *Renoir O Pintor da Vida*, pp. 223–7; see Bibliography for his other publications.

5 Respectively, White, 'An analysis of Renoir's Development from 1877 to 1887'; *Impressionism in Perspective*; *Renoir: His Life, Art, and Letters*; *Impressionists Side by Side*; 'Renoir et Jean, 1894–1919'; 'Renoir's Trip to Italy'; 'The *Bathers* of 1887 and Renoir's Anti-Impressionism'; and others.

6 Dauberville and Dauberville, *Renoir:*

catalogue raisonné des tableaux, pastels, dessins et aquarelles, hereafter Dauberville.

7 E.g., my *Renoir: His Life, Art, and Letters* was purchased by 1,254 libraries in 18 different countries across North America, Europe, the Middle East, Australasia and the Far East.

8 Guillaume Apollinaire, 'Dans petits pots...', *Paris-Journal*, 23 July 1914, in *Apollinaire on Art*, p. 425.

9 Many of these letters were published in 1984 in Cassatt, *Cassatt and Her Circle: Selected Letters*.

10 Such as the Musée des Lettres et Manuscrits, Paris.

11 Pissarro to his son Lucien, Eragny, 23 February 1887, in *Correspondance de Camille Pissarro*, vol. 2, p. 131.

12 Unpublished, Renoir to Maurice Gangnat, Cagnes, 24 March 1907, private collection.

13 Mme Émile Blanche (Félicie Blanche) to Dr Blanche, Dieppe, *c.* 20 July 1881, in Blanche, *La Pêche aux souvenirs*, pp. 444–5.

14 Renoir to Jeanne, Bourbonne-les-Bains, n.d. [August 1908], in Gélineau, *Jeanne Tréhot, la fille cachée de Pierre Auguste Renoir*, pp. 49–50, 52–3 (repro. of letter).

15 See White, 'Renoir et Jean, 1894–1919'.

16 Renoir to André, Cagnes, 2 January 1910, in White, *Renoir*, p. 245.

17 Unpublished, Renoir to artist [Congé?], n.l., 1 February 1896, in Los Angeles, Getty Research Institute.

18 Sacha Guitry, documentary video of Renoir painting, 1915, available on www.youtube.com/watch?v=qHOeN7HXj3k, accessed 1 December 2016.

19 Unpublished, André to Paul Durand-Ruel, Cagnes, 24 December 1917, in Paris, Archives Durand-Ruel.

20 Theo van Rijsselberghe to his wife, Nice, 21 August 1918, in Paris, Librairie Les Argonautes, letter no. 134.

21 Unpublished, Georges Rivière to Renoir, Paris, 21 December 1913, private collection.

22 Herbert, *Renoir's Writings on the Decorative Arts*, p. 20.

23 Renoir, 'L'Art décoratif et contemporain'.

24 Renoir, 'La Société des Irrégularistes'; see also Herbert, *Renoir's Writings on the Decorative Arts*, p. 19.

25 Renoir, 'Lettre d'Auguste Renoir à Henry Mottez'; see also Herbert, *Renoir's Writings on the Decorative Arts*, p. 47.

26 Herbert, *Renoir's Writings on the Decorative Arts*, p. 49

27 See e.g. Jean Renoir, *Renoir My Father*, *passim*.

28 See Herbert, *Renoir's Writings on the Decorative Arts*, pp. xi–xii; further discussion throughout this book. Between my 1984 Renoir book and this 2017 book, I have changed my mind and no longer feel that Renoir should be labelled an 'anti-Semite'.

29 Bailey, *Renoir's Portraits*, p. 106.

30 'Women's Suffrage', http://teacher. scholastic.com/activities/suffrage/history. htm, accessed 1 December 2016.

31 Julie Manet, *Growing Up with the Impressionists*, entry of 14 September 1898, p. 145; French edn, *Journal*, p. 188.

32 See White, *Impressionists Side by Side*, 'Morisot and Renoir', pp. 212–57.

33 Renoir to Durand-Ruel, n.l. [L'Estaque], n.d. [26 February 1882], in Venturi, *Les Archives de l'impressionnisme*, vol. 1, p. 122.

34 White, *Impressionists Side by Side*, p. 217.

35 Renoir to [Philippe Burty], Cagnes, 8 April 1888, in White, *Renoir: His Life, Art, and Letters*, p. 202.

36 See Herbert, *Renoir's Writings on the Decorative Arts*, pp. xii–xiii.

Chapter 1 1841–77

1 A group portrait, *Forty-Three Painters in Gleyre's Atelier*, in Bailey, *Renoir's Portraits*, pp. 88–9, pl. 1, shows Renoir in profile to the right, fourth row down and third person from left.

2 Kropmanns, 'Renoir's Friendships' in *Renoir: Between Bohemia and Bourgeoisie*, p. 242.

3 Renoir, *Écrits et propos sur l'art*, p. 271.

4 Edmond Maître quoted by Blanche to his father, Dr Émile Blanche, Dieppe, 15 August 1882, in Blanche, *Pêche aux souvenirs*, p. 441.

5 Hugon, 'Les Aïeux de Renoir et sa maison natale', p. 454.

6 Different versions of the family's last name, 'Renouard', 'Reynouard' and 'Renoir', are found in the artist's rental agreements, school registrations and friends' letters until he was close to fifty and well known. See Félicie Blanche to her husband, Dr Émile Blanche, Dieppe, 18 September 1879, in Blanche, *La Pêche aux souvenirs*, pp. 440–41, where it is spelt 'Renouard'.

7 For a portrait of Renoir's father see Dauberville, vol. 1, pl. 531. Pierre Renoir sold the portrait to Vollard in 1917 for 12,000 francs. For Léonard see Hugon, 'Les Aïeux de Renoir', p. 454.

8 For a portrait of Renoir's mother see Dauberville, vol. 1, pl. 324.

9 For a portrait of Pierre-Henri see *ibid.*, pl. 533. Renoir painted Marie-Elisa in 1866; *ibid.*, pl. 426. Like her mother, Lisa became a dressmaker. In 1864, she married Charles Leray, an embroidery designer; his brother was a painter who exhibited at the Salon between 1844 and 1879; see Patry, 'Renoir's Early Career: From Artisan to Painter', pp. 55–6. No known portrait of Victor exists. He became a tailor like his father and married Eugénie Mallet, a dressmaker. Like other French tailors, Victor went to work for a while in St Petersburg, Russia.

10 For the birth certificate see Hugon, 'Les Aïeux de Renoir', p. 454.

11 Anne Régnier, his father's mother, stayed in Limoges with her other children and died on 23 April 1857.

12 Patry, 'Renoir's Early Career', p. 55. The Paris population in 1841 was 935,261.

13 For the Temple de l'Oratoire see Robert McDonald Parker, 'Topographical Chronology', in Bailey, *Renoir Landscapes, 1865–1883*, p. 269. For the rue de la Bibliothèque see Bailey, *Renoir's Portraits*, p. 104.

14 Jean Renoir, *Renoir*, 1962, p. 147; 1981, p. 160.

15 Baron Georges-Eugène Haussmann (1809–91) was commissioned to renovate Paris by Emperor Napoleon III. His reforms spanned 1852 until the end of the century. Renoir later, in his writings on art, expressed dislike of the new Paris, which he felt was created more by machines than by craftsmen. See Herbert, *Renoir's Writings on the Decorative Arts*, pp. 1–4.

16 Archive cited in Bailey, *Renoir's Portraits*, p. 272 n. 7.

17 The average daily earnings for a Parisian tailor *c*. 1850 were 3.6 francs, which was 20 centimes less than the average for Parisian workers. See Patry, 'Renoir's Early Career', p. 55.

18 Bailey, *Renoir's Portraits*, p. 106: '[Jean] Renoir's testimony remains valuable, not least in the suggestion that his aunt Blanche, of whom the artist [Renoir] left such a sympathetic portrait, was Jewish.' See also Bailey, 'Renoir's Portrait of his Sister-in-Law', p. 686.

19 For the English edn see Stephanie Manthey, 'Chronology', in *Renoir: Between Bohemia and Bourgeoisie*, p. 276. [Pierre-Henri Renoir], *Collection complète de chiffres et monogrammes*, 1863, designed and engraved by H. Renoir, pupil of S. Daniel, engraver, 58 rue Neuve St-Augustin, Paris, Bibliothèque Nationale de France, Département des Estampes et de la Photographie; Patry, 'Renoir's Early Career', p. 72, fig. 14.

20 Bailey, *Renoir's Portraits*, p. 272 nn. 7, 12.

21 Patry, 'Renoir's Early Career', p. 57.

22 *Ibid.*, p. 56. To give some idea of US dollar values during Renoir's life, 1 franc in 1850 equalled $3.23 in 2013 dollars, in 1860 $2.54, in 1900 $3.03, in 1910 $3.44, in 1914 $2.82 and in 1920 $0.82.

23 *Ibid.*, p. 57.

24 Paintings by Watteau, Fragonard and Boucher were acquired by the Louvre in 1849, 1852 and 1855. Manthey, 'Chronology', p. 276.

25 Patry, 'Renoir's Early Career', p. 58; for two vases see p. 72, fig. 15.

26 Dauberville, vol. 1, pl. 654. An 1858 drawing was in the collection of Renoir's nephew Edmond Renoir Jr.

27 Patry, 'Renoir's Early Career', p. 58; for one of the chandeliers and drawings see *ibid.*, figs 17–20.

28 *Ibid.*, p. 61. See also Didot-Bottin, *Annuaire-Almanach du commerce*, 1859.

29 Bailey, *Renoir's Portraits*, p. 91; Parker, 'Topographical Chronology', p. 269.

30 Manthey, 'Chronology', p. 276.

31 *Hector and Paris*, collection of Edmond Renoir Jr, see Paris, Musée d'Orsay, Documentation; *Venus and Cupid*, Dauberville, vol. 1, pl. 584; *Homer with Shepherds*, 54.6 x 21.5 cm (21½ x 8½ in.), *ibid.*, pl. 655; *Bacchanale*, 21.5 x 29.2 cm (8½ x 11½ in.), Paris, Musée d'Orsay, Documentation.

32 Dauberville, vol. 1, pls 226, 246.

33 Edmond Renoir, 'Cinquième Exposition de "La Vie Moderne"', p. 335.

34 Le Coeur, *Edmond Renoir, Pierre Auguste Renoir*, p. 22 n. 5.

35 Dauberville, vol. 1, pl. 324

36 Parker, 'Topographical Chronology', p. 269.

37 Bailey, *Renoir's Portraits*, p. 88. When he was admitted to the École des Beaux-Arts, Renoir gave his home address as 29 place Dauphine, 1st arrondissement, home of his friend Laporte; Parker, 'Topographical Chronology', p. 269.

38 We know the reactions of his professors only through Renoir's own words; Moncade, 'Le Peintre Renoir et le Salon d'Automne', repr. in Renoir, *Écrits, entretiens et lettres*, pp. 9–10, trans. in White, *Impressionism in Perspective*, pp. 23, 24.

39 Parker, 'Topographical Chronology', p. 269.

40 Renoir, recorded in the diary of Jacques-Félix Schnerb, aged 30, on 27 June 1909, cited in Renoir, *Écrits et propos sur l'art*, p. 237.

41 Renoir to [Paul] Durand-Ruel, n.l. [Algiers], n.d. [March 1882], in *Correspondance de Renoir et Durand-Ruel*, vol. 1, p. 11 (while Caroline Durand-Ruel Godfroy, the editor, dates this letter March 1881, its content makes March 1882 more likely).

42 Salon of 1863, rejected; 1864 and 1865, accepted. In 1866, one work was accepted and one rejected, but Renoir withdrew the accepted work before the show. 1867,

rejected; 1868, 1869 and 1870, accepted; 1872, rejected; 1873, rejected, so he exhibited at the 1873 Salon des Refusés. Renoir also exhibited at the Salons of 1878, 1879, 1881 and 1890.

43 Moncade, 'Le Peintre Renoir', p. 9.

44 Gurley, 'Renoir a beaucoup puisé chez Manet', pp. 132–9.

45 White, *Renoir: His Life, Art, and Letters*, p. 32.

46 Dauberville, vol. 1, pl. 283; Émile Zola, *L'Événement illustré*, 24 May 1868, in Venturi, *Archives de l'impressionnisme*, vol. 2, p. 276.

47 White, *Renoir: His Life, Art, and Letters*, pp. 26–8.

48 Édouard Manet to Albert Wolff, 19 March [1877], in Wilson-Bareau, *Manet by Himself*, p. 181; French edn, *Manet par lui-même*, p. 181.

49 Renoir to Manet, Capri, 28 December 1881, in White, 'Renoir's Trip to Italy', p. 348.

50 Unpublished, Manet to Renoir, 30 December 1881, private collection.

51 Bailey, *Renoir's Portraits*, p. 5.

52 Dauberville, vol. 1, pls 526, 451, respectively.

53 *Ibid.*, pls 525, 524, respectively. The portrait was in Sisley's studio at his death and was inherited by his daughter. William Sisley was a merchant who traded in luxury goods.

54 Bailey, *Renoir's Portraits*, p. 267, fig. 104; compared to the painting, p. 93.

55 Renoir quoted in Julie Manet, *Growing Up with the Impressionists*, entry of 11 October 1897, p. 113; French edn, *Journal*, p. 134.

56 Renoir to Bazille, Porte Maillot, 3 July 1865, in Renoir, *Écrits, entretiens et lettres*, p. 112.

57 Bazille to his parents, n.l., n.d., in Poulain, *Bazille et ses amis*, p. 101.

58 Note from Bazille's father in François-Bernard Michel, *Bazille, 1841–1870: Réflexions sur la peinture* (Paris, 1992), cited in Kropmanns, 'Renoir's Friendships', p. 249 n. 19.

59 Unpublished, Renoir to Bazille, n.l., n.d., private collection.

60 Dauberville, vol. 1, pl. 283.

61 Bazille to his parents, n.l. [Paris], spring 1867, in Marandel and Daulte, *Frédéric Bazille and Early Impressionism*, p. 175 n. 63.

62 Bazille to his parents, n.l. [Paris], n.d. [February 1867], in Poulain, *Bazille et ses amis*, p. 114.

63 Renoir cited in Pach, 'Pierre-Auguste Renoir', p. 614.

64 'Claude Monet parle de Renoir', *Bulletin de la vie artistique* (1 January 1920), p. 87.

65 Girard, *Renoir et Albert André, une amitié*, p. 53.

66 On Monet and Renoir see White, *Impressionists Side by Side*, pp. 56–105.

67 Claude Monet to Camille Pissarro, Argenteuil, 12 September 1873, in Wildenstein, *Claude Monet: biographie et catalogue raisonné*, vol. 1, p. 429.

68 Monet to Bazille, Saint-Michel, 9 August 1869, in *ibid.*, p. 426.

69 Renoir to Bazille, Louveciennes, n.d. [September 1869], in Poulain, *Bazille et ses amis*, p. 155.

70 Dauberville, vol. 1, pls 113–16.

71 Monet to Bazille, n.l. [Saint-Michel], 25 September 1869, in Wildenstein, *Monet: biographie*, vol. 1, p. 427.

72 For Monet's and Renoir's side-by-side paintings, as well as Renoir's portraits of the Monets, see White, *Impressionists Side by Side*, pp. 60–105.

73 *Charles Le Coeur*, p. 26.

74 *Ibid.*, pp. 196–7.

75 Jules Le Coeur to his mother, n.l., 24 August 1863, in *ibid.*, p. 217 n. 7.

76 Auguste Rousselin (1841–1916); *ibid.*, p. 225.

77 *Ibid.*, p. 206.

78 Marie Le Coeur Fouqué to Fernand Fouqué, n.l., 22 March 1865, in *ibid.*, p. 31 n. 6.

79 Parker, 'Topographical Chronology', p. 270.

80 Marie Le Coeur to unknown person, n.l., 29 March 1866, in *Cahiers d'aujourd'hui* (January 1921), n.p.

81 Dauberville, vol. 1, pls 21, 22, 49, 284, 311.

82 Fernand Fouqué to Félicie Le Coeur, n.l., 1 April 1866, in *Charles Le Coeur*, p. 26.

83 Jules Le Coeur to his mother, n.l., n.d., in Cooper, 'Renoir, Lise and the Le Coeur Family', p. 164.

84 Dauberville, vol. 1, pl. 78.

85 Cooper, 'Renoir, Lise and the Le Coeur Family', p. 172, pl. 20.

86 Dauberville, vol. 1, pls 560, 346, 532, 491, 492 561, 514, respectively. For the portrait of Charles's wife and the bust of Charles see Daulte, *Auguste Renoir: catalogue raisonné*, pls 63, 100.

87 Dauberville, vol. 1, pls 675, 676.

88 Patry, 'Renoir's Early Career', p. 75, pl. 24.

89 Parker, 'Topographical Chronology', p. 273.

90 *Ibid.*, p. 270.

91 Marie Fouqué to unknown person, n.l., 19 March 1866, in *Cahiers d'aujourd'hui* (January 1921), n.p.

92 See the photograph of Jules Le Coeur, 1865, in Bailey, *Renoir's Portraits*, p. 270, fig. 107.

93 See Renoir's *Jules Le Coeur and his Dogs walking in Fontainebleau Forest*, 1866, in Dauberville, vol. 1, pl. 78.

94 Since Jules Le Coeur wrote Mathieu Tréhot a letter on 8 December 1864, he could have met the Tréhot sisters in 1864.

95 Dauberville, vol. 1, pls 395, 673.

96 *Ibid.*, pls 396, 413, 286. Around two years later, their eleven-year-old brother, Louis-Félix Tréhot, modelled for *Boy with Cat*, 1868–9; *ibid.*, pl. 559.

97 *Ibid.*, pls 578, 283, 410, 293, 596, 576, respectively. *Lise with an Umbrella* and *The Bohemian* were accepted to the Salon the year after their creation. All the other paintings were submitted to the Salon of the year they were created.

98 *Ibid.*, pl. 256.

99 Renoir to Bazille, n.l., n.d. [September or October 1869], in Poulain, *Bazille et ses amis*, p. 156.

100 Bailey, *Renoir's Portraits*, p. 104.

101 *Ibid.*, p. 17.

102 Dauberville, vol. 1, pl. 257.

103 Renoir to Bazille, n.l., *c.* October 1869, in Poulain, *Bazille et ses amis*, p. 155.

104 Daulte, *Frédéric Bazille*, pls 46, 44, 45, 50, 55, respectively.

105 Dauberville, vol. 1, pl. 593.

106 Bailey, *Renoir's Portraits*, p. 92. Marie Lescouezec was also a florist.

107 Monet married Camille in 1870; Sisley did not marry Marie until 1897. Other artist friends did similarly: Cézanne recognized Paul Cézanne Jr in 1872 and married Hortense Fiquet in 1886; Pissarro recognized Lucien Pissarro in 1863 and married Julie Vellay in 1870. In contrast, Berthe Morisot married Eugène Manet in 1874 and had their daughter Julie four years later.

108 Le Coeur, 'Le Peintre, son premier modèle et ses premiers amateurs', p. 204.

109 Renoir to Bazille, Ville-d'Avray, late August 1868, in Poulain, *Bazille et ses amis*, pp. 153–4.

110 Bailey, *Renoir's Portraits*, p. 103.

111 Gélineau, 'Jeanne, fille d'Auguste Renoir', pp. 223–7.

112 Le Coeur, *Renoir au temps de la bohème*, pp. 81–2.

113 Le Coeur, 'Le Peintre, son premier modèle', p. 204; she also gave a false residence, Fontainebleau.

114 Le Coeur, *Renoir au temps de la bohème*, p. 83, for Clémence's acknowledgment on 4 December 1878. Françoise died at her mother's home in 1894.

115 Le Coeur, 'Le Peintre, son premier modèle', p. 205.

116 Lise Tréhot's grandchildren remember calling their aunt Clémence 'Tante Le Coeur', in *ibid.*, p. 223 n. 147.

117 Le Coeur, *Renoir au temps de la bohème*, p. 82.

118 See the excellent Fuchs, *Abandoned Children*.

119 Le Coeur, *Renoir au temps de la bohème*, p. 83.

120 Bazille to Maître, n.l. [Méric], 2 August 1870, in Gélineau, *Jeanne Tréhot, la fille cachée*, p. 18.

121 Le Coeur, *Renoir au temps de la bohème*, pp. 83, 82, respectively.

122 Gélineau, *Jeanne Tréhot, la fille cachée*, p. 19.

123 *Ibid.*, p. 21.

124 Fuchs, *Abandoned Children*, p. 196.

125 Renoir to Jeanne, Bourbonne-les-Bains, n.d. August 1908 [repro. in Gélineau, *Jeanne Tréhot, la fille cachée*, pp. 52–3].

126 Alain Renoir, personal communication with the author; he also said that Jean Slade, the son of Renoir's model, Gabrielle, was never told about Jeanne.

127 Camille Pissarro to his son Lucien, Eragny, 23 February 1887, in *Correspondance de Camille Pissarro*, vol. 2, p. 131.

128 The Blanchet grocery was on the corner of rue Ramey and rue Custine and situated next to rue Caulaincourt and rue Girardon where, coincidentally, Renoir would move twenty years later.

129 Marie-Désirée Gautier, Mme Blanchet, was probably related to Augustine and François's friends, Alphonse Gautier and Louise Gautier, who became Jeanne's friends.

130 Gélineau, *Jeanne Tréhot, la fille cachée*, p. 27 n. 9.

131 Fuchs, *Abandoned Children*, p. 241. The state also paid to educate all children through those years.

132 Unpublished, Jeanne Tréhot Robinet to Ambroise Vollard, Madré, 1 May 1917, Paris, Bibliothèque des Musées Nationaux du Fonds Vollard, Ms. 421 on microfilm.

133 Gélineau, *Jeanne Tréhot, la fille cachée*, p. 23.

134 *Ibid.*, pp. 22, 23, 24. In Ste-Marguerite-de-Carrouges, a religious community of nuns worked together to educate young girls.

135 *Ibid.*, 13 June 1885, 24 November 1885, 2 February 1893, p. 24.

136 *Ibid.*, p. 26.

137 For his portrait of his sister, 1866, see Dauberville, vol. 1, pl. 426, later acquired by Vollard.

138 See *ibid.*, pl. 531. Two years before the painter's death, Pierre Renoir sold Vollard this portrait of his grandfather for 12,000 francs; Bailey, *Renoir's Portraits*, p. 271, pl. 6.

139 For the portrait of Pierre-Henri see Dauberville, vol. 1, pl. 533. Two years before the painter's death, Pierre Renoir also sold Vollard this portrait of his uncle. See also Bailey, *Renoir's Portraits*, p. 106; for Blanche's portrait see p. 272, fig. 115. Thirteen years before Renoir's

death, Durand-Ruel acquired this portrait of Mme Pierre-Henri Renoir. See Bailey, 'Renoir's Portrait of his Sister-in-Law', pp. 684–7.

140 Unpublished military record book, 26 August 1870, 1 October–21 December 1862, 5 January–5 March 1864, 10e Régiment de Chasseurs, Libourne, private collection.

141 Envelope postmarked 28 October 1870, cited in Bailey, *Renoir's Portraits*, p. 274 n. 1.

142 Maître and Renoir to Bazille, [Paris], n.d. [summer 1870], in Poulain, *Bazille et ses amis*, p. 184.

143 Maitre to his father, n.l., February 1871, in Bailey, *Renoir's Portraits*, p. 275 n. 20.

144 Bazille's father cited in Kropmanns, 'Renoir's Friendships', pp. 248–9 n. 19; French in Michel, *Bazille*, p. 302.

145 Bailey, *Renoir's Portraits*, p. 270.

146 Monneret, *L'Impressionnisme et son époque*, vol. 1, p. 163; vol. 2, p. 20.

147 *Ibid.*, vol. 1, p. 119.

148 Renoir to Charles Le Coeur, Vic-en-Bigorre, 1 March 1871, in Cooper, 'Renoir, Lise and the Le Coeur Family', p. 327.

149 French forces numbered 909,951 men (492,585 active soldiers and 417,366 in the reserves). See Wawro, *The Franco-Prussian War*; Howard, *The Franco-Prussian War*.

150 Then, from 1873 to 1881, Renoir's annual rent at 35 rue Saint-Georges in the 9th arr. was 900 francs; Bailey, *Renoir's Portraits*, p. 48 n. 134. See also Archives de Paris, Appartement Archives.

151 Maître to his father, Paris, June 1871, in Bailey, *Renoir's Portraits*, p. 275 n. 17.

152 Dauberville, vol. 1, pls 534, 326, 452, 362, respectively, the last also Bailey, *Renoir Portraits*, p. 276, fig. 123.

153 Bailey, *Renoir's Portraits*, p. 275 n. 15.

154 Rapha holds the same fan that Renoir would soon put into a still life that included Manet's print, *The Cavaliers*; see *ibid.*, p. 276, fig. 124.

155 Renoir to Paul Durand-Ruel, Nice, 23 March 1912, in *Correspondance de Renoir et Durand-Ruel*, vol. 2, p. 99.

156 Dauberville, vol. 1, pl. 413.

157 Ibid., pl. 396.
158 Le Coeur, 'Le Peintre, son premier modèle', p. 214.
159 Ibid., p. 222 nn. 138, 141.
160 Ibid., p. 223, nn. 154, 155.
161 Dauberville, vol. 1, pls 346, 514.
162 Marie Le Coeur cited in Le Coeur, 'Le Peintre, son premier modèle', p. 215.
163 Ernest Guérin to his cousin Louise Le Coeur, n.l., 19 January 1875, in Charles Le Coeur, p. 32 n. 21.
164 Ibid., pl. 211.
165 Edmond Renoir, article in La Vie moderne 11 (19 June 1879), repr. in Venturi, Archives de l'impressionnisme, vol. 2, pp. 336–7.
166 Dauberville, vol. 1, pls 262, 209, 211, 213, 214, respectively.
167 Jean Renoir, Renoir, My Father, p. 334. Gabrielle, who was a neighbour of Jean Renoir during the time he wrote the book, said that she and other female models posed as the young male shepherd Paris in the Judgment of Paris, 1913, Dauberville, vol. 5, pl. 4278; see pp. 247, 287.
168 Rivière, Renoir et ses amis.
169 Dauberville, vol. 1, pls 299, 370, 206, 419, respectively.
170 Bailey, Renoir's Portraits, p. 284 n. 26. Henriot sold it to Durand-Ruel for 400 francs in December 1881.
171 Dauberville, vol. 1, including pls 224, 381, 460, 461, 466, 644; see pls 434, 463 for the medallions.
172 Ibid., pl. 462.
173 Ibid., pls 462, 344, 435, 462, 468, respectively.
174 Caillebotte's will cited in Berhaut, Caillebotte, p. 281.
175 Dauberville, vol. 1, pls 603, 209, 295, respectively; Bords de la Seine à Champrosay, pl. 138; Le Pont de chemin de fer à Chatou, pl. 192; La Place Saint-Georges, Paris; Soleil couchant à Montmartre (the last two not reproduced in Dauberville).
176 Berhaut, Caillebotte, p. 281.
177 Dauberville, vol. 1, pls 111, 26, respectively.
178 White and White, Canvases and Careers, pp. 124–61.
179 For works by Cézanne in Renoir's collection see Venturi, Cézanne, son art, son oeuvre, vol. 1: in oil, Thatched Cottages in Auvers, 1872–3, pl. 135; Landscape, 1879–82, pl. 308; Struggle of Love, c. 1875–6, pl. 380; Turning Road at La Roche-Guyon, 1885, pl. 441; in watercolour, Nude Bathers, 1882–94, pl. 902; for Carafe et Bol, 1879–82, s ee Cézanne Watercolors, pl. V.
180 See Cameron, France and the Economic Development of Europe, 1800–1914.
181 Rewald, The History of Impressionism, p. 394.
182 Moncade, 'Le Peintre Renoir', p. 9.
183 Dauberville, vol. 1, pl. 493; Leroy, Le Charivari, 25 April 1874, in White, Renoir: His Life, Art, and Letters, p. 51.
184 Dauberville, vol. 1, pl. 262.
185 Zola quoted in Bailey, Renoir's Portraits, p. 17 n. 159.
186 Dauberville, vol. 1, pl. 209.
187 Albert Wolff, review, Le Figaro, 3 April 1876, repr. in White, Renoir: His Life, Art, and Letters, p. 58.
188 Armand Guillaumin to Dr Gachet, Paris, 24 February 1877, in Gachet, Lettres impressionnistes, pp. 72–3.
189 Dauberville, vol. 1, pl. 233. Eugène Murer (on whom see nn. 206, 211,/5 below) acquired this work.
190 That year, 1877, Renoir painted a profile portrait of Rivière's head; ibid., pl. 546.
191 'G.R.', L'Impressionniste 1, repr. in Venturi, Archives de l'impressionnisme, vol. 2, p. 307.
192 Ibid., pp. 308–14.
193 L'Impressionniste 2, repr. in ibid., pp. 315–21.
194 Ibid., pp. 308, 309.
195 Rivière, L'Impressionniste, 21 April 1877, in ibid., p. 322.
196 Renoir, '[Letter to the director of L'Impressionniste: Journal d'Art]'; Renoir, '[Contemporary Decorative Art]', both in ibid., pp. 321–2, 326–9. For discussion of the identity of 'un peintre' see Herbert, Renoir's Writings on the Decorative Arts, pp. 93–9.
197 Rewald, History of Impressionism, p. 601.

198 'G. Rivière', article in *L'Impressionniste*, 'L'exposition des impressionnistes', repr. in Venturi, *Archives de l'impressionnisme*, vol. 2, pp. 315–17.
199 White, *Renoir: His Life, Art, and Letters*, p. 57.
200 Dauberville, vol. 1, pl. 617; White, *Renoir: His Life, Art, and Letters*, p. 102, c. 1880, oil on wood, location unknown.
201 *Ibid.*, p. 529.
202 Théodore Duret (1838–1927) was heir to the Duret cognac fortune. Japan had gone through a long period of isolation from 1635 to 1853, after which foreigners started entering the country.
203 Dauberville, vol. 1, pl. 410.
204 *Ibid.*, pl. 283.
205 Renoir to Duret, n.l., n.d. [1875], in 'Renoir et la famille Charpentier', p. 39; Renoir to Duret, n.l., 15 October 1878, in New York, Morgan Library & Museum, Adolphe Tabarant Collection.
206 Murer's real name was Hyacinthe Eugène Meunier. For his collection see Daulte, *Renoir: catalogue raisonné*, including 7 scenes of daily life: pls 84, 188, 193, 197, 225, 236, 273; 5 portraits: pls 117, 246, 247, 248, 249; 1 figure, pl. 165. Because of financial difficulties Murer sold his collection in 1890, most of it going to the dentist Dr Georges Viau.
207 Shikes and Harper, *Pissarro*, p. 136.
208 Dauberville, vol. 1, pls 576, 233, 274, 543, 273, 335, 207, 336, 96 respectively.
209 *Ibid.*, pls 547, 421, 422, 565.
210 Bailey, *Renoir's Portraits*, p. 17; see also p. 48 n. 156.
211 For Pissarro's *Eugène Murer*, 1878, Springfield Museum of Fine Arts, see Rewald, *History of Impressionism*, p. 414; for his *Marie Murer*, 1877, pastel, private collection, see p. 412.
212 Eugène Murer's notes c. 1877–8 quoted in Tabarant, *Pissarro*, p. 35.
213 One of Charpentier's three purchases was *Fisherman*; Dauberville, vol. 1, pl. 263.
214 *Ibid.*, pls 239, 465, 486, 499; see also Bailey, *Renoir's Portraits*, p. 296 n. 1, pp. 299–300; Robida, *Le Salon Charpentier et les impressionnistes*, pls XIV, XV.
215 Dauberville, vol. 1, pls 379, 544.
216 *Ibid.*, pls 636–8.
217 Robida, *Le Salon Charpentier*, pls X, XI.
218 See Renoir's letters to the Charpentiers in 'Renoir et la famille Charpentier', pp. 32ff.
219 *Ibid.*, p. 32; repro. in Gentner, *Album d'une vie: Pierre-Auguste Renoir*, n.p. [1875–77].
220 Daudet commissioned from Renoir a pastel portrait of his baby in 1875 and a painting of his wife in 1876; Dauberville, vol. 1, pls 605, 431.
221 Renoir's illustrations included *The Boches' Apartment* (*La Loge des Boches*), *Father Bru trampling in the Snow to feel warmer* (*Le père Bru piétinait dans la neige pour se réchauffer*), *Lantier and Gervaise spending a very Pleasant Evening at a Cabaret* (*Lantier et Gervaise passèrent une très agréable soirée au café-concert*).
222 Dauberville, vol. 1, pl. 677, a watercolour and pencil drawing, c. 1877.
223 *Ibid.*, pls 213, 433, 581, 635.
224 [Renoir], *L'Impressionniste*, 14 and 28 April 1877, in Venturi, *Archives de l'impressionnisme*, vol. 2, pp. 321–2, 326–9.
225 Dauberville, vol. 1, pl. 229.
226 *Ibid.*, pls 272, 461, 463; see also White, *Renoir: His Life, Art, and Letters*, pp. 78–9.
227 Renoir had painted a portrait of Legrand's daughter in 1875; Dauberville, vol. 1, pl. 495.
228 *Ibid.*, pl. 545.
229 Renoir to Georges Charpentier, n.l., n.d., in Renoir, 'Renoir et la famille Charpentier', pp. 32–4.
230 Renoir to Charpentier, n.l., n.d., *ibid.*, p. 34.

Chapter 2 1878–84

1 Dauberville, vol. 1, pl. 224; vol. 2, pls 1001, 999, 1000, respectively.
2 See Bailey, *Renoir's Portraits*, pp. 1–51, 'Portrait of the Artist as a Portrait Painter'.
3 Duret, *Les Peintres impressionnistes*, May 1878, showing Renoir's drawing, *Lise with a Parasol*, repro. in Duret, *Histoire des peintres impressionnistes*, pp. 27–8.

4 Pissarro to Caillebotte, Pontoise, n.d. [March 1878], in *Correspondance de Camille Pissarro*, vol. 1, p. 110.

5 Dauberville, vol. 1, pl. 406. Cézanne also submitted work to the 1878 Salon but was rejected, while Monet did not submit anything. Sisley followed Renoir's example at the Salon.

6 *Ibid.*, pl. 239.

7 According to Duret, as cited in Bailey, *Renoir's Portraits*, pp. 17, 48 n. 158. Thirty years later, the Metropolitan Museum bought it for 84,000 francs; see here Ch. 5, p. 230.

8 Renoir to Mme Charpentier, n.l., 30 November 1878, in Renoir, 'Renoir et la famille Charpentier', p. 35.

9 Renoir to Mme Charpentier, n.l., n.d., in *ibid.*

10 Dauberville, vol. 1, pl. 493; Distel, *Impressionism: The First Collectors*, p. 157.

11 See de Waal, *The Hare with Amber Eyes*, for the Ephrussi family.

12 Cézanne to Chocquet, L'Estaque, 7 February 1879, in Cézanne, *Paul Cézanne: Correspondance*, p. 181.

13 Venturi, *Archives de l'impressionnisme*, vol. 2, pp. 262–3.

14 Dauberville, vol. 1, pls 239, 381; Robida, *Le Salon Charpentier et les impressionnistes*, pl. XIV, respectively.

15 Renoir interviewed by C.-L. de Moncade, 'Le peintre Renoir et le Salon d'Automne', 15 October 1904, repr. in Renoir, *Écrits, entretiens et lettres*, p. 9.

16 Renoir to Mme Charpentier, n.l., n.d. and 30 November [1878], in 'Renoir et la famille Charpentier', pp. 32, 34, 35.

17 Renoir to Georges Charpentier, n.l., n.d. [*c*. June 1878], *ibid.*, p. 32.

18 Bailey, *Renoir's Portraits*, pp. 167, 298 n. 96.

19 Renoir to Caillebotte, n.l. [Paris], n.d. [May 1879], excerpt in Paris, Hôtel Drouot sale catalogue, 5 June 1991, no. IX.

20 Bailey, *Renoir's Portraits*, p. 297, nn. 51–4.

21 Pierre Dax, 'Chronique', *L'Artiste* (March 1879), cited in *ibid.*, n. 42.

22 Renoir to Mme Charpentier, n.l. [Paris], n.d. [1879], in 'Renoir et la famille Charpentier', p. 34.

23 Pissarro to Murer, Pontoise, 27 May 1879, in *Correspondance de Pissarro*, vol. 1, p. 133.

24 This could be the pastel of Mlle Samary, 1877, Dauberville, vol. 1, pl. 644.

25 Renoir to Mme Charpentier, n.l., n.d. [1879], in 'Renoir et la famille Charpentier', p. 34.

26 Renoir, *Acrobats of the Cirque Fernando*, 1878–79 (Angelina and Francisca Wartenberg), and sketches of 1879, Dauberville, vol. 1, pls 251, 636–8, respectively. See also Le Coeur, *Edmond Renoir, Pierre Auguste Renoir*, p. 7.

27 Edmond Renoir, *La Vie moderne* 11 (19 June 1879), repr. in Venturi, *Archives de l'impressionnisme*, vol. 2, pp. 337–8.

28 *Ibid.*, pp. 336–8.

29 Renoir to Mme Charpentier, n.l., *c*. 1879–80, in 'Renoir et la famille Charpentier', p. 35.

30 See Bailey, *Renoir, Impressionism, and Full-Length Painting*, pp. 146–8. See also Dauberville, vol. 2, pl. 1542.

31 Renoir, *Wagner*, 24 February 1883; *Country Dance*, 3 November 1883; *Couple in Street* for Lhôte's short story, *Un idéal*, 8 December 1883; one of Edmond reading and *Couple on a Hillside* for his story 'L'Étiquette', 15 December 1883; two of *The Dancer Rosita Mauri*, 22 December 1883; copy of Manet's *Fifer*, 12 January 1884; *Country Dance*, 26 January 1884. See Rewald, *Renoir Drawings*, pls 4, 5, 9–11, 17–20, 24, 27; see also Rewald, 'Auguste Renoir and his Brother', pp. 171–88.

32 Wildenstein, *Monet: or the Triumph of Impressionism*, vol. 1, pp. 158–9; *Lavacourt* was accepted and *Floating Ice* was rejected.

33 Dauberville, vol. 1, pls 215, 487, 605, 607, respectively. Durand-Ruel bought *Mussel Fishers at Berneval* for 2,500 francs in November 1880 and *Sleeping Girl with Cat* in January 1881 for 2,500; Bailey, *Renoir's Portraits*, p. 18.

34 Cézanne to Zola, n.l. [Paris], 4 July 1880, in Cézanne, *Paul Cézanne: Correspondance*, p. 194.

35 For Cézanne's copy see White, *Renoir: His Life, Art, and Letters*, p. 102.

36 At the Salon of 1879, he exhibited 4 portraits and received 14 commissions; at the Salon of 1880, he exhibited 2 and received 16 commissions; at the Salon of 1881, he exhibited 2 and received 8 commissions; at the Salon of 1882, he sent 1 and received 9 commissions; lastly, at the Salon of 1883, he sent 1 and received 5 commissions. See Dauberville, vols 1 and 2.

37 Distel, *Impressionism: The First Collectors*, p. 164.

38 See text and n. 10 above.

39 Dauberville, vol. 1, pl. 504.

40 Renoir to Caillebotte, n.l. [Paris], n.d. [June 1879]; excerpt in Hôtel Drouot sale catalogue, 5 June 1991, no. IX.

41 In 1879, he painted 9 portraits and 2 genre scenes; in 1880, 1 portrait; in 1881, 1 portrait; in 1883, 1 portrait; in 1884, 2 portraits and 1 genre.

42 Dauberville, vol. 1, pls 550, 240, 8, 10, respectively.

43 Painted at Wargemont for Durand-Ruel, *Peaches and Grapes*, 1881; *Landscape at Wargemont*, 1879; *Water Scene (The Wave)*, 1879; *Seaside at Wargemont*, 1880, *ibid.*, pls 46, 77, 152, 155, respectively.

44 Mme Blanche to Dr Émile Blanche, Dieppe, 18 September 1879, in Jacques-Émile Blanche, *La Pêche aux souvenirs*, pp. 440–41.

45 Dauberville, vol. 1, pls 241, 244, 245.

46 For the versions rejected by Blanche and sent to Durand-Ruel see *ibid.*, pls 242, 243.

47 Roberts, *Jacques-Émile Blanche*, p. 29, citing Jacques-Émile Blanche, *Propos de peinture: de David à Degas* (Paris: Émile-Paul Frères, 1919), pp. 237, 83.

48 Legrand's real name was Alma-Henriette Leboeuf. Bailey, *Renoir's Portraits*, p. 13.

49 Homeopathy is a form of treatment based on the idea of serial dilution to cause less potent symptoms in a healthy person. In its advent in the late nineteenth century it became popular because, unlike other medical techniques of the time, it would at least do no harm.

50 Renoir to Dr Gachet, 35 rue Saint-Georges [Paris], n.d. [January 1879], in Gachet, *Lettres impressionnistes*, pp. 81–2.

51 Renoir to Dr Gachet, n.l. [Paris], n.d. [January 1879], *ibid.*, p. 83.

52 Dr de Bellio, Le Comte Georges de Bellio, was a Romanian homeopathic doctor in Paris.

53 Renoir to Dr Gachet, Paris, January 1879, *ibid.*, p. 84.

54 Renoir to Dr Gachet, n.l. [Paris], n.d. [January 1879], *ibid.*, pp. 83–4. Later, Renoir gave Dr Gachet a profile portrait of Margot; Dauberville, vol. 1, pl. 337.

55 Renoir to Dr de Bellio, n.l. [Paris], n.d. [25 February 1879], *ibid.*, p. 85.

56 Essoyes census, fr.wikipedia.org, accessed 12 December 2016.

57 For letters of 1867–74 about Aline and one from Aline see Pharisien, *Les Célébrités d'Essoyes, ce village qui a conquis Renoir*, pp. 19–56.

58 See *ibid.*, p. 27. See also Pharisien and Chartrand, *Victor Charigot, son grand-père*.

59 Legal decision of 27 May 1862, in Pharisien, *Célébrités d'Essoyes*, p. 30.

60 Victor Charigot to Emilie Maire Charigot, Blythfield, 28 March 1884, in Pharisien, *Célébrités d'Essoyes*, pp. 34–7.

61 Victorine Charigot to Emilie Charigot, n.l. [Essoyes], 29 August 1870, in *ibid.*, p. 45.

62 Victorine Charigot to Emilie Charigot, n.l. [Essoyes], 24 October 1869, *ibid.*, p. 47.

63 *Ibid.*, pp. 49, 52.

64 Victorine Charigot to Emilie Charigot, n.l. [Essoyes], n.d., *ibid.*, p. 54.

65 See Julie Manet, *Journal*, p. 130.

66 Victorine Charigot to Emilie Charigot, n.l. [Essoyes], 24 October 1869, in Pharisien, *Célébrités d'Essoyes*, p. 47.

67 Victorine Charigot to Emilie Charigot, n.l. [Essoyes], n.d., in *ibid.*, p. 53.

68 Victorine Charigot to Emilie Charigot, n.l. [Essoyes], 1872, in *ibid.*, p. 55.

69 Victorine Charigot to Emilie Charigot, n.l. [Essoyes], n.d., in *ibid.*, p. 52.

70 Victorine Charigot to Emilie Charigot, n.l. [Essoyes], 29 May 1870, in *ibid.*, p. 53.

71 Victorine Charigot to Emilie Charigot, n.l. [Essoyes], n.d., in *ibid.*, p. 54.

72 Victorine Charigot to Emilie Charigot, n.l. [Essoyes], 29 May 1870, in *ibid.*, p. 53.

73 Victorine Charigot to Emilie Charigot,
n.l. [Essoyes], July 1868, in *ibid.*, p. 54.

74 Aline Charigot to Emilie Charigot, n.l.
[Essoyes], 10 July 1871, in *ibid.*, p. 48.

75 Victorine Charigot to Emilie Charigot,
n.l. [Essoyes], 4 August 1872, in *ibid.*, p. 55.

76 Victorine Charigot to Emilie Charigot,
n.l. [Essoyes], August 1872, in *ibid.*.

77 Victorine Charigot to Emilie Charigot, n.l.
[Essoyes], August 1874, in *ibid.*, pp. 55–6.

78 Charles Durand-Ruel to the author,
personal communication, 27 August
1981.

79 Julie Manet, *Growing Up with the
Impressionists*, entry of 19 September
1895, p. 67; French edn, *Journal*, p. 66.

80 Unpublished, Renoir to Aline, *c.*
September 1878, private collection.

81 *Renoir Personal Artifacts and Archives
Collection* contains Renoir's letters
to Aline.

82 Unpublished, Renoir to Aline, n.l., n.d.
[August–September 1882], private
collection.

83 Unpublished, Renoir to Aline,
[Mustapha] Algiers, *c.* 20 February 1881,
private collection.

84 Unpublished, Renoir to Aline, n.l., n.d.
[*c.* 1881], private collection.

85 Unpublished, Renoir to Aline, Dieppe,
n.d. [August–September 1882], private
collection.

86 Unpublished, Renoir to Aline, n.l.,
n.d. [*c.* 1883], private collection.

87 Unpublished, Renoir to Aline, n.l.,
n.d. [1880–85], private collection.

88 E.g., unpublished, Renoir to Aline, n.l.,
n.d. [1879–81], private collection.

89 Unpublished, Renoir to Aline, n.l.,
n.d. [*c.* 1879], private collection.

90 Unpublished, Renoir to Aline, n.l.,
n.d. [August 1881], private collection.

91 For the famous example of the *Judgment
of Paris*, 1908 (Dauberville, vol. 4,
pl. 3471), Renoir first used a male actor
and later his model Gabrielle to pose
for the figure of Paris.

92 *Ibid.*, vol. 1, pls 583, 224, 254,
respectively.

93 *Ibid.*, vol. 2, pl. 999.

94 For mothers and children, *ibid.*, vol. 1,
pls 215, 250, 254, 255; for nudes pls 590,

589, 582; vol. 2, pls 1295, 1296, 1323;
vol. 3, pl. 2493.

95 *Ibid.*, vol. 1, pl. 217.

96 For portraits of Alphonse Fournaise
and his daughter Alphonsine see *ibid.*,
pls 515, 321, 469, 472, respectively.

97 Renoir to Georges de Bellio, Chatou, n.d.
[*c.* 1881], excerpt in Paris, Librairie Henri
Saffroy, sale catalogue, n.d., no. 1314.

98 Dauberville, vol. 1, pl. 307.

99 Unpublished, Renoir to Aline, n.l.
[Dieppe], n.d. [August–September 1882],
private collection.

100 For the identities of these figures see
The New York Times, Sunday, 9 April
2006, p. 33.

101 Renoir to Paul Bérard, Chatou, n.d.
[September 1879], in 'Lettres de Renoir
à Paul Bérard', p. 3.

102 Unpublished, Renoir to Aline, n.l., n.d.
[August 1881], private collection.

103 Renoir to Paul Bérard, n.l. [Chatou],
n.d. [mid-September 1880], in 'Lettres
de Renoir à Paul Bérard', pp. 4–5.

104 Renoir had painted André Bérard
during the summer of 1879 dressed
in his school outfit and carrying books;
Dauberville, vol. 1, pl. 567.

105 Renoir to Duret, n.l., 13 February 1880,
in Braun, *L'Impressionnisme et quelques
précurseurs*, pp. 10–11.

106 Pissarro to Lucien Pissarro, n.l., 22
January 1899, in *Correspondance de
Camille Pissarro*, vol. 5, pp. 10–11.
Even though Renoir broke his right arm
again in September 1897 (see Ch. 4),
Pissarro was probably thinking of the
1880 break, both because they were
closer friends at that time and because
the quality and quantity of Renoir's
paintings after the 1880 break were
indeed astonishing.

107 Dauberville, vol. 1, pls 252, 487, 250, 485,
respectively; commissioned portraits: pls
342, 424, 472, 476, 506–8, 551, 568, 569.

108 *Mme Charpentier and her Children* is
153.7 x 190.2 cm (60½ x 75 in.).

109 Unpublished, Renoir to Aline, Algiers,
n.d. [*c.* 15 March 1881], private collection.

110 *Ibid.*

111 Unpublished, Renoir to Aline, n.l., n.d.
[August 1881], private collection.

112 Unpublished, Renoir to Aline, n.l., n.d. [August–September 1882], private collection.

113 Unpublished, Renoir to Aline, Dieppe, n.d. [August–September 1882], private collection.

114 Unpublished, Renoir to Aline, n.l., n.d. [August 1881], private collection.

115 Dauberville, vol. 1, pls 368, 372.

116 Unpublished, Renoir to Aline, n.l., n.d. [c. 1883], private collection.

117 Dauberville, vol. 1, pl. 506. Ephrussi commissioned Renoir to make a drawing after the portrait of Irène, published in *Gazette des Beaux-arts* (July 1881); see Bailey, *Renoir's Portraits*, p. 11, fig. 11.

118 Dauberville, vol. 1, pl. 253; see Bailey, *Renoir's Portraits*, p. 181; de Waal, *Hare with Amber Eyes*, p. 83; see also here Ch. 4, p. 204, n. 110.

119 Renoir to Duret, Algiers, 4 March 1881, in Benjamin, *Renoir and Algeria*, p. 143.

120 Renoir to Duret, n.l., [18 April] 1881, in *Écrits et propos sur l'art*, p. 115.

121 Unpublished letters, private collection.

122 Unpublished, Renoir to Aline, Algiers, n.d. [April 1881], private collection.

123 Renoir to Mme Marguerite Bérard, Algiers, n.d. [c. 28 February 1881], in Benjamin, *Renoir and Algeria*, p. 144.

124 Unpublished, Renoir to Aline, n.l. [near Algiers], n.d. [c. 15 March 1881], private collection.

125 Unpublished, Renoir to Aline, n.l. [Algiers], n.d. [c. 15 March 1881], private collection.

126 Unpublished, Renoir to Aline, n.l. [Algiers], n.d. [c. March 1881], private collection.

127 Unpublished, Renoir to Aline, n.l. [Algiers], n.d. [mid-March 1881], private collection.

128 Renoir to Morisot, Pornic, n.d. [summer–autumn 1892], in Morisot, *Berthe Morisot: The Correspondence*, p. 172; French edn, *Correspondance de Berthe Morisot*, p. 170.

129 Unpublished, Renoir to Aline, n.l. [Algiers], n.d. [c. 15 February 1881], private collection.

130 Unpublished, Renoir to Aline, Algiers, n.d. [c. 15 March 1881], private collection.

131 Unpublished, Renoir to Aline, Algiers, 29 February 1881, private collection.

132 Unpublished, Renoir to Aline, n.l. [Mustapha], n.d. [c. 20 February 1881], private collection.

133 Dauberville, vol. 1, pls 101, 158, 201, 308, respectively.

134 Renoir to Mme Marguerite Bérard, Algiers, n.d. [c. 28 February 1881], in Benjamin, *Renoir and Algeria*, p. 144.

135 Unpublished, Renoir to Aline, [c. 20 February 1881], see n. 83 above.

136 Renoir to Duret, Algiers, 4 March 1881, in Benjamin, *Renoir and Algeria*, p. 143.

137 Renoir to Mme Marguerite Charpentier, n.l. [Algiers], n.d. [4 March 1881], in *ibid.*

138 Renoir to Charles Ephrussi, Algiers, 28 February 1881, in *ibid.*

139 Renoir to Mme Marguerite Bérard, Algiers, n.d. [c. 28 February 1881], in *ibid.*, p. 144.

140 Renoir to Paul Bérard, Algiers, 1881, in *ibid.* For two landscapes Renoir did at this time see Dauberville, vol. 1, pls 157, 158.

141 Unpublished, Renoir to Aline, n.l. [Algiers], n.d. [c. 15 March 1881], private collection.

142 Dauberville, vol. 1, pl. 223. Other landscapes he painted include *Field of Bananas, Algiers* and three paintings entitled *Garden of Essai, ibid.*, pls 201, 101, 200, 202, respectively; *Ravine of the Wild Woman*, 1882, in Benjamin, *Renoir and Algeria*, pl. 85.

143 Dauberville, vol. 1, pl. 158.

144 *Ibid.*, pls 308, 345, 384.

145 Unpublished, Renoir to Aline, n.l. [Mustapha], n.d. [c. 20 February 1881], private collection.

146 Unpublished, Renoir to Aline, n.l. [Algiers], n.d. [c. 15 March 1881], private collection.

147 Le Coeur, *Edmond Renoir, Pierre Auguste Renoir*, p. 7.

148 Unpublished, Renoir to Aline, n.l. [Algiers], n.d. [c. 15 March 1881], private collection.

149 Unpublished, Renoir to Aline, n.l. [Algiers], n.d. [mid-April 1881], private collection.

150 Unpublished, Renoir to Aline, n.l. [Algiers], n.d. [c. 15 March 1881], private collection.

151 Ibid.

152 Unpublished, Renoir to Aline, n.l. [Algiers], n.d. [March 1881], private collection.

153 Unpublished, Victor Charigot to Aline, Winnipeg, Canada, 2 August 1880, private collection.

154 Unpublished, Renoir to Aline, n.l. [Algiers], n.d. [c. 15 March 1881], private collection.

155 Unpublished, Renoir to Aline, n.l. [Algiers], n.d. [April 1881], private collection.

156 Unpublished, Renoir to Aline, n.l. [Algiers], n.d. [15 April 1881], private collection.

157 Unpublished, Renoir to Aline, n.l. [Algiers], n.d. [April 1881], private collection.

158 Renoir to Duret, n.l. [Chatou], n.d. [Easter Monday, 18 April 1881], in Renoir, Écrits, entretiens et lettres, p. 115.

159 Renoir to Duret, Algiers, 4 March 1881, in White, Renoir: His Life, Art, and Letters, p. 105.

160 Pissarro to his son Lucien, Eragny, 23 February 1887, in Correspondance de Camille Pissarro, vol. 2, p. 131.

161 Unpublished, Renoir to Aline, n.l. [Louveciennes], n.d. [c. 1881], private collection.

162 Unpublished, Renoir to Aline., n.l., n.d. [July–September 1882], private collection.

163 Dauberville, vol. 1, pls 254, 478.

164 Unpublished, Renoir to Aline, Dieppe, n.d. [July 1881], private collection.

165 Unpublished, Renoir to Aline, n.l., n.d. [summer 1881], private collection.

166 Dauberville, vol. 1, pls 282, 488, 558, 572, 574.

167 Mme Émile (Félicie) Blanche to Dr Blanche, Dieppe, c. 20 July 1881, in Blanche, Pêche aux souvenirs, pp. 443–4.

168 Jacques-Émile Blanche to his father, Dr Blanche, Dieppe, 20 July 1881, in ibid., pp. 444–5.

169 Blanche to his father, 15 August 1882, in ibid., p. 441.

170 Jacques-Émile Blanche bought the oil study for Shepherd, Cow, and Sheep, 1886, and Large Bathers of 1887, Dauberville, vol. 2, pls 1048, 1292.

171 Benjamin, Renoir and Algeria, p. 42.

172 Dauberville, vol. 1, pl. 583.

173 Manet, Growing Up with the Impressionists, entry of 19 September 1895, p. 67; French edn, Journal, p. 66.

174 Renoir, Renoir, My Father, p. 239.

175 Dauberville, vol. 1, pls 596, 603.

176 Renoir to Charles Deudon, Naples, n.d. [December 1881], in White, 'Renoir's Trip to Italy', pp. 347–8.

177 Renoir to Manet, Capri, 28 December 1881, ibid., p. 348.

178 André Renoir: Carnet de Dessins – Renoir en Italie et en Algérie.

179 Renoir to Bérard, Venice, 1 November 1881, excerpt in Hôtel Drouot sale catalogue, 16 February 1979, no. 69.

180 Renoir to Mme Charpentier, Venice, n.d. [autumn 1881], in White, 'Renoir's Trip to Italy', p. 346.

181 Renoir to Deudon, n.l., November 1881, ibid., p. 347.

182 Renoir to Durand-Ruel, Naples, 21 November 1881, ibid.

183 Renoir to Mme Charpentier, L'Estaque, n.d. [late January or early February 1882], ibid., p. 350.

184 See Herbert, Renoir's Writings on the Decorative Arts, pp. 69–71.

185 Renoir to Bérard, Capri, 26 December 1881, excerpt in Hôtel Drouot sale catalogue, 16 February 1979, no. 72.

186 Renoir to Manet, Capri, 28 December 1881, in White, 'Renoir's Trip to Italy', p. 348.

187 Monneret, L'Impressionnisme et son époque, vol. 2, p. 90.

188 Renoir to Deudon, n.l., n.d. [December 1883], in White, 'Renoir's Trip to Italy', p. 350.

189 Unpublished, Manet to Renoir, n.l., 30 December 1881, private collection.

190 Renoir to Deudon, Naples, n.d. [December 1881], in White, 'Renoir's Trip to Italy', p. 348.

191 Dauberville, vol. 1, pls 439, 480, 438, 2 55, respectively.

192 White, 'Renoir's Trip to Italy', pl. 24.

193 Dauberville, vol. 2, pl. 1253; Renoir to M. Charpentier, n.l., n.d., in 'Renoir et la famille Charpentier', p. 38.

194 Renoir to unnamed friend [Georges Charpentier], n.l. [Palermo], 14 January 1882, in White, 'Renoir's Trip to Italy', pp. 350, 349, respectively.

195 Cosima Wagner quoted in Distel, *Renoir* (2010), p. 209.

196 Dauberville, vol. 2, pl. 1464. Four years later, the Charpentiers sold their Wagner portrait to Robert de Bonnières. In 1893, Renoir was commissioned to make a replica for Cheramy and borrowed the portrait from Bonnières; *ibid.*, pl. 1257.

197 Dauberville, vol. 1, pls 162, 161, 198, 163, 160, 170, 169, 165–7, 199, respectively.

198 Renoir to Paul Durand-Ruel, Naples, 21 November 1881, in Renoir, *Correspondance de Renoir et Durand-Ruel*, vol. 1, p. 15.

199 Renoir to Bérard, Naples, 26 November 1881, excerpt in Hôtel Drouot sale catalogue, 16 February 1979, no. 70.

200 Rivière, 'L'exposition des impressionnistes', *L'Impressionniste: journal d'art* 2 (14 April 1877), repr. in Venturi, *Archives de l'impressionnisme*, vol. 2, p. 316.

201 Renoir to Paul Durand-Ruel, Naples, 21 November 1881, in *Correspondance de Renoir et Durand-Ruel*, vol. 1, p. 15.

202 Renoir to Mme Charpentier, L'Estaque, late January or early February 1882, in White, 'Renoir's Trip to Italy', p. 350.

203 White, 'Renoir's Trip to Italy', pl. 25; Dauberville, vol. 1, pl. 44, respectively.

204 For the portrait see Dauberville, vol. 1, pl. 508.

205 *Ibid.*, vol. 2, pl. 1295.

206 Renoir to Durand-Ruel, n.l. [L'Estaque], 23 January 1882, in *Correspondance de Renoir et Durand-Ruel*, vol. 1, p. 20.

207 For landscapes by Renoir and Cézanne see White, *Renoir: His Life, Art, and Letters*, p. 123; Dauberville, vol. 2, pl. 774, and pl. 775 for a second landscape painted there.

208 Renoir quoted in Cézanne to Zola, n.l. [Aix], 10 March 1883, in Cézanne, *Paul Cézanne: Correspondance*, p. 209.

209 Renoir quoted in Pach, 'Pierre-Auguste Renoir', *Scribner's Magazine*, May 1912, repr. in Wadley, *Renoir: A Retrospective*, p. 245.

210 Renoir to Durand-Ruel, n.l. [L'Estaque], 14 February 1882, in *Correspondance de Renoir et Durand-Ruel*, vol. 1, p. 21.

211 Renoir to Durand-Ruel, L'Estaque, 19 February 1882, in *ibid.*, p. 23.

212 Pissarro to Monet, Paris, n.d. [*c.* 24 February 1882], in *Correspondance de Camille Pissarro*, vol. 1, p. 155.

213 Renoir to Chocquet, L'Estaque, 2 March 1882, excerpt in Hôtel Drouot sale catalogue, 23 June 1969, no. 197.

214 Renoir to Durand-Ruel, L'Estaque, 26 February 1882, in *Correspondance de Renoir et Durand-Ruel*, vol. 1, pp. 26–7.

215 Rough draft, Renoir to Durand-Ruel, n.l., n.d. [L'Estaque, 26 February 1882], enclosed in Edmond Renoir to Durand-Ruel, n.l., n.d. [L'Estaque, 26 February 1882], in *ibid.*, p. 30.

216 Renoir to Durand-Ruel, Algiers, March 1882 [misdated 1881], in *ibid.*, p. 11.

217 Renoir to Durand-Ruel, Algiers, n.d. [March 1882], in *ibid.*, p. 35.

218 Renoir to Bérard, n.l. [L'Estaque], n.d. [late February or early March 1882], in Benjamin, *Renoir and Algeria*, pp. 144–5.

219 Renoir to Bérard, n.l. [Algiers], n.d. [March 1882], in White, *Renoir: His Life, Art, and Letters*, p. 124.

220 Renoir to Durand-Ruel, Algiers, n.d. [March 1882], in *Correspondance de Renoir et Durand-Ruel*, vol. 1, p. 31.

221 Renoir to Bérard, Algiers, 14 March 1882, in Benjamin, *Renoir and Algeria*, p. 145.

222 Renoir to Bérard, Algiers, n.d. [April 1882], excerpt in Paris, Librairie de l'Abbaye, catalogue, n.d., no. 248.

223 Renoir to Bérard, n.l., n.d [summer 1882], in White, *Renoir: His Life, Art, and Letters*, p. 125.

224 Dauberville, vol. 2, pls 912, 913; Benjamin, *Renoir and Algeria*, fig. 71; Dauberville, vol. 2, pl. 773, respectively.

225 Renoir to Durand-Ruel, Algiers, n.d. [March 1882], in *Correspondance de Renoir et Durand-Ruel*, vol. 1, p. 31.

226 Dauberville, vol. 2, pls 1056, 1057; Benjamin, *Renoir and Algeria*, fig. 113;

Dauberville, vol. 2, pls 1055, 1259, 1017, 1018, respectively.

227 Unpublished, Renoir to Bérard, n.l. [Algiers], n.d. [March 1882], private collection.

228 Dauberville, vol. 1, pl. 345; vol. 2, pl. 1058; vol. 1, pl. 384, respectively.

229 Unpublished, Bérard to Renoir, Paris, 23 April 1882, private collection.

230 Renoir to Mme Charpentier, L'Estaque, n.d. [late January or early February 1882], in White, 'Renoir's Trip to Italy', p. 350. For the pastel of Mlle Charpentier see Robida, Le Salon Charpentier, pl. XV.

231 Renoir to Bérard, L'Estaque, n.d. [early March 1882], in Bailey, Renoir's Portraits, p. 344.

232 Renoir to Bérard, n.l., 22 June 1882, ibid., pp. 190, 311 n. 7.

233 Dauberville, vol. 2, pls 967, 1003, 1059, 1254.

234 Ibid., pl. 1044, related drawing pl. 1091; for another recently renamed portrait from Mme Clapisson's collection, probably also of her, see pl. 1146.

235 Ibid., pl. 912

236 Unpublished, Renoir to Bérard, Paris, October 1882, in Paris, Archives Durand-Ruel.

237 Unpublished, Renoir to Aline, n.l. [Dieppe], n.d. [August–September 1882], private collection.

238 Unpublished, Renoir to Aline, Dieppe, [August–September] 1882, private collection.

239 Aline to Renoir, n.l. [Paris], n.d. [summer 1882], in Jean Renoir, Renoir, My Father, pp. 313–14; French edn, Renoir, mon père (1981), p. 344.

240 Renoir to Durand-Ruel, Algiers, n.d. [March 1882], in Correspondance de Renoir et Durand-Ruel, vol. 1, p. 35.

241 Renoir to Duret, n.l., n.d., in 'Renoir et la famille Charpentier', p. 39.

242 Manet, Growing Up with the Impressionists, entry of 16 June 1898, p. 138; French edn, Journal, p. 167.

243 As a preparatory study for City Dance, Renoir had painted Valadon's head, which he then reversed; Dauberville, vol. 2, pl. 1159. See Tabarant, 'Suzanne Valadon et ses souvenirs de modèle',

pp. 626–9, of 1921, almost forty years later, when Valadon was 56, but her recollections may not be reliable.

244 Bailey, Renoir, Impressionism, and Full-Length Painting, p. 168.

245 Duret's preface to Durand-Ruel catalogue, April 1883, quoted in ibid., p. 183.

246 Ibid., p. 197, quoting Meier-Graefe, Auguste Renoir (French, 1912), p. 110.

247 Pissarro to Lucien Pissarro, Osny, 10 April 1883, in Correspondance de Camille Pissarro, vol. 1, p. 192.

248 Bailey, Renoir, Impressionism, and Full-Length Painting, p. 212.

249 In 1883, the Boston Mechanics Building, or Hall, was located at the intersection of Huntington Avenue and West Newton Street, but was razed in the early 1960s.

250 Renoir's medal from Boston is still in the family.

251 Bailey, Renoir, Impressionism, and Full-Length Painting, p. 194.

252 Ibid., p. 201, fig. 6; Rewald, Renoir Drawings, p. 17, fig. 5 for 1883 engraving. For two soft-ground etchings of the same subject of c. 1890 see Delteil, Le Peintre-graveur illustré, Renoir section, pls 1, 2.

253 Dauberville, vol. 2, pl. 1065; at the time he also made an oil on cardboard sketch of M. Léon Clapisson, pl. 1251.

254 Renoir to Durand-Ruel, Naples, 21 November 1881, in Correspondance de Renoir et Durand-Ruel, vol. 1, p. 15.

255 Anne-Marie Hagen, called Charlotte Berthier, lived with Caillebotte from 1883 until his death in 1894. They never married.

256 Dauberville, vol. 2, pl. 1064.

257 Caillebotte's will cited in Berhaut, Caillebotte, pp. 251–2.

258 See Distel, Renoir, p. 150.

259 The cousins Alfred Nunès and Camille Pissarro had been born in Saint-Thomas in the Antilles.

260 Dauberville, vol. 2, pl. 1207 (of Aline Esther Nunès, 1875–1965); pl. 126 (of Robert Nunès, 1873–1957). Alfred's brother, Lionel, was a lawyer who, in May 1884, helped Renoir develop the text of his Grammaire des arts; see Correspondance de Camille Pissarro, vol. 1, pp. 299–300 n. 2.

261 Nochlin, 'Degas and the Dreyfus Affair', pp. 96–116.

262 Unpublished, Renoir to Aline, Yport, August 1883, private collection.

263 Unpublished, Renoir to Aline, n.l. [Yport], August 1883 [different letter], private collection.

264 For the address see unpublished letter, Renoir to Aline, n.l. [Yport], August 1883 [different from preceding], private collection.

265 Unpublished, Renoir to Bérard, Yport, 21 August 1883, private collection.

266 Aline to Renoir, Paris, n.d. [c. 1883], in Jean Renoir, Renoir, My Father, p. 314; French edn, Renoir, mon père (1981), pp. 343–4.

267 Ibid. (French edn, p. 343).

268 Unpublished, Renoir to Aline, Yport, n.d. [August 1883], private collection.

269 Unpublished, Renoir to Aline, Dieppe, n.d. [1882–83], private collection.

270 In 1883, Renoir and Edmond had a falling out and went their separate ways; see Le Coeur, Edmond Renoir, Pierre Auguste Renoir, p. 7.

271 Unpublished, Renoir to Aline, Yport, August 1883, private collection.

272 Unpublished, Renoir to Aline, Dieppe, n.d. [c. 1882–1883], private collection.

273 Unpublished, Renoir to Aline, Dieppe, n.d. [c. 1882–83], [different letter], private collection.

274 Renoir to Durand-Ruel, Guernsey, 27 September 1883, in Correspondance de Renoir et Durand-Ruel, vol. 1, p. 40.

275 Dauberville, vol. 2, pl. 1063.

276 Unpublished, Renoir to Aline, n.l. [Monte Carlo], n.d. [December 1883], private collection.

277 Ibid.

278 Unpublished, Renoir to Aline, n.l. [Monte Carlo], n.d. [December 1883], private collection.

279 The group exhibit of 1882 was the last show where Caillebotte, Monet, Renoir, Pissarro, Degas and Sisley exhibited together.

280 Renoir to Durand-Ruel, n.l. [Genoa], n.d. [December 1883], in Correspondance de Renoir et Durand-Ruel, vol. 1, p. 41.

281 See White, Impressionists Side by Side, pp. 62–5, 66–71, 80–81, 98–9, 100, 269 (he and Caillebotte painted Melon and Dish of Figs together in 1882), 270, 246–7, respectively.

282 Monet to Durand-Ruel, Giverny, n.d. [12 January 1884], in Venturi, Archives de l'impressionnisme, vol. 1, p. 268.

283 Monet to Durand-Ruel, Bordighera, 28 January 1884, ibid., p. 271.

284 Albert Wolff, 'Quelques Expositions', Le Figaro, 2 March 1882, p. 1.

285 Monet to Alice Hoschedé, n.l. [Cap d'Antibes], n.d. [21 January 1888], in Wildenstein, Claude Monet: biographie, vol. 3, p. 225.

286 [Renoir], 'La Société des Irrégularistes', n.d. [May 1884], in Venturi, Archives de l'impressionnisme, vol. 1, p. 129.

287 Ibid., pp. 128–9.

288 Renoir to Durand-Ruel, n.l., n.d. [May 1884], in Correspondance de Renoir et Durand-Ruel, vol. 1, p. 42. See also Herbert, Renoir's Writings on the Decorative Arts, pp. 108–53.

289 Monet to Pissarro, Giverny, 11 November [1884], in Wildenstein, Claude Monet: biographie, vol. 2, p. 256.

290 Monet to Pissarro, Giverny, late November 1884, in ibid.

291 See Renoir to Burty, n.l., n.d. [c. 1886], Paris, Archives du Louvre.

292 Unpublished, Renoir to Mallarmé, Paris, c. 1892, Paris, Bibliothèque Doucet.

293 Dauberville, vol. 2, pls 1264, 1263, 1200, 1148, 1147, respectively.

294 E.g. Cézanne, Self-Portrait, 1879–82; Louis Guillaume, c. 1879–82; Madame Cézanne, 1883–87, in Schapiro, Paul Cézanne, pp. 53, 57, 59, respectively.

295 Dauberville, vol. 2, pl. 1292.

296 See e.g. Puvis's Young Women by the Sea, 1879, in Distel, Renoir, p. 252.

297 Renoir to Bérard, Paris, c. 1884, excerpt in Hôtel Drouot sale catalogue, 11 June 1980, no. 96; Dauberville, vol. 2, pl. 1231.

298 Dauberville, vol. 2, pl. 965. Renoir continued work on the large canvas at his new Paris studio, 37 rue Laval.

299 Ibid., pls 1261, 1079, respectively.

300 Monet to Alice Hoschedé, Bordighera, 12 March 1884, in Wildenstein, *Claude Monet: biographie*, vol. 2, p. 244.

301 Renoir to Durand-Ruel, n.l., n.d. [15 May 1884], in *Correspondance de Renoir et Durand-Ruel*, vol. 1, p. 42. See also Monet to Durand-Ruel, Giverny, 15 May 1884, in Venturi, *Archives de l'impressionnisme*, vol. 1, p. 278.

Chapter 3 1885–93

1 Dauberville, vol. 2, pls 1066, 999, 1001, respectively.

2 Unpublished birth certificate from 18th arrondissement of Paris, 23 March 1985, in Ville de Paris, 18ème arrondissement, Mairie Annexe.

3 (Léonard-)Victor Renoir had worked as a tailor in Russia but had returned penniless to Paris in 1885.

4 Renoir to Murer, n.l., n.d. [August or September 1887], in Gachet, *Lettres impressionnistes*, p. 95.

5 Pissarro to his son Lucien, Eragny, 23 February 1887, in *Correspondance de Camille Pissarro*, vol. 2, p. 131.

6 Dauberville, vol. 2, pls 969, 970, 971, 1477, 1478, 1574–7, respectively.

7 For a medieval example of the nursing infant Jesus holding his foot, see New York, Morgan Library & Museum, Ms. M.855, y, Sacramentary for Seitenstetten Abbey, Austria, 1260–64. My thanks to Colum P. Hourihane of the Index of Christian Art, Princeton University.

8 See Steinberg, *The Sexuality of Christ in Renaissance Art and in Modern Oblivion*.

9 Dauberville, vol. 2, pls 1021, 972, 1394, 1614, 1581, respectively.

10 *Ibid.*, pls 943, 944, 947, 948, 953–5.

11 *Ibid.*, pls 1265–7, 1270, 1276–83, 1285, 1403, 1404, 1549; Stella, *The Graphic Work of Renoir*, pl. 27.

12 Dauberville, vol. 2, pls 1268, 1269, 1271–4, 1399.

13 Unpublished, Renoir to Caillebotte, n.l., 28 May 1886, private collection.

14 Unpublished, Renoir to Murer, Boulogne, n.d. [June 1887], private collection.

15 Dr Hippolyte-Marie-Jean-Michel Latty; Dauberville, vol. 2, pl. 709.

16 Unpublished, Renoir to Aline, n.l. [le Vésinet], n.d. [August 1887], private collection.

17 Unpublished, Renoir to Dr de Bellio, Boulogne, 25 June 1887, in Paris, Musée Marmottan, Archives.

18 Renoir to Murer, n.l., n.d. [c. 30 June 1887], in Gachet, *Lettres impressionnistes*, p. 95.

19 Renoir to Murer, n.l., 14 July 1887, in *ibid.*, p. 104.

20 Renoir to Murer, n.l., summer 1887, in *ibid.*, p. 96.

21 Unpublished, Renoir to Aline, n.l., 17 June 1887, private collection.

22 Renoir to Bérard, n.l. [Paris], 23 December 1889, excerpt from Hôtel Drouot sale catalogue, 15 December 1989, no. 146.

23 Renoir to Bérard, n.l., 29 December 1900, excerpt from Hôtel Drouot sale catalogue, 11 June 1980, no. 101.

24 Dauberville, vol. 2, pls 1230, 1263, 1264; for the fourth portrait see Daulte, *Auguste Renoir: catalogue raisonné*, pl. 472. Goujon was the recently elected senator for Ain, a region near Switzerland.

25 Unpublished, Renoir to Aline, n.l. [Dieppe], n.d. [November 1885], private collection.

26 Pissarro to his son Lucien, Paris, n.d. [21 January 1886], in *Correspondance de Camille Pissarro*, vol. 2, p. 18.

27 Pissarro to Lucien, Eragny, 1 June 1887, *ibid.*, p. 178.

28 Renoir painted 13 portraits in 1880, 7 in 1881, 9 in 1882, 5 in 1883, as opposed to 3 in 1884, 4 in 1885, none in 1886, 1 in 1887, 2 in 1888 and 1 each in 1889 and 1890.

29 Renoir to Bérard, n.l. [Paris], 18 October [1886], in Renoir, *Écrits, entretiens et lettres*, p. 135. His new studio was at 35 boulevard Rochechouart, 9th arr.

30 Renoir to Berthe Morisot and Eugène Manet, Essoyes, [1 December] 1888, in Morisot, *Berthe Morisot: The Correspondence*, p. 144; French edn, *Correspondance de Berthe Morisot*, p. 142.

For a photograph of the Essoyes house in which Renoir, Aline and Pierre lived in autumn 1888 see Pharisien, *Renoir de vigne en vin à Essoyes*, p. 15. For the laundresses see Daulte, *Renoir: catalogue raisonné*, pl. 572.

31 Bailey, *Renoir, Impressionism, and Full-Length Painting*, p. 149.

32 See two letters from Renoir to Murer, Essoyes, December 1888, in Gachet, *Lettres impressionniste*, p. 98.

33 Unpublished lease agreement, Le Vésinet, 15 June 1887, private collection: 'Between the undersigned: M. William, the owner, living on rue Alphonse Pallison, in Le Vésinet, on the one hand, and: M. Pierre Renoir living in Paris at 35 boulevard Rochechouart, on the other hand…to rent…a grey house in Le Vésinet with an enclosed garden, on 33 rue de la Station…from June 16, 1887 until 1 April 1888, for "seven hundred and fifty francs" paid half at the signing of those present and the current balance on October 1, of this year…the tenant has no right to sublet…. When frost comes the renter must stop the water and drain the pipes or he will be responsible for the subsequent damage that could take place.'

34 Renoir to Bérard, Essoyes, 4 October 1885, in Bailey, *Renoir, Impressionism, and Full-Length Painting*, p. 149. It has recently been suggested that Renoir first went to Essoyes in autumn 1888; see Distel, *Renoir*, p. 234, on whether the first visit was in 1885 or 1888.

35 Renoir to Murer, Gennevilliers, 1 September 1886, in Gachet, *Lettres impressionniste*, p. 99.

36 Renoir to Eugène Manet, Essoyes, [29 December 1888], in Morisot, *Correspondence*, p. 145; French edn, *Correspondance de Berthe Morisot*, pp. 142–3.

37 Cézanne, *Paul Cézanne: Correspondance*, pp. 218–20.

38 Cézanne to Zola, 11 July 1885, in *ibid.*, p. 220.

39 Cézanne to Zola, La Roche-Guyon, 6 July 1885, *ibid.* Danchev in *The Letters of Paul Cézanne*, p. 234, dates this letter 15 June.

40 White, *Renoir: His Life, Art, and Letters*, pl. 157 (Cézanne); Dauberville, vol. 2, pl. 901.

41 Dauberville, vol. 2, pl. 803.

42 Venturi, *Cézanne*, vol. 1, p. 441. Cézannes in Renoir's collection included 3 other paintings and 2 watercolours: *Thatched Cottages in Auvers*, 1872–3, *ibid.*, p. 97, pl. 135; *Landscape*, 1879–82, p. 132, pl. 308; *Bacchanale (Struggle of Love)*, c. 1875–6, p. 148, pl. 380; *Nude Bathers*, 1882–94, watercolour, p. 251, pl. 902; for plates see *ibid.*, vol. 2, pls 35, 83, 104, 281; for *Carafe and Bowl*, 1879–82, see *Cézanne Watercolors*, p. 25, no. 7, pl. V, on which see following text.

43 Renoir to Durand-Ruel, n.l. [La Roche-Guyon], n.d. [15 June–11 July 1885], in *Correspondance de Renoir et Durand-Ruel*, vol. 1, p. 45.

44 Renoir to Durand-Ruel, Saint-Briac, 24 August 1886, in *ibid.*, p. 53.

45 Renoir to Monet, n.l. [Saint-Briac], n.d. [c. 1 August–30 September 1886], in Geffroy, *Claude Monet*, vol. 2, pp. 23, 24.

46 Monet to Alice Hoschedé, n.l. [Cap d'Antibes], n.d. [21 January 1888], in Wildenstein, *Monet: biographie*, vol. 3, p. 225.

47 Unpublished, Renoir to Caillebotte, n.l., n.d. [c. 1885], private collection.

48 Renoir to Monet, Aix-en-Provence, [mid-January 1888], excerpt from Paris, Artcurial sale catalogue, n.d. 13 December 2006, no. 242.

49 Renoir to Monet, Martigues, n.d. [1 February 1888], excerpt from *ibid.*, lot 243.

50 Unpublished, Cézanne to Zola, n.l., 10 March 1889, Paris, Bibliothèque National, 24516, Ff.492–605.f582.

51 Renoir, *Mont Ste-Victoire*, 1889 (Dauberville, vol. 2, pl. 922), with Cézanne, *Mont Ste-Victoire*, c. 1889 (Lucy and House, *Renoir in the Barnes Foundation*, p. 124), and Renoir, *Mont Ste-Victoire*, c. 1889 (Dauberville, vol. 1, pl. 921) with Cézanne, *Mont Ste-Victoire*, c. 1888–90 (Rewald, *Cézanne*, p. 177). Renoir, *Pigeon Tower at Bellevue*, 1889–90 (Dauberville, vol. 2, pl. 920), with Cézanne, *Pigeon Tower at Bellevue*,

1888–90 (Lucy and House, *Renoir in the Barnes Foundation*, p. 123). Renoir also painted *Pigeon Tower of Bellevue* (estate of Montbriant), 1889, oil on canvas, 54 x 65 cm (21¼ x 25⅝ in.), location unknown, Dauberville, vol. 2, pl. 918, and *Study for Pigeon Tower at Bellevue* (estate of Montbriant), oil on canvas, 46 x 55 cm (18⅛ x 21 in.), location unknown.

52 See Shiff, *Cézanne and the End of Impressionism*.

53 Unpublished, Renoir to Murer, Petit-Gennevilliers, n.d. [postmarked 29 September 1888], Paris, Bibliothèque Doucet.

54 Berhaut, *Caillebotte*, p. 217, pl. 391.

55 *Ibid.*, p. 226, pl. 418, *Mme Renoir in the Garden at Petit-Gennevilliers*. For the visit see Renoir to Murer, Petit-Gennevilliers, 28 September 1891, in Gachet, *Lettres impressionnistes*, pp. 106–7.

56 Dauberville, vol. 2, pl. 1064.

57 See Price, *Puvis de Chavannes*, vol. 2, p. 206, cat. no. 230 (1877–86); pp. 302–3, cat. nos 324, 325 (*c.* 1887); pp. 448–9, cat. no. A 135 (n.d.).

58 Dauberville, vol. 2, pl. 1393 (repeated in error as pl. 1067).

59 *Ibid.*, pl. 1209.

60 *Ibid.*, pls 1394, 972, respectively, both signed 'Renoir'.

61 *Ibid.*, pl. 1398, signed 'Renoir 87'.

62 *Ibid.*, pls 969–71, 1292, 1574–7, 1290, 1291, 1510–25, 1563–70, 1599A–C, respectively.

63 Morisot, *Correspondence*, p. 145; French edn, *Correspondance de Berthe Morisot*, p. 128.

64 Dauberville, vol. 2, pls 1574–7, 1602.

65 Renoir to Bérard, La Roche-Guyon, [17 August 1886], excerpt from Hôtel Drouot sale catalogue, 16 February 1979, no. 74.

66 Dauberville, vol. 2, pls 970, 1148.

67 Unpublished, Renoir to Bérard, n.l., n.d [c.1886], private collection.

68 Renoir to Murer, Gennevilliers, 1 September 1886, in Gachet, *Lettres impressionnistes*, p. 99.

69 Unpublished, Renoir to Monet, Paris, 15 October 1886, Paris, Archives Durand-Ruel.

70 Pissarro to his son Lucien, Paris, 14 April 1887, in *Correspondance de Pissarro*, vol. 2, p. 151.

71 Monet to his wife, Kervilahouen, 17 October 1886, in Wildenstein, *Monet: biographie*, vol. 2, p. 281.

72 See White, 'The *Bathers* of 1887 and Renoir's Anti-Impressionism'.

73 Renoir to Bérard, Paris, 18 October 1886, in White, *Renoir: His Life, Art, and Letters*, p. 166.

74 Dauberville, vol. 2, pl. 970.

75 Mirbeau, 'Impressions d'art', *Le Gaulois* (16 June 1886), in White, *Renoir: His Life, Art, and Letters*, p. 165.

76 Renoir to Mirbeau, n.l., 16 June 1886, in *ibid.*

77 Pissarro to his son Lucien, Paris, [27 July 1886], in *Correspondance de Pissarro*, vol. 2, p. 63.

78 Price, *Puvis de Chavannes*, vol. 2, pp. 178–9.

79 For preparatory drawings, see White, '*Bathers* of 1887 and Renoir's Anti-Impressionism'.

80 Morisot, *Correspondence*, p. 145; French edn, *Correspondance de Berthe Morisot*, p. 128.

81 Distel, *Renoir*, p. 252; see Ch. 2 n. 296.

82 White, *Renoir: His Life, Art, and Letters*, p. 173.

83 Dauberville, vol. 2, pls 967, 1003, 1059, 1254.

84 Pissarro to his son Lucien, Paris, 1 October 1888, in *Correspondance de Pissarro*, vol. 2, p. 254.

85 Pissarro to Lucien, Paris, [14 May 1887], in *ibid.*, pp. 164, 163–64, respectively.

86 Pissarro to Lucien, Eragny, [20 September 1887], in *ibid.*, p. 200.

87 Pissarro to Lucien, Paris, [15 May 1887], in *ibid.*, pp. 166–7.

88 Pissarro to Lucien, Paris, [16 May 1887], in *ibid.*, p. 169.

89 Pissarro to Lucien, Paris, 1 October 1888, in *ibid.*, p. 254.

90 Wyzewa, 'Pierre-Auguste Renoir' (1890); also cited in Wadley, *Renoir: A Retrospective*, p. 181.

91 Gustave Geffroy, 'Auguste Renoir', *La Vie artistique*, 1894, cited in Wadley, *Renoir: A Retrospective*, p. 189.

92 Vincent van Gogh to his brother Theo, Arles, 4 and 5 May 1888, cited in *ibid.*, p. 168. Van Gogh bought two small Renoirs; see Rabinow, *Cézanne to Picasso*, p. 277.

93 White, *Renoir: His Life, Art, and Letters*, p. 174. J.-É. Blanche also purchased *Basket of Peaches and Grapes*, Dauberville, vol. 1, pl. 47.

94 Monet to Durand-Ruel, Giverny, 13 May 1887, in Venturi, *Archives de l'impressionnisme*, vol. 1, pp. 325–6.

95 White, *Renoir: His Life, Art, and Letters*, p. 175, drawings p. 176; see also Dauberville, vol. 2, pls 1481, 1232; White, *Impressionists Side by Side*, pp. 236–8.

96 Draft, Renoir to Durand-Ruel, L'Estaque, n.d. [*c.* 26 February 1882], in *Correspondance de Renoir et Durand-Ruel*, vol. 1, p. 30.

97 See White, *Impressionists Side by Side*, pp. 212–57, 'Renoir and Morisot'.

98 Julie Manet, *Growing Up with the Impressionists*, entry of 14 September 1898, p. 145; French edn, *Journal*, p. 188.

99 Unpublished, Renoir to Aline, n.l., n.d. [17–20 June 1887], private collection.

100 Renoir to Durand-Ruel, Cagnes, 25 December 1908, in *Correspondance de Renoir et Durand-Ruel*, vol. 2, p. 35.

101 Morisot to Mallarmé, Mézy, 14 July 1891, in Morisot, *Correspondence*, p. 182; French edn, *Correspondance de Berthe Morisot*, p. 160.

102 Morisot to Mallarmé, Mézy, autumn 1891, in Morisot, *Correspondence*, p. 185; French edn, *Correspondance de Berthe Morisot*, p. 163.

103 Renoir to Bérard, Paris, 24 September 1887, excerpt from Hôtel Drouot sale catalogue, 11 June 1980, no. 94.

104 Renoir to Durand-Ruel, Martigues, n.d. [11–12 March 1888], in *Correspondance de Renoir et Durand-Ruel*, vol. 1, p. 61; French in Venturi, *Archives de l'impressionnisme*, vol. 1, p. 140.

105 Renoir to Murer, n.l., n.d. [March 1883], in Gachet, *Lettres impressionnistes*, p. 92.

106 Juliette Adam (1836–1936), the feminist writer (not Madeleine Adam, whose portrait Renoir had painted in 1887). Renoir to unknown recipient [Philippe Burty], Cagnes, 8 April 1888, in White, *Renoir: His Life, Art, and Letters*, p. 202; typescript in Paris, Archives Durand-Ruel. François Daulte to the author, Lausanne, 9 December 1981: 'Lastly, as to the 8 April 1888 letter cited in my catalogue, it is in the Durand-Ruel archives, and except for the greeting, I cited it fully. At the time of the publication of my catalogue, the letter had been unpublished, protected by the copyright of my book. The letter was addressed by Renoir to his friend, Philippe Burty.'

107 Manet, *Growing Up with the Impressionists*, entry of 31 January 1899, p. 159; French edn, *Journal*, p. 215.

108 Charles Baudelaire, *Mon coeur mis à nu*, ed. Claude Pichois, Textes Litteraires Français (Geneva: Droz, 2001), p. 16 (written early 1860s, first published 1897, 30 years after Baudelaire's death).

109 Rheumatoid arthritis results in chronic, systemic inflammation that may affect many tissues and organs, but principally attacks flexible joints. It can be painful and can lead to substantial loss of functions and mobility.

110 Unpublished, Renoir to unidentified male recipient, n.l., n.d. [*c.* 9 August 1888], private collection.

111 Renoir to Charpentier, Essoyes, 29 December 1888, in 'Renoir et la famille Charpentier', p. 38.

112 Renoir to Eugène Manet, Essoyes, early January 1889, in Morisot, *Correspondence*, p. 163; French edn, *Correspondance de Berthe Morisot*, p. 143.

113 Renoir to Eugène Manet, n.l. [Essoyes], n.d. [January 1889], in *ibid.* At this time, Degas had problems with his vision.

114 Unpublished, Renoir to Durand-Ruel, n.l. [Essoyes], n.d. [December1888], Paris, Bibliothèque Nationale.

115 Renoir to Murer, n.l. [Essoyes], 2 January 1889, in Jean Renoir, *Renoir* (1962), p. 263.

116 Renoir to Bérard, n.l., 9 October 1889, in White, *Renoir: His Life, Art, and Letters*, p. 126.

117 In July 1892 he still was suffering from his teeth: Renoir to Paul Gallimard, n.l.,

July 1892, extract from New York, Parke-Bernet, 1961, sale number 2058, no. 457.

118 E.g. Dauberville, vol. 2, pls 1293, 1294.

119 Mellerio, 'Les Artistes à l'atelier-Renoir', n.p.

120 'Nos artistes: le peintre P.A. Renoir chez lui'.

121 Renoir to Roger-Marx, n.l., 10 July [1888], in White, *Renoir: His Life, Art, and Letters*, p. 185.

122 Renoir to Durand-Ruel, Tamaris, 5 March 1891, in *Correspondance de Renoir et Durand-Ruel*, vol. 1, p. 71.

123 Renoir to Bérard, Tamaris, 5 March 1891, in Renoir, *Écrits, entretiens et lettres*, p. 141.

124 Renoir to Durand-Ruel, n.l. [Le Lavandou], 23 April 1891, in *Correspondance de Renoir et Durand-Ruel*, vol. 1, p. 80.

125 Pissarro to his son Lucien, Eragny, 14 July 1891, in *Correspondance de Pissarro*, vol. 3, p. 105.

126 The Mendès daughters whom Renoir painted were Huguette (1871–1964), Claudine (1876–1937) and Helyonne (1879–1955).

127 Renoir to Catulle Mendès, Paris, n.d. [*c.* January 1888], excerpt from Hôtel Drouot sale catalogue, 13 December 1989, no. 160.

128 Salon of 1890, no. 2024, as *Portraits of Mlles M...*, Dauberville, vol. 2, pl. 966.

129 *Ibid.*, pls 1150, 1152 (exhibited 1890 in Brussels), 1154, 1165, 1256, respectively.

130 Durand-Ruel, interview of 28 November 1910, repr. in Geffroy, *Claude Monet*, vol. 1, p. 61.

131 Rewald, *History of Impressionism*, p. 544 n. 5.

132 Venturi, *Archives de l'impressionnisme*, vol. 2, p. 216.

133 Durand-Ruel to Fantin-Latour, Paris, 21 August 1886, in *ibid.*, p. 252.

134 See *Correspondance de Renoir et Durand-Ruel*, vol. 1, p. 270 n. 24; again held under the patronage of the American Association of Art.

135 Venturi, *Archives de l'impressionnisme*, vol. 2, p. 218.

136 Renoir to Durand-Ruel, n.l. [Paris], 12 May 1887, in *Correspondance de Renoir et Durand-Ruel*, vol. 1, p. 56.

137 *Ibid.*, p. 274 n. 44.

138 Renoir to Monet, n.l., 11 August 1889, in Geffroy, *Claude Monet*, vol. 1, p. 245.

139 Renoir to Monet, n.l., 10 January 1890, in *ibid.*

140 Duret to Caillebotte, Paris, n.d. [*c.* 1889], in Berhaut, *Caillebotte*, p. 247.

141 Monet to Pissarro, n.l., 22 July 1891, in *Correspondance de Pissarro*, vol. 3, p. 112 n. 1.

142 Dauberville, vol. 2, pl. 993; 990–92, 994 for the others.

143 In December 1889, Gallimard purchased his first Renoir from Durand-Ruel, the 1882 version of the *Blonde Bather*; *ibid.*, pl. 1295.

144 Bailey, *Renoir's Portraits*, p. 323 n. 15 cites evidence of the Madrid trip from the *Éclair* interview of 9 August 1892. See Renoir to Jeanne Baudot, Grasse, 24 April 1900, in Baudot, *Renoir, ses amis, ses modèles*, p. 94.

145 Dauberville, vol. 2, pls 1154 (signed and dated painting), 1165 (unsigned, undated sketch).

146 Renoir to Gallimard, n.l., n.d., excerpt from Marburg, Stargardt, 3–4 December 1963, sale catalogue, no. 565.

147 Unpublished, Renoir to Gallimard, Beaulieu, 27 April 1893, in Paris, Institut Néerlandais.

148 See Baudot, *Renoir, ses amis, ses modèles*, pp. 8–11.

149 Unpublished marriage certificate, 'Extraits des minutes des actes de mariage', Ville de Paris, 9th arrondissement, 14 April 1890, no. 154/339, private collection.

150 *Livret de famille*, private collection.

151 Dauberville, vol. 2, pl. 1178.

152 Renoir to Murer, n.l. [Paris], 30 October 1890, in Gachet, *Lettres impressionnistes*, p. 101.

153 Manet, *Growing Up with the Impressionists*, entry of 3 September 1893, p. 37; French edn, *Journal*, p. 18.

154 Renoir to Dr Gachet, n.l., 17 September 1890, in Gachet, *Lettres impressionnistes*, p. 87.

155 Manet, *Growing Up with the Impressionists*, entry of 14 September 1898, p. 145; French edn, *Journal*, p. 188.

156 *Ibid.*, entry of 31 December 1896, p. 104; French edn, *Journal*, pp. 119–22.

157 *Ibid.*, entry of 11 September 1898, p. 142; French edn, *Journal*, p. 187.

158 Renoir to Berthe Morisot, n.l., n.d. [*c.* 1892], in *Hommage à Berthe Morisot et à Pierre-Auguste Renoir*, p. 27.

159 See Renoir's letters to Morisot after her husband's death in Morisot, *Correspondence*, pp. 191–212.

160 *Ibid.*, p. 144.

161 Dauberville, vol. 2, pl. 1603; Delteil, *Le Peintre-graveur illustré*, vol. 17, pl. 3, etching.

162 Renoir to Stéphane Mallarmé, n.l., n.d. [*c.* 1890], in White, *Renoir: His Life, Art, and Letters*, p. 178. Although Durand-Ruel planned several painter-printmaker exhibitions, Renoir's etching was not in fact included.

163 Stéphane Mallarmé, *Pages* (Brussels: Edmond Deman, 1891); dedication from Mallarmé, excerpt from Hôtel Drouot book sale catalogue, 4 June 1986, no. 39.

164 Dauberville, vol. 2, pl. 1256.

165 Victorine Charigot to Emilie Charigot, [Essoyes], n.d., in Pharisien, *Célébrités d'Essoyes*, p. 54.

166 Hôtel du Lion d'Or and Châlet des Rochers, both in Pornic; Hôtel des Voyageurs in Pont-Aven.

167 Dauberville, vol. 2, pls 867, 927, 959 (Pornic, 1892); pls 859–65 (Noirmoutier); pls 780, 866, 924, 926, 1656 (Pont-Aven).

168 Renoir to Morisot, Pornic, n.d. [5 September 1892], in Morisot, *Correspondence*, p. 195; French edn, *Correspondance de Berthe Morisot*, p. 170.

169 Renoir to Bérard, Pornic, 5 September 1892, excerpt from Hôtel Drouot sales catalogue, 22 June 1979, no. 108.

170 Renoir to Murer, Pont-Aven, n.d. [1892], in Gachet, *Lettres impressionnistes*, p. 108.

171 See Ch. 1, p. 50 above for Lise's marriage and later children.

172 Unpublished, Renoir to 'Mlle Jeanne Renoir', Paris, 11 February 1892, private collection. Envelope reproduced in Gélineau, *Jeanne Tréhot, la fille cachée*, p. 30.

173 Unpublished, Renoir to Jeanne Tréhot, 14 February 1892, private collection.

174 Gélineau, *Jeanne Tréhot, la fille cachée*, pp. 23–4.

175 She remained with them until her death in 1934 aged 63. During the war, in a letter to Vollard, Jeanne wrote: 'they have always been very kind to me'; unpublished, Jeanne Tréhot Robinet to Vollard, Madré, 1 May 1917, in Paris, Bibliothèque des Musées Nationaux du Fonds Vollard, Ms. 421 on microfilm.

176 Unpublished baptism certificate, 23 May 1875, from the Mayor of Ste-Marguerite-de-Carrouges. For a reproduction see Gélineau, *Jeanne Tréhot, la fille cachée*, p. 22.

177 *Ibid.*, pp. 23–4.

178 *Ibid.*, p. 24.

179 *Ibid.*

180 Fuchs, *Abandoned Children*, pp. 237, 238. Only married people could reclaim abandoned children.

181 Unpublished, Renoir to 'Mlle Jeanne Renoir', 14 February 1892, private collection.

182 Envelope and unpublished letter, Renoir to Louis Robinet, Paris, 19 June 1893, private collection.

183 Unpublished, Renoir to Jeanne Tréhot, n.l., 19 June 1893, private collection.

184 Gélineau, *Jeanne Tréhot, la fille cachée*, pp. 16, 22, 24.

185 *Ibid.*, p. 35.

186 Unpublished, Renoir to Jeanne, n.l., 30 June 1893, private collection.

187 Unpublished, Renoir to Jeanne, n.l., 3 July 1893, private collection.

188 Unpublished, Renoir to Jeanne, n.l., 5 July 1893, private collection.

189 Unpublished, Renoir to Jeanne, n.l., 7 July 1893.

190 Unpublished civil wedding document, 9 July 1893, Ste-Marguerite-de-Carrouges, private collection.

191 Unpublished marriage contract, 7 July 1893, Ste-Marguerite-de-Carrouges, private collection.

192 Religious wedding document reproduced in Gélineau, *Jeanne Tréhot, la fille cachée*, p. 33.

193 *Ibid.*, p. 36. Gélineau thinks Renoir went directly from Ste-Marguerite for a week.

194 Unpublished, Renoir to Jeanne Tréhot Robinet, Paris, 13 July [1893], private collection.

Chapter 4 1894–1900

1 'Extrait des minutes des actes de naissance du 18e arrondissement de Paris, Année 1894', in Paris, Préfecture du Département de la Seine, 18e arrondissement.

2 Renoir to Marie Meunier, 15 or 16 September 1894, in Gachet, *Lettres impressionnistes*, p. 109.

3 Renoir to Monet, n.l. [Paris], 16 September 1894, excerpt from Artcurial sale catalogue, 13 December 2006, no. 256.

4 Renoir to Morisot, Paris, 17 September 1894, in Morisot, *Correspondence*, p. 184; French edn, *Correspondance de Berthe Morisot*, p. 182.

5 Morisot to Renoir, n.l., n.d., in *ibid.*, p. 208; French edn, p. 182.

6 'Certificat de Baptême pour mariage, Jean Georges Renoir, 1 juillet 1895', in Paris, Archives de la Paroisse de Saint-Pierre de Montmartre.

7 Renoir to Georges Durand-Ruel, Paris, n.d. [1 July 1895], in *Correspondance de Renoir et Durand-Ruel*, vol. 1, p. 97.

8 Geffroy, 'Auguste Renoir', *La Vie artistique*, 1894, in Wadley, *Renoir: A Retrospective*, pp. 187–91.

9 Unpublished, Renoir to Geffroy, Paris, 23 June 1896, in Los Angeles, Getty Research Institute, CJPV87-A516.

10 Thadée Natanson, 'Renoir', *La Revue blanche*, May 1896, in Wadley, *Renoir: A Retrospective*, pp. 215–16.

11 Frantz Jourdain, in *La Patrie*, 23 June 1896, cited in Baudot, *Renoir, ses amis, ses modèles*, p. 40.

12 *Renoir in the 20th Century*, p. 382, cat. no. 130. See Jean Renoir, *Renoir, My Father* (1958), p. 278 B, where the second photograph is also wrongly captioned as *Mme Renoir and Claude*, 1901. [Jean

Renoir didn't realize that this photo was not of his brother Claude but of himself.]

13 In 1895, Gabrielle's stepbrother married Marie Victorine Maire, Aline's cousin, thus establishing a relationship between the Renoirs and the Renards; Dauberville, vol. 3, pl. 2034. Julie Manet described Gabrielle as Jean's nursemaid (*bonne*) but Gabrielle could not have nursed Jean since she had never given birth; Manet, *Growing Up with the Impressionists*, entry of 10 August 1895, p. 62; French edn, *Journal*, p. 58.

14 Dauberville, vol. 3, pls 2038, 2056–8, 2060.

15 A large oil sketch for *The Artist's Family*, 161 x 130 cm (63⅜ x 51⅛ in.), private collection, *ibid.*, pl. 2034, indicates that Renoir planned a painting with Gabrielle seated with Jean in her arms, Aline standing behind them and a young girl kneeling at the left, without Pierre.

16 *Ibid.*, pl. 2032. See Lucy and House, *Renoir in the Barnes Foundation*, pp. 147–8.

17 Bailey, *Renoir's Portraits*, pp. 40, 43.

18 Lucy and House, *Renoir in the Barnes Foundation*, p. 147; Distel, *Renoir*, p. 294.

19 Herbert, *Renoir's Writings on the Decorative Arts*, pp. 20, 62.

20 Manet, *Growing Up with the Impressionists*, entry of 5 December 1897, p. 119; French edn, *Journal*, p. 143.

21 Renoir to Bérard, n.l., 7 December 1893, excerpt from Paris, Librairie de l'Abbaye, sale catalogue 246 [n.d.], no. 232.

22 Manet, *Growing Up with the Impressionists*, entry of 31 January 1899, p. 159; French edn, *Journal*, p. 214–15.

23 Berhaut, *Caillebotte*, p. 281. For discussion of this will see Chs 1, pp. 53–4, and 2, p. 123 above.

24 Renoir to Monet, n.l., 15 March [1894], excerpt from Artcurial sale catalogue, 13 December 2006, no. 252.

25 Berhaut, *Caillebotte*, p. 281, codicil of 5 November 1889.

26 Berhaut, *Caillebotte*, p. 281. For Caillebotte's collection see Ch. 1, p. 54 above.

27 For *The Rowers* see Berhaut, *Caillebotte*, pl. 75. Renoir to Monet, n.l., 15 March

[1894], excerpt from Artcurial sale catalogue, 13 December 2006, no. 252. The *Rowers* had been exhibited at the second Impressionist show in 1876, and was in the group sale of 1877. Durand-Ruel had exhibited it in New York in 1886. At Caillebotte's death, it was still with Durand-Ruel.

28 *Ibid.*, p. 57.

29 Gérôme and *The Artist* quoted in White, *Renoir: His Life, Art, and Letters*, p. 200.

30 Manet, *Journal*, entry of 17 March 1894, p. 30 (not in Eng. edn). For a drawing of Paule see Dauberville, vol. 2, pl. 1452.

31 Renoir to Morisot, [Paris], [January 1894], in Morisot, *Correspondence*, p. 205; French edn, *Correspondance de Berthe Morisot*, p. 179.

32 Dauberville, vol. 2, pls 1421 (pastel study), 997 (painting). Renoir later used this profile image of Morisot for an etching; Delteil, *Le Peintre-graveur illustré*, vol. 17, pl. 4.

33 Morisot, *Correspondence*, p. 205.

34 Renoir to Morisot, Paris, 31 March 1894, in *ibid*; French edn, *Correspondance de Berthe Morisot*, p. 179.

35 Manet, *Growing Up with the Impressionists*, addendum of August 1961, p. 81, when Jean Renoir and his wife, Dido, went to visit her, then Mme Rouart.

36 Renoir to Mme Alice Monet, n.l., 3 March 1895, excerpt in Artcurial sale catalogue, 13 December 2006, no. 257.

37 Renoir to Pissarro, n.l., 3 March 1895, extract from Paris, Charavay, bulletin cat. no. 786 [n.d.], letter no. 41187.

38 Renoir to Monet, n.l. [Paris], 16 March 1895, excerpt in Artcurial sale catalogue, 13 December 2006, no. 258.

39 *Ibid.* Later, Geneviève did marry, to one Edmond Bonniot.

40 Manet, *Growing Up with the Impressionists*, entry n.d. [late October/ early November 1895], p. 71, French edn, *Journal*, p. 71.

41 Unpublished, Renoir to Julie Manet, n.l., n.d. [*c.* February 1896], private collection.

42 Manet, *Growing Up with the Impressionists*, entries of 1895–1900; French edn, *Journal*.

43 Unpublished, Aline to Paule Gobillard, Paris, 29 October 1897, private collection. Around 1896, Mallarmé suggested that Charlotte Lecoq could be housekeeper-companion to Julie, Jeannie and Paule; she stayed with Julie and her family until her death.

44 2–4 July 1898; 10–13 September 1898; 24 September 1898; 1 October 1898; 27 December 1898.

45 Manet, *Growing Up with the Impressionists*, pp. 61–71 (1895); 111–14 (1897); 138–9, 141–50, 155 (1898); 180–84 (1899); French edn, *Journal*, pp. 57–70 (1895); 131–7 (1897); 168–9 (1898); 186–9, 208 (1899).

46 *Ibid.*, entry of 8 August 1895, p. 62; French edn, p. 58; addition in French only.

47 *Ibid.*, entry of 29 November 1895, p. 76; French edn, p. 74.

48 Dauberville, vol. 3, pls 2027, 2030, 2042–4, 2046–50, 2052, 2533.

49 Manet, *Growing Up with the Impressionists*, entry of 4 October 1895, p. 69; French edn, *Journal*, p. 70.

50 Manet, *Journal*, entry of 4 August 1899, p. 247 (not in Eng. edn).

51 *Ibid.*, entry of 12 August 1899, p. 250.

52 Dauberville, vol. 3, pl. 2353.

53 Manet, *Journal*, entry of 9 August 1899, p. 249 (not in Eng. edn).

54 Manet, *Growing Up with the Impressionists*, entry of 28 October 1897, p. 116; French edn, *Journal*, p. 139.

55 Jeanne Gobillard to Jeanne Baudot, n.l., n.d. [September 1898], in Baudot, *Renoir, ses amis, ses modèles*, p. 84.

56 Renoir to Bérard, n.l., July 1895, excerpt from New York, Swann Auction House, 17 May 1951, sale no. 290, no. 117.

57 Renoir to Geffroy, Paris, 10 July 1896, excerpt from Paris, Charavay, 6 April 1981, no. 257.

58 Manet, *Journal*, entries of 10 and 19 January 1899, pp. 212, 213 (neither in Eng. edn).

59 Manet, *Growing Up with the Impressionists*, entries of 4 and 9 August 1899, pp. 182, 183; French edn, *Journal*, pp. 247, 248.

60 According to modern rheumatology; my thanks to Dr Gerald Harris.

61 Régnier, *Renoir peintre du nu*, cited and trans. in Muehsam, *French Painters*, p. 516.

62 Renoir to Paul Durand-Ruel, n.l. [Nice], n.d. [February 1899], in *Correspondance de Renoir et Durand-Ruel*, vol. 1, p. 102.

63 Renoir to Bérard, Cagnes, 28 March 1899, excerpt from Hôtel Drouot sale catalogue, 11 June 1980, no. 97.

64 Manet, *Journal*, entry of 27 October 1895, p. 70 (not in Eng. edn).

65 As recorded in *ibid.*, entries of 5 and 26 February 1898, pp. 127–8.

66 See *Correspondance de Renoir et Durand-Ruel*, vol. 1, pp. 107–13.

67 Unpublished, Renoir to Jeanne Baudot, Grasse, 10 January 1900, private collection.

68 See Renoir to Durand-Ruel, Grasse, 16 March 1900, in *Correspondance de Renoir et Durand-Ruel*, vol 1, p. 129; unpublished, Renoir to Jeanne Baudot, Grasse, 31 March [1900], private collection.

69 Manet, *Growing Up with the Impressionists*, entry of 9 August 1899, p. 183; French edn, *Journal*, pp. 248–9.

70 Unpublished, Renoir to Jeanne Baudot, 31 March 1900, private collection.

71 Renoir to Paul Durand-Ruel, [Aix-le-Bains], 29 August 1899, in *Correspondance de Renoir et Durand-Ruel*, vol. 1, p. 115.

72 Manet, *Journal*, entry of 29 November 1895, p. 73 (not in Eng. edn).

73 Unpublished, Aline to Jeanne Baudot, n.l., n.d. [*c*. August 1897], private collection.

74 Manet, *Growing Up with the Impressionists*, entry of 22 September 1897, p. 112; French edn, *Journal*, pp. 132–3.

75 *Ibid.*, entry of 4 August 1899, p. 182; French edn, *Journal*, p. 247.

76 Natanson, 'Renoir', in Wadley, *Renoir: A Retrospective*, p. 215.

77 Manet, *Growing Up with the Impressionists*, entries of 5 and 26 February 1898, pp. 127–8; French edn, *Journal*, pp. 152, 153.

78 Manet, *Journal*, entry of 10 January 1899, p. 212 (not in Eng. edn).

79 See Ch. 2 n. 186

80 Renoir to Monet, n.l., 23 August 1900, in Baudot, *Renoir, ses amis, ses modèles*, p. 50.

81 Monet to Geffroy, Giverny, 23 August 1900, in Wildenstein, *Monet: biographie*, vol. 4, p. 348.

82 Unpublished (in English), Théodore E. Butler to Philip Hale, Giverny, 7 October 1900, in Paris, Archives Durand-Ruel.

83 Monet to friend [M. de Conchy?], Giverny, 16 June 1901, in White, *Impressionists Side by Side*, p. 105.

84 Renoir to Durand-Ruel, n.l. [Louveciennes], 20 August 1900, in *Correspondance de Renoir et Durand-Ruel*, vol. 1, p. 138.

85 Renoir to the Musée National de la Légion d'Honneur, Paris, August 1900, in White, *Renoir: His Life, Art, and Letters*, p. 217.

86 Manet, *Growing up with the Impressionists*, entry of 3 December 1897, p. 119; French edn, *Journal*, p. 143.

87 *Ibid.*, entry of 1 February 1897, p. 108; French edn, *Journal*, p. 123.

88 *Ibid.*, entry of 28 September 1897, p. 112; French edn, *Journal*, p. 133.

89 White, *Impressionism in Perspective*, pp. 3–6.

90 Manet, *Growing up with the Impressionists*, entry of 28 July 1899, pp. 181–2; French edn, *Journal*, p. 246.

91 Nochlin, 'Degas and the Dreyfus Affair', pp. 96–116.

92 Manet, *Growing up with the Impressionists*, entry of 15 January 1898, p. 124; French edn, *Journal*, p. 148.

93 Newspaper subscriptions are one way to estimate percentages of Dreyfusards vs. anti-Dreyfusards. Anti-Dreyfusard subscriptions totalled 2,170,000 in *La Libre Parole*, *L'Anti Sémite*, *La Croix*, *Le Pèlerin*, *L'antijuif*, *Le Petit Journal*; in contrast, Dreyfusard subscriptions in *L'Aurore* and *Le Siècle*, for example, totalled 200,000; see www.e-ir.info/2012/06/06/the-significance-of-the-dreyfus-affairs-on-politics-in-france-from-1894–to-1906/, accessed 26 December 2016.

94 Monneret, *L'Impressionnisme*, vol. 3, p. 115.

95 Nochlin, 'Degas and the Dreyfus Affair', p. 96.

96 *Ibid.*, pp. 107, 97, 106, 115 nn. 49, 52, respectively.

97 Manet, *Journal*, entry of 20 September 1899, p. 255 (not in Eng. edn).

98 Unpublished, Renoir to Bérard, n.l., n.d. [1899], private collection. See related letter from Renoir to Durand-Ruel, n.l. [Cagnes], 2 March 1899, in *Correspondance de Renoir et Durand-Ruel*, vol. 1, p. 108.

99 Bailey, 'Renoir's Portrait of his Sister-in-Law', p. 686.

100 See Bailey, *Renoir's Portraits*, p. 6; also Melanson, 'The Influence of Jewish Patrons on Renoir's Stylistic Transformation in the Mid-1880s'.

101 Dauberville, vol. 2, pls 1207, 1260.

102 Renoir, 'La Société des Irrégularistes', n.d. [May 1884], in Venturi, *Archives de l'impressionnisme*, vol. 1, p. 129.

103 See *Correspondance de Renoir et Durand-Ruel*, vol. 1, p. 268 n. 7.

104 Manet, *Growing up with the Impressionists*, entry of 11 October 1897, p. 113; French edn, *Journal*, p. 135. Félix Fénéon was an anarchist and critic who in 1884 founded *La Revue indépendante*; he also worked for Bernheim-Jeune.

105 Paul Signac, diary entry of 11 February 1898, quoted in *Correspondance de Pissarro*, vol. 4, p. 455 n. 1.

106 Shikes and Harper, *Pissarro: His Life and Work*, p. 307.

107 Dauberville, vol. 3, pl. 2559.

108 See *Correspondance de Camille Pissarro*, vol. 5, pp. 385, 390–91.

109 Dauberville, vol. 1, pp. 21–70; 5 letters from Renoir to Bernheim written by Gabrielle, pp. 72–80; 3 letters from Renoir to Bernheim written by Pierre Renoir, pp. 81–4.

110 See *ibid.*, pp. 13, 298; the Bernheims sold it in 1940 to a Brazilian collector who in 1952 sold it to the São Paulo Museum of Art. See also Ch. 2 n. 118 above.

111 Guy-Patrice Dauberville, Bernheim-Jeune & Cie, Paris, to the author, 5 October 2012.

112 E.g., Renoir to M. Bernheim, n.l., 1898, in Dauberville, vol. 1, p. 23.

113 *Ibid.*, p. 100.

114 Unpublished, Renoir to Gallimard, Grasse, 28 January 1900, private collection.

115 See Bailey, *Renoir's Portraits*, p. 217.

116 Renoir to Geffroy, Paris, 10 July 1896, excerpt from Charavay, 6 April 1981, no. 257.

117 As noted by Manet, *Journal*, entry of 6 October 1896, p. 113 (not in Eng. edn).

118 *Ibid.*, entry of 20 October 1898, p. 198; *Growing up with the Impressionists*, p. 148.

119 Renoir to Durand-Ruel, Amsterdam, n.d. [October 1898], in *Correspondance de Renoir et Durand-Ruel*, vol. 1, p. 101.

120 Girard, *Renoir et Albert André*, p. 11.

121 Rabinow, *Cézanne to Picasso: Ambroise Vollard, Patron of the Avant-Garde*, 'Renoir', pp. 298.

122 Dauberville, vol. 1, pl. 582.

123 Rabinow, *Cézanne to Picasso*, pp. 144, 275, 398.

124 Pissarro to his son Lucien, Paris, 21 November 1895, in *Correspondance de Camille Pissarro*, vol. 4, p. 119.

125 Pissarro to Lucien, Paris, 20 January 1896, in *ibid.*, vol. 4, p. 153.

126 Rabinow, *Cézanne to Picasso*, p. 276. On 22 October 1895, Vollard bought from Renoir 2 paintings, 5 pastels and 5 pages of drawings for 600 francs; five days later he bought 8 more paintings for 800 francs.

127 *Ibid.*, pp. 275–6, 277. Renoir also exchanged one of his works portraying a woman's head for a small still life by Cézanne; *Cézanne Watercolors*, cat. no. 7, p. 25.

128 Dauberville, vol. 1, pl. 264.

129 Stella, *Graphic Work of Renoir*, pls 6–8; Delteil, *Peintre-graveur illustré*, vol. 17, pls 6–8; see related oil study, *c.* 1895–7, in Dauberville, vol. 3, pl. 2059. Geffroy, *La Vie artistique*, n.p.

130 Stella, *Graphic Work of Renoir*, pls 29, 30; Delteil, *Peintre-graveur illustré*, vol. 17, pls 29, 30.

131 Ambroise Vollard, *L'Album des Peintres-graveurs*, 1896, and *L'Album d'estampes originales de la Galérie Vollard*, 1898.

132 See Ch. 2 nn. 105–7 above.

133 Georges Durand-Ruel to Renoir, Paris, 21 September 1897, in *Correspondance de Renoir et Durand-Ruel*, vol. 2, p. 100.

134 Unpublished, Aline to Vollard, Essoyes, 7 September 1897, Paris, Bibliothèque des Musées Nationaux du Fonds Vollard, Ms. 421 on microfilm.

135 Rabinow, *Cézanne to Picasso*, p. 146.

136 *Ibid.*, p. 149, n. 15.

137 *Ibid.*, p. 277.

138 Manet, *Growing up with the Impressionists*, entries of 17 November, 23 December 1897, pp. 118, 121; French edn, *Journal*, pp. 141, 145–6.

139 Manet, *Journal*, entry of September 1897, p. 130 (not in Eng. edn).

140 Manet, *Growing up with the Impressionists*, addendum of August 1961, p. 81; French edn, *Journal*, p. 75.

141 Manet, *Journal*, entry of 17 August 1895, p. 60 (not in Eng. edn).

142 *Ibid.*, pp. 60–61.

143 *Ibid.*, entry of 23 December 1897, p. 146.

144 Unpublished, Renoir to Jeanne Baudot, n.l., 31 March 1900, private collection.

145 Baudot, *Renoir, ses amis, ses modèles*, p. 84.

146 Renoir to Bérard, Cagnes, n.d. [1899], excerpt from Hôtel Drouot sale catalogue, 11 June 1980, no. 98.

147 Manet, *Growing up with the Impressionists*, entry of 5 February 1898, p. 127; French edn, *Journal*, p. 152.

148 Renoir to Durand-Ruel, Magagnosc, Grasse, 16 December 1900, in *Correspondance de Renoir et Durand-Ruel*, vol. 1, p. 141.

149 Unpublished, Albert André to Durand-Ruel, n.l., 17 December 1900, Paris, Archives Durand-Ruel.

150 Renoir to unknown friend, Paris, *c.* 1898, excerpt from Charavay, January 1997, no. 45185.

151 Renoir to Bérard, n.l. [Louveciennes], July 1895, excerpt from New York, Swann Auction House, 17 May 1951, no. 117.

152 Manet, *Growing up with the Impressionists*, addendum of August 1961, p. 81; French edn, *Journal*, p. 75.

153 *Ibid.*, entry of 4 July 1898, p. 139; French edn, *Journal*, p. 169.

154 *Ibid.*, entry of 29 November 1895, p. 76; French edn, *Journal*, p. 74.

155 See Pharisien, *Renoir de vigne en vin*, p. 29.

156 Renoir to Julie Manet, Louveciennes, 5 September 1898, in Braun, *Renoir*, p. 10.

157 Manet, *Growing up with the Impressionists*, entry of 18 October 1896, p. 104; French edn, *Journal*, p. 116.

158 Georges Durand-Ruel to Renoir, Paris, 21 September 1897, in *Correspondance de Renoir et Durand-Ruel*, vol. 1, p. 100.

159 Manet, *Growing up with the Impressionists*, entry of 18 October 1896, p. 104; French edn, *Journal*, p. 116.

160 *Ibid.*, entry of 16 October 1897, p. 114; French edn, *Journal*, p. 136.

161 *Ibid.*, entry of 16 June 1898, p. 138; French edn, *Journal*, p. 167; *Jean holding a Hoop*, Dauberville, vol. 3, pl. 2377.

162 Manet, *Journal*, entry of 16 December 1896, p. 119 (not in Eng. edn).

163 *Ibid.*, entry of 2 July 1898, p. 168; *Growing up with the Impressionists*, p. 138.

164 Unpublished, Renoir to Jeanne Baudot, Berneval, n.d. [July 1898]; Grasse, 31 March 1900, private collection.

165 Renoir to Monet, n.l. [Paris], 16 March 1895, excerpt from Artcurial, 13 December 2006, no. 258.

166 Manet, *Growing up with the Impressionists*, entry of 3 December 1895, p. 78; French edn, *Journal*, p. 74.

167 Unpublished, Renoir to Congé, n.l., 1 February 1896, in Los Angeles, Getty Research Institute, CJPV87-A603.

168 Renoir to Murer, Paris, 4 February 1897, in Gachet, *Lettres impressionnistes*, p. 110.

169 Renoir to Jeanne Baudot, Grasse, n.d. [*c.* February 1900], in Baudot, *Renoir, ses amis, ses modèles*, p. 87.

170 Dauberville, vol. 3, pl. 2041.

171 *Ibid.*, pls 2374, 2363, 2479, 2548, respectively.

172 Pharisien, *Pierre Renoir*, p. 28.

173 Manet, *Growing up with the Impressionists*, entry of 10 August 1895, p. 62; French edn, *Journal*, p. 58.

174 *Ibid.*, addendum of August 1961, p. 81; French edn, *Journal*, p. 75.

175 *Ibid.*, entry of 24 September 1895, p. 68; French edn, *Journal*, p. 67.

176 *Ibid.*, entry of 27 October 1895, p. 70 (not in Eng. edn).

177 Renoir to Durand-Ruel, n.l. [Cagnes], n.d. [April 1899], in *Correspondance de Renoir et Durand-Ruel*, vol. 1, p. 113.

178 Unpublished notes, Aline to Bérard, n.l., *c.* 1898, in Paris, Archives Durand-Ruel.

179 Unpublished, Renoir to Jeanne Baudot, Grasse, 7 February 1900, private collection.

180 Unpublished, Renoir to Jeanne Baudot, Grasse, 31 March 1900, private collection.

181 Pharisien and Chartrand, *Victor Charigot*, p. 102.

182 Jean to Pierre Renoir, 8 May 1946, quoted in *ibid.*, p. 73.

183 *Ibid.*, pp. 104, 129.

184 Renoir to Julie Manet, Grasse, 17 January 1900, in White, *Renoir: His Life, Art, and Letters*, p. 217.

185 Renoir to Durand-Ruel, n.l. [Avignon], 24 May 1900, in *Correspondance de Renoir et Durand-Ruel*, vol. 1, p. 135.

186 Renoir to Durand-Ruel, Grasse, 30 May 1900, excerpt from Berlin, Stargardt, November 1962, catalogue no. 559, no. 563.

187 Unpublished, Renoir to Jeanne Tréhot Robinet, n.l., n.d. [*c.* 9 February 1899], private collection.

188 Unpublished, Renoir to Jeanne Tréhot Robinet, n.l., n.d. [early February 1899], private collection.

189 *Ibid.*

190 Unpublished, Renoir to Jeanne Tréhot Robinet, n.l. [Paris], 9 February 1899, private collection.

191 Unpublished, Vollard to Jeanne Tréhot Robinet, Paris, 9 February 1899, private collection.

192 Unpublished, Renoir to Jeanne, see n. 190 above.

193 *Ibid.*

194 Unpublished, Renoir to Jeanne Tréhot Robinet., n.l. [Louveciennes], 15 August 1900, private collection.

195 This is confirmed by Renoir's letter to Jeanne in 1908 in which he writes about repairing and hiring out the oven; Renoir to Jeanne Tréhot Robinet, Bourbonne-les-Bains, n.d. [August 1908], in Gélineau, *Jeanne Tréhot, la fille cachée*, p. 50.

196 Unpublished, Renoir to Louis Robinet, Grasse, 1 February 1901, private collection.

Chapter 5 1901–09

1 Renoir to unidentified male friend, Paris, 4 September 1901, in Dauberville, vol. 1, pp. 29–30.

2 Extract from birth certificate, Département de l'Aube, Arrondissement de Troyes, Canton d'Essoyes, Commune d'Essoyes, 4 August 1901, 6 p.m., 'Born in our commune, Claude Renoir, of masculine sex, from Pierre-Auguste Renoir, artist painter, and Aline Victorine Renoir, without profession.'

3 Unpublished, Renoir to Mme Baudot, Essoyes, 4 August 1901, private collection.

4 Renoir to Téodor de Wyzewa, n.l., 7 August 1901, trans. excerpt in Boston, Mass., Rendell sale catalogue 129, *c.* 1977, no. 370.

5 Unpublished, Renoir to Jeanne Baudot, Essoyes, 8 August 1901, private collection.

6 Aline's father's full name was Claude-Victor Charigot, and his older brother, with whom Aline lived when her mother left Essoyes, was Claude; Pharisien, *Célébrités d'Essoyes*, pp. 19–20.

7 See n. 5 above.

8 Baptism certificate, 21 August 1902, private collection.

9 Customarily, the Renoir family took a train from Paris and the Muniers picked them up at the railway station.

10 Dauberville, vol. 4, pl. 3443.

11 Renée Jolivet was born in Châtillon-sur-Seine on 20 December 1885, was married twice and died in 1973. See Bailey, *Renoir's Portraits*, pp. 236, 330 nn. 14, 15.

12 Dauberville, vol. 4, pl. 3125.

13 Coco wears the same outfit in a photograph of 1902; Bailey, *Renoir's Portraits*, p. 331, fig. 290.

14 Dauberville, vol. 4, pl. 3124.

15 For the two paintings on the same wall see Bailey, *Renoir, Impressionism, and Full-Length Painting*, p. 168, fig. 2.

16 For Renoir's military record book see Ch. 1 n. 140 above. Aline's blue eyes and red hair are evident in her 1885 portrait (Dauberville, vol. 2, pl. 1066 is in black and white). Unpublished military record book of Jean Renoir, 1913–40, Paris, Service Historique de l'Armée de Terre, dossier 41/9912, copy courtesy of private collection; later, Jean developed Aline's robust plumpness.

17 Renoir to P. Alfred Cheramy, Le Cannet, 25 February 1902, excerpt from Paris, Charavay, leaflet, September 1975, no. 36688.

18 For Sainte-Croix see Ch. 4 p. 212 above.

19 Renoir to Jeanne Baudot, n.l. [Essoyes], August 1903, in Baudot, *Renoir, ses amis, ses modèles*, p. 100.

20 Renoir stayed in Bourbonne-les-Bains from 12 August to 15 September 1904; see *Correspondance de Renoir et Durand-Ruel*, vol. 1, pp. 228–34.

21 Renoir to Mlle Cornillac [Maleck], n.l. [Essoyes], n.d. [21 August 1901], in 'Lettres de Renoir à quelques amis', p. 46.

22 Josse Bernheim-Jeune (b. 1870) married Mathilde Adler (b. 1882) and Gaston (also b. 1870), married Suzanne (b. 1883).

23 Unpublished, Renoir to Jeanne Baudot, (Cannes) Le Cannet, 25 March 1903, private collection.

24 Renoir to Paul Durand-Ruel, Cannes le Cannet, 3 February 1902, in *Correspondance de Renoir et Durand-Ruel*, vol. 1, p. 165.

25 Unpublished, Renoir to Jeanne Baudot, (Cannes) Le Cannet, 26 March 1902, private collection.

26 Unpublished, Albert André to Durand-Ruel, n.l., 2 March [1902], in Paris, Archives Durand-Ruel.

27 Renoir to Aline, Paris, 22 February 1904, in White, *Renoir: His Life, Art, and Letters*, p. 222.

28 Renoir to Marguerite Cornillac [Maleck], n.l. [Cagnes], n.d. [9 April 1903], in 'Lettres de Renoir à quelques amis', p. 48.

29 Renoir to Wyzewa, Paris, 1 May 1902, trans. excerpt from Rendell, sale catalogue 107, n.d., no. 231.

30 Unpublished, Renoir to Jeanne Baudot, Cagnes, 4 December 1903, private collection.

31 Renoir to Georges Rivière, Cagnes, 29 February 1908, excerpt from Berlin, Stargardt, March 1988, sale catalogue 641, no. 708.

32 Unpublished, Renoir to Maurice Gangnat, Paris, 2 September 1908, private collection.

33 Unpublished, Renoir and Gabrielle to Gangnat, Wessling, summer 1910, private collection.

34 Renoir to Rivière, Bourbonne-les-Bains, 25 August 1906, in White, *Renoir: His Life, Art, and Letters*, p. 234.

35 E.g., the artist Jacques-Félix Schnerb, 'Visites à Renoir et à Rodin', p. 175, 'one of Renoir's maids' (diary entry, February 1907).

36 Julie Manet, *Growing up with the Impressionists*, entry of 10 August 1895, p. 62; French edn, *Journal*, p. 58.

37 Renoir and Gabrielle to Gangnat, Wessling, summer 1910, in White, *Renoir: His Life, Art, and Letters*, p. 245.

38 Gabrielle to Marguerite Cornillac, Cagnes, 14 November 1905, in 'Lettres de Renoir à quelques amis', p. 54.

39 Renoir to M. Bernheim, Cagnes, 23 January 1906, in Dauberville, vol. 1, p. 33.

40 Renoir to Marguerite Cornillac, n.l. [Cagnes], 15 April 1904, in 'Lettres de Renoir à quelques amis', p. 52.

41 Renoir to André, Cagnes, 2 January 1909, in *ibid.*, p. 55.

42 Schnerb, 'Visites à Renoir et à Rodin', p. 175, referring to *The Reclining Nude*, 1903, exhibited at the Salon d'Automne of 1905, and *Seated Woman in Oriental Costume*, c. 1905–7, Dauberville, vol. 4, pls 3502, 3480, respectively.

43 Unpublished, Renoir and Gabrielle to Rivière, n.l. [Cagnes], n.d. [c. 11 January 1908], Paris, Institut Néerlandais, Fondation Custodia (Collection F. Lugt).

44 Renoir to Aline, Paris, 22 February 1904, in White, *Renoir: His Life, Art, and Letters*, p. 222.

45 Renoir to Durand-Ruel, Cagnes, 11 February 1909, in *Correspondance de Renoir et Durand-Ruel*, vol. 2, p. 41.

46 Dauberville, vol. 1, p. 100; Drucker, *Renoir*, p. 221.

47 C.-L. de Moncade, 'Le Peintre Renoir et le Salon d'Automne', quoted in Renoir, *Écrits, entretiens et lettres*, pp. 9, 10; trans. in White, *Impressionism in Perspective*, pp. 23, 24.

48 Dauberville, vol.. 1, pls 224, 254.

49 White, *Impressionism in Perspective*, p. 24.

50 Renoir quoted in Schnerb, diary entry of 27 June 1909, repr. in 'Visites à Renoir et à Rodin', p. 176.

51 Paris, Hôtel Drouot, Lagarde-Samary sale, 25–7 March 1903, including Renoir's *Woman with a Fan*, bought by Paul Rosenberg for 10,000 francs, Dauberville, vol. 1, pl. 344.

52 Renoir to Jeanne Baudot, Cagnes, 25 April 1903, in Baudot, *Renoir, ses amis, ses modèles*, pp. 100–01.

53 Purchased from the Charpentier estate sale after the deaths of M. Charpentier in 1905 and Mme Charpentier in 1904. Bénédite, 'Madame Charpentier and her Children by Auguste Renoir', pp. 237, 240.

54 Georges Durand-Ruel to Renoir, Paris, 13 March 1901, in *Correspondance de Renoir et Durand-Ruel*, vol. 1, pp. 148–9.

55 Unpublished, Durand-Ruel to Renoir, Paris, March 1903, in Paris, Archives Durand-Ruel.

56 See Renoir to Durand-Ruel, n.l. [Cagnes], n.d. [after 26 December 1903], in *Correspondance de Renoir et Durand-Ruel*, vol. 1, p. 209; see also Distel, *Renoir*, p. 329.

57 Unpublished, Renoir to Jeanne Baudot, Le Cannet, 10 February 1903, private collection.

58 Renoir to André, Cagnes, 24 December 1903, in 'Lettres de Renoir à quelques amis', p. 51.

59 Durand-Ruel to Renoir, Paris, 23 December 1903, in *Correspondance de Renoir et Durand-Ruel*, vol. 1, pp. 201–2.

60 Unpublished, Renoir to André, Le Cannet, 2 March 1903, in Paris, Archives Durand-Ruel.

61 Renoir to Durand-Ruel, n.l. [Cagnes], 13 January 1904; Cagnes, 10 February 1904, in *Correspondance de Renoir et Durand-Ruel*, vol. 1, pp. 211, 218.

62 See Distel, *Renoir*, p. 329.

63 Renoir to Durand-Ruel, Le Cannet, 9 March 1902, in *Correspondance de Renoir et Durand-Ruel*, vol. 1, pp. 169–70.

64 Renoir to Durand-Ruel, n.l. [Essoyes], 20 September 1904, in *ibid.*, p. 239.

65 Moncade, 'Le Peintre Renoir et le Salon d'Automne', p. 11; trans. in White, *Impressionism in Perspective*, p. 24.

66 House and Distel, *Renoir*, pp. 316–17: in 1902, Durand-Ruel exhibited 47 works; in 1903, 23; in 1904, 69; in 1905, 70; in 1906, 22; in 1907, 86; in 1908, 165 (in Paris and New York); in 1909, 32.

67 The Bernheims seem to have sold their first Renoir in 1897; see Distel, 'Vollard and the Impressionists', p. 146.

68 Renoir to Alexandre Bernheim, Cagnes, 6 December 1909, in Dauberville, vol. 1, p. 38.

69 Renoir to Durand-Ruel, [Cannes], 25 April 1901, in *Correspondance de Renoir et Durand-Ruel*, vol. 1, pp. 155–6. L'Abbé Gauguin's art collection sold for 127,400 francs in May 1901.

70 Durand-Ruel to Renoir, Paris, 4 May 1901, in *ibid.*, p. 157.

71 For Renoir to Bernheim from 1898 onwards see Dauberville, vol. 1, pp. 21–86.

72 Unpublished, Durand-Ruel to Renoir, Paris, March 1903, in Paris, Archives Durand-Ruel.

73 Unpublished, Durand-Ruel to Renoir, Paris, 22 December 1908, in *ibid*.

74 Renoir to Durand-Ruel, Cagnes, 25 December 1908, in *Correspondance de Renoir et Durand-Ruel*, vol. 2, p. 35.

75 See Georges Durand-Ruel to Renoir, Paris, 10 January 1911, in *ibid.*, p. 71.

76 Renoir to Durand-Ruel, n.l. [Bourbonne-les-Bains], 4 September 1904, in *ibid.*, vol. 1, p. 232.

77 Redon to Mlle Paule Gobillard, Cannes, 26 February 1901, in Redon, *Lettres d'Odilon Redon*, p. 46.

78 Renoir to Bérard, Essoyes, 22 September 1903, excerpt in Paris, Librairie de

l'Abbaye, n.d., sale catalogue 246, no. 231.

79 Unpublished, Georgette Dupuy to Jeanne Tréhot, 4 May 1909, private collection.

80 Unpublished, André to Durand-Ruel, n.l. [Cagnes], n.d. [May 1908], in Paris, Archives Durand-Ruel.

81 Renoir to André, Cagnes, 16 February 1905, in 'Lettres de Renoir à quelques amis', p. 53.

82 Renoir to Ferdinand Deconchy (on whom see n. 113 below), n.l., 14 July 1904, excerpt in Berlin, Stargardt, 24–5 November 1964, sale catalogue no. 570, no. 903.

83 Renoir to André, Bourbonne-les-Bains, 16 August 1904, in White, *Renoir: His Life, Art, and Letters*, p. 223.

84 Unpublished, Renoir to André, Bourbonne-les-Bains, 17 August 1904, in Paris, Archives Durand-Ruel Archives.

85 Unpublished, Renoir to Jeanne Baudot, Bourbonne-les-Bains, 30 August 1904, private collection.

86 Renoir to Vollard, Aix-les-Bains, 5 May 1901, in Drucker, *Renoir*, p. 141.

87 Renoir to Julie Manet Rouart, Essoyes, 23 September 1904, in Roger-Marx, *Renoir*, p. 83.

88 Renoir to Durand-Ruel, n.l. [Essoyes], 18 September 1904, in *Correspondance de Renoir et Durand-Ruel*, vol. 1, p. 237.

89 Dauberville, vol. 4, pls 3473–6, 3523.

90 *Ibid.*, vol. 1, pl. 583; vol. 2, pl. 1292, respectively.

91 Renoir to Paule Gobillard, Cagnes, 4 January 1907, in White, *Renoir: His Life, Art, and Letters*, p. 235.

92 Unpublished, Georges Rivière to Renoir, n.l. [Paris], 28 February 1908, private collection.

93 Dauberville, vol. 1, pl. 603.

94 Wyzewa, diary entry of 29 January 1903, in Wadley, *Renoir: A Retrospective*, p. 234.

95 For the portraits of Mme Fritz (Betty) Thurneyssen see Dauberville, vol. 4, pl. 3139. Rubens paintings in the Pinakothek: *Rubens and Isabella Brant in the Honeysuckle Bower, Hélène Fourment in her Bridal Gown, Madonna in a Garland of Flowers, The Rape of the Daughters of Leucippus, The Death of Seneca, The Drunken Silenus, The Battle of the Amazons, The Great Last Judgment, The Entombment of Christ, The Fall of the Damned, The Massacre of Innocents, Landscape with Herd of Cows*; oil sketches: *Lion Hunt* and *The Landing in Marseilles* and *Council of the Gods* for the Medici Cycle.

96 Pach, 'Pierre-Auguste Renoir', repr. in Wadley, *Renoir: A Retrospective*, p. 245; French in Renoir, *Écrits, entretiens et lettres*, p. 14.

97 Dauberville, vol. 4, pl. 3471.

98 For Renoir's studies for *Judgment of Paris* see Dauberville, vol. 4, pls 3566, 3567, 3582.

99 *Ibid.*, pl. 3519; Anacreon (582–485 BC).

100 For a male river god, oil study, 55 cm x 1.5 cm, see Paris, Documentation Orsay.

101 Unpublished, Renoir to Georges Rivière, n.l., n.d. [*c.* 1908], private collection.

102 Renoir to a male friend, Cagnes, 12 November 1908, excerpt in Paris, Charavay, November 1959, sale catalogue 702, no. 27.443.

103 Renoir to Marguerite Cornillac [Maleck], Cagnes, 9 April 1903, in 'Lettres de Renoir à quelques amis', p. 48.

104 La Grande Louise was Marie Louise Petit, née Goyard (1866–1926), a cook who stayed with the Renoirs until her death. Clément Munier was the caretaker of the Essoyes house. Unpublished, Renoir to Aline, n.l., 11 July 1908, private collection.

105 Renoir records a 'Mlle. Georgette Maliverney, chez Mme. Charlet, rue Marie Stuart, 21'; notebook, n.d., n.p. [p. 16], private collection. By 1908, Georgette (b. 1872) was living with Raoul Dupuy (b. 1873), a decorative painter from Grenoble, and called herself Georgette Dupuy, or Mme Raoul Dupuy, though they did not marry until December 1915. See Gélineau, *Jeanne Tréhot, la fille cachée*, pp. 56–7.

106 Pharisien, *Quand Renoir vint paysanner*, pp. 47–8, 57. In an email to the author on 25 February 2017, Bernard Pharisien, Essoyes native and scholar, said that his recent research shows that renovations began in 1898 and were completed a few years afterwards.

107 See Paris, Hôtel Drouot, Gangnat collection, 24–5 June 1925.

108 Dauberville, vol. 4, pl. 3438.

109 Unpublished, Renoir to Maurice Gangnat, Cagnes, 1 January 1907, private collection.

110 Dauberville, vol. 4, pls 3251, 3252.

111 Unpublished, Renoir to Gangnat, Cagnes, 2 March 1907, private collection.

112 Unpublished, Renoir to Gangnat, Cagnes, 24 March 1907, private collection.

113 Mlle Savournin, whose parents owned the elegant Hotel Savournin in Cagnes, had married Ferdinand Deconchy, a painter friend of Renoir's, in 1894; later, he was mayor of Cagnes in 1912–19.

114 Claude Renoir, 'Une visite', *Renoir aux Collettes*, 2 (1961), n.p. For the purchase see Isabelle Pintus, 'Sur les traces de Renoir dans les archives', p. 130.

115 See Pharisien, *Quand Renoir vint paysanner*, p. 65.

116 Renoir to Durand-Ruel, Cagnes, 15 November 1908, in *Correspondance de Renoir et Durand-Ruel*, vol. 2, p. 34.

117 Unpublished, Rivière to Renoir, Montreuil, 9 November 1909, private collection.

118 The first Paris subway system, the 'métro' (*métropolitain*), opened on 19 July 1900; Pigalle station, near Renoir's apartment and studio, opened in 1902.

119 Schnerb, diary entry of 27 June 1909, repr. in 'Visites à Renoir et à Rodin', p. 176.

120 Jeanne Baudot wrote of Aline's dishes in *Renoir, ses amis, ses modèles*, pp. 68–9.

121 Renoir to Durand-Ruel, Cagnes, 25 March 1907, in *Correspondance de Renoir et Durand-Ruel*, vol. 2, p. 10.

122 Renoir to Julie Manet Rouart, Cagnes, 20 March 1908, in Renoir, *Écrits, entretiens et lettres*, p. 151.

123 Renoir to Victor Mottez, n.l., 10 July 1909, excerpt in Paris, Librairie L'Echiquier, n.d., sale catalogue, no. 13.

124 Unpublished, Gabrielle to Vollard, n.l., n.d. [*c.* 13 June 1911], in Paris, Bibliothèque des Musées Nationaux du Fonds Vollard, Ms. 421 on microfilm. Renoir and Gabrielle to Maurice Gangnat, Wessling, summer

1910, in White, *Renoir: His Life, Art, and Letters*, p. 245.

125 Denis, *Journal*, entry of March 1906, vol. 2, p. 35.

126 Renoir to Paule Gobillard, Cagnes, 1908, in White, *Renoir: His Life, Art, and Letters*, p. 241 n. 83.

127 Dauberville, vol. 4, pl. 3315.

128 Unpublished, Renoir to Gangnat, Cagnes, 12 and 19 February 1908, private collection.

129 Renoir to Julie Manet Rouart, Cagnes, 20 March 1908, in Braun, *Renoir*, p. 12.

130 Unpublished, Renoir to Rivière, Cagnes, 26 March 1908, private collection.

131 Unpublished, Aline to Durand-Ruel, Cagnes, 23 October 1908, in Paris, Archives Durand-Ruel.

132 Unpublished, Renoir to Rivière, 3 August 1909, in University of Texas, Austin, archives.

133 Unpublished, Renoir to Mme Gangnat, n.l., 9 November 1909, private collection.

134 Dauberville, vol. 4, pl. 3389; Edmond Renoir became engaged to Hélène Rivière at that time.

135 Rabinow, *Cézanne to Picasso*, p. 279.

136 *Ibid.*, p. 284.

137 Dauberville, vol. 1, pl. 114; for *Young Woman Seated Outdoors, Young Woman Seated Inside* and *Woman and Child* see Rabinow, *Cézanne to Picasso*, pp. 283, 301, no. 167 (Paris, Bibliothèque des Musées Nationaux du Fonds Vollard, Ms. 421 [5, 2], fol. 170).

138 Rabinow, *Cézanne to Picasso*, p. 283.

139 *Ibid.*, pp. 280, 301 n. 105 (Fonds Vollard, Ms. 421 [4, 10], pp. 1–2).

140 *Ibid.*, p. 281: on 16–17 February 1906, he bought two pastel heads for 1,000 francs from an Hôtel Drouot auction.

141 Unpublished, Renoir to André, Bourbonne-les-Bains, 17 August 1904, in Paris, Institut Néerlandais, Fondation Custodia (Collection F. Lugt).

142 Rewald, *Cézanne: A Biography*, pp. 254–5.

143 Cézanne to Gasquet, Aix-en-Provence, 8 July 1902, in Cézanne, *Paul Cézanne: Correspondance*, p. 289.

144 Delteil, *Peintre-graveur illustré*, vol. 17, pl. 34; Stella, *Graphic Work of Renoir*, pl. 34.

145 Haesaerts, *Renoir Sculptor*, pl. XXVI.
146 Distel, *Renoir*, p. 391 n. 28, citing Rewald, *The Paintings of Paul Cézanne*, no. 485, *Cottages in Auvers-sur-Oise*, c. 1872–73; no. 539, *House among the Trees*, 1881; *Turn in the Road at La Roche-Guyon*, 1885; *Battle of Love*, 1880; Rewald, *Les Aquarelles de Cézanne*, no. 107, *Jug and Bowls*; no. 132, *Bathers*.
147 Renoir to Monet, Cagnes, 6 December 1909, in Baudot, *Renoir, ses amis, ses modèles*, pp. 110–11.
148 Unpublished, Alice Monet to Germaine Salerou, Giverny, 22 October 1905, private collection.
149 Unpublished, Alice Monet to Germaine Salerou, Giverny, 25 October 1906, *ibid.*
150 Unpublished, Alice Monet to Germaine Salerou, n.l. [Paris], 26 October 1906, *ibid.* For the lost drawing of Monet see White, *Impressionists Side by Side*, p. 104.
151 Haesaerts, *Renoir Sculptor*, pl. 25.
152 Stella, *Graphic Work of Renoir*, pls 37, 337–48, respectively; Delteil, *Peintre-graveur illustré*, vol. 17, pls 37–48.
153 White, *Renoir: His Life, Art, and Letters*, p. 228.
154 Rabinow, *Cézanne to Picasso*, p. 280.
155 Dauberville, vol. 4, pl. 3388.
156 Renoir to Vollard, Cagnes, 5 May 1908, in White, *Renoir: His Life, Art, and Letters*, p. 241.
157 Dauberville, vol. 4, pl. 3392. Héran, 'Vollard, Publisher of Maillol's Bronzes', pp. 172–81. Maillol completed the statue in 1900.
158 Frère, *Conversations de Maillol*, pp. 237–8.
159 *Ibid.*
160 Renoir to Vollard, Essoyes, 12 September 1906, in White, *Renoir: His Life, Art, and Letters*, p. 235.
161 Frère, *Conversations de Maillol*, pp. 237–8.
162 Héran, 'Vollard, Publisher of Maillol's Bronzes', p. 176.
163 Frère, *Conversations de Maillol*, pp. 238–9.
164 Haesaerts, *Renoir Sculptor*, pl. III, d. 21.5 cm (8½ in.); pl. IV, 26 cm (10¼ in.).
165 Dauberville, vol. 1, pl. 479.
166 Unpublished, André to Durand-Ruel, n.l., 2 April 1903, in Paris, Archives Durand-Ruel.
167 See Yeatman, *Albert André*, pp. 26, 83 (André's *Vue des Collettes*, 1908).
168 Renoir to Durand-Ruel, Cannes le Cannet, Villa Printemps, 3 February 1902, in *Correspondance de Renoir et Durand-Ruel*, vol. 1, p. 165.
169 Unpublished, André to Durand-Ruel, n.l., 2 March 1902, Paris, Archives Durand-Ruel.
170 Yeatman, *Albert André*, p. 24 (*Renoir Seated in the Garden*, 1901).
171 For this André made at least seven pen drawings showing Renoir from different vantage points; see Girard, *Renoir et Albert André, une amitié*, p. 25; of two preparatory oil sketches one is now owned by the Musée Albert André de Bagnols-sur-Cèze. He also made several versions in different sizes and degrees of finish: pp. 27–8, 38–40.
172 Dauberville, vol. 3, pl. 2390.
173 Renoir to Durand-Ruel, Cagnes, 19 May 1903, in *Correspondance de Renoir et Durand-Ruel*, vol. 1, p. 187.
174 Dauberville, vol. 4, pls 3357, 3028, respectively.
175 White, *Renoir: His Life, Art, and Letters*, p. 227.
176 Renoir to Marguerite Cornillac, n.l. [Cagnes], n.d. [14 November 1905], in 'Lettres de Renoir à quelques amis', p. 54.
177 Schnerb, 'Visites à Renoir et à Rodin', p. 176.
178 Unpublished, Rivière to Renoir, Montreuil, 2 October 1909, private collection.
179 Unpublished, Renoir to Rivière, on reverse Gabrielle to Rivière, n.l., c. 11 January 1908, in Paris, Institut Néerlandais, Fondation Custodia (Collection F. Lugt).
180 Dauberville, vol. 3, pls 2387–9.
181 Jean Renoir, *Renoir* (1962), pp. 365, 368–9.
182 Renoir to Marguerite Cornillac, Cagnes, 9 April 1903, in 'Lettres de Renoir à quelques amis', p. 48.
183 Unpublished, Renoir to Jeanne Baudot, Cagnes, 4 December 1903, private collection.

184 Unpublished, Renoir to André, Cagnes, 8 December 1903, Paris, Institut Néerlandais, Fondation Custodia (Collection F. Lugt).

185 Unpublished, Alain Meunier to Renoir, n.l. [Paris], n.d. [January 1905], private collection.

186 Unpublished, Rivière to Renoir, Paris, 11 April 1908, private collection.

187 Jean Renoir, 'Pour tout vous dire', 1958 interview.

188 Jean Renoir, *Renoir, My Father*; French edn, *Renoir*.

189 Jean Renoir, 'Pour tout vous dire'.

190 E.g., Renoir to Julie Manet, n.l., January 1896 (Pierrot); Renoir to Aline, n.l., 22 February 1904 (Cloclo), both unpublished, private collection; Renoir to Jeanne Baudot, Cagnes, 25 April 1903 (Clo), in Baudot, *Renoir, ses amis, ses modèles*, p. 101.

191 Unpublished, Renoir to Jeanne Baudot, Cagnes, 23 November 1903, private collection.

192 E.g., unpublished, Jean Renoir to Renoir, Sisteron, 16 June 1919, private collection.

193 Unpublished, Renoir to Jean Renoir, Cagnes, 10 March 1918, private collection.

194 E.g., unpublished, Renoir to Pierre Renoir, Cagnes, 14 May 1908, private collection.

195 Unpublished, Renoir to Jeanne Baudot, Cagnes, 9 May 1905, private collection.

196 Unpublished, Renoir to Aline, n.l. [Paris], 12 July 1908, private collection.

197 Renoir to unidentified male friend, Cagnes, 12 November 1908, excerpt from Paris, Charavay, November 1959, sale catalogue 702, no. 27.443.

198 Pierre Renoir, interview with Jany Casanova, *Paris-Soir*, 9 March 1938, quoted in Pharisien, *Pierre Renoir*, p. 34.

199 Pierre Renoir, interview, 'En causant avec Monsieur Renoir', *Le Matin*, 6 February 1937, quoted in *ibid.*

200 Renoir to Paul Gallimard, Paris, 28 December 1902, excerpt from Berlin, Stargardt, 3–4 December 1963, sale catalogue 565, no. 761.

201 Unpublished, Renoir to Gallimard, Paris, *c.* 1903, in Paris, Archives Durand-Ruel.

202 Unpublished, Renoir to Albert André, n.l., n.d. [1909–10], in *ibid.*

203 In 1946, the Conservatoire was split into the Conservatoire National Supérieur d'Art Dramatique and the Conservatoire National Supérieur de Musique et de Danse de Paris.

204 Renoir to Bernheim, Cagnes, 10 May 1906, in Dauberville, vol. 1, p. 34, repro. p. 35.

205 Renoir to Durand-Ruel, Cagnes, 11 January 1908, in *Correspondance de Renoir et Durand-Ruel*, vol. 2, p. 18.

206 Renoir to Aline, n.l., 22 February 1904, in White, *Renoir: His Life, Art, and Letters*, p. 222.

207 Renoir to André, Cagnes, 8 December 1903, in *ibid.*, p. 229.

208 Pharisien, *Pierre Renoir*, p. 36 n. 15.

209 Unpublished, Pierre Renoir to Vollard, Paris, n.d. [*c.* 1905–10], in Paris, Bibliothèque des Musées Nationaux du Fonds Vollard, letter 346.

210 Unpublished, Pierre Renoir to Vollard, Paris, n.d. [*c.* 1905–10], in *ibid.*

211 Pierre Renoir, unpublished military record book, 31 May 1906, private collection.

212 *Ibid.*, Paris, 13 June 1906.

213 For Renoir's military record book see Ch. 1 n. 140 above.

214 Renoir to Misia [Mme Natanson, later Mme Edwards], Paris, 3 July 1906, excerpt from Paris, Librairie de l'Abbaye, *c.* summer 1975, sale catalogue 215, no. 123.

215 Unpublished, Renoir to Aline, n.l. [Paris], 12 July 1908, private collection.

216 Pharisien, *Pierre Renoir*, pp. 30–31, 483–4.

217 Georges Pioch, review, *Comoedia*, n.d. [1909], quoted in *ibid.*, pp. 31–2.

218 Pharisien, *Pierre Renoir*, p. 53.

219 Unpublished, Renoir to Pierre Renoir, n.l., n.d. [*c.* 10 January 1909], private collection.

220 Paul Paulin, a dentist and sculptor, made several flattering busts of contemporary artists, including Degas, Monet and Pissarro. In 1904, various

casts of his Renoir bust appeared in tinted plaster and in bronze; see F. M., 'Le mois artistique', pp. 175–6.

221 Unpublished, Renoir to Pierre, n.l., n.d. [c. 1909], private collection.

222 Schnerb, 'Visites à Renoir et à Rodin', p. 176.

223 Unpublished receipt, Isaïe [Isaiah] Hébert to Jeanne Tréhot Robinet, Madré, 2 August 1908, private collection.

224 Unpublished, Vollard to Jeanne Tréhot Robinet, Cabourg, 11 April 1908, private collection.

225 Unpublished receipt, Hébert to Tréhot Robinet.

226 Unpublished, Renoir to Vollard, Cagnes, 5 May 1908, private collection.

227 Unpublished, Vollard to Jeanne Tréhot Robinet, Paris, 29 July 1908, private collection.

228 Renoir to Jeanne, Bourbonne-les-Bains, n.d. [August 1908], in Gélineau, *Jeanne Tréhot, la fille cachée*, pp. 49–50, 52–3 (repro. of letter).

229 *Ibid.*, p. 53.

230 Unpublished, Renoir to Jeanne Tréhot Robinet, n.l., n.d. [c. 10 October 1908], private collection.

231 Unpublished, Renoir to Jeanne Tréhot Robinet, Paris, 30 October 1908, private collection.

232 Unpublished, Renoir's will, Paris, 14 October 1908, private collection; most of the will has been published in Gélineau, *Jeanne Tréhot, la fille cachée*, p. 51.

233 Unpublished, Renoir to Jean Renoir, Cagnes, 15 September 1914, private collection.

234 See Durand-Ruel to Renoir, Paris, 8 February 1909: 'Monet told me that you think to travel around Italy in May'; Renoir to Durand-Ruel, Cagnes, 11 February 1909: 'For my trip to Italy, it is not yet certain. I am worried I will drag around in hotels and will get more bad out of it than good. We'll see', in *Correspondance de Renoir et Durand-Ruel*, vol. 2, pp. 37, 41. The project was first postponed and then abandoned.

235 Unpublished, Renoir to Jeanne Tréhot Robinet, n.l. [Cagnes], n.d. [c. February 1909], private collection; part published in Gélineau, *Jeanne Tréhot, la fille cachée*, p. 55. There is no evidence that Renoir went to Venice or Egypt at that time.

236 Unpublished, Gabrielle to Jeanne Tréhot Robinet, n.l., n.d. [c. 1908–12], private collection.

237 See *Annuaire statistique de la France: résumé rétrospectif 1966* (Paris: INSEE [National Institute for Statistics and Economic Studies], 1966), p. 438.

238 Unpublished, Renoir to Jeanne Tréhot Robinet, 1 August 1909, private collection.

239 Unpublished, Gabrielle to Jeanne Tréhot Robinet, n.l., n.d. [c. 1908–1912], private collection.

240 *Ibid.*

241 Unpublished, Renoir to Jeanne Tréhot Robinet, n.l., n.d. [c. 10 October 1908], private collection.

242 Unpublished, Renoir to Jeanne Tréhot Robinet, n.l. [Cagnes], n.d. [c. 1909], private collection.

243 Gélineau, *Jeanne Tréhot, la fille cachée*, p. 57

244 Unpublished, Renoir to Georgette Dupuy, n.l., n.d. [1908], private collection.

245 Unpublished, Georgette Dupuy to Jeanne Tréhot Robinet, n.l. [Cagnes], 4 May 1909, private collection.

246 Unpublished, Georgette Dupuy to Jeanne Tréhot Robinet, Paris, n.d. [spring 1909], private collection.

247 Unpublished, Georgette Dupuy to Jeanne Tréhot Robinet, Paris, n.d. [May 1909], private collection.

248 Unpublished, Georgette Dupuy to Jeanne Tréhot Robinet, Paris, 15 July 1909, private collection.

249 Unpublished, Renoir to Jeanne Tréhot Robinet, Paris, n.d. [c. 14 July 1909], private collection.

250 Unpublished, Georgette Dupuy to Jeanne Tréhot Robinet, Paris, 23 August 1909, private collection.

251 Unpublished, Renoir to Jeanne Tréhot Robinet, n.l. [Paris], September 1909, private collection.

252 See Le Coeur, 'Lise Tréhot: portrait d'après nature', p. 6.

Chapter 6 1910–15

1 Dauberville, vol. 4, pl. 3391, acquired by Durand-Ruel.

2 *Ibid.*, pl. 3455, 120 x 77 cm (47¼ x 30¼ in.). For Watteau's painting see Bailey, *Renoir's Portraits*, p. 334, fig. 298.

3 Dauberville, vol. 4, pl. 3465.

4 Renoir had seen this painting of the heir to the Spanish throne during a trip to Madrid in 1892; Bailey, *Renoir's Portraits*, p. 336, fig. 303.

5 Undated but a 1910 entry in Maurice Denis's diary notes that Renoir was working on an oil portrait of his wife; Denis, *Journal*, vol. 2, p. 334 n. 1.

6 Belloni, *Pompeian Painting*, pl. II. Renoir admired these frescoes in 1881 in the Naples Archaeological Museum.

7 For a 1912 photograph of Renoir, Aline and Coco in Essoyes (see p. 273)

8 Dauberville, vol. 5, pls 4168, 4206.

9 *Portrait of Pierre*, 44 x 36.5 cm (17⅜ x 14⅜ in.); *Frontal Self-Portrait*, 47 x 36 cm (18½ x 14⅛ in.); *ibid.*, vol. 4, pls 3397, 3390, respectively.

10 See n. 1 above.

11 Renoir to Renée Rivière, n.l. [Nice], 23 February 1912, in White, *Renoir: His Life, Art, and Letters*, p. 253.

12 Jean Renoir, *Renoir, My Father* (1958), pp. 445–56.

13 Renoir to Rivière, Nice, 5 February 1912, in White, *Renoir: His Life, Art, and Letters*, p. 253.

14 Gabrielle to Vollard, Cagnes, 12 June 1912, excerpt from Hôtel Drouot sale catalogue, 6 June 1976.

15 Unpublished, Aline to Durand-Ruel, Cagnes, 18 June 1912, in Paris, Archives Durand-Ruel.

16 Aline to Durand-Ruel, 21 June 1912, in *Correspondance de Renoir et Durand-Ruel*, vol. 2, p. 112.

17 Dauberville, vol. 1, pp. 72–80.

18 Renoir to Durand-Ruel, Cagnes, 25 February 1911, in *Correspondance de Renoir et Durand-Ruel*, vol. 2, p. 78.

19 Aline's cousin was Paul Parisot; unpublished, Aline to Durand-Ruel, Cagnes, 11 March 1911, in Paris, Archives Durand-Ruel.

20 Unpublished, Mary Cassatt to Louisine Havemeyer, Grasse, 21 May [1913], in New York, Metropolitan Museum, Archives.

21 Unpublished, Aline to Durand-Ruel, Cagnes, 15 October 1913, in Paris, Archives Durand-Ruel.

22 For a photograph of Baptistin see Gélineau, 'La Vie de Jeanne Tréhot, fille d'Auguste Renoir', p. 19.

23 Sowerwine, *France since 1870*, p. 107.

24 *Bis* means the second dwelling in a shared building so that one doorway is 57 [57A] and the next is 57bis [57B]

25 Unpublished, Renoir to unidentified recipient, Cagnes, 24 November 1911, in Los Angeles, Getty Research Institute. At this time, Renoir's nephew Edmond Renoir Jr was living at Les Collettes.

26 Renoir to unidentified recipient, n.l. [Nice], 21 November 1911, English excerpt in Boston, Mass., Rendell sale catalogue 130, no. 120.

27 Renoir to André, Nice, 16 January 1914, in 'Lettres de Renoir à quelques amis', p. 58.

28 Unpublished, Renoir to unidentified recipient, Cagnes, 24 November 1911, in Los Angeles, Getty Research Institute.

29 Durand-Ruel to unidentified recipient, n.l., December 1912, in White, *Renoir's Life, Art, and Letters*, p. 253. For a photograph of Renoir being carried in his portable chair by André and La Boulangère see White, *Renoir: His Life, Art, and Letters*, p. 241.

30 Unpublished, Cassatt to Havemeyer, Grasse, 27 February [1913], in New York, Metropolitan Museum, Archives, Box 1, Folder 11.

31 *Ibid.*, 30 April [1913].

32 *Renoir in the 20th Century*, p. 105 n. 45. Reinhart collected Renoir's work and eventually owned seven paintings and several lithographs and bronzes.

33 *Ibid.*, cat. nos 161–72.

34 Cassatt to Havemeyer, Grasse, 4 December [1913], in Cassatt, *Cassatt and Her Circle*, p. 313.

35 Joseph Durand-Ruel to Renoir, Paris, 6 December 1915, in *Correspondance de Renoir et Durand-Ruel*, vol. 2, pp. 162–3.

36 Unpublished, Gabrielle to Vollard, Croissy-sur-Seine, n.d. [26 August 1911], in Paris, Bibliothèque des Musées Nationaux du Fonds Vollard, Ms. 421 on microfilm.

37 Monet to Bernheim-Jeune, Giverny, 28 August 1911, in Wildenstein, *Monet: biographie*, vol. 4, p. 382. The same day he also wrote of the visit to Durand-Ruel, in Venturi, *Archives de l'impressionnisme*, vol. 1, p. 428.

38 Monet to Durand-Ruel, Giverny, 26 June 1913, in Venturi, *Archives de l'impressionnisme*, vol. 1, p. 437.

39 LeRoy C. Breunig in Apollinaire, *Apollinaire on Art*, p. xvii. Apollinaire, review in *Le Petit Bleu*, 9 February 1912, in *ibid.*, p. 204; French edn, *Chroniques d'art (1902–1918)*, p. 278.

40 Apollinaire, *Apollinaire on Art*, p. 425.

41 Pach, 'Pierre-Auguste Renoir', p. 606. The interview was modified in Pach, *Queer Thing, Painting*, pp. 104–15.

42 Henry Dauberville (Josse Bernheim-Jeune's son), repr. in Dauberville, vol. 1, pp. 13–14 (n.d. but before late 1913 when Gabrielle left the Renoirs).

43 Meier-Graefe, *Auguste Renoir*.

44 André, *Renoir*.

45 Monet to Renoir, Giverny, 23 October 1912, in Wildenstein, *Monet: biographie*, vol. 4, p. 386.

46 Monet, *Banks of the Seine at Argenteuil*, sold to Bernheim-Jeune in 1912; *Terrace at Ste-Addresse*, sold to Durand-Ruel in 1913; see Rewald, *History of Impressionism*, pp. 357, 153, respectively.

47 Renoir, *Parisian Lady*, sold 1912 to Knoedler Gallery, Paris; *Morning Ride in the Bois de Boulogne*, 261 x 226 cm (102¾ x 89 in.), sold 1912 to Paul Cassirer; Dauberville, vol. 1, pls 299, 247, respectively.

48 *Catalogue des tableaux composant la collection Maurice Gangnat*, Paris, 24–25 June 1925.

49 Dr Albert Barnes to Leo Stein, n.l., 30 March 1913, in Lucy and House, *Renoir in the Barnes Foundation*, p. 21.

50 The Barnes Foundation, formerly in Merion, PA, now in the centre of Philadelphia.

51 Drucker, *Renoir*, pp. 221–2. Paintings were exhibited in Belgium, Britain, Denmark, France, Germany, Hungary, Norway, Russia, Spain, Sweden, Switzerland and the USA.

52 Mirbeau, *Renoir*.

53 Gustave Coquiot, *Rodin* (Paris: Éditions Bernheim-Jeune, 1915), with sanguine drawing of the sculptor by Renoir reproduced as the frontispiece; see also White, *Renoir: His Life, Art, and Letters*, p. 286. In 1915–17, Vollard used this drawing as the basis for a medallion of the sculptor; Haesaerts, *Renoir Sculptor*, pl. XXVII.

54 Renoir to Bernheim, Nice, 12 November 1913, in Dauberville, vol. 1, p. 49.

55 Unpublished, Gustave Coquiot to Rodin, Paris, 8 March [1914], in Paris, Musée Rodin, Archives.

56 Dauberville, vol. 5, pl. 4424; see unpublished, Renoir to M. Bernheim, Cagnes, n.d. [*c.* 1914], in Paris, Archives Bernheim-Jeune.

57 Delteil, *Peintre-graveur illustré*, vol. 17, pl. 49; Stella, *Graphic Work of Renoir*, pl. 49; Johnson, *Ambroise Vollard, éditeur*, p. 146. Renoir's role in making black-and-white as well as colour lithographs from 1898 onwards was described in a 1911 letter from Vollard to A. M. Gutbier, repr. in Distel, *Renoir*, p. 308.

58 Unpublished, Cassatt to Louisine Havemeyer, Grasse, 30 April [1913], in New York, Metropolitan Museum, Archives, Box 1, Folder 11.

59 Renoir to André, Cagnes, 17 November 1914, in White, *Renoir: His Life, Art, and Letters*, p. 272.

60 Renoir to André, Cagnes, 2 January 1910, in *ibid.*, p. 245.

61 Mirbeau, *Renoir*, pp. ix, xi.

62 Renoir to Vollard, Nice, 25 January 1914, Eng trans. excerpt in New York, Lucien Goldschmidt and Pierre Brès, sale catalogue 5, 1941, no. 215.

63 Aline to Durand-Ruel, Cagnes, 10 February 1911, in *Correspondance de Renoir et Durand-Ruel*, vol. 2, p. 73.

64 Bailey, *Renoir's Portraits*, pp. 246, 335 n. 1.

65 See Herbert, *Renoir's Writings on the Decorative Arts*, p. 189 n. 3. Renoir calls attention to the Raphael in a note to his 'Lettre d'Auguste Renoir à Henri Mottez', 1910.

66 André, *Renoir*, p. 36. The Louvre's Veronese, *Wedding Feast at Cana* (1562–63), is 677 × 994 cm (266½ × 391 in.).

67 Pach, 'Pierre-Auguste Renoir', p. 614.

68 Cennini's book contains both medieval and Renaissance workshop precepts to teach craftsmen working under a master making frescoes. In 1858, the painter Victor Mottez, a former pupil of Ingres who was particularly interested in frescoed architectural decoration, translated Cennini's book into French. Mottez had died in 1897. Mottez's son Henri and Renoir had decided to reissue the French translation in homage to Victor Mottez. See White, *Renoir: His Life, Art, and Letters*, p. 250.

69 Henri Mottez to Albert Chapon (an editor at Bibliothèque de l'Occident), n.l., 19 November 1909, in *ibid.*, p. 250. In March 1910, Denis visited Mottez in Nice and Renoir in Cagnes and they discussed the essay, and in August, Denis sent Renoir's eight-page preface to Chapon; *ibid.*, pp. 250–55. See also Herbert, *Renoir's Writings on the Decorative Arts*, pp. 158–91.

70 'Renoir's Published Letter to Henri Mottez, 1910', preface to Cennino Cennini, *Le Livre de l'art ou traité de la peinture*, in Herbert, *Renoir's Writings on the Decorative Arts*, p. 190; Fr. 'Lettre d'Auguste Renoir à Henri Mottez', p. 260.

71 Jean Renoir, *Renoir, My Father* (1958), p. 147; French edn, p. 160.

72 'Renoir's Published Letter to Henri Mottez, 1910', in Herbert, *Renoir's Writings on the Decorative Arts*, p. 188, Fr. 'Lettre d'Auguste Renoir à Henri Mottez', p. 258.

73 According to Haesaerts, *Renoir Sculptor*, pp. 24, 39–40, pls VIII, IX, Renoir made a soft-wax tiny head of the variant of the small version of *Venus*, *c.* 1913, h. 16.5 cm (6½ in.).

74 Renoir to André, Cagnes, 28 April 1914, in White, *Renoir: His Life, Art, and Letters*, p. 261.

75 Renoir to Vollard, Cagnes, 19 April 1914, in Eng. in Johnson, *Ambroise Vollard*, p. 41.

76 Unpublished, Rivière to Jean Renoir, Paris, 29 October 1914, private collection.

77 See White, *Renoir: His Life, Art, and Letters*, p. 255 for repro. of 1913 version; p. 236 for 1908 version. The 1913 version is more crowded, including a flying Mercury and a distant Greek temple; Renoir also changed the stances of the two left-hand nudes.

78 Gabrielle to Bernheim-Jeune, Cagnes, n.d. [1913], in Dauberville, vol. 1, p. 72. Both versions are similar in size: the 1908 is 82 × 101.6 cm (32¼ × 40 in.); the 1913, 72 × 92 cm (28⅜ × 36¼ in.), *ibid.*, vol. 5, pl. 4278.

79 For the *Paris* busts, both 1915, see Haesaerts, *Renoir Sculptor*, pls XXXIII, XXXIV, XXXVII.

80 For the small *Venus* statuette see n. 73 above; for the medium-size *Venus*, 1913, 61 cm (24 in.), see *ibid.*, pls V–VII; for the large statue, 1915–16, see pls XIV–XXI.

81 Small bas-relief, 1915, unpublished, see *ibid.*, p. 40; large high-relief, 1916, pls X–XIII.

82 For repro. of the watercolour, 30.5 x 23 cm (12 x 9 in.), see White, *Renoir: His Life, Art, and Letters*, pp. 244, 261.

83 Renoir to André, Cagnes, 16 February 1914, in *ibid.*, p. 264; the Venus of Arles is 193 cm (76 in.); Venus de Medici, 152.4 cm (60 in.).

84 Cassatt to Durand-Ruel, Grasse, spring 1914, in Venturi, *Archives de l'impressionnisme*, vol. 2, p. 135.

85 Unpublished, Jean Renoir to Guino, Cagnes, 27 October 1913, in Boston Public Library, archives. The 'Renée' mentioned was perhaps Renée Jolivet, who had been Coco's nursemaid.

86 Renoir to Vollard, Nice, 25 January 1914, in White, *Renoir: His Life, Art, and Letters*, p. 264.

87 See Jean Renoir, *Renoir, My Father* (1958), p. 355.

88 Dauberville, vol. 2, pl. 1005.

89 Renoir to Aline, Cagnes, 24 June 1911, in *La Maison de Renoir aux Collettes*, p. 18, repro. of letter.

90 Renoir to André, Nice, 16 January 1914, in 'Lettres de Renoir à quelques amis', p. 58.

91 Cassatt to Joseph Durand-Ruel, Grasse, 17 February [1914], trans. in *Cassatt and Her Circle*, p. 315.

92 Renoir to Arsène Alexandre with note from Gabrielle on the back, Cagnes, 12 May 1912, in *Maison de Renoir aux Collettes*, p. 17.

93 Unpublished, Gabrielle to Vollard, Croissy-sur-Seine, n.d. [20 August 1911], in Paris, Bibliothèque des Musées Nationaux du Fonds Vollard, Ms. 421 on microfilm.

94 Unpublished, Renoir to Gangnat with note from Gabrielle on the back, Wessling, Germany, n.d. [August 1910], private collection.

95 Unpublished, Gabrielle to Vollard, n.l., n.d. [*c.* 13 June 1911], in Paris, Bibliothèque des Musées Nationaux du Fonds Vollard, Ms. 421 on microfilm.

96 Unpublished, Renoir to Gangnat, n.l. [Cagnes], 18 February 1913, private collection.

97 Unpublished, Cassatt to Louisine Havemeyer, Grasse, 30 April [1913], in New York, Metropolitan Museum, Archives, Box 1, Folder 11.

98 Aline to Durand-Ruel, n.l. [Cagnes], 22 April 1914, in *Correspondance de Renoir et Durand-Ruel*, vol. 2, p. 142. Unpublished receipt, Aline to Vollard, n.l., 19 January 1900, in Paris, Bibliothèque des Musées Nationaux du Fonds Vollard, Ms. 421 on microfilm.

99 Unpublished, Cassatt to Louisine Havemeyer, Mesnil-Beaufresne, 6 September [1912], in New York, Metropolitan Museum, Archives, Box 1, Folder 10.

100 Unpublished, Renoir to Gangnat, Cagnes, 24 November 1910, private collection.

101 Unpublished, Aline to Durand-Ruel, Cagnes, 11 March 1911, in Paris, Archives Durand-Ruel.

102 Unpublished, Aline to Vollard, Essoyes, 19 August 1913, in Paris, Bibliothèque des Musées Nationaux du Fonds Vollard, Ms. 421 on microfilm.

103 Lucienne Bralet was a chambermaid at Les Collettes who later took care of Pierre's son Claude, and posed for Renoir.

104 Madeleine Bruno quoted in Pharisien, *Célébrités d'Essoyes*, p. 121.

105 Unpublished, Renoir to Paule Gobillard, Cagnes, 16 December 1912, private collection.

106 Edmond Jr modelled for Renoir during his childhood; see Dauberville, vol. 2, pls 1268, 1269, 1271–4, 1399.

107 Unpublished, Rivière to Aline Charigot, Paris, 20 November 1912, private collection.

108 Unpublished, Rivière to Renoir, Paris, 28 November 1912, private collection.

109 Unpublished, Cassatt to Louisine Havemeyer, Grasse, 27 February [1913], in New York, Metropolitan Museum, Archives, Box 1, Folder 11.

110 Unpublished, Gabrielle to Vollard, Croissy-sur-Seine, n.d. [26 August 1911], in Paris, des Musées Nationaux du Fonds Vollard, Ms. 421 on microfilm.

111 Cassatt to Durand-Ruel, Grasse, 17 February [1915], in Venturi, *Archives de l'impressionnisme*, vol. 2, pp. 135–6.

112 Unpublished, Cassatt to Louisine Havemeyer, Mesnil-Beaufresne, 16 July [1913], in New York, Metropolitan Museum, Archives, Box 1, Folder 11.

113 Unpublished, Cassatt to Havemeyer, Grasse, 28 December [1913], in *ibid.*

114 Henry Dauberville, *La Bataille de l'impressionnisme*, p. 215.

115 Renoir to Georges Durand-Ruel, n.l. [Cagnes], 20 December 1913, in *Correspondance de Renoir et Durand-Ruel*, vol. 2, p. 135.

116 Cassatt to Havemeyer, Grasse, 11 January [1914], in *Cassatt and Her Circle*, p. 308, where it is misdated 11 January 1913.

117 Joseph Durand-Ruel to Georges Durand-Ruel, Nice, 20 April 1914, in *Correspondance de Renoir et Durand-Ruel*, vol. 2, p. 258 n. 172.

118 Unpublished, Cassatt to Havemeyer, Grasse, 12 March [1915], in New York,

Metropolitan Museum, Archives,
Box 1, Folder 13.

119 Unpublished, Gabrielle to Vollard,
Cagnes, n.d. [*c.* 1910], in Paris,
Bibliothèque des Musées Nationaux
du Fonds Vollard, Ms. 421 on microfilm
(dating from mention of Gaston
Bernheim's visit to Cagnes for Renoir
to paint a portrait of his wife; see
Dauberville, vol. 4, pl. 3143).

120 Unpublished will of Jeanne Marguerite
Tréhot, Madré, 12 June 1913, private
collection.

121 Unpublished, Rivière to Renoir, Paris,
21 December 1913, private collection.

122 André, *Renoir*, p. 37.

123 Conrad Hensler Slade (1871–1950)
came from a distinguished Boston
family. His father, Daniel Dennison
Slade (1823–96), was a physician at
Harvard Medical School who worked
with the renowned scientist Louis
Agassiz, and was a friend of Oliver
Wendell Holmes and Longfellow.
After Conrad graduated from Harvard
College in 1894, he went to Paris to
study sculpture but decided he did not
want to be a sculptor. He then returned
to Boston to study architecture but
soon abandoned that and in 1896
returned permanently to Paris where
he embarked on a career as a painter.

124 Unpublished, Conrad Slade to his
mother, Cagnes, 1906, private collection.

125 Unpublished, Gabrielle to Jeanne Tréhot,
Cagnes, 8 December 1913, private
collection ('Hôtel Savournin, Cagnes
[Alpes-Maritimes], Ouvert Toute l'Année,
Téléphone No. 9').

126 Unpublished, Renoir to Jeanne Tréhot
Robinet with note from Gabrielle
up the side with confirmation of 100
francs, n.l., 28 December 1910, private
collection.

127 Unpublished draft of will of Jeanne
Tréhot Robinet, Madré, n.d. [*c.* 1914],
private collection.

128 Unpublished, Georgette Dupuy to
Jeanne Tréhot, n.l., n.d. [*c.* 1908–10],
private collection.

129 Unpublished, Renoir to Jeanne Tréhot
Robinet, n.l., July 1910, private collection.

130 Unpublished, Georgette Dupuy to
Jeanne Tréhot Robinet, n.l. [Paris], n.d.
[July 1910], private collection. In August
1910, Renoir accepted the invitation
of Dr Fritz Thurneyssen and spent the
month in Wessling-am-See near Munich.
Gabrielle, Aline, Pierre, Jean, Coco and
Renée Rivière went too. Renoir painted
Mme Thurneyssen and her Daughter
and *Portrait of Wilhelm Muhlfeld*,
Dauberville, vol. 4, pls 3139, 3395; see
also Bailey, *Renoir's Portraits*, pp. 252–8.

131 Unpublished, Renoir to Jeanne Tréhot
Robinet, n.l. [Wessling], n.d. [August
1910], private collection.

132 Unpublished, Renoir to Jeanne Tréhot
Robinet, n.l., 28 December 1910, private
collection.

133 Renoir to Durand-Ruel, n.l. [Cagnes],
12 January 1912, in *Correspondance
de Renoir et Durand-Ruel*, vol. 2, p. 88.

134 Unpublished, Gabrielle to Vollard,
n.l. [Cagnes], n.d. [*c.* 1912]; in Paris,
Bibliothèque des Musées Nationaux
du Fonds Vollard, Ms. 421 on microfilm.

135 Renoir to Georges Durand-Ruel,
n.l. [Cagnes], 25 March 1915, in
*Correspondance de Renoir et Durand-
Ruel*, vol. 2, p. 158.

136 Renoir to Paul Durand-Ruel, Cagnes,
14 February 1910, in *ibid.*, p. 52.

137 Renoir to André, Cagnes, 19 March 1913,
in 'Lettres de Renoir à quelques amis',
p. 57. Coco's communion took place on
22 May 1913.

138 Jean Renoir to Coco Renoir, n.l. [Joigny],
19 May 1913, in *Jean Renoir Letters*,
p. 4; French edn, *Jean Renoir,
Correspondance*, p. 4.

139 Renoir to Arsène Alexandre with
note from Gabrielle on back, Cagnes,
12 May 1912, in *Maison de Renoir aux
Collettes*, p. 17.

140 Renoir to Bernheim, Cagnes, 12
November 1913, in Dauberville, vol. 1,
p. 49.

141 See unpublished postcard, Pierre Renoir
to Vollard, Paris, n.d. [*c.* 1910], in Paris,
Bibliothèque des Musées Nationaux
du Fonds Vollard, Ms. 421 on microfilm.

142 Unpublished, Gabrielle to Vollard,
n.l., n.d. [*c.* 13 June 1911], in *ibid.*

143 Unpublished, Aline to Paul Durand-Ruel, Essoyes, 8 September 1912, in Paris, Archives Durand-Ruel.

144 Renoir to Monet, n.l. [Paris], 25 August 1911, excerpt in Paris, Artcurial sale catalogue, 13 December 2006, no. 273.

145 Unpublished, Pierre Renoir to Vollard, Paris, 30 April 1910, in Paris, Bibliothèque des Musées Nationaux du Fonds Vollard, Ms 421 on microfilm.

146 Unpublished, Pierre Renoir to Vollard, n.l. [Paris], n.d. [c. 1910], in ibid.

147 Pharisien, Pierre Renoir, pp. 484–7.

148 Ibid., p. 449.

149 Unpublished, Rivière to Aline Charigot, Paris, 20 November 1912, private collection. The play was by Arthur Bernède and Aristide Bruant.

150 Reviews by Pierre Gilbert and Edmond Sée, respectively, in Comoedia 1912, quoted in Pharisien, Pierre Renoir, p. 69. The Latin comoedia, like the French comédie, encompasses comedy, drama and tragedy.

151 Reviews by Georges Casella in Comoedia 1913, quoted in ibid., p. 76.

152 Dauberville, vol. 5, pls 4077, 4078, 4102, 4103, 4128, 4159, 4160.

153 Unpublished, Renoir to Vollard, Cagnes, 18 December 1915, in Paris, Bibliothèque des Musées Nationaux du Fonds Vollard, Ms. 421 on microfilm.

154 Renoir to Geffroy, Cagnes, 30 March 1918, excerpt from Paris, Charavay, 7 December 1979, no. 130-6. Dauberville, vol. 5, pl. 4078.

155 Dauberville, vol. 5, pl. 4077; this 1913 portrait was hanging in Renoir's Paris studio in 1914 while he was painting Tilla Durieux, pl. 4192; see White, Renoir: His Life, Art, and Letters, p. 262.

156 Véra was the eldest daughter of Hippolyte Roche and Aimée de Kovalensky (of Polish origin). Véra's granddaughter, Sophie Renoir, was brought up thinking that Véra was Jewish; personal communication, n.d.

157 Véra won first prize in tragedy at the Conservatory and graduated in 1904 (a year before Pierre).

158 Elisabeth Rachel Félix (1821–58); Aimée-Olympe Desclée (1836–74); Sarah Bernhardt (1845–1923).

159 Tribute found in unpublished papers of Bataille, who died in 1922; published posthumously in Comoedia, 15 September 1922; quoted in Pharisien, Pierre Renoir, p. 72.

160 Claude was a Charigot family name: see Ch. 2 above. Coco/Claude was twelve at his nephew's birth. Albert André and Pierre Renoir had become friends.

161 According to certain Jewish customs, a newborn may be given either the name of a deceased close relative or a name with the same first initial. Véra's father's name was Hippolyte, which may be the source of the name Henri.

162 Some five weeks before Véra gave birth, Rivière wrote to Jean Renoir that Pierre and Véra had been to his Paris apartment for lunch; unpublished, Rivière to Jean Renoir, Paris, 29 October 1914, private collection.

163 Unpublished, Pierre Renoir to Durand-Ruel, Paris, 25 June 1915, in Paris, Archives Durand-Ruel.

164 Jean Renoir, 'Pour tout vous dire'. François-Michel le Tellier, Marquis de Louvois (1641–91).

165 Jean Renoir in Braudy, 'Renoir at Home: Interview', p. 189.

166 See Cardullo, Jean Renoir Interviews, p. ix.

167 Unpublished, Rivière to Aline, Paris, 20 November 1912, private collection.

168 Denis, entry n.d. [1913], Journal, vol. 2, pp. 150–51.

169 Dragoon, dragon in French, is the name for a mounted infantryman armed with a carbine, who dismounted to fight on foot. During the later eighteenth century and the Napoleonic Wars, dragoon regiments in most armies evolved into conventional cavalry.

170 See unpublished, Colonel d'Aouitte [not clear] to Renoir, Joigny, 17 February 1913, in University of California Los Angeles, Arts Library Special Collections, Jean Renoir Papers.

171 Unpublished, Jean Renoir's military record book, Paris, 17 February 1913, copy in Paris, Documentation Orsay.

172 Jean Renoir to Aline, n.l., n.d. [c. 17 February 1913], in *Jean Renoir Letters*, p. 4.

173 Jean describes these colours in 'Pour tout vous dire'.

174 Unpublished, Jeanne Baudot to Renoir, Louveciennes, 29 December 1913, private collection.

175 See n. 170 above.

176 Unpublished, Rivière to Renoir, Paris, 30 April 1913, private collection.

177 Unpublished, Rivière to Renoir, Paris, 21 December 1913, private collection.

178 Unpublished, Rivière to Renoir, Paris, 7 December 1913, private collection.

179 Jean Renoir to Aline Renoir, n.l. [Joigny], n.d. [c. January 1914], in *Jean Renoir Letters*, p. 6.

180 Renoir to Durand-Ruel, n.l. [Nice], 27 January 1914, in *Correspondance de Renoir et Durand-Ruel*, vol. 2, p. 138.

181 Paris, Durand-Ruel, January–April 1914, group show including works by André and eight still lifes and flowers by Renoir.

182 Jean Renoir to André, n.l., 10 April [1914], in *Jean Renoir Letters*, p. 7.

183 Jean Renoir to Aline, n.l. [Luçon], 9 April 1914, in *ibid.*, p. 6.

184 Renoir to André, n.l. [Cagnes], 28 April 1914, in 'Lettres de Renoir à quelques amis', p. 61.

185 Drucker, *Renoir*, pp. 221–2.

186 Durieux, *Séances de pose chez Renoir en 1914*, p. 19. See also Bailey, *Portraits*, pp. 259–61. For a photograph of Renoir painting the actress from his wheelchair see White, *Renoir: His Life, Art, and Letters*, p. 262.

187 Durieux, *Séances de pose*, pp. 15–26.

188 See n. 130 above. The following year, Renoir painted a portrait of their son, Alexander; Dauberville, vol. 5, pl. 4267.

189 Bailey, *Renoir Portraits*, p. 260.

190 Durieux, *Séances de pose*, p. 21.

191 *Ibid.*, p. 23.

192 *Ibid.*, p. 27. Durieux took the portrait with her when she left Germany in 1933, first to Switzerland and then Zagreb. Then it went to the Cassirer Gallery

in Amsterdam, who sold it to America in 1935. Eventually it went to the Stephen C. Clark collection and, in 1960, entered New York's Metropolitan Museum, where it is on view.

193 Sowerwine, *France since 1870*, p. 117.

194 Silke, 'Jean Renoir on Love, Hollywood, Authors, and Critics', p. 135; his 1937 film, *Grand Illusion*, expresses this optimism.

195 Unpublished, Renoir to André, Cagnes, n.d. [late September 1914], in Paris, Institut Néerlandais, Fondation Custodia (Collection F. Lugt).

196 Renoir to unidentified recipient, Cagnes, 12 October 1914, excerpt in Stargardt sale catalogue 567, 26–27 May 1964, no. 831.

197 Renoir to Georges Durand-Ruel, n.l. [Cagnes], 25 March 1915, in *Correspondance de Renoir et Durand-Ruel*, vol. 2, p. 158.

198 Sowerwine, *France since 1870*, p. 109.

199 Pierre Renoir, interview with Jean Trigery, *L'Union française*, October 1943, in Pharisien, *Pierre Renoir*, p. 81.

200 Renoir to André, Cagnes, n.d. [late September 1914], in White, *Renoir: His Life, Art, and Letters*, p. 271.

201 Unpublished, Renoir to Mme Gangnat, Cagnes, 31 October 1914, private collection.

202 Pierre Renoir, interview, *Le Matin*, 6 February 1937, in Pharisien, *Pierre Renoir*, p. 82.

203 See *ibid.*, pp. 449–500.

204 Unpublished, Renoir to Army headquarters, Cagnes, 15 September 1914, in University of California Los Angeles, Arts Library Special Collections, Jean Renoir Papers.

205 Unpublished, Chief of the Headquarters of the Company, 1st Regiment of Dragoons, to Renoir, Luçon, 21 September 1914, in *ibid.*

206 Jean's son explained that his father had told him that he had gonorrhoea at this time; interview with the author, September 2006. See also *Jean Renoir Letters*, p. 7.

207 Unpublished, Renoir to Mme Gangnat, Cagnes, 31 October 1914, private collection.

208 Renoir to André, Cagnes, 17 November 1914, in White, *Renoir: His Life, Art, and Letters*, p. 272.

209 Renoir to Durand-Ruel, n.l. [Cagnes], 29 October 1914, in *Correspondance de Renoir et Durand-Ruel*, vol. 2, p. 148.

210 Unpublished, Rivière to Jean Renoir, Paris, 29 October 1914, private collection.

211 Renoir to Monet, Cagnes, 22 November 1914, excerpt in Paris, Artcurial sale catalogue, 13 December 2006, no. 276.

212 Unpublished, André to Durand-Ruel, Laudun, 12 December 1914, in Paris, Archives Durand-Ruel.

213 Unpublished marriage certificate, Véra and Pierre Renoir, Cagnes, 23 December 1914, private collection.

214 Unpublished, André to Durand-Ruel, Cagnes, 20 December 1914, in Paris, Archives Durand-Ruel.

215 Unpublished, Cassatt to Louisine Havemeyer, Grasse, 20 January [1915], in New York, Metropolitan Museum, Archives, Box 1, Folder 13.

216 Unpublished marriage certificate, Véra and Pierre Renoir; Renoir signed the day before the wedding, Aline signed at the ceremony.

217 Unpublished, André to Georges Durand-Ruel, Laudun, 29 December 1914, in Paris, Archives Durand-Ruel.

218 Unpublished marriage certificate, Véra and Pierre Renoir.

219 *Ibid*; Pharisien, *Pierre Renoir*, p. 83.

220 Dauberville, vol. 5, pl. 4222, inherited by Claude Renoir Jr; pl. 4273.

221 While Pierre waited for arm surgery, he had several smaller procedures, such as the removal of bone fragments; see Renoir to André, Cagnes, 17 November 1914, in White, *Renoir: His Life, Art, and Letters*, p. 272: 'Pierre writes me this morning that he is still waiting for the bone scraping that is supposed to take place one of these days.'

222 Unpublished, André to Durand-Ruel, Cagnes, 20 December 1914, in Paris, Archives Durand-Ruel.

223 Renoir to Georges Durand-Ruel, [Cagnes], 25 March 1915, in *Correspondance de Renoir et Durand-Ruel*, vol. 2, p. 158.

224 Renoir to André, n.l. [Cagnes] 16 April 1915, in White, *Renoir: His Life, Art, and Letters*, p. 272 n. 84.

225 Unpublished, Rivière to Renoir, Paris, 21 June 1915, private collection.

226 Pharisien, *Pierre Renoir*, p. 94 n. 3. Pharisien learned of Pierre's abdomen injuries from Elisa Ruis, Pierre's last wife, whom Pharisien met in 1999. Alain Renoir (Pierre's nephew) gave me the same information, interview, September 2006.

227 Unpublished, Cassatt to Louisine Havemeyer, Grasse, 20 January [1915], in New York, Metropolitan Museum, Archives, Box 1, Folder 13.

228 Georges Durand-Ruel to Renoir, Paris, 25 January 1915, in *Correspondance de Renoir et Durand-Ruel*, vol. 2, p. 157.

229 Unpublished, Cassatt to Durand-Ruel, Nice, 5 March 1925, in Paris, Archives Durand-Ruel.

230 Renoir to Georges Durand-Ruel, n.l. [Cagnes], 25 March 1915, in *Correspondance de Renoir et Durand-Ruel*, vol. 2, p. 158.

231 Unpublished, Renoir to André, Cagnes, 16 April 1915, in Paris, Institut Néerlandais, Fondation Custodia (Collection F. Lugt).

232 Nogueira and Truchaud, 'Interview with Jean Renoir', 1968, p. 180.

233 Alain Renoir, interview with the author, September 2006.

234 Unpublished, Jean Renoir's military record book, 7 July 1915, private collection.

235 Renoir to Gaston Bernheim de Villers, Cagnes, 24 May 1915, in Dauberville, vol. 1, p. 70.

236 Jean Renoir, 'Pour tout vous dire'.

237 This operation was invented by the French surgeon Lucien Laroyenne (1831–1902).

238 Aline to Rivière, Gérardmer, n.d. [*c.* 14 May] 1915, in *Jean Renoir Letters*, p. 9.

239 Aline to Rivière, Gérardmer, n.d. [16 May] 1915, in *ibid*.

240 Aline to Rivière, Gérardmer, 22 May 1915, in *ibid*., p. 10.

241 Aline to Rivière, Gérardmer, 26 May 1915, in *ibid*.

242 Unpublished, Rivière to Renoir, Paris, 21 June 1915, private collection.

243 Jean Renoir's joking name for a nurse with big breasts.

244 Jean to Aline, n.l. [Besançon], 22 June 1915, in *Jean Renoir Letters*, p. 11.

245 Jean to Aline, n.l. [Besançon], 21 June [1915], in *Jean Renoir, Correspondance 1913–1978*, p. 11.

246 Renoir to Bernheim, n.l. [Nice or Cagnes], 24 June 1915, in Dauberville, vol. 1, p. 60.

247 Jean to Aline, n.l. [Besançon], 26 June 1915, in *Jean Renoir Letters*, p. 11.

248 *Ibid.*

249 Renoir to Marguerite André, Nice, 26 June 1915, in White, *Renoir: His Life, Art, and Letters*, p. 273.

250 Unpublished, Pierre Renoir to Durand-Ruel, Paris, 25 June 1915, in Paris, Archives Durand-Ruel.

251 Unpublished death certificate, 27 June 1915, Ville de Nice, Archives.

252 Unpublished, Renoir to Vollard, Cagnes, 1 July 1915, in Paris, Bibliothèque des Musées Nationaux du Fonds Vollard, Ms 421 on microfilm.

253 Renoir to Marguerite André, Cagnes, 3 July 1915, in White, *Renoir: His Life, Art, and Letters*, pp. 273, 276 (French p. 273).

254 Pharisien and Chartrand, *Victor Charigot*, pp. 121–3.

255 For Victor Renoir see Chs 1 and 3 above. Victor had been a tailor in Russia and in France was one of the witnesses on Pierre's birth certificate in 1885.

256 Burial document, Essoyes, 22 September 1915, in Pharisien and Chartrand, *Victor Charigot*, p. 125; see also pp. 121–3.

257 Cassatt to Louisine Havemeyer; see n. 113 above.

258 Nine months after Renoir died, on 12 August 1920, Pierre purchased a cemetery plot for his father in Essoyes adjacent to his mother's plot. See Pharisien and Chartrand, *Victor Charigot*, p. 134.

259 Dauberville, vol. 2, pl. 969, 81.3 x 64.8 cm (32 x 25½ in.).

260 *Ibid.*, vol. 5, pl. 4004, 51 x 40.5 cm (20⅛ x 16 in.).

261 Unpublished, Renoir to Guino, Essoyes, 23 July 1916, private collection.

262 Haesaerts, *Renoir Sculptor*, pl. XXXII (plaster); White, *Renoir: His Life, Art, and Letters*, p. 270 (bronze).

263 Dauberville, vol. 2, pl. 1066.

264 Unpublished receipt, Renoir to Guino, Cagnes, 11 January 1918, private collection. This painted plaster bust is in the Musée d'Orsay, Paris.

265 Haesaerts, *Renoir Sculptor*, pl. XXXV.

266 For another version of Guino's 1913 bust of Renoir, at the Musée des Collettes, see White, *Renoir: His Life, Art, and Letters*, p. 257.

267 Unpublished, Cassatt to Durand-Ruel, Grasse, 12 February 1914, in Paris, Archives Durand-Ruel.

268 Unpublished, Renoir to Durand-Ruel, Nice, 28 June 1915, in Paris, Archives Durand-Ruel.

269 Renoir to R. Umehara, Cagnes, 2 August 1918, in Hanako Shimada, 'L'Amitié entre Renoir et Umehara', p. 13.

270 Unpublished, Thérèse Mélanie Charigot to Jean Renoir, Essoyes, 11 December 1915, private collection.

271 *Ibid.*

272 See Ch. 4, p. 213 and n. 183; Pharisien and Chartrand, *Victor Charigot*, pp. 104, 129.

273 White, *Renoir: His Life, Art, and Letters*, p. 284.

274 Unpublished, Renoir to Vollard, Cagnes, 17 December 1915, in Paris, Bibliothèque des Musées Nationaux du Fonds Vollard, Ms. 421 on microfilm.

275 Unpublished, Renoir to Gangnat, Cagnes, 18 December 1915, private collection.

276 Unpublished, Renoir to Vollard, Cagnes, 18 December 1915, in Paris, Bibliothèque des Musées Nationaux du Fonds Vollard, Ms. 421 on microfilm.

277 *Ibid.*

278 Unpublished, Renoir to Gangnat, see n. 275 above.

279 Unpublished, Renoir to Jeanne Baudot, Cagnes, 30 December 1915, private collection.

280 Renoir to André, Cagnes, 3 January 1916, in White, *Renoir: His Life, Art, and Letters*, p. 276.

281 See n. 113 above.

282 See n. 114 above.

283 Claude Renoir, 'Renoir, sa toile à l'ombre d'un parasol', n.p.

Chapter 7 1915–19

1 Unpublished, Renoir to Guino, Cagnes, 17 November 1915, private collection.

2 Renoir to Georges Durand-Ruel, n.l. [Cagnes], 29 November 1916, in *Correspondance de Renoir et Durand-Ruel*, vol. 2, p. 178.

3 Monet to Georges Durand-Ruel, Giverny, 13 December 1916, in Venturi, *Archives de l'impressionnisme*, vol. 1, p. 444.

4 Unpublished, André to Georges Durand-Ruel, Cagnes, 19 December 1916, in Paris, Archives Durand-Ruel.

5 Unpublished, André to Paul Durand-Ruel, Cagnes, 24 December 1917, in *ibid*.

6 Renoir to Paul or Joseph Durand-Ruel, Cagnes, 16 March 1918, in *Correspondance de Renoir et Durand-Ruel*, vol. 2, p. 230.

7 Unpublished, André to Paul Durand-Ruel, Marseilles, 2 May 1918, in Paris, Archives Durand-Ruel.

8 Renoir to Jeanne Baudot, Cagnes, 22 May 1918, in Baudot, *Renoir, ses amis, ses modèles*, p. 89.

9 Sacha Guitry, *Ceux de chez nous*, 1915, available on www.youtube.com/watch?v=v3ZjfK9uYDY, accessed 20 December 2016.

10 Guitry's completed silent film of 22 minutes was shot between June and October 1915 and first shown in Paris on 22 November 1915. Many other famous people appeared in the film, including Sarah Bernhardt, Degas, Monet and Rodin.

11 E.g. a 1917 film with Jean Renoir and Vollard; see n. 140 below.

12 My thanks to the rheumatologist Dr Gerald Harris. See also the late photographs of Renoir in White, *Renoir: His Life, Art, and Letters*, pp. 262–3, 266.

13 *Ibid*., p. 272.

14 Evident in André's 1914 portrait drawing, in *ibid*., p. 257.

15 Renoir to André, Cagnes, 21 February 1918, in 'Lettres de Renoir à quelques amis', p. 67.

16 André, *Renoir*, pp. 32–4.

17 Dauberville, vol. 5; White, *Renoir: His Life, Art, and Letters*, pp. 229, 236, 254, 255, 258, 259, 273, 279.

18 Dauberville, vol. 2, pl. 932.

19 See White, *Renoir: His Life, Art, and Letters*, p. 279.

20 This elongated nude is of Gabrielle; Dauberville, vol. 4, pl. 3502. Negotiations for the sale had begun in March 1917; see *Correspondance de Renoir et Durand-Ruel*, vol. 2, pp. 190, 260 n. 184.

21 Georges Durand-Ruel to Renoir, 6 November 1917, Paris, in *Correspondance de Renoir et Durand-Ruel*, vol. 2, p. 221.

22 Georges Durand-Ruel to Renoir, Paris, 26 August 1918, in *ibid*., p. 235.

23 André, *Renoir*, p. 53.

24 Unpublished document of acceptance to the Légion d'Honneur, Cagnes, 25 March 1919, in Paris, Musée National de la Légion d'Honneur.

25 Dédée later became an actress with the screen name Catherine Hessling.

26 Dauberville, vol. 5, pl. 4328, from Jean Renoir's collection.

27 Unpublished, André to Georges Durand-Ruel, see n. 4 above.

28 André and Elder, *L'Atelier de Renoir*, André's foreword, pp. 11–12.

29 Unpublished, Léon Marseille to Richard Guino, Paris, 24 May 1917, private collection.

30 Conrad had studied Classics at Harvard and loved Greece; author interview with their son, John Slade, 3 October 2004.

31 Unpublished, Gabrielle to Jeanne Tréhot Robinet, Cagnes, 26 March 1918, private collection.

32 The paintings included a bust of Gabrielle in a white shirt from when she was *c*. 16 years old, 50.8 x 38 cm (20 x 15 in.); another bust from when she was *c*. 30 years old, both exhibited at Hatfield Gallery, Los Angeles, 1943; a sketch of her head on a canvas with other figures; a pen drawing; private collection.

33 Unpublished, Cassatt to Marie-Thérèse Durand-Ruel, Grasse, 31 January 1916, in Paris, Archives Durand-Ruel.

34 Unpublished, André to Georges Durand-Ruel, Marseilles, 19 May 1917, in *ibid*.

35 Jeanne's letters to her father continued to be sent to Vollard, Gabrielle or Baptistin Ricord, Renoir's chauffeur.

36 Unpublished, Gabrielle Renard to Jeanne Tréhot Robinet, Cagnes, 26 March 1918, private collection.

37 Unpublished, Baptistin Ricord to Jeanne Tréhot Robinet, Cagnes, 19 November 1919, private collection.

38 Unpublished, Jeanne Tréhot Robinet to Vollard, Madré, 1 May 1917, in Paris, Bibliothèque des Musées Nationaux du Fonds Vollard, Ms. 421 on microfilm.

39 *Ibid.*

40 *Ibid.*

41 *Ibid.*

42 Unpublished, Georgette Dupuy to Jeanne Tréhot Robinet, Paris, 12 August 1919, private collection.

43 Pharisien, *Pierre Renoir*, p. 84.

44 Jean Renoir, *My Life and My Films*, p. 41.

45 Joseph Durand-Ruel to Renoir, Paris, 6 December 1915, in *Correspondance de Renoir et Durand-Ruel*, vol. 2, p. 162.

46 Unpublished, Renoir to Gangnat, n.l. [Cagnes], 6 October 1918, private collection.

47 Pharisien, *Pierre Renoir*, p. 85.

48 Unpublished, Pierre Renoir to Guino, Paris, 3 July 1916, private collection.

49 Renoir to Joseph Durand-Ruel, Cagnes, 19 September 1916, in *Correspondance de Renoir et Durand-Ruel*, vol. 2, p. 176.

50 Gimpel, *Journal d'un collectionneur*, p. 32. Renoir entrusted the remaining paintings in Paris and Essoyes to friends.

51 Unpublished, Véra Sergine to Durand-Ruel, Paris, 31 March 1918, in Paris, Archives Durand-Ruel: 1,000 francs. Unpublished, Véra Sergine to Durand-Ruel, Paris, *c.* 3 May 1918, in *ibid*: 1,000 francs. Unpublished, Véra Sergine to Durand-Ruel, 1 January 1919, in *ibid*: 2,000 francs.

52 Marie-Émilie Réallon in *La Rampe*, 84 (April 1917), quoted in Pharisien, *Pierre Renoir*, p. 89.

53 Pharisien, *Pierre Renoir*, pp. 488, 489–90; they appeared in Maurice Allous's play, *La Main qui tient l'épée*.

54 Pharisien, *Pierre Renoir*, pp. 487–500.

55 *Ibid.*, p. 85, unidentified article, 24 September 1915.

56 *Ibid.*, p. 86.

57 Casualty numbers from Robert Wilde, *Casualties of the First World War*, at http://europeanhistory.about.com/cs/worldwar1/a/blww1casualties, accessed 15 January 2017; Colin Nicolson, *The Longman Companion to the First World War* (New York: Routledge, 2001); International Encyclopedia of the First World War, http://encyclopedia.1914-1918-online.net/home.html, accessed 26 January 2017; similar statistics from Michel Huber, *La Population de la France pendant la guerre* (Paris: Presses Universitaires de France; Carnegie Endowment for International Peace; New Haven, CT: Yale University Press, 1931, p. 420; , https://en.wikipedia.org/wiki/World_War_I_casualties, accessed 26 January 2017). The French wounded came to 4,266,000. In 1914, out of a population of 39,600,000 men and women, about 7,500,000 French soldiers (18% of the population) were mobilized. By the end of the war, the military deaths (including missing persons) were 1,397,800, nearly 10% of the active adult male population. Because much of the war was fought in France, 300,000 civilians died, mostly from famine and disease. The total French deaths were 1,697,800 (4% of the population).

58 Renoir to R. Umehara, Cagnes, 2 August 1918, in Shimada, 'L'Amitié entre Renoir et Umehara', p. 13; see also Ch. 6 n. 269 above.

59 Renoir to Marguerite (Maleck) André, Cagnes, 8 July 1915, in White, *Renoir: His Life, Art, and Letters*, p. 276.

60 Unpublished hospital certificate of stay, Paris, 7 July 1915, private collection.

61 Jean became enamoured with Chaplin's works, which sparked his interest in film, in which he made his career.

62 Unpublished, Paul Cézanne junior to his wife [Renée Rivière], Cagnes, 22 October 1915, private collection.

63 Renoir to Jeanne Baudot, Paris, 3 August 1915, excerpt in Paris, Librairie L'Autographe, sale catalogue, 20 May 1993, no. 255.

64 Renoir, and Jean Renoir on the back, to Georges Rivière, Nice, 1 November 1915, in White, *Renoir: His Life, Art, and Letters*, p. 276. Élie Faure (1873–1937), the well-known doctor, art historian and author, met Renoir in 1907 through Albert André.

65 Unpublished, Élie Faure to Renoir, Hyères, 8 November 1915, private collection.

66 Jean Renoir to Commandant [name unknown], n.l. [Paris], n.d. [late 1915], in *Jean Renoir Letters*, p 12; French edn, *Jean Renoir, Correspondance*, p. 31.

67 Renoir to André, Cagnes, 3 January 1916, in White, *Renoir: His Life, Art, and Letters*, p. 277 (French on p. 276).

68 Unpublished, Jean Renoir to Guino, Military Aviation School, Ambérieu, 18 January 1916, private collection. In Jean Renoir, 'Pour tout vous dire', he says that he was initially told that he could not be a pilot because of his slight astigmatism.

69 Unpublished aviation military booklet, Ambérieu, 16 June 1916, private collection.

70 *Ibid.*

71 Jean Renoir, 'Pour tout vous dire'.

72 Jean's international licence number was in the 900s; Jean Renoir, 'Pour tout vous dire'.

73 Unpublished Status of Service (*État de services*) papers of Jean Renoir, 4 September 1916, private collection. On the way, Jean stopped in Paris and saw his godfather: see Georges Durand-Ruel to Renoir, Paris, 21 September 1916, in *Correspondance de Renoir et Durand-Ruel*, vol. 2, p. 177.

74 Jean Renoir, *My Life and My Films*, pp. 149–50; French edn, p. 136. A Caudron was a French plane, primarily for reconnaissance though it was also used for bombardments; photograph p. 136, Eng. edn only.

75 Renoir to unidentified recipient, n.l., 5 September 1916, excerpt in Hôtel Drouot sale catalogue, 5 April 1962, no. 185.

76 Unpublished, André to Georges Durand-Ruel, Cagnes, 19 December 1916, in Paris, Archives Durand-Ruel.

77 Jean Renoir, 'Pour tout vous dire'.

78 Unpublished, Jean Renoir to Georges Durand-Ruel, n.l., 2 July 1917, in Paris, Archives Durand-Ruel.

79 Unpublished, Jean Renoir to Guino, n.l., 8 May 1917, in Façade Gallery, New York, exh. cat., n.d; medallion reproduced in White, *Renoir: His Life, Art, and Letters*, p. 257.

80 See also *Renoir in the 20th Century*, cat. no. 176.

81 Bonnard, *Renoir*, 1916, etching, 27 x 20 cm (10⅝ x 7⅞ in.), signed 'Bonnard'; White, *Renoir: His Life, Art, and Letters*, p. 257. From 1909, Bonnard (26 years younger) often visited him. Renoir gave him an oil of a nude (95 x 175 cm; 37⅜ x 68⅜ in.) signed at the upper right: 'To my friend, Bonnard, Renoir', sold Paris, Palais Galliera, 19 June 1963.

82 Unpublished, André to Georges Durand-Ruel, Cagnes, n.d. [*c.* 25 December 1916], in Paris, Archives Durand-Ruel.

83 Renoir to Dr Baudot, Cagnes, January 1917, in Baudot, *Renoir, ses amis, ses modèles*, p. 88.

84 Unpublished, André to Durand-Ruel, n.l., n.d. [1918], in Paris, Archives Durand-Ruel.

85 Unpublished, Jean Renoir to Guino, n.l., 8 May 1917, in Façade Gallery, New York, exh. cat., n.d. Sopwiths were British planes also available to the French.

86 Jean's most acclaimed film, *Grand Illusion*, deals with the war, in which the main character, played by Jean Gabin, is a pilot who wears Jean's actual pilot's uniform. Gabin's character is wounded in the arm, as was Pierre Renoir.

87 Unpublished, Jean Renoir to Renoir, 29 August 1917, in Paris, Archives Durand-Ruel.

88 Unpublished, Renoir to Jean Renoir, n.l., *c.* 1917, private collection.

89 Unpublished military record book of Jean Renoir, 1913–40, copy in Paris, Documentation Orsay; effective from

30 September 1917, he became a lieutenant by decree of 7 October 1917, legal order of 9 October 1917.

90 Georges Durand-Ruel to Renoir, Paris, 15 September 1917, in *Correspondance de Renoir et Durand-Ruel*, vol. 2, p. 213.

91 Unpublished, Jean Renoir to Georges Durand-Ruel, n.l., 29 December [1917], in Paris, Archives Durand-Ruel.

92 Joseph Durand-Ruel to Renoir, Paris, 24 January 1918, in *Correspondance de Renoir et Durand-Ruel*, vol. 2, p. 225.

93 Unpublished, Renoir to Jean Renoir, Cagnes, 16 March 1918, private collection.

94 Unpublished military record book of Jean Renoir, 1913–40.

95 *Ibid.*

96 Unpublished, President of the Council, Ministry of War, to Jean Renoir, Paris, 19 February 1919, private collection.

97 Unpublished military record book of Jean Renoir, 1913–40.

98 Georges Durand-Ruel to Renoir, Paris, 14 May 1919, in *Correspondance de Renoir et Durand-Ruel*, vol. 2, p. 237.

99 Unpublished military record book of Jean Renoir, 1913–40.

100 *Ibid*; the level of his Croix de Guerre was Silver Star and Bronze Palm (Etoile d'Argent, Palme). He served from 2 August 1914 to 23 October 1919.

101 Jean Renoir, 'Pour tout vous dire'.

102 White, *Renoir: His Life, Art, and Letters*, p. 261.

103 Unpublished, Claude Renoir to Guino, n.l., n.d. [April 1917], private collection.

104 Unpublished, Pierre Renoir to Guino, Paris, 18 November 1917, private collection.

105 Unpublished, Jean Renoir to Durand-Ruel, n.l. [Cagnes], 12 July 1919, in Paris, Archives Durand Ruel.

106 For a ceramic pot by Jean Renoir see Lucy and House, *Renoir in the Barnes Foundation*, pp. 64, 65 n. 38.

107 See Ch. 1 nn. 24–5 above.

108 Apollinaire, 'Dans petits pots…', *Paris-Journal*, 23 July 1914, in *Apollinaire on Art*, p. 425.

109 Claude Renoir, *Seize aquarelles*, n.p.

110 Georges Durand-Ruel to Renoir, Paris, 15 September 1917, in *Correspondance de Renoir et Durand-Ruel*, vol. 2, p. 212.

111 Renoir to André, Cagnes, 2 January 1916, in White, *Renoir: His Life, Art, and Letters*, p. 277, French on p. 276.

112 *Renoir in the 20th Century*, p. 398, *Renoir and Coco in the Garden of Les Collettes*, 1914–15.

113 Unpublished, Renoir to Vollard, Essoyes, 12 June 1916, in Paris, Bibliothèque des Musées Nationaux du Fonds Vollard, Ms 421 on microfilm.

114 Unpublished, Clément Meunier to Guino, Essoyes, 17 April 1917, private collection.

115 Unpublished, André to Georges Durand-Ruel, see n. 4 above.

116 Unpublished, André to Georges Durand-Ruel, see n. 82 above.

117 Apollinaire, 'Dans petits pots…', p. 425.

118 Unpublished, André to Paul Durand-Ruel, Laudun, November 1916, in Paris, Archives Durand-Ruel.

119 Unpublished, André to Georges Durand-Ruel, see n. 115 above.

120 Renoir to Georges Durand-Ruel, Cagnes, 28 January 1917, in *Correspondance de Renoir et Durand-Ruel*, vol. 2, p. 184.

121 See Yeatman, *Albert André*, p. 28.

122 Unpublished, André to Georges Durand-Ruel, Marseilles, 12 March 1917, in Paris, Archives Durand-Ruel.

123 Unpublished, André to Georges Durand-Ruel, Marseilles, 21 June 1917, in *ibid*.

124 Unpublished, André to Georges Durand-Ruel, Cagnes, 28 June 1917, in *ibid*.

125 Girard, *Renoir et Albert André*, pp. 27, 28: *Petit portrait de Renoir de profil*, 1918, oil on cardboard, Musée Albert-André, Bagnols-sur-Cèze; two studies, *Renoir painting in Profile*, 1919, oil on canvas, Cagnes-sur-mer, Musée Renoir; *Renoir seated*, 1918/19, graphite.

126 Unpublished, André to Georges Durand-Ruel, Marseilles, n.d. [1918], in Paris, Archives Durand-Ruel.

127 Renoir to André, Cagnes, May 1919, in 'Lettres de Renoir à quelques amis', p. 69.

128 Renoir to Georges Durand-Ruel, Cagnes, 30 September 1917, in *Correspondance de Renoir et Durand-Ruel*, vol. 2, p. 218.

129 Cassatt to Paul Durand-Ruel, Grasse, 9 February 1918, in Venturi, *Archives de l'impressionnisme*, vol. 2, p. 136.

130 Unpublished, Cassatt to Havemeyer, Grasse, 24 August 1918, in New York, Metropolitan Museum, Archives, Box 1, Folder 16.

131 Renoir to Monet, 24 March 1916, in Baudot, *Renoir, ses amis, ses modèles*, p. 111.

132 Georges Durand-Ruel to Renoir, Paris, 11 May 1917, in *Correspondance de Renoir et Durand-Ruel*, vol. 2, p. 196.

133 *Ibid.*, p. 197: 'I paid your rent for April (1,150.35 francs).'

134 Georges Durand-Ruel to Renoir, Paris, 1 May 1917, in *ibid.*, p. 195.

135 As Renoir's chief dealers, the Durand-Ruels had mounted 66 exhibitions with Renoir's work, 33 in Europe and 33 in the US.

136 The Bernheims showed Renoir's work in 15 exhibitions in Paris over 1900–19; see Dauberville, vol. 1, p. 100.

137 Josse later changed his surname to Dauberville and Gaston changed his to Bernheim de Villers.

138 Renoir's works were included in Bernheim group shows: 'Modern Painting', 14–23 June 1917; group show, 14–28 March 1919; group show, 14 December 1919–15 January 1920. From 1920 to 1986, the Bernheim Gallery included Renoir's works in 34 group exhibitions. They also had two individual Renoir exhibitions, in 1927 of nudes, flowers and children, and in 1938 of portraits. See Dauberville, vol. 1, pp. 100–4.

139 When visiting Renoir in Cagnes, Vollard sometimes also visited Cassatt: Cassatt to Havemeyer, Grasse, 4 August [1918], in New York, Metropolitan Museum, Archives, Box 1, Folder 16.

140 Negative owned by Gaumont Actualités; copy owned by Harvard University, Film Archive, given by Alain Renoir, Jean's son, who received a doctorate from Harvard in 1956.

141 Unpublished, André to Georges Durand-Ruel, Cagnes, 28 June 1917, in Paris, Archives Durand-Ruel.

142 Unpublished, André to Georges Durand-Ruel, Marseilles, 30 June 1917, in *ibid.*

143 Unpublished receipt, Paris, 10 December 1917, in Paris, Bibliothèque des Musées Nationaux du Fonds Vollard, Ms. 421 on microfilm; portrait of Léonard Renoir, Dauberville, vol. 1, pl. 531.

144 *Ambroise Vollard dressed as a Toreador*, 1917 (August), Dauberville, vol. 5, no. 4265; White, *Renoir: His Life, Art, and Letters*, p. 278. For the two earlier portraits, of 1906 and 1908, see Dauberville, vol. 4, pls 3388, 3392, respectively.

145 See Rabinow, *Cézanne to Picasso*, p. 19, *Portrait of Mme de Galéa* (1912, Dauberville, vol. 5, no. 4062) and photograph of her posing for Renoir.

146 Dauberville, vol. 5, pls 4058A–4058W and 4059A–4059F.

147 *Ibid.*, pl. 4283.

148 Unpublished, Cassatt to Havemeyer, Grasse, 24 August 1918, in New York, Metropolitan Museum, Archives, Box 1, Folder 16.

149 See *Renoir in the 20th Century*, p. 344.

150 Unpublished, André to Guino, Cagnes, 28 February 1917, in Cagnes, Musée Renoir.

151 Unpublished, Jean Renoir to Guino, Ambérieu-en-Bugey, 18 January 1916, private collection.

152 Unpublished, Jean Renoir to Guino, n.l., 4 July 1917, private collection.

153 Reproduced in White, *Renoir: His Life, Art, and Letters*, p. 271.

154 Pastel of Cézanne for Chocquet in 1880, Dauberville, vol. 1, pl. 617. A cast of Renoir's medallion of Cézanne was set up on a fountain in Cézanne's birthplace, Aix-en-Provence.

155 *Ibid.*, vol. 2, pl. 1253; Wagner medallion never completed.

156 Pastel of Monet commissioned by Vollard; White, *Impressionists Side by Side*, pl. 104.

157 Pastel of Rodin commissioned by Bernheim for his album; White, *Renoir: His Life, Art, and Letters*, p. 286.

158 Haesaerts, *Renoir Sculptor*, p. 41.

159 *Ibid.*, pl. XXVIII, 35 x 28 cm (14 x 11 in.). See also see Ch. 6 nn. 77–81 above.

160 *Ibid.*, pl. XXIX, 35 cm (14 in.).

161 *Ibid.*, pl. XXXVIII, 123 x 135 x 55 cm (48 x 53 x 22 in.).

162 Aral, 'Renoir-Guino, duo-duel', p. 101.

163 Renoir to Vollard, Cagnes, 7 January 1918, in *ibid.*

164 *Ibid.*

165 Renoir to Morel, Cagnes, 3 September 1918, in Haesaerts, *Renoir Sculptor*, p. 33.

166 Haesaerts, *Renoir Sculptor*, pls XLIV, XLVI, *Dancer with Tambourine* I and II, both 58 x 41 cm (23 x 16 in.); pls XLV, XLVII, *Flute Player* and detail.

167 *Ibid.*, p. 43.

168 *Ibid.*, p. 33.

169 Dussaule, *Renoir à Cagnes et aux Collettes*, p. 88, bronze, h. 55 cm (22 in.); see also *Renoir in the 20th Century*, p. 80.

170 Gimpel, *Journal d'un collectionneur*, 15 August 1918, p. 65.

171 Ambroise Vollard, *Paul Cézanne*, deluxe edn (Paris, 1914); standard (Paris: Crès & Cie., 1919; expanded 1924).

172 Gimpel, *Journal d'un collectionneur*, 6 September 1918, p. 70. Vollard was Bernard's dealer and in 1911 had published *Lettres de Vincent van Gogh à Émile Bernard*.

173 See Rabinow, *Cézanne to Picasso*, p. 288. The New York art magazine, *The Soil*, translated Vollard's article as 'How I came to know Renoir' in 1916–17 over 5 issues.

174 Rabinow, *Cézanne to Picasso*, p. 149 n. 22; see also Vollard, *La Vie et l'oeuvre de Pierre-Auguste Renoir*.

175 Renoir to Vollard, Cagnes, 3 March 1918, in Vollard, *La Vie et l'oeuvre*, p. vii.

176 *Ibid.*

177 Georges Durand-Ruel to Renoir, Paris, 14 May 1919, in *Correspondance de Renoir et Durand-Ruel, 1907–19*, vol. 2, p. 237.

178 Vollard, *La Vie et l'oeuvre*, and album of 1,400 reproductions of paintings, pastels and drawings with 2 original etchings; see Johnson, *Ambroise Vollard*, p. 163.

179 Renoir to J.-É. Blanche, n.l., 10 October 1919, in Roberts, *Jacques-Émile Blanche*, p. 149 (Eng. trans.).

180 Later, Matisse acquired six other Renoir paintings, further colour lithographs, and etchings; Butler, 'Matisse aux Collettes', p. 111.

181 See *ibid.*; Benjamin, 'Why did Matisse Love Late Renoir?' in *Renoir in the 20th Century*, pp. 136–43.

182 Butler, 'Matisseaux Collettes', pp. 111–16.

183 Matisse to Amélie Matisse, Nice, 13 January 1918, in Butler, 'Matisse aux Collettes', p. 112.

184 Benjamin, 'Why did Matisse Love Late Renoir?', pp. 140–41.

185 *Ibid.*, p. 138, photograph with Matisse, Renoir and Pierre Renoir, March 1918. See also photograph with Claude, Matisse, Pierre Renoir, Greta Prozor and Renoir, probably spring 1919, in Butler, 'Matisse aux Collettes', p. 112.

186 Matisse to Amélie Matisse, Nice, 9 May 1918, in Butler, 'Matisse aux Collettes', p. 113.

187 Paul Rosenberg to Picasso, n.l. [Paris], 29 July 1919, in *Exposition Picasso collectionneur, Picasso und seine sammlung*, p. 202.

188 Dauberville, vol. 3, pl. 2403; *Renoir in the 20th Century*, p. 213.

189 Picasso, *Seated Bather drying her Foot*, repro. in *Renoir in the 20th Century*, p. 211.

190 *Ibid.*, pp. 211, 212.

191 Picasso, *Renoir*, 1919, graphite and charcoal on paper, 61 x 49.3 cm (24⅛ x 19¼ in.). For the 1912 photograph of Renoir in his studio (Paris, Musée National Picasso, Archives), see White, *Renoir: His Life, Art, and Letters*, p. 256; Madeline, 'Picasso 1917 to 1924', pp. 124–5.

192 Picasso, *Village Dance*, repro. in Madeline, 'Picasso 1917 to 1924', p. 132.

193 *Ibid.*, pp. 122–35.

194 Jean Renoir, *Renoir*, pp. 456–7.

195 For *Variant of The Bathers*, 1903, 111.8 x 166.4 cm (44 x 65½ in.), and its preparatory study, brown, white and red chalk on brown paper, 104 x 162.6 cm (41 x 64 in.), see White, *Renoir: His Life, Art, and Letters*, p. 228.

196 Unpublished, Dédée to Vollard, n.l., 17 June 1920, in Paris, Bibliothèque des Musées Nationaux du Fonds Vollard, Ms. 421 on microfilm.

197 Unpublished telegram, Jean Renoir to André, Cagnes, 4 December 1919,

in Paris, Institut Néerlandais, Fondation Custodia (Collection F. Lugt).

198 Unpublished, Pierre Renoir to Georges Durand-Ruel, Cagnes, 9 December 1919, in Paris, Archives Durand-Ruel.

199 Unpublished, Pierre Renoir to Paul Durand-Ruel, Cagnes, 23 December 1919, in *ibid.*

200 Unpublished, Jean Renoir to Georges Durand-Ruel, Cagnes, 20 December 1919, in *ibid.*

201 Félix Fénéon, letter to the editors, *Bulletin de la vie artistique*, 15 December 1919, n.p; see Renoir, *Écrits, entretiens et lettres*, p. 172.

202 Unpublished death certificate, Cagnes, 3 December 1919, Registre des Actes de l'État-civil, Acte de Décès, Mairie de Cagnes-sur-Mer, Alpes Maritimes, Arrondissement de Grasse, no. 65.

203 Funeral oration to Renoir by Abbé Baume, parish priest of Cagnes, recorded in *La Vie* (Paris), 1 January 1920, trans. in Wadley, *Renoir: A Retrospective*, pp. 276–7; repr. in Renoir, *Écrits, entretiens et lettres*, pp. 174–5. See also Pharisien and Chartrand, *Victor Charigot*, p. 123.

204 Unpublished, Pierre Renoir to Georges Durand-Ruel, see n. 198 above.

205 Pharisien and Chartrand, *Victor Charigot*, p. 130.

206 *Ibid.*, pp. 125–7.

207 *Ibid.*, p. 126 n. 17, from allotment certificate, Essoyes, Hôtel de Ville, signed by Pierre Renoir of 30 rue de Miromesnil, Paris, and by M. Roger, the mayor, pp. 124–6, repro. p. 127.

208 *Ibid.*, p. 135 for repro. of Essoyes parish ms. stating that Renoir and Aline had been in Essoyes cemetery since June 1922.

209 *Ibid.*, repro. pp. 113, 114.

210 Monet to Geffroy, Giverny, 8 December 1919, in Wildenstein, *Monet: biographie*, vol. 4, p. 403, letter no. 2328.

211 Monet to Fénéon, n.l. [Giverny], *c.* mid-December 1919, in *ibid.*, letter no. 2329.

212 Monet to Joseph Durand-Ruel, Giverny, 17 January 1920, in Venturi, *Archives de l'impressionnisme*, vol. 1, p. 455.

213 Unpublished, Cassatt to Havemeyer, Paris, 4 December 1919, in New York, Metropolitan Museum, Archives, Box 1, Folder 17.

214 Unpublished, Pierre Renoir to Georges Durand-Ruel, see n. 198 above.

215 Unpublished, Pierre Renoir to Paul Durand-Ruel, Cagnes, 17 December 1919, in *ibid.*

216 Unpublished typescript, Renoir death inventory, drawn up by Louis Asselin, notary, Paris, 13 March 1920, 9 pp., private collection.

217 André and Elder, *L'Atelier de Renoir*. In 1922, the Galerie Barbazanges and Renoir's sons signed a contract for the purchase of 300 of the works from Renoir's studio; *Renoir in the 20th Century*, p. 381. Besides the works in Renoir's possession, there were others that had been left with Durand-Ruel.

218 Unpublished will of Renoir, 14 October 1908, reissued 6 December 1919, Paris, private collection.

219 Unpublished, Pierre Renoir to Jeanne Tréhot Robinet, n.l., 17 December 1919, private collection.

220 Unpublished, E. Duhau (notary) to Jeanne Tréhot, Paris, 27 December 1919, private collection.

221 Unpublished, Pierre Renoir to Jeanne Tréhot, Essoyes, September 1919, private collection.

222 Personal communication from the heirs of Jeanne Tréhot's foster family, 18 June 2003.

Afterword

1 Pharisien, *Pierre Renoir*, pp. 449–82.

2 Pierre Renoir to Louis Jouvet, 30 June 1934, in *ibid.*, p. 83.

3 *Ibid.*, pp. 135, 139, 163, 224.

4 For facts about the family see Serge Lemoine and Serge Toubiana, eds, *Renoir/Renoir*; Pharisien and Chartrand, *Victor Charigot*; Pharisien, *Célébrités d'Essoyes*; Pharisien, *Quand Renoir vint paysanner en Champagne*.

5 Pharisien and Chartrand, *Victor Charigot*, p. 106.

6 Albert Barnes bought 42 pieces of Jean's pottery of 1919–22, now in the Barnes

Foundation in Philadelphia; Lucy and House, *Renoir in the Barnes Foundation*, p. 65.

7　White, 'Renoir et Jean, 1894–1919', pp. 51–9.

8　Herbert, 'Introduction', p. xii.

9　A list of exhibitions in which Renoir's work appeared from 1874 to 1970 can be found in Daulte, *Auguste Renoir*, vol. 1, pp. 69–74. In the 1930s, his works appeared in 34 shows (17 solo); in the 1940s, in 16 shows (8 one-man); in the 1950s, in 24 shows (17 solo); in the 1960s, in 22 shows (10 solo).

10　See *The Sunday Oklahoman*, 17 October 1982, p. 8: 'In a press release, the Oklahoma Art Center director, Lowell Adams, is quoted as saying Pierre [sic] Renoir's "The Luncheon of the Boating Party" was purchased by Phillips in 1923 for $185,000 and that the value of the painting has increased 100 times the original price. That would place the painting's value at 12.5 million dollars.... A New York art dealer and prominent art expert, Richard Feigen... made the following estimates on the value of several of the paintings being exhibited here...Renoir's "Luncheon of the Boating Party" – 12 million to 15 million dollars, and maybe even more – "A top piece of work".'

11　François Duret-Robert, 'Un Milliard pour un Renoir?' in Pierre Cabanne et al., *Renoir*, p. 266.

12　Sold by the Whitney family to a Japanese industrialist named Ryoei Saito, who later resold the work for only $50 million.

13　See map in Daulte, *Auguste Renoir*, p. 95. Renoir's home at Les Collettes in Cagnes-sur-Mer is open to the public.

14　White, 'An Analysis of Renoir's Development from 1877 to 1887', pp. 154–5.

SELECTED BIBLIOGRAPHY

Adhémar, Hélène, with the collaboration of Sylvie Gache. *L'Exposition de 1874 chez Nadar (rétrospective documentaire)*. Exh. cat. Paris: Réunion des Musées Nationaux, 1974.

André, Albert. *Renoir*. Paris: Georges Crès, Éditions Cahiers d'Aujourd'hui, 1919, reissued 1923.

—. *Renoir: Carnet de dessins – Renoir en Italie et en Algérie (1881–1882)*. Pref. and intro. Georges Besson. 2 vols. Paris: Daniel Jacomet, 1955.

—, and Marc Elder. *L'Atelier de Renoir*. 2 vols. Paris: Bernheim-Jeune, 1931. Repr. in 1 vol. San Francisco: Alan Wofsy Fine Arts, 1989.

Apollinaire, Guillaume. *Chroniques d'art (1902–1918)*. Ed. L.-C. Breunig. Paris: Gallimard, 1960. *Apollinaire on Art: Essays and Reviews, 1902–1918*. Ed. LeRoy C. Breunig. Trans. Susan Suleiman. New York: Da Capo Press, 1972.

Aral, Guillaume. 'Renoir-Guino, duo-duel'. In *Renoir et les familiers des Collettes*, 2008, pp. 97–110.

Assouline, Pierre. *Discovering Impressionism: The Life of Paul Durand-Ruel*. New York: Vendome Press, 2004.

Bailey, Colin B. *Renoir, Impressionism, and Full-Length Painting*. Exh. cat. New York: Frick Collection, 2012.

—. *Renoir's Portraits: Impressions of an Age*. Exh. cat. Ottawa: National Gallery of Canada; New Haven and London: Yale University Press, 1997.

—. 'Manet and Renoir: An Unexamined Dialogue'. In *Manet: Portraying Life*. Exh. cat. Toledo, OH: Toledo Museum of Art, 2012; London: Royal Academy of Arts, 2013.

—. 'Renoir's Portrait of his Sister-in-Law'. *Burlington Magazine* 137 (October 1995): 684–7.

—, et al. *Renoir Landscapes, 1865–1883*. Exh. cat. London: National Gallery, 2007.

Barnes, Albert C., and Violette de Mazia. *The Art of Renoir*. Merion, PA: Barnes Foundation Press, 1935.

Bataille, Marie-Louise, and Georges Wildenstein. *Berthe Morisot: catalogue des peintures, pastels et aquarelles*. Paris: Les Beaux-Arts, 1961.

Baudot, Jeanne. *Renoir, ses amis, ses modèles*. Paris: Éditions Littéraires de France, 1949.

Belloni, Gianguido. *Pompeian Painting*. Milan: Officine Grafiche Ricordi, 1962.

Bénédite, Léonce. 'Madame Charpentier and her Children by Auguste Renoir'. *Burlington Magazine* (December 1907). Repr. in Wadley, *Renoir: A Retrospective*, 1987, pp. 237–40.

Benjamin, Roger. *Renoir and Algeria*. Exh. cat. Williamstown, Mass: Sterling and Francine Clark Art Institute; New Haven and London: Yale University Press, 2003.

—. 'Why Did Matisse Love Late Renoir?' In *Renoir in the 20th Century*, 2009, pp. 136–45.

Bérard, Maurice. *Renoir à Wargemont*. Paris: Larose, 1938.

—. 'Un Diplomate ami de Renoir'. *Revue d'histoire diplomatique* (July–September 1956): 239–46.

Berhaut, Marie. *Caillebotte: sa vie et son œuvre: catalogue raisonné des peintures et pastels*. Paris: Fondation Wildenstein and Bibliothèque des Arts, 1994.

Bertin, Célia. *Jean Renoir*. Paris: Librairie Académique Perrin, 1986; repr. Paris: Éditions du Rocher, 1994.

Besson, Georges. *Renoir*. Paris: Crés, 1929.

—. 'Arrivée de Matisse à Nice'. *Le Point, revue artistique* 21 (July 1939): 41–2.

Blanche, Jacques-Émile. *La Pêche aux souvenirs*. Paris: Flammarion, 1949.

—. *Portraits of a Lifetime, The Late Victorian Era: The Edwardian Pageant 1870–1914*. Trans. and ed. Walter Clement. London: J. M. Dent & Sons, 1937.

Boime, Albert. *The Academy and French Painting in the Nineteenth Century*. New York and London: Phaidon, 1971.

Bomford, David, Jo Kirby, John Leighton and Ashok Roy. *Art in the Making: Impressionism*. Exh. cat. London: National Gallery; New Haven and London: Yale University Press, 1990.

Braudy, Leon. 'Renoir at Home: Interview', 1970. In Cardullo, *Jean Renoir Interviews*, pp. 186–93.

Braun, Galerie d'Art. *L'Impressionnisme et quelques précurseurs*. Exh. cat. Paris, 22 January–13 February 1932.

—. *Renoir*. Exh. cat. Paris, 14 November–3 December 1932.

Brettell, Richard R. *Impressionism: Painting Quickly in France 1860–1890*. Exh. cat. Williamstown, Mass: Clark Art Institute; New Haven and London: Yale University Press, 2000.

Burnham, Helen. 'Changing Silhouettes'. In Gloria Groom, ed. *Impressionism, Fashion, and Modernity*. Exh. cat. Art Institute of Chicago; New York: Metropolitan Museum of Art; Paris: Musée d'Orsay, 2012, pp. 253–69.

Butler, Augustin de. *Lumière sur les impressionnistes*. Paris: L'Échoppe, 2007. Pamphlet.

—. *Le Rire de Renoir*. Paris: L'Échoppe, 2009. Pamphlet.

—. 'Ce Renoir que l'on ne saurait voir'. Lecture at Musée d'Orsay, Paris, 20 May 2008, 16pp booklet.

—. 'Matisse aux Collettes'. In *Renoir et les familiers des Collettes*, 2008, pp. 111–16.

—. 'Renoir aux Collettes: l'atelier du jardin'. *Revue de l'art* 161 (2008): 41–8.

—. 'A Youth in the Louvre'. In *Renoir: Between Bohemia and Bourgeoisie*, 2012, pp. 79–92.

—, and Lionel Dax. *Impressions La Roche-Guyon*. Paris: L'Amandier, 2011. Pamphlet.

Butler, Ruth. *Hidden in the Shadow of the Master: The Model-Wives of Cézanne, Monet, and Rodin*. New Haven and London: Yale University Press, 2008.

Cabanne, Pierre, et al. *Renoir*. Paris: Hachette, 1970.

Cameron, Rondo. *France and the Economic Development of Europe, 1800–1914: Conquests of Peace and Seeds of War*. Princeton University Press, 1961.

Cardullo, Bert, ed. *Jean Renoir Interviews*. Jackson: University Press of Mississippi, 2005.

Cassatt, Mary. *Cassatt and Her Circle: Selected Letters*. Ed. Nancy Mowll Mathews. New York: Abbeville, 1984.

Catalogue des tableaux composant la collection Maurice Gangnat: 160 tableaux par Renoir.

Pref. Robert de Flers and Élie Faure. Paris: Hôtel Drouot, 24–25 June 1925.

Cézanne, Paul. *Paul Cézanne: Correspondance*. Ed. John Rewald. Paris: Bernard Grasset, 1937; repr. 1978.

—. *The Letters of Paul Cézanne*. Ed. Alex Danchev. London: Thames & Hudson, 2013.

Cézanne Watercolors. Exh. cat. New York: Knoedler; Chanticleer Press, 1963.

Clergue, Denis-Jean. *La Maison de Renoir: Musée Renoir du Souvenir*. Cagnes-sur-Mer: R. Zimmermann, 1976.

Conforti, Michael, et al. *The Clark Brothers Collect: Impressionist and Early Modern Paintings*. New Haven and London: Yale University Press, 2006.

Cooper, Douglas. 'Renoir, Lise and the Le Coeur Family: A Study of Renoir's Early Development'. *Burlington Magazine* 101 (May, September–October 1959): 163–71, 322–8.

Danchev, Alex. *Cézanne: A Life*. New York: Pantheon Books, 2012.

Dans l'intimité des frères Caillebotte, peintre et photographe. Exh. cat. Paris: Musée Jacquemart-André, 2011.

Dauberville, Guy-Patrice, and Michel Dauberville. *Renoir: catalogue raisonné des tableaux, pastels, dessins et aquarelles*. 5 vols. Paris: Éditions Bernheim-Jeune, 2007–14.

Dauberville, Henry. *La Bataille de l'impressionnisme*. Paris: Éditions Bernheim-Jeune, 1967; 2nd ed. 1973.

Dauberville, Jean. *En Encadrant le siècle*. Paris: Éditions Bernheim-Jeune, 1967.

Daulte, François. *Auguste Renoir*. Paris: Diffusion Princesse, 1974.

—. *Auguste Renoir: catalogue raisonné de l'oeuvre peint*. Vol. 1: *Figures, 1860–1890*. Lausanne: Durand-Ruel, 1971.

—. *Frédéric Bazille*. Paris: Bibliothèque des Arts, 1992. Catalogue of paintings.

Delteil, Loys. *Le Peintre-graveur illustré*. Vol. 17: *Pissarro/Sisley/Renoir*. Paris: Loys Deltiel, 1923.

Denis, Maurice. *Journal*. 3 vols. Paris: La Colombe, 1957–59.

— [Pseud. Pierre L. Maud]. 'Le Salon du Champs-de-Mars (et) l'Exposition de Renoir'. *La Revue Blanche* (25 June 1892). Repr. in Denis, *Théories*, p. 19.

—. *Théories, 1890–1910*. Paris: L. Rouart and J. Watelin, 1920.

Didot-Bottin. *Annuaire-Almanach du commerce, de l'industrie, de la magistrature et de l'administration: ou almanac des 500,000 addresses de Paris...*. 1859. Paris: Firmin Didot Frères.

Distel, Anne. *Impressionism: The First Collectors*. New York: Abrams, 1990.

—. *Renoir*. Trans. John Goodman. New York: Abbeville, 2010; Paris: Citadelles et Mazenod, 2009.

—. 'Vollard and the Impressionists: The Case of Renoir'. In Rabinow, *Cézanne to Picasso*, 2006, pp. 142–9.

—, ed. *Renoir O Pintor da Vida*. Exh. cat. São Paulo: Museu de Arte, 2002.

—, et al. *Gustave Caillebotte: Urban Impressionist*. New York: Abbeville, 1995.

Drucker, Michel. *Renoir*. Paris: Pierre Tisné, 1944.

Dumas, Anne. 'Ambroise Vollard, Patron of the Avant-Garde'. In Rabinow, *Cézanne to Picasso*, pp. 2–27.

Durand-Ruel, Paul-Louis and Flavie, eds. *Paul Durand-Ruel: Memoirs of the First Impressionist Art Dealer (1831–1922)*. Paris: Flammarion, 2014.

Durand-Ruel Snollaerts, Claire. *Paul Durand-Ruel: Discovering the Impressionists*. Paris: Gallimard, 2015.

Duret, Théodore. *Les Peintres impressionnistes*. 1878; repr. in Théodore Duret, *Histoire des peintres impressionnistes*. Paris: Floury, 1922.

Durieux, Tilla. *Séances de pose chez Renoir en 1914*. Paris: L'Échoppe, 2009.

Dussaule, Georges. *Renoir à Cagnes et aux Collettes*. Cagnes-sur-Mer: Éditions Ville, 1995.

Exposition Picasso collectionneur, Picasso und seine Sammlung. Ed. Hélène Seckel. Exh. cat. Paris: Musée Picasso; Munich: Kunsthalle der Hypo-Kulturstiftung, 1998.

Fénéon, Félix. *Les Impressionnistes en 1886*. Paris: Publications de la Vogue, 1886; repr. in Félix Fénéon, *Au-delà de l'Impressionnisme*. Paris: Hermann, 1966.

Frère, Henri. *Conversations de Maillol*. Geneva: Pierre Cailler, 1956.

Fuchs, Rachel Ginnis. *Abandoned Children: Foundlings and Child Welfare in Nineteenth-Century France*. Albany: State University of New York Press, 1984.

Gachet, Paul. *Deux amis des impressionnistes: Le Docteur Gachet et Murer*. Paris: Éditions des Musées Nationaux, 1956.

—. *Lettres impressionnistes au Dr Gachet et au Murer*. Paris: Bernard Grasset, 1957.

Geffroy, Gustave. *Claude Monet: sa vie, son œuvre*. 2 vols. Paris: Crès, 1924.

—. *La Vie artistique*. Paris: Dentu, 1894.

Gélineau, Jean-Claude. *Jeanne Tréhot, la fille cachée de Pierre Auguste Renoir*. Essoyes: Éditions du Cadratin, 2007.

—. 'La Boulangère, modèle de Renoir'. *Association des Amis du Musée Renoir* 6 (Cagnes-sur-Mer, January 2006): 13–21.

—. 'Jeanne, fille d'Auguste Renoir'. In Distel, *Renoir O Pintor da Vida*, pp. 223–7.

—. 'L'Orne au XIXe siècle: culture et société'. *Revue de la Société historique et archéologique de l'Orne* 3 (September 2003): n.p.

—. 'À la recherche de Georgette Pigeot'. *Association des Amis du Musée Renoir* 8 (Cagnes-sur-Mer, 2008): 21–6.

—. 'La Vie de Jeanne Tréhot, fille d'Auguste Renoir'. *Association des Amis du Musée Renoir* 4 (Cagnes-sur-Mer, July 2003): 10–21.

Gentner, Florence. *Album d'une vie: Pierre-Auguste Renoir*. Paris: Chêne, Hachette-Livre, 2009.

Gimpel, René. *Journal d'un collectionneur, marchand de tableaux*. Paris: Calmann-Lévy, 1963. *Diary of an Art Dealer*. Trans. John Rosenberg. New York: Farrar, Straus and Giroux, 1966.

Girard, Alain. *Renoir et Albert André, une amitié, 1894–1919*. Exh. cat. Bagnols-sur-Cèze: Musée Albert-André de Bagnols-sur-Cèze, 2004.

—. 'Renoir et Albert André: une amitié'. In *Renoir et les familiers des Collettes*, 2008, pp. 9–43.

Groom, Gloria, ed. *Impressionism, Fashion, and Modernity*. Exh. cat. Art Institute of Chicago; New York: Metropolitan Museum of Art; Paris: Musée d'Orsay, 2012.

Gurley, Elizabeth Ryan. 'Renoir a beaucoup puisé chez Manet'. *Connaissance des arts* (May 1973): 132–9.

Haesaerts, Paul. *Renoir Sculptor*. New York: Reynal & Hitchcock, 1947.

Hauptman, William. 'Delaroche's and Gleyre's Teaching Ateliers and their Group Portraits'.

Studies in the History of Art 18 (1985): 79–119.

Héran, Emmanuelle. 'Vollard, Publisher of Maillol's Bronzes: A Controversial Relationship'. In Rabinow, *Cézanne to Picasso*, pp. 72–181.

Herbert, Robert L. 'Introduction'. In Jean Renoir, *Renoir, My Father*, pp. ix–xiii.

—. *Renoir's Writings on the Decorative Arts*. New Haven and London: Yale University Press, 2000.

Hommage à Berthe Morisot et à Pierre-Auguste Renoir. Ed. Serge Gauthier. Exh. cat. Limoges: Musée Municipal, 1952.

House, John. 'Renoir's Baigneuses of 1887 and the Politics of Escapism'. *Burlington Magazine* 134, no. 1074 (September 1992): 578–85.

—, Anne Distel et al. *Renoir*. Exh. cat. London: Hayward Gallery; Paris: Grand Palais; Boston: Museum of Fine Arts, 1985.

Howard, Michael. *The Franco-Prussian War: The German Invasion of France 1870–1871*. London: Rupert Hart-Davis Ltd, 1961; New York: Macmillan, 1962.

Hugon, Henri. 'Les Aïeux de Renoir et sa maison natale'. *La Vie Limousine* (25 January 1935): 453–5.

Huth, Hans. 'Impressionism comes to America'. *Gazette des Beaux-Arts* 29 (April 1946): 225–52.

Isaacson, Joel, et al. *The Crisis of Impressionism, 1878–1882*. Exh. cat. Ann Arbor: University of Michigan Museum of Art, 1980.

Jensen, Robert. 'Vollard and Cézanne: An Anatomy of a Relationship'. In Rabinow, *Cézanne to Picasso*, 2006, pp. 28–47.

Joëts, Jules, ed. 'Lettres inédites: les impressionnistes et Chocquet'. *L'Amour de l'art* 16 (April 1935): 120–25.

Johnson, Una E. *Ambroise Vollard, éditeur: Prints, Books, Bronzes*. Exh. cat. New York: Museum of Modern Art, 1977.

Kropmanns, Peter. 'Renoir's Friendships with Fellow Artists – Bazille, Monet, Sisley'. In *Renoir: Between Bohemia and Bourgeoisie*, 2012, pp. 237–54.

Le Coeur, Charles (1830–1906), architecte et premier amateur de Renoir. Exh. cat. Paris: Musée d'Orsay; Paris: Réunion des Musées Nationaux, 1997.

Le Coeur, Marc. *Renoir au temps de la bohème: l'histoire que l'artiste voulait oublier*. Paris: L'Échoppe, 2009.

—. 'L'Art décoratif et contemporain (Avril 1877): un portrait de Renoir entre les lignes'. *La Revue du Musée d'Orsay* 30 (Autumn 2010): 6–17.

—. 'A Drawing of Renoir in 1866'. *Burlington Magazine* 140, no. 1142 (May 1998): 319–22.

—. 'Le Peintre, son premier modèle et ses premiers amateurs: l'histoire dont Renoir ne voulait pas parler'. In Distel, *Renoir O Pintor da Vida*, pp. 196–223.

—. 'Renoir's Silences'. In *Renoir: Between Bohemia and Bourgeoisie*, 2012, pp. 223–34.

—. 'Le Salon annuel de la Société des amis des arts de Pau, quartier d'hiver des impressionnistes de 1876 à 1879'. *Histoire de l'art* 35/36 (October 1996): 57–70.

—. 'Lise Tréhot: portrait d'après nature'. *Association des amis du musée Renoir* 4 (Cagnes-sur-Mer, July 2003): 5–9.

—, ed. *Edmond Renoir, Pierre Auguste Renoir*. Paris: L'Échoppe, 2009.

Lemoine, Serge, and Serge Toubiana, eds. *Renoir/Renoir*. Exh. cat. Paris: Cinémathèque Française and Éditions de la Martinière, 2005.

Lucy, Martha, and John House. *Renoir in the Barnes Foundation*. New Haven and London: Yale University Press, 2012.

M., F. 'Le mois artistique' [about Paul Paulin]. *L'Art et les artistes* (January 1910): 175–6.

Madeline, Laurence. 'Picasso 1917 to 1924: A "Renoirian" Crisis'. In *Renoir in the 20th Century*, 2009, pp. 122–35.

Maison de Renoir aux Collettes, La. Exh. cat. Cagnes-sur-Mer: Association des Amis du Musée Renoir, n.d. [c. 2001].

Manet, Julie. *Growing Up with the Impressionists: The Diary of Julie Manet*. Trans., ed. and intro. Rosalind de Boland Roberts and Jane Roberts. London: Sotheby's Publications, 1987.

—. *Journal (1893–1899): sa jeunesse parmi les peintres impressionnistes et les hommes de lettres*. Preface by Jean Griot. Paris: Klincksieck, 1979.

Marandel, J. Patrice, and François Daulte. *Frédéric Bazille and Early Impressionism*. Exh. cat. Art Institute of Chicago, 1978.

Meier-Graefe, Julius. *Auguste Renoir*. Munich: R. Piper, 1911. French edn, *Auguste Renoir*. Trans. A. S. Maillet. Paris: Floury, 1912. With additional reproductions, Leipzig: Klinkhardt und Biermann, 1929.

Melanson, Elizabeth. 'The Influence of Jewish Patrons on Renoir's Stylistic Transformation in the Mid-1880s'. *Nineteenth-Century Art Worldwide* 12, no. 2 (2013), www.19thc-artworldwide.org.

Mellerio, André. 'Les Artistes à l'atelier-Renoir'. *L'Art dans les deux mondes* (31 January 1891), n.p.

Mérigeau, Pascal. *Jean Renoir*. Paris: Flammarion, 2012.

Mermillon, Marius. *Albert André*. Paris: G. Crès & Cie, 1927.

Mirbeau, Octave. *Correspondance avec Claude Monet*. Ed. Pierre Michel and Jean-François Nivet. Paris: Éditions du Lérot, 1990.

—, ed. *Renoir*. Exh. cat. Paris: Bernheim-Jeune, 1913. With 58 reviews by other critics.

Moffett, Charles S. *The New Painting: Impressionism, 1874–86*. Exh. cat. San Francisco: Fine Arts Museums of San Francisco, 1986; Washington, DC: National Gallery of Art, 1986.

Moncade, C.-L. de. 'Le Peintre Renoir et le Salon d'Automne'. *La Liberté de penser: la revue démocratique* 10 (15 October 1904). Repr. in Renoir, *Écrits, entretiens et lettres*, pp. 9–11; trans. in White, *Impressionism in Perspective*, pp. 21–4.

Monet, Claude. *Archives Claude Monet: Correspondance d'Artiste*. Sale cat. Paris: Artcurial, 13 December 2006.

Monneret, Sophie. *L'Impressionnisme et son époque*. 4 vols. Paris: Denoël, 1978–81.

Moreau-Nélaton, Étienne. *Manet, raconté par lui-même*. 2 vols. Paris: Henri Laurens, 1926.

Morisot, Berthe. *Berthe Morisot: The Correspondence with her Family and Friends: Manet, Puvis de Chavannes, Degas, Monet, Renoir and Mallarmé*. Trans. Betty W. Hubbard, ed. Denis Rouart, intro. and notes Kathleen Adler and Tamar Garb. Mt Kisco, NY: Moyer Bell, 1987.

—. *Correspondance de Berthe Morisot*. Ed. Denis Rouart. Paris: Quatre Chemins-Éditart, 1950.

Muehsam, Gerd, ed. *French Painters and Paintings from the Fourteenth Century to Post-Impressionism: A Library of Art Criticism*. New York: Ungar, 1970.

Niculescu, Remus. 'Georges de Bellio, l'ami des impressionnistes'. *Revue roumaine d'histoire de l'art* 1, no. 2 (1964): 209–78.

Nochlin, Linda. 'Degas and the Dreyfus Affair: A Portrait of the Artist as an Anti-Semite'. In Norman L. Keeblatt, ed. *The Dreyfus Affair: Art, Truth and Justice*. Berkeley: University of California Press, 1987, pp. 96–116.

Nogueira, Rui, and François Truchaud. 'Interview with Jean Renoir' (1968). In Cardullo, *Jean Renoir Interviews*, pp. 169–85.

Nord, Philip. 'The New Painting and the Dreyfus Affair'. *Historical Reflections/Réflexions historiques* 24, no. 1 (1998): 115–36.

'Nos artistes: le peintre P.-A. Renoir chez lui'. *L'Éclair* (9 August 1892). Interview.

Pach, Walter. *Queer Thing, Painting: Forty Years in the World of Art*. New York and London: Harper & Brothers, 1938.

—. *Renoir*. New York: Abrams, 1950.

—. 'Pierre-Auguste Renoir'. *Scribner's Magazine* 51 (January–June 1912): 606–15.

Parker, Robert McDonald. 'Topographical Chronology, 1860–1883'. In Colin B. Bailey et al. *Renoir Landscapes, 1865–1883*. Exh. cat. London: National Gallery, 2007.

Patry, Sylvie. 'Pierre-Auguste Renoir: Madame Georges Charpentier and Her Children'. In Gloria Groom, ed. *Impressionism, Fashion, and Modernity*. Exh. cat. Art Institute of Chicago; New York: Metropolitan Museum of Art; Paris: Musée d'Orsay, 2012, pp. 244–51.

—. 'Renoir and Decorative Art: "A Pleasure without Compare"'. In *Renoir in the 20th Century*, 2009, pp. 44–59.

—. 'Renoir's Early Career: From Artisan to Painter'. In *Renoir: Between Bohemia and Bourgeoisie*, 2012, pp. 53–76.

Perruchot, Henri. *La Vie de Renoir*. Paris: Hachette, 1964.

Pharisien, Bernard. *Les Célébrités d'Essoyes, ce village qui a conquis Renoir*. Bar-sur-Aube: Éditions Némont, 1998.

—. *Gabrielle d'Essoyes*. Éditions Némont, 2014.

—. *Quand Renoir vint paysanner en Champagne*. Bar-sur-Aube: Éditions Némont, 2009.

—. *Pierre Renoir*. Bar-sur-Aube: Éditions Némont, 2003.

—. *Renoir de vigne en vin à Essoyes*. Bar-sur-Aube: Éditions Némont, 2012.

—, and Pierre Chartrand. *Victor Charigot, son grand-père*. Bar-sur-Aube: Éditions Némont, 2007.

Pintus, Isabelle. 'Sur les traces de Renoir dans les archives'. In *Renoir et les familiers des Collettes*, 2008, pp. 129–34.

Pissarro, Camille. *Correspondance de Camille Pissarro*. Ed. Janine Bailly-Herzberg. Vol. 1, Paris: Presses Universitaires de France, 1980; Vols 2–5, Paris: Valhermeil, 1986–91.

—. *Camille Pissarro: Letters to His Son Lucien*. Ed. Lucien Pissarro and John Rewald. Santa Barbara and Salt Lake City: Peregrine Smith, 1981.

Poulain, Gaston. *Bazille et ses amis*. Paris: Renaissance du Livre, 1932.

Price, Aimée Brown. *Pierre Puvis de Chavannes*. 2 vols. New Haven and London: Yale University Press, 2010.

Pullins, David. 'Renoir and the Arts of Eighteenth-Century France: Points of Origin'. In *Renoir: Between Bohemia and Bourgeoisie*, 2012, pp. 257–72.

Rabinow, Rebecca, ed. *Cézanne to Picasso: Ambroise Vollard, Patron of the Avant-Garde*. Exh. cat. New York: Metropolitan Museum of Art; New Haven and London: Yale University Press, 2006.

—, and Jayne Warman. 'Selected Chronology'. In Rabinow, *Cézanne to Picasso*, pp. 275–99.

Rathbone, Eliza, et al. *Impressionists on the Seine: A Celebration of Renoir's Luncheon of the Boating Party*. Exh. cat. Washington, DC: Phillips Collection; Berkeley, CA: Counterpoint, 1996.

Redon, Odilon. *Lettres d'Odilon Redon, 1878–1916*. Pref. M. A. Leblond. Paris and Brussels: G. van Oest, 1923.

Régnier, Henri de. *Renoir, peintre du nu*. Paris: Bernheim-Jeune, 1923.

Renoir, Claude. *Seize aquarelles et sanguines de Renoir accompagnées de 'Souvenirs sur mon père'*. Paris: Quatre Chemins – Éditart, 1948.

—. 'Renoir, sa toile à l'ombre d'un parasol'. Repr. in *Renoir: Exposition du cinquantenaire (1919–69)*. Exh. cat. Les Collettes, Cagnes-sur-Mer, 1969, n.p.

Renoir, Edmond. 'Cinquième Exposition de "La Vie Moderne"'. *La Vie moderne* 11 (19 June 1879). Repr. in Venturi, *Archives de l'impressionnisme*, vol. 2, pp. 334–8.

Renoir, Jean. *Écrits 1926–1971*. Paris: Pierre Belfond, 1974.

—. *Lettres d'Amérique*. Paris: Presses de la Renaissance, 1984.

—. *My Life and My Films*. Trans. Norman Denny. New York: Atheneum, 1974; *Ma vie et mes films*. Paris: Flammarion, 1974.

—. *Jean Renoir Letters*. Trans. Craig Carlson, Natasha Arnoldi and Michael Wells. Ed. David Thompson and Lorraine LoBianco. London and Boston, Mass.: Faber & Faber, 1995. French edn: *Jean Renoir, Correspondance 1913–1978*. Ed. David Thompson. Paris: Plon, 1998.

—. *Renoir, My Father*. Boston and Toronto: Little, Brown, 1958; 'Renoir My Father'. *Look* 26 (6 November 1962): 50–68; repr. *Renoir, My Father*. Trans. Randolph and Dorothy Weaver, intro. Robert L. Herbert. *New York Review of Books*, 2001; French edn, *Renoir*. Paris: Hachette, 1962; repr. *Renoir, mon père*. Paris: Gallimard, 1981.

—. *Renoir on Renoir: Interviews, Essays, and Remarks*. Cambridge University Press, 1989.

—. 'Pour tout vous dire'. Interview by Jean Serge. Ina/Radio France, 1958.

Renoir, Paul, and Marie-Paule Renoir. *Pierre Auguste Renoir: photographies de sa vie privée, avec des textes de Paul Renoir, à l'occasion du 150ème anniversaire de la naissance de Renoir*. Dortmund: Galerie Utermann; Hasselt, Belgium: Galerij Philippe Fryns, 1991.

—. *Si Renoir m'était conté*. Hasselt, Belgium: Galerij Philippe Fryns, 1991.

Renoir, Paul, Michel Guino and M. G. Roy. *Pierre Auguste Renoir/Richard Guino, sculptures et dessins*. Nice: Imprimix, 1974.

Renoir, Paul, and Stefano Pirra. *125 dessins inédits de Pierre Auguste Renoir*. Turin: Edizioni d'Arte Pinacoteca, 1971.

Renoir, Pierre-Auguste. Articles by date: [signed 'Un Peintre']. 'Lettre au directeur de "L'Impressionniste"'. *L'Impressionniste: journal d'art* (14 April 1877). Repr. in Venturi, *Archives de l'impressionnisme*, vol. 2, pp. 321–2. See also Herbert, *Renoir's Writings on the Decorative Arts*.

—. 'L'Art décoratif et contemporain'.
L'Impressionniste: journal d'art (28 April
1877). Repr. in Venturi, *Archives de
l'impressionnisme*, vol. 2, pp. 326–9.
See also Herbert, *Renoir's Writings on
the Decorative Arts*.

—. 'La Société des Irrégularistes'. May
1884. Repr. in Venturi, *Archives de
l'impressionnisme*, vol. 1, pp. 127–9.
See also Herbert, *Renoir's Writings
on the Decorative Arts*.

—. 'Lettre d'Auguste Renoir à Henri Mottez'.
In Cennino Cennini, *Le Livre de l'art ou
traité de la peinture*. Ed. Henri Paul Mottez.
Paris: Bibliothèque de l'Occident, 1910,
pp. v–xii. Rev. and expanded edn of
*Le Livre de l'art ou Traité de la peinture
par Cennino Cennini*. Ed. and trans. Victor
Mottez. Paris: 1858. See also Herbert,
Renoir's Writings on the Decorative Arts.

—. Letters and Interviews:

—. *Correspondance de Renoir et Durand-Ruel*.
Ed. Caroline Durand-Ruel Godfroy. Vol. 1:
1881–1906; vol. 2: 1907–1919. Lausanne:
Bibliothèque des Arts, 1995. [Updated
edn of Renoir's letters in Venturi, *Archives
de l'impressionnisme*, 1939]

—. *Écrits, entretiens et lettres sur l'art*. Ed.
Augustin de Butler. Paris: Éditions de
l'Amateur, Collection Regard sur l'Art, 2002.

—. *Écrits et propos sur l'art*. Ed. Augustin de
Butler. Paris: Hermann Éditeurs, 2009.

—. 'Lettres de Renoir à Paul Bérard (1879–
1891)'. Ed. Maurice Bérard. *La Revue de
Paris* (December 1968): 3–7.

—. 'Lettres de Renoir à quelques amis'. Ed.
Augustin de Butler. In *Renoir et les familiers
des Collettes*, pp. 45–69.

—. 'Renoir et la famille Charpentier: lettres
inédites'. Ed. Michel Florisoone. *L'Amour
de l'art* 19 (February 1938): 31–40.

Renoir aux Collettes. Exh. cat. Cagnes-sur-Mer:
Musée Renoir, 1961.

*Renoir: Between Bohemia and Bourgeoisie. The
Early Years*. Exh. cat. Basel: Kunstmuseum;
Ostfildern; Hatje Cantz, 2012.

Renoir et les familiers des Collettes. Exh. cat.
Cagnes-sur-Mer: Musée Renoir and Château-
musée Grimaldi, 2008.

*Renoir in the 20th Century; Renoir au XXe
siècle*. Exh. cat. Paris: Galeries Nationales;
Los Angeles County Museum of Art;
Philadelphia Museum of Art; Ostfildern:
Hatje Cantz, 2009.

*Renoir Personal Artifacts and Archives
Collection*. Sale cat. Potomac, MD: Hantman's
Auctioneers and Appraisers, 14 May 2005.

Rewald, John. *Les Aquarelles de Cézanne:
catalogue raisonné*. Paris: Arts et Métiers
Graphiques, 1984.

—. *Cézanne: A Biography*. New York:
Abrams, 1986.

—. *The History of Impressionism*. 4th ed.
New York: Museum of Modern Art, 1973.

—. *The Paintings of Paul Cézanne: A Catalogue
Raisonné*. New York: Abrams, 1996.

—. *Post-Impressionism: From Van Gogh to
Gauguin*. New York: Museum of Modern Art,
1962.

—. *Renoir Drawings*. New York and London:
Thomas Yoseloff, 1958.

—. 'Auguste Renoir and his Brother'. *Gazette
des Beaux-Arts* 6, no. 27 (March 1945):
171–88.

—, ed. *Paul Cézanne: Correspondance*.
See Cézanne.

Riopelle, Christopher. 'Renoir: The Great
Bathers'. *Philadelphia Museum of Art
Bulletin* 86, no. 367/368 (Fall 1990):
2–3, 5–40.

Rivière, Georges. *Renoir et ses amis*. Paris:
Floury, 1921.

—. 'L'Exposition des impressionnistes'.
L'Impressionniste: journal d'art 1 (6 April
1877): 2–6. Repr. in Venturi, *Les Archives
de l'impressionnisme*, vol. 2, 308–14.

Roberts, Jane. *Jacques-Émile Blanche*.
Montreuil: Éditions Gourcuff Gradenigo,
2012.

Robida, Michel. *Le Salon Charpentier
et les impressionnistes*. Paris: Bibliothèque
des Arts, 1958.

Roesch-Lalance, Marie-Claude. *Bourron-
Marlotte: si les maisons racontaient*.
Bourron-Marlotte: Amis de Bourron-
Marlotte, 1986.

Roger-Marx, Claude. *Renoir*. Paris: Floury,
1937.

Schapiro, Meyer. *Paul Cézanne*. 2nd ed.
New York: Abrams, 1962.

—. *Impressionism: Reflections and Perceptions*.
New York: Braziller, 1997.

—. 'The Nature of Abstract Art'. *Marxist
Quarterly* 1, no. 1 (January–March 1937):

2–23. Repr. in Meyer Schapiro, *Modern Art: 19th and 20th Centuries, Selected Papers.* New York: George Braziller, 1978, pp. 185–211.

Schneider, Marcel. 'Lettres de Renoir sur l'Italie'. *L'Âge d'or – études* 1 (1945): 95–9.

Schnerb, Jacques- Félix. 'Visites à Renoir et à Rodin: carnets inédits de Jacques-Félix Schnerb' (1907–09). *Gazette des Beaux-Arts* 101, no. 1368–73 (April 1983): 175–6.

Schulman, Michel. *Frédéric Bazille, 1841–1870: catalogue raisonné.* Paris: Éditions de l'Amateur, 1995.

Shiff, Richard. *Cézanne and the End of Impressionism: A Study of the Theory, Technique, and Critical Evaluation of Modern Art.* University of Chicago Press, 1984.

Shikes, Ralph E., and Paula Harper. *Pissarro: His Life and Work.* New York: Horizon Press, 1980.

Shimada, Hanako. 'L'Amitié entre Renoir et Umehara'. *Association des amis du Musée Renoir* 8 (Cagnes-sur-Mer, 2008): 6–15.

Silke, James R. 'Jean Renoir on Love, Hollywood, Authors, and Critics'. In Cardullo, *Jean Renoir Interviews*, pp. 121–36.

Sowerwine, Charles. *France since 1870: Culture, Politics and Society.* New York: Palgrave, 2001.

Spurling, Hilary. *Matisse the Master: A Life of Henri Matisse – The Conquest of Colour, 1909–1954.* New York: Knopf, 2005.

—. *The Unknown Matisse: A Life of Henri Matisse: The Early Years, 1869–1908.* New York: Knopf, 1999.

Steinberg, Leo. *The Sexuality of Christ in Renaissance Art and in Modern Oblivion.* Chicago and London: University of Chicago Press, 1996.

Stella, Dr Joseph G. *The Graphic Work of Renoir: Catalogue Raisonné.* London: Graham Johnson/Lund Humphries, 1975.

Tabarant, Adolphe. *Pissarro.* Paris: Rieder, 1924; New York: Dodd, Mead and Co., 1925.

—. 'Suzanne Valadon et ses souvenirs de modèle'. *Le Bulletin de la vie artistique* (December 1921): 626–9.

Thiébault-Sisson, François. 'Claude Monet'. *Le Temps* (27 November 1900). Interview, repr. in Rewald, *The History of Impressionism.* 4th ed, p. 197.

Todd, Pamela. *The Impressionists at Home.* London: Thames & Hudson, 2005.

Van Claerbergen, Ernst Vegelin, and Barnaby Wright, eds. *Renoir at the Theatre: Looking at La Loge.* Exh. cat. London: Courtauld Gallery; London: Paul Holberton, 2008.

Venturi, Lionello. *Les Archives de l'impressionnisme: lettres de Renoir, Monet, Pissarro, Sisley et autres. Mémoires de Paul Durand-Ruel. Documents.* 2 vols. Paris and New York: Durand-Ruel, 1939; repr. New York: Burt Franklin, 1968.

—. *Cézanne, son art, son oeuvre.* 2 vols. Paris: Paul Rosenberg, 1936. Repr., San Francisco: Alan Wofsy Fine Arts, 1989.

Vollard, Ambroise. *Pierre-Auguste Renoir: Paintings, Pastels and Drawings.* Paris: Vollard, 1918; repr. San Francisco: Alan Wofsy Fine Arts, 1989.

—. *Tableaux, pastels et dessins de Pierre-Auguste Renoir.* 2 vols. Paris: Vollard, 1918.

—. *La Vie et l'oeuvre de Pierre-Auguste Renoir.* Paris: Vollard, deluxe edn 1919; standard edn, *Auguste Renoir 1841–1919*, Paris: Crès & Cie., 1920; repr. 1954.

Waal, Edmund de. *The Hare with Amber Eyes: A Hidden Inheritance.* London: Chatto and Windus; New York: Farrar, Straus and Giroux, 2010.

Wadley, Nicholas, ed. *Renoir: A Retrospective.* New York: Hugh Lauter Levin, 1987.

Wawro, Geoffrey. *The Franco-Prussian War: The German Conquest of France in 1870–1871.* Cambridge University Press, 2003.

White, Barbara Ehrlich. *Impressionists Side by Side: Their Friendships, Rivalries, and Artistic Exchanges.* New York: Alfred A. Knopf, 1996. German edn, *Die Grossen Impressionisten-Befreundete Rivalen.* Munich: Kindler Verlag, 1996.

—. *Renoir: His Life, Art, and Letters.* New York: Abrams, 1984; repr. New York: Abradale, 1988; New York: Abrams, 2010. French edn, *Renoir.* Paris: Flammarion, 1985.

—. 'An Analysis of Renoir's Development from 1877 to 1887'. Ph.D. dissertation, Columbia University, 1965.

—. 'The *Bathers* of 1887 and Renoir's Anti-Impressionism'. *Art Bulletin* 55 (March 1973): 106–26.

—. 'Renoir', *Portraits* 2, no. 7 (Autumn 1992): 1–8.

—. 'Renoir et Jean, 1894–1919'. In Lemoine and Toubiana, *Renoir/Renoir*, pp. 51–9.

—. 'Renoir's Girl Outdoors: A Stylistic and Developmental Analysis', *North Carolina Museum of Art Bulletin* (September 1970): 12–28.

—. 'Renoir's Sensuous Women'. In Thomas B. Hess and Linda Nochlin, eds. *Woman as Sex Object: Studies in Erotic Art, 1730–1970.* New York: Newsweek, 1972, pp. 166–81.

—. 'Renoir's Trip to Italy'. *Art Bulletin* 51 (December 1969): 333–51.

—, ed. *Impressionism in Perspective.* Englewood Cliffs, NJ: Prentice-Hall, 1978.

White, Harrison C., and Cynthia A. White. *Canvases and Careers: Institutional Change in the French Painting World.* New York: John Wiley, 1965.

Wildenstein, Daniel. *Claude Monet: biographie et catalogue raisonné.* 5 vols. Lausanne: Bibliothèque des Arts; Paris: Fondation Wildenstein, 1974–91.

—. *Monet: or the Triumph of Impressionism.* 4 vols. Cologne: Taschen; Paris: Fondation Wildenstein, 1999.

Wilson-Bareau, Juliet, ed. *Manet by Himself: Correspondence and Conversation.* Boston: Bulfinch Press-Little Brown, 1991. French edn, *Manet par lui-même: correspondance et conversations.* Paris: Éditions Atlas, 1991.

Wyzewa, Téodor de. 'Pierre-Auguste Renoir'. *L'Art dans les deux mondes* (6 December 1890). Repr. with additions in Téodor de Wyzewa, *Peintres de jadis et d'aujourd'hui.* Paris: Perrin & Cie., 1903.

Yeatman, Evelyne. *Albert André.* Paris: Jouvé, 1990.

Zola, Émile. *Ecrits sur l'art.* Ed. Jean Pierre Leduc-Adine. Paris: Gallimard, 1991.

—. *Emile Zola: Salons.* Ed. E. W. J. Hemmings and Robert J. Niess. Geneva: Librairie Droz; Paris: Librairie Minard, 1959.

PHOTOGRAPH CREDITS

akg-images 85a

Alamy Jeremy Hoare 355

Bridgeman Images Museum of Fine Arts, Boston, Massachusetts/Picture Fund 8, 94;
The Art Institute of Chicago, Illinois/Mr. and Mrs. Lewis Larned Coburn Endowment; through
prior bequest of Annie Swan Coburn to the Mr. and Mrs. Lewis Larned Coburn Memorial Fund;
through prior acquisition of the R. A. Waller Fund 278; Musée Marmottan Monet, Paris 42a;
Barnes Foundation, Philadelphia, Pennsylvania/Bridgeman Images 86b, 198, 242; Private
Collection/Archives Charmet 203; Tallandier 320

Comité Caillebotte, Paris 172, 174

Dallas Museum of Art The Wendy and Emery Reves Collection, 1985.R.58. Image courtesy
Dallas Museum of Art 87a

Archives Durand-Ruel Photo Durand-Ruel & Cie 200a

Hartford, Wadsworth Atheneum Museum of Art The Ella Gallup Sumner and Mary
Catlin Sumner Collection Fund (1953.251). Photo Allen Phillips/Wadsworth Atheneum 245b

Los Angeles County Museum of Art (www.lacma.org) Gift through the Generosity
of the Late Mr. Jean Renoir and Madame Dido Renoir, M.79.40 245a

New York, Metropolitan Museum of Art The Walter H. and Leonore Annenberg Collection,
Gift of Walter H. and Leonore Annenberg, 1998, Bequest of Walter H. Annenberg, 2002 196;
Bequest of Stephen C. Clark, 1960 305; Catharine Lorillard Wolfe Collection, Wolfe Fund, 1970 91

Philadelphia Museum of Art Purchased with the W. P. Wilstach Fund (W1957-1-1) 133;
The Mr. and Mrs. Carroll S. Tyson, Jr., Collection (1963-116-13) 194b

RMN Musée d'Orsay, conservé au musée du Louvre, Paris. Photo RMN-Grand Palais
(musée d'Orsay)/image RMN-GP 64; Photo Musée d'Orsay, Dist. RMN-Grand Palais/Patrice
Schmidt 86a, 221; Photo RMN-Grand Palais (musée d'Orsay)/Jean-Gilles Berizzi 90b;
Photo RMN-Grand Palais (musée d'Orsay)/Hervé Lewandowski 195, 200b, 246b

Richmond, Virginia Museum of Fine Arts Collection of Mr. and Mrs. Paul Mellon 88b
(Photo Katherine Wetzel), 244

Scala, Florence Christie's Images, London 180

Drazen Tomic 6, 7

Toronto, Art Gallery of Ontario Gift of Reuben Wells Leonard Estate, 1954 (53/27) 248b

Washington, D.C., National Gallery of Art Collection of Mr. and Mrs. Paul Mellon (1985.64.35)
82a; Gift of Margaret Seligman Lewisohn in memory of her husband (1954.8.2) 243b

Williamstown, Massachusetts, Sterling and Francine Clark Art Institute photos Michael Agee
(1955.584) 89; (1955.609) 92b; (1955.589) 194a; (1955.611) 199

ACKNOWLEDGMENTS

My greatest debt is to Columbia Professor of Art History Meyer Schapiro, my mentor, teacher and inspiration, who in 1961 suggested a Renoir topic for my doctoral dissertation. With no Renoir letter anthology, he proposed I create an archive of copies of published and unpublished letters by, to and about Renoir, which now includes more than three thousand letters.

The Renoir family aided this letter quest: Renoir's son Claude (Coco) and his son Paul (who allowed me to Xerox the family letter archive); Jean's son, Alain; Claude junior's daughter, Sophie (always generous and helpful); the foster family of Jeanne Tréhot Robinet; Edmond Renoir junior; Julie Manet Rouart; Gabrielle's son; as well as numerous heirs of Renoir's artist and patron friends.

Renoir's dealers' heirs provided copies of primary source materials: Charles Durand-Ruel, Flavie Durand-Ruel, Paul-Louis Durand-Ruel, Claire Durand-Ruel Snollaerts and Caroline Durand-Ruel Godfroy. Also, most helpful were the Bernheim heirs: Guy-Patrice Dauberville and Michel Dauberville.

My thanks go to many public institutions with letters and photographs, especially Documentation Orsay and numerous archives in the USA, France, Brazil and Holland. Thanks also go to: Georges Alphandéry; Colin B. Bailey; Emily Beeny; Mathieu and Solange Bellanger; Roger Benjamin; Maurice Bérard; Jacqueline Besson; Elisa Bourdonnay; Richard Brettell; Norma Broudy; Augustin de Butler; Aline Cézanne; Philippe Cézanne; Marjorie Cézanne-Justet; M. and Mme Jacques Chardeau; Guy Cogeval; Anne Distel; Claudia Einecke; Alicia Faxon; Isabelle Gaëtan; Philippe Gangnat; Jean-Claude Gélineau; H. Spencer Glidden; Jean Griot; Gloria Groom; Gilbert Gruet; Michel and Corine Guino; Carlos van Hasselt; Jacqueline Henry; Robert L. Herbert; René Herbinière; M. and Mme Christopher Hottinger; John House; Anahid Iskian; Marc Le Coeur; Martha Lucy; J. Patrice Marandel; Paule Monacelli; Sophie Monneret; Delphine Montalant; Linda Nochlin; Monique Nonne; Maryse Olevera; Robert Parker; Sylvie Patry; Bernard Pharisien; Colette Pierreyre; Philippe Piguet; Joachim Pissarro; Katia, Lionel and Sandrine Pissarro; Eliza Rathbone; Cathie Reami; Christian Renaudeau d'Arc; Joseph J. Rishel; Jane Roberts; Denis Rouart; Yves Rouart; Agathe Rouart-Valéry; Manuel and Robert Schmit; Pierre Simon; John L. Slade;

Susan Stein; Jennifer Thompson; Serge Toubiana; Jean-Marie and Claire Joyes Toulgouat; Yves Tréton; Bernard Vassor; and Karl Wieck.

At Tufts University, where I taught from 1965, I have had wonderful student assistants, fluent in French, who helped me with my Renoir letter archive and with my Renoir writings: Zoé E. Bolesta; Bethany Peacemaker-Arrand Bonudei; Erin M. Bruynell; Sarah Elizabeth Ferguson; Jennifer Fidlon-Bugat; Karen R. Gerlach; Julie Rachel Levy; Florence Merle-Strauss; Dalia Palchik; Ruby H. Salter; David Smythe; Anna R. Vanderspek; and Margaret Jane Wiryaman. For three years, Léa Cavat (who had her primary and secondary education in Paris) improved my translations. Tufts staff were helpful: Rosalie Bruno; Amey C. Callahan; Christine Cavalier; Kathleen DiPerna; Ann Marie Ferraro; Joanne M. Grande; and Amy West.

Two eminent professors, Columbia University's Theodore Reff and University of Minnesota's Gabriel P. Weisberg, have been of great support.

Outside the world of scholarship, most helpful were: Lawrence Adamo; Mel Berger; Jim Dowrey (my wonderful computer consultant); John D. Goodson; Elisabeth Gracy; Stephen Greenwald; Didier and Martine Halimi; Gerald Harris; Alan Hedge; Paul S. Jellinger; Anne Miller; Jeremy N. Ruskin; and Stuart Wachter.

I want to thank my extraordinary Thames & Hudson/London team: Roger Thorp, Amber Husain, Kate Burvill and my marvellous editor, Katharine Ridler; and my Thames & Hudson/New York team: Christopher Sweet, Harry Burton and Sarah Thegeby.

Finally, thanks to my literary agent Claudia Cross and my international rights agent Melissa Sarver White of Folio Literary Mgt.

This book, which took twelve years to write, owes much to the love and support of those closest to me – my husband and best friend, Leon S. White, and my sons David S. White and Joel S. White, Joel's wife, Heidi Boncher, and their children, my granddaughters, Ella Rae White and Nina Ariel White.

Barbara Ehrlich White, PhD
Adjunct Professor of Art History Emerita,
Tufts University, Medford, Massachusetts
Chevalier des Arts et des Lettres

INDEX

Numbers in *italics* refer to black and white illustrations and photographs; numbers in **bold** refer to colour plates. Unless otherwise specified all works are by Renoir and are on canvas or paper.